European Furniture in The Metropolitan Museum of Art

EUROPEAN FURNITURE
in The Metropolitan Museum of Art
Highlights of the Collection

Daniëlle O. Kisluk-Grosheide · Wolfram Koeppe · William Rieder

Photography by Joseph Coscia, Jr.

The Metropolitan Museum of Art, New York

Yale University Press, New Haven and London

Foreword

Visitors to the European Sculpture and Decorative Arts galleries and period rooms at The Metropolitan Museum of Art enjoy one of the finest collections of European furniture in the world. The curatorial staff of the department as well as outside specialists research and regularly write about these objects in essays for scholarly journals and exhibition catalogues, and the new information reaches the general public by way of wall labels, websites, and audio tours. Yet neither the collection as a whole nor a selection of its most interesting pieces has ever been the subject of a significant publication.

This eagerly awaited volume presents 103 superb pieces of furniture. Every aspect of these Museum objects is examined, from their craftsmanship to their collection history. The works are of many types and styles, but all were chosen for their exceptionally high level of quality. Most are of French, English, German, or Italian origin, reflecting major areas of departmental strength, but there are more than a few outstanding examples from other countries as well. They range in date from the Renaissance, through the collection's high point in the eighteenth century, to the last quarter of the nineteenth century.

The three authors of this volume—Daniëlle O. Kisluk-Grosheide, Wolfram Koeppe, and William Rieder—have long experience of this collection, as their numerous publications listed in the bibliography attest. All three began their careers at the Museum during the time when James Parker, who died in 2001 and to whom this volume is dedicated, was the principal curator of furniture in the department.

It is a pleasure to recognize the role played in the genesis of this book by my predecessor, Olga Raggio. She supervised the acquisition of many of the objects discussed here, and her expertise was a valuable resource for the authors. In the field of decorative arts, curators work closely with conservators and scientists. The contributions of members of the Departments of Objects Conservation and Scientific Research are gratefully acknowledged. New photography is an important element of this book. Joseph Coscia, Jr.'s images reveal to the reader not only the beauty of the furniture but also the intricacies of each piece's fabrication. Multiple views and details are an invaluable aid to comprehending furniture's many aspects. Accordingly, a CD-ROM of supplementary images has been added to this volume—for the first time in a Museum publication. None of this would have been possible without the approval of Director Philippe de Montebello, whose insistence on excellence set the standard for this as for all projects in the Museum.

As the introductory chapter documents, the Metropolitan's European furniture collection reflects the taste and generosity of a number of private collectors, beginning a century ago. One of the guiding lights of its formation and enrichment, Mrs. Charles Wrightsman, remains an inspiration to and active supporter of the department. Through the Friends of European Sculpture and Decorative Arts, under the presidency of Frank R. Richardson, she and a number of other collectors generously subsidized some expenses of this publication. Another "Friend," Andrew Augenblick, made an additional gift. The authors and the department are grateful to all of these supporters for making possible the publication of this splendid and timely book, which we hope will be the first in a series on the departmental collections.

Ian Wardropper
Iris and B. Gerald Cantor Chairman,
European Sculpture and Decorative Arts

Acknowledgments

The authors are most grateful to Philippe de Montebello, Director of the Metropolitan Museum, for his enthusiastic support of this publication from its inception. Special thanks are due to Ian Wardropper, Iris and B. Gerald Cantor Chairman of the Department of European Sculpture and Decorative Arts, for his unfailing encouragement.

We express our appreciation to Shirley Allison, Elizabeth Lee Berszinn, Roger Haapala, Marva Harvey, Robert Kaufmann, Jeffrey Munger, Marina Nudel, Erin E. Pick, Olga Raggio, Melissa Smith, Clare Vincent, Melinda Watt, and all the other members of our department for their assistance in various ways. In particular we thank Rose Whitehill for compiling the glossary. We wish to acknowledge the efforts of former and current departmental technicians William Kopp, Eric Peluso, and Bedel Tiscareño, who safely transported pieces of furniture for examination, treatment, and photography, and Denny Stone, Collections Manager, who coordinated many of these moves. We are grateful to Charlotte Vignon and Florian Knothe, Annette Kade Art History Fellows, for their contributions.

Every art book must have good illustrations. Thanks to Joseph Coscia, Jr., Associate Chief Photographer at the Metropolitan, this book has the very best. We appreciate the kind assistance of Barbara Bridgers, General Manager for Imaging and Photography, The Photograph Studio, and her staff, especially that of Robert Goldman and Thomas Ling. We are much indebted to Lawrence Becker, Sherman Fairchild Conservator in Charge, Objects Conservation Department, and to conservators Linda Borsch, Nancy C. Britton, Marijn Manuels, Pascale Patris, and Richard E. Stone. We are especially grateful to conservator Mechthild Baumeister for her willingness to share her time and expertise helping us to analyze various woods and explaining technical aspects of furniture construction.

In the Editorial Department, we thank John P. O'Neill, Editor in Chief, for supervising every aspect of the book's editorial preparation and production and for allowing us to miss several deadlines. Special thanks go to our unsurpassed editor, Ellyn Allison, who, in her very kind and self-effacing manner, smoothed out the manuscripts of three authors who sometimes contradicted each other. Without the painstaking efforts of Jayne Kuchna, the references in the endnotes and the bibliography would have been filled with errors and omissions. Minjee Cho carefully directed the setting, layout, and revisions of the type. Our warm thanks go to Douglas J. Malicki, who oversaw the production of the book and the CD-ROM, and to Peter Antony, Chief Production Manager. Bruce Campbell was responsible for the elegant design. We are grateful to Catarina Tsang and David Weinstock for their fine work on the CD-ROM and to Elaine Luthy for her meticulously prepared index.

Kenneth Soehner, Arthur K. Watson Chief Librarian, and the staff of the Thomas J. Watson Library made it possible for us to carry out the necessary research by ordering new publications for the project and accommodating countless requests for interlibrary loans. We owe many thanks as well to archivist Jeanie M. James for carefully checking crucial facts.

Family, friends, and colleagues in other institutions have read our manuscripts, shared information, and offered useful advice. We are particularly indebted to Janice Barnard, Christian Baulez, Renate Eikelmann, C. Willemijn Fock, John Hardy, Eugene J. Kisluk, Jörn Lohmann, Michelangelo Lupo, Edmée Reit, Bertrand Rondot, Achim Stiegel, and Lucy Wood.

Daniëlle O. Kisluk-Grosheide, Wolfram Koeppe, and William Rieder
Curators, European Sculpture and Decorative Arts

Notes to the Reader

The Book

One hundred and three pieces of furniture in the Museum's collection are featured in this book. Each is shown in a large color illustration that bears the number of the object and its entry. All other illustrations in the entries are numbered consecutively, from Figure 1 in the first entry to Figure 138 in the last. The illustrations in the introductory chapter are not numbered.

In the entry headings, information about each object is always given in the same sequence; the omission of any line of information, such as the name of the maker, indicates that the information is not available or that the line is not applicable. The name of each object is given in English, followed by the name in the original language if that name is also in common use. Birth and death dates of makers, designers, and others who worked on the furniture are given in the heading when they are known. Life dates for other significant persons are given in the text. Measurements are given to the nearest eighth of an inch, with the height preceding the width, preceding the depth.

The author's initials follow the text of each entry. Translations of quoted material are by the authors unless otherwise stated in the notes. When "left" and "right" are used in descriptions of furniture, the viewpoint is always the observer's.

Bibliographical references are cited in the notes in abbreviated form. The corresponding full citations are given in the bibliography.

The symbol CD is used in the entries to indicate that a pertinent image may be found on the CD-ROM (see below). These references are to images that illustrate a point in the text or enrich a description of the furniture in a way that the book illustrations do not do. There are many more images on the CD-ROM than are referred to in the entries; the reader is encouraged to use the disk whenever possible to enhance enjoyment and appreciation of the book.

The CD-ROM

Additional images are accessible on a CD-ROM disk in a sleeve at the back of the book. They include full views, zooms, and details of the featured pieces and some additional images of matching furniture. Warranty, license-agreement, and permitted and prohibited use information is given on the last screen of the CD-ROM. The sequence of objects in the book is the same as that on the CD-ROM. Go to "Contents" (the second screen) to find a link to the object you want to study in greater detail.

Following are instructions for installing and running the CD-ROM:

Minimum System Requirements (Mac): 660MHz G3 running Mac OS x 10.2 with 256 MB memory and a CD-ROM drive. **To open:** double click the MET file located on the CD-ROM.

Minimum System Requirements (PC): Windows 2000/XP.1.2 GHz (2 GHz recommended) with 256 MB of memory (512 MB recommended) and a CD-ROM drive. **To open:** The file should auto-run. If it does not, double-click the MET.exe file located on the CD-ROM.

European Furniture in The Metropolitan Museum of Art

A Brief History of the Collection

DANIËLLE O. KISLUK-GROSHEIDE

The collection of postmedieval European furniture at The Metropolitan Museum of Art bears witness to the sophisticated taste of several generations of generous donors and committed trustees, as well as to the foresight and connoisseurship of astute Museum curators. Its range and depth are impressive, and as this book attests, it boasts a wealth of objects that are not only exemplary in their beauty and craftsmanship but also of great historical and cultural interest. Most of the pieces discussed in this volume are currently on display and are enjoyed by thousands of visitors each year in a series of permanent galleries and in European period-room settings for which the Museum is equally renowned.

In a statement issued to the public on 3 March 1871, the founders of the Metropolitan declared that the institution should have among its holdings representative examples not only of painting and sculpture but also of the decorative arts. It was their intention and special wish "to begin at an early day the formation of a collection of industrial art, of objects of utility to which decorative art has been applied, ornamental metal-work, carving in wood, ivory and stone, painted glass, glass vessels, pottery, enamel, and all other materials." The Museum officers further observed that the political and social changes then taking place in Europe made that time a particularly favorable one for purchasing decorative items and that the need to form such a collection as tasteful models for "our mechanics and students" was most pressing. The collection would clarify for the design student "what can be done in art, and where the limits are set[,] to overpass which is excess and consequent failure."

Although European furniture was not specifically mentioned in the statement, it must certainly have been the founders' intention to acquire in this area as well. Gifts and purchases of European furniture during the first three decades of the Museum's existence were neither numerous nor exceptionally memorable, but that situation began to change after the turn of the century, when several significant German pieces were acquired. In 1903 an ivory collector's cabinet (no. 13) made in Augsburg between 1655 and 1659, but initially thought to be eighteenth-century Italian, was bought at the estate sale of Henry G. Marquand (1819–1902). A discriminating collector and patron (see also the entry for no. 103), Marquand was one of the founding trustees and benefactors of the Museum and had served as its president from 1889 to 1902. Two years later, an imposing Nuremberg *Fassadenschrank* (cupboard with an architectural facade) was added to the collections (no. 8). Both of these purchases, and many others over the years, were made possible through a generous endowment fund established by Jacob S. Rogers (d. 1901), a manufacturer of locomotives in Paterson, New Jersey, for the purpose of acquiring art objects and books. With other funds, such as those received in 1917 from Isaac D. Fletcher (ca. 1845–1917), a director of coal companies, the Museum made additional acquisitions of furniture.

A number of exceptional gifts and bequests have made the Metropolitan's collection one of the most important in the world.

Its initial strength in French furniture was the result of a gift in 1906 from the financier and philanthropist J. Pierpont Morgan (1837–1913), who was elected the Museum's president in 1904. Earlier in 1906, Morgan had purchased, for four million French francs, the collections of French eighteenth-century and medieval art assembled by the Parisian architect, decorator, and ceramist Georges Hoentschel (1855–1915). Both collections were housed in a special gallery built for that purpose on the boulevard Flandrin in Paris (see illustration below). Whereas the medieval works of art were merely a loan, Morgan presented the French decorative artworks to the Museum outright. By May 1907, 364 packing cases containing the Hoentschel collections were stored in the Museum's basement. The eighteenth-century portion, comprising more than 1,600 objects, included furniture, several pieces of which had a royal provenance (see no. 46); a study collection of woodwork; and some 750 gilt-bronze mounts. This unrivaled gift led not only to the establishment of a Department of Decorative Arts, with Rembrandt scholar William R. Valentiner as curator, but also to the creation of a new wing designed by the architects McKim, Mead and White, which opened to the public on 15 March, 1910 (see illustration on page 3). Over the years, the department underwent many changes. In 1935 its present scope

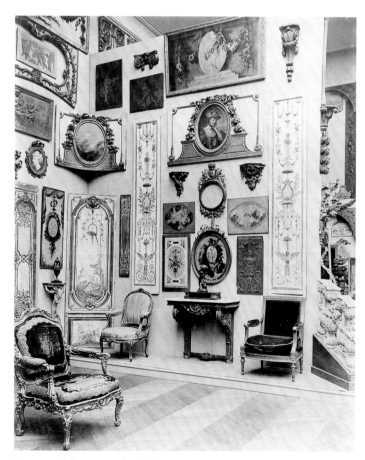

Photograph from an undated album showing some of the French objects in the Georges Hoentschel collection at 58, boulevard Flandrin, Paris.

was determined, and in 1977 it assumed its current title, Department of European Sculpture and Decorative Arts—ESDA, for short.

Significant pieces of European furniture entered the Museum through the generosity of other New York donors, such as William K. Vanderbilt (1848–1920). In his bequest, Vanderbilt left the Metropolitan a famous black-lacquer and gilt-bronze secretary and matching commode made by the French cabinetmaker Jean-Henri Riesener for Queen Marie Antoinette (nos. 82, 83). Today they are possibly the best-known pieces of royal furniture outside France. Subsequent benefactors presented outstanding objects that had also been commissioned for the use of the unfortunate queen. In 1941 Ann Payne Blumenthal (d. 1973), the second wife of George Blumenthal (1858–1941), a trustee of the Museum and for seven years its president, donated a daybed, armchair, and fire screen by Jean-Baptiste-Claude Sené for Marie Antoinette's Cabinet de Toilette at the Château de Saint-Cloud (nos. 86–88). Three years later, Susan Dwight Bliss (d. 1966) enriched the collections with an armchair from Versailles by François Foliot II (no. 74), and at the end of the decade the Museum received a mechanical table (no. 77) from the estate of the stockbroker and well-known collector of old master paintings Jules S. Bache (1861–1944). This last piece was the second table by Riesener with a Versailles provenance to enter the Museum. An earlier table by the queen's favorite cabinetmaker (no. 73) had been an astute purchase at the 1932 sale that dispersed the contents of the Blumenthal residence in Paris.

The cultural foundation established in 1929 by the chain-store magnate, art collector, and philanthropist Samuel H. Kress (1863–1955) made an unprecedented gift to the Metropolitan in 1958. Consisting mostly of French decorative artworks, it included many delightful pieces of Sèvres porcelain and no fewer than seventeen porcelain-mounted objects, a large number of which had been amassed by a banker to the British royal family, Sir Charles Mills (1792–1872). The generosity of the Kress Foundation has made the Museum the foremost repository in the world of porcelain-mounted furniture and the envy of many another institution (see nos. 63, 67).

Meanwhile, the fledgling Department of Decorative Arts was augmenting the Museum's holdings of English furniture. The pace was slow at first but quickened markedly in 1914 with a bequest from former assistant secretary of state John L. Cadwalader (d. 1914). A member of the Museum's board of trustees from 1901 until his death, Cadwalader left the Metropolitan thirty-three pieces of British eighteenth-century furniture and twice that many examples of Chelsea porcelain. Growth in this field continued with the 1918 purchase of twenty-three English objects, mostly chairs (for example, no. 19), from the collection of George S. Palmer (1855–1934), a textiles manufacturer in New London, Connecticut. Palmer's outstanding collection of American furniture was acquired by the Museum as well. In 1924 three permanent galleries were installed to house the Museum's by then

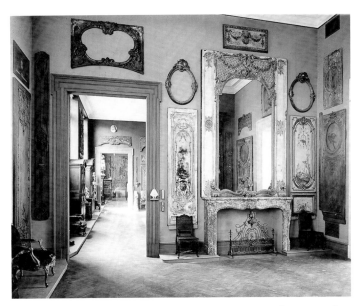

The French decorative-arts galleries in the Morgan Wing at the Metropolitan Museum shortly after they opened, in 1910.

considerable holdings of English furniture, which ranged in style from Elizabethan to Sheraton. They formed a modest complement to the American Wing, which had opened on the north side of the Museum the same year. The spacious new galleries (see illustration on page 4, above) were quickly filled with additional purchases, among them—in 1926—a striking Palladian side table attributed to the carver Matthias Lock (no. 43). Also in 1926 the Museum acquired the so-called Backgammon Players Cabinet (no. 99). Decorated with a painting by Sir Edward Burne-Jones, it had been made by Morris, Marshall, Faulkner and Company for the London International Exhibition of 1862. Appreciation of nineteenth-century exhibition pieces was still in its infancy—there was, in fact, a general contempt for furniture from the Victorian era—thus, this acquisition showed remarkable foresight.

During the Depression the Museum obtained two outstanding mid-eighteenth-century rooms: the Dining Room from Kirtlington Park, Oxfordshire, and the Dining Room from Lansdowne House, in London. They were kept in storage until the 1950s, when a third example, the Tapestry Room from Croome Court, Worcestershire, was given by the Kress Foundation (see fig. 93). The installation of all three period rooms prompted additional purchases and donations of English furniture, such as the marquetry-decorated cabinet on stand from the Marion E. and Leonard A. Cohn collection (no. 24). None, however, shaped the Museum's holdings of English art so markedly as did the many gifts and large bequest of Irwin Untermyer (1886–1973). A justice of the appellate court in New York and for many years a Museum trustee, Untermyer collected voraciously in the fields of European bronzes and English silver, needlepoint, and porcelain, but his great passion was clearly English furniture. Numerous pieces made

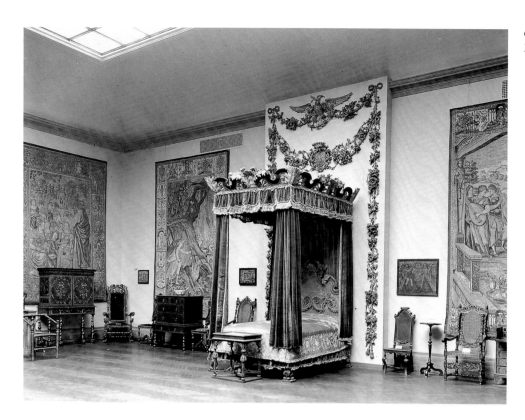

of oak, walnut, and mahogany—all of very high quality—that once furnished Judge Untermyer's Fifth Avenue apartment (see illustration below) now line the walls of the Museum's Annie Laurie Aitken Galleries. A selection is included in this publication. One of the most distinguished is a beautiful mahogany china table in the style of Thomas Chippendale (no. 55).

In 1973 the news of an unexpected bequest reached the Museum. The gift included not only Impressionist and Postimpressionist paintings and a choice group of German silver and porcelain pieces that would bring depth to an area already well represented in the Museum but also a splendid assemblage of Rococo furniture from southern Germany and France. A warm regard for the Metropolitan, fostered by furniture curator James Parker, had convinced Emma Alexander Sheafer (1891–1973), the widow of stockbroker Lesley G. Sheafer (d. 1956), to make this princely gift. Although their initial interest had been in contemporary American paintings and furniture, Mr. and Mrs. Sheafer shifted their attention after World War II to French and German art. They made purchases in Hamburg and Munich at a time when the German decorative arts were generally not fashionable in America. Mrs. Sheafer's bequest included a unique set of garden-room seat furniture from Schloss Seehof near Bamberg (see no. 61). It had graced the Sheafers' apartment in Manhattan for many years (see illustration on page 5, above).

Quite early in its history, the Museum bought some magnificent Italian Renaissance pieces. One of them, a Florentine marriage chest, or *cassone*, with a painted battle scene inset on the front, was a particularly fortunate purchase in 1916 (no. 2). Dating to the 1460s, it is one of a very few *cassoni* that have been preserved with their painted decoration intact. Other notable Italian acquisitions were, in 1930, a late-fifteenth-century *sgabello* chair and, in 1958, a magnificent inlaid marble and *pietre dure* table (nos. 5, 7). A rare example of a practical form invested with humanistic meaning, the former is illustrated in many books on furniture.

The latter was designed to fill a focal position in the state rooms of the Farnese Palace in Rome. Important Italian objects from the Baroque and Rococo periods made their way into the Museum during the late 1960s and early 1970s through the generosity of Lilliana Teruzzi (1899–1987), a former opera singer. While living in Italy before World War II, she purchased such outstanding pieces of Roman furniture as a highly sculptural display case and a pair of striking fourteen-foot-high bookcases from the Palazzo Rospigliosi (nos. 15, 33). An Italian table reflecting the late-eighteenth-century fashion for ancient Egyptian art (no. 70) was a gift of the investment banker and art collector Robert Lehman (1892–1969) in 1941, the year he became a trustee of the Metropolitan Museum. It was the only Lehman object to enter the European decorative-arts department. The collection assembled by Robert and his father, Philip Lehman, known for its strength in Italian Renaissance and early Northern Renaissance paintings, old master drawings, and works in majolica and Venetian glass,

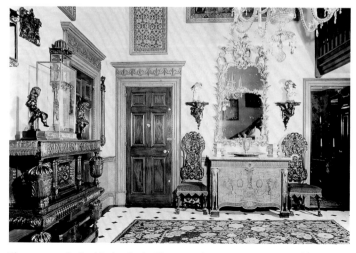

The entrance hall of Judge Irwin Untermyer's apartment at 960 Fifth Avenue, New York, in 1974.

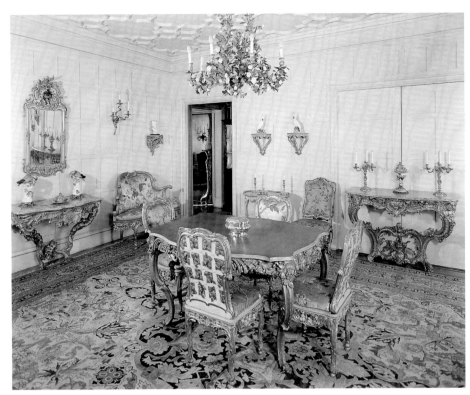

was to be housed in a special wing at the Museum named for the donor that opened in 1975.

Old master paintings, Renaissance bronzes, porcelain figures from various European manufactories, and furniture came in 1982 as a gift from Belle Linsky (d. 1987). She and her husband, Jack Linsky (1897–1980), who had developed a modest stationery business into a large and successful corporation, amassed their diverse and exemplary collection largely in New York. Outstanding pieces of French furniture—several by makers whose work was not yet displayed in the Museum, such as a commode by the French *ébéniste* Charles Cressent (no. 44) and a mechanical table ordered from Jean-François Oeben by Madame de Pompadour (no. 60)— further fleshed out the Museum's holdings of French art (see illustration at right).

By far the most important donors to the Museum in the area of French furniture and decorative arts have been Mr. and Mrs. Wrightsman. The discerning taste, specialized interest, and unsurpassed generosity of the oil executive Charles B. Wrightsman (1895–1986) and his wife, Jayne, have made the Museum's collection of French furniture and furnishings world-renowned. Splendid pieces, frequently with a royal association (see nos. 57, 84, 89), are on view in the period rooms and permanent galleries that fittingly bear the Wrightsmans' name (see illustration on page 6). Many objects were gifts from their private collection, one of the finest in the country, which they began to assemble in 1952. Others were acquired with the Museum in mind and paid for by the Wrightsman Fund. Widowed in 1986, Mrs.Wrightsman, who is a trustee of the Museum and was for many years the chairman of the Acquisitions Committee, has continued her support of and interest in the institution, as the marvelous additions of the past two decades illustrate. For instance, the installation in 1987 of a state bedchamber—a room devoted to the arts of the French Baroque—led to the purchase not only of an exquisite marquetry table by Pierre Gole (no. 14) but also of a unique writing desk by

Alexandre-Jean Oppenordt, one of the few surviving pieces of furniture executed for Louis XIV (no. 17). More recent acquisitions that were made possible by Mrs. Wrightsman have not been restricted to French works of art. They include a rare English gilt-wood chandelier and an exquisite table made almost entirely of Berlin porcelain (nos. 30, 96).

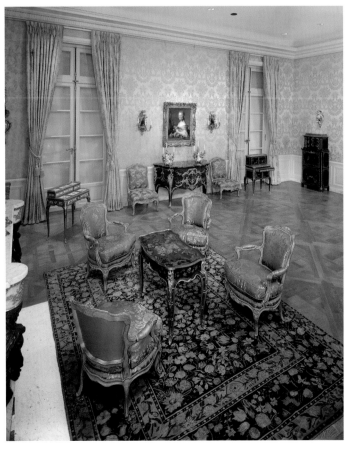

The Jack and Belle Linsky salon at the Metropolitan Museum in 1984. The Metropolitan Museum of Art, The Jack and Belle Linsky Collection, 1982.

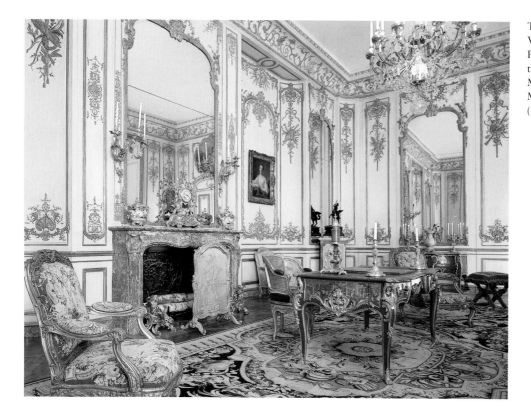

The Varengeville Room, from the Hôtel Varengeville, 217, boulevard Saint-Germain, Paris, part of the Wrightsman Galleries at the Metropolitan Museum about 1995. The Metropolitan Museum of Art, Purchase, Mr. and Mrs. Charles Wrightsman Gift, 1963 (63.228.1).

Despite rising prices and strong competition among institutions worldwide for major pieces of furniture, the Museum has been able to secure objects of exceptional beauty and historical interest for its collections during the past two decades. The purchase in 1995 of a floral-marquetry cabinet on stand attributed to Jan van Mekeren (no. 27), a welcome addition to the small group of Dutch objects already in the Museum, reflects a departmental determination to expand in areas that are less well represented. In 2002 the successful pursuit of a cut-steel center table made at the Tula armory and formerly at Pavlosk Palace (no. 79), for instance, brought the first piece of what is hoped will be a representative collection of Russian furniture to the Museum. Efforts to improve the nineteenth-century holdings, stimulated by the planning of the Iris and B. Gerald Cantor Galleries for nineteenth-century sculpture and decorative arts, which opened in 1991, are gradually beginning to pay dividends. Through gifts and purchases, several important examples have enriched the department. One of the most notable of these is an extraordinary Merovingian-style armoire made by Charles-Guillaume Diehl, Emmanuel Frémiet, and Jean Brandely (no. 101). Future acquisitions will undoubtedly fill other gaps and further augment the superior collection of European furniture that is among the glories of The Metropolitan Museum of Art.

Over the years, various curators and their colleagues in other institutions have written about aspects of the furniture holdings in the Museum's *Bulletin* and *Journal*, in other periodicals, and in exhibition catalogues, many of which are listed in the bibliography of this book. Between 1958 and 1973 Yvonne Hackenbroch and Sir Francis J. B. Watson compiled comprehensive multivolume catalogues of the Untermyer and Wrightsman collections, respectively. In 1964 the furniture donated to the Museum by the Samuel H. Kress Foundation was published with the rest of the gift in a volume written by James Parker, Edith Appleton Standen, and Carl Christian Dauterman. And, celebrating the opening of the Linsky Galleries, *The Jack and Belle Linsky Collection in The Metropolitan Museum of Art*, a catalogue of both the fine and the decorative arts, was issued in 1984. Though these are all important scholarly works, they are specialized. Given the importance of the European furniture assembled at the Metropolitan, it is surprising that no publication has yet been devoted to the collection as a whole or even to a selection of some of the choicest objects. We are therefore pleased to present this volume to the public and hope that the glorious furnishings discussed and illustrated on its pages and in the accompanying CD-ROM will receive the widespread recognition that they deserve.

Highlights of the Collection

1.

Cupboard (*credenza* or *armadio*)

Italian (Florence or Siena), ca. 1450–80
Poplar wood and walnut inlaid with various
woods; iron locks, handles, and key
H. 45 ½ in. (115.6 cm), w. 86 in. (218.4 cm),
d. 25 in. (63.5 cm)
Rogers Fund, 1945
45.39

Like many of his contemporaries, the historian Benedetto Dei (1418–1492) admired the illusionistic effects that the Florentine artisans who specialized in wood inlay, or intarsia, were achieving. In his *Memorie* (1470) he remarked that he had been in Florence at the time when these craftsmen began making "intarsia perspectives and figures in [such] a way that they seemed [to be] painted."[1] By this he meant that, like the Florentine painters, they had learned to construct scenes, objects, and three-dimensional patterns according to the rules of perspective.

The intarsia cutters worked with a "palette" of small pieces of wood of many different types and colors, inserting and gluing them into cutout hollows of a wooden matrix, such as the walnut carcase of this cupboard. The woods used for intarsia were generally available locally from timber merchants, or they might be supplied by the patron—perhaps a wealthy individual who had ordered a chest inlaid with scrolls in the Moorish style, or a religious body or communal institution that required doors, cabinets, or choir stalls inlaid with pictorial scenes.[2] Federigo da Montefeltro (1422–1482), the duke of Urbino, had the walls of his small study, or *studiolo*, at Gubbio covered entirely with intarsiated paneling, which is today one of the glories of the Metropolitan's collection.[3]

Several of the decorative motifs seen in the intarsia of the Museum's cupboard are executed in a form of inlay called *tarsia a toppo* (see fig. 1). For this type of work the craftsman would assemble hundreds of tiny pieces of wood of different species and various geometric shapes, glue them together to form a solid block, and cut them into slices,

which he then inserted in geometric patterns into a solid wooden matrix.[4] That the work of manipulating the minute pieces required intense concentration and extraordinary dexterity is evident when one looks below the doors of this cupboard at the base, whose pattern recalls water- or wind-driven machinery or bridges. The perspectival and mechanical studies of Leonardo da Vinci, Piero della Francesca, and Francesco di Giorgio come inevitably to mind.[5] The equally intricate *tarsia a toppo* inlay on the doors is in the abstract Moorish interlace style, reflecting influence from the Islamic world.[6]

If the *tarsia a toppo* decoration on the cupboard attests to the skill of the human hand, the large, finely grained walnut panels in the center of the doors may be said to represent the simple beauty of natural materials. Like the slabs of alabaster on top of the Farnese table (see the entry for no. 7) they center and balance the whirl of ornament around them.

Credenze (sideboards or cupboards) are frequently mentioned in Italian inventories of the fifteenth century, and there is pictorial evidence that the form with two doors was fully developed by this time.[7] For example, a painting of 1482 by Filippino Lippi (ca. 1457–1504) shows the Virgin Mary kneeling in a contemporary bedroom setting beside a cupboard much like the Museum's example.[8] The type developed from simple trestle tables that were set against a wall and often covered with sumptuous textiles.[9] The undecorated top of the Museum's cupboard may once have been covered by an Arabian or Coptic carpet with colorful interlace border designs like those that are imitated in the door inlay.[10] Such textiles would have made an appropriate backdrop for the display of choice objects and fine plate. A similar "credenza of cupboard form" appears in a Venetian woodcut of 1517 showing a room for dining and living.[11] The doors of the cupboard are ajar, suggesting that precious and practical objects like metal candle-

sticks or the large basin standing on top could be stored within.

Rather than furnishing a domestic interior such as the two just mentioned, the Museum's cupboard may have been made for a church or monastery, where it would have been used to secure embroidered vestments or liturgical vessels. Neither the wrought-iron handles on the doors nor the design of the inlay nor any other detailing, however, identify the piece as a "sacristy cabinet," as it was classified when the Museum acquired it.[12] The ornamental vocabulary of the intarsia cutters tended to be much the same for ecclesiastical and secular furniture.

In whatever setting it found a place, undoubtedly the cupboard's role was to affirm the prestige of the owner through the beauty of its craftsmanship and to protect the contents committed to it from thievish fingers. By good fortune, it is still accompanied by a contemporary, finely crafted key that fits the iron locks perfectly.[CD] W K

1. Quoted in Wilmering 1999, p. 3. See also C. E. Gilbert 1988, pp. 202–3.
2. Wilmering 1999, p. 3.
3. Acc. no. 39.153. On its acquisition by the Museum, see Raggio 1999, pp. 3–11.
4. Wilmering 1999, p. 64; see also pp. 68–73.
5. Toni 1987; Raggio 1999, p. 125, fig. 5-82, p. 155, fig. 5-131.
6. Patterns similar to those in the *toppo* borders of the Museum's cupboard doors appear on the paneling in the sacristy of Santa Croce in Florence.
7. P. Thornton 1991, pp. 205–29.
8. Filippino Lippi, *Annunciation*, Museo Civico, San Gimignano; ibid., p. 182, pl. 200.
9. Frick Collection 2003, p. 470 (entry by Wolfram Koeppe).
10. Gruber 1994, pp. 54–57, 70, 110; and Paolini 2002, pp. 70–72, no. 10, detail photograph on p. 71.
11. The term was used by Peter Thornton in a discussion of the many forms and uses of these cabinets; see P. Thornton 1991, p. 196 (the woodcut is illustrated as pl. 220).
12. On "sacristy cabinets," see Massinelli 1993, pl. XV; Paolini 2002, pp. 57–61, nos. 4, 5. See also a related "sacristy" cabinet in the Detroit Institute of Arts (acc. no. 35.60).

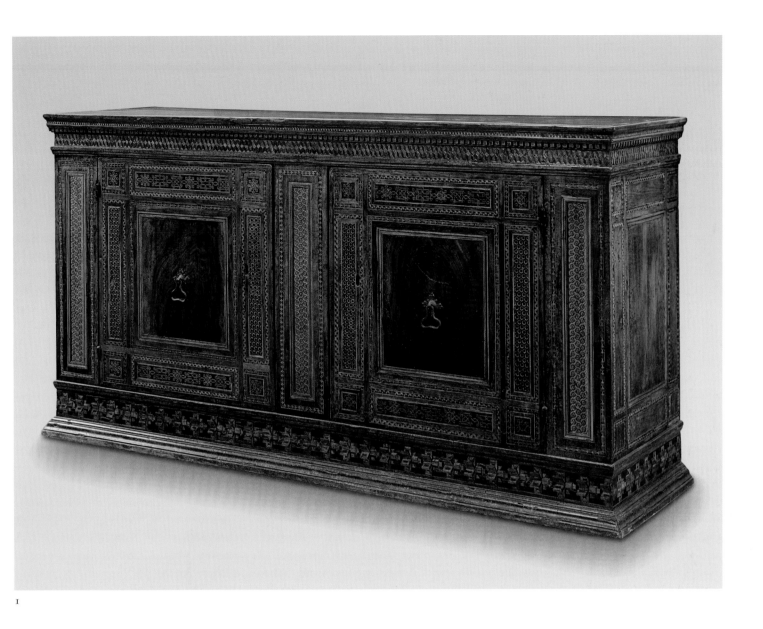

1

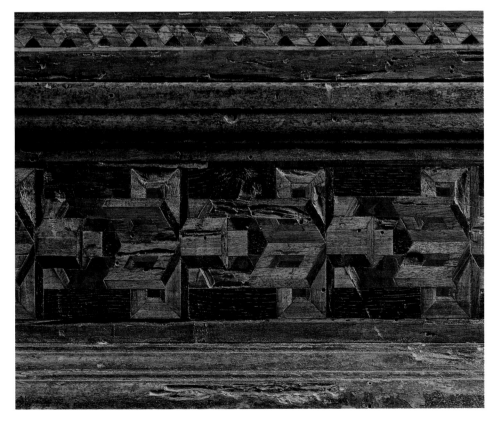

Fig. 1. Detail of the geometric *tarsia a toppo* inlay on the base of the cupboard.

2.

Chest (*cassone*)

Italian (Florence), after 15 August 1461 and possibly around the summer of 1465
Attributed to the workshop of Apollonio di Giovanni di Tomaso (ca. 1415/17–1465) and Marco del Buono di Marco (1403?–1489)
Poplar wood, linen, and polychromed and gilded gesso; the front panel painted in tempera and gold
H. 39½ in. (100.3 cm), w. 77 in. (195.6 cm), d. 32⅞ in. (83.5 cm); front panel 15¼ x 49½ in. (38.7 x 125.7 cm)
John Stewart Kennedy Fund, 1914
14.39

In his *Lives of the Most Eminent Painters, Sculptors, and Architects,* published in 1550 and 1568, Giorgio Vasari (1511–1574) devoted little space to the decorative arts. He did, however, comment at some length on the elaborately embellished marriage chests called *cassoni,* which he said were painted by some of the best artists of the mid-fifteenth century: "The citizens of those times used to have in their apartments great wooden chests in the form of a sarcophagus, with the corners shaped in various fashions, and there were none that did not have the said chests painted; and besides the stories that were wrought on the front and on the ends, they used to have the arms, or rather, insignia of their houses painted on the corners, and sometimes elsewhere. And the stories that were wrought on the front were for the most part fables taken from Ovid and from other poets, or rather, stories related by the Greek and Latin historians, and likewise chases, jousts, tales of love, and other similar subjects, according to each man's particular pleasure. Then the inside was lined with cloth or with silk, according to the rank and means of those who had them made, for the better preservation of silk garments and other precious things. . . . And for many years this fashion was so much in use that even the most excellent painters exercised themselves in such labours, without being ashamed, as many would be today, to paint and gild such things."[1] Although there are indications that marriage chests were in use throughout Italy, from the Trentino to Calabria, many of the most outstanding examples were likely made in Florence.[2] There, the decorative artists, and especially the *pittori di casse,* the painters of chests, formed a special subunit of the Florentine Guild of Saint Luke, the association of painters. What is more, the documentation on painted *cassoni* is richest in Florence. The workshop ledgers of Apollonio di Giovanni di Tomaso and his partner, Marco del Buono di Marco, who most probably made the Metropolitan's *cassone,* are still extant. Covering the years 1446 to 1463, they indicate that the workshop was very active; in the year 1452 alone it produced twenty-three pairs of chests.[3]

Very few *cassoni* have survived intact; most have been stripped of their painted panels, which today hang on the walls of museums and private collections, considered works of art in their own right.[4] In this respect, and in the subjects chosen for the paintings on the front and sides, this chest is exceptional. On the front is a panoramic depiction of Trebizond (now Trabzon), a Byzantine town on the Black Sea, on 15 August 1461, the day when the Turkish sultan Mehmed II (1430–1481) and his Ottoman forces conquered this very last Christian stronghold in the East.[CD] Trebizond is shown at the right; in the background at the left Constantinople, which Mehmed had taken in 1453, can be identified by the dome of its most famous building, the Hagia Sophia, Church of the Holy Wisdom. The events of that day and the important figures and architectural landmarks are recorded in a rather naive, compressed way, and some are captioned,[5] possibly following a fictive Turkish map of that period. Painted on each side of the chest is a curled scroll inscribed "M.E.Z.Z.E." on which is perched a falcon (see fig. 2). These are the *imprese,* or devices, of Filippo Strozzi (1428–1491): the falcon is a rebus of the family name (*strozziere* means falcon); and the letters refer to *mezzelune* (half moons or crescents, three of which figure in the Strozzi arms).[6]

The subject of the front panel had great significance for the Strozzi family. The

Fig. 2. Left side of the chest, decorated with the *impresa* of Filippo Strozzi.

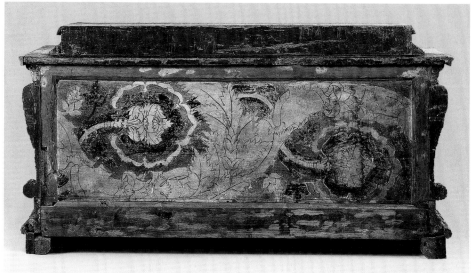

Fig. 3. Back of the chest.

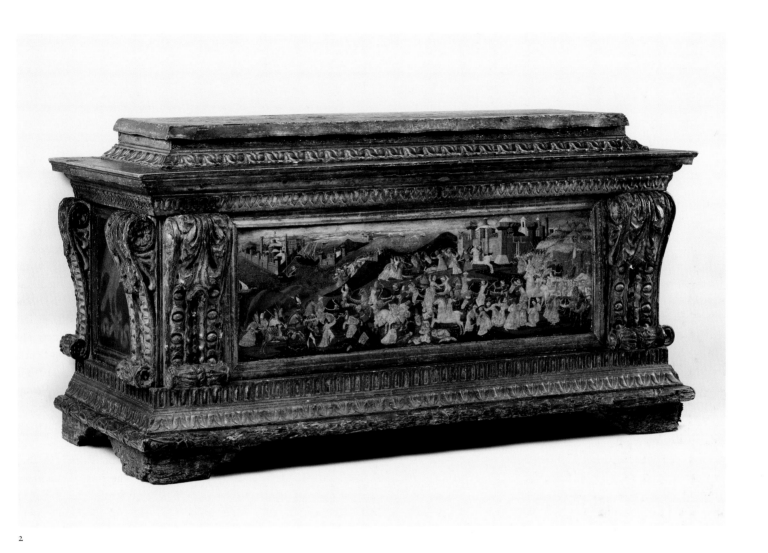

2

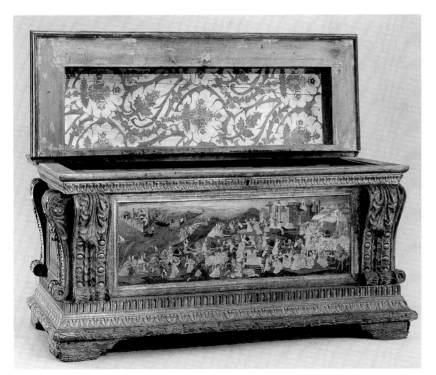

Fig. 4. General view of the chest with the hinged
lid raised.

conquest of Trebizond resulted in the exclusion of the Venetians from the eastern Mediterranean. The Florentines took over Venetian properties in Constantinople and enlarged their own influence in the East, stimulating the Tuscan economy. Filippo and his brothers, who managed the family's far-flung banking empire, were banished between 1458 and 1466 from Florence but maintained a strong interest in these events.

During his exile Filippo continuously ordered furniture from Florence. Did he intend to marry and decide to commission this precious chest one or two years before his anticipated return to his native city, in order to be ready to flaunt his increased power and wealth during the public marriage procession?[7] The fascination in Europe at this time with *turquerie*—everything decorative from the Ottoman Empire—was suppressed in Italy by fear of the Muslims, whose presence centuries earlier in Sicily and whose piracy in the Mediterranean and ferocious raids on the Italian coast were not forgotten. But, as we have seen, the Strozzi would have had personal reasons for choosing a Turkish theme for this chest.

The top of the chest is covered with a thick linen cloth that was dipped in wet plaster; when dry, it formed a tableclothlike arrangement, lapping down over the edge. This top may originally have been colorfully lacquered or painted to imitate a luxurious fabric, and precious objects at other times stored in the chest would have been dis-

played there on special occasions. Parts of the interior and the back of the chest are painted in the so-called pomegranate pattern, most likely in imitation of contemporary Italian textiles or imports from the Ottoman world (see figs. 3, 4). The fruit of the pomegranate tree (*Punica granatum*) symbolized fertility and plenty, sensuous love, and compassion and was also considered an aphrodisiac. What could be a more perfect decoration for a marriage chest?[8]

The distinguished scholar of Italian Renaissance sculpture and influential director of the Berlin museums Wilhelm von Bode (1845–1929) once remarked, "Italian furniture and interior decoration were collected [in the late nineteenth century] with the idea of providing an adequate framework for Italian Renaissance paintings and sculpture, of evoking, however superficially, the contemporary life style, as reflected in the houses and their furnishings."[9] During Bode's era, *cassoni* were regarded as icons of their period and appreciated immensely as a fusion of painting, sculpture, and furniture at a very high level of execution. Aesthetically and historically, the Museum's *cassone* is still considered one of the most outstanding examples of its kind.[10] WK

I am most grateful to Princess Maria Angelica dell'Drago, Dominico Savini, Don Gerolamo Strozzi, and Michelangelo Lupo for discussing with me the heraldry on the present chest.

1. Vasari 1996, vol. 1, p. 267.

2. Dal Prà 1993, pp. 382–83, no. 126 (entry by Wolfram Koeppe); see also Miziołek 1996.

3. Syson and D. Thornton 2001, p. 70. On the workshop, see also Stechow 1944; and Gombrich 1985.

4. Syson and D. Thornton 2001, p. 70.

5. The inscriptions are as follows: 1. On the walls of the city at left: "GO[N]STANTINOPOLI" (Constantinople). 2. Within the walls of the city at left, the names of two churches: "S FRA[N]CESCO" (San Francesco); "ʃ. SOFIA." (Hagia Sophia). 3. "DEILO.PER . . . ORI" (undeciphered). 4. On the walls of the city at left center: "PERA." (Pera, now Beyoğlu, Galata). 5. On the Bosporus: "LOSTRETTO." (the strait). 6. On the walls of the city at center: "LOSCUTARIO" (Scutari, now Üsküdar); farther back: "CHASTEL NVOVO" (the new fort—that is, Rumeli Hisari). 6. On the walls of the city at right: "TREBIZOND[A]." 7. Next to the conqueror (misidentified): "TAN[B]VRLANA" (Tamerlane). The inscriptions identifying the strait, Trebizond, and Tamerlane are recorded but no longer visible. See Baetjer 1995, p. 17.

6. Only in late-nineteenth-century publications is the falcon called the heraldic crest of the family's coat of arms; see Rietstap 1884–87, vol. 2, p. 858; Scalini 1992; and Koeppe 1994b, pp. 28–29. The funeral monument of Carlo Strozzi (died 1517), formerly in San Giovanni dei Fiorentini in Naples, does display the Strozzi arms with the falcon. Severely damaged during World War II, the church was later pulled down; see Litta 1818–83, vol. 6 (1839), pl. XXI; and Strazzullo 1984. For more on the meaning of Filippo Strozzi's *imprese*, see Nickel 1974; and Koeppe 1994b, pp. 28–29.

7. Shortly after his return to Florence in 1466, Strozzi married Fiametta de Donato Adimari.

8. Reichet 1856; Heilmeyer 2001, p. 20 (I thank Mrs. Lucrecia Obolensky Mali for this reference).

9. Quoted in Nützmann 2000, p. 11.

10. Schubring 1915, p. 283, nos. 283–85, pls. LXV–LXVII; Zeri 1971, pp. 101–3; Baetjer 1995, p. 17; Callmann 1999; Syson and D. Thornton 2001, p. 71, fig. 51.

3.

Hip-joint armchair (*sillón de cadera* or *jamuga*)

Spanish (Granada), ca. 1480–1500
Walnut and elm, partly veneered and inlaid with different woods, ivory, bone (camel?), and pewter; covered in silk velvet not original to the armchair
H. 36½ in. (92.7 cm), w. 24 in. (61 cm), d. 19½ in. (49.5 cm)
Fletcher Fund, 1945
45.60.41a,b

This armchair consists of four S-shaped supports on two runnerlike stands. The disks that join two of the supports at front and two at back suggest that the chair can be folded up like a pair of scissors. This is not possible, however. The supports will collide above the turning point, allowing only a small degree of movement. This impractical arrangement can easily be explained by the

chair's derivation. It descends from the *sella curulis*, or curule chair, an ancient Roman folding seat used by consuls and high officials. In its elegant medieval interpretation, the thronelike chair—by then called a *faldistorium*—continued to symbolize secular power, and as the customary seat of the higher clergy, it also came to express the authority of the church.[1] The folding mechanism was

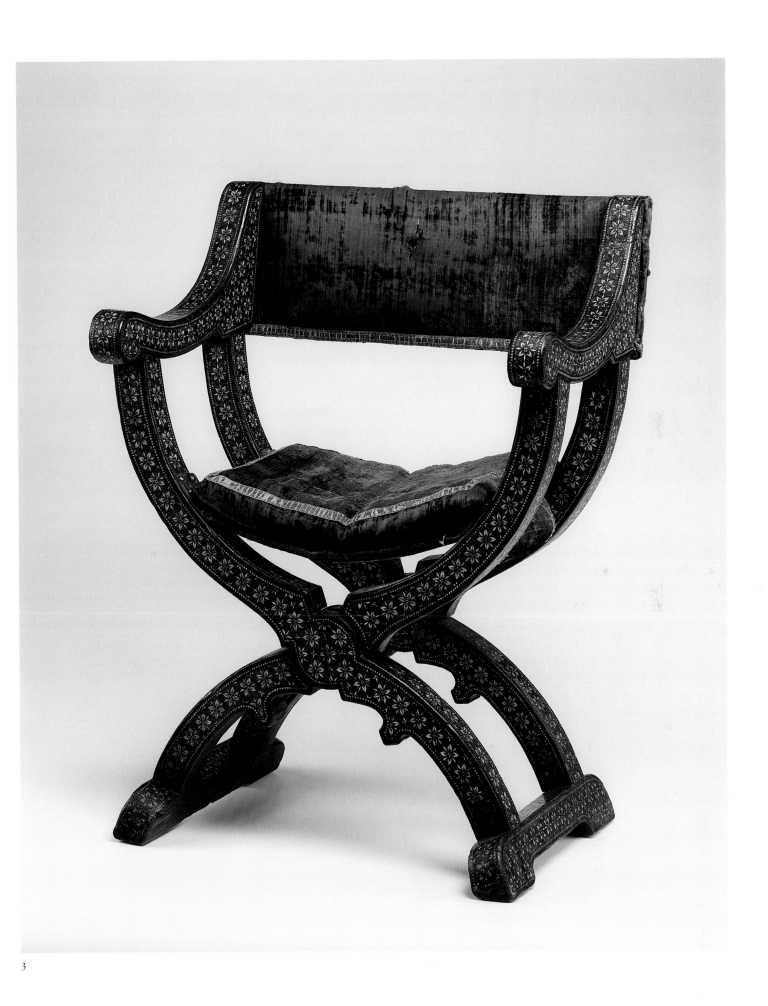

Fig. 5. Detail of a hip-joint armchair, Spanish (Granada), ca. 1480. The Metropolitan Museum of Art, New York, Robert Lehman Collection, 1975 (1975.1.1978). A section of the inlay on the front of the right arm support is missing, and in the cavities behind it there are fragments of parchment with Kufic letters on them. The parchment was reused as support material beneath the marquetry before it was glued to the body of the chair.

eventually eliminated, and the place where the joint had been was marked with an ornamented disk.

By the late fifteenth century the seat and back of the curule chair were usually covered with a luxurious textile or embossed and stamped leather, and the frame was ornately inlaid and carved. Contemporary paintings suggest that the decoration on some examples may have reached a surreal level of exaggeration. The golden Throne of Scipio, seen in a *cassone* painting of 1490–1500 in the Courtauld Institute of Art Gallery, London, is embellished with cornucopias and lions' paws.[2]

The precious *tarsia a toppo* marquetry on the frame of the Museum's chair consists of tiny polygonal pieces of different colored woods, bone, and metal arranged in geometric patterns.[3] Some of the configurations, such as a minute square made up of nine even smaller squares, can be fully appreciated only with the aid of a magnifying instrument.[4] CD The "points" dependent from the legs of the Museum's chair make the crescents that they form resemble Gothic ogee arches; however, the broken

curves are also reminiscent of the Moorish arcades surrounding the Court of the Lions in the Alhambra at Granada and of the Moorish-Renaissance facade of the Palacio de Jabalquinto in Baeza of about 1490.[5]

The Spanish terms for the curule chair are *sillón de cadera* (hip-joint chair) and *jamuga* (saddle for a woman, or sidesaddle).[6] As the chair type spread throughout Europe and parts of Spanish America it acquired many other names. In the mid-nineteenth century, during the Renaissance Revival, it was known as a Dante or Savonarola chair. Possibly for this reason the present chair and three related examples in the Museum (see fig. 5) were mistakenly catalogued until recently as sixteenth-century Italian furniture.[7] Also evocative of Italy is the marquetry, which resembles twelfth-century Cosmati work[8] as well as *lavoro alla certosina*, a type of wood inlay very popular, especially in northern Italy, during the fourteenth and fifteenth centuries.[9] Nevertheless, it should be remembered that both of these inlay techniques reflect the influence of Islamic woodwork.

The most convincing reason for attributing the present chair to a workshop in Granada is the existence of a very similar chair formerly in the collection of Paul Almeida, Madrid.[10] The backrest, which retains its original leather cover, is decorated with an embossed Arabic inscription dedicated to the last Muslim sovereign of Granada, Muhammad XI, called Boabdil, who reigned from 1482 until his abdication after the battle of Lucena in 1492 (he died in 1538). It was therefore probably made before the sultan was forced into exile, leaving his beloved residence in Granada. The Alhambra court workshop possibly created that chair and all four of the Museum's hip-joint chairs.

An origin in Granada may be supported by a fifteenth-century document that mentions a commission for three *sillónes de cadera* from Granada to be used in the Cathedral of Toledo.[11] (One of them is still kept in the cathedral treasury.) The fact that three chairs were ordered may indicate that they were used during the Mass at high church feasts, when two would have been placed on either side of the third, the bishop's elevated chair, which would have been more elaborately upholstered and decorated than those of his concelebrants.

Hip-joint chairs remained accoutrements

of the mighty throughout the 1500s, not slipping out of fashion for at least another century. Like Hispano-Moresque pottery, they may have been exported from Spain to Italy,[12] stimulating the production of less sophisticated inlaid chairs on the peninsula. A noblewoman is seen seated in a handsome example in a portrait now in the Metropolitan.[13] An etching that illustrates the abdication of control of the Netherlands by Emperor Charles V (1500–1558) in Brussels in 1555 (fig. 6) shows hip-joint armchairs,[14] as does a portrait of the powerful archbishop of Canterbury Thomas Cranmer (1489–1556) ten years before he was burned at the stake.[15] A detailed list of property in the 1556 will of Sir John Gage of Firle Place in Sussex includes five Spanish-made chairs decorated with colored bone inlay.[16]

The ritual function of the *sillón de cadera* has remained alive in Spain until our own times. The Spanish king Juan Carlos I (b. 1938) and H. H. Shah Kerim Aga Khan (b. 1936) were seated side by side on two such inlaid throne-chairs on the occasion of the Aga Khan Award ceremony at the Alhambra on 5 June 1990.[17] W K

1. Wanscher 1980.

2. Morley 1999, p. 90, fig. 158.

3. On this type of intarsia decoration, see the entry for no. 1 in this book and Wilmering 1999, p. 64, fig. 2-4, and p. 72.

4. Identically fashioned squares decorate several other chairs. This suggests, but does not prove, that all of them originated in the same workshop. The squares on one chair in the Lemmers-Danforth Sammlung, Wetzlar, are illustrated close up in Koeppe 1992, pp. 75–76, no. M8a, b.

5. See Junquera y Mato 1992, pp. 289, 279. For the Hispano-Moresque style in furniture, see Ferrandis Torres 1940.

6. Alonso Pedraz 1986; for the etymology, see the excellent summary in Gontar 2003, n. 38. See also Burr 1964, fig. 11; and Ciechanowiecki 1965, p. 62, fig. 191.

7. Two chairs were acquired in 1945 (the present example and acc. no. 45.60.40a), and two entered the Metropolitan with the Robert Lehman Collection (acc. nos. 1975.1.1978,1979) in 1975. One example with a leather cover (45.60.40a) was published in Gontar 2003, fig. 27, as having been produced about 1500 in Granada, a date and location originally proposed by the present author, on whose unpublished research notes in the files of the Department of European Sculpture and Decorative Arts, Metropolitan Museum, the Gontar attribution was based. On the Spanish origin of these and other inlaid hip-joint armchairs, see the comprehensive study in Koeppe 1992, pp. 75–76, no. M8a, b, color ill. p. 172. The two Lehman chairs will be discussed in a forthcoming catalogue raisonné of the furniture in the Robert Lehman Collection by William Rieder and Wolfram Koeppe.

Fig. 6. *The Abdication of Charles V in Brussels, 1555.* Etching in Franz and Abraham Hogenberg, *Geschichtsblätter* (1570), ed. Fritz Hellwig, facsimile edition (Nördlingen, 1983).

8. One of the most prominent examples is the episcopal throne in Santa Balbina in Rome; see Morley 1999, p. 64, fig. 107.

9. An example is illustrated in ibid., p. 102, fig. 174, and another is a chest in the Museum's collection (acc. no. 07.97). A third is in the Rijksmuseum, Amsterdam (acc. no. BK–16629).

10. Peter Dreyer brought this piece to my attention and made its examination possible in 1991. Two related chairs in the Lemmers-Danforth Sammlung, Wetzlar,

have the same provenance; Koeppe 1992, pp. 75–76, no. M8a, b, color ill. p. 172.

11. Feduchi 1969, p. 75, n. 37.

12. T. Wilson 1989.

13. Acc. no. 32.100.66; see Baetjer 1995, p. 38. For a portrait of Bianca Cappello, the second wife of Francesco I de' Medici (r. 1574–87), by Alessandro Allori (1535–1607), standing next to a hip-joint chair with different inlay patterns, see Langedijk 1981–87, vol. 1, pp. 317, 319, no. 11, fig. 12, 11.

14. Castelnuovo 1990, p. 13, fig. 1.

15. Wells-Cole 1997, p. 37.

16. Beard 1997, p. 28. I thank Daniëlle Kisluk-Grosheide for bringing this to my attention.

17. *Connaissance des arts*, no. 475 (September 1991), p. 7. I am most grateful to H.S.H. the late Princess Margarete of Isenburg-Birstein for steering my thoughts toward a possible Spanish origin for the chair type and for mentioning in 1985 the existence of several such armchairs at the Museo Arqueológico, Granada.

4.

Chest (*cassone*)

Italian (Florence or Lucca), ca. 1480–95
Poplar wood; painted and gilded gesso
H. 38½ in. (97.8 cm), w. 80½ in. (204.5 cm),
d. 32½ in. (82.6 cm)
Rogers Fund 1916
16.155

Italian inventories and descriptions of Renaissance-period households document the importance of great chests in the main bedchamber, or *camera*. This room was the center of an upper-class woman's existence, as she was encouraged to live mostly indoors and to avoid lingering at open windows or in the semipublic courtyard of the family house.[1] In this chamber she would proudly display the cradle she had been given on her marriage (see fig. 10) and also wedding chests, or *cassone*, containing her trousseau.[2]

The finest fifteenth-century *cassoni* were decorated with panel paintings or with intarsia inlay (see the entries for nos. 1, 2) or, like the example discussed here, with scenes in *pastiglia*, a variety of gesso relief applied in layers and painted or gilded. Later, in the sixteenth century, many were embellished with relief carving, usually in walnut (see no. 6). Hunts and jousts were sometimes shown on these chests, but the most popular subjects were mythological tales of love and fertility. Their immodesty fired the reformer Girolamo Savonarola (1452–1498) to exhort the Florentines to choose more uplifting themes—from the lives of the saints, for example.[3] But the *cassoni* workshops produced what was in demand, and romantic tales of the loves of the gods continued to sell.

The subject on the front of this *cassone* is taken from Ovid's *Metamorphoses*.[4] The distraught earth goddess Ceres is seen riding in her dragon-yoked chariot, her torch kindled from the fires of Mount Etna, through a fairy-tale forest inhabited by satyrs, in search of her abducted daughter, Proserpina.[CD] In her distress, Ceres has allowed the crops to fail, leaving humankind to starve.

According to Paul Schubring, the Museum's chest had a companion piece, now lost but formerly in the collection of the Palazzo Guinigi in Lucca.[5] The relief on the front of that *cassone* illustrated the beginning of the story, in which Pluto, god of the underworld, carries off Proserpina as she is picking flowers with her companions, the daughters of Oceanus. The extremely faint, hitherto unidentified coat of arms held by a sphinx on the right end of the Museum's *cassone* would seem to be that of a lady who married a member of the Guinigi family; however, no documentary evidence exists to prove that the Museum's example came from the Palazzo Guinigi. It was acquired from the collection of Elia Volpi (1858–1938), a Florentine dealer and collector with close ties to many noble Italian families.[6]

The figural scene on the Museum's *cassone* is exceptional in the depth of the relief, which is achieved in the fragile medium of matrix-molded gesso.[7] It is probable that the workshop was experimenting with the technique in order to speed up production. In the fifteenth century, little time elapsed between a betrothal and the wedding, and workshops often had to rush to fill orders for *cassoni* on schedule.

The shape of this chest and the relief decoration on the front reflect the influence of ancient Greek and Roman sarcophagi.[8] A well-known model for a front panel with a continuing narrative was *The Miracle of the Strozzi Boy* on Lorenzo Ghiberti's famous bronze *Shrine of Saint Zenobius*, executed for the Duomo in Florence between 1432 and 1442. The style of the Museum's *cassone* relief, however, reflects the classicizing trend in Florentine sculpture and painting of the late fifteenth century. The pastoral mood of the Ceres panel is perhaps closest to that of the early paintings of Piero di Cosimo (1461/62–1521?), especially *The Return from the Hunt* and *Hunting Scene*, both now also in the Metropolitan Museum.[9]

Very closely related to this chest is a pair of *cassoni* in the Philadelphia Museum of Art decorated with the same subjects as the present piece and its lost companion (see fig. 7).[10] Several similar but less elaborate chests, and also several similar front panels cut from *cassoni*, have been identified in various private and public collections.[11] WK

1. Contemporary literature, however, suggests that occasionally a lady might break the rules and tryst with a lover in her bedchamber. In Giovanni Boccaccio's *Decameron* (8.8) a gentlewoman named Fiammetta tells a tale of cuckoldry in which a large *cassone* is at the heart of the mischief; see Boccaccio 1982, pp. 614–19.

2. Syson and D. Thornton 2001, p. 71.

3. Philadelphia Museum of Art 1995, p. 115 (entry by Dean Walker).

4. *Metamorphoses*, bk. 5, ll. 385–424.

5. Schubring 1923, p. 235, nos. 75, 76, pl. XI. The arms of the Guinigi family were painted on the shields held by carved sphinxlike creatures at the corners of the lost *cassone*.

6. Catalogue of the Elia Volpi collection sale, American Art Association, New York, 21–27 November 1916, nos. 439, 440.

7. Pommeranz 1995, pp. 5–17; and Bassett and Fogelman 1997, pp. 40, 63.

8. For a Hellenistic example of about 300 B.C., see Morley 1999, p. 107, fig. 185; for an ancient sculpture on the theme of The Rape of Proserpina, see Bober and Rubinstein 1987, p. 57.

9. Acc. nos. 75.7.1, 2. See Baetjer 1995, p. 32.

10. Schubring 1923, p. 235, no. 75; and Philadelphia Museum of Art 1995, pp. 114–15 (entry by Dean Walker).

11. See Odom 1966, p. 99 and figs. 49, 50; *Italian Cassoni* 1983, nos. 33–37; and Massinelli 1993, pl. XIV.

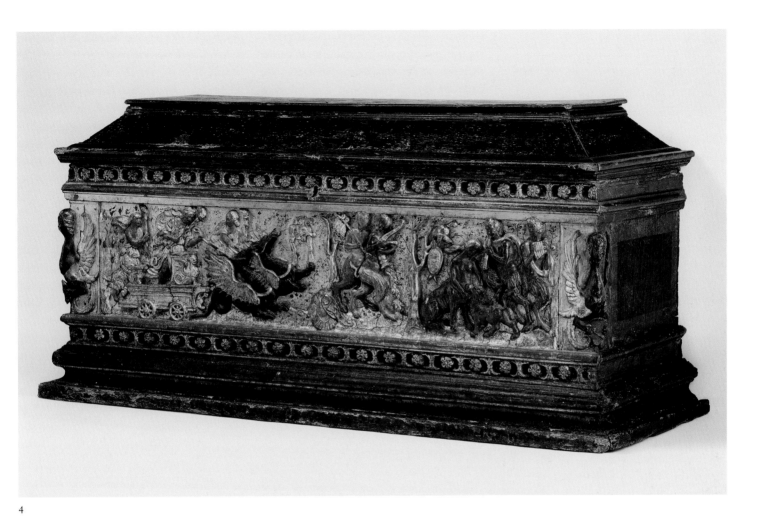

4

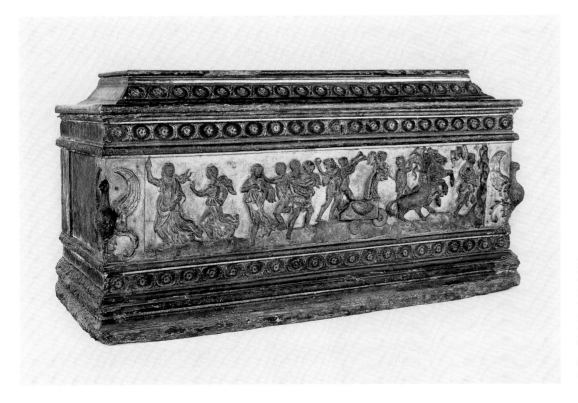

Fig. 7. Chest, Italian (Tuscany), late fifteenth century. Wood with painted and gilded gesso decoration, 36⅜ x 47⅛ x 28⅜ in. Philadelphia Museum of Art, Purchased with the Joseph E. Temple Fund (1944-15-6). The subject shown on the long panel is Pluto Abducting Proserpina.

5.

Chair (*sgabello a tre gambe*)

Italian (Florence), ca. 1489–91
Attributed to the workshop of Giuliano da
Maiano (1432–1490) and Benedetto da Maiano
(1442–1497)
Walnut, maple, ebony, ebonized wood, and fruit-
wood; traces of gilding and paint
H. 58 in. (147.3 cm), w. 16¾ in. (42.5 cm),
d. 16½ in. (41.9 cm)
Fletcher Fund, 1930
30.93.2

The Strozzi chair is one of the best-known and most often published pieces of seating furniture in the world.[1] Shortly after 1900, in a period when Italian Renaissance furniture was as highly prized as old-master paintings, Hans Stegmann called it a "unicum known the world over... a masterwork of charming beauty, one of the most beautiful Florentine pieces of furniture

around."[2] Given its celebrity, it is astonishing that the most recent publications on the chair rely on information in the 1930 catalogue of the collection of the Viennese banker Albert Figdor, who acquired it in the 1870s from Prince Strozzi in Florence, and ignore later investigations.[3]

The form of the *sgabello* derives from a low stool with three legs (*a tre gambe*) mounted at an angle, a very simple type of seat that had been popular since ancient times.[4] By adding an elongated backrest, the designer demonstrated unusual sensitivity to shape and ornament and a degree of subtlety that is rarely found in furniture. The decoration on the back, sides of the seat, and feet consists of delicately carved elements and a small line of geometric inlay.[CD] The latter is consciously contrasted with the dramatic

veining of the walnut wood. The elegant concept and the attention given to minute details indicate that this was a very special commission for all the artisans involved.

The backrest seems comparable in silhouette to a peacock's feather. A plain center panel supports the tondo on top, in the "eye" of which the Strozzi coat of arms with three crescent moons (*arme delle tre lune*) and lavish acanthus decoration stand out against a punched background (fig. 8). Crowning this is the image of a molting falcon. In the background, feathers cascade down in a circular movement from the spread wings of the bird.

The three crescents within a shield can be seen again on the reverse of the tondo, in front of a fluted sun motif.[CD] The encircling band consists of four rosettes at the cardinal

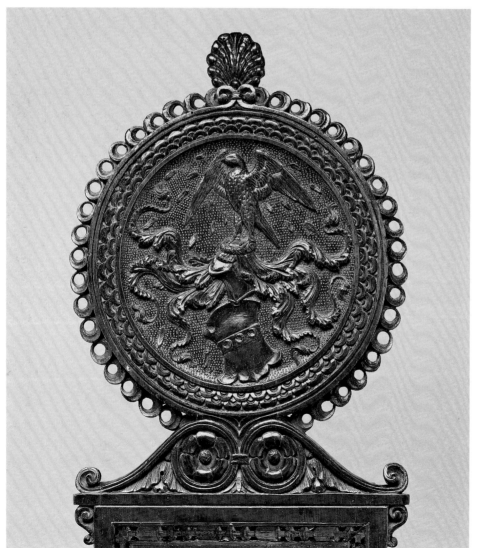

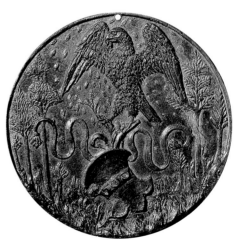

Fig. 8. Front of the tondo at the top of the chair back.

Fig. 9. Medal of Filippo Strozzi (reverse), attributed to Niccolò Fiorentino, 1488–89. Cast bronze, diam. 3½ in. National Gallery of Art, Washington, D.C. (1957.14.880).

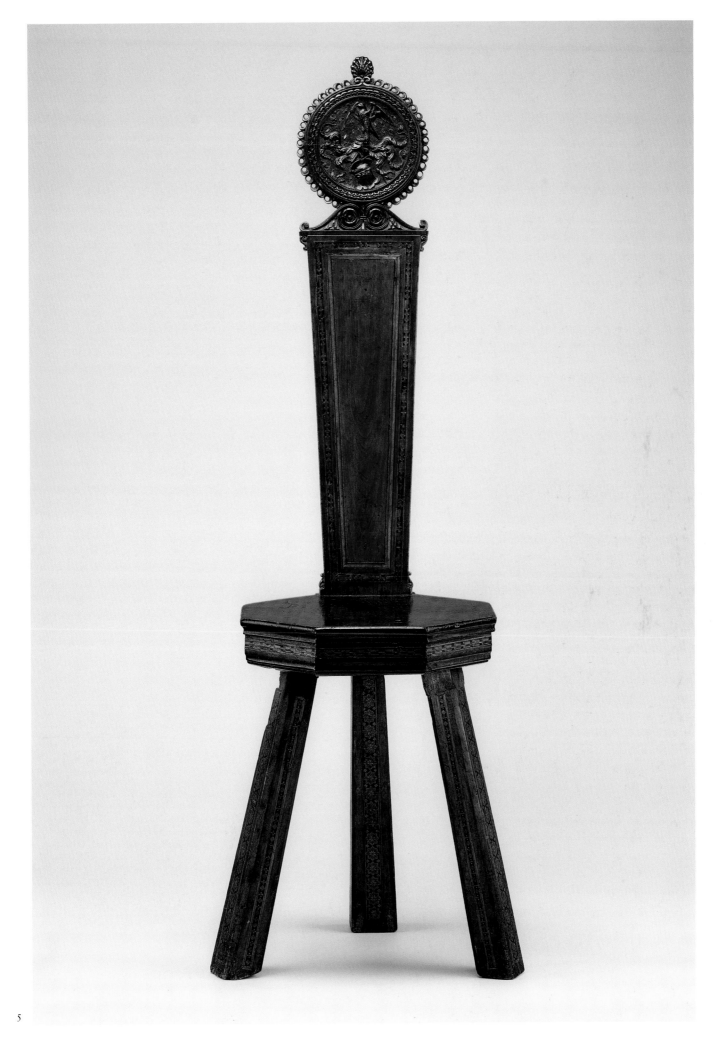

points connected by feathered scales arranged in divergent directions. The whole tondo—front and back—is framed by a wreath of crescent moons, another allusion to the house of Strozzi.[5] Following Wilhelm von Bode, Frida Schottmüller remarked that the reverse of a medal made for Filippo di Matteo di Simone Strozzi (1428–1491), in the "manner of Niccolò Fiorentino," was used as the model for the front of the tondo (fig. 9).[6] Other early writers ascribed the medal as well as the design of the *sgabello* to the workshop of Giuliano and Benedetto da Maiano. Both brothers were regularly employed by Strozzi.[7] Documents show that in 1467 Filippo Strozzi ordered from Giuliano da Maiano a richly inlaid *cassone* for himself, as well as a *lettuccio,* or bench.[8] The medal, which has now convincingly been attributed to Niccolò Fiorentino (1430–1514), was probably commissioned for the cornerstone ceremony at the Strozzi Palace, on 6 August 1489.[9] It exists in multiple copies and could easily have been examined by other artisans.[10]

As a conspicuous display object, embellished on all sides and intended to be freestanding, the *sgabello* should be interpreted in the context of the Strozzi Palace. With the crescent moon as a connecting element, it fits seamlessly into the decoration of the building. The moon motif can be found not only in the biforium windows of the facade and the famous large iron lanterns but also in the interior, in the supporting brackets, fireplace frames, and furniture panels. While it might be too much to say that the presence of such motifs characterizes a "decorative program," the heraldic sickle moons displayed for everyone to see are an inseparable part of a totality, of a propaganda project to enhance the grandeur of the aristocratic owner, Filippo Strozzi (see the entry for no. 2).[11]

The falcon, Filippo's personal emblem, or *impresa,* on the tondo also functions as a rebus: the Italian word for falconer is *strozziere.* A molting falcon has always been a metaphor for renewal. But what is meant here is not that all the feathers will be shed and replaced, as is the case with ducks, for instance, which become incapable of flying for several weeks and fall easy prey to carnivores. The spread, flawless wings of the swift falcon prove that its plumage renews itself only partially and that the bird always remains capable of defending itself and of

attacking potential enemies. The falcon of Filippo's *impresa* thus signifies a prepared readiness in the face of trial, a potential for renewal and for overcoming adversity.

The similarity between the tondo and the medal not only proves that both must be directly linked to Filippo Strozzi as patron but also gives a clue to the date of the chair: the execution of the commission must have taken place between 1489, when the medal was struck and work on the palace begun, and 15 May 1491, the day of Strozzi's death. Any time after that is highly unlikely, since Strozzi's successor would almost certainly have chosen a different decoration, fashioned to represent himself.

A calculated choice, probably, and if so a stroke of genius, are the three legs, which will correct the chair's position on uneven ground; they form a firm base for the tondo, underlining the strength, sturdiness, and discipline of the owner, who never gives up hope and steadfastly supports his family and friends. These virtues had characterized Filippo during his exile from Florence between 1458 and 1466.[12]

The intellectual ferment in fifteenth-century Florence undoubtedly played a role in the chair's conception. In his treatise *De Re Aedificatoria* (On the Art of Building) Leonbattista Alberti (1404–1472) put forward the revolutionary idea that different types of buildings should be designed to reflect the requirements of those who live and work in them. As Martin Kemp has pointed out, some of Alberti's immediate successors went still further, maintaining that every aspect of architecture, "from the design of a capital at the top of a column to the overall plan of a city was to be governed by a rigorously proportional geometry."[13] These ideas could easily be extended to apply to a palace and its furnishings. Another intriguing reflection in the Strozzi chair of the passionate interest among the Florentine intellectuals in the ordering of space is the fact that the octagonal seat reflects the floor plan of the Florentine Baptistery, even to the high altar's niche. That protruding space is filled in the chair by the elongated back, which supports Filippo Strozzi's *impresa.*[14] The Baptistery was the building that Filippo Brunelleschi (1377?–1446), who had revolutionized painting by working out a method for accurately reproducing the third dimension on a flat surface, used as the subject of his famous perspective projections.[15] The ideas

of Alberti and Brunelleschi flowed through the Florentine artistic community as the money of the Medici bank flowed through politics. No innovative artist could help but respond to this creative climate.

The *sgabello* is not a marvel of comfort, but it was not intended to be. A display piece, it represents a rare combination of a practical medieval form and a humanistic Renaissance design. Certainly it is one of the most unusual pieces of furniture ever made, one in which meaning and beauty mingle in unrivaled harmony.[16] WK

1. This entry is based on Koeppe 1994b.

2. Stegmann 1909.

3. *Die Sammlung Dr. Albert Figdor* 1930, pt. 1, vol. 2, no. 657. The latest publication is Paolini 2002, pp. 68–70, no. 9. The author of that work mentions several times in error that two chairs of this design are in the Metropolitan Museum's collection.

4. Ancient tripod tables that have survived suggest that there may have been matching chairs, like the "folding" silver tripod from the Hildesheim Treasure; see Liversidge 1965, p. 17, fig. 32. Many tripod chairs appear in medieval illustrations; see Ash 1965, p. 26, fig. 55, and Morley 1999, p. 90, fig. 158.

5. In 1995 the Strozzi chair was superbly restored by Marijn Manuels, Associate Conservator, Department of Objects Conservation, Metropolitan Museum. He replaced missing pieces, including several crescents, around the tondo. See the conservation report in the archives of the Sherman Fairchild Center for Objects Conservation, Metropolitan Museum.

6. Schottmüller 1921, p. XXVII; see also Strozzi 1851; and Sale 1979, pp. 7–99.

7. Pedrini 1948, p. 55.

8. Sale 1979, p. 12.

9. Scher 1994, p. 135, no. 44.

10. Hill 1930, no. 1018.

11. On the Strozzi arms, see Nickel 1974; and Seelig 2002, pp. 59–65.

12. Sale 1979, pp. 9–14.

13. Kemp 1992, p. 99.

14. Paolucci 1994, vol. 2, pp. 29, 205.

15. Kemp 1992, p. 98, fig. 4.

16. The chair is unique; several existing interpretations of the form are of a much later date. Two similar examples formerly in the Mannheimer collection and now in the Rijksmuseum, Amsterdam, are simplified nineteenth-century versions. I am most grateful to Reinier Baarsen for examining them with me in 1998 and for giving me the opportunity to study related material in the Rijksmuseum files. Two other examples, in the Lemmers-Danforth Sammlung, Wetzlar, must also be dated to the nineteenth century, although I described them in 1992 as "Florence, circa 1490"; see Koeppe 1992, pp. 74–75, no. M7a, b, color ill. p. 169, where some further examples are also mentioned. Two chairs in the Museo della Fondazione Horne, Florence, are closely related to the Lemmers-Danforth pieces, but I have not yet been able to examine them personally there; see Paolini 2002, pp. 68–70, no. 9.

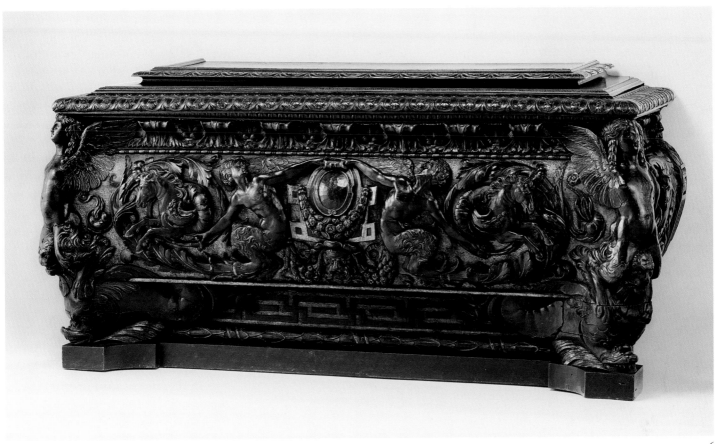

6.

Chest

Italian (Rome), ca. 1550–60
Walnut, carved and partially gilded
H. 34 in. (86.4 cm), w. 71 ⅝ in. (181.9 cm),
d. 26 ½ in. (67.3 cm)
Gift of Stanley Mortimer, 1954
54.161

Sumptuously ornamented chests called *cassoni* or *forzieri* played an important role in the wedding rituals of Renaissance Italy.[1] Between the thirteenth and fifteenth centuries, a woman's right to inherit from her parents and her husband diminished as society became more patriarchal. Accordingly, the dowry—the financial allotment she was given by her family on her marriage—increased in importance. In theory it was hers, but in reality the dowry was administered by her husband, who assumed responsibility to increase its value. Before the wedding, one or two pairs of chests were ordered and delivered to the bride's house, where they were filled with her marriage portion.[2] If, as was often the case, the bride was escorted in a formal procession from her parents' house to the bridegroom's residence, the *cassoni* were carried along as testimony to the wealth of the two families and the bond between them. When ordered in pairs, the chests could be decorated with the coats of arms of both houses. At princely weddings, the dowry might fill many *cassoni* of different sizes and styles of decoration. The bridal procession of Isabella d'Este (1474–1539) from Ferrara to Mantua in 1490 included no fewer than thirteen chests, which the Ferrarese court artist Ercole de' Roberti (ca. 1450–1496) had painted and also decorated with gold purchased in Venice.

Roman *cassoni* of the second half of the sixteenth century are characterized by skillfully executed relief carvings that either illustrate narratives, often after ancient Roman writers, or are lavishly ornamental. The latter is the case with the Museum's chest and its pair.[3] The two pieces differ only in a few details and slightly in their degree of preservation. In former times they could probably have been distinguished by the coats of arms painted on the front in the strapwork cartouches, but none of the polychrome decoration has survived. All the raised parts were once gilded, and this decoration has been partly preserved, albeit with much retouching. In both examples the layered *plateaux* of the lid are replacements.

The quality and the imaginative design of the carving are outstanding, clearly the work of a talented artist. Thus, the acanthus volutes in the frieze below the lid have been designed as three-dimensional handles, and the arms of the two satyrs are fully rounded, crowning the cartouches.[CD] The corner joints of the chest have been ingeniously concealed by winged caryatids seated on dolphins, each holding a grotesque mask between her lions' feet.[CD] The sarcophagus shape of the carcase, the classical meander band on the base, and the turbulent acanthus foliage reveal the designer's study of antique Roman monuments.[4] The intricately twisted satyr figures with asses' ears and angels' wings, whose goats' feet end in acanthus spirals, reflect

Fig. 10. *Design for Five Chests and a Cradle*, Italian (Rome), third quarter of the sixteenth century. Pen drawing. Private collection.

drawing was very likely part of a designer's model book, which he would show to a client as an indication of the variety of objects his workshop was able to create.[8]

The dolphin was associated with the sea god in classical times and became a symbol of long life. The creature is also shown as a companion of Venus (*Venus marina*), and as such is symbolic of love. As the companion of the seafaring Dionysus, the classical god of erotic ecstasy, this intelligent animal guaranteed safe travel. Given these attributes, what would be more fitting than to send a bride's dowry to her bridegroom in a pair of *cassoni* supported on the backs of dolphins? Bridal chests continued to be made in the seventeenth and early eighteenth centuries.[9] The Sèvres-porcelain-mounted jewel coffers on stand, of which Marie Antoinette received an example in 1770, the year of her marriage, is a playful development of this type of furniture at the end of the ancien régime in France (see the entry for no. 67).

W K

1. The text of this entry is adapted from Koeppe 1994b; see also Koeppe 1995, p. 15.
2. P. Thornton 1991, p. 353, pl. 377; and Miziołek 1996, pl. 3.
3. The accession number of the pair to this chest is 55.197.
4. Similarly inspired by the decoration on classical Roman monuments is the Farnese table (see the entry for no. 7); for another sarcophagus-shaped chest with acanthus decoration, see Morley 1999, p. 107, fig. 184.
5. For a similar example, see ibid., p. 107, fig. 187.
6. On acanthus *rinceaux*, see Reinhardt 1996, pp. 97, 104. On Raphael's Logge decorations, see Fagiolo dell'Arco 1983, p. 261. On Perino del Vaga, see *Dictionary of Art* 1996, vol. 24, pp. 419–20 (entry by Richard Harprath).
7. A comparably dramatic corner design with caryatids of somewhat lesser quality characterizes a *cassone* in the Manchester City Art Galleries (Manchester City Art Gallery 1983, p. 52, no. 35), and a *cassone* with similarly lush acanthus foliage can be seen in the Musée des Arts Décoratifs in Paris (Reinhardt 1996, p. 101).
8. Related chests are illustrated in a drawing in a private New York collection (Callman 1980, p. 35, no. 29) and in another in the Lodewijk Houthakker collection (Fuhring 1989, vol. 1, p. 334, no. 510).
9. Bremer-David 1993, p. 3, no. 4.

prior knowledge of Michelangelo's inventions. The corner caryatids that emphasize the swelling body of the chest[5] recall the creations of Bartolommeo Ammanati (1511–1592), especially his fountain designs for the Villa Giulia, in Rome. The vigorous shapes of the acanthus tendrils with opening blossoms, from which the torsos of stallions energetically protrude, the *rinceaux* relief, and the crisply carved details evoke the designs of Perino del Vaga (1501–1547), thereby documenting the influence of Raphael's Logge for Pope Leo X at the Vatican on the artistic generation that followed;[6] however, the extreme Mannerist exaggeration of the composition's dynamics and the style of the figures are clear indication that

the chest was created in Rome between 1550 and 1560.[7]

The delicately modeled snouts of the dolphins at the corners of the base, many of which are damaged, show that such chests needed a platform, such as the modern ones on which this pair rest today. Drawings and contemporary interior views prove the existence of pedestals in Renaissance times. An incredibly rare survival is a late-sixteenth-century drawing (fig. 10) showing five alternative forms of chests, four of which are standing on differently molded bases, accompanied by an equally grand embellished cradle. Cradles were frequently given to a couple as a meaningful wedding gift, less often at the birth of their first child. The

7.
Table

Italian (Rome), ca. 1568–73
Designed by Jacopo Barozzi da Vignola
(1507–1573); the marble piers carved by
Guglielmo della Porta (d. 1577) and by the
Farnese Palace workshop under his supervision;
the pietre dure *top attributed to Giovanni*
Mynardo (Jean Ménard; ca. 1525–1582)
Marbles of different colors, semiprecious stones,
Egyptian alabaster; residue of paint of different
colors on the piers
H. 3 ft. 1½ in. (95.3 cm), w. 12 ft. 4¼ in.
(379.1 cm), d. 5 ft. 6¼ in. (168.3 cm)
Harris Brisbane Dick Fund, 1958
58.57a–d

The Farnese table, one of the most beautiful and evocative pieces of Renaissance furniture in existence, was acquired by the Museum in 1958. Two years later, curator Olga Raggio presented it as a "rediscovered work by Vignola" in a magisterial article that has remained a model for subsequent studies in the history of furniture.[1]

In its form—a marble top supported on three marble piers—the table reflects ancient Roman prototypes, such as are depicted in ancient frescoes.[2] Each pier is carved in the center of each side with a grotesque torso and a coat of arms and on each end with a sphinx emerging from foliage. The top is a slab of white marble sumptuously inlaid in ancient Roman style with many different colored marbles and with semiprecious stones called *pietre dure*. So rich is the inlay that the white marble matrix is visible only in the lines that surround various borders and the larger geometric figures, which include medallions, cartouches, rectangles, and ovals. In the center of the slab, enclosed within black slate borders decorated with *pietre dure* rosettes and stylized lilies, are two panels of Egyptian alabaster.[3]

The coats of arms on the piers are embellished with six lilies carved on oval panels surmounted by a cross and a *galero*, or cardinal's hat.[CD] Lilies appear again on the tabletop (fig. 11), not only in the narrow *pietre dure* borders but also in the wide border of noble *rosso antico* marble, where they are bracketed by pairs of stylized *peltae*, or ancient Roman shields, which "protect" them, as important dignitaries would be guarded by armed foot soldiers. The lilies, rosettes, cross, and hat all refer to Alessandro Farnese (1520–1589), "the Great Cardinal," a man of enormous wealth and an enthusiastic patron of the arts.[4] He envisioned the precious table as a focal point in the state rooms of the Farnese Palace in Rome, which was under construction during the sixteenth century. This magnificent building housed not only a large collection of Renaissance and Mannerist paintings commissioned or acquired by Alessandro and other members of his family—portraits by Titian (ca. 1487–1576), frescoes by Annibale Carracci (1560–1609), Francesco Salviati (1510–1553), and Daniele da Volterra (1509–1566)—but also wonderful works of antique sculpture, such as the *Farnese Hercules*, the *Urania*, the *Flora*, and the *Farnese Bull*. Originally placed in the main hall of the palace, where it would have harmonized with both the contemporary and the ancient works of art that filled the room,[5]

7

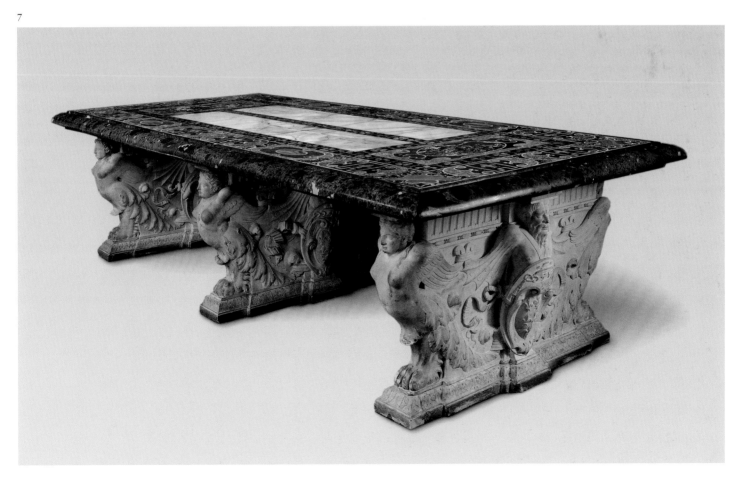

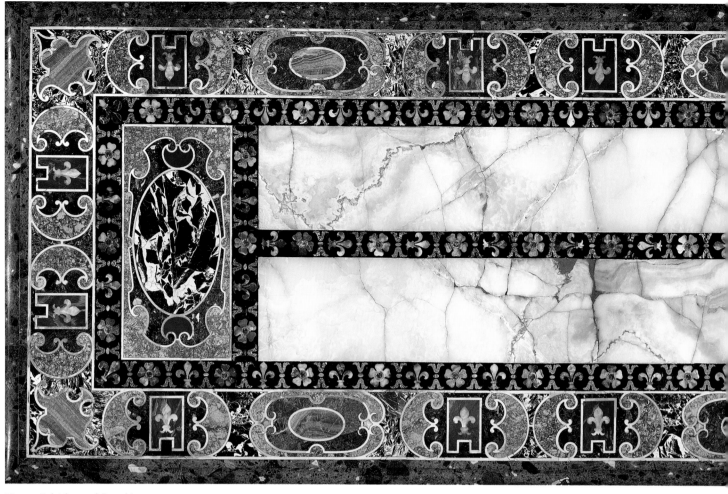

Fig. 11. Inlaid top of the table.

the Farnese table was later installed in the Philosophers' Hall, an elaborately furnished room next to the Carracci Gallery, on the Tiber side of the palace.[6] It is described as being in that room in all the seventeenth- and eighteenth-century Roman guidebooks that mention the treasures of the palace. The German poet Johann Wolfgang von Goethe (1749–1832) probably saw it there on his visit to Rome in the spring of 1787, although by then, in one of the largest art transfers in history, many of the paintings and sculptures had been removed to Naples by King Charles III of Spain (1716–1788), who had inherited the palace from his Farnese mother. Goethe said wryly, "If they could take also the Carracci Gallery, they would do it."[7]

An inventory of the Farnese Palace compiled in 1653 indicates what a high value was placed on the table. In the absence of the owner of the house, the "large table of hard and soft stones, the center being of Oriental alabaster, supported by three mar-

ble feet in the shape of harpies with the arms of the Lord Cardinal" was protected "in a wooden box [with] a chain that loops to close it and in the middle a small mattress full of wool, covered with a quilted checkered cloth." There was also "a cover for this table, made of tooled and gilded leather with four fringes, decorated borders, and fleur-de-lys."[8] It is as though the table—which is so heavy that even with the aid of a modern lifting device it can only be moved by a dozen men—was regarded as an *objet de vertu*, some precious gold or rock-crystal bibelot that could easily be packed up in a beautiful leather case and travel with its owner.[9]

The Farnese table and especially its top were created after the designs of Jacopo Barozzi da Vignola, who began working at the palace shortly before 1547 under the supervision of Michelangelo (he became the cardinal's chief architect about 1550).[10] Since Alessandro adopted the coat of arms carved on the table legs only in 1566, Vignola's design must date from or after

that year. Inventories of the Farnese Palace made in 1566 and 1568 include references to other inlaid tables—two of alabaster, two of porphyry, and one set with many different types of stone.[11] It is thus probable that the Museum's table was under construction in the late 1560s—certainly by 1573, when Vignola died.

Vignola's design masterfully contrasts the piers, whose vigorous modeling creates wonderful effects of light and shadow, with the flat, reflective, and richly colored top. Its ornamental details, such as the winged sphinxes and heraldic symbols, convey the idea of majesty and magnificence that would have been important to Cardinal Alessandro. A recent examination of the piers has disclosed slight residues of paint in small areas under the profiles supporting the top. This astonishing discovery may change the current estimation of the table, for if the piers were originally painted, then the overall appearance of the piece must have been quite different.[12]

Many of Vignola's favorite decorative motifs appear on the tabletop, for example, the confronted *peltae* and the broken rectangles enclosing the Farnese lilies. He may have discovered them in the patterns of ancient Roman floors, such as the one in the Curia of Diocletian in Rome.[13] Other ancient works with *peltae* ornaments are to be found at Ostia, the port of ancient Rome,[14] where in 1547, shortly after Vignola began to work for Cardinal Alessandro, the architects went "to get colored marbles for the Palace."[15] All the stones used for the table are of ancient origin, and many of them were taken from the Baths of Caracalla, where excavations were begun in the 1540s under the supervision of the cardinal. For him and for his architects and stonemasons they represented the opulence of imperial Rome, the capital of a vanished empire, and their reuse must have seemed to be physical proof that Rome was indeed the Eternal City. The two alabaster panels were probably stripped from Egyptian monuments and

brought to Italy in ancient times. They are of especial beauty, "the climax," as Raggio observes, "of the whole composition. Large, pure, and quiet, they fulfill the promise of their sumptuous frame. Their hard onyxlike translucent surface, marked by wavy, irregular amber[-colored] veins and elusive whitish formations, has the mysterious attraction of light clouds traveling through a misty sky, or of the frozen ripples of bottomless waters."[16]

At the time the table was under construction, the sculptor Guglielmo della Porta was in charge of the palace workshop where ancient sculptures were restored and excavated stone was reshaped into furnishings for the rooms. Close inspection reveals that the piers were carved by more than one person. This is to be expected, for it reflects workshop practice: as master in charge, Della Porta supervised the workmen who transformed Vignola's designs into stone, carved major elements himself, and added the final touches. In creating these furnishings Della Porta and his masons were emulating ancient artists—not imitating them (*imitatio*) but attempting to surpass them (*superatio*).[17] The *pietre dure* and classical inlay are believed to have been done by a little-known French master named Jean Ménard, called in Italy Giovanni Mynardo, who was considered one of the finest craftsmen in stone intarsia and mosaic decoration working in Rome during the 1560s.[18]

The Farnese table is listed in an inventory of the palace made in 1796 but not in one of 1834. The next record of the table's existence is in a fire-insurance document drawn up shortly after 1844 for Hamilton Palace in South Lanarkshire, Scotland.[19] We may suppose that, like many other Italian antiquities, the treasured table of the Farnese family was acquired by some English or Scottish grandee while on a tour of Italy. In 1919 it was sold at auction from Hamilton Palace to Viscount Leverhulme (1851–1925) for his London collection. Forty years later, in 1958, the monumental table, created to affirm the Great Cardinal's status, erudition, and taste, was transported across the Atlantic to be admired again, as one of the jewels of the Metropolitan Museum's encyclopedic collection. WK

1. Raggio 1960.
2. For a pier from a prototypical Roman table, see Morley 1999, p. 24, fig. 24. For a fresco in which such a table is depicted, see Morley 1999, p. 30, fig. 36. This fresco from the House of the Vettii in Pompeii had not been excavated at Vignola's time; however, similar illustrations of classical tables may have been accessible to him.
3. Dolci 2003, p. 109, fig. 2.
4. Robertson 1986; and Jestaz 1995, p. 54.
5. Robertson 1986.
6. Ginzburg Carignani 2000.
7. Quoted in Raggio 1960, p. 213.
8. Quoted in ibid., p. 215.
9. See Syndram and Scherner 2004, p. 263, no. 141 (entry by Jutta Kappel).
10. On Vignola's work at the Farnese Palace, see Raggio 1960, pp. 223–25. See also Morley 1999, pp. 107, fig. 189 (the present table), 108–9, fig. 192 (the Guicciardini table designed by Vignola and made in wood by Fra Damiano da Bergamo).
11. See Jestaz 1995, p. 55.
12. I am most grateful to Jack Soultanian Jr., Conservator, Department of Objects Conservation, Metropolitan Museum, for having confirmed and further investigated this observation, which was made when the table was moved in 2002.
13. See Guidobaldi 2003, p. 47, fig. 53. For similar shield-shaped forms (*peltae*), see Guidobaldi 2003, p. 64, fig. 78. See also the sixth-century pattern illustrated in the same essay, p. 70, fig. 93, which is similar to the border design of the present table.
14. Di Castro, Peccolo, and Gazzaniga 1994, fig. 23.
15. Quoted in Raggio 1960, p. 219.
16. Ibid., p. 218.
17. Koeppe 1989a, p. 37; see also Irmscher 1988, p. 3067.
18. Ronfort 1991–92, p. 139; and Raggio 1994, p. 8.
19. Raggio 1960, p. 215.

8.

Cupboard (*Fassadenschrank*)

South German (Nuremberg), early seventeenth century
Oak and pine carcase; pearwood and plum, Hungarian ash, maple, and other woods
H. 8 ft. 8 in. (264.2 cm), w. 7 ft. (213.4 cm), d. 2 ft. 6¼ in. (76.8 cm)
Rogers Fund, 1905
05.22.2

During the sixteenth and seventeenth centuries in Central Europe, the term "wood-worker" did not define a single trade. Instead, there were cabinetmakers and chairmakers, each represented by their own guild. The lathe-turned parts of wooden furniture could not be made in the shop but had to be bought from members of an independent turners' guild and the hardware ordered from a master blacksmith. This complex system had been developed to protect guild members from outside competition and to guarantee them a minimum wage. Each master—that is, each qualified member of a guild—was allowed to employ only two journeymen and one or sometimes two apprentices. Only the artisans who worked for one of the many courts of the scattered German territorial states were exempt from these regulations.[1]

Apprentices in the extremely conservative cabinetmakers' guild were required to create a masterpiece, or chef d'oeuvre, of highly complicated design in order to qualify as a master. The guilds in different German towns—from the free imperial cities of Augsburg and Nuremberg in southern Germany to the urban strongholds of the Hanseatic League in the north—had diverse requirements for masterpieces. Nor were all the candidates for mastership in a given guild treated equally in this respect. A "foreign" journeyman—and in the patchwork configuration of states in the Holy Roman Empire, that might mean a man born a stone's throw from the boundary lines of the region under a guild's control—often had to produce a more elaborate and costlier masterpiece than a local applicant for membership. A guild member's son or son-in-law or the prospective husband of a master's widow, all of whom were likely to acquire an already established workshop, were also assigned an easier task.[2] The cabinet piece not only had to demonstrate the design skills of the journeyman and his acquaintance with the architectural theory of the period[3]—for the practice of imitating architecture in furniture was widespread in Germany—but also had to show his mastery of joinery. Sometimes the assignment even included producing a simple structure, such as a window frame. The candidates had to invest money to buy the materials they needed and were unable to earn anything during the time they spent working on the piece. In most cases they were forced to sell their high-quality masterpiece immediately after presenting it to the aldermen of the guild, in order to pay city taxes, to cover entrance contributions to various guild funds, and to raise the capital to establish their own business.

We do not know if the Museum's splendid cupboard was a masterpiece; certainly it represents a tour de force of cabinetmaking. This type of cupboard with an architectural front (hence its German name, *Fassadenschrank*—literally, "facade cabinet") became popular in Germany during the late Gothic period. The Museum's example clearly reflects Italian Renaissance palace architecture of the sixteenth century. Certain carved elements on the pediments and in the niches and also the hardware ornaments indicate that it should be dated to the early seventeenth century, although its form in general would suggest the period between 1550 and 1575. It consists of a drawer-podium supporting a two-door cabinet, a drawer-cornice, a second two-door cabinet, and at the top a hollow cornice. The form developed from the simple idea of placing two similar chests on top of each other to create an optical unit (see fig. 12).[4] Characteristic details are the heavy wrought-iron handles, two on each side, which made it possible to dismantle the object quickly in case of fire.[5]

The cupboard's majestic appearance derives from its balanced proportions, and

Fig. 12. Cupboard by Master "HS" (active 1536–69), ca. 1536–40. Woodcut in Simon Jervis, *Printed Furniture Designs before 1650* (Leeds, 1974).

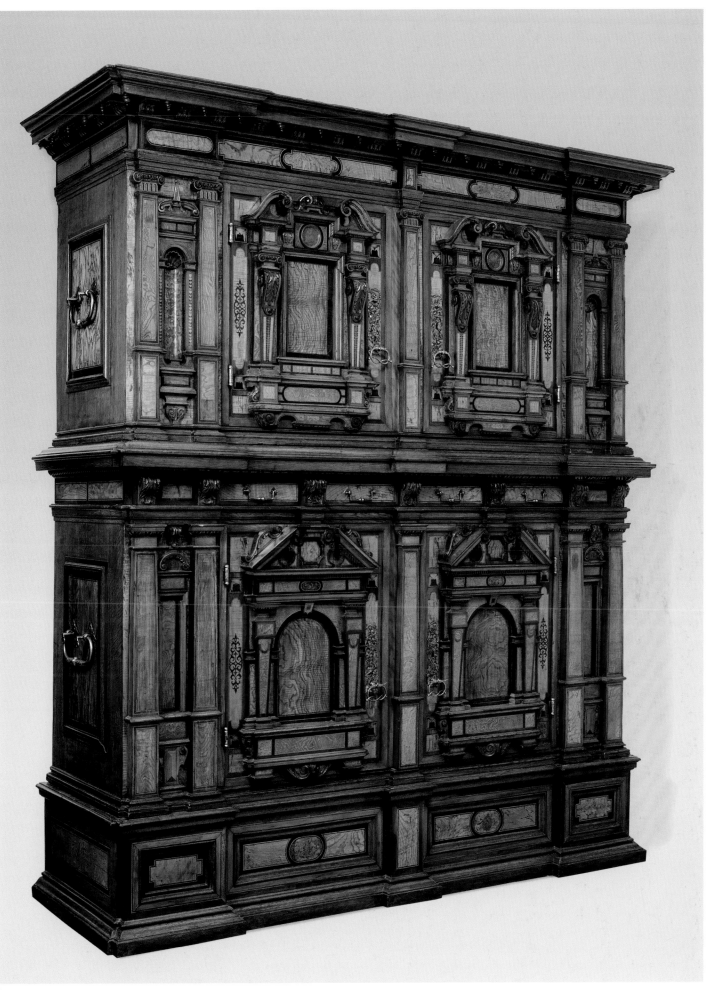

its visual interest lies in architectural details such as the projecting and recessed components of the front and the use of woods of different colors and grain, which evoke the marble slabs on Renaissance facades.[6] CD When new, these woods must have offset each other to an even more striking effect. Unusual is the pretzel shape of the handles.[CD]

Large cupboards were often built to contain a bride's linens. The long pine shelves of this one are marked with numbers (from one through thirty-one) to indicate exactly where rolls of fabric or folded items should be placed.[7]

This *Fassadenschrank* and a related cupboard were among the first pieces of Central European furniture to enter the Metropolitan Museum, and they remain the most important examples of their type in North American museums.[8] W K

1. Stürmer 1978, p. 800; Stürmer 1982; Stürmer 1986; and Wilk 1996, pp. 84, 98 (entries by Sarah Medlam; the two German cabinets she discusses are eighteenth-century; however, the guild situation had not changed since the late medieval period).

2. Ash 1965, p. 34, fig. 86; Huth 1965, p. 48, fig. 136 (dated 1541); Meister 1965, p. 146, fig. 572; Kreisel 1968, pp. 74–76, 180–85, figs. 91, 93, 101, 142–51, 389, 390; Koeppe 1991b; Koeppe 1992, pp. 118, 157–59, 162–64, 168, 192–94, nos. M52, M88, M92, M97, color ills. pp. 190, 192, 242; and Morley 1999, p. 74, fig. 129.

3. The ten-part treatise *De architectura* (after 17 B.C.) by the Roman architect Vitruvius Pollio was very influential. It had been reissued in Latin in 1485 in Rome by Giovanni Sculpicio. One of the best-known editions north of the Alps was Sebastiano Serlio's treatise *Regole generali di architettura sopra le cinque maniere de gli edifici*, published in 1537 in Venice and translated into German in 1542; Günther 1988. Another important German translation of Vitruvius's *De architectura*, with added illustrations, was *Vitruvius Teutsch* by Walther Hermann Ryff (Rivius) of Nuremberg (ca. 1500–after 1545), published in 1548. Ryff, who added his own commentary, dedicated the work "to all artistic craftsmen, foremen, stonecutters, builders, headgear makers and gun-

smiths, . . . painters, sculptors, goldsmiths, cabinet-makers, and all who have to use the compass and the guiding ruler in an artistic manner." Thus, Ryff intended his publication not for a small circle of humanist connoisseurs but for practicing craftsmen, including the makers of fine furniture; see Dann 1988, especially p. 81.

4. Windisch-Graetz 1982, p. 265, no. 238; Koeppe 1992, pp. 157–59, no. M88, color ill. p. 190.

5. For similar cabinets, see Meister and Jedding 1958, fig. 101; Bauer, Märker, and Ohm 1976, figs. 17, 18 (the captions to these two illustrations are in reverse positions); Windisch-Graetz 1983, pp. 356–57, nos. 213, 294; and Koeppe 1992, pp. 117–18, no. M52, color ill. p. 183.

6. Forssman 1956, pp. 39ff.

7. The cabinet was restored in 1993–94 by John Canonico, Conservator, Department of Objects Conservation, Metropolitan Museum. Damaged shelves in the upper compartment have not been replaced.

8. The accession number of the related cabinet is 05.22.1.

9.

Cabinet

Italian (Florence), 1606–23
Oak and poplar veneered with various exotic hardwoods; ebony moldings; marble plaques; slate (paragon); pietre dure work consisting of colored marbles, rock crystal, and other hardstones
H. 23¼ in. (59.1 cm), w. 38⅛ in. (96.8 cm), d. 14⅛ in. (35.9 cm)
Wrightsman Fund, 1988
1988.19

"The Barberini family in the later sixteenth and seventeenth centuries presents a virtual paradigm of the well-managed Roman family. The Barberini recognized that the way to power and wealth lay through the Church and that the perpetuation of the family was dependent on marriage; and they accordingly consistently pursued both of those channels of family development. For several generations they were blessed with sufficient male offspring, and they managed this natural resource to the benefit of the family as a whole."[1] In line with this tradition, Maffeo (1568–1644), the second youngest of Antonio

Barberini's six sons, left Florence in 1584, to take up residence and continue his education at the Collegio Romano in Rome as a protégé of his uncle Monsignor Francesco Barberini (1528–1600), the apostolic protonotary.[2] Maffeo later graduated from Pisa University as doctor of law. He returned to Rome in 1588–89 to embark on a meteoric ascent through the ecclesiastical hierarchy of the Vatican. From 1604 to 1607 he was accredited as papal nuncio to Henry IV's court in Paris, following an initial legation to France in 1602. This first Bourbon king (r. 1589–1610) had married Maria de' Medici (1573–1642), who came from Florence, the town where Maffeo was born and most of his family still lived. In the culturally stimulating environment of Paris, Maffeo acquired a refined taste for the arts and enjoyed many luxuries that had previously been beyond his reach. It may have been in Paris, too, that he redesigned the Barberini coat of arms for his own use, changing the wasps into bees and adding

the sun symbol and laurel leaves of Apollo, patron of poets.[3] CD After his appointment to the Sacred College of Cardinals in 1606, he added a *galero*, the flat, red wide-brimmed cardinal's hat adorned with scarlet tassels.

These arms are set like a jewel in the center of the Museum cabinet's pediment. Three golden bees stand out against a lapis lazuli ground within a scrollwork cartouche that is embellished with stylized laurel sprigs and leaves and is surmounted by the *galero*. Probably because the panel is small, the *galero* is shown with six tassels on each side instead of the fifteen appropriate for a cardinal. Maffeo Barberini was elected pope on 6 August 1623 and took the name Urban VIII. Eager to immortalize his pontificate and to secure a place for his family among Europe's aristocracy, he became a great patron of the arts and named his brother and three of his nephews cardinals. This nepotism made the Barberini family rich beyond measure, and their building programs changed the appearance of Baroque

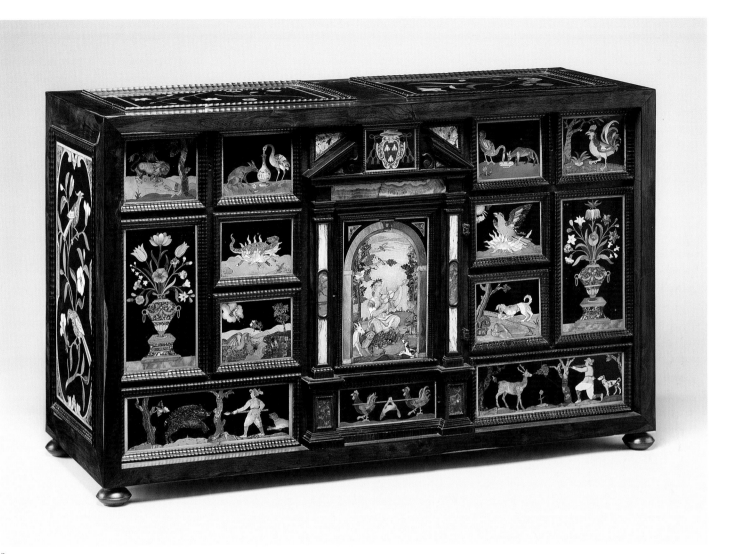

9

Rome.[4] The Barberini bees and laurel leaves appear on many of Urban VIII's commissions, one of the most significant of which was the baldachin designed by Gianlorenzo Bernini (1598–1680) and built between 1624 and 1633 in Saint Peter's.[5]

On the door of the central compartment of the Museum's cabinet Orpheus, the legendary Thracian poet, is seen playing a *lira da braccio*, an early type of viol, and charming various button-eyed animals and grotesque beasts with his music.[CD] Clare Vincent has noted that "this panel is flanked by six subjects of animal cunning or foolishness taken from woodcuts in Francisco Tuppo's Aesop's *Fables* (Naples, 1485). These include the greedy dog who drops his morsel while trying to gobble up the one reflected in the water—the reflection is cleverly achieved in reverse-painted rock crystal. Below are animals hunting and hunted, with a witty revenge of cocks on their hunter, a fox."[6] In comparison with the poetic Orpheus scene above, this merciless illustration—the cocks

Fig. 13. This drawer front on the left side of the cabinet is inlaid with the image of a salamander on a pyre and framed by ebony ripple moldings. The front of the carcase of the cabinet is veneered with exotic wood (*Piratinera guianensis*).

are carrying the dead beast home on a stick—bespeaks an awareness of sudden changes in which a pleasant life is turned "upside down" into tragedy.

The panels to left and right of the door, in the top register, show the salamander, impervious to fire (fig. 13), and the phoenix, a bird that according to classical myth lived for centuries and then burned itself to ashes, from which a new, young phoenix arose. The salamander was an emblem of Francis I of France (1494–1547)—a celebrated patron of art and poetry such as Maffeo wished to be—and the phoenix was the device of Pope Clement VIII (1536–1605), who had granted Maffeo the position of nuncio at the French court.[7] This logical interpretation of the panels' symbolism has been questioned by Michael Bohr, who dated the cabinet much later, to about 1665–75;[8] it is difficult, however, to dismiss the revised Barberini coat of arms as evidence that the cabinet's first owner was the young Florentine who had been papal nuncio at the court of Henry IV. There is subtler evidence, too, that connects the cabinet with Maffeo. The phoenix, which symbolizes chastity and resurrection, looks up toward the sun that represents Apollo, the god who played for the Muses on Mount Parnassus as Orpheus played for the animals. Apollo is often represented with a crown of laurel in recognition of his achievements as patron of poetry and music.[9] As we have seen, both laurels and the Apollonian sun were added by Maffeo to his arms, the presence of which at the top of the cabinet reinforces the looser symbolism of the other plaques on this outstanding piece of furniture, which is clearly intended to glorify the owner as artist and as arbiter of the arts.

Only the exact dating of the cabinet remains mysterious. In 1606, when Maffeo was made a cardinal, he could still be considered a "son of Florence." That the cabinet was a propaganda gift from the grand dukes of Tuscany, the family of Maria de' Medici, to Maffeo on that occasion is speculative but possible. Yet the subject matter of the panels suggests an intimate knowledge of Maffeo's ambitions, and it seems more likely that he commissioned the cabinet himself or that it was a present from his own family or friends in honor of his elevation to cardinal, or of some other auspicious event that occurred between 1606 and August 1623, when he adopted the papal coat of arms.[10]

The *pietre dure* plaques reflect the high technical standard of the grand-ducal workshop in Florence, the Galleria dei Lavori.[11] Large panels with floral branches and colorful birds executed after designs possibly provided by Jacopo Ligozzi (1547–1626) decorate the cabinet's sides and—very unusually—the top. This suggests that the cabinet was originally supported on a low stand that would permit close viewing of the top from above. The stand was most likely a simple table draped with precious fabric. All the panels are framed by ripple moldings that are designed to catch the light, especially that of candles in a dark room.[12]

The carcase construction of the cabinet and its ripple moldings relate it to a cabinet made for the Medici, now in the Palazzo Vecchio in Florence, dating to about 1615–20,[13] and to a cabinet in the National Gallery of Canada, Ottawa.[14] The technical perfection of the works seems to indicate that all three pieces were produced by German craftsmen settled in Florence. The employment of several German craftsmen at the Galleria is documented, as is the unusual fact that some of them owned their tools and lathes, which they may have brought with them from Germany.[15] Oak is rarely used in the construction of contemporary Florentine cabinets.[16] Nevertheless, we know that some foreign masters brought with them the materials they were accustomed to use and received reimbursement later. Given the sumptuousness of the other materials used on the Museum's cabinet, especially the exotic snakewood on the front between the drawers, the extra expense for oak to create a stable construction seems minor.[17]

The Orpheus scene is based on an etching by Antonio Tempesta (1555–1630).[18] The theme appears also on the imitation damascened-iron fittings on Milanese furniture and on cast-bronze plaques.[19] The theme would become one of the Galleria's most popular products: no less than eighteen pieces of furniture, each with a slightly varied central Orpheus plaque and different animal panels, are documented.[20] This indicates that panels could be commissioned separately and then mounted later according to the taste of the individual patron. The most impressive examples are a show cabinet of 1660–70 in the collection of Juan March Ordinas at Palau March in Palma de Mallorca[21] and at the Château de Beloeil, Mons, Belgium, a pair of Sicilian cabinets with red coral mounts surrounding the *pietre dure* panels.[22] The Barberini cabinet seems to be by far the earliest and most elaborately conceived object of this extensive group depicting Orpheus charming the animals.

WK

1. Waddy 1990, p. 128.

2. On the life and papacy of Maffeo Barberini, Pope Urban VIII, see *Dictionary of Art* 1996, vol. 3, pp. 205–7 (entry by John Beldon Scott); Schütze 2005 (I thank Olga Raggio for bringing this important reference to my attention); and Catholic Encyclopedia (online at www.newadvent.org/cathen/15218b.htm).

3. *Dictionary of Art* 1996, vol. 3, p. 205 (entry by John Beldon Scott).

4. Waddy 1990, p. 130.

5. These four bronze spiral columns are covered with laurel branches. Several other works of art commissioned by the Barberini family in the pope's honor include this specific floral motif. *Allegory of Divine Providence,* a fresco by Pietro da Cortona (1596–1669) in the Palazzo Barberini ordered by Urban's nephew Cardinal Francesco Barberini, idealizes the pope's pontificate, his moral standards, and his political and especially his poetic skills. The center is dominated by the papal arms, three bees encircled by a laurel wreath. A putto nearby holds the laurel crown awarded to worthy poets. See *Dictionary of Art* 1996, vol. 3, pp. 206–7 (entry by John Beldon Scott).

6. Metropolitan Museum of Art 1988, pp. 28–29 (entry by Clare Vincent). For the woodcuts, see Tuppo 1485, *fabulea* 2, 6, 18, 23, 35.

7. Metropolitan Museum of Art 1988, p. 29 (entry by Clare Vincent); and Freiberg 1995. The salamander was also at this time an emblem of France. On the facade of San Luigi dei Francesi (the French church in Rome, completed 1589), the salamander guards the portals. On the left is the device of Francis I with his motto "Nutrisco et extingo" (I nourish and destroy), but on the right the salamander is surrounded by the legend "Erit Chri[s]tianorum lumen in igne" (The light of the Christians will be in the fire).

8. Bohr 1993, pp. 200–203, no. III.

9. Hall 1979, p. 26.

10. Martin 1987, pp. 133–36.

11. Giusti, Mazzoni, and Pampaloni Martelli 1978; Baldini, Giusti, and Pampaloni Martelli 1979; and Ramond 1994, pp. 63–66.

12. For these moldings, see Greber 1956, pp. 335–38; and Koeppe 1992, pp. 103–4, no. M38.

13. Baldini, Giusti, and Pampaloni Martelli 1979, pp. 291–92, no. 101, pl. 143.

14. Acc. no. 28145.

15. Bohr 1993, p. 16.

16. Ibid., pp. 200–203, no. III.

17. González-Palacios 1982, p. 38; and Bohr 1993, pp. 311–12, doc. no. 317.

18. Buffa 1984, p. 124.

19. Hughes 1996, vol. 1, p. 126, no. 21; and Wilk 1996, p. 62, figs. 1, 2 (entry by Tessa Murdoch).

20. Information in the archives of the Department of European Sculpture and Decorative Arts, Metropolitan Museum.

21. Junquera y Mato 1992, p. 261. I was not able to examine the March cabinet personally for this study.

22. Gismondi and Richard 1988, fig. 9. I am grateful to H.S.H. the prince de Ligne, Château de Beloeil, Belgium, for bringing this information to my attention.

10.

Cabinet (*beeldenkast*)

Dutch, 1622

Oak

H. 96 in. (243.7 cm), w. 83 in. (210.7 cm),
d. 35 in. (88.8 cm)

Inscribed on the book carved on the drum
beneath the feet of Prudence: "DEN 27 IN
APRILIS ANNO 1622 STILO NOVO VAERT
WEL." Inscribed beneath the figures in the upper
frieze are their names: "ARESTOTVLVS,"
"MATHEVS," "MARCVS," "LVCAS,"
"IOANNES," "DALIDA EN SAMSON."

Fletcher Fund, 1964
64.81

Monumental cabinets of this type, known in modern Dutch as *beeldenkasten* (cabinets with figures) in reference to the usually female caryatids carved on them, were among the most costly and impressive pieces of furniture made in the Northern Netherlands during the first half of the seventeenth century.[1] Architectural in structure, this four-door example consists of a base and two main sections topped by a broad frieze and a protruding cornice. A large drawer with a convex front forming a second frieze separates the upper part from the one below. The base, also fitted with a drawer, is raised off the floor by two dragon-shaped supports.[2] The entire cabinet is richly decorated with exquisite carving, especially on the front, which is embellished by six caryatids supporting Ionic capitals. From left to right, flanking the doors in the upper register are the three Theological Virtues: Hope with a book, Charity with three infants, and Faith with an anchor and a dove.[CD] Three of the four Cardinal Virtues—Prudence with a snake, who probably held a mirror in her missing hand, Justice with a sword and scales, and Fortitude with a pillar—flank the doors from left to right in the lower register. The drums underneath the feet of the three Cardinal Virtues are carved with figures from the Old Testament. They are, again from left to right, King David playing the harp (fig. 14), Judith handing the head of Holofernes to her maidservant, and Samson slaying the lion by breaking its jaw. The sides of the cabinet display vertical panels. Framed by moldings, the center of each panel is composed of three pieces of oak. The pieces at top and bottom are triangular,

creating the illusion of depth. The door panels on the front are oriented horizontally and decorated with biblical stories. The single panels in the upper section are devoted to the judgment of Solomon and Queen Esther kneeling before her husband, the Persian King Ahasuerus.[3] Episodes from the life of Joseph are rendered on the double panels of the lower doors. The top two show, from left to right, the young Joseph relating his dreams to his father and brothers, and Joseph being lifted from the pit and sold into slavery. Those below are divided into two scenes each: the one to the left depicts Joseph fleeing Potiphar's wife and Joseph in prison, explaining the dreams of Pharaoh's butler and baker.[CD] The panel on the right illustrates Joseph interpreting Pharaoh's dreams and the episode when Joseph's silver cup is found in his brother Benjamin's corn sack (fig. 15).

The frieze that runs along the facade and sides of the cabinet beneath the cornice is divided into six sections by modillions carved with a winged angel's head. Depicted on the front are the Four Evangelists with their symbols and their names inscribed between large foliated scrolls. On the left can be seen Phyllis riding on the Greek philosopher Aristotle's back, and on the right Delilah is holding shears to cut locks of hair from Samson's head.[CD] Different hunting scenes, which seem to be purely ornamental, are rendered on the convex frieze below. On the left side of the cabinet hares are chased by hounds. The quarries on the front are stag and ox. These scenes are separated by three lions' heads, each with a ring in its mouth; the one in the center serves as a drawer pull. A boar is hunted on the cabinet's right side. The carved scrolls and fruit baskets on the drawer front in the base create a certain trompe l'oeil effect since the sequence is broken at the center, giving the impression that the motifs continue behind the central lion's head.[4]

Although a number of *beeldenkasten* have survived, few are dated. The inscription and date, 27 April 1622, on the Museum's piece make it the earliest example of certain date known to exist (see fig. 14).[5] A special event may have taken place on that day,

possibly a wedding, since such large cupboards were often commissioned for, or presented to, a bride, who would use it to store her linens. It has been suggested that the themes of their decoration are linked to marriage, since they are allegories of male and female valor and virtues.[6] Indeed, during the sixteenth and seventeenth centuries illustrations of biblical stories served as didactic examples of moral behavior and were regularly used in the Netherlands as embellishment for furniture and other objects of daily use.[7]

The Theological and Cardinal Virtues represented as caryatids might be seen as the pillars of a Christian marriage or, more generally, of a society based on the Christian creed. The judgment of King Solomon symbolized justice and wisdom, and Queen Esther's courageous intercession on behalf of her people exemplified a wife's beneficial influence within a marriage.[8] The complex story of Joseph has been said to illuminate the love of family,[9] but individual episodes could be interpreted differently. Joseph's rejection of Potiphar's wife, a beloved theme in Dutch art, may be seen as an allegory of chastity and as a warning

Fig. 14. Carving on the left drum of the cupboard showing King David playing the harp. The book on the table beside him has an inscription and a date.

Fig. 15. Carving on a lower door panel of the cupboard showing Joseph explaining Pharaoh's dreams (left) and Joseph's steward finding his master's silver cup in the corn sack of Joseph's brother Benjamin.

against lust and adultery.[10] Samson in combat with the lion is readily understood as an emblem of Fortitude, under whose feet he is depicted on the cabinet.[11] Especially popular as instructive examples were the biblical heroines—the brave and chaste Judith, for instance, who saved her people by beheading Holofernes, a general who had laid siege to the Jewish city of Bethulia. But the story of Judith and Holofernes could have a different interpretation as well. In association with depictions of Delilah and Samson and of Phyllis and Aristotle, it can be seen as an illustration of a man's misfortunes at the hands of a scheming woman.[12] The inscribed book on the drum beneath King David might be a reference to the Psalms, of which he is traditionally believed to be the author.

Although it is not known who was responsible for the creation of this magnificent cabinet, it must reflect the collaboration of both a cabinetmaker and a master carver. According to guild regulations, a cabinetmaker was not allowed to execute more than the simplest of carvings. The carver of this cabinet has paid remarkable attention to minute details, such as the patterns of

garments and their trim or the depiction of dreams in three of the Joseph panels. For instance, the cows that appeared in Pharaoh's first dream symbolizing seven years of plenty and seven years of famine to come can be clearly distinguished. The idea of rendering the king's dream as well as those of Joseph and of the baker and the butler in medallions above their heads must have been derived from engravings.[13] Probably all these representations were adapted from popular print sources or Bible illustrations. Some of the scenes in the panels, such as that of Jacob interpreting Pharaoh's dreams (fig. 15), are related to compositions by the Haarlem painter and draftsman Maarten van Heemskerck (1498–1574), who produced numerous designs for prints with subjects from the Old and New Testaments (see fig. 16).

In several ways the Museum's cabinet is different from extant *beeldenkasten* of later date. Two of the five modillions on the front do not correspond to uprights below and therefore make little sense in architectural terms. In later cabinets there are usually only three such carved brackets and they

Fig. 16. Dirck Volkertsz Coornhert, *Interpreting the Dreams of Pharaoh*, etching after Maarten van Heemskerck, ca. 1549–50. The Metropolitan Museum of Art, New York, The Elisha Whittelsey Collection, The Elisha Whittelsey Fund, 1966 (66.613.11).

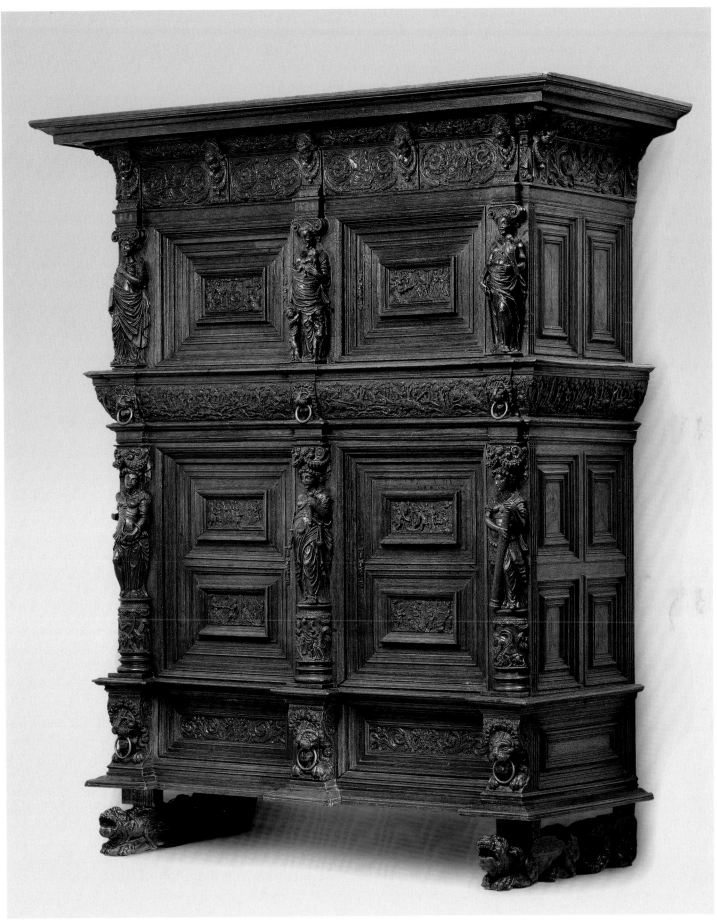

are placed directly above the caryatids. Whereas cabinets of this type are generally supported on ball feet, this example has dragon's feet, which appear to be related to the fanciful creatures seen in furniture designs by Hans Vredeman de Vries (1527–1604) and his son Paul (1567–after 1630).[14] The fact that an episode from the life of Queen Esther is depicted also attests to the early date of the Museum's piece. Esther's popularity as one of the Old Testament heroines waned in the Netherlands during the early seventeenth century in favor of the chaste Susanna. A number of *beeldenkasten* of a slightly later date are decorated with carved scenes of Susanna.[15]

Beeldenkasten are traditionally thought to have originated in the western coastal region of the Netherlands called Holland;[16] however, since a substantial number of examples displaying carving of varied quality is known today, it is likely that the type was fashionable from the outset in other areas of the country as well.

The cabinet is first recorded in the collection of D. G. Bingham of Utrecht, whence it was sold at auction in 1923.[17] Bought at that sale by the Amsterdam dealer Étienne Delaunoy, the cabinet was acquired at an unknown date by the newspaper magnate and collector William Randolph Hearst (1863–1951).[18]

D K - G

1. See Baarsen 1993b and Reinier Baarsen's entry in Luijten et al. 1993, pp. 415–16, no. 73.

2. When the cabinet was acquired by the Museum, it had three dragon supports. The central one was removed because it was considered to be a later addition.

3. This scene was long thought to depict the Queen of Sheba's visit to Solomon, but the fact that the king is extending his scepter to the kneeling woman makes it clear that he is Ahasuerus, forgiving Esther for entering his presence without having been summoned; see Veldman 1993, pp. 133, 136, no. 155/1.

4. Baarsen 1993b, p. 208.

5. The date "DEN 27 IN APRILIS ANNO 1622" is followed by the words, partly in Latin and partly in Dutch, "STILO NOVO VAERT WEL," meaning "in the new style, fare well." "In the new style" probably refers to the change made in 1582 from the Julian to the Gregorian calendar, which was accepted at different times by different countries. In the Julian calendar (old style) the date would have been 12 April 1622. Related *beeldenkasten* decorated with six caryatids are known, but none is dated. See, for instance, Haags Gemeentemuseum 1975, no. 5; "Nederlandse Kunst- en Antiekbeurs" 1979, p. 634; and Flemming 1992, p. 2372.

6. Lunsingh Scheurleer 1961, p. 46; and Baarsen 1993a, pp. 24–25, no. 9.

7. See the catalogue of an exhibition in Utrecht devoted to this topic: Kootte 1991.

8. Brooke 1992, p. 53.

9. Baarsen 1993b, p. 207. A cabinet with scenes from the life of Joseph in the Gemeentemuseum, The Hague, is illustrated in Haags Gemeentemuseum 1975, no. 5. Another, in the Museum für Kunst und Gewerbe, Hamburg, is illustrated in Feulner 1980, pl. 232.

10. Maarten van Heemskerck used this theme as an illustration of the Tenth Commandment: You shall not covet your neighbor's servant. See Brooke 1992, pp. 20–21.

11. Hall 1979, pp. 271–72.

12. Ibid., pp. 31, 181, 272.

13. See, for instance, *Thesaurus Sacrarum Historiaru Veteris Testamenti*, published by Gerard de Jode (Antwerp, 1579), pls. 92, 95, 96.

14. Jervis 1974b, nos. 149, 154, 328, 330–31.

15. Kootte 1991, p. 49, fig. 46, p. 89, no. 43; and Veldman 1991, pp. 40–41.

16. This idea is based on the fact that one cabinet was made at Hoorn. The resemblance of the female caryatids on the pulpit of the Nieuwe Kerk in Amsterdam, carved in 1648–49 by Albert Vinckenbrinck (1604/5–1664/65), has further strengthened this theory. See Luijten et al. 1993, p. 416, no. 73 (entry by Reinier Baarsen).

17. Frederik Muller et Cie., Amsterdam, 26–29 June 1923, lot 626.

18. It was sold from Hearst's collection at a sale at Hammer Galleries, New York, in 1941, lot 126-1.

11.

Cabinet on stand

French (Paris), ca. 1645
Oak and poplar wood veneered with ebony, ivory, stained ivory, bone, and various marquetry woods, including kingwood and amaranth; ebonized pearwood; gilt-bronze capitals and bases; plated-iron hardware
Stamped on the back of the cabinet and on the back of the stand: "RESTORED 1884–5 HERTER BROTHERS." Inscribed on two bone panels: "Roma" and "1561."
H. 74½ in. (189.2 cm), w. 66 in. (167.6 cm), d. 23 in. (58.4 cm)
Gift of Mrs. Harold Fowler, 1931
31.66a,b

Exotic woods such as ebony became available in Europe through the overseas trade initiated by the Portuguese during the sixteenth century. Imported from faraway places such as Madagascar and the surrounding islands, ebony was admired for its dark, almost black color; its hardness; and its lustrous surface. Too rare and precious to be used as solid wood, ebony was almost exclusively reserved for veneering. This technique, introduced into France from Germany and the Low Countries, was to exert great influence on the making of case, or storage, furniture. In fact, the seventeenth-century French cabinetmakers who worked with ebony veneer became known as *menuisiers en ébène,* and later *ébénistes,* a term still used today.

Using carved and engraved ornament and a variety of ripple moldings that create marvelous light reflections on the glossy dark surface, these craftsmen decorated a new type of furniture in France: the imposing ebony cabinet.[1] Unlike the small late-sixteenth- and seventeenth-century table cabinets made in Augsburg and Antwerp that were meant to be seen in the round, these large and sumptuous pieces were intended to stand against the wall and thus are never veneered on the back. Like the collector's cabinet, they were used for the safekeeping of jewelry, medals, documents, and curiosities[2] and were commissioned by important patrons such as Cardinal Richelieu (1585–1642).[3]

The Museum's example is constructed in two sections. The upper part—the cabinet proper—is fitted with two doors on the front, surmounted by a frieze concealing a drawer on each side, and crowned by a protruding cornice.[4] The lower section comprises the stand, whose frieze encloses two drawers and is supported by six slightly projecting columns in front and at the back by half columns and pilasters with panels between them. These ringed columns and pilasters, with Ionic capitals similar to those found on contemporary buildings, lend an architectural character to the cabinet.[5] This is further emphasized by the articulation of the door panels, where fluted pilasters, flanking shallow niches containing figural sculptures, directly correspond to the columns below, giving the cabinet a structural unity (fig. 17). Behind the doors is a tier of five drawers on either side of a central compartment.[CD] This compartment is enclosed by two more doors, each decorated to

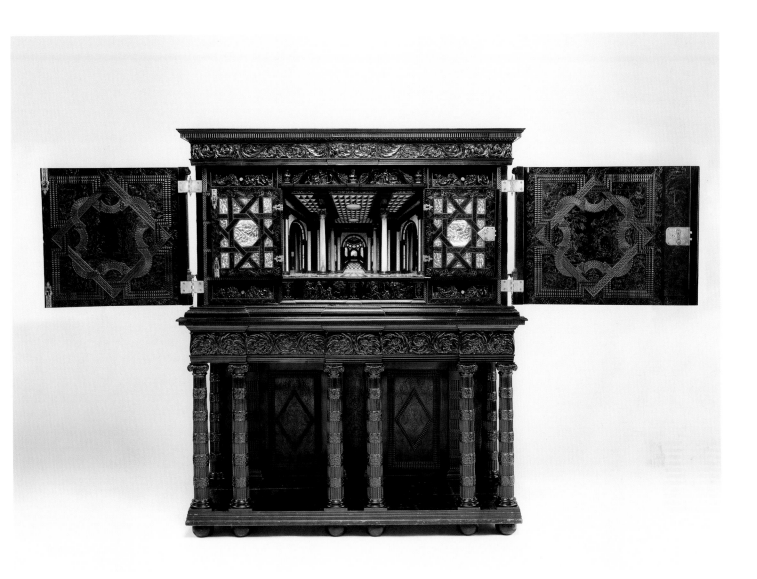

resemble a pedimented Corinthian colonnade.

Whereas some ebony cabinets display mythological figures or scenes based on contemporary literature, it is stories from the Old Testament that are found on the Museum's cabinet. Some of them are based on woodcut illustrations from *Figures historiques du Vieux Testament* (see figs. 18, 19). This book was first published in 1596, and a second edition was issued in 1614 by Jean Le Clerc in Paris. Depicted on the exterior of the left door is the judgment of Solomon, and on the right door is the meeting of Solomon and the Queen of Sheba. Both are enclosed in elaborate cartouches and framed by intricate moldings and engraved flowers. On the sides of the cabinet are rendered, respectively, the prophet Ahija with Jereboam and Solomon made king.⁽ᴰ⁾ The plinth has episodes from the lives of Tobias, Judith, Susanna, and David. Carved on the outside of the interior doors are Isaac blessing Jacob on the right and

Esau selling his birthright on the left. The smaller panels on the drawer front below the compartment are representations of Hagar and Ishmael sent into the wilderness by Abraham and their rescue by an angel. In several of these scenes the figures from the woodcuts have been faithfully copied, although they were enlarged on the cabinet. The compositions, however, were generally simplified in the interest of clarity and in some cases, as with the images of Hagar and Ishmael, one woodcut served as an inspiration for two panels.

Female personifications of the Theological Virtues, Faith, Hope, and Charity, stand in the niches on the exterior of the cabinet, while two Cardinal Virtues, Prudence and Justice, are seated inside the broken pediments on the interior doors. Putti frolicking with hybrid sea creatures decorate the fronts of the two tiers of drawers, and engraved landscape scenes framed by ripple moldings further embellish the inside

of the outer doors. It is not clear whether a specific iconographic scheme was intended. The association of the Theological and Cardinal Virtues with the biblical heroines Judith, Susanna, and Hagar suggests an allusion to the so-called *Femmes Fortes* (literally, "strong women"). This theme gained importance in art during the first half of the seventeenth century, when the queen mothers of France Marie de Médicis (1573–1642) and Anne of Austria (1601–1666) served as regents for their young sons, the future Louis XIII and Louis XIV, and it found literary expression in Pierre Le Moyne's popular *La galerie des femmes fortes.*[6] Published in Paris in 1647 and dedicated to Anne of Austria, this book consisted of a series of engravings of illustrious women from antiquity to modern times.

In strong contrast with the monochromatic decor of the rest of the cabinet, the central compartment, known as a *caisson* in the seventeenth century, is brightly colored.⁽ᴰ⁾

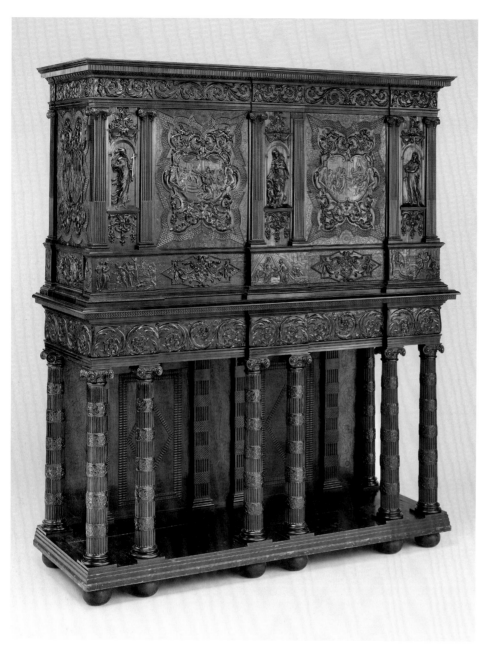

Treated as a sumptuous architectural interior, it was meant to surprise the viewer and enchant the eye.[7] The checkered floor and ceiling, the marbleized ivory cornice, and the two ivory columns in front that simulate coral are original, but other elements, such as the mirrored arcades and central apse, are later replacements. Although the cabinet was treated several times during the nineteenth century, they most likely date to a major restoration that was undertaken in 1884–85 by Herter Brothers, as stamps on the back indicate.[8CD] This leading New York cabinetmaking and interior-decorating firm, established by Gustave Herter (1830–1892) and his younger brother Christian (1839–1883), specialized in the adaptation of European historical styles.[9] The brothers' role as restorers of antique furniture is less well known; certainly this aspect of their work would have given them inspiration for new designs.[10] During this restoration the drawers were rebuilt and the back of the cabinet proper was replaced, as were the lower shelf and the feet. The shelf must originally have protruded in the center and at either end to echo the projections of the columns and the entablature above, as can be seen on other cabinets. Shaped apron ornaments, now missing, were probably placed between the front columns. The restorers must have tried to reuse as many of the seventeenth-century elements as possible; however, the angels engraved on bone panels to either side of the central apse, holding a plaque inscribed,

Fig. 17. General view of the cabinet on stand with the doors closed.

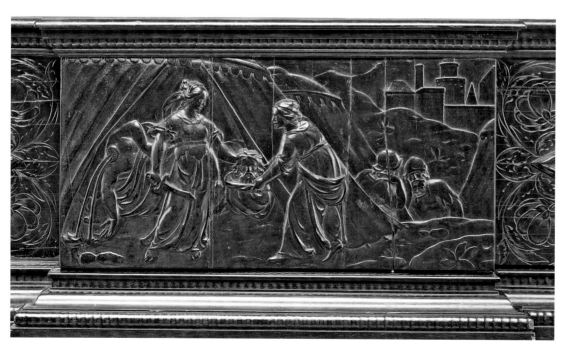

Fig. 18. Carving of Judith with the Head of Holofernes on the front of the cabinet's plinth.

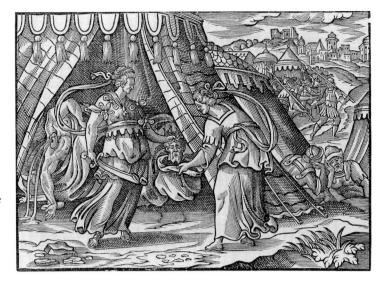

Fig. 19. *Judith with the Head of Holofernes,* woodcut attributed to Jean Cousin the Younger (1522–1594) in the second edition of *Figures historiques du Vieux Testament,* published by Jean Le Clerc (Paris, 1614). The Metropolitan Museum of Art, New York, Harris Brisbane Dick Fund, 1931 (31.65).

respectively, "Roma" and "1561," were certainly not original.[CD]

One indication of how rare and precious ebony was during the first half of the seventeenth century is the fact that the columnar legs are made of blackened, so-called ebonized, pearwood. In an attempt to reduce the overall cost, ebony veneer was applied at eye level on the superstructure, while the cheaper, ebonized substitute was chosen for the lower part, which would, after all, receive less attention than the top. Another indication of thrift is the practice of inlaying thin pieces of ebony into the oak substrate. This was done, as on the outside of the outer doors, at varying levels in order to create a layered effect and, at the same time, to minimize the use of the imported wood.

The various ripple moldings were produced with the help of a machine with a manual crank and a plane that would cut the repetitive decoration into the strips of ebony.[CD] Originating in Nuremberg about 1600, this type of molding was quickly adopted elsewhere but fell out of favor after 1700.[11] In fact, when André-Jacob Roubo (1739–1791) wanted to describe the production of such moldings in his standard work *L'art du menuisier,* published in Paris between 1769 and 1775, he had to reconstruct a special machine on the basis of earlier descriptions because no existing examples could be found.[12]

The use of white ivory and, especially, tinted ivory that simulates coral, semiprecious stones, or marble lends the *caisson* its brightness. Contemporary manuals reveal that a speckled or veined effect could be achieved by coating those parts of the ivory that were to remain white with removable

wax before dipping it in a colored dye, a technique not unlike batiking a piece of fabric.[13] The Parisian cabinetmaker Adriaan Garbrand and his son-in-law Pierre Gole (ca. 1620–1684) used such ivory columns stained to resemble coral in their expensive ebony cabinets.[14] A beautiful example is in the Rijksmuseum, Amsterdam.[15] Like the Museum's cabinet, the themes of its decoration derive from the Old Testament and there is marbleized ivory in its interior. It is more luxurious, however, but this is perhaps partly due to the alterations made in the interior compartment of the Metropolitan's example during the nineteenth-century restoration. A comprehensive study of the *caissons* in all extant ebony cabinets is needed before this one can be attributed to a specific workshop.

Ebony cabinets fell out of favor during the second half of the seventeenth century.[16] They received renewed interest during the nineteenth century, when elements stripped from old examples were sold and new cabinets were constructed from older parts.[17] At that time it was no longer known where these pieces of furniture had originated—in Flanders, Italy, or France.[18]

This cabinet was brought to America from Europe by one of its former owners, Richard Meade, the father of George Gordon Meade (1815–1872). Born in Spain, the younger Meade served as a Union general in the American Civil War. Sold by his family after his death, the cabinet was exhibited in 1882 at the Memorial Hall in Philadelphia, where a dispute about its ownership arose.[19] Following the Herter Brothers' restoration of 1884–85, it was acquired by Mrs. Robert Hoe as a gift for her husband, a Museum

trustee from 1870 to 1892, and given to the Museum by their granddaughter, Mrs. Harold Fowler, in 1931.　　　D K - G

1. Recent literature on ebony cabinets includes: Alcouffe and De Bellaigue 1981, pp. 6–21. See also Alcouffe 2002a; Alcouffe 2002b; Castelluccio 2002, pp. 85–110; and Gaillemin 2002.

2. Castelluccio 2002, pp. 103, 110.

3. A large ebony cabinet of this type is described in Cardinal Richelieu's 1642 inventory; see Levi 1985, pp. 54–55.

4. The Museum's cabinet was first published in Remington 1931.

5. See, for instance, the half columns on the facade of the former Palais des Tuileries, Paris; Gébelin 1927, no. 132, pl. LXXXII.

6. Ian Wardropper has suggested this in an unpublished paper. Queen Anne of Austria had ceiling frescoes based on this theme in her bedchamber at the Louvre; Bodart 1975, p. 44. See also Baumgärtel and Neysters 1995, pp. 71–78, 170–74, no. 55 (entry by Bettina Baumgärtel); and Gaehtgens 1995, pp. 71–78.

7. In some cabinets, pleasantly scented wood was used to satisfy the nose as well. Madame de Bietz, for instance, specified the use of "bois de couleurs et qui aye de bonne senteur" for the *caisson* of the cabinet she commissioned in 1641; Archives Nationales, Paris, minutier central, LXXXVII, 117, 1 April 1641; quoted in Castelluccio 2002, p. 99.

8. "Curious Suit" 1882. I am grateful to Mechthild Baumeister, Conservator, Department of Objects Conservation, Metropolitan Museum, for bringing this article to my attention. The cabinet was said to be in a "shockingly dilapidated" state before restoration; see "Remarkable Cabinet" 1885, p. 17. When the interior was reconstructed, the secret drawers were lost. Restoration presently under way at the Museum turned up clear evidence of them after the back of the cabinet had been removed. For a detailed description of the recent conservation campaign, see Baumeister and Rabourdin forthcoming.

9. *Herter Brothers* 1994, pp. 13–14.

10. The shape of a cabinet on stand by Herter Brothers, in a private collection, for instance, is reminiscent of these ebony cabinets. Ibid., pp. 212–14, no. 41 (entry by Catherine Hoover Voorsanger).

11. Jutzi and Ringger 1986.

12. Ibid., pp. 52–54; Chapuis 1992, p. 77.

13. Michaelsen, Barthold, and Weissmann 2003.

14. *Un temps d'exubérance* 2002, p. 237, no. 137 (entry by Daniel Alcouffe).

15. Baarsen 2000b, pp. 48–53.

16. Louis XIV's 1663 inventory shows that he did not own any of these cabinets, preferring boulle work and colored marquetry; Alcouffe 2002b, p. 216.

17. Edward Holmes Baldock (1777–1845), an antiques dealer, is known to have sold parts taken from dismembered ebony cabinets. See De Bellaigue 1975, pp. 20–21.

18. Remington 1931; and Alcouffe 2002b, p. 216. They were established as being French and attributed to Jean Macé (ca. 1602–1672) in Lunsingh Scheurleer 1956.

19. "Remarkable Cabinet" 1885, p. 17.

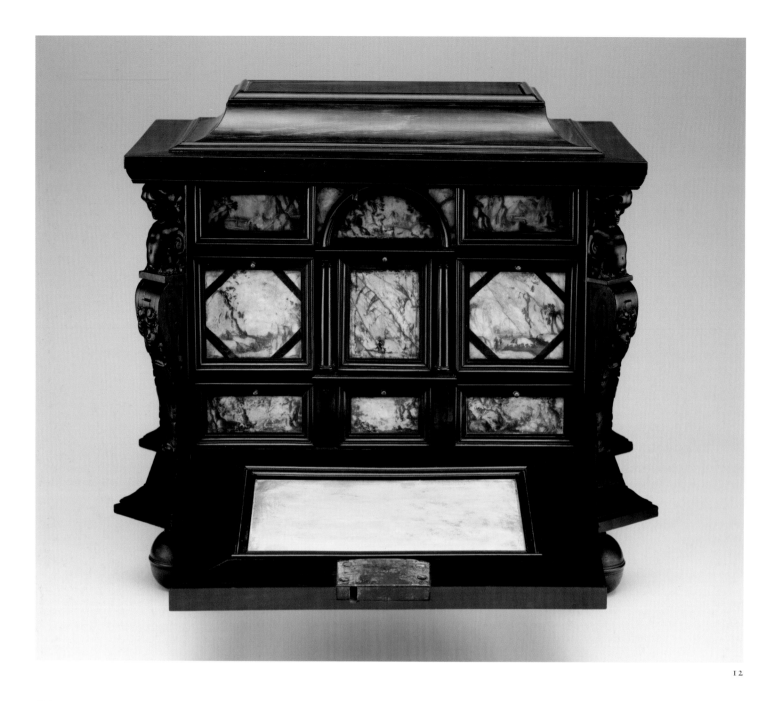

12.

Coffer

Probably Dutch, mid-seventeenth century
Pine veneered with ebony and macassar
ebony; padauk wood; painted alabaster;
ivory; mirror glass
H. 14⅝ in. (37.1 cm), w. 16½ in. (41.9 cm),
d. 11¾ in. (29.9 cm)
Pasted inside the compartment in the lid is a
round label on which is printed: "Hodgson
Bequest 250."
Gift of Audrey B. Love in memory of
her husband C. Ruxton Love Jr., 1975
1975.367

A number of seventeenth-century ebony coffers with carved caryatid half figures at the canted corners have been preserved. They are generally thought to be Flemish.[1] This is not surprising since Antwerp was known from the late sixteenth century as a center for the production of ebony furniture, especially collectors' cabinets. Often incorporating small painted or embroidered scenes from the Bible or from Ovid's *Metamorphoses* or plaques of silver or ivory, these luxury cabinets became collectible objects in their own right and found an international market through the activities of the firm

Forchhondt and other Antwerp art dealers.[2]

Supported on four small ball feet (see fig. 20), the Museum's casket has simple moldings on all sides of the exterior and is fitted with a hinged fall front. Enlivening its rectilinear shape is the gentle incurving outline of the elevated, cushion-shaped lid. In addition, the term figures that are set on consoles placed at an angle and wearing auricular-style headdresses add a touch of sculptural richness. With its fleshy and curvilinear forms of ornament resembling the lobes of the human ear, the auricular style was developed during the early seventeenth

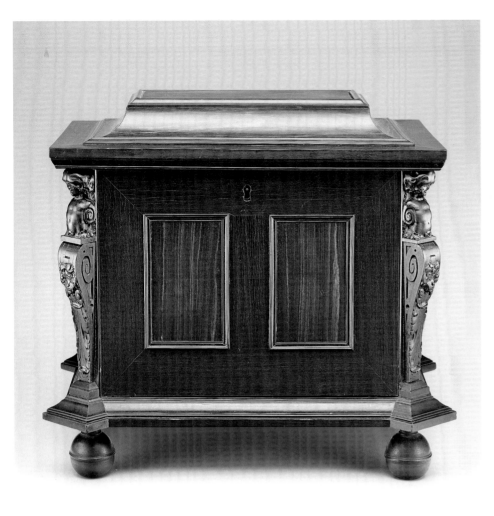

Fig. 20. General view of the coffer with the lid and the fall front closed.

ment in the middle are four drawers that conceal three additional hidden ones. Two are placed behind the central recess and can be accessed by removing the drawer immediately to the right.[CD] The third is fitted in the double bottom of the drawer to the left and is disclosed when the lower sliding part in the back of the drawer is opened.[CD]

Painted to show a vaulted structure on its exterior, the small drop-front panel in the middle is set back a little so that it rests on a narrow ledge when lowered. Within is a mirrored, five-sided compartment with a tiled floor, whose checkers are made of ebony and ivory.[CD] This recess, called a *perspectiefje* (literally, "little perspective"), could be used to hold a small, treasured object that could be seen and admired from all sides through its reflection in the mirrors.

Unlike the carcase, which is made of pine, the coffer's drawers and compartments are of padauk, a tropical hardwood with a deep crimson color. A sliding panel in the top of the lid reveals an additional space for the storage of documents or valuables.[CD] Pieter de Hooch (1629–1684) depicted a similar coffer in use as a jewelry casket with a necklace draped over one of its opened drawers in his painting *A Woman at Her Toilette with an Officer* of about 1665.[3] The genre painter De Hooch was active in Delft and later, from 1660 or 1661, in Amsterdam,

century by Dutch goldsmiths and became widespread in northern Europe.

The alternating use of black ebony and brown-black striped macassar ebony on the stepped rim of the lid and the rectangular panels of the body brings subtle tonal variations to the otherwise severe appearance of the casket. In contrast, the interior is more colorful and harbors several surprising components. The inside of the lid, for instance, which encloses a large compartment, is embellished with an alabaster plaque painted in monochrome that shows a mountainous landscape populated by travelers and shepherds. The coffer's interior is visually divided into three parts, with two tiers of drawers on either side of a central section covered by a drop-front panel.[CD] The latter is flanked by ebony half columns and surmounted by a half-circular pediment. Monochrome landscape scenes on alabaster plaques are mounted on the real drawer fronts as well as on the two simulated ones in the upper row. Arranged on either side of and below the compart-

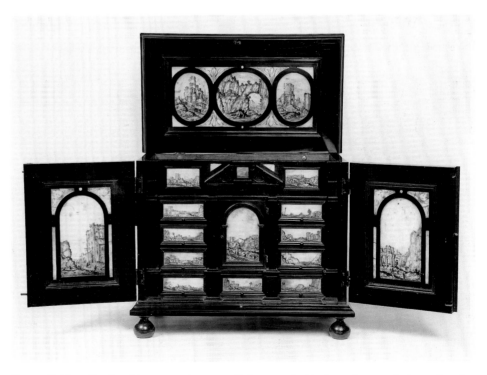

Fig. 21. Cabinet, Dutch, mid-seventeenth century. Oak veneered with ebony; ivory, padauk wood, and cedarwood; painted marble plaques; 19 x 21¼ x 12¼ in. Collection of the Hannema De Stuers Fundatie, Heino.

and it is possible that the Museum's coffer was made in the Northern Netherlands as well.[4]

It is documented that as early as about 1590 at least one cabinetmaker in Amsterdam worked with ebony. Initially imported to Europe by Portuguese merchants, this exotic wood became more readily available following the establishment of the Dutch East India Company in 1602. As a result, the number of ebony workers increased in Amsterdam, and in 1626 a special subdivision of the Saint Joseph's Guild, to which the cabinetmakers belonged, was created for them. From then on, each ebony worker in the city had to submit a hexagonal cabinet as well as a frame of ebony to the guild as masterpieces.[5] Contemporary sources from the first half of the seventeenth century confirm the production of ebony cabinets not only in Amsterdam but also in The Hague.[6] Since ebony furniture remained costly, imitations were made in ebonized

wood and even in blackened whalebone. One successful Amsterdam cabinetmaker who worked both in ebony and in pressed whalebone was Herman Doomer (ca. 1595–1650). Several important cabinets veneered with ebony and other imported woods and embellished with carving and mother-of-pearl inlay have been attributed to him.[7]

The painted alabaster panels that decorate the Museum's coffer are stylistically likely to be the work of a Dutch artist. They display similarities with the painted decoration of a larger collector's cabinet that is considered to be Dutch as well (fig. 21).[8] Like the present coffer, this cabinet, which is in the collection of the Hannema De Stuers Fundatie, Heino, has drawers made of hard padauk wood. The carving on the Museum's coffer is reminiscent of work attributed to Doomer, and it is entirely possible that this elegant piece originated in Amsterdam.[9]

DK-G

1. See Van Herck 1972, pp. 84–85, no. 91; and Fabri 1989, p. 121, no. 7. Similar caskets thought to be Flemish were sold at Christie's, South Kensington, London, 18 November 1992, lot 73, and at Sotheby's, Monaco, 11 December 1999, lot 9. The Museum's casket was published as Flemish in Farmer 1978, pp. 22, 66, no. 61.
2. Fabri 1991, pp. 176–84. See also Fock 1992, pp. 75–78.
3. This painting is at Apsley House, London; P. C. Sutton 1980, p. 98, no. 70, pl. 73.
4. It was first suggested that the Museum's coffer could have originated in the Northern Netherlands in Westermann 2001, pp. 70, 206, no. 103 (entry by Daniëlle Kisluk-Grosheide).
5. Lunsingh Scheurleer 1942, p. 36; and Baarsen 1996, p. 740.
6. Jervis 1968, p. 136; and Drossaers and Lunsingh Scheurleer 1974, p. 193, no. 270.
7. Baarsen 1996.
8. Its painted decoration is said to be on marble; see Bergvelt and Kistemaker 1992, pp. 55–56, no. 82 (entry by Reinier Baarsen). See also a closely related cabinet that was sold at Sotheby's, Amsterdam, 11 June 2003, lot 84.
9. Baarsen 2002, p. 191.

13.

Collector's cabinet

German (Augsburg), ca. 1655–59
Cabinetry by the workshop of Melchior Baumgartner (1621–1686); engraved decorations on the exterior probably English, second quarter of the nineteenth century; silver applications by Jeremias Sibenbürger (ca. 1583–1659); the three parcel-gilt silver plaques by an unknown earlier master, possibly a member of the Lencker family
Oak, pine, walnut, cedar, ebony, and rosewood; ivory veneer and silver veneer; silver; silver-gilt moldings; gilded yellow-metal mounts; the drawers lined with aquamarine-colored silk
H. 28¼ in. (71.8 cm), w. 24½ in. (62.2 cm), d. 15¾ in. (40 cm)
Marked on the silver base of the left column of the interior central aedicula are the interlaced letters l and S inside an oval and also the Augsburg town mark for the years 1655–60
Rogers Fund, 1903
03.18

During the sixteenth century, collecting rare, beautiful, and valuable objects became a fashionable pursuit among the princes and wealthiest citizens of the Holy Roman Empire. Many of their palaces contained a room called a *Kunstkammer* or a *Kunst- und Wunderkammer* (chamber for artworks and

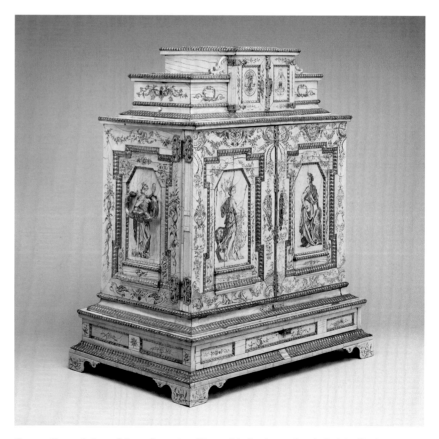

Fig. 22. General view of the collector's cabinet with the doors closed. Originally the ivory panels framed by gilded ripple moldings were unadorned. The engraved figural decoration was added in the nineteenth century.

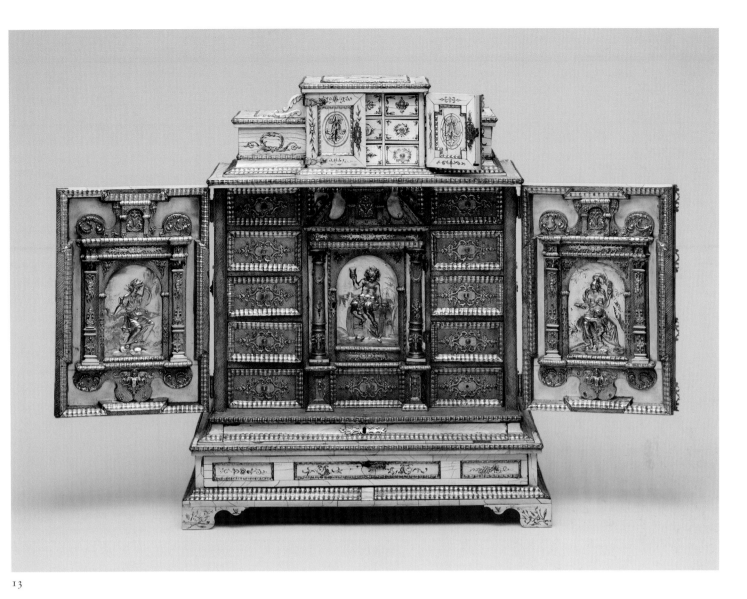

13

curiosities). Here the treasures were displayed, frequently in a sequence of interconnected spaces dedicated to various fields of collecting.[1] The three principal categories were *naturalia* (products of nature), *artificialia* or *artefacta* (products of the human hand), and *scientifica* (scientific instruments, such as astrolabes and clocks).[2] The intention was to suggest the wealth and learning of the collector and to impress foreign guests.

Some collectors of small objects commissioned elaborate cabinets decorated with semiprecious stones or exotic woods, such as ebony (see the entry for no. 12), or other sumptuous material. These pieces were furnished with many drawers and secret compartments, which offered diverse storage opportunities. Some were designed to stand against a wall in the company of other display cases. Others stood independently, like the Metropolitan's example, which is finished on all sides; this type of cabinet could be said to represent in miniature format an entire *Kunstkammer*, which was itself a metaphor

for the known world in all its diversity.

The Museum's cabinet is completely encased in ivory and has only a few gilded yellow-metal mounts that are essential for its use, such as the auricular-style handle on each side and the key plates (see fig. 22). The many wooden moldings—on the attic story and the base, as well as around the vertical panels on the facade—are decorated with a ripple pattern and gilded. During the day these would reflect the incoming sunlight, but at night the myriad silver notches would catch and intensify every flickering ray of the candles, giving a satinlike sheen to the smooth ivory panels. This river of silver ripples must always have drawn viewers, like bedazzled moths, to a closer inspection of the piece.

Exotic ivory, purchased by the ounce like silver or gold, was prized for its creamy white, fine-grained surface, which was frequently compared to a woman's skin and for that reason, perhaps, often used for implements and requisites of the toilette.

Since the Middle Ages such items were stored in ivory-decorated boxes, some of the finest examples of which were made at the Embriachi workshop in Venice.[3]

The decoration engraved on the ivory veneer—large figures representing Wisdom (left side), Strength and Tolerance (front), and Knowledge (right side)[4] and a wealth of abstract and naturalistic ornaments—were probably applied in the second quarter of the nineteenth century in England. That the original intention had been to make a strong contrast between a grand but plain exterior and a dazzling display concealed behind the cabinet's doors was not taken into consideration. The style of the engravings, especially the rocaille-like formations in the corners of the doors and the clumsily stylized Tudor rose on the top, is typical of the nineteenth-century taste for reviving earlier stylistic forms and combining them haphazardly.

The front opens to reveal a pyrotechnical sparkle of silver and partly gilded applica-

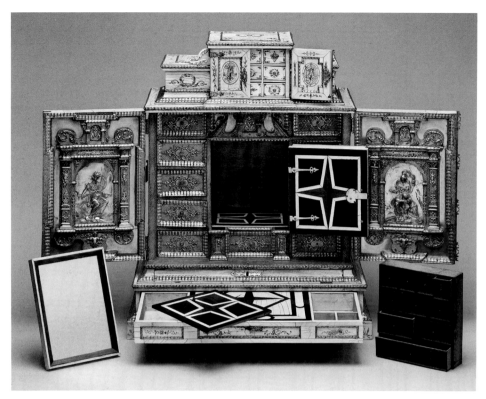

Fig. 23. General view of the collector's cabinet with the doors opened. The box standing on the ground at right has been removed from the central compartment, and the marquetry-decorated panel that usually conceals it has been placed on the open drawer in the base of the cabinet. That drawer is fitted with a dressing mirror (standing at left), a game board (partly visible beneath the panel), and compartments for toilette and writing implements.

tions. There are three figural silver plaques, three richly carved architectural structures, and many drawer fronts, each decorated with ornamental pressed silver foil. The central plaque, framed within a columned aedicula, conceals a door to a compartment that is veneered on all sides with ebony, ivory, and other exotic woods in a four-pointed-star pattern (fig. 23). The back wall can be removed to access ten drawers of different sizes. A toilette mirror is contained in the drawer below. In the large base drawer of the cabinet there is a tablet inlaid with ivory and exotic woods. This could be used for writing or gaming. An inkwell, a sander, and gaming pieces could be stored here in drawers with a sliding top. The tablet could also serve as a tray to display precious objects ordinarily hidden away in the drawers. The attic story is fronted by doors concealing a nest of drawers, and there are drawers in the sides of the top as well.

Such cabinets were a specialty of the cabinetmakers and the goldsmiths of the free imperial city of Augsburg. These master craftsmen worked in collaboration under the supervision of a coordinating merchant or middleman—a professional much like the eighteenth-century Parisian *marchands-merciers*. The most prolific of these person-ages was the Augsburg art dealer and court correspondent Philipp Hainhofer (1578–1647),[5] who is famous for three large and ingeniously conceived cabinets made to his specifications in the first third of the seventeenth century by Ulrich Baumgartner (ca. 1580–1652).[6] The Museum's cabinet is a relatively late example, produced in the unstable period after the end of the Thirty Years' War, when Augsburg gradually replaced Nuremberg as the center of goldsmithing in Central Europe.[7]

The three large figural plaques inside the cabinet are more skillfully worked than the other silver applications, which are attributed to the Augsburg silversmith Jeremias Sibenbürger, whose stamp is on the left column of the aedicula.[8] CD The plaque framed by the tabernacle shows Bacchus, the Roman god of wine.CD On the left door is a plaque with the figure of Ceres, the goddess of agriculture.CD Her cutoff sickle suggests that all three plaques were trimmed before they were put in place. The figure on the right door is Venus, goddess of love.CD The Mannerist style of the plaques indicates they were made no later than 1610–25. They are a tour de force of the goldsmiths' art, displaying a wide range of relief techniques. Particularly accomplished are the fine dia-mond stippling in the background and the fluid repoussé work. They are undoubtedly the work of a great master, such as one of the members of the Lencker family.[9]

The theme of the plaques was in particular favor at the court of Emperor Rudolph II (r. 1576–1612),[10] whose *Kunstkammer* in the imperial residence at Prague, incidentally, was perhaps the most encyclopedic of all. It illustrates a line from *The Eunuch*, written in 161 B.C. by the Roman dramatist Terence, "Sine Cerere et Libero friget Venus" (without Ceres and Bacchus, Venus would freeze), meaning that without food and wine, love grows cold.[11] Since the figure of Bacchus is in the center and framed by an aedicula with full columns, the implication is that wine trumps both food and love in the equation; however, Bacchus was also god of erotic ecstasy, as the seed pattern on the columns suggests. The intended meaning here may instead be the one expressed in a verse in the *Parvus Mundus*, an emblem book by Laurentius Haechtanus, published in 1579 in Antwerp: "Where sobriety reigns, there is fleshy lust, cold as ice; but be plentiful with an abundance of grain, wine, and beer, and voluptuousness will prevail."[12] The sensuously textured ivory and the iconography of the silver plaques indicate that this cabinet was a sophisticated wedding gift furnished with valuables that included toiletry accessories to remind its future owner to take care of her beauty and remember her conjugal obligation to love her husband and appreciate his attentions.[13]

Several similar ivory cabinets from Augsburg are known. Melchior Baumgartner, the son of Ulrich, maker of the three splendid Hainhofer cabinets, crafted two for the Munich court, which are today at the Bayerisches Nationalmuseum. One, decorated with lapis lazuli, gilded silver, and enamel, cost the enormous sum of 3,150 guilders in 1655.[14] The cabinetry and veneering of these two princely commissions are of even higher quality than that of the present piece, but the Augsburg workshops functioned independent of the courts and were obliged to make products at different price levels. A cabinet with similar silver columns was on the art market in the 1970s,[15] and another with related interior marquetry but incorporating Florentine *pietre dure* panels (see the entry for no. 9) was acquired some years ago by the Rijksmuseum, Amsterdam.[16] A much simpler cabinet with ivory

veneer is in the Museo Poldi Pezzoli, Milan,[17] and a cabinet of smaller size, possibly used as a jewelry cabinet, is in the Lemmers-Danforth Sammlung, Wetzlar.[18] WK

1. Wolfram Koeppe, "Collecting for the Kunstkammer," Timeline of Art History (online at www.metmuseum.org).

2. Koeppe 2004, pp. 80–81.

3. Herzog and Ress 1958, col. 1337; Scheicher 1995.

4. Note by Clare Vincent in the archives of the Department of European Sculpture and Decorative Arts, Metropolitan Museum, after Cecchini 1976.

5. Gobiet 1984.

6. Kreisel 1968, figs. 382, 383; and Alfter 1986, nos. 26–38.

7. The Augsburg town mark on the Museum's cabinet is only partly legible; most likely it is the one for the years 1655–60 (see Seling 1980, no. 90), although it could also be the one for 1626–29 (see Seling 1980, vol. 3, suppl., no. 43). A date in the late 1650s is also attractive on stylistic grounds, because in the form of its column capitals and other ornamental details the Museum's cabinet seems to be related to two cabinets at the Bayerisches Nationalmuseum, Munich, by Melchior Baumgartner (see below at n. 14).

8. Seling 1980, no. 1263.

9. On the Lenckers, see Bachtler 1978. For similar reliefs by Christoph Jamnitzer, see Eikelmann 2002.

10. On the theme of Ceres, Bacchus, and Venus in the work of Hendrick Goltzius (1558–1617), Bartholomäus Spranger (1546–1611), and the Prague school, see Nichols 1992, p. 4; and Leeflang et al. 2003, pp. 275–76, no. 99 (entry by Lawrence W. Nichols).

11. *The Eunuch*, bk. 4, l. 732.

12. Renger 1976–78, p. 194. The triad of gods illustrating Terence's maxim is rarely depicted in the decorative arts, and it appears only on objects of the highest quality. The best-known adaptations are seen on a gold beaker of about 1600 by Paulus van Vianen (1558–1613) in a private collection and a silver tankard by the famous Hamburg goldsmith Jürgen Richels (1641–1710) of about 1680 in the Lemmers-Danforth Collection, Wetzlar; Koeppe 1992, pp. 471–73, no. GO15, color ill. p. 446. The theme also appears on an ornamental Flemish or Dutch vase at the Metropolitan Museum (acc. no. 2000.492; see "Recent Acquisitions" 2001, p. 32 [entry by Daniëlle Kisluk-Grosheide]), which was most likely created to decorate a temporary wooden facade set up in front of a grand town house on the occasion of a wedding or the visit of a dignitary, in the tradition of the triumphal arch; see Baarsen et al. 2001, p. 97, no. 27 (entry by Reinier Baarsen). The iconography of this piece was identified by the present author.

13. Alfter 1986 does not mention the Museum's cabinet. It has been published in Kisluk-Grosheide 1994, p. 166, fig. 26; and Baarsen 2000a, fig. 16. The latter offers a lengthy discussion of the cabinet but does not identify the iconography.

14. Himmelheber 1975; Alfter 1986, nos. 26–38; and Baumstark and Seling 1994, vol. 2, pp. 272–79, no. 64 (entry by Lorenz Seelig).

15. *Apollo* 93 (February 1971), p. 55.

16. Baarsen 2000a, figs. 6, 7; and Baarsen 2000b, pp. 16–21.

17. Balboni Brizza 1995, p. 60, no. 10. The intarsia panels are a later addition, possibly replacing panels of silver or semiprecious stones.

18. Koeppe 1992, pp. 238–40, no. M141, color ill. p. 256.

14.

Table

French (Paris), ca. 1660
Attributed to Pierre Gole (ca. 1620–1684)
Oak and fruitwood veneered with tortoiseshell, stained and natural ivory, ebony, and other woods; gilt-bronze mounts
H. 30⅞ in. (78.4 cm), w. 41⅛ in. (104.6 cm), d. 27 in. (68.6 cm)
Gift of Mr. and Mrs. Charles Wrightsman, 1986
1986.38.1

When it was sold from Mentmore Towers, Buckinghamshire, in 1977, this exceptional table was described as in the manner of Leonardo van der Vinne. A talented artist of Flemish or Dutch origin, Van der Vinne made marquetry furniture at the Medici court in Florence during the second half of the seventeenth century.[1] In the mid-1980s, however, the table was reattributed to Pierre Gole,[2] based on documentary evidence and after comparison with a few extant pieces thought to be by the same hand.

Gole, who was born in Bergen, near Alkmaar, the Netherlands, went to Paris about 1643 and there was apprenticed to Adriaan Garbrand (also recorded as Adrien Garbrant), a cabinetmaker known for his work in ebony.[3] Having married Garbrand's daughter Anne in 1645, Gole eventually took over the workshop. He continued in the manner of his father-in-law, making large, elaborate cabinets veneered with ebony.[4] On 26 September 1651 Gole was named *menuisier en esbène ordinaire du roi* (maker of ebony furniture, or *ébéniste*, to the king).[5] It was not until the mid-1650s that this talented master began to specialize in exquisite floral marquetry, a new and colorful type of veneer decoration that put an end to the fashion for solemn ebony furniture. Gole was one of the first cabinetmakers to work in this new technique and may, in fact, have introduced it in Paris.

Gole supplied two cabinets decorated with flowers, birds, and insects in ivory, tortoiseshell, and various kinds of woods to Cardinal Jules Mazarin (1602–1661). They were mentioned in the inventory drawn up after Mazarin's death in an entry that, most exceptionally, included the maker's name.[6] Chief minister to Louis XIV (1638–1715), Mazarin was a great connoisseur who amassed an impressive art collection. The cardinal clearly favored Gole's work because, not long before his death, he commissioned the artist to make two important cabinets as gifts to the king in memory of himself.[7]

Working primarily at his own shop in the rue de l'Arbre-Sec but at times also at the Manufacture Royale des Meubles de la Couronne, in the Hôtel des Gobelins, where, beginning in 1662, furnishings for the royal residences were produced, Gole received many commissions from the crown. A well-known tapestry at the Château de Versailles recording a royal visit to the manufactory on 15 October 1667 shows the chief artists employed there displaying examples of their work.[8] In the foreground three craftsmen are carrying a precious table for inspection by the king. Decorated with elaborate marquetry in a tortoiseshell ground, the table is thought to be the work of Gole, who himself is, almost certainly, depicted behind it. The table in the tapestry may have been one of the many pieces by Gole that were destined for Versailles, a hunting lodge that Louis XIV enlarged and transformed into his principal residence and in 1682 made the seat of his court and government.

Since nothing is known about the early history of the Museum's table, one can only guess that it was among the more than one hundred tables, often supplied with a pair of matching candlestands (*guéridons*), that Gole made for the crown.[9] Its rectangular top is veneered with tortoiseshell and divided by decorative bands of ivory and

43

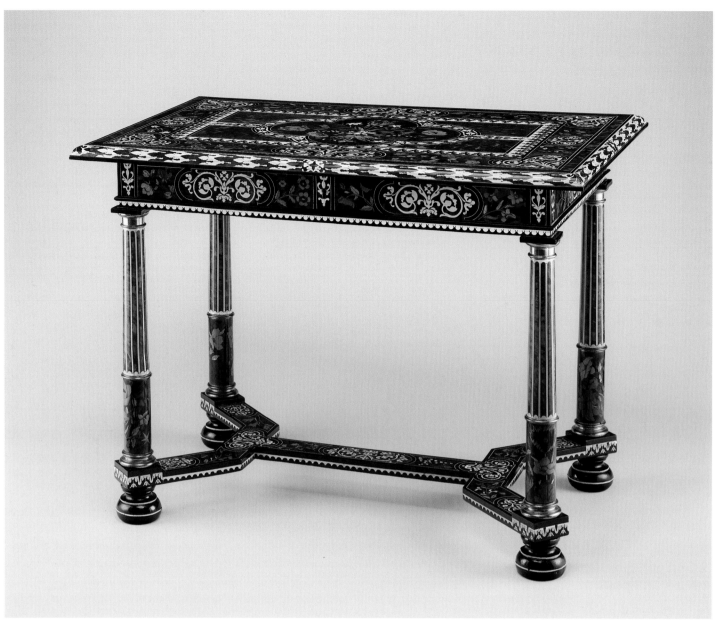

14

ebony into different segments, in the manner of *pietre dure* (hardstone) mosaic works, by which it may have been inspired (fig. 24). The central motif consists of a four-lobed cartouche containing a stylized bouquet tied with a bow-knotted ribbon. The flowers, executed in different woods and ivory, do not overlap and have been almost symmetrically arranged. In an attempt to heighten the sense of naturalism—and to enrich the vivid color scheme that intensifies the resemblance to *pietre dure*—green-tinted ivory was chosen for the leaves. Gole was the only cabinetmaker working for the French crown to make such extensive use of this exotic material, both colored and in its natural state.[10]

Several of the ornamental borders appear to be characteristic features of the artist's

oeuvre. Examples are the band of ivory and tortoiseshell laurel leaves running along the edge of the tabletop and the large and small circles of ivory and ebony on the frieze and along the sides of the double-Y–shaped stretcher that joins the legs.[11] The ebony and ivory decoration on the stretcher seems to be composed of the leftovers from the decorations on the frieze, which are more beautiful and legible, suggesting that the *ébéniste* made frugal use of the expensive materials. The four tapering, columnar legs, which are also considered to be typical of Gole's work, end in ebony bun feet decorated with ivory stringing. They display simulated fluting of ivory above and floral marquetry below. The Tuscan capitals, the ring moldings or so-called astragals, and the

bases—all of which are crafted of gilded bronze—must have been ordered elsewhere, for Gole's workshop did not have a foundry.

The Museum's table is thought to date about 1660 because a very similar table was listed in Mazarin's inventory of 1661. Since it was not mentioned in an inventory of the cardinal's possessions drawn up in 1653, the table must have entered his collection after that year. The description of Mazarin's table includes a reference to a marquetry butterfly above the central bouquet, possibly about to alight on one of the flowers.[12] This creature is not present on the Museum's piece, which does, however, include a moth-like insect in one of the outer borders.[CD]

During the nineteenth century this richly decorated piece of furniture was at Ment-

more Towers, the stately mansion built by the architect Joseph Paxton (1801–1865) for Baron Mayer Amschel de Rothschild (1818–1874). It was probably among the many French furnishings that the baron acquired for Mentmore, but this is not documented. In 1874 his only daughter, Hannah (1851–1890), inherited the house as well as her late father's fortune. She and her husband, Archibald Philip Primrose, the fifth earl of Rosebery (1847–1929), a liberal politician who served as England's prime minister in 1894–95, added considerably to the Mentmore collections, making them world renowned.[13] The table could have been one of their purchases. A catalogue of the contents of Mentmore published in 1884 listed in the library a French "table inlaid with marqueterie" of "the Louis XIII period." This may possibly have been the one now attributed to Gole.[14] D K - G

1. Catalogue of a sale by Sotheby Parke Bernet on behalf of the executors of the sixth earl of Rosebery, Mentmore, Buckinghamshire, vol. 1, 18–20 May 1977, pp. 276–77, lot 875.

2. Lunsingh Scheurleer 1984, pp. 336–37, figs. 17, 18. The table was first published in an entry by James Parker in Metropolitan Museum of Art 1986, pp. 28–29, and most recently in Lunsingh Scheurleer 2005, pp. 81, 90–91, 251, figs. 44, 50, 51.

3. For information about Gole, see Lunsingh Scheurleer 2005.

4. One of these pieces is thought to be in the collection of the Rijksmuseum, Amsterdam. See Lunsingh Scheurleer 1993, pp. 82, 84, fig. 2; and Baarsen 2000b, pp. 48–53, figs. 55–59.

5. Ronfort 1985, pp. 36, 38.

6. Lunsingh Scheurleer 1980, p. 380.

7. Ibid., pp. 380, 384. These cabinets have not been preserved.

8. The tapestry belongs to the ambitious *Story of the King* series woven at the Gobelins Manufactory starting in 1665; Meyer 1980a, pp. 109–16.

9. A list of furnishings supplied by Gole to the crown is given in Lunsingh Scheurleer 2005, pp. 231–38.

10. A small table attributed to Gole in the collection of the J. Paul Getty Museum, Los Angeles, is decorated with blue-tinted wood on an ivory ground, in imita-tion of porcelain; see G. Wilson 1985, pp. 61–66.

11. These borders are also found on a cabinet on stand attributed to Gole in the collection of the Victoria and Albert Museum, London; see Wilk 1996, pp. 66–67 (entry by Carolyn Sargentson). See also a cabinet in the Rijksmuseum, Amsterdam; Baarsen 2000b, pp. 52–55, figs. 60–62.

12. "Une table d'escaille de tortue profilée et presque toute couverte d'ornemens d'ivoire, au milieu de laquelle est un grand ovale à quatre angles dans lequel est un bouquet de diverses fleurs de bois et d'ivoire liez d'un ruban de bois au dessus duquel est un papillon aussy de bois; avecq son pied à quatre collomnes d'escaille de tortue profilées d'ivoire par la moitié et l'autre moitié de fleurs de bois, dont les bases, astragalles et chappitaux sont de cuivre doré. Longue de trois pieds six poulces, large de deux pieds quatre poulces." This description of Mazarin's table in the 1661 inventory is quoted in Lunsingh Scheurleer 1984, p. 336.

13. See Sir Francis Watson's introduction to the Mentmore sale catalogue, vol. 1, pp. ix–xiii.

14. *Mentmore* 1884, vol. 2, p. 63, no. 72. In addition, "numerous tables of marqueterie and boule" stood against the walls of the Gallery; *Mentmore* 1884, vol. 2, p. 152.

Fig. 24. Top of the table.

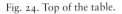

Showcase on stand (*scarabattola*)

Italian (Rome), late seventeenth century
Walnut; carved, painted, and gilded linden wood;
mirror glass
H. 91 in. (231.1 cm), w. 60 in. (152.4 cm),
d. 24½ in. (62.2 cm)
Gift of Madame Lilliana Teruzzi, 1972
1972.73

With its strong sculptural character and striking theatricality, this vitrine, or *scarabattola,* is a beautiful example of Roman Baroque furniture.[1] Strictly symmetrical in its decoration, the piece consists of an upper section, the actual display cabinet with its glazed doors and splayed sides, and the stand below, with its bearded atlas who seems to carry the weight of the top nonchalantly on his extended palms. This entirely gilded figure is kneeling on the representation of a rocky ground that has been painted dark green and has tufts of gilded grass.[CD] A sense of dynamism is achieved through the muscularity of his slightly twisted body, the luxurious curls, and the swirling drapery that conceals his nudity. The atlas is framed by a large floral swag extending from the corners at the back of the vitrine down to the base. Directing the viewer's attention to the central crest ornament, four joyfully gesticulating putti perched on the cabinet with their festoons of flowers create a feeling of vivacity and movement (fig. 25), while in the center a female mask set against a large scrolling cartouche augments the overall sculptural richness.[CD] Additional gilded carving, in the form of winged caryatids with feathered headdresses emerging from pendant floral swags, embellishes the stiles of the cabinet.

The painter, architect, and preeminent sculptor Gianlorenzo Bernini (1598–1680) exerted a profound influence on the decorative arts of the Roman Baroque.[2] His novel use of color is reflected in the strong contrast between the walnut and the gilded and painted surfaces of this cabinet. The sense of movement and emotion that the artist instilled in his figural compositions is most clearly echoed here in the effortless strength of the atlas and in the frolicking putti.

Showcases of this kind were commissioned to hold an array of small precious objects. Between 1726 and 1729, for instance, the carver Anton Francesco Gonnelli (1688–1735) executed three impressive *scarabattole* to hold the amber and ivory collections of the Medici grand dukes in Florence.[3] More than utilitarian pieces of furniture, these splendid vitrines became works of art in their own right. The mirrored inner back of the Museum's cabinet makes it possible to view simultaneously from the front and from behind the treasures placed inside and, through reflection, doubles them in number.

Unfortunately, little is known about the early history of this important display case. It came to the Museum as the gift of Lilliana Teruzzi, one of the Metropolitan's more colorful benefactors.[4] Born Lilliana Weinman, she became an opera singer known professionally as Lilliana Lorma and performed in Europe during the 1920s and 1930s, when she was briefly married to the Italian Fascist general Attilio Teruzzi (1882–1950). According to the donor, she acquired this piece of furniture in 1933 from Prince Cesare Ludovico Ottoboni (b. 1888). He was a descendant of a prestigious noble family who counted Pope Alexander VIII (1610–1691) and his grandnephew Cardinal Pietro Ottoboni (1667–1740) among its members. The latter was a great patron of the arts, whose opulent Roman residence, the palace of the Cancelleria, was described by Pietro Rossini in a contemporary guidebook, *Mercurio errante delle grandezze di Roma* (1693), as one of the most culturally active courts in Rome.[5] It is known that Ottoboni had several cases for medals, and others to hold his large collection of medallions; in the absence of further documentation, one can only wonder if the Museum's piece was one of these cabinets.[6] At the time of his death Cardinal Ottoboni left more than four hundred paintings, most of which he had inherited from Pope Alexander VIII, as well as many debts. As a result, his art collections and the furnishings of his palace were immediately dispersed.[7]

DK-G

1. Metropolitan Museum of Art 1975, p. 259 (entry by Penelope Hunter-Stiebel).
2. Walker 1999, pp. 3–6.
3. Colle 1997, pp. 82–83, pls. XVIII, XIX, pp. 180–85, nos. 52, 53 (entries by Enrico Colle).
4. See Draper 1994, pp. 20–21.
5. Olszewski 1999, p. 93.
6. Olszewski 2004, pp. 16, 221.
7. Olszewski 1989, p. 33.

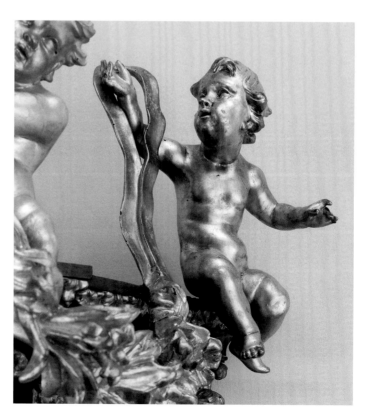

Fig. 25. Detail of the crest of the showcase on stand.

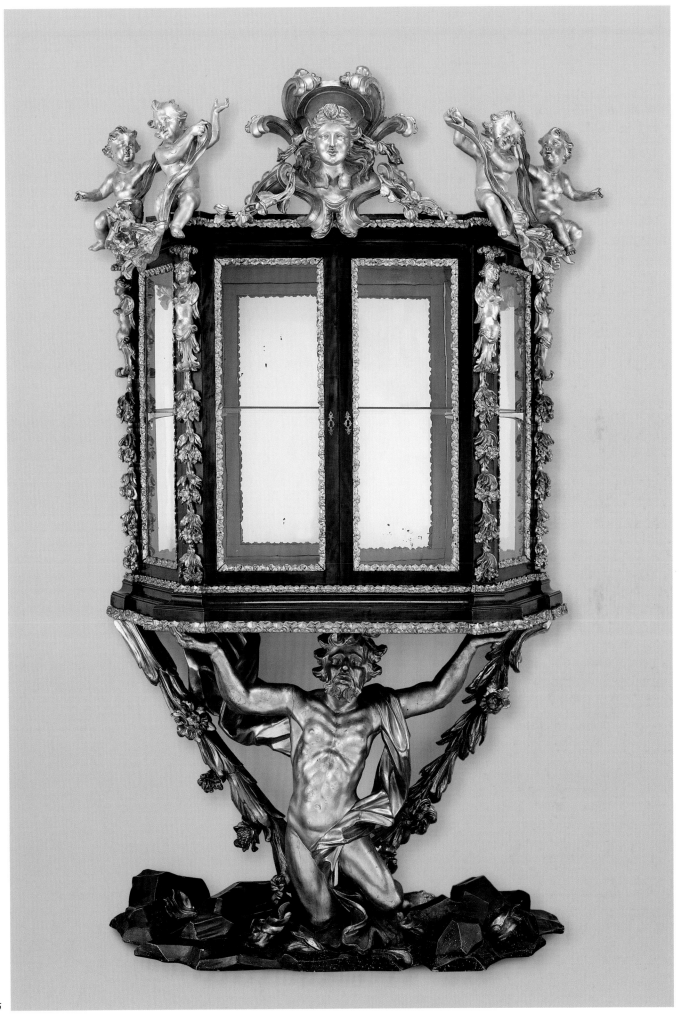

16.

Mirror frame

German (Danzig, now Gdańsk, Poland),
ca. 1680–1700
Dark-stained pine; replaced mirror glass
H. 75 in. (190.5 cm), w. 64 in. (162.6 cm),
d. 4 in. (10.2 cm)
Rogers Fund, 1967
67.171

Large parade mirrors became increasingly fashionable throughout Europe during the Baroque period, and they were often conceived as part of an ensemble, with matching console tables and candlestands. This development was supported by technical advances that made it possible to produce larger plates of mirror glass and driven by the ambition of princes to imitate the magnificent Galerie des Glaces in the suite of state rooms at Versailles, created in 1681–84 by Charles Le Brun (1619–1690) for Louis XIV of France.[1]

At the end of the seventeenth century, goods and artistic ideas flowed through northeastern Europe along trade routes that connected English and Netherlandish ports with the cities along the Baltic Sea and points east. The latest fashions were eagerly received and copied as closely as local craftsmen could manage and local patrons could afford. This mirror was once believed to be of Dutch origin,[2] but its putti nestled among a tangle of jaggedly lobed acanthus leaves have proved to be very similar to works in wood by the cabinetmakers and virtuoso carvers of the independent town of Danzig, one of the most prosperous trade centers on the Baltic seacoast and a gateway to Russia. Large quantities of household goods, such as Dutch case furniture and English chairs,[3] were imported into Danzig during the seventeenth and eighteenth centuries, as were luxury items like the popular Chinese blue-and-white porcelains. The grotesque dragon-monsters on this mirror, with their intriguingly intertwined necks and long tails, were obviously inspired by the decorations on the porcelain exported from East Asia.[CD] Dragons have been part of both Eastern and Western imagery for millennia, but seventeenth-century European craftsmen were probably unaware of their symbolism as water deities in the East and of Satan in the West.

This frame offers an ingenious combination of decorations from both traditions. The elements of chinoiserie are dominated by the acanthus-leaf ornament, however, which was especially popular in Europe at just the time this mirror was made.[4] The plant's twisting and luxuriant pattern of growth fulfilled the Baroque period's desire for ornate and extravagant ornamentation. The acanthus designs by the French engraver Jean Le Pautre (1618–1682) and by his follower Paul Androuet Ducerceau (1630–1710)[5] were adapted and exaggerated by such ornamentists in the German-speaking world as the Viennese court cabinetmaker Johann Indau (1651–1690)[6] and the Augsburg masters Johann Unselt and Johann Conrad Reuttimann.[7] In Bohemia and parts of Silesia, acanthus decoration was taken to an unprecedented extreme in the altarpieces called *Akanthusaltäre*. These were conceived in the pure spirit of ornamental fantasy, as the rioting vegetation completely conceals the function of the objects it decorated.[8] In the entrance and banquet halls of grand town houses the acanthus crept across chairs, tables, and large armoires and up staircases and along wall paneling; in the form of stucco ornament it also decorated ceilings. The result was an impressive decorative unity that transmitted a feeling of lushness and prosperity, which reflected the owner's social status.[9]

A rich and varied display of acanthus ornament covers the structural elements of the Museum's piece. Bold sprays on the sides break up its rectangular shape, and shorter tendrils frame the uprising crest, giving it that expressive contour so characteristic of the late Baroque style. Almost hidden in the leaves are small figures with symbolic meaning. Several putti hold the dragons' tails, and others face a double-headed eagle and a goat located in the crest.[CD] The eagle may refer to the Holy Roman Empire. The goat undoubtedly is the heraldic device of the mirror's first owner, but since the rampant goat is featured in the coat of arms of many noble families in Danzig, Pomerania, and Mecklenburg, this person has not been identified. Putti and doves, which flank the crest and peer out of the leaves, have

symbolized love since antiquity, and doves bespeak constancy, as well. Thus, these winged boys and these birds are the chief attributes of Venus, goddess of erotic love.[10] This theme is extended by the small figures of a satyr and a satyress, who brazenly inhabit the big acanthus volutes (fig. 26). Such mythological creatures were regarded as symbols of decadence and sexual debauchery. Therefore, this radiant work of art may have been a wedding present whose purpose was both to delight and also to caution the recipient as to the danger of excess.

Mirror frames carved—sculpted might be the better term—with such virtuosity are rare. A design for a looking glass by Andrea Brustolon (1660–1732), of about 1690, in the Museo Civico in Belluno shows a similar, intricately carved frame. An annotation on the drawing states that "the left side is devoted to the Arts and Sciences, the right to Valour, and it is crowned with an allegory of Love."[11] A print published in Graz, Austria, in 1679 by Matthias Echter (1653–1701/3) showing a related putti-populated acanthus frame with agitated openwork *rinceaux* may have inspired a similar carved

Fig. 26. Detail of the left side of the mirror frame showing a satyr on acanthus leaves.

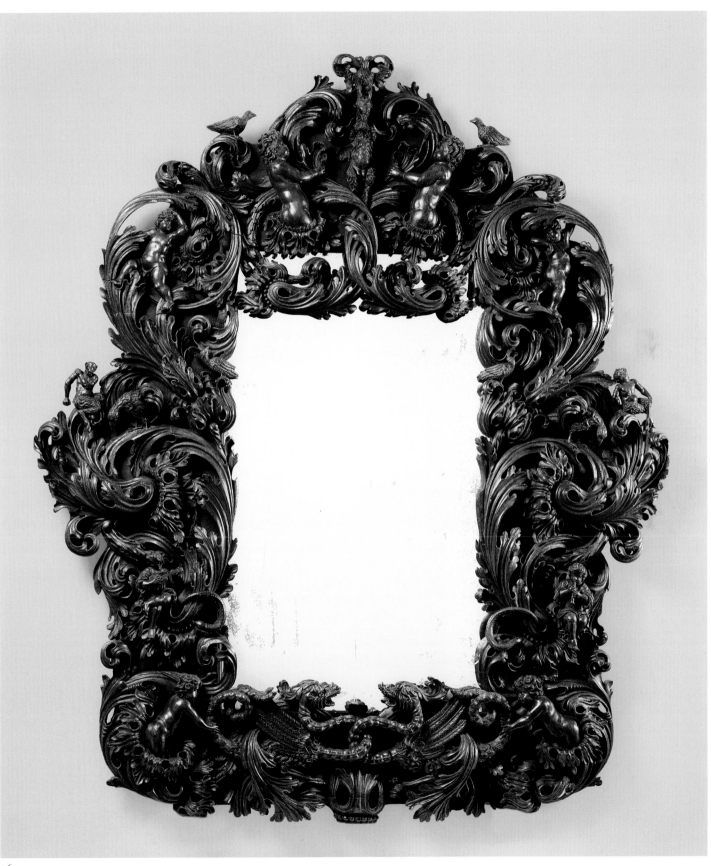

wooden example in the Museo Correr in Venice.[12] An English frame in the collection of the marquess of Exeter is decorated with putti, floral elements, and acanthus foliage, and its carver was probably influenced by designs of the English wood-carver Grinling Gibbons (1648–1721).[13] An elaborate Dutch boxwood mirror frame of the late seventeenth century is preserved in the Museum für Kunst und Gewerbe, Hamburg.[14] WK

1. Olga Raggio in Raggio et al. 1989, p. 6, fig. 7.
2. Note in the archives of the Department of European Sculpture and Decorative Arts, Metropolitan Museum. For a Dutch example, see the entry for no. 20, a painting frame adapted as mirror. See also Raggio 1994, p. 12, fig. 9 (where she describes the mirror as from Danzig, following a file note by the present writer).
3. Behling 1942; Koeppe 1992, p. 161, no. M91, p. 165, no. M94, color ill. p. 241; and North and Snapper 1990.
4. Reinhardt 1996, p. 130.
5. Berliner and Egger 1981, vol. 3, nos. 1105ff. and 1124ff.
6. Ibid., no. 1060ff.
7. Reinhardt 1996, pp. 130, 146.
8. Hamperl and Rohner 1984.
9. C. H. Baer 1912, figs. 104, 105 (left). A splendid example of rich acanthus decoration is in the historic town hall of Gdańsk.
10. Hall 1979, p. 10.
11. Honour 1965b, p. 71, fig. 224.
12. Reinhardt 1996, p. 130.
13. Coleridge 1965, p. 89, fig. 300.
14. Möller 1962.

17.

Writing desk (*bureau brisé*)

French, ca. 1685
Designed and possibly engraved by Jean Bérain (1638/39–1711); made by Alexandre-Jean Oppenordt (1639–1715)
Oak, pine, and walnut veneered with ebony, rosewood, and marquetry of engraved brass on tortoiseshell; gilt-bronze moldings; steel hinges
H. 30⅜ in. (77.2 cm); w. 41¾ in. (106 cm); d. 23⅜ in. (59.4 cm)
Gift of Mrs. Charles Wrightsman, 1986
1986.365.3

Fig. 27. General view of the writing desk with the hinged top opened.

In the early 1660s the young Louis XIV (1638–1715) and his chief minister, Jean-Baptiste Colbert (1619–1683), decided to set up an establishment where paintings, sculptures, furniture, and tapestries for the French royal palaces would be manufactured. Their plan was to improve the quality of French luxury goods in order to reduce the number of foreign imports, thereby bolstering the French economy. They also planned to turn the focus of French art on the glorification of the king, a strategy that was part of a long struggle for power between the monarchy and the aristocracy. Various workshops were brought together at the site of the former premises of the Gobelins family of dyers in Paris, and the hugely talented Charles Le Brun (1619–1690) was named director. In an edict of 1667, the king officially established the factory as the Manufacture Royale des Meubles de la Couronne. In the words of his edict, the Gobelins workers included "the painters of greatest reputation, tapestry weavers, sculptors, goldsmiths, cabinetmakers and other workers of the greatest abilities in all of the fine and decorative arts. . . . The works that such artists produce there outshine the art and beauty of the most precious things from foreign countries."[1]

Le Brun tightly controlled the output of the many artisans working at the Gobelins and at the Louvre workshop, insisting on the highest standards of quality for everything produced there, from *bibelots* to *bureaux*. It was he who built the "golden cage" in which the king captured the aristocracy. In the exquisitely furnished palaces of Versailles, the Grand Trianon, and Marly, Louis created "a pattern of expensive daily living that kept the aristocracy [who were] seeking preferments constantly occupied," completely focused on his will and his wishes as absolute monarch.[2] The court became a showcase for the style known as Louis

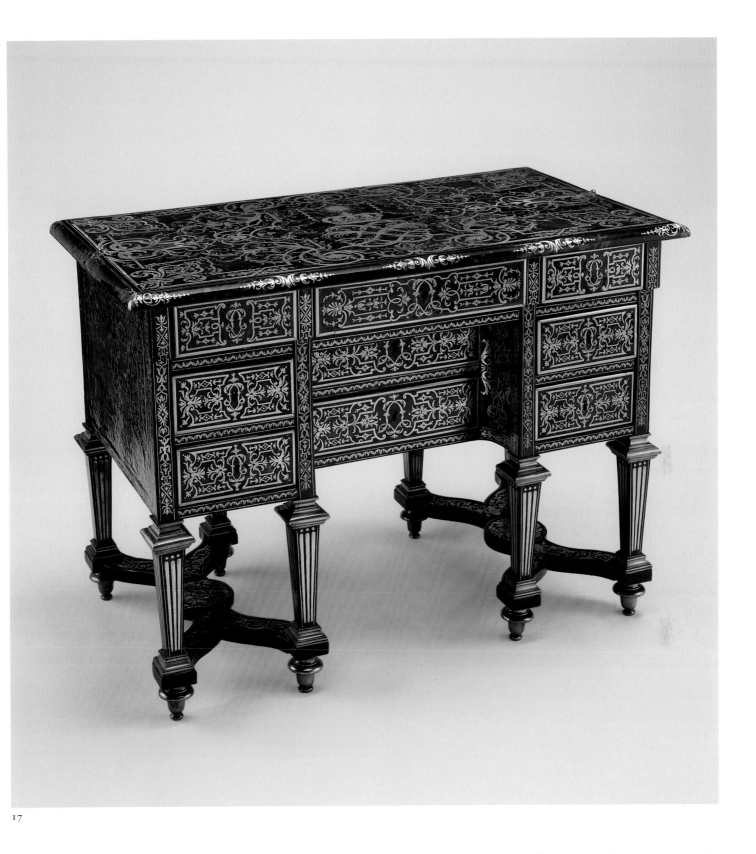

17

Quatorze, which was dominant in Europe until the eighteenth century.[3]

Sumptuous marquetry furniture was one specialty of the Gobelins and the Louvre workshop that cabinetmakers in other countries tried to copy, rarely with success. Workshops outside of France lacked the technical know-how, not to mention the huge sums needed to buy the inlay materials. Exceptionally costly were pieces like the

present writing desk that are veneered with tortoiseshell and brass or pewter. They became known by the name of their most illustrious maker, André-Charles Boulle (1642–1732), who was given a workshop at the Galerie du Louvre in 1672.[4] He did not invent the boulle-work technique (which was made possible by the introduction of the fretsaw "some time around the 1620s, well before . . . Boulle himself . . . was

born"),[5] but he added to its perfection by enshrining the marquetry in an ostentatious cage of ormolu mounts (see the entries for nos. 25, 31).

This writing desk is one of the few documented objects made for the private use of Louis XIV at Versailles. The form is called *bureau brisé*, literally "broken desk," because the hinged front half of the flat top can be flipped back, or "broken," to reveal a narrow

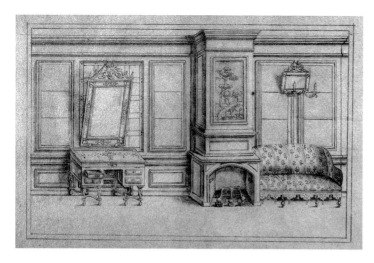

Fig. 28. *"Grand Cabinet" with Writing Desk and Mirror,* late seventeenth century. Pen drawing. Bibliothèque de la Conservation, Versailles.

writing surface (fig. 27). The latter can be extended by a fall-front panel which—in its upright position—simulates on the outside a sequence of three false drawers. The *bureau brisé* and its variants, possibly based on the innovations of the cabinetmaker Pierre Gole (ca. 1620–1684),[6] who delivered the first of many examples to the crown in 1669, were at some point in the nineteenth century dubbed *bureaux Mazarins,* despite the absence of any evidence that Cardinal Mazarin (who died in 1661) could ever have penned his letters on such a piece.[7] Contemporary illustrations document the use of these desks as dressing tables, surmounted by a mirror and sometimes flanked by candlestands (see fig. 28).[8] From the *bureau brisé* form, too, there emerged one of the best-known types of parade furniture, the *bureau plat,* or flat-surfaced writing desk (see the entry for no. 57), which even today is a symbol of power and influence in executive offices.[9]

Tortoiseshell forms the ground for the brass inlay decoration of this desk. The cabinetmaker was a relatively unknown Dutch-born craftsman named Alexandre-Jean Oppenordt. He had become a French citizen in 1679 and entered the service of the king in 1684 at the Louvre workshops.[10] On 25 July of the following year he received a payment for this desk and a matching example, in which brass forms the ground for the tortoiseshell inlay. Both were intended for the king's personal study at Versailles.[11] The elaborate decoration on the desktop features Louis's crowned monogram of interlaced *L*'s beneath a radiant sun symbol engraved with a now indistinct Apollo's mask (fig. 29). These royal emblems are surrounded by a cartouche of symmetrical arabesque scrolls and a rambling vine ornament that plays with the traditional motifs

of the monarchy in a novel way. At each corner of the desk is an oversize fleur-de-lis, the symbol of France; this placement gracefully suggests that Louis's kingdom extended to the "four corners of the earth."[CD] At either end of the table is yet another reference to the Sun King: the lyre of Apollo. The designer of this sophisticated pattern was Jean Bérain, who trained as an engraver. Bérain may even have had a hand in tooling the engravings on the inlay;[12] sadly,

only small areas of engraving survive to suggest the beauty of the surface when new. The interior of the desk is veneered with exotic, fine-grained rosewood, whose sober sheen makes a fine contrast with the red-underpainted tortoiseshell and glittering brass on the outside.[CD] Although it was considered a special honor to work for the royal household, there were disadvantages: documents reveal that the locks for this desk were supplied in 1685 by the *serrurier* Pierre Roger, who was not compensated for his work until 1691.[13]

In the posthumous inventory of Louis XIV's possessions, compiled in 1718, the Museum's desk and its companion piece have been identified as number 516.[14] A generation later, in 1751, they were considered old-fashioned, and even the fact that they had almost certainly been used by the Sun King himself did not guarantee them a place in the royal collection. In July of that year they were purchased by different buyers, together with their protective red leather covers, at a sale of the king's furniture.[15] The Museum's desk, veneered in the

Fig. 29. Detail of the royal emblems inlaid on the top of the writing desk.

more stylish *première partie* manner, with a bright inlay in a dark ground, did not resurface until 1984, when it was consigned by a Texas collector to a New York auction house and sold to a Paris dealer. Its origins as a piece of royal furniture had been forgotten.[16] The whereabouts of the second desk are unknown; it was sold in a much altered state of preservation from the collection of Lady Juliet Duff in 1963.[17] WK

1. "Edict du Roi" (1667), Archives Nationales, Paris, O¹ 2040ᵃ. Cited (in translation) from Stürmer 1986, p. 240. See also Alcouffe and De Bellaigue 1981, pp. 28, 42; and Koeppe 1996, p. 181 and figs. 2a,b.
2. R. Gordon Alden, "Patronage," sec. 12 of "France," in *Dictionary of Art* 1996, vol. 11, pp. 560–62.
3. Germer 1997; and Bettag 1998.
4. On this type of marquetry, see the entry for no. 18.
5. Chastang 2001, pp. 17–20, 26–35. I am most grateful to Yannick Chastang, London, and to Mechthild Baumeister, Conservator, Department of Objects Conservation, Metropolitan Museum, for discussing different types of marquetry at length with me.
6. On Gole, see the entry for no. 14.
7. Fleming and Honour 1989, p. 137.
8. P. Thornton 1990, p. 30, fig. 31, and p. 45; and Koeppe 1996, p. 181, fig. 3.
9. H. Graf 1989.
10. Archives Nationales, Paris, O¹ 1082. On Oppenordt and this desk, see James Parker in Raggio et al. 1989, pp. 14–15. See also Ronfort 1986.
11. This study, called the *Petit Cabinet,* was in the north wing of the building; see James Parker in Raggio et al. 1989, p. 15. Guiffrey 1881–1901, vol. 2, col. 761, lists the payment as follows: "25 juillet [1685]: à Jean Oppenor, ébéniste, pour compartimens faits aux deux bureaux du petit cabinet de S.[a] M.[ajesté] . . . 240 [livres]" (On 25 July [1685]: to Jean Oppenor, cabinetmaker, 240 livres for making two writing desks for the small study of His Majesty).
12. Brevet, 29 October 1679, Archives Nationales, Paris, O¹ 105¹, p. 431. See also Ronfort 1986, p. 49. For Bérain's design, see Pons 1996, p. 167.
13. Guiffrey 1881–1901, vol. 3, col. 524.
14. No. 516 is discussed in Guiffrey 1885–86, vol. 2, p. 175. I am grateful to Florian Knothe, Annette Kade Art History Fellow, 2005–2006, Metropolitan Museum, for this archival information. See also Ronfort 1986, pp. 47, 49; and Kisluk-Grosheide 2005, pp. 66–67.
15. Ronfort 1986, pp. 48–49.
16. Catalogue of a sale at Christie's, New York, 21 November 1984, lot 194.
17. Catalogue of the Lady Juliet Duff collection sale, Sotheby's, London, 12 July 1963, lot 163.

18.

Wig cabinet (*cabinet de toilette*)

German, ca. 1685
Johann Daniel Sommer II (1643–?after 1692)
Oak and walnut veneered with ebony, ebonized wood, and marquetry of pewter and mother-of-pearl on horn over paint, simulating tortoiseshell; silver; brocaded damask not original to the wig cabinet
H. 16 in. (40.6 cm), w. 18 in. (45.7 cm), d. 13½ in. (34.3 cm)
Purchase, Rogers Fund and Cynthia Hazen Polsky Gift, 2004
2004.417

This wig cabinet is one of the most elaborate examples of its kind, a work of great refinement and supreme craftsmanship.[1] The exterior is decorated with extremely fine boulle marquetry, which retains many of the original engraved details.[2] Furthermore, it is an early example of the migration of this type of metal-and-tortoiseshell (or horn) marquetry and the High Baroque style in French furniture to the German-speaking cultural areas (see the entries for nos. 14, 17). It is obvious that the creator of this cabinet, Johann Daniel Sommer II, occupies a key position in the history of European furniture-making. Unfortunately, the most important facts about his career remain obscure. He was born in 1643 into a dynasty of craftsmen. His grandfather was a carpenter, and his father, Eberhardt Sommer (1610–1677), worked as a carpenter, master builder, and gunmaker in the Franconian town of Künzelsau beginning in 1642. Other members of the family are documented as skillful craftsmen and gifted sculptors.[3] Johann Daniel married in Künzelsau in 1667 and lived there until 1679. Then he sold his properties and moved to an unknown destination. One of his elaborate pieces, a traveling apothecary made for Karl August, margrave of Brandenburg-Kulmbach (1663–1731), contains silver utensils stamped with the Augsburg town mark for 1692–1700. One of these objects, a mortar, is dated 1692. By the late 1600s, however, Augsburg silver, especially sets of toiletry and pharmaceutical items, was esteemed all over Germany; thus, the assumption that Sommer lived in Augsburg must remain speculative. Besides, in Augsburg Sommer could not have used painted horn as a substitute for tortoiseshell as is done in the Museum's piece. The town guaranteed the quality of its luxury goods and ruled that "nobody should be deceived with ox-horn."[4]

It is inconceivable that the Museum's wig cabinet could have been realized without firsthand knowledge of contemporary French designs and marquetry and cabinet-making techniques. Sommer most likely gained experience in Paris during his journeyman's travels before returning to Künzelsau. In the French capital he may have worked with a man named Jacques Sommer, a supposed relative who is mentioned as a cabinetmaker there until 1669.

His widow continued the workshop, receiving a last payment in 1683.[5] He supplied Cardinal Jules Mazarin (1602–1661) and other members of the French court with elaborately decorated sets of furniture that included a mirror, matching table, and two candlestands. Alternatively, Georg Himmelheber has suggested that Johann Daniel Sommer may have worked closely with the French royal cabinetmaker Pierre Gole (ca. 1620–1684); he mentions a table by Gole in the Museum's collection (no. 14 in this book) as a possible link.[6] By the early 1660s Gole and his workshop were producing intricately inlaid furniture for the royal household of the Sun King. Whether Sommer ever worked with the great French marqueteur André-Charles Boulle (1642–1732) is not known. Boulle, only three months older than Sommer, became a master no earlier than 1666, by which time Sommer must have returned to Germany, for that year he supplied a game board and a dated and signed table to Count Albrecht von Hohenlohe-Langenburg.[7] It seems clear that Boulle and Sommer were influenced by an older master, probably Gole, but why so gifted a cabinetmaker and ornamentist as Sommer returned to his provincial roots instead of becoming a celebrated *ébéniste* in Paris like so many other German journeymen remains a mystery. The famous tapestry depicting a visit of Louis XIV to the court

furniture workshop at Gobelins in 1667 illustrates a red (perhaps tortoiseshell) table with elaborate marquetry thought to be by Gole. It is extremely similar to Sommer's table of 1666 for Count Albrecht. The only noticeable difference is that the table seen in the tapestry has opulent gilt-bronze mounts, whereas Sommer's table has very refined but simpler pewter moldings.[8] The tortoiseshell and metal marquetry applied to both pieces was probably produced by the same technique. Sheets of tortoiseshell and metal were stacked together, a design was laid on the top sheet, and then all the sheets in the stack were cut together. The cutouts could be

assembled in master patterns of light material set in a dark ground (*première partie*) or dark material on a light ground (*contre partie*).[9] It can be assumed that Sommer introduced this technique to Germany; moreover, the date on Count Albrecht's table suggests that Sommer may have played a major role in the development of this marquetry style in Paris while employed at Gole's workshop. If he was apprenticed as a boy in Germany to his uncle Johann Eberhart Sommer (1614–1693), who made guns richly inlaid with silver or pewter designs, Johann Daniel may have acquired metalworking skills before traveling to Paris.[10] It is not difficult to imagine

the nephew transforming his uncle's playful volutes into his own signature zigzags.

The Museum's wig cabinet, with a lid in the style of a Chinese pagoda as an exotic detail, was a portable repository for that essential item of formal masculine attire, the wig. Dressing the hair and adjusting the wig were an important part of a gentleman's morning toilette, or *lever*,[11] when he was accustomed to receive the most important guests of the day as a special gesture of personal appreciation. As the occasion was public, all the accessories on the dressing table had to reflect the owner's taste and status. The extensive use of polished pewter

Fig. 30. Detail of the top of the wig cabinet. In the center of the inlay is the cipher of Prince-Bishop Johann Gottfried von Guttenberg under lily-of-the-valley sprays. His initials, "JVG," appear twice, in a mirror image of each other.

of the Museum's wig cabinet. His full coat of arms appears on a carved ivory cartouche that surmounts the pediment over the center of the cabinet's facade. The cabinet can be identified in various inventories of the Guttenberg family and was recently acquired by the Würth Collection in Künzelsau, the town where Johann Daniel Sommer was born and spent much of his life.

Currently no more than twelve objects can be securely attributed to Sommer. The wig cabinet is undoubtedly one of the finest and best-preserved examples, all of which were made during the first vigorous phase of the expansion of luxury furniture-making in Central Europe. Furniture with boulle marquetry (let us call it "Sommer marquetry" in this case, since it was executed long before Boulle gained fame) became

(presumably in imitation of silver) and the precious silver mounts on this wig cabinet made it impossible that the object should escape the eye of any visitor.[12]

In its form—an elongated octagonal compartment mounted on a stepped base—the wig cabinet is typically South German.[13] When the cabinet appeared on the art market in 1996, it was attributed to Ferdinand Plitzner (1678–1724),[14] who may have studied with Sommer.[15] The key to identifying the patron, to attributing the work firmly to Johann Daniel Sommer, and to dating it at about 1685 are the cipher "JVG" on the cabinet's hinged lid (fig. 30) and the stylized rose that appears in the center of several of the marquetry panels.[CD] Both refer to Johann Gottfried von Guttenberg (1654–1698), prince-bishop of Würzburg and duke of Franconia. The rose is part of the Guttenberg coat of arms. The use of the prince-bishop's monogram without the Guttenberg arms and the fact that the rose is almost hidden among the other marquetry decorations indicate that Guttenberg considered the wig cabinet a very personal item. Much more elaborately decorated but with almost identical ornamental details is a collector's cabinet, dated 1685, that the prince-bishop purchased from Sommer (fig. 31).[16] This cabinet, which stood in the public rooms of the episcopal palace, shows Johann Gottfried's official cipher as prince-bishop and duke on the central door, under a canopy of lily-of-the-valley sprays that resembles the one crowning the bishop's cipher on the lid

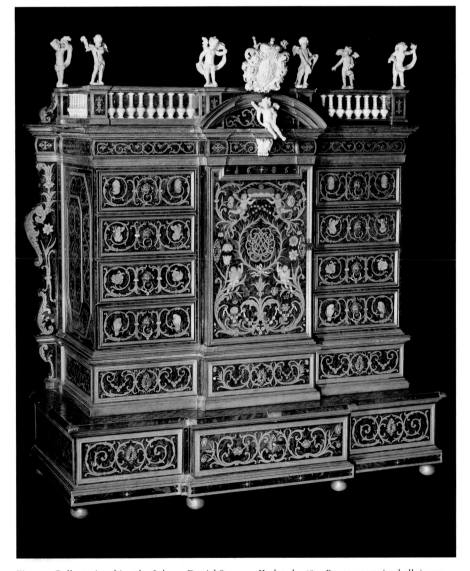

Fig. 31. Collector's cabinet by Johann Daniel Sommer II, dated 1685. Pewter, tortoiseshell, ivory, mother-of-pearl; 48⅜ x 45¼ x 20½ in. Reinhold Würth Collection, Künzelsau. The door is inlaid with the initials and abbreviated official title of Prince-Bishop Johann Gottfried von Guttenberg under lily-of-the-valley sprays. The interlaced letters are "JGEHFOD" (Johannes Godefridus Episcopus Herbipolensis [ac] Franciae [ac] Orientalis Dux).

very highly regarded in the south German princely courts of the late Baroque period.

W K

1. Havard 1887–90, vol. 4, cols. 1431–50. Based on extensive archival research and his familiarity with personal correspondence of the period, Alain Gruber has determined that many richly embellished boxes with only one large compartment dating from about 1650 to about 1750 were originally intended for the storage of wigs. Frequently decorated with gilded mounts and extravagant inlay, including *pietre dure,* these boxes are often mistakenly described as jewelry caskets. Dr. Gruber was kind enough to discuss this topic with me in New York on 16 November 2004.

2. The drawer locks may once have had massive silver plates, which were removed and melted down, most likely during the Napoleonic wars. The keyholes were subsequently filled with silver rosettes decorated with engraved lotus leaves; see the conservation report in the archives of the Department of European Sculpture and Decorative Arts, Metropolitan Museum.

3. Grünenwald 1951–52, p. 280; and Kraut 1988, p. 36.

4. Alfter 1986, p. 91.

5. Guiffrey 1881–1901, vol. 2, col. 391. See also Knothe 2002, pp. 28–36, on Sommer's widow and their daughter Catherine Sommer, who married the cabinetmaker Philippe Poitou (ca. 1640–1709).

6. Himmelheber 1988, pp. 124, fig. 5 (the Museum's piece by Gole), 125, figs. 6, 7 (pieces by Gole inspired by Sommer).

7. Ibid., p. 125.

8. The tapestry is illustrated in Raggio et al. 1989, pp. 4–5, fig. 5. On p. 52 of Pradère 1989, there is a detail illustration of the tapestry that includes the table.

9. The technique was being used in Germany for marquetry in wood almost two generations earlier, as a South German buffet dated 1573 and other sixteenth-century pieces from Ulm and Cologne demonstrate; see Koeppe 1992, pp. 118–20, 120–22, 126–27, nos. M53, M54, M60, color ills. pp. 250, 257.

10. Braun 1988, p. 144, fig. 5.

11. Havard 1887–90, vol. 4, cols. 1431–50; and P. Thornton 1990, pp. 230–33.

12. On the special pewter alloy used in the marquetry, see the condition report on the wig cabinet dated 30 September 2004 in the archives of the Department of European Sculpture and Decorative Arts.

13. Koeppe 1992, p. 206, no. M107, color ill. p. 250, and p. 242, M142, color ill. p. 257.

14. Catalogue of a sale at Sotheby's, New York, 12 January 1996, lot 1044 (described as South German). See also *Medieval and Renaissance Sculpture* 1997 (in which the cabinet is attributed to Ferdinand Plitzner). The object was acquired by a Los Angeles private collector who subsequently lent it to the Los Angeles County Museum of Art until 2004, when it was acquired by the Metropolitan.

15. On Plitzner's connections with Sommer, see Kreisel and Himmelheber 1983, pp. 82–90; Koeppe 1996, p. 184, no. 276; and Loescher 1997.

16. Angelmaier, Freyer, and Huber 2004.

19.

Armchair

English, ca. 1685–88
Walnut; covered in modern velvet
H. 57 in. (144.8 cm), w. 30¾ in. (78.1 cm),
d. 19¾ in. (50.2 cm)
On the top rail is the crest of James II and
Mary of Modena.
John Stewart Kennedy Fund, 1918
18.110.18

This armchair is the finest example of its type and period in the Museum. In the center of the crest atop its back is a cipher with the initials of King James II of England (1633–1701) and of his consort, Mary Beatrice, a princess of the house of Este (1658–1718), held by a lion and a unicorn, the royal supporters of England and Scotland.[CD] The shell, a device of King James's, and the eagle, an attribute of his consort, also appear prominently: shells are carved at the center of the blocks on top of the front legs and on top of the stiles flanking the crest; the latter support eagles' heads, which appear again, together with their wings, as feet for the front legs. Each front leg is in the form of a young blackamoor holding garlands and supporting a cushion, probably referring to the supporters of the Royal African Company, a trading company to Africa, to whom the chair might have belonged (fig. 32). It would probably have been used only on ceremonial occasions by the chairman of the company.

The chair has experienced some changes throughout its history. The back was originally upholstered and the seat caned. When acquired in 1918, it had casters, and there was evidence that it had originally been

Fig. 32. Detail of the front left leg of the armchair.

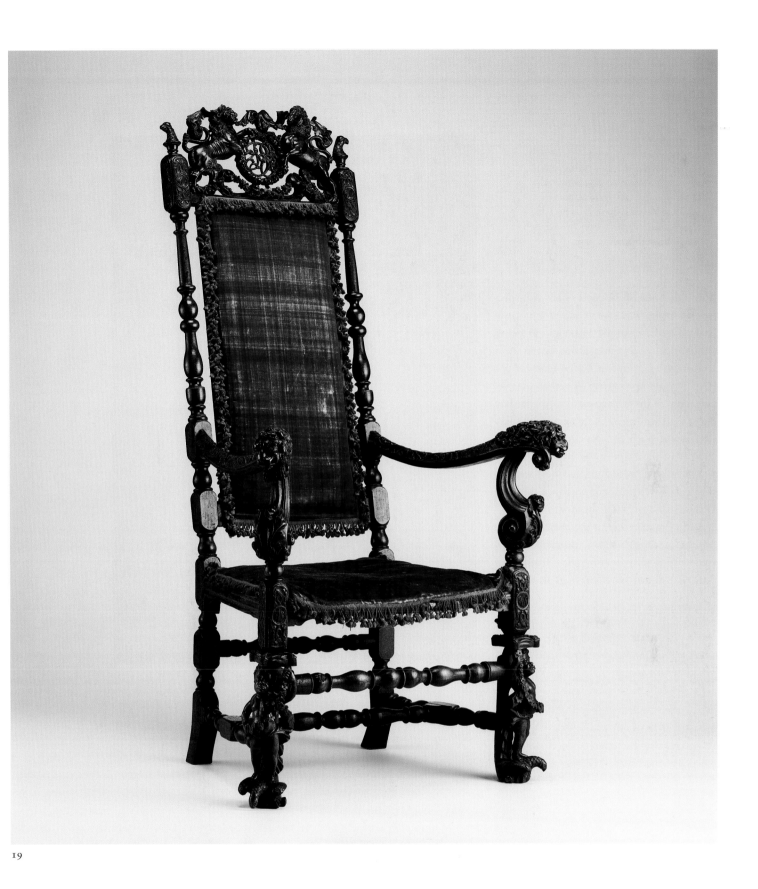

19

painted black and gilded. Today no such evidence remains. Chairs of this type usually have an elaborately carved and pierced front stretcher, for which the present turned stretcher must be a replacement.

This armchair came to the Museum together with twenty-three other pieces of English furniture from the collection of George S. Palmer, a serious collector, though little known today. It has been published several times, most soberly by Joseph Breck in 1918[1] and most passionately in 1983 by Humphry Wakefield: "The sense of live movement in this carving is as powerful and emotionally satisfying as that any tree or human form could provide. The snarling lion masks at the arms, with their wild manes, menace anyone who approaches the personage they guard."[2] CD WR

1. Breck 1918, pp. 274, 277, fig. 2.
2. Wakefield 1983, p. 116.

20.

Frame

Dutch, ca. 1685–1700
Johannes Hannart (d. 1709)
Oak veneered with ebony; boxwood and
ebonized boxwood; modern mirror glass
H. 66 in. (167.7 cm), w. 39 in. (99 cm)
Signed on the oval cartouche at the bottom:
"Joh: Hanat."
Gift of Irwin Untermyer, 1964
64.101.1223

Fig. 34. Detail of the cartouche at the base of the frame showing the maker's signature.

A tour de force of the carver's art, this spectacular frame was one of many gifts from Irwin Untermyer to the Museum.[1] Fitted as a mirror, it used to adorn one of the walls in the dining room of Judge Untermyer's Fifth Avenue apartment. Together with its pair, now in the Rijksmuseum, Amsterdam (fig. 33), it was most likely made to display a marriage portrait.[2] As testament to the identity of the sitter in the painting, a coat of arms surmounted by a coronet, and not yet positively identified, was incorporated in the cresting.[3] CD The monogram "ACC" appears on the crest of the twin mirror in Amsterdam, but this, too, cannot be associated with a particular family. Resembling cameos, the low-relief carvings in the oval

Fig. 33. Frame by Johannes Hannart, ca. 1685–1700. Oak veneered with ebony, boxwood, and ebonized boxwood; 66 x 39 in. Rijksmuseum, Amsterdam (RBK 16506).

cartouches that are part of the decoration at the bottom of both frames seem to make additional allusions to the couple's armorial bearings.CD The Museum's example has four putti adorning a lamb with floral garlands—perhaps a reference to the lamb or sheep found in the first and fourth quarters of the coat of arms. The cartouche in the frame at the Rijksmuseum shows several cupids pursuing an escaping swan—probably an allusion to the three swimming swans in the other two quarters of the coat of arms. The cupids with their bows and arrows were then, as now, symbols of love and would, after all, have been very appropriate subjects for the frame of a marriage portrait.

The Museum's object is veneered with ebony and decorated with very finely carved pieces of applied boxwood. The contrast between the nearly black background and the adhered ornament must have been particularly striking when the boxwood was fresh and lighter in color than it is today. The innermost molding is ornamented with a guilloche-and-rosette pattern, whereas the one on the outside displays a continuous string of bellflowers. Exemplifying great dexterity on the part of the artist, tiny vines with curling tendrils, leaves, and clusters of grapes were attached to the central border of the frame. The fruit-bearing vine may be emblematic of fecundity or may refer to Psalm 128, in which a wife is described as a fruitful vine at the side of her husband's house. This kind of symbolism is not unusual in seventeenth-century Dutch art.[4] Since this part of the frame is slightly convex, the carver may have cut the motifs with a small fretsaw from a similarly shaped piece of boxwood in order to be able to glue

20

it to the curving ground. A similar technique was used for the cartouche below and for the field of the coat of arms.

Contrasting with the continuous decoration in low relief are the crest and the lower part of the frame, both of which are adorned with splendid ornament in high relief. Acanthus leaves and a pair of large swans perched on volutes (the pendant in Amsterdam has eagles instead) flank the coat of arms, which is placed within a scrolling cartouche. The elegant birds with long, curving necks and outstretched wings are holding three-dimensional floral festoons in their beaks. These garlands hang down the sides of the frame and are draped in swags that overlap the top of the frame in three places.[CD] The carving includes a wealth of naturalistic flowers and plant materials, such as anemones, sunflowers, lilies, oak leaves, and acorns—but, surprisingly, only one or two tulips. Similar scrolling acanthus leaves and floral garlands hanging over volutes surround the cartouche below the frame. The attention to detail is truly amazing, as can be seen in the long pistils carved in the round inside the lily blossoms and in the swans' wing feathers, which are distinguished from the down on their breasts. Particularly beautiful are the tips of the acanthus leaves that curl around their gracefully curving necks. Very refined, too, is the carving of the cartouche surrounding the coat of arms. It is punched with a dense, almost granular, pattern except for the lowest part, which is scaled. With its variety of high-relief carving, low-relief decoration, and patterned surfaces flanked by moldings of boxwood and ebonized boxwood, the frame is reminiscent of the goldsmith's art.

The sculptor Johannes Hannart (or Hannaert), who signed this magnificent frame with an abbreviated version of his name (fig. 34), is not a familiar figure today. Born in Hamburg at an unknown date, he was established in the Netherlands in or before 1679, the year he was married at The Hague. He must have been successful there, since he was named *stadsbeeldsnijder*, or municipal carver, in 1682.[5] The elaborately carved frame, dated 1685, that surrounds a group portrait of the members of the city council painted three years earlier by Jan de Baen (1633–1702) was most likely the product of an official commission awarded to Hannart in this capacity.[6] Embellished

with various coats of arms, ribbons, and garlands of flowers and oak leaves, the gilded and polychrome frame is surmounted by a coronet and acanthus scrolls not unlike those on the Museum's example.

Several of his few extant pieces show that Hannart worked not only in wood, as one would expect of a carver, but also in stone,[7] indicating that the traditional division between stone sculptors and woodcarvers was no longer strictly adhered to at the end of the seventeenth century.[8] Between 1690 and 1692, for instance, Hannart collaborated on a stone fountain, still in situ at the fish market in Leiden, probably after a design by the architect Jacob Roman (1640–1716). Hannart was paid for the models he made for the marble decoration of the fountain, and he also executed the main sculptural group of tritons on top.[9]

Hannart's association with Roman dated back to at least 1681, the year that Roman was appointed *stadstimmerman*, or municipal carpenter, of Leiden, a post that allowed him, in fact, to be active as a designer and as an architect.[10] Although he was trained as a carver in the studio of his father, Pieter Roman, the younger Roman increasingly turned his attention to architecture. Having moved to Leiden in 1681 to take up his new position, Roman rented his house in The Hague to Hannart, to whom he also sold the contents of his workshop. Through Roman, who in 1689 became the official architect to the Dutch stadholder and king of England, William III of Orange-Nassau (1650–1702), Hannart may have gained access to the court in The Hague. This connection may have resulted in a commission to make a plaster model for a lifesize statue of the stadholder (the statue itself was never completed).[11] In addition, it may have brought Hannart in contact with the architect and designer Daniel Marot (1661–1752) (see the entries for nos. 22, 26). Employed by William III, Marot collaborated with Roman on Het Loo, the stadholder's hunting lodge near Apeldoorn, which was later enlarged to a palace. Hannart was, in fact, one of the sculptors who executed the large stone vases designed by Marot for the gardens of Het Loo.[12] It is, therefore, not very surprising that the Museum's frame bears some resemblance to Marot's works. The manner in which the carving extends beyond the rectangular frame at the top is quite reminiscent of a design for mirror frames by

Marot.[13] In certain respects the rich and dense decoration of the frames is also similar to allegorical vignettes painted in miniature by Jacques Bailly (1629–1679) for the borders of tapestries of the Four Seasons by Charles Le Brun (1619–1690). Especially close is Bailly's depiction of eagles perched on a straight ledge and holding garlands of fruits and flowers in their beaks, as found in a vignette symbolizing Winter.[14] These vignettes were engraved by Sébastien Le Clerc (1637–1714) and published in Paris a number of times beginning in 1668 as *Devises pour les tapisseries du Roy*. German versions of this book, with engravings by Johanna Sibylla Küsel (ca. 1650–1717), were published by her husband, Johann Ulrich Kraus (1655–1719), in Augsburg in 1687, 1709, and 1710.

Mounted as mirrors, Hannart's pair of frames were lent by the dealer M. Harris and Sons to the London "Art Treasures Exhibition 1932."[15] D K-G

1. Hackenbroch 1958a, p. 79, figs. 397–99, pls. 344, 345. See also Metropolitan Museum of Art 1977, p. 102, no. 185 (entry by William Rieder).

2. Rijksmuseum 1952, pp. 262–63, no. 342.

3. The device of three swimming swans could be the bearing of the Van Swanenburgh family of Leiden, and it has been suggested that the sheep are the bearing of the Heydanus family. In 1662 Karel Heydanus (1636–1679) married Jacoba van Swanenburgh (1642–1676) in Leiden; see Pelinck 1960, p. 154, n. 12. But, given the date of their marriage, it does not seem likely that the present frames were commissioned for their wedding portraits. Their only daughter, Adriana Christina Heydanus (after 1662–1699), never married; see Lunsingh Scheurleer, Fock, and Van Dissel 1992, p. 284.

4. See, for instance, the use of fruit and a vine in a family portrait by Pieter de Hooch (1629–1684); Liedtke 2001, p. 274, no. 27 (entry by Walter Liedtke).

5. Obreen 1877–90, vol. 6, p. 206, n. 1; and Staring 1965, p. 226. In 1683 he and other sculptors joined Pictura, the brotherhood of painters in The Hague; Obreen 1877–90, vol. 5, p. 137.

6. This portrait and its frame are in the collection of the Historisch Museum, The Hague. They are on display in the city hall. Van Thiel and De Bruyn Kops 1984, p. 32.

7. The artist is known to have made a tomb monument for Schelhammer, minister of the Lutheran Church in The Hague. In place in 1699, it is now lost; see Neurdenburg 1948, p. 237.

8. Fock 1994, pp. 35, 40.

9. Blok 1918; and Neurdenburg 1948, pp. 232, 236, fig. 186.

10. Fock 1989, p. 28.

11. Staring 1965, p. 222.

12. Neurdenburg 1948, pp. 237–38.

13. Baarsen et al. 1988, pp. 147–48, nos. 91, 92 (entries by Deborah Sampson Shinn).

14. See Grivel and Fumaroli 1988, p. 101, pl. 41, pp. 115–16.

15. *Art Treasures Exhibition* 1932, no. 92.

21.

Armchair

French, ca. 1690–1710
Carved and gilded walnut; covered in late-
seventeenth-century wool velvet (moquette)
not original to the armchair
H. 46½ in. (118.1 cm), w. 28 in. (71.1 cm),
d. 23¼ in. (59.1 cm)
Purchase, Gift of Mr. and Mrs. Charles
Wrightsman, by exchange, 1983
1983.526

In the most recent catalogue of the furniture at Versailles,[1] where two related armchairs *à châssis* (with drop-in seats) are on display in the refurbished bedroom of Louis XIV, this extraordinary chair model was described as "to be dated probably to the second quarter of the eighteenth century."[2] This proposed dating was based on "the setting back of the armrest supports" and "the absence of a stretcher" between the legs.[3] The chair's overall appearance, however, as well as the Italianate, trapezoidal form of the seat make an earlier date much more plausible. Also, the ornamentation and the minimally curved, rather straight-looking arms with their stylized-volute "hand knobs" (see fig. 36) betray the pervasive influence of Charles Le Brun (1619–1690), director of the royal manufactory at the Gobelins and of the Académie Royale de Peinture et de Sculpture (since 1663) under Louis XIV. Le Brun's playfully arranged designs are echoed in many decorative works of the late seventeenth century, for example, four embroidered wall hangings of about 1685 and an ingeniously designed side table of about 1690, both in the collection of the Museum.[4]

Another argument put forward in the Versailles catalogue for a date after Louis's death in 1715 is a perceived similarity between the burly, branchlike legs of this chair model and the *pieds de biche,* or legs turned three-quarters forward and terminating in a doe's foot that became popular for furniture during the early Régence period (see the entry for no. 28).[5] The fanciful, imaginative leg design of this chair model, based on a series of incurving segments (*chantournés en dedans*), is far more sophisticated than the *pieds de biche.* It is firmly rooted in the zoomorphic foot forms of the seventeenth century and can be visually documented in the Grand Galerie at Versailles

as early as 1684.[6] If the present chair model is datable between 1690 and 1710, it is one of the first examples made with a drop-in upholstered seat.

A date of about 1690 to 1710 is especially attractive because it enables us to entertain the idea that the suite of seat furniture to which this chair belongs re-created in gilded wood the silver furniture at Versailles that was melted down in 1689 to pay for the king's military campaigns.[7] This idea is supported by the simulated drapery ornamentation on the armrests. This so-called lambrequin motif (see the entry for no. 33) is rarely found in contemporary French woodwork but is fairly common in the products of the court goldsmiths. Laurence Buffet-Challié observed of another example of this model, in the Lopez-Willshaw collection in Paris, that "the woodwork of this armchair [of] *c.* 1700 is carved almost as if it were the work of a goldsmith. The curved frame to the back and the seat, and the absence of

stretchers anticipate the style of the eighteenth century."[8]

A recent discovery in a French publication of 1837 may offer a key to settling all these arguments. In his *Moyen-Âge pittoresque: Monumens d'architecture, meubles et décors* Philippe Moret published a lithograph of this chair model (fig. 35). The short caption gives no medium, dimensions, or other details about it, but the description reads, "Armchair used as King Stanislas's throne," and a provenance is given: "from the collection of M. Schwiter."[9] The king referred to must be the Polish prince Stanislas Leszczyński (1677–1766), who was elected king of Poland in 1704 and displaced in 1709 by Augustus the Strong of Saxony (1670–1733). In 1725 his fortunes rose again, when his daughter Maria was married to Louis XV (1710–1774). As the French king's father-in-law, Leszczyński was made duke of Lorraine and took up residence in Nancy, transforming that town

Fauteuil ayant servi de trône au Roi Stanislas.
Chaises diverses

tirées de la Collection de M.ᵣ Schwiter.

N° 18.

Fig. 35. *Throne of King Stanislas.* Detail of a lithograph by Th. Boys in Philippe Moret, *Moyen-Âge pittoresque: Monumens d'architecture, meubles et décors du Xᵉ au XVIIᵉ siècle,* vol. 1 (Paris, 1837).

into a major cultural center of the Rococo period.[10] The splendor-loving Leszczyński regularly received furnishings and luxury goods from the French court as gifts, and the opulent chair seen in the lithograph, the Museum's example, and other pieces of the suite may have been among them. By Leszczyński's time the style was certainly out of fashion, but their royal pedigree, flamboyant opulence, and highly unusual appearance must have been as fascinating then as they are today. At some point, the suite was broken up and scattered. We do not know if the armchair in the Schwiter collection was a wooden example (which, by the way it is characterized, seems likely) or if it was a silver version that had escaped the mint.[11] It was, however, called a throne, indicating not only a royal association but also that in 1837 only a single example was known. We remain in the dark as regards the Schwiter collection. A Louis-August Schwiter (1808–1889), later Baron Schwiter, is recorded in a portrait by Eugène Delacroix (1798–1863), today in the National Gallery, London (NG 3286). In his inventory of public-sale catalogues, Frits Lugt (1884–1970) mentions that a collector named Schwiter sold works of art at a series of auctions in Paris between 11–12 December 1863 and 16–17 December 1864 and that some of the lots included furniture.[12] WK

1. Arizzoli-Clémentel 2002, pp. 178–79, no. 59.
2. Ibid., p. 178. See also Meyer 1980b, p. 246.
3. Arizzoli-Clémentel 2002, pp. 178–79, no. 59.
4. On the wall hangings, see Alice M. Zrebiec in Raggio et al. 1989, p. 32 and color ills. pp. 10–11. On the side table, which is based on designs by Le Brun, see James Parker in Raggio et al. 1989, pp. 22–23 and p. 3, fig. 4.
5. Arizzoli-Clémentel 2002, p. 178 (but the proposed interpretation of the *pied de biche* is not sound); and Koeppe 1996, p. 185, fig. 5.
6. The chair's branchlike legs are unusual in the same way as are the animal legs of the side tables in the Grand Galerie seen in an etching of 1684 by Sébastien Le Clerc (1637–1714) in Raggio et al. 1989, p. 6, fig. 7.
7. Salmann 1962, p. 74, fig. 6; and Aprà 1972, p. 26, fig. 17.
8. Buffet-Challié 1965, p. 84, figs. 278, 279.
9. "Fauteuil ayant servi de Trône au Roi Stanislas"; Moret 1837–40, vol. 1, pl. 18. There is a copy of this book in the Thomas J. Watson Library, Metropolitan Museum.
10. *Stanislas* 2004.
11. I hope that this rather speculative entry will encourage scholars to investigate the archives at Nancy and in Stanislas's residences and that their research will shed light on the mystery of these important chairs.
12. I am most grateful to Florian Knothe, Annette Kade Art History Fellow, 2005–2006, Metropolitan Museum, for sharing with me the fruits of his research on Schwiter.

Fig. 36. Detail of the left side of the chair. Stylized lambrequin motifs decorate the arms.

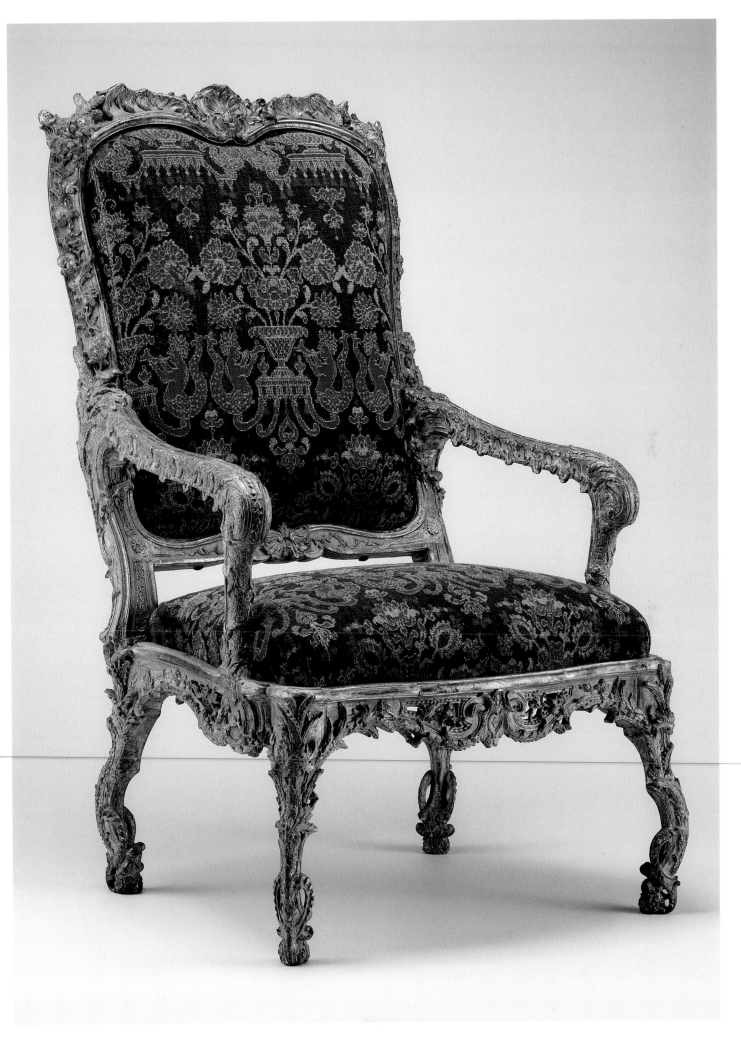

State bed

English, ca. 1698
Oak; covered in silk damask, some of it replaced
H. 12 ft. (365.8 cm), l. 6 ft. 6 in. (198.1 cm),
w. 5 ft. (152.4 cm)
Gift of Mr. and Mrs. William Randolph Hearst Jr.,
1968
68.217.1

Thomas, Baron Coningsby (1656–1729), a friend and courtier of William III of England (1650–1702), ordered this state bed about 1698 for his own residence, Hampton Court, near Leominster, in Herefordshire. Starting about 1680, he carried out extensive alterations in the house and laid out the gardens, both of which are depicted in two panoramic views painted about 1699 by Leonard Knyff (see fig. 37).[1] Coningsby was a curious and extravagant gentleman, obsessed with the knightly history of his family, which he reenacted in portraiture, in heraldry, and in romantic, medieval-style joustings. More than a little unbalanced, he died in 1729, after years of wandering vaguely in his fantasy world.

In the great English country houses of the late seventeenth century, the state bed evolved into the most lavish (and expensive) piece of furniture in the house, the cost often exceeding the rest of the contents combined. As a great confection of velvet, damask, and silk, edged with gold and silver braid and the most elaborate passementerie, it required the skills of the leading mercers, upholsterers, and trimmings-makers of the period. Often it was upholstered en suite with chairs, stools, curtains, and wall hangings. While, in principle, it was reserved for a visit of the sovereign, when such a visit failed to materialize, the state bed served as a bold status symbol.

These beds were frequently inspired by the designs of William III's architect Daniel Marot (1661–1752), who illustrated several in two published suites of engravings (see fig. 38).[2] With their elaborate testers and strongly scrolled headboards, they were the most prominent examples of furniture in the English Baroque style.

This state bed is one of two from Hampton Court. It was made for Coningsby's own use. The other, covered in red damask, was placed in the state bedroom, called The King's Bedroom, and is now in the bedchamber of William III at Het Loo Palace, near Apeldoorn, in the Netherlands.[3]

During the remodeling of Hampton Court in the nineteenth century, the blue bedroom was altered and the bed stored in an attic, where it was spotted in 1911 by H. Avray Tipping of the magazine *Country Life,* who wrote, "So fine a bed of the Marot type in such unusually perfect state is rare indeed."[4] Later, he elaborated on his find: "When, at my special desire, it was again set up (the brew-house seemed the only place lofty enough for this purpose), it was found to be in its entirety and in admirable condition."[5] In 1925 it was sold to the dealer Permaine of Bond Street, London, who sold it shortly thereafter to the American newspaper publisher William Randolph Hearst (1863–1951). Whether intended by Hearst for St. Donat's, his castle in Wales, or for San Simeon in California is not known, but in 1968, still packed in the crates of 1925, it was given by his son and daughter-in-law to the Metropolitan Museum. When finally completely unpacked and examined with a view to its restoration in 1986, the bed was in a considerably less perfect state than it had been in 1911. There followed an extensive conservation project to clean the original damask and fringes on the tester and headboard and to commission new matching silk damask to replicate the fragile headcloth and to provide new curtains and bedspread, which had been lost.[6] CD Even with the new silk damask, this bed is in a remarkable state of preservation. WR

1. On Hampton Court, see the following three publications: Cornforth 1973; *Country House Portrayed* 1973; and Cormack 1985, pp. 136–37.
2. Two plates with beds of similar design, the title page and pl. 34, are illustrated in White 1982, pp. 85–86, figs. 4, 5.
3. Vliegenthart 2002, p. 205, fig. 339.
4. Tipping 1911, p. 791.
5. Tipping 1928, p. 20.
6. Britton 2001. The new damask was woven by Richard Humphries, Humphries Weaving Company, Halstead, Essex, England.

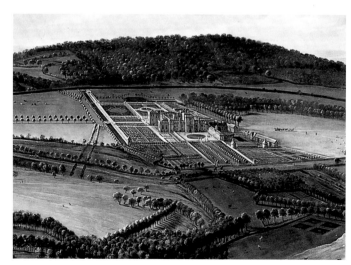

Fig. 37. Leonard Knyff (1650–1721), *The North Prospect of Hampton Court, Herefordshire* (detail), ca. 1699. Oil on canvas, 58¾ x 84⅜ in. Yale Center for British Art, New Haven, Connecticut, Paul Mellon Collection.

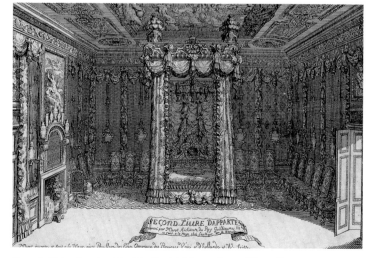

Fig. 38. Title plate (etching) in Daniel Marot, *Second livre d'appartements,* 1703. The Metropolitan Museum of Art, New York, Harris Brisbane Dick Fund, 1930 (30.4.[12]).

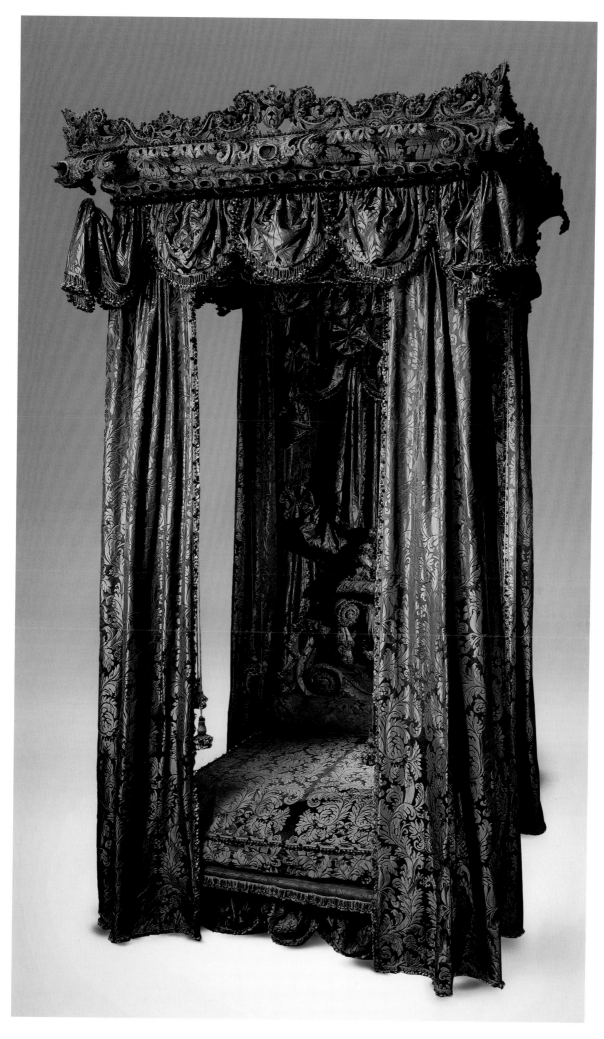

22

23.

Cabinet (*armoire*)

French (Paris), ca. 1700
Attributed to André-Charles Boulle (1642–1732)
Oak veneered with macassar and Gabon ebony,
ebonized fruitwood, burl wood, and marquetry
of tortoiseshell and brass; gilt-bronze mounts
H. 91¾ in. (233 cm), w. 48 in. (121.9 cm),
d. 19 in. (48.3 cm)
Fletcher Fund, 1959
59.108

In 1688 the Parisian cabinetmaker Auburtin Gaudron, who worked for the French court after the death of Pierre Gole (ca. 1620–1684), delivered for Louis XIV's apartment at the Château de Marly a "large and beautiful cabinet with architectural bronze mounts and marquetry of copper and ebony with amaranth."[1] Such armoires (closed cabinets or wardrobes) were ostentatious parade objects intended to stand grandly in a public room. The above description of the marquetry on Gaudron's armoire and of his piece's architectural form document that at this time André-Charles Boulle was not the only maker of these cabinets, for success has always sparked imitation in the competitive Parisian artistic environment. Nonetheless, the products of Boulle's workshop are distinguished from those of his competitors by sculptural details of unusual quality applied to the carcase structure. Boulle's furniture bears some of the best gilt-bronze ornaments ever made (see also no. 31).[2] The eight intricate corner mounts on the doors of the Museum's cabinet depict wind gods with flowing locks—six with a mature face and two with a young, beardless face—blowing a gale through pursed lips (fig. 39).[3] The facade-like front, on a modest base with later *toupie* feet, is divided by a vertical molding of pilaster form with brass on tortoiseshell (*première partie*) marquetry. Its small capital penetrates an egg-and-dart molding with a projecting Vitruvian-scroll frieze above. The cabinet's top has concave sides and a rectangular base, lending the whole composition an almost pagoda-like look.[4]

The patterns of the different inlaid panels correspond to those on other Boulle workshop pieces; these panels may have been prefabricated and held for stock, as mounts very often were, especially those frequently applied, such as rosettes, scrolls, and hinges.[5] The mounts on the Museum's cabinet, which are integrated with and partly echo the two-dimensional inlaid decor, intensify the sparkling appearance of the piece. There are similarities between this cabinet and a remarkable drawing by Boulle in the Musée des Arts Décoratifs in Paris that strengthen the attribution to Boulle (fig. 40).[6]

Certain features of this cabinet shed light on the economically oriented nature of Boulle's workshop. The degree of chiseling and finish on the bronze mounts gradually increases as they approach eye level; moreover, the exotic and very expensive ebony—which was purchased by the pound—is replaced by ebonized local fruitwood in the upper quarter of the cabinet (above eye

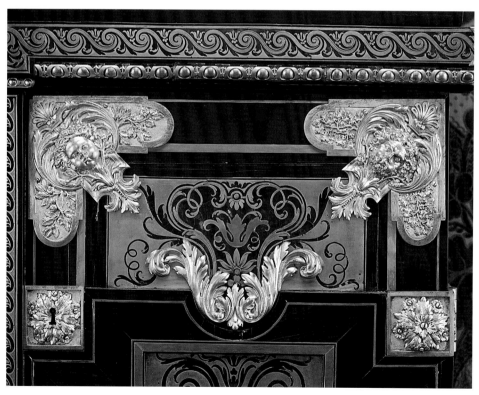

Fig. 39. Detail of the mounts at the top of the right door of the cabinet.

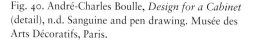

Fig. 40. André-Charles Boulle, *Design for a Cabinet* (detail), n.d. Sanguine and pen drawing. Musée des Arts Décoratifs, Paris.

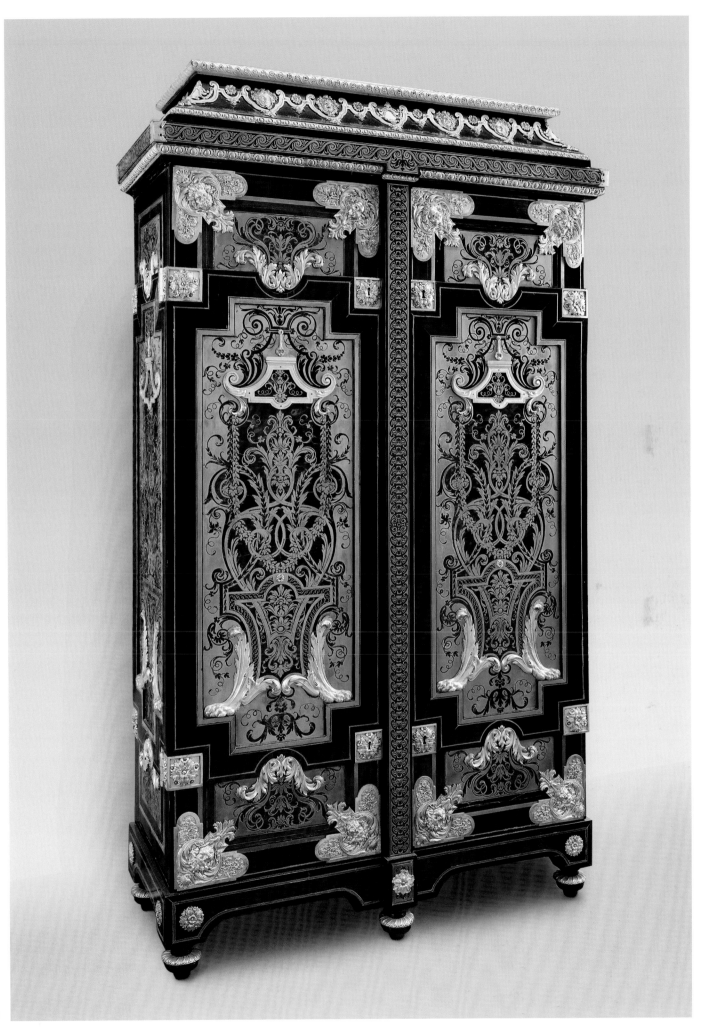

23

level). A similar thrift was practiced on the inside of the doors, which are not inlaid.[CD] Instead, they are veneered with local burl wood that was probably stained to imitate much more valuable tortoiseshell.[7] Still, the interior must have looked strikingly attractive, especially when the three shelves (now lost) were filled with works of art or precious books. The outside of the Museum's armoire is for the most part veneered with *contre partie* (dark on light) marquetry, which was about 20 percent less expensive than *première partie*. This suggests that a matching cabinet decorated similarly but predominantly in *première partie* once existed. In spite of its enormous size, the object is surprisingly easy to dismantle; it comes apart in fifteen to twenty minutes.

The cabinet has unfortunately lost nearly all of its former engraved decoration, which means that its current appearance is distorted. This type of wear may be due to the materials used. Tortoiseshell and wooden veneer are organic, as is the oak used to build the carcase. The inlaid metal has a totally different coefficient of expansion, and as a result the boulle marquetry is constantly "working." Already in the eighteenth century it was said that major parts of the surface would have to be restored "every generation" (roughly every twenty-five to thirty years), and each smoothing of the surface reduced the depth of the engraved decoration and the thickness of the veneers themselves.[8]　　　　WK

1. "grand et belle armoire toutte d'architecture de bronze et de marqueterie de cuivre et d'ébeine avec bois violet"; quoted in Verlet 1963, pp. 9–10. See also Koeppe 1992, pp. 199–201, no. M104, color ills. pp. 245, 246.

2. Fuhring 1994; and Hughes 1996, vol. 2, pp. 541–840.

3. It has been suggested that these corner mounts were added in the late eighteenth century, despite the fact that they are stylistically close to contemporary French sculpture. See Ronfort 2001. I thank Daniëlle Kisluk-Grosheide for this reference.

4. See Hughes 1996, vol. 2, pp. 817–24, no. 172 (this object has an identical central molding and a similar top).

5. Ibid. See Pradère 1989, pp. 67–108, on the paw feet ending in acanthus sprays; these stock items are discussed in almost all descriptions of the Boulle workshop.

6. Fuhring 1994, p. 23.

7. I thank Mechthild Baumeister, Conservator, Department of Objects Conservation, Metropolitan Museum, for discussing this issue with me. For stained burl wood, see Baumeister et al. 1997. On the cabinet, see also Molinier 1902b, vol. 1, pl. 5; catalogue of the Eugène Kraemer collection sale, Galerie Georges Petit, Paris, 2–5 June 1913, no. 359; catalogue of the Antoine-Alfred Agénor, duc de Gramont, collection sale, Galerie Georges Petit, Paris, 22 May 1925, lot 52 (for a similar example, see also lot 51); catalogue of an anonymous sale at Palais Galliéra, Paris, 11 June 1965, lot 96; and James Parker in Raggio et al. 1989, pp. 18, 19.

8. I am most grateful to the late Count Alexander zu Münster, who was a major conservator of boulle work and of pieces from the Roentgen workshop (see the entry for no. 72), for allowing me to observe the activity at his own workshop for extended periods of time.

24.

Cabinet on stand

English, ca. 1700
Pine veneered with marquetry of walnut, burl walnut, and holly; oak drawers; walnut legs; brass hardware, some of it replaced
H. 62¾ in. (159.4 cm), w. 45¾ in. (116.2 cm), d. 21 in. (53.3 cm)
From the Marion E. and Leonard A. Cohn Collection, Bequest of Marion E. Cohn, 1966
66.64.15

This cabinet on stand is decorated with so-called seaweed marquetry of holly and walnut. Enclosing multiple drawers for the safekeeping of valuables, this type of case furniture has antecedents in the imposing ebony showpieces created in Paris largely during the reign of Louis XIII (1610–43) and in the collector's cabinets made of precious materials in centers like Augsburg and Antwerp (see the entries for nos. 11, 13).

It is generally thought that the use of marquetry was introduced in England by foreign cabinetmakers after the restoration to the throne of Charles II (1630–1685) in 1660.[1] Many of them were either Dutch or French Huguenot craftsmen skilled in the latest Continental techniques. This cabinet is almost entirely decorated with marquetry, which, in contrast to the process of inlaying, involves placing a decorative veneer over the wooden carcase, or body, of a piece of furniture. A clear distinction between the two techniques was not always kept, however, and the term "inlayer" was generally used in England to identify those craftsmen and cabinetmakers who practiced both proper inlay and marquetry.[2]

Particularly popular in England during the post-Restoration period was the Dutch-style naturalistic floral marquetry used for clocks and case furniture. More stylized, two-dimensional patterns—such as arabesque and scrolled seaweed decoration, both generally considered to be typically English[3]—were also applied, with striking results.

The Museum's cabinet has a flat-topped rectangular superstructure that rests on an open stand (fig. 41). The upper part is fitted with two doors that enclose thirteen drawers arranged around a central compartment. Behind a small door, this compartment houses six shallow drawers, two large and four small (fig. 42). A projecting cornice and a barrel-fronted frieze forming a single large drawer surmount the cabinet.[CD] The stand encloses one large drawer, on the front of which vertical divisions in the marquetry indicate the position of the S-shaped legs below.[CD] The six legs are all modern replacements, most likely exact copies of the original ones but made of solid walnut and fitted between flat capitals and square plinths that are also later additions. Enlivening the otherwise boxlike appearance of the cabinet, the two angled legs at the corners form a transition between the front legs that are placed straight and those at the back, which are positioned sideways. The shaped, interlaced stretcher supported on six bun feet harmonizes with the outline of the lobed

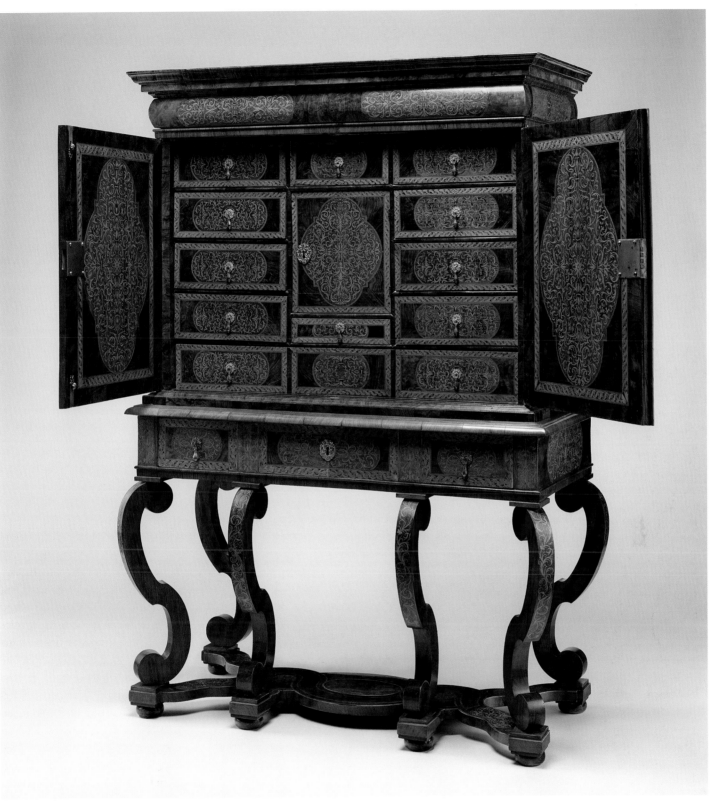

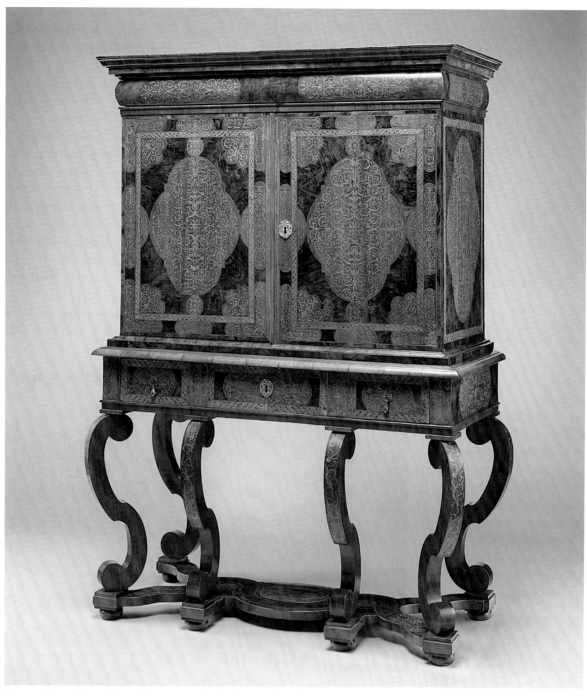

Fig. 41. General view of the cabinet on stand with the doors closed.

marquetry reserves on the sides and on the door panels, as well as with the decoration, consisting of simple stringing, inside the central compartment.

The dense seaweed marquetry of scrolling foliage and floral motifs is strictly symmetrical. Adapted to the size of each reserve, it is small on the drawer fronts and larger on the doors and sides. The marquetry process facilitated repetition of these intricate patterns. Following the lines of the design with a fine fretsaw, the cabinetmaker would carefully cut through stacked layers of holly and walnut veneer that had been temporarily pinned or glued together. Once this difficult task was finished, the different

layers were separated. The patterns of holly were fitted into the spaces cut in the walnut ground to form a panel that was then applied to the carcase.[4] So-called book-matched marquetry could also be created by the simultaneous sawing of bundled veneers. For this cabinet, it meant using four sheets of veneer that were cut together, two for the background and two for the ornamentation. Half of these were then turned over, just like the pages of a book, and adhered to the oak substrate side by side so that a strictly symmetrical decoration was achieved with a joint in the middle.[5] CD The seaweed marquetry in the large cartouches on the doors and sides of the cabinet on stand is book-

matched but that in the smaller reserves is not.

With the exception of the guilloche borders on the drawer fronts, which are all holly, the marquetry consists of holly against a walnut ground. An even stronger contrast must originally have existed when the now-darkened holly was nearly white and the brown walnut, today somewhat dulled and grayish, was fresh. The walnut is cut in a radial plane in order to get an even-grained surface that would show off the lighter decoration at its best. All the detailing was done by saw cuts and not by engraving. In order to achieve the effect of shading, the holly wood was partially scorched in hot sand. Whereas the holly may originally have

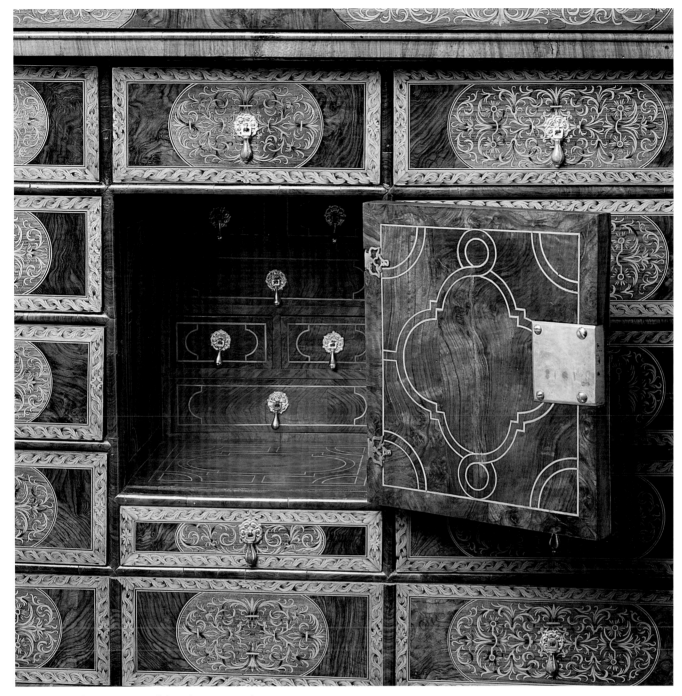

Fig. 42. Central compartment of the cabinet on stand.

looked like more costly ivory, the areas surrounding the seaweed-marquetry reserves are veneered with a richly figured burl walnut that resembles a brecchiated marble or tortoiseshell. To create even greater play of patterning, the cabinetmaker used crossbanded veneer for the various moldings on the cabinet and on the stand (some of which is modern).

The simple shape of the superstructure is a perfect vehicle for the intricate seaweed decoration, which has been compared not only to lace and filigree but also to the elaborate marquetry of André-Charles Boulle (1642–1732; see the entries for nos. 23, 31).[6] In England the artist most regularly

associated with this kind of work was Gerrit Jensen (d. 1715), who supplied furniture to the English crown;[7] however, the seaweed marquetry that covers the entire surface of a pair of cabinets thought to have been made by Jensen, now in the collection of the duke and duchess of Devonshire at Chatsworth, Derbyshire, is clearly different and rules out a similar attribution for the Museum's piece.[8] D K-G

1. Coleridge 1965, p. 91; and *Dictionary of Art* 1996, vol. 20, p. 468.

2. Kirkham 1980, p. 415.

3. A seaweed-marquetry cabinet at Kingston Lacy in Dorset, however, has two Dutch signatures in its

interior, and another Dutch cabinet has seaweed-marquetry borders; see Baarsen 1988a, pp. 25–26, figs. 22, 23.

4. Edwards 1964, pp. 326–27.

5. Corkhill 1989, pp. 53, 332. When veneers were bundled, it was easy to reverse those used for the ground and those used for the inlay, creating a dark ground with a light pattern (*première partie*) and a light ground with a dark pattern (*contre partie*). This type of marquetry is not found on the Museum's cabinet.

6. See for instance, Percival 1927, p. 235; and Symonds 1929, pp. 76–77.

7. Beard and C. Gilbert 1986, pp. 485–87 (entry by Gervase Jackson-Stops).

8. Bowett 2002, pp. 188–92, 200–201, figs. 6.23– 6.26, 7.9–7.11.

25.

Armchair

English, ca. 1700
Attributed to Thomas Roberts (active
1685–1714)
Ebonized beech; covered in Genoese velvet
H. 48 in. (122 cm), w. 28 in. (71.1 cm), d. 32 in.
(81.3 cm)
Purchase, Gift of Irwin Untermyer, by exchange,
and Bequests of Bernard M. Baruch, Ruth Mabee
Lachman Greenleaf, and Irwin Untermyer, by
exchange, 1998
1998.297.1

This armchair, and a matching example also in the Museum's collection, are from a large suite comprising a state bed, eight armchairs, four side chairs, and a pair of stools made for Daniel Finch, second earl of Nottingham (1647–1730) for the state bedroom of his country seat, Burley-on-the-Hill, in Rutland. The bed, two armchairs, and the pair of stools are now displayed in William and Mary's palace at Het Loo, near Apeldoorn, in the Netherlands.[1]

Daniel Finch was secretary of state and privy councillor to William III (1650–1702). After retiring from the government in 1696, he began to build his country house at Burley-on-the-Hill, saying "to live in the country . . . and mind his own affairs and estate . . . is part of a gentleman's calling."[2] Although the house was not entirely finished until the 1720s, the state bedroom was largely complete by 1701. The earliest known reference to the suite in the eighteenth century is in the diaries of the first duchess of Northumberland, who slept in the room in 1771.[3] The furniture is recorded at Burley in inventories of 1772 and 1826 and in a photograph of the state bedroom taken in 1923 (fig. 43).[4]

Finch almost certainly commissioned this set from Thomas Roberts, the prominent London chairmaker, who provided much of the seat furniture for the royal household.[5] In his bills the scrolled feet and arms of this type of chair are described as "horsebone."[6] The tall, raked backs and flared and scrolled arms reflect the style of Daniel Marot (1661–1752), the French architect and designer who worked closely with William and Mary at their palaces both in Holland and in England. The front rails are carved with a series of C-scrolls centered on an earl's coronet.[CD] The chairs retain their original Genoese five-color velvet covers with matching tasseled fringes.

WR

1. Vliegenthart 2002, p. 74, fig. 90. A side chair from the suite is in the Denver Art Museum, Denver, Colorado.

2. Important English Furniture, catalogue of a sale at Sotheby's, London, 10 July 1998, p. 206, lot 84.

3. Northumberland 1926. The diaries are now at Alnwick Castle, Northumberland.

4. Hussey 1923, pp. 254–57, figs. 1, 8, 10. Several accounts suggest that this suite predates Burley-on-the-Hill. Hussey believed that it was made in 1693, when Daniel Finch's father, Heneage Finch (1621–1682), was created earl of Nottingham. When Hussey described it in the 1920s, the bed was believed to have been made for the use of Queen Mary when she attended the christening of Lady Charlotte Finch at Cleveland House, the London mansion opposite St. James's Palace occupied by Daniel Finch from 1689 until 1695. Four armchairs and one side chair were destroyed in a fire at Burley in 1908. The suite was offered for sale together with the contents of Burley by the auction house of Knight, Frank and Rutley, on 20 May 1947, lots 275, 276; the bed, chairs, and stools remained unsold and were retained by the family. The suite passed by descent to E. R. Hanbury, who sold it at Christie's, London, on 6 July 1989, lots 148–52. Two armchairs and three side chairs were sold again at Sotheby's, London, on 10 July 1998, lots 84–86. The Metropolitan Museum acquired the two armchairs as lot 84. The accession number of the second is 1998.297.2.

5. Beard and C. Gilbert 1986, pp. 752–54 (entry by Gervase Jackson-Stops).

6. Bowett 1999.

Fig. 43. Photograph of the state bedroom, Burley-on-the-Hill, Rutland, showing Thomas Roberts's set of furniture in situ in 1923.

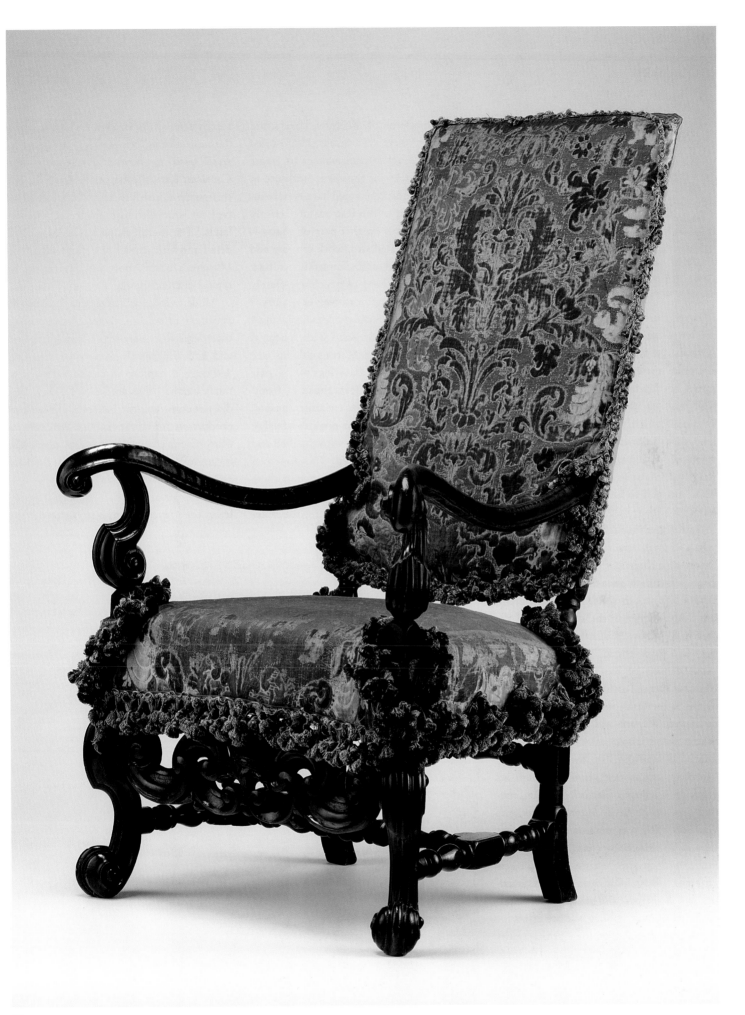

26.

Side chair

Dutch, ca. 1700

Walnut; covered in modern velvet

H. 54¾ in. (139.1 cm), w. 22½ in. (57.2 cm),
d. 19 in. (48.3 cm)

Pasted on the back of the left stile is a round
sticker on which are printed and inscribed,
respectively: "Irwin Untermyer Collection";
and "145A" and "F." Written in crayon on
the inside of the seat rail: "52759."

Gift of Irwin Untermyer, 1964

64.101.909

A strong, versatile wood with a lustrous surface, walnut lends itself well to polishing. With its fine and even grain, it also allows elaborate carving, as is beautifully illustrated by this imposing side chair and its pair, also in the Museum's collection.[1] Fashionable both in the Netherlands and in England for a brief period at the end of the seventeenth century, chairs of this kind, with shaped uprights and an openwork back, are said to be in the style of Daniel Marot (1661–1752).[2]

Son of the French architect Jean Marot (1619–1679), the younger Marot left France as a Huguenot émigré to escape religious persecution after the revocation of the Edict of Nantes in 1685. He became architect and designer to the stadholder of the Dutch Republic, William III of Orange-Nassau (1650–1702). Working in a personal version of the French court style, Marot influenced artistic developments both in the Netherlands and in England, where he served William and his consort Mary Stuart (1662–1694) after they succeeded jointly to the English throne in 1689. Marot's work is best known through his engravings, a large collection of which, entitled *Oeuvres de Sr. D. Marot, architecte de Guillaume III*, was published for the first time in The Hague in 1703.[3] Derived from French fashions, his designs include subjects ranging from buildings and gardens, interiors and fireplaces, and textiles and metalwork to furniture. Among Marot's prints for seat furniture, however, there are no chairs with carved and pierced backs. Instead, reflecting contemporary French traditions, the formal chairs with tall upright backs represented in Marot's work are completely upholstered (see fig. 44). It was perhaps the

intricate patterns of the show covers and their trim in these illustrations that inspired Dutch and English chairmakers to create openwork backs for their seat furniture in this style.[4] Candlelight would have been beautifully reflected in the lustrous and crisply carved ornament on this pair of chairs—such as the foliated strapwork cresting and the urn and shield motifs framed in scrolling acanthus leaves, both of which are closely related to Marot's decorative vocabulary.[CD] Chairs with turned baluster legs and shaped crossed stretchers crowned with a central finial are also seen in Marot's designs (see fig. 44). Whereas the back legs of this pair end in ordinary ball feet, those in front, which terminate in paws, are more unusual.

It is, in fact, not always possible to tell in which country a tall chair with a carved and openwork back originated. This has been further complicated by the fact that these so-called Anglo-Dutch chairs enjoyed a resurgence of popularity during the nine-

teenth century. From about 1820 on, such "antique chairs," as well as later copies, were used to furnish Elizabethan and Carolean Revival interiors in England. For this purpose London dealers imported this type of seat furniture from the Netherlands.[5] The overall shape as well as the fine detail and high quality of the carving of the Museum's chairs, however, appear to be typical of Dutch work.

Made in large sets and placed along the periphery of a room, these tall chairs were considered to be part of the wall decoration and had a primarily decorative function. Although a number of chairs with elaborately carved backs are known today, they did not constitute the majority of the chair production during the reign of William and Mary. Completely upholstered or caned seat furniture was far more common in England and the Netherlands at the time.[6]

This chair and its pair were part of the Irwin Untermyer collection and stood in the

Fig. 44. Designs for upholstered furniture and valances, etching in Daniel Marot, *Second livre d'appartements* (before 1703). The Metropolitan Museum of Art, New York, Harris Brisbane Dick Fund, 1930 (30.4[17]).

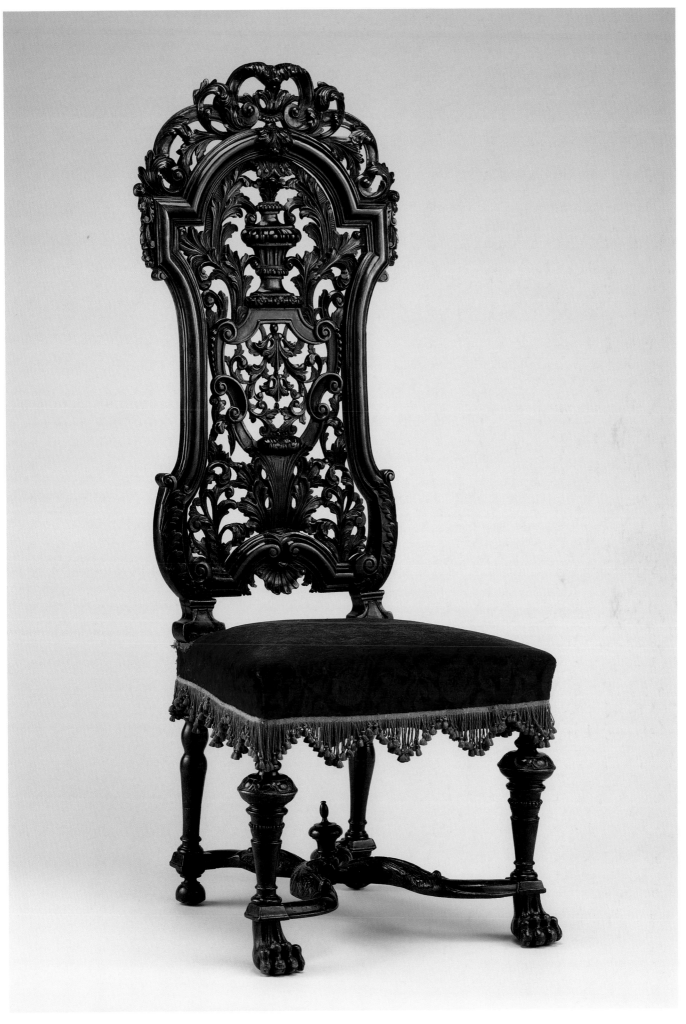

entrance hall of the judge's apartment at 960 Fifth Avenue (see illustration on page 4, below). They were formerly in the possession of Sallie A. Hert at Lyndon Hall, Louisville, Kentucky. She had acquired them in 1931 from the New York antiques dealer French and Company, together with three identical ones. The group of five was offered as three separate lots in the auction of the Hert estate in 1949. French and Company bought them all back and sold this pair to Judge Untermyer.[7] Another chair of the set was purchased by the William Rockhill Nelson Gallery of Art and Atkins Museum of Fine Arts in Kansas City.[8]

DK-G

1. Hackenbroch 1958a, pp. 17–18, figs. 65, 66, pls. 42, 43; and Baarsen et al. 1988, p. 159, no. 110 (entry by Deborah Sampson Shinn). The accession number of the second chair is 64.101.910.
2. Edwards 1964, p. 129.
3. Dee 1988, p. 82.
4. Baarsen 1993a, p. 74, no. 34.
5. Bowett 2002, pp. 272–73.
6. Baarsen 1988a, p. 24.
7. Catalogue of the Sallie A. Hert collection sale, Parke-Bernet Galleries, New York, 25–26 November 1949, lots 264–66.
8. See the correspondence of Ross E. Taggart in the archives of the Department of European Sculpture and Decorative Arts at the Metropolitan Museum. The whereabouts of the two chairs that made up the third lot of the Hert sale are not known.

27.

Cabinet on stand

Dutch, ca. 1700–1710
Attributed to Jan van Mekeren (1658–1733)
Oak veneered with rosewood, olive wood, ebony, holly, tulipwood, barberry, and other partly stained marquetry woods
H. 70¼ in. (178.4 cm), w. 53⅞ in. (136.8 cm), d. 22½ in. (57 cm)
Ruth and Victoria Blumka Fund, 1995
1995.371a,b

Despite a 1624 regulation stipulating that members of the Amsterdam cabinetmakers' guild who offered their wares for sale in the company's shop had to mark their work,[1] very few pieces of Dutch furniture are signed. As a result, it is the exception rather than the rule that extant pieces of Dutch furniture can be ascribed to a certain maker. Based on their naturalistic floral marquetry of exceedingly high quality, however, a group of cabinets, including this one in the Museum's collection,[2] has been attributed to Jan van Mekeren.[3]

Born in Tiel, Gelderland, Van Mekeren established himself in or shortly before 1687 as an independent master in Amsterdam, where he was also a merchant in wood.[4] Since the headquarters of the Dutch East India Company was in Amsterdam, that city was the foremost European market for exotic woods. A grandson of Van Mekeren's, also named Jan, continued this aspect of the business after 1733, when his grandfather died. Based on a list of his debtors at the time of his death, Van Mekeren appears to have prospered by specializing in the production of luxury furniture created mostly for the Amsterdam elite. The 1733 inventory of his shop describes a large assemblage of walnut and oak furniture in stock. Entries for four unfinished doors with flowers, two incomplete tables with flowers, as well as a small cabinet with saw-cut flowers provide proof that Van Mekeren created fine floral marquetry.[5]

Resting on an open support, the Metropolitan's cabinet has a simple, boxlike superstructure with a slightly projecting

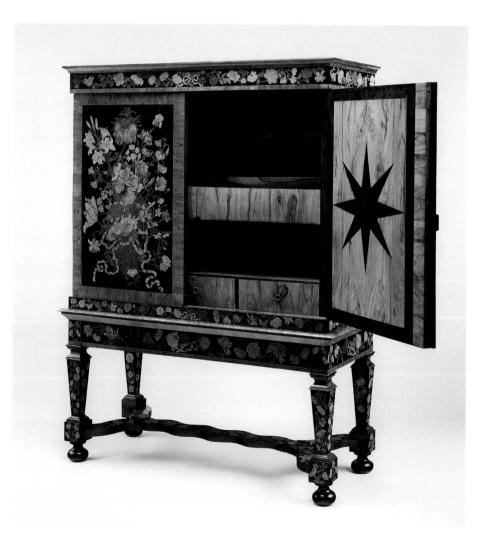

Fig. 45. General view of the cabinet on stand with the right door open.

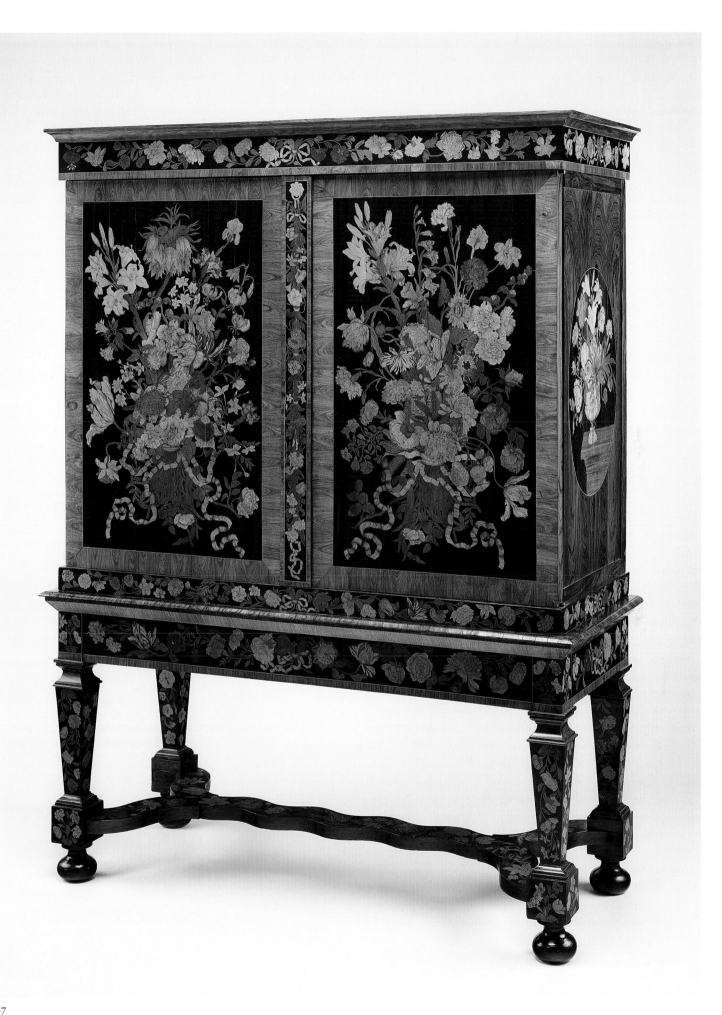

cornice and base, both embellished with a meandering trail of flowers tied with a bow at the center of the front and sides. The central upright, similarly decorated with a string of flowers and ribbons apparently suspended from a ring at the top, visually divides both doors but is actually part of the right door.[CD] The cabinet's lock is hidden behind a sliding panel in the center of this upright. Most of the cabinetmaker's attention has been lavished on the two door panels, which open to reveal an interior fitted with three shelves of varying depth and five drawers for the storage of fine linens and other treasured possessions. On the inside, the doors have an eight-pointed star of deep brown-black rosewood against a lighter olive-wood background surrounded by a border of rosewood (fig. 45). On the outside they display large bouquets of naturalistic flowers against an ebony ground that is framed by a tulipwood border. Among the many exquisite flowers to be seen gathered with a flowing ribbon are tulips, crown imperials, lilies, daffodils, peonies, anemones, roses, irises, and hyacinths. Each of the cabinet's side panels displays a vase of flowers standing on the edge of a table or plinth inside an oval ebony medallion that is surrounded by beautifully figured rosewood.[CD] Less refined are the more repetitive flowers found on the front of the large drawer in the stand, or on the tapering legs and the double-Y–shaped, serpentine stretcher.

Upon examination, it becomes clear that of the more than two hundred elaborate flowers decorating the piece, several occur more than once, sometimes in reverse.[6] This repetition was achieved through the technique of cutting a packet of different veneers together. Having affixed a design to the top layer, the cabinetmaker would take up his fretsaw and cut as many identical flowers as there were layers in the packet.[7] Variation was obtained by arranging the veneers, and thus the colors, differently and by sometimes turning the cut flower over to reverse the design.[CD] By cleverly choosing bright yellow woods like barberry for the daffodils and the crown imperial, for instance, and by enhancing the nearly white holly wood with natural dyes, Van Mekeren achieved a very rich and naturalistic palette, not unlike those of contemporary flower painters. Unfortunately, the organic stains commonly used during this period, which were made from the extracts of plants and

exotic woods, are not very durable, and not a trace is left of them. Only the green dye, based on copper salts, that was applied to the stems and leaves has retained some of its vivid color.[8] Details such as the veining of the leaves or petals were achieved with tiny saw cuts, and additional shading effects were created by scorching parts of certain pieces of veneer in hot sand.

Some of the flowers, such as the tall lily stalk, the striking crown imperial, or the variegated tulip with its twisted petals, can easily be recognized on other pieces thought to be by Van Mekeren. This particular tulip is very close to one included in an engraving by the flower painter Jean-Baptiste Monnoyer (1636–1699), in a series entitled *Livres de plusieurs paniers de fleurs,* published by Nicolas de Poilly (1626–1696) in Paris.[9] Other species in Van Mekeren's oeuvre bear resemblance to illustrations in earlier florilegia, or flower books, such as the *Hortus Floridus* by Crispijn van de Passe (1614).

The dazzling use of exotic veneers, not only for the background but also for the borders and moldings of the cabinet, more than makes up for the lack of sculptural enrichment of the case and stand. Veneer diagonally cut from logs of tulipwood, resembling the irregular pattern of a beautiful moiré silk, frames the central fields on the doors. Adhered to the top edge of the stand are pieces of veneer sawn in the same manner but from thinner branches of tulipwood, whose concentric growth rings, recurring repeatedly, create the illusion of a three-dimensional beaded border. Although there are many similarities, some differences between this cabinet and five related case pieces attributed to Van Mekeren are obvious as well.[10] The one in the Museum is noticeably smaller in size than the rest, for instance. Whereas the doors of the other cabinets display large flower arrangements in vases that are placed on the edge of a table,[11] the composition in which the sumptuous floral bunches are tied with ribbons appears to be unique to the present piece. This design is related to the decoration of one of the tables attributed to Van Mekeren at Amerongen Castle, near Utrecht, where additional loose blooms as well as birds and butterflies have been arranged around the bouquet.[12] Birds and insects present in the marquetry of most of the other extant cabinets are absent here, possibly due to the smaller size of the piece.

Floral marquetry of such high quality is rare, and only a few artists were skilled enough to practice this costly and time-consuming technique, which was fashionable in the Netherlands from the late seventeenth century through the first decade of the eighteenth century. It may have been developed during the 1650s by the Dutch-born cabinetmaker Pierre Gole (ca. 1620–1684), who was active in Paris supplying many pieces of furniture with elaborate floral marquetry decoration to the French court (see the entry for no. 14). The technique was subsequently very successfully practiced by André-Charles Boulle (1642–1732), cabinetmaker to Louis XIV of France, sometimes in combination with the marquetry of tortoiseshell and brass that was named for him (see the entries for nos. 23, 31). DK-G

1. Known as the Kistenmakerspand (Chest-makers Building), the shop was located in the Kalverstraat. See Lunsingh Scheurleer 1942, p. 39.

2. "Recent Acquisitions" 1996, pp. 32–33 (entry by Daniëlle Kisluk-Grosheide).

3. This attribution was first proposed in Lunsingh Scheurleer 1941. For related pieces, see the cabinet and table in the collection of the Rijksmuseum, Amsterdam; Baarsen 1993a, pp. 56–59, nos. 25, 26. One cabinet is at Charlecote Park, Warwickshire; Baarsen 1988b, p. 225, figs. 2, 4. Another cabinet is in the Victoria and Albert Museum, London; Wilk 1996, pp. 76–77 (entry by Sarah Medlam). Two cabinets with matching tables and candlestands (*guéridons*) are at Amerongen Castle, the Netherlands; Lunsingh Scheurleer 1964, pp. 361–64. Another, rather different, cabinet is at Belton House, Lincolnshire; Baarsen 1988b, pp. 227, figs. 6, 7.

4. Lunsingh Scheurleer 1941.

5. "Vier blomdeuren onop gemaakt; twee tafels met bloemen ingelegt meede onopgemaakt; een kasje met gezaagde bloemen." This excerpt from the inventory is quoted in ibid., p. 184. Constituting only a small percentage of Van Mekeren's stock, pieces with floral marquetry were no longer fashionable in the 1730s; Baarsen 1988b, p. 226.

6. Manuels 2001, p. 2. Marijn Manuels, Associate Conservator, Department of Objects Conservation, Metropolitan Museum, undertook the conservation treatment of the Museum's cabinet.

7. Manuels 2001, p. 2.

8. Ibid., p. 3.

9. The engraving of Monnoyer's tulip, part of a design showing a basket with flowers, is illustrated in *Katalog der Ornamentstich-Sammlung* 1894, p. 297.

10. No technical study has yet been undertaken to compare the structural aspects of all the cabinets attributed to Van Mekeren.

11. This decoration is found on the doors of the cabinets in Amsterdam, London, Amerongen Castle, and Charlecote Park (see n. 3 above) and on a door panel derived from a similar cabinet in a private collection, The Hague. The cabinet at Belton House is more stylized, with a flower vase resting on foliage scrolls.

12. See the catalogue of a sale at Christie's, Amsterdam, 10–11 May 1984, lot 798.

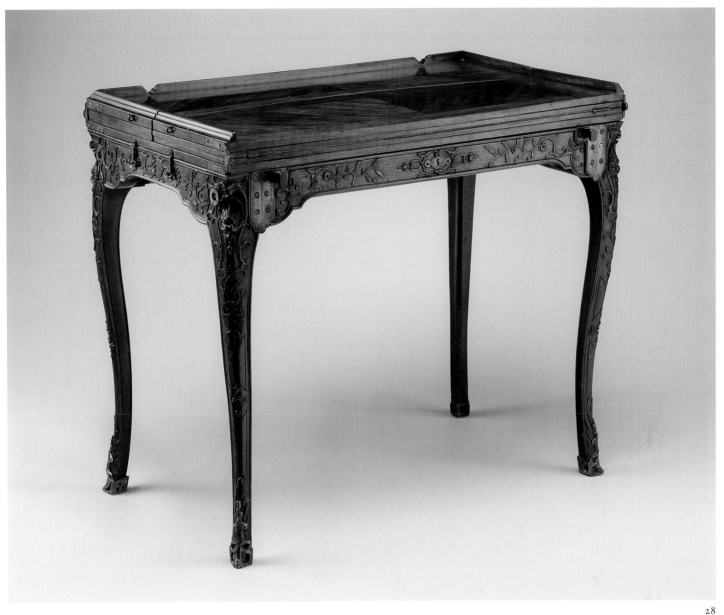

28.

Traveling table (*table de voyage* or *table de carrosse*)

French, ca. 1700–1720
Carved walnut; gilt-bronze mounts; steel hinges;
linings of felt and leather
H. 28½ in. (72.4 cm), w. 33¼ in. (84.5 cm),
d. (closed) 19¾ in. (50.2 cm), d. (extended)
58¼ in. (148 cm)
The Jack and Belle Linsky Collection, 1982
1982.60.83

The Château de Saint-Cloud, near Paris, belonged to the ducs d'Orléans until 1785. In the estate inventory of the furnishings in the rooms of Duchesse Élisabeth Charlotte (1652–1722), called Madame, sister-in-law of Louis XIV, there is mentioned a carved writing desk made of walnut on *pieds de biche* (doe's feet). The French term could be

taken literally, because zoomorphic feet for furniture was a very fashionable conceit in the seventeenth century. But the term could also refer to the slim, stylized S-curved legs of late Louis XIV and early Régence style that suggest the sweetly elegant stance of the deer. This leg shape, seen also on the Museum's table, appeared about 1700 at the latest—certainly not in the Rococo period, as has long been maintained.[1]

This refined and ingeniously constructed table[2] is a very rare example of a type of multifunctional furniture that was specifically invented for rough and space-limited journeying via coach. Before the advent of the automobile, a traveler could not count

on finding the comforts of home at a place where he found himself benighted or stranded by unforeseen events, such as a broken axle—a misfortune that occurred often on unpaved roads.

The fashionable *pieds de biche* of the Museum's table are hinged to the top and can be folded and locked underneath, making the piece easy to pack away (fig. 46).[3] When standing, it could be used for serving food and beverages, and the raised molding along three sides would prevent valuable and fragile items from sliding off the beautifully grained surface. The fine, flat-carved decoration on the apron conceals a drawer for storing utensils. The tabletop can be

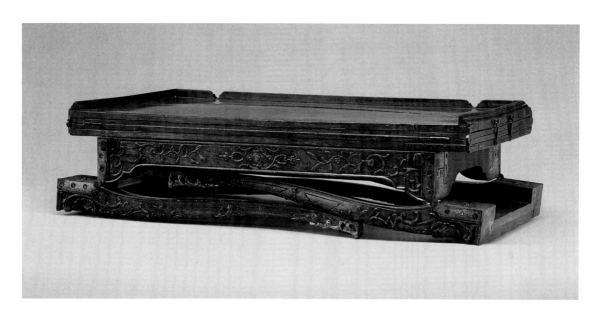

extended by unfolding several leaves on either side (fig. 47). These are supported by steel pull-out bars. There is a surface covered with leather for writing and another covered with felt for playing cards or dicing.[CD] Fully extended, the table could accommodate a company of at least six diners. The legs are decorated with a highly sophisticated design of low-relief carving incorporating floral sprays, small fruits, shell motifs, and interlaced strapwork.

The only known walnut table with similar folding mechanisms is very close to this table in its measurements. It once belonged to the princes de Condé and is now in the Musée des Arts Décoratifs in Paris.[4] W K

1. Koeppe 1996, pp. 184–85, fig. 5.

2. Baetjer et al. 1986, pp. 165–66, no. A.5 (entry by James Parker).

3. Yet another name for this type of table is *table pliante,* or folding table; Havard 1887–90, vol. 4, col. 1208.

4. Brunhammer 1964, p. 64; Kjellberg 1978–80, vol. 1, fig. 117; and Verlet 1982a, p. 132, fig. 29.

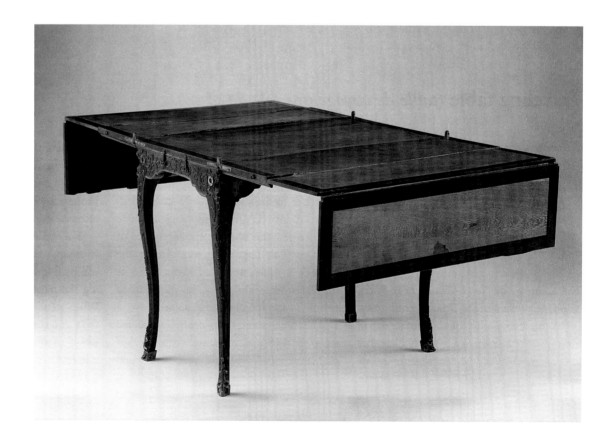

Fig. 47. General view of the traveling table extended for dining.

29.

Mirror

German (Augsburg), ca. 1710
Silver by Johann Valentin Gevers (ca. 1662–
1737), except for the medallions, possibly by
Johann Andreas Thelot (1655–1734)
Oak and pine veneered with tortoiseshell, silver,
silver gilt, and green-stained ivory; mirror glass
H. 78⅞ in. (200.3 cm), w. 39¾ in. (101 cm)
On the lambrequin decoration at the top of the
frame is the pinecone mark of Augsburg for
the years 1708–10 and the heart-shaped mark
and initials "JVG" of Johann Valentin Gevers.
Wrightsman Fund, 1989
1989.20

This sumptuous mirror beautifully evokes the wealth of silver furnishings at the Versailles of Louis XIV (1638–1715) and, to a lesser extent, at other European Baroque palaces.[1] Well documented in contemporary descriptions, the 167 pieces of silver furniture in Louis's state rooms, as counted by a Swedish architect, Nicodemus Tessin the Younger (1654–1728), were mostly made at the Manufacture Royale des Meubles de la Couronne at the Hôtel des Gobelins, in Paris.[2] Symbolizing the glory and magnificence of the Sun King, this opulent furniture astonished and dazzled all who saw it. Foreign rulers sought to emulate the example set by Louis, and long after his silver furniture had been melted down to pay for his military campaigns, similar costly pieces were still ordered for the state apartments of princely and other aristocratic residences all over Europe.

One of the most important centers for working precious metals was the German city of Augsburg, and many of the pieces of silver furniture known today originated there. Unlike the furnishings executed for Louis XIV, which were nearly all made of solid silver, the objects executed in Augsburg consisted of a wooden core covered by thin silver plates. Augsburg silversmiths also supplied silver and silver-gilt mounts for the embellishment of luxurious objects veneered with tortoiseshell and tinted ivory, such as the Museum's mirror.

The pronounced geometric projections of the mirror's colorful frame are typical of the South German Baroque. The feature seems to have been particularly fashionable in Augsburg, as is seen in the stepped stands of clock cases, altars, and cabinets that were also executed there. The elaborate silver and silver-gilt mounts, however, rendered in a strictly symmetrical manner, are French in character. The volutes, bandwork, acanthus foliage, tasseled lambrequin motifs, fruit and flower baskets, birds, masks, and drapery ornament appear to have been inspired by the designs of the influential French architect Jean Bérain (1638/39–1711). Bérain's decorative style was disseminated abroad by Huguenot craftsmen who left France in 1685 after the revocation of the Edict of Nantes. Jeremias Wolff (1663/73–1724) and other Augsburg publishers sold pirated copies of Bérain's designs during the late seventeenth century and early eighteenth century. In addition, many German silversmiths had spent several years of training abroad, often in Paris, and foreign journeymen came to work in Augsburg, stimulating the exchange of ideas and adoption of new styles.

Marks on the silver-gilt lambrequin suspended from the elaborately decorated crest and overlapping the top of the mirror's frame (fig. 48) identify it as the work of the Augsburg silversmith Johann Valentin Gevers and date it between 1708 and 1710.[3] Gevers was most likely also responsible for the seated allegorical figures of Prudence with a mirror and snake, on the right, and Temperance holding calipers and a bridle, on the left, as well as for the rest of the silver crest decoration.[CD] This work suggests that Gevers was familiar with Bérain's designs.

The four silver medallions with scenes in relief, however, were probably not executed by Gevers. They are in the style of Johann Andreas Thelot, an Augsburg silversmith known for his figural reliefs, and may have originated in his workshop.[4] It would not have been the first time that works of these silversmiths were used together. A magnificent Augsburg altar clock on table-stand in the Bayerisches Nationalmuseum, Munich, for instance, also combines mounts by Gevers with reliefs by Thelot.[5] The cartouche-shaped medallions that flank the top of the mirror glass depict a courting couple dressed according to the fashion of the French aristocracy during the 1690s (see fig. 49).[CD] The pair of medallions below may represent two of the continents. The one on the right with a crown, a scepter, and a horse as her attributes is probably Europe.[CD] The treasure chest and camels in the background of the left medallion may indicate that Asia is depicted. It is unusual to find two rather than all four continents represented in a decorative scheme. Perhaps this mirror originally had a pair that was embellished with representations of America and Africa. If so, the crest of the pair may have displayed the allegorical figures of Justice and Fortitude, which, together with Temperance and Prudence found on this piece, would have represented the four Cardinal Virtues.

Pieces of engraved glass are inserted in the superstructure and the lower part of the frame. The largest of them is in the form of a lambrequin with a silver-gilt, fringed, and tasseled border and is mounted on the mirror's cresting, underneath the baldachin-shaped top. Probably resilvered, this section is engraved with a female bust crowned with laurel leaves and surrounded by a laurel wreath and palm branches.[CD]

The wooden core of the mirror was first veneered with tortoiseshell and ivory and then set with pieces of glass according to contemporary practice. To enhance the color of the tortoiseshell, derived from sea turtles, a layer of gold leaf was applied underneath, and additional spots were painted on the inside to increase its mottled effect. Tinted green, the ivory was probably colored with verdigris using a technique described in manuals of the period.[6] Tiny nails, many of them now missing, were used to fasten the silver mounts to the frame. The plain strips of silver were not nailed but placed directly on a wooden molding from which they received their form. A mold, or perhaps a special rolling device, was used to shape and pattern the gadrooned and decorated bands of silver.[7] They were not directly attached to the wooden molding underneath; instead, a layer of resin mixed with glue was applied in between. By pressing the thin pieces of silver on this adhesive layer, the motifs were imprinted in the underlying mixture as well. Some of these silver bands were originally gilded. Much of this has been lost through repeated polishing, but traces are still visible in certain areas that are hard to clean.

Fig. 48. Detail of the silver-gilt lambrequin decoration at the top of the mirror. Various silver marks are visible.

It was the specialty of a certain type of cabinetmaker, referred to as *Silberschreiner* or *Silberkistler*, to veneer the surface of furniture with tortoiseshell, ivory, and occasionally semiprecious stones.[8] Since this type of furniture was extremely costly, it was generally only made to order through an agent, or *Silberhändler*, who served as middleman between the patron and the various artists involved. The agents submitted designs for approval to the client, selected the silversmith to whom they supplied the necessary silver, and chose the *Silberschreiner*, who mounted the different elements together on a wooden core. In addition, the agents were responsible for the packing and shipping of the finished objects and for all the financial aspects involved.

Although it bears some resemblance to a mirror now in the Severočeské Museum in Liberec, Czech Republic, nothing is known about the early history of the Metropolitan Museum's mirror.[9] During the twentieth century it was, for a considerable time, with the Parisian antiques dealership established by Jacques Seligmann (1858–1923). When the firm lent it to the "Chefs-d'oeuvre de la curiosité du monde" exposition in Paris in 1954,[10] it was described as "the single piece of goldsmith's work most commented on in the exhibition."[11] Subsequently in private hands, this splendid example of German Baroque furniture was offered for sale in 1988,[12] and the Museum acquired it the following year. DK-G

1. The text of this entry is adapted from an entry by the present author in "Recent Acquisitions" 1990, pp. 26–27; and from Kisluk-Grosheide 1991.
2. Hernmarck 1953, pp. 113–14; Buckland 1983, pp. 271–79, 283; and Buckland 1989.
3. Seling 1980, vol. 3, pp. 23, 291.
4. Praël-Himmer 1978, pp. 42–45, 70–71, nos. 38, 39, 80, figs. 37–40, 42–45, 81–83.
5. Illustrated in Seling 1980, vol. 1, p. 349, no. 1077, and vol. 2, fig. 1077.
6. *Kunst- und Werck-Schul* 1707, p. 1314.
7. Brandner et al. 1976, p. 60; and Rudolph 1999.
8. The silver turner Joh. Christoph Rembold described the practice of these craftsmen in letters he sent to the Augsburg goldsmiths' guild between 1699 and 1705: "[They] let the goldsmiths make plate with which they then veneer and cover all kinds of mirror frames, wall sconces, *guéridons*, tables, chairs, caskets, and writing cabinets, etc. They decorate such [objects] also with solid foliage, images, and many mounted stones"; ([Sie] lassen die Goldschmide bleche schlagen, Fourniren und überdeken hernach damit allerhand Spiegel Ramen, Wandleuchter, Gueridons, Tische, Sessel, Trühlen und Schreibkasten etc. Zieren auch solche mit Massivem Laubwerk, bildern und villen gefassten Steinen); quoted in Rathke-Köhl 1964, p. 60, n. 223.
9. Discussed and illustrated in Kisluk-Grosheide 1991, pp. 4, 15, figs. 17, 18.
10. *Chefs-d'oeuvre de la curiosité du monde* 1954, no. 306, pl. 145.
11. "la pièce d'orfèvrerie la plus commentée de l'exposition"; "La glace la plus extraordinaire" 1954, p. 67.
12. Allegedly, it was in the possession of J. Rossignol, whose family offered it for sale at Ader Picard Tajan, Paris, 17 March 1988, lot 87.

Fig. 49. Medallion next to the mirror glass at upper left.

30

Chandelier

84

English, ca. 1710–15
Attributed to James Moore (ca. 1670–1726)
and John Gumley (d. 1729)
Gilded gesso on wood; gilt-metal mounts
H. 46 in. (117 cm), diam. 46 in. (117 cm)
Purchase, Wrightsman Fund, and Mrs. Charles
Wrightsman Gift, by exchange, 1995
1995.141

This is one of a pair of chandeliers commissioned about 1710 by James, third Viscount Scudamore (1684–1716), for the state apartments at Holme Lacy, Herefordshire.[1] They may have been ordered to celebrate his marriage in 1710. In the richly decorated Baroque plasterwork of the saloon and dining room where they were hung, the chandeliers were a particularly harmonious addition. Holme Lacy later descended to the earls of Chesterfield; it was sold in 1910 by the tenth earl, who in 1917 moved many of the contents to Beningbrough Hall, North Yorkshire, where the chandeliers remained until 1958.[2]

30

84

With its eight acanthus-scroll branches, its lambrequined octagonal stem, and its gilt-metal mounts in the form of feather-plumed masks, the chandelier is in the French "arabesque" manner of William III's architect Daniel Marot (1661–1752), who included designs for similar chandeliers in his *Nouveau livre d'orfèvrerie,* a pattern book for goldsmiths.[3] [CD]

They are attributed on stylistic grounds to the court cabinetmakers James Moore and John Gumley, who specialized in finely carved gilt-gesso furniture.[4] A closely related pair of chandeliers was commissioned from Moore and Gumley by King George I (1660–1727) for Kensington Palace.[5] W R

1. The house is illustrated in Latham 1904–9, vol. 3, pp. 237, 247. The pair to this chandelier is in a private collection in Canada.

2. The chandeliers are shown in a photograph of about 1925 of the saloon at Beningbrough Hall in Fowler and Cornforth 1974, p. 18, fig. 2. They were sold in a house sale at Beningbrough by the dealers Curtis and Hanson, 10–13 June 1958, lots 638, 639. The present chandelier was subsequently acquired by William Redford, London. It was bought by Mallet and Son, London, in 1972 and sold the following year to Gerald Hochschild. It was sold from the Hochschild collection at Sotheby's, London, 1 December 1978, lot 15. On 22 April 1995, it was acquired by the Metropolitan Museum at Christie's, New York, lot 243.

3. Marot n.d. (before 1703), pl. 6.

4. Beard and C. Gilbert 1986, pp. 618–19 (entry by Geoffrey Beard).

5. One is now in the Victoria and Albert Museum, London; the other hangs in the mansion house of Brympton d'Evercy, Somerset, England.

31.

Commode

French, ca. 1710–20
Workshop of André-Charles Boulle (1642–1732)
Walnut veneered with ebony and marquetry of engraved brass on tortoiseshell; gilt-bronze mounts; green antique marble top, reshaped or not original to the commode
H. 34½ in. (87.6 cm), w. 50½ in. (128.3 cm), d. 24¾ in. (62.9 cm)
Painted on the underside of the carcase in eighteenth-century script: "3." Engraved on a keyhole escutcheon are various marks, including interlaced L's. Impressed with a chisel on the top of the carcase: the roman numerals IIII, XII, and XIII.
The Jack and Belle Linsky Collection, 1982
1982.60.82

In 1708, the prototypes for this commode, then called a pair of *bureaux,* were delivered to the Grand Trianon by André-Charles Boulle. The duc d'Antin, director of the king's buildings, wrote to Louis XIV: "I was at the Trianon inspecting the second writing desk by Boulle; it is as beautiful as the other and suits the room perfectly."[1] Not until the Trianon inventory of 1729 were the pieces described as "commodes." (They are often called *commodes Mazarines* because they stood during the nineteenth century and the first third of the twentieth in the Bibliothèque Mazarine in Paris.)[2] From the beginning, the design proved to be immensely popular, although it has also been criticized for an "awkward treatment of forms," meaning, in particular, the four extra spiral legs that were required to support the weight of the bronze mounts and marble top.[3] [CD] Nevertheless, the Boulle workshop made at least five other examples of this expensive model, including the Metropolitan's. Traditionally, they have been dated between 1710 and 1732, the year of Boulle's death; by 1730, however, the decorative style of the Sun King's long reign had been supplanted by the lighter forms of the Régence and early Rococo, and a date of 1710–20 is probably more accurate.

It seems strange that the duc d'Antin and probably Boulle himself should have called this new type of chest a *bureau,* yet they may have seen it in connection with the *bureau plat,* a flat-topped desk with a large writing surface that was currently being developed. A very fine example of the celebrated Boulle *bureau plat* is the one made for Louis-Henri de Bourbon (1692–1740), prince de Condé, for the Château de Chantilly.[4]

The design of the commode reflects the view of the late Louis Quatorze period that court art should be characterized by opulence and swagger. John Morley has pointed out that "the extraordinary way in which its body is, as it were, slung between the eccentric legs is somewhat reminiscent of carriage construction."[5] Indeed, if the tapering spiral supports behind the paw feet could be removed, the resemblance would be even more striking. Like one of the splendid carriages that rolled down the road to Versailles—a moving "billboard" for the glorification of its owner[6]—this commode was intended to impress.

A look at some details reveals the unsurpassed skill and artistic imagination of the Boulle workshop. The three-dimensional acanthus-leaf scroll mount on the upper drawer was a signature ornament of Boulle's, one that he employed on many pieces.[7] [CD] Its design is echoed in the light-catching two-dimensional brass-and-tortoiseshell marquetry on both drawer fronts. This refinement extends the movement along the surface of the piece and heightens the bulging appearance of the body, as if some power within was pressing the surface outward. This effect of surface tension is one of the reasons why Boulle's pieces dominate the space around them, becoming the focal point of any interior. Extraordinary are the female figures with paw-and-acanthus feet that support the sarcophagus-shaped body (figs. 51, 52).[8]

Fig. 50. Detail of the underside of the commode. The number 3 painted on the carcase is possibly a room number; or, though less likely, it may mark the piece as third in a set of four.

The sensitive finishing of the bronze surface of these sculptures is especially noticeable in the matted, feathery look of the wings, which is achieved by chiseling, and in the sheen of the burnished areas.

André-Charles Boulle, who was named King's Cabinetmaker, Chaser, Gilder, and Engraver in 1672,[9] headed an important workshop at the Louvre. He did not invent the metal-and-tortoiseshell marquetry technique named for him (see the entry for no. 18), but he perfected it, and it bestows upon his creations a unique look, raising them to a level of artistry where furniture becomes sculpture. Through his etchings Boulle publicized his exquisitely fashionable line of products, both stimulating and reflecting a new taste for luxurious furnishings.[10] Every collector of grand French furniture has acquired a "Boulle," either an original workshop example or one of the countless copies that were made during the late-eighteenth, nineteenth, and twentieth centuries.[11] WK

1. "J'ai été à Trianon pour voir le second bureau de Boulle; il est aussi beau que l'autre et sied à merveille à cette chambre"; quoted in Metropolitan Museum of Art 1984, p. 206, no. 126 (entry by William Rieder).

2. They were installed at the Château de Versailles in 1932.

3. James Parker in Raggio et al. 1989, pp. 20–21. See also *Louis XIV* 1960, p. 19, nos. 84, 85, pl. XXXV; Samoyault 1979, pp. 68, 84–85; and Meyer 2002, pp. 54–57, no. 9.

4. Arizzoli-Clémentel 2002, pp. 42–45, no. 6.

5. Morley 1999, p. 154, fig. 275.

6. Wackernagel 1966.

7. Hughes 1996, vol. 2, p. 644, no. 138. I am most grateful to Yannick Chastang, London, for bringing this detail to my attention when we examined the commode, in the company of Mechthild Baumeister, Conservator, Department of Objects Conservation, Metropolitan Museum, in March 2004.

8. The screws with which they are attached to the body are unusually large. They can be seen as a particular workshop feature, as they repeatedly recur on pieces by Boulle. For a similar sarcophagus-shaped commode, see Hughes 1996, vol. 2, pp. 632–38, no. 136.

9. "ébéniste, ciseleur, doreur et sculpteur du roi"; Pradère 1989, p. 67.

10. Ibid., pp. 66–108.

11. For copies, see Paolini, Ponte, and Selvafolta 1990, pp. 382, 393; and Dell 1992a, pp. 233–46.

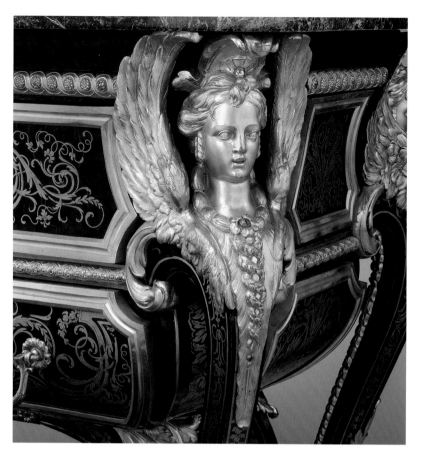

Fig. 51. Detail of the mount on the right front corner of the commode. Like the other winged-sphinx mounts, it is attached with exceptionally heavy screws.

Fig. 52. Detail of the right rear corner of the commode from which the winged-sphinx mount has been removed, revealing the roman numeral IIII punched on the carcase.

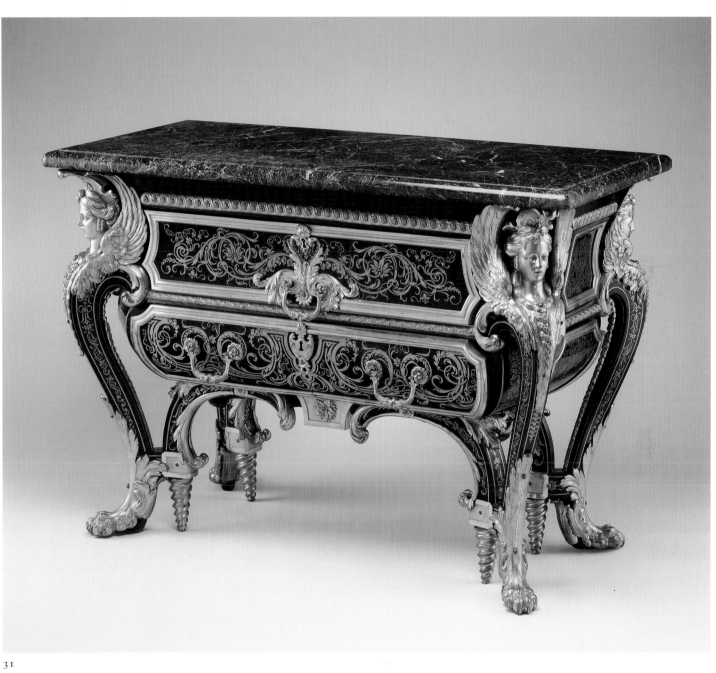

31

32.

Side chair

English, ca. 1715
Attributed to Richard Roberts (active 1714–29)
Beech and oak veneered with burl walnut, parcel-gilt; covered in silk velvet
H. 41¾ in. (106 cm), w. 25 in. (63.5 cm),
d. 29 in. (73.7 cm)
Harris Brisbane Dick Fund, 1960
60.134.2

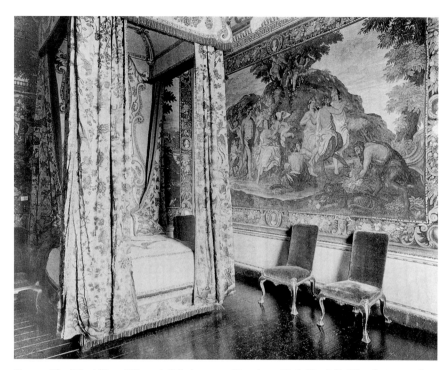

Fig. 53. The "Cov'd" or "Wrought" Bedroom at Houghton Hall, Norfolk. The chairs standing against the wall belong to the same set as the present side chair.

Purchased from a set of six offered at Sotheby's, London, in 1960, this side chair and a matching example that is also in the Museum are thought to be part of a large suite—side chairs, two settees, and one winged easy chair—commissioned by Sir Robert Walpole, later first earl of Orford (1676–1745), for the Restoration house in Norfolk that he inherited in 1700.[1] Walpole began to remodel the house in 1716 but soon after, in 1720, decided instead to demolish it and build a new mansion, Houghton Hall, one of the great Palladian houses of England. Where the set was placed and how it was upholstered in the original house are not known, but for the new house, Walpole re-covered the set in green silk velvet, the splendid material that most of the pieces in this set retain.

A great deal of this material was used at Houghton: as wall hangings in the Green Velvet Drawing Room, on the famous bed designed by William Kent (1685–1748) in the state bedchamber, and in the adjoining dressing room. The 522 yards of material needed for these three rooms and for the two suites of furniture they contained were probably made in two weavings, which would explain the color variation between the celadon and olive green of the state bed and the blue green of these chairs and those in the other suite from these rooms.[2]

The six chairs sold in 1960 are now dispersed among four museums: the present pair; a pair in the National Gallery of Victoria, Melbourne, Australia; a single chair in the Victoria and Albert Museum, London; and a single chair at Temple Newsam House, near Leeds.[3] In their frames and upholstery, these six chairs are identical to the chairs from the large set at Houghton, but there is one difference: the six have a close-nailed border above the seat rail, whereas the Houghton chairs have a silver galloon trimming. There is also no record of when the six chairs left Houghton.

Exactly how many side chairs were originally in the large set is not entirely clear. Today eighteen side chairs remain at Houghton from a set of twenty-two, four of which were sold as two pairs in the Houghton sale at Christie's, London, in 1994.[4] If those twenty-two chairs are grouped with this set of six, the original set must have contained twenty-eight side chairs in addition to the two settees and a single easy chair. On the other hand, it may have started as a smaller set and been expanded when the group was reupholstered for the new house. Inventories at Houghton record that the set was originally placed in the "Cabinett" and in the "Cov'd" or "Wrought" Bedchamber (see fig. 53).

The attribution to Richard Roberts is based on an account of a considerable debt owed by Walpole in 1729 to a "Thomas Roberts." Thomas Roberts, carver and joiner to the royal household, worked in Marylebone Street, London, under the sign of The Royal Chair, until his death in 1714. He was succeeded by Richard Roberts, presumably his son, who was active at just the time when Walpole redecorated the first house. Richard's death date is unknown, but his name disappears from the household accounts at Houghton in 1729, when the business appears to have been assumed by a second Thomas, a brother or son of Richard. The debt may have been to this second Thomas or a holdover of an outstanding debt to Richard.[5] Another set of chairs of this model but with needlework covers was formerly at Chicheley Hall in Buckinghamshire and is now on loan to Montacute House in Somerset.[6] WR

1. Sotheby's, London, 29 January 1960, lot 117. The accession number of the Museum's second chair is 60.134.1.
2. The latter is the so-called Satyr-Mask Suite, from which two pairs of side chairs were sold at Christie's, London, 8 December 1994, lots 131, 132.
3. C. Gilbert 1978a, vol. 1, p. 57, no. 57 (16/60). The chair at the Victoria and Albert is W.15-1960.
4. Christie's, London, 8 December 1994, lots 126, 127.
5. Beard and C. Gilbert 1986, pp. 752–54 (entry by Gervase Jackson-Stops).
6. I am grateful to the late John Cornforth for this information. The set at Chicheley consisted of a settee and ten chairs upholstered in gros point and petit point. See Oswald 1936, pp. 535, 539, fig. 2.

33.

Bookcase on stand

Italian (Rome), ca. 1715
Walnut and poplar; iron hinges and locks, metal
wire; antique silk and linen brocatelle door cur-
tains not original to the bookcase
H. 13 ft. 3 in. (403.9 cm), w. 7 ft. 10 in.
(238.8 cm), d. 2 ft. (61 cm)
Gift of Madame Lilliana Teruzzi, 1969
69.292.1

During the seventeenth and eighteenth centuries Rome was the capital of the Papal States. All the important administrative departments of the Roman Catholic Church were located within its walls. Of these, the Sacred College of Cardinals was the most significant. Only its members could vote in conclave for the next Vicar of Christ, a new pope. To become a part of this powerful body was the ultimate goal of everyone pursuing a career within the hierarchy of the church. The Sacred College and the papal household, the *familia pontificia*, were dominated by a relatively small group of aristocratic and cardinalitial families. Nonetheless, there was also a steady stream of foreign nobility into Rome eager to gain positions or influence. Many of them lingered for the pleasure of observing the many public spectacles that were part of the display of ecclesiastical power. Spectacle was an integral component of daily life in the Eternal City, and the line between a staged performance and everyday routine was imprecisely defined.

In this milieu, keeping up appearances was of the utmost importance. The design of furniture naturally reflected this. In addition to large console tables with pier mirrors, ostentatiously decorated display cabinets and bookcases were obligatory features of the public rooms of Roman palaces (see also no. 15).[1] At the Palazzo Chigi, the library was designed by the painter, sculptor, and architect Gianlorenzo Bernini (1598–1680), and its shelves were built by the famous cabinetmaker Antonio Chiccheri, a specialist in wood-coffered ceilings.[2] Often pieces were ordered in twos or even fours to achieve a perfect symmetry in the stagelike setting of a room.[3] The colossal dimensions of the Museum's pair of bookcases—only one of which is illustrated here—made them a suitable backdrop for the grandest occasions at the Palazzo Rospigliosi, the residence on Rome's Quirinal Hill of a distinguished family with close ties to the Vatican.[4] The bookcases' heavy facades exude a strength and enduring vitality in a way that is unusual for furniture but is often found in the Roman architecture of Francesco Borromini (1599–1667) and his followers. They are an embodiment of the dramatic and vigorous design of the late Baroque and exquisite examples of sculptural furniture carving.[5]

The stands of the cases look much like contemporary console tables.[6] An artistic detail of great refinement is the use of grotesque masks on the aprons and legs.[CD] The humorous faces relieve the composition's heaviness, as do the carved draperies and the noble lambrequin motifs, symbolic of worldly and ecclesiastical power. This fringelike ornament, sometimes with a tassel, originated in medieval times as the scarf worn across a knight's helmet. The most prominent example of its use in later times is on the baldachin by Bernini, erected in 1624–33, in Saint Peter's Basilica. That colossal bronze structure was inspired by the canopy used at every papal coronation from the fifteenth century to 1963, when Paul VI ascended the throne of Saint Peter.[7] Here the lambrequin alludes to the elevated status of the Rospigliosi as a papal family and suggests that the lockable cases, which resemble the cabinets for church reliquaries,[8] contain books and manuscripts that are to be cherished and guarded as "relics of knowledge." The heavy broken-volute pediments surmounted by a grand cartouche that once displayed the heraldry of the family are in notable contrast to the stands.[9] The oval frames are shaped like late Baroque marble portrait or heraldic medallions of the type found on Roman tombs or other commemorative structures.[10] The ornamental language has prompted a cautious attribution of the design of the bookcases to Nicola Michetti (1675–1758), who worked as architect for Prince Giovanni Battista Rospigliosi from 1710 onward.[11]

The Rospigliosi bookcases were bought by Lilliana Teruzzi at the sale of Prince Gerolamo Rospigliosi in 1932.[12] She recognized the grandeur of the objects and committed herself to the purchase, despite the fact that her Roman residence was not large enough to accommodate them; when she left Italy in 1939, she sent them to a warehouse in London. They came to the Museum in 1969, eighteen years before Madame Teruzzi's death, largely thanks to the efforts of Museum curator James Parker, who admired her fine collection of Italian Baroque and Rococo furniture and persuaded her that the Metropolitan, which had relatively little in that area, would warmly appreciate her princely gift.[13] W K

I am grateful to the late Princess Elvina Pallavicini and Michelangelo Lupo for their comments and help with this entry.

1. See "Recent Acquisitions" 1999, p. 34 (entry by Wolfram Koeppe). (The table discussed in that entry was acquired with funds from The Isak and Rose Weinman Foundation, which was established by Madame Lilliana Teruzzi, the donor of the present bookcases, in memory of her parents.)

2. Waddy 1990, p. 56.

3. J. Friedman and Caracciolo 1993, pp. 14–15 (with an illustration of pairs of matching tables in the Galleria Colonna, Rome); see also Walker and Hammond 1999.

4. The accession number of the pair to the bookcase illustrated here is 69.292.2.

5. Honour 1965a, p. 154, fig. 572 (a Roman showcase); see also "Recent Acquisitions" 1999, p. 34 (entry by Wolfram Koeppe).

6. "Recent Acquisitions" 1999, p. 34 (entry by Wolfram Koeppe).

7. Fernández 1999, p. 152; and Rogasch 2004, p. 176. For the lambrequin motif, see Fagiolo dell'Arco 1983, p. 139 (lower ill.); Kreisel and Himmelheber 1983, fig. 391; Koeppe 1991a, p. 70 and n. 20, figs. 1, 7, 13; and *Der Glanz der Farnese* 1995, p. 32, fig. 12.

8. Koeppe and Lupo 1991; and Spiazzi 1995.

9. The panels presently in the cartouches (but hardly visible in the photographs in this book) are modern reproductions after historical photographs of the almost illegible painted inserts.

10. J. Paul Getty Museum 1998, p. 81, no. 27 (entry by Marietta Cambareri and Peter Fusco).

11. Metropolitan Museum of Art 1975, p. 256 (entry by Penelope Hunter-Stiebel); *Patterns of Collecting* 1975, p. 40; and Parker 1983, pp. 229–37, figs. 2–8.

12. Sale, Palazzo Rospigliosi, Rome, 12–24 December 1932.

13. Draper 1994, p. 21.

34.

Card table

English, ca. 1720
Oak; carved and gilded gesso; lined with modern
felt; iron fittings
H. 29⅝ in. (75.3 cm), w. 33¾ in. (85.7 cm),
d. 14¾ in. (37.5 cm)
Stamped on the inside of the back frieze:
"58907X."
Gift of Irwin Untermyer, 1963
63.148

In his preface to *The Court-Gamester* (1720), Richard Seymour stated, "Gaming is become so much the Fashion among the *Beau-Monde*, that he who in Company should appear ignorant of the Games in Vogue, would be reckoned low-bred, and hardly fit for Conversation."[1] Gamesters, or instruction manuals that set forth the rules of various games, were regularly published from 1674 onward, and tutors or gaming masters were employed to educate young ladies in the fine accomplishment of card playing.[2] During the reign of Queen Anne (1702–14) the British government, hoping to profit from the passion for gaming that kept the country in its thrall, went so far as to impose duties on packs of playing cards.[3] Given the social importance of card games, it is not surprising that during the late seventeenth century special tables used for this pursuit were introduced.

Resting on four slender legs that are decorated with a carved lambrequin motif at the knee and terminate in club feet below, this card table has a rectangular folding top with rounded, protruding forecorners. The supporting frame is hinged in six places and can be transformed from a rectangle into a square when the rear legs are pulled backward (fig. 54). The top can then be folded back to rest on the expanded frame. Iron hooks placed on the inside of the table prevent it from folding inward once the table is in use. This system, called concertina construction because of its resemblance to the musical instrument of that name,[4] was an improvement over an earlier device, whereby one back leg would swing out at an angle of ninety degrees, supporting the extended top but leaving the table slightly unstable.[5]

The Museum's card table is entirely gilded on the outside and displays fine carved gesso ornament on the closed top, the frieze, and parts of the legs. Against a punched ground, the top is symmetrically decorated with a central strapwork cartouche enclosing a large quatrefoil of acanthus leaves. Scrolling oak branches with acorns and tendrils surround this cartouche.[CD] The back corners are embellished with a shell motif and those in front with an acanthus spray within a shield-shaped cartouche. A large shell flanked by palm fronds decorates the frieze in front. The top is lined on the inside with modern green felt and has four oval depressions, one on each side. Placed off-center because of the hinges, these wells were intended to hold the counters of ivory, tortoiseshell, metal, or bone that were used by wealthy players instead of coins.[6] On the circular dished projections at the four corners, which are decorated with a carved gesso rosette of acanthus leaves, candlesticks would be placed to provide the players with light during their game.

Gilded gesso decoration originated in France. The technique was practiced in England from the late seventeenth century and became most popular about 1730 (an example of that date in this catalogue is no. 37). Layers of gesso, a mixture of gypsum or chalk and animal glue, were applied to the wooden carcase of a piece of furniture. Once these layers had dried, the gesso was cut to create raised ornament in the reserved areas. The surrounding ground was often punched with a small tool, producing a random pattern of tiny circles, as on this table. The entire surface was subsequently water-gilded, which allowed the possibility of burnishing the object. A tool set either with a dog's tooth or a fragment of hematite or agate was used for this purpose.[7] Only certain decorative details were polished, in order to make a contrast with the rest of the piece. This technique is clearly visible on the frieze of the table in front, where burnished elements of the shell

Fig. 54. General view of the card table partly extended.

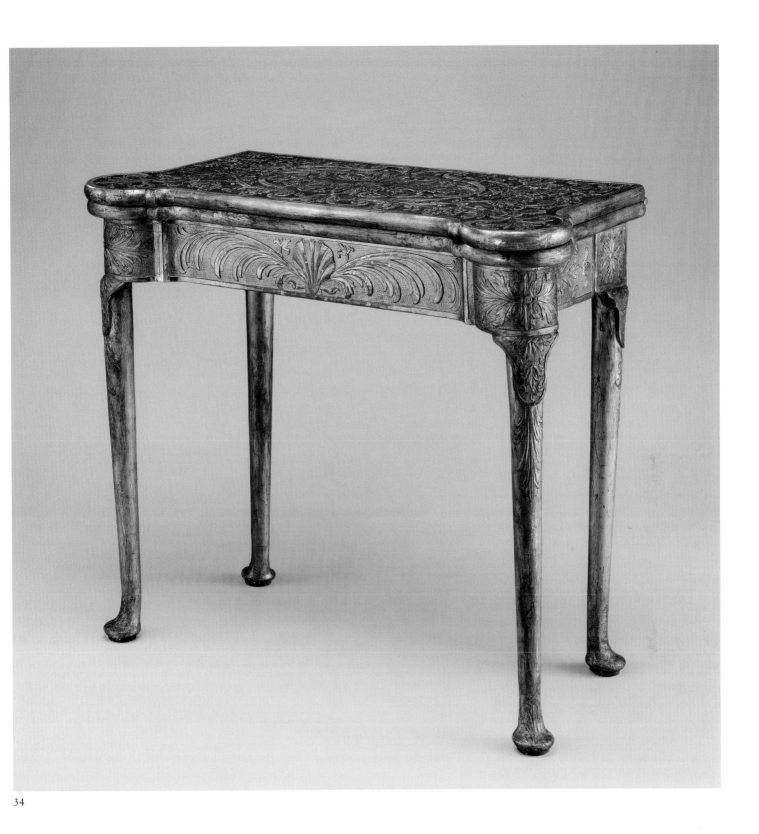

34

and the palm leaves alternate with those that are matt. By gilding the different patterned and textured surfaces, wonderful light reflections were produced, not unlike those struck off solid metal. The embossed silver furniture that was fashionable at European courts during the Baroque period may have stimulated the taste for such gilded pieces (see the entry for no. 29).

Some English cabinetmakers specialized in gilt-gesso furniture—James Moore (ca. 1670–1726), for instance, who incised his name on certain pieces—but it is not known who executed this table.[8] It was among the few gilded pieces acquired by the well-known collector of English furniture Judge Irwin Untermyer, who generally preferred objects of plain oak, walnut, and mahogany. The table is said to have come from the collection of the earls of Carnarvon at Highclere Castle, Newbury, Berkshire.

DK-G

1. Seymour 1720, p. v.
2. Hargrave 1930, pp. 205–6.
3. Ibid., p. 182.
4. The concertina is similar to but smaller than an accordion.
5. Macquoid and Edwards 1983, vol. 3, p. 194.
6. Joy 1982, p. 28.
7. Macquoid and Edwards 1983, vol. 2, p. 242.
8. Beard and C. Gilbert 1986, pp. 618–19 (entry by Geoffrey Beard).

35.

Side chair

English, 1724–36
Attributed to Thomas How (active 1710–33)
Walnut and walnut veneer, parcel-gilt, the seat
rails of beech; gilded lead mounts on the knees
and front rail; verre églomisé panel mounted on
the splat; covered in contemporary needlework
not original to the chair
H. 41 in. (104 cm), w. 23 in. (58.5 cm), d. 22 in.
(56 cm)
Numbered on the top of the front seat rail: "X."
Gift of Irwin Untermyer, 1964
64.101.936

Sutton Scarsdale in Derbyshire was remodeled and refurbished by Nicholas, fourth and last earl of Scarsdale (d. 1736), beginning in 1724. Probably shortly after that date he commissioned a set of furniture—comprising twelve chairs, two settees, and a pair of pedestals—from which this chair comes. He had his arms, painted in *verre églomisé* (reverse-painted glass), mounted on the splats of the chairs and settees and on the pedestals.[CD] On his death the Scarsdale peerage became extinct; thus, the arms provide a narrow and very specific date range for this set of furniture.

This use of a coat of arms on *verre églomisé* is very rare (if not unique) in English furniture of this period, as is the incorporation of pedestals, intended to support either candelabra or busts, en suite with a set of seat furniture. These features, as well as the very high quality of the design and construction, make this one of the most important sets made during the period.

The attribution to the cabinetmaker Thomas How is based on a lead plate found in the courtyard of Sutton Scarsdale that listed the architect and the fifteen principal tradesmen involved in the remodeling and furnishing of the house.[1] Among the names was that of "Thomas How of Westminster, Gentleman, Upholsterer." Although little known today, How was one of the leading furniture makers of the time, with premises in the Westminster area of London. He worked extensively for the fifth earl of Salisbury at Hatfield House in Hertfordshire.[2]

The twentieth century was kind neither to Sutton Scarsdale nor to this set of furniture. The house was abandoned about 1920 and still stands, though only just, as a vine-covered, roofless ruin. While the set was in France during the first decade of the century, several chairs were lent to the Exposition Universelle et Internationale in Brussels in 1910, where they were destroyed in a fire in the British section of the exposition.[3] The remainder of the set passed to Annie C. Kane, in whose New York house another conflagration, in 1921, destroyed more chairs, a pedestal, and a settee.[4]

The known survivors of the set are this chair, a matching example, and a pedestal (fig. 55) in the Metropolitan Museum;[5] two chairs now in the Frick Collection supplied to Henry Clay Frick (1849–1919) by Sir Charles Allom about 1915–16;[6] two chairs at Temple Newsam House, near Leeds;[7] and one chair at the Cooper-Hewitt, National Design Museum, Smithsonian Institution, New York.[8]

The chairs have been copied at various dates. Sir Charles Allom had two reproductions made for Frick to complement the pair of original chairs he had already sold to him. Allom was one of the leading English decorators of the time and was responsible for much of the interior decoration on the main floor of the Frick house. More recent copies exist in a private American collection. In the 1920s, side tables and sideboards were made to match the seat furniture. W R

1. Jourdain 1919, p. 171.

2. Beard and C. Gilbert 1986, p. 453 (entry by Christopher Gilbert).

3. Boyce 1910, p. 142.

4. Metropolitan Museum of Art 1977, p. 74, no. 128 (entry by William Rieder); and Rieder 1978a, pp. 182–83.

5. The chairs were acquired from Mrs. Kane's collection by the dealer Frank Partridge, who sold them in 1944 to Irwin Untermyer. The latter gave them to the Museum in 1964. The second chair (acc. no. 64.101.937) is numbered "I" on top of the front seat rail.

6. The numbers on the seat rails are "VIIII" and "XII." See Rieder 1978a, p. 184, n. 6.

7. C. Gilbert 1998, pp. 581–82, no. 696. These chairs are numbered "VII" and "XI."

8. It was bequeathed to Cooper-Hewitt by Annie C. Kane in 1926 (1926.22.58). This example is numbered "VI." See Hinckley 1971, p. 63, fig. 64.

Fig. 55. Pedestal attributed to Thomas How, 1724–36. Walnut, *verre églomisé* panel attached with gilded-lead mounts; h. 46⅞ in. The Metropolitan Museum of Art, New York, Bequest of Annie C. Kane, 1926 (26.260.98).

36.

Secretary

Italian (Venice), ca. 1730–35
Pine; carved, painted, gilded, and varnished linden
wood decorated with colored decoupage prints;
mirror glass; the inside of the fall front lined with
silk not original to the secretary
H. 8 ft. 6 in. (259.1 cm), w. 3 ft. 8 in. (111.8 cm),
d. 1 ft. 11 in. (58.4 cm)
Fletcher Fund, 1925
25.134.1a,b

Influenced by the English bureau bookcase, this type of writing cabinet was introduced in Italy during the first half of the eighteenth century.[1] The Museum's example consists of three parts. The upper section is fitted with two arched and mirrored doors that would have beautifully reflected the light of candles placed on the two small pull-out shelves just below. Behind the doors are thirteen drawers surrounding a central niche (fig. 56), as well as various hidden compartments and drawers rediscovered during recent conservation treatment.[2] The middle section has a sloping fall front that encloses six tiny drawers as well as a sliding panel that conceals a shallow well with two additional drawers. Three large drawers below form the third section. Resting on four carved feet, the secretary is crowned by a scrolling pediment and three urn-shaped finials on the top. The construction is very basic; all the attention has been lavished on the surface decoration, which is executed in a decoupage technique known in Italian as *lacca povera* or *lacca contrafatta*.

Practiced by professionals and amateurs alike, the art of decoupage consists of coloring and cutting out copperplate engravings, pasting them on a specially prepared surface, and varnishing them afterward. Conceived as a cheaper substitute for Asian lacquer, decoupage became especially fashionable in Europe during the 1720s and was continuously practiced throughout the eighteenth century.[3] In 1727, for instance, Mademoiselle Charlotte Aïssé (1693–1733) wrote from Paris to her friend and confidante Madame Calandrini in Geneva: "We are here at the height of a new passion for cutting up colored engravings. . . . Everyone, great and small, is snipping away. These cuttings are pasted on sheets of cardboard and then varnished. They are made into wall panels, screens, and fireboards. There are books of engravings costing up to 200 livres; women are mad enough to cut up engravings worth 100 livres apiece. If this fashion continues, they will cut up Raphaels."[4]

Attesting to its popular success, special manuals containing step-by-step descriptions of the technique and useful formulas for varnishes were published in various languages.[5] Although some of these treatises advised applying the ground color on a preparatory layer of gesso, this was not done in the case of the Museum's secretary.[6] Now appearing green because the varnish on top has yellowed, the originally light blue paint, composed of animal glue and Prussian blue and lead-white pigments, was

Fig. 56. General view of the secretary with the doors opened and the fall front lowered.

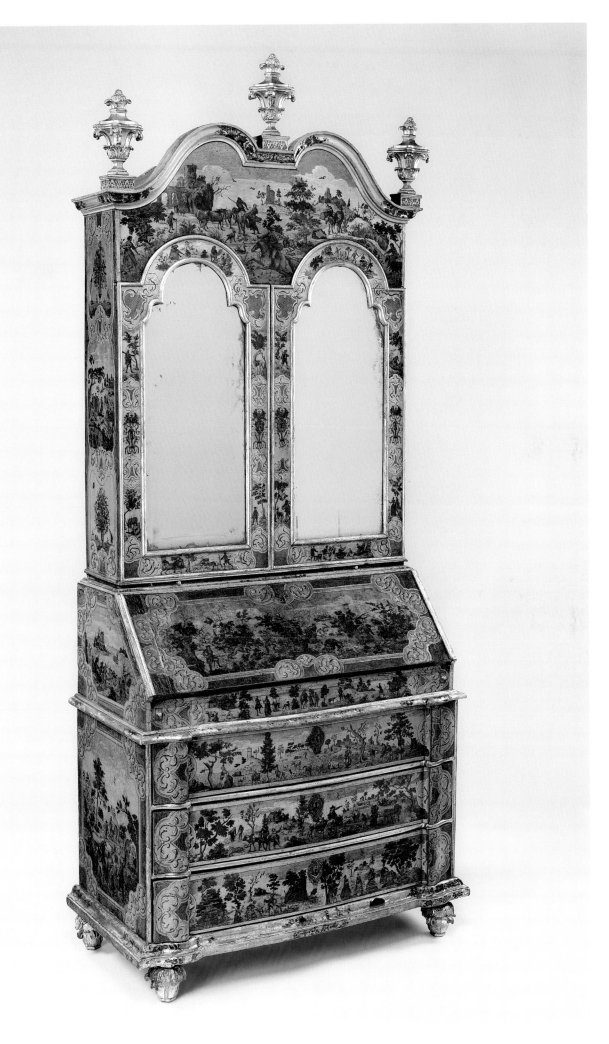

Fig. 57. Design in *Oeuvres des étampes gravées d'après les tableaux et desseins de feu Antoine Watteau*, a set of six engravings by Louis Crépy *fils*, ca. 1727. The Metropolitan Museum of Art, Gift of Mr. and Mrs. Herbert N. Straus, 1928 (28.113 [3]).

Fig. 58. *Lacca povera* decoration inside the right door of the secretary.

painted directly on the wood.[7] Linden was used here, and not only did its fine, close grain provide a smooth surface but its softness made it easy to carve, as is suggested by the gilded finials and feet of the secretary. Colored and cutout figures, ornaments, and scenes were next carefully arranged and pasted on the drawer fronts, doors, and sides of the secretary with adhesive. Contemporary sources suggested using either gum water—a secretion of plants or trees dissolved in water—or fish glue, made of isinglass dissolved in a mixture of brandy and water.[8]

Special prints for this kind of decoration, often with a variety of motifs in different sizes, were published in various countries—in Augsburg by Martin Engelbrecht (1684–1756), in Bassano by the firm of Giovanni Antonio Remondini (1643–1711) and his successors, and in London by Robert Sayer (1725–1793/94).[9] Ornament prints by French artists were also available for decoupage purposes. The *Mercure de France*, for instance, included an advertisement in November 1727

for six engravings by Louis Crépy *fils* (fig. 57); published by Edme-François Gersaint (ca. 1696–1750) in Paris, they were based on a screen painted by Antoine Watteau (1684–1721). The advertisement suggested, "[These gallant] scenes on a white ground would make excellent designs for decoupage, the technique used by ladies nowadays to make such pretty pieces of furniture."[10]

Examination of the secretary's paper decorations confirms that these prints by Crépy (b. ca. 1680) were indeed used in this manner, since the large figures pasted on the inside of both doors were cut from a reverse copy of the set (fig. 58). Most of the identified images however, did not come from prints specially made for decoupage but derive from a wide variety of French and German sources. Executed by a diverse group of seventeenth- and eighteenth-century engravers, some of the Arcadian landscapes with peasants and travelers are after paintings by the Dutch artist Nicolaes Berchem (1620–1683). Figures taken from at least

seven such engraved compositions after Berchem are found on the lower sides, crest, and top drawer of the secretary.[CD] Some of the hunting scenes on the sloping fall front originate in engravings by Johann Elias Ridinger (1698–1767), who specialized in the depiction of such outdoor activities as horseback riding and hunting. Allegorical figures, derived from a series of French prints, were pasted on either side of the interior doorframes and in the central niche.[CD] Symbolizing seven months of the year, they represent various gods and goddesses with their symbols and signs of the zodiac, each in a fanciful architectural frame. Reversed copies of engravings after the tapestry designs *Les Douze Mois Grotesques* by Claude Audran (1658–1734) were cut up to provide these personifications.[11] Chinoiserie scenes of Asians in horse-drawn carriages, sleighs, sedan chairs, and boats, taken from unknown print sources, are found on the small drawers and inside the secretary's fall front.[CD] Some of these images—for instance, the artificial rock formations found in Chinese gardens and the natural bridge—were clearly inspired by illustrations from the pages of such travel books on East Asia as Joan Nieuhof's *Het gezantschap der Neêrlandtsche Oost-Indische Compagnie*, first published in 1665, or Pieter van der Aa's *La galerie agréable du monde* of 1729.

Once the decoupage decorations were in place, certain details in the landscape setting as well as lines framing the scenes were added with paint and gold leaf, and the various moldings were gilded. Finally the secretary received several coats of varnish composed of mastic, copal, and sandarac. This not only created a smooth, lustrous surface not unlike the lacquer it tried to imitate but also helped to protect the paper cuttings and keep them in place.

Despite the hotchpotch of decoration, a certain harmony of design has been achieved by the skillful arrangement of the images over both the interior and the exterior of the secretary and by the consistent application of a green, red, and orange palette when coloring them. This harmony and also the large size of the piece of furniture and the remarkable dexterity shown in cutting out very delicate motifs make it clear that a professional artist rather than a skilled amateur must have been responsible. The existence of a nearly identical writing cabinet, decorated with some of the same

prints, further underscores this point because, very likely, the two pieces came from the same workshop.[12]

The Museum acquired the secretary in Venice, and its overall shape and embellishment also suggest an origin in this city, where painted, lacquered, and *lacca povera* furniture was very much in vogue during the eighteenth century. As a rare surviving example, it is a splendid testament to the once popular art of decoupage. D K - G

1. Much of the information in this entry is derived from Kisluk-Grosheide 1996.
2. This treatment was done in 2003–4 in the Museum's Sherman Fairchild Center for Objects Conservation by Gaby Petrak, Sherman Fairchild Conservation Fellow, 2003–2004, under the guidance of Mechthild Baumeister.
3. Metken 1978, pp. 101–7.
4. "On est ici dans la fureur de la mode pour découper des estampes eluminées, tout comme vous avez vu que l'on a été pour le bilboquet. Tous découpent, depuis le plus grand jusqu'au plus petit. On applique ces découpures sur des cartons, et puis on met un vernis là-dessus. On fait des tapisseries, des paravents, des écrans. Il y a des livres d'estampes qui coûtent jusqu'à deux cents livres, et des femmes qui ont la folie de découper des estampes de cent livres pièce. Si cela continue, ils découperont des Raphaël." Quoted from *Lettres de Mademoiselle Aïssé* 1943, p. 97.
5. See *Anhang von der Laquier-Kunst*, published as a supplement to Teuber 1740. Jean-Félix Watin's influential *L'art de faire et d'employer le vernis; ou, L'art du vernisseur*, first published in Paris in 1772 and many times republished, also contained recipes for decoupage varnishes.
6. Weil and Urban 1994, p. 95.
7. The technical analysis was done by Richard Newman and Michele Derrick at the Scientific Research Laboratory, Museum of Fine Arts, Boston.
8. Isinglass was recommended by J. M. Cröker in his manual *Der wohlanführende Mahler* (Cröker 1743, p. 187, quoted in Weil and Urban 1994, pp. 96, 99, n. 7) and by Johann Martin Teuber in *Mechanici auch Kunst und Silber Drechslers in Regensburg* (Teuber 1740, p. 203). Jean-Félix Watin, in his *L'art du peintre, doreur, vernisseur* (Watin 1778, p. 278), advised using gum water, as did Robert Sayer in *The Ladies Amusement; or, Whole Art of Japanning Made Easy* (Sayer 1762 [1966 ed.], p. 5). The glue used on the Museum's cabinet has not been positively identified.
9. The title of Sayer 1762 (see n. 8 above) suggests that the subject is japanning; instead, the book offers patterns and instructions for the art of decoupage.
10. "Le sieur Crépy, le fils, grave actuellement 6 morceaux en hauteur, d'après un paravant peint par Watau, dont les compositions sont très galantes. De pareils sujets, peints sur des fonds blancs, conviennent à merveille aux *découpures*, dont les dames font aujourd'hui de si jolis meubles"; *Mercure de France*, November 1727, p. 2492, quoted in Havard 1887–90, vol. 2, cols. 60–61.
11. Tapestries based on Claude's designs were woven at the Gobelins Manufactory in 1709–10 for the Grand Dauphin (1661–1711), son of Louis XIV; Fenaille 1903–23, vol. 3 (1904), pp. 73–80. The designs were first engraved by Claude's younger brother Jean Audran (1667–1756) and published in 1726. Reversed copies of this series were made by Tobias Lobeck and published in Augsburg by Johann Daniel Herz (1693–1754) at an unknown date.
12. The near twin of the Museum's secretary is illustrated in Morazzoni 1954–57, vol. 1, pl. XXXI.

37.

Settee

English, ca. 1730–35
Gilded gesso on walnut; covered in eighteenth-century silk damask not original to the settee
H. 41 in. (104.1 cm), w. 67½ in. (171.5 cm), d. 26 in. (66 cm)
Fletcher Fund, 1924
24.136.1

This settee is from a large suite of furniture that comprised at least four settees, eight side chairs, four stools, and two side tables.[1] Of these, the following are known: two settees and six chairs in the Queen's Audience Room at Windsor Castle;[2] twenty-one side chairs (of which only two or possibly three appear to be genuine) in the Queen's Drawing Room and Presence Chamber at Windsor;[3] two side tables in the Long Gallery at Upton House, Warwickshire;[4] two stools in the Great Chamber at Parham Park, West Sussex;[5] and the present settee and one stool (fig. 59) in the Metropolitan Museum.[6]

The set has often been published as having come from Stowe in Buckinghamshire, the great Palladian house that was formerly the property of the duke of Buckingham and Chandos and is now a school. No set of this (or larger) configuration appears in the "Inventory of the Household Furniture &c. at Stowe House," dated January–February 1839, when Richard Grenville, second duke of Buckingham and Chandos (1797–1861), inherited the estate.[7] Nor does it appear nine years later when he sold most of the contents in the famous Stowe sale of 1848. The catalogue of this sale is not a convenient document for identifying pieces of furniture, as the entries are frustratingly brief (for example, "A noble pier table"). Many attempts have been made to link pieces of this set with specific lots in the sale. None succeed.[8]

Herbert Hall Mulliner was probably the first to suggest the Stowe provenance. In his book *The Decorative Arts in England, 1660–1780*, published in 1924 and actually written by Margaret Jourdain, it was stated about the stool now in the Metropolitan Museum that it was originally at Stowe.[9] The idea gained momentum in the 1930s, when the two settees and six side chairs now at Windsor (from the first group above) were flatly described in the catalogue of the W. Hearst sale in 1939 as having come from Stowe.[10] The next step was taken by Museum curator Preston Remington in 1954, when he declared that the Metropolitan settee was made *for* Stowe.[11]

The question of attribution remains as unsettled as that of provenance. The set was first attributed to the cabinetmaker James Moore (ca. 1670–1726) by Ralph Edwards and Margaret Jourdain in the third revised edition of their *Georgian Cabinet-Makers* (1955).[12] James Moore died in 1726, leaving a group of signed or otherwise documented pieces that are consistent in style. His tables usually have straight or tapered baluster legs, often with stretchers combining distinctive diamond- and U-shaped forms. The type of cabriole legs with lions' masks seen on the present set are without parallel in his documented or securely attributed work.[CD] They are more closely related to the legs on several groups of mahogany chairs dating from the late 1720s and 1730s.[13]

The present set is, in my opinion, by an as yet unknown cabinetmaker from an as yet unknown house, carved and gilded about 1730–35, in a transitional style applying an earlier decorative vocabulary of interlacing patterns in fretwork on shapes

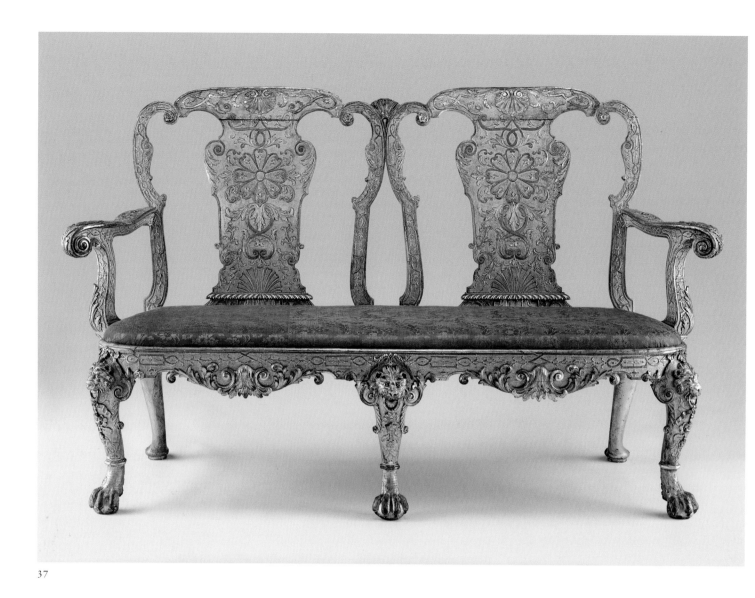

37

that were by this period beginning to be carved in mahogany. A peculiar conclusion, perhaps, given the extraordinarily high quality of design and carving, but one that reflects the present state of research. WR

1. This entry is based on Rieder 1978b.
2. Ibid., p. 9, no. I, pl. 21.
3. Ibid., no. II.
4. Ibid., no. III, pl. 22.
5. Ibid., no. IV, pl. 22.
6. Ibid., nos. V, VI, pls. 23A, 23B.
7. MS, Huntington Library, San Marino, California.
8. Rieder 1978b, n. 11.
9. Mulliner 1924, fig. 58; quoted in ibid., p. 10.
10. Rieder 1978b, p. 10.
11. Remington 1954, p. 114.
12. Edwards and Jourdain 1955, p. 43, pl. 32.
13. Hackenbroch 1958a, pls. 100–103, figs. 127–30; Victoria and Albert Museum 1965, no. 61; and Metropolitan Museum of Art 1977, pp. 78–79, no. 136 (entry by William Rieder).

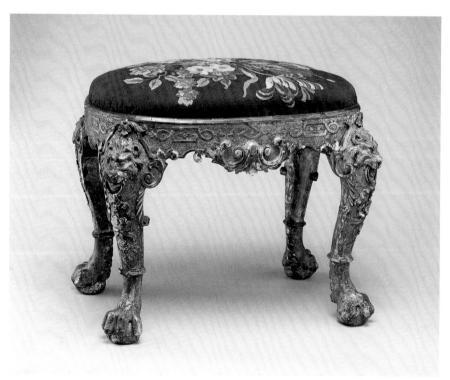

Fig. 59. Footstool, English, ca. 1730–35. Gilded gesso on walnut, covered in eighteenth-century Soho tapestry not original to the footstool; 20 x 22½ x 16 in. The Metropolitan Museum of Art, New York, Gift of Irwin Untermyer, 1964 (64.101.957).

38.

Candlestand (*guéridon*)

German (Munich), ca. 1735
Linden wood; cut and gilded gesso; Tegernsee
limestone top
H. 34⅛ in. (87.9 cm); diam. of top 10¼ in.
(26 cm)
Anonymous Gift, in memory of Charles Bain
Hoyt, 1952
52.56.1

The candlestand, or *guéridon*, was a practical piece of household furniture used to support a candlestick, a candelabrum, or later an oil lamp.[1] When sets of furniture with matching ornamentation came into vogue in the seventeenth century, candlestands became an important part of aristocratic interior decoration. In some cases their large size made them impossible to move without considerable effort. In the residences of the very rich, parade sets were frequently made out of silver;[2] in most cases these sets comprised a side table, a mirror, and two *guéridons*. Flanking the table, the candlestands supported candelabra fitted with four or more candles to maximize the light.[3] Versailles was filled with silver furniture until 1689, when Louis XIV had it all melted down to pay his armies; after that, the taste for it gradually diminished in the European courts until the 1730s (see the entry for no. 29).

The candlestand discussed here, one of a pair in the Museum's collection,[4] was made to be moved about as needed among the smaller rooms that became fashionable as the eighteenth century advanced. Some details of the decoration, like the trelliswork on the legs (see fig. 60), are reminiscent of silver furniture and of goldsmith's work. The form of the stands is certainly based on earlier silver designs.[5] It is evident, however, that the designer of this piece was familiar with the new style of ornamentation that was being adapted from France. The lobed and shell-encrusted, or rocaille, formations of the Rococo are present, but, as is also true of the contemporary South German commode in this book (no. 40), the basic form of the furniture has not been distorted or obliterated by them. The piece is a straightforward tripod structure, its bold scroll feet clearly attached to the stand. The additive

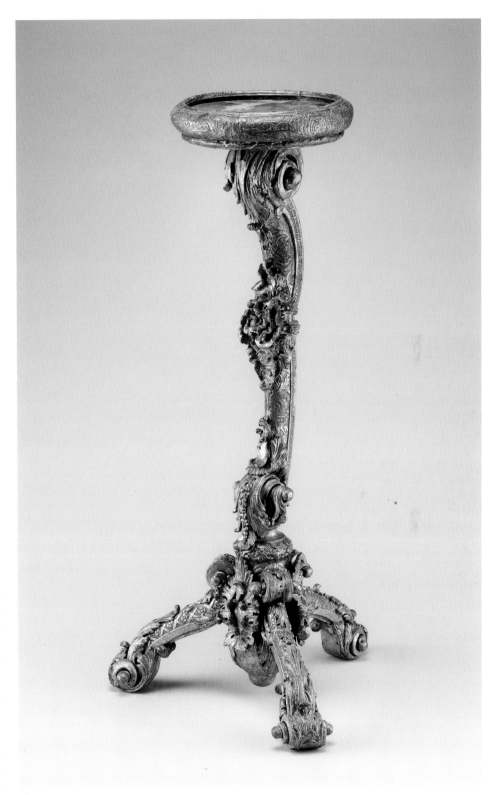

38

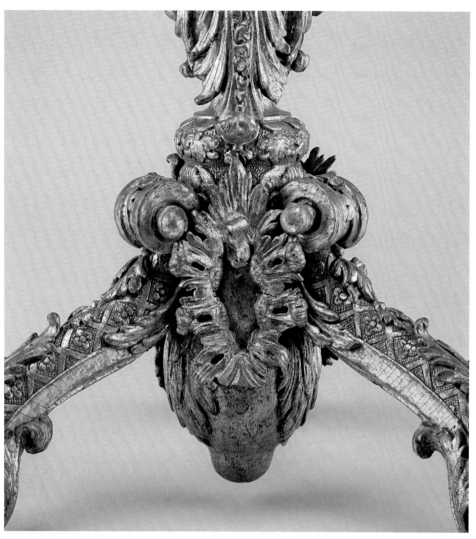

Fig. 60. Detail of the front of the candlestand.

ing at the same time.[9] Munich, the capital of the Electorate of Bavaria, was an exception to a certain degree. In 1781, of the 38,000 inhabitants of the city no fewer than 5,000 had a formal appointment at or association with the court as members of the Electoral household (*Hofstaat*). The Bavarian Elector was continually in financial difficulties and succumbed to the temptation to raise money by selling guild exemptions (thus the associated privileges were not as meaningful as, for example, in Paris). The present candlestands could have been made at the workshop associated with the Elector's court; alternatively, they could have been created at a workshop in one of the large cloisters or other religious communities in the region, where medieval rights of asylum had been extended to protect a luxury trade that would otherwise have been opposed and persecuted by the guilds. W K

1. Havard 1887–90, vol. 2, cols. 1225–32; and Reyniès 1987, vol. 2, pp. 716–22. For a late-eighteenth-century English example, see the entry for no. 80 in this book.

2. P. Thornton 1990, p. 232. See also Bencard 1992.

3. Koeppe 1991a.

4. The accession number of the matching stand is 52.56.2. The present stand was severely damaged by a Museum visitor in 1997. It was subsequently brought back to its former condition by Pascale Patris, Associate Conservator, Department of Objects Conservation, Metropolitan Museum. On the beautiful Tegernsee limestone set in the top of both stands, see Grimm 1990, no. 177.

5. For examples of earlier designs at the Munich Residenz, see Langer and Württemberg 1996, pp. 122–24, no. 20 (entry by Alexander Herzog von Württemberg). For additional examples, see Koeppe 1991a; and Baumstark and Seling 1994, vol. 2, pp. 326–402, nos. 76–97.

6. They were made by Wenzeslaus Miroffsky (d. 1759) between 1733 and 1734. See Langer and Württemberg 1996, pp. 155–62, nos. 32, 33 (entries by Alexander Herzog von Württemberg). For the "lobed rocailles" in Cuvilliés's ornamental designs, see Laran 1925, pls. 23, 25, 69, 80.

7. Langer 2000, pp. 130–32. For an example of Augsburg silver *guéridon*, see Baumstark and Seling 1994, vol. 2, pp. 486–87, no. 137 (entry by Gisela Haase).

8. As titular head of all the guilds, the sovereign could override guild regulations; Stürmer 1979a, p. 503.

9. Watson 1966b, p. 589.

rather than fully unified nature of the decoration suggests a date of 1730–35, which is consistent with the trelliswork ground of the gilding. During these years François Cuvilliés (1695–1768) designed five elaborately gilded console tables for the Green Gallery at the Munich Residenz, where they have survived, in situ, 270 years of turbulent history.[6] They mark a major step toward the fully Rococo silvered console tables by Cuvilliés in the Hall of Mirrors at the Amalienburg hunting lodge in the park of Nymphenburg Palace outside Munich.[7] The Metropolitan's candlestands cannot be associated directly with Cuvilliés; however,

their controlled and bold shape, the picturesque lobed shell forms, and asymmetrical ornament indicate that the maker had first-hand knowledge of the decorative work going on at the palace in Munich at this time.[CD]

The refined execution of the Museum's *guéridons* indicates they were made in an organized workshop incorporating several specialized workers: a wood-carver, a gesso worker, and a gilder. Guild regulations all over Europe prohibited this type of privileged arrangement, and only rarely were they relaxed.[8] Even at the court of Louis XVI, after 1776, there were never more than three privileged cabinetmakers work-

39.

Card table

English (London), ca. 1735–40
Giles Grendey (1693–1780)
Lacquered and gilded beech; lined with felt
H. 29 in. (73.7 cm), w. 35 ⅜ in. (89.9 cm),
d. 36 in. (91.4 cm)
Gift of Louis J. Boury, 1937
37.114

Part of a very large set, this card table and a matching side chair (fig. 61), also in the Museum's collection, are among the few pieces of English furniture at the Metropolitan that can be attributed with certainty to a London maker. A paper trade label is pasted underneath the seat of the chair identifying it as originating in the workshop of Giles Grendey.^{CD} The label reads: "GILES GRENDEY, St John's Square, Clerkenwell, LONDON, Makes and Sells all Sorts of Cabinet Goods, Chairs, Tables, Glasses etc." Not many cabinetmakers used such paper labels, and Grendey seems to have marked only a small number of pieces dating to the period from about 1735 until 1750.[1]

Born in Gloucestershire, Grendey served his apprenticeship with a joiner in London, where he stayed the rest of his career as a cabinetmaker in Aylesbury House at the above-mentioned address. In 1726 one of his apprentices filed a complaint against Grendey for having beaten him in "a very barbarous manner."[2] A hot-tempered character, perhaps, but nevertheless very successful in his trade, Grendey did not work much for the landed gentry and was primarily known for his well-made but rather common pieces of furniture in walnut and

39

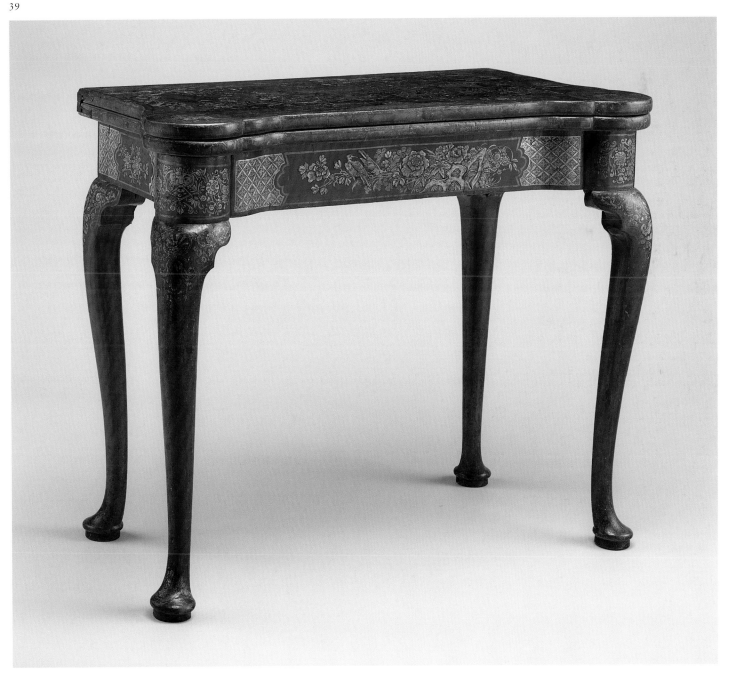

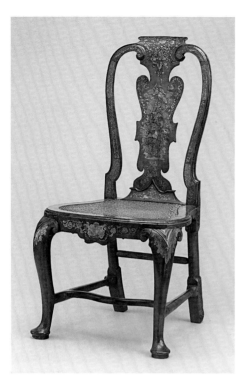

Fig. 61. Side chair by Giles Grendey, ca. 1735–40. Lacquered and gilded beech, caned seat; 41½ x 21½ x 19¾ in. The Metropolitan Museum of Art, New York, Gift of Louis J. Boury, 1937 (37.115).

mahogany for middle-class use. Newspaper accounts of an early morning fire on 3 August 1731 reveal that he also provided furniture for export; the fire allegedly destroyed one thousand pounds' worth of goods in his workshop that were packed for exportation the next morning.[3] Although English furniture was regularly shipped to Spain when the relations were peaceful between the two countries, Grendey is the only craftsman known to have been engaged in this trade.[4] Many of these pieces were adapted to the Spanish taste, having flat surfaces that lent themselves to opulent decoration, often against a brightly lacquered background.

The Museum's side chair and card table illustrate this very well. Almost exactly two hundred years after their arrival in Spain, they were sold with seventy other pieces of the same set from the salon at Infantado Castle, near San Sebastián, the residence of the dukes of Lazcano. It has generally been assumed that this furniture had always been in the possession of the Lazcano family and that it was ordered during the 1730s, probably before 1739, when war broke out between England and Spain. This may have been when Don Juan de Dios de Silva y Mendoza (1672–1737) was the tenth duke, or otherwise later, under the eleventh

duchess, Maria Francisca Alfonsa de Silva Mendoza y Sandoval (1707–1770). There are no documents to confirm this supposition, and caution is needed because there is, apparently, some evidence that the dukes of Infantado built up their art collection largely during the nineteenth century.[5] All that is known for certain is that the German dealer Adolph Loewi (1888–1977), who had shops in Venice and, later, also in America, visited the castle in 1930 and acquired most, but not all, of the crimson-lacquered suite of furniture.[6] Stock records show that Loewi bought fifty side chairs, twelve armchairs, two daybeds, two pairs of mirrors, a pair of candlestands, a card table, and a tripod tea table. During the following year Loewi sold some thirty pieces to the lawyer, banker, and art patron Walter Tower Rosen (1875–1951) for his Caramoor estate in Katonah, New York.[7] Other pieces are in public collections in London, Leeds, and Melbourne.[8]

The card table, with its slender cabriole legs ending in pad feet, is a concertina-action table (see the entry for no. 34).[CD] Its folding top is decorated with a scene of a noble horseman approaching a palatial structure with blossoming trees in the background (fig. 62). Accompanied by footmen carrying banners and musicians playing pipes, he is awaited at the entrance by several women and their attendants. Variations of this scene are found on other pieces attributed to Grendey. The rounded front corners have a heraldic beast inscribed in a circular scrollwork border, and the central scene is

framed at the top corners by diaper-patterned trelliswork that encloses rosettes. The main decorative element of the chair is the Asian male figure holding an umbrella depicted on the back splat.[CD] These exotic figures vary slightly on each of the known side chairs; the armchairs show a couple sharing one umbrella. The frames of both the table and the chair are further elaborately embellished with interlaced designs, shells, birds, masks, floral ornament, and trelliswork. Rendered in gold with silver accents, now discolored, and with many details such as the patterns in the garments as well as the outlines executed in black, the decoration is painted flat against the lacquered ground and partially over raised surfaces modeled in gesso. Unfortunately, the japanned surfaces have not reacted well to climatic changes; they started to crackle and flake not long after they entered the Museum's collection in 1937 and have been restored several times. The originally bright crimson color has changed to a dull orange-red but is visible in those areas where the gesso of the raised ornament is missing and the preparatory ground layer is exposed.

The technique of imitating Asian lacquer, in this case of red and gold Chinese lacquer, was practiced in England not long after the first lacquered wares had arrived from East Asia. Since the main ingredient of genuine lacquer, the sap of *Rhus vernicifera*, was not available in Europe, look-alike varnishes were created, generally with either gum-lac or shellac.[9] Various manuals, such as the influential *Treatise of Japaning and Varnishing*

Fig. 62. Top of the card table.

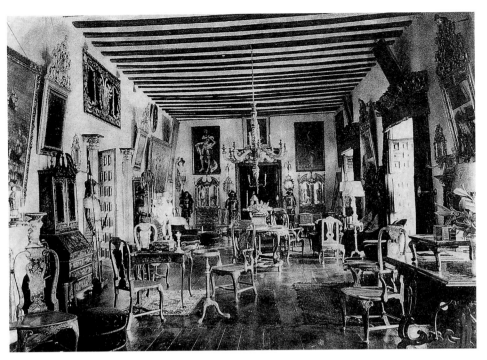

Fig. 63. Undated photograph of the salon at Infantado Castle, Lazcano, filled with many pieces of the suite of furniture by Giles Grendey.

pean taste and fashion. In this case the side chair displays certain traditional features no longer fashionable in England during the 1730s, such as the high cabriole legs that are connected by stretchers and the caned seat that was more suitable to the hot Spanish climate. A second card table, not acquired by Loewi and possibly the one visible in the late-nineteenth-century photograph of the salon at Lazcano (fig. 63), was later in the collection of Richard Hoyt.[11] Its present whereabouts are not known. DK-G

1. Jervis 1974a.
2. Beard and C. Gilbert 1986, pp. 371–72 (entry by Simon Jervis).
3. Ibid., p. 371. See also C. Gilbert 1971, p. 544.
4. Huth 1971, pp. 38–39.
5. C. Gilbert 1971, p. 550.
6. For information about Loewi's life, see Raggio 1999, pp. 4, 180, n. 13.
7. C. Gilbert 1978a, vol. 1, pp. 79–81, no. 61. Some of the Rosen furniture was later sold from Caramoor. The sales were held at Christie's, New York, 2 February 1980, lot 215, and 14 April 1984, lots 153–56.
8. The Victoria and Albert Museum, London, has one daybed, and another is in the National Gallery of Victoria, Melbourne. Temple Newsam House, near Leeds, acquired a pair of armchairs and six side chairs in 1970. See C. Gilbert 1971.
9. Macquoid and Edwards 1983, vol. 2, pp. 266–71.
10. Stalker and G. Parker 1688 (1960 ed.), pp. 24–25.
11. It was acquired by French and Company, New York, in or before 1978; C. Gilbert 1978a, vol. 1, p. 81.

by John Stalker and George Parker, published in 1688, offered technical advice, recipes, and designs to both professionals and amateurs who were engaged in the popular art of japanning, as it became known. This and other instruction books suggested making colored varnishes by adding various pigments: to produce the common red, vermilion should be used, but for a darker, deeper red, dragon's blood, a reddish resinous substance found on the berries of the dragon tree, was required.[10] Readers were advised to choose metal dust, either of brass, which looks like gold, or silver, for the decoration.

The advantages of japanned furniture over imported genuine lacquer pieces were not only that it was less expensive but also that it could be made to conform to Euro-

40.

Commode

German (Munich), ca. 1735–40
Attributed to François Cuvilliés (1695–1768); carving by Johann Joachim Dietrich (1690–1753)
Pine and linden wood; carved, partially painted, and gilded gesso, partly incised; Tegernsee limestone top
H. 33¼ in. (84.5 cm), w. 51½ in. (130.8 cm), d. 24½ in. (62.2 cm)
Fletcher Fund, 1928
28.154

When in the eighteenth century "a French aristocrat or *nouveau riche* had a stately home built for him, in Paris or in the provinces, he was well advised to listen to his architect's warning that the cost of construction amounted to no more than a mere quarter of total expenditure, and that the rest would have to be spent on interior decoration in order to make the edifice conform to the accepted patterns of living in the grand manner."[1] This wry observation in Louis-Sébastien Mercier's *Tableau de Paris* (1780) held true not only in France but in other countries as well, since the European upper classes looked to Paris for everything

à la mode. But the princes of the often small, scattered territories of the Holy Roman Empire lacked the financial resources to build and decorate on a grand scale. Thus, economy and thrifty inventiveness reigned in the workshops of most south German courts. Appearance counted for everything, trumping inconspicuous quality. In cabinetmaking, cheap pine or spruce was used as a secondary wood instead of oak or other hardwood for carcase construction, and paint was chosen instead of veneer to bedeck it. A handsome design in combination with an imaginative execution compensated for skimping on the fabric of show

pieces that emulated much more expensive Parisian works. This kind of furniture, known as *Bildhauermöbel* ("sculptor's furniture"; see also no. 38),[2] reflected the mutual efforts of a designer, a cabinetmaker for the body, an artisan carver (called in German a *Schneidkistler*, or "cut-cabinetmaker"), and a skillful gilder and painter *(Fassmaler).*[3]

The exuberant gilded decoration on this commode—in particular, the corner terms with satyrs' heads emerging from scroll feet—alludes to the works of celebrated Parisian masters of veneer and ormolu, such as André-Charles Boulle (1642–1732) and, in the next generation, Charles Cressent (1685–1768), whose metal mounts frequently attract more attention than the veneered furniture itself (see the entries for nos. 31, 44). These heavy metal mounts (and especially their labor-intensive mercury gilding) were infinitely more expensive than gilded wooden substitutes. This commode's gilded decoration is not even completely wood-based: the side-panel and drawer-front ornaments are cut into applied gesso, in the way plaster was applied to the ceilings and walls of contemporary south German churches and then painted and gilded so that the architecture seems to vanish, creating the illusion of "heaven on earth." When new, the skillfully water-gilded satyrs' heads and openwork aprons could surely be mistaken for gilt-bronze. Comparable examples that are less worn indicate that great care must have been given to the final finish and polishing of the gilded and painted areas of this commode to achieve a smooth and sparkling surface.[4] It is interesting to note that in comparison with French furniture the body is only slightly serpentine and that the gilded ornaments form a refined frame for the carcase in the way a precious-metal setting intensifies the look of a sparkling jewel. Only the functional hardware—the handles and the escutcheons, which protect the painted surface surrounding the key-holes from being scratched by the metal keys—is of cast and gilded bronze.[CD] Their relatively flat surface—the result of a poor job of chasing—is another indication that economy played a role in the assembly of this showcase piece.

The commode's design can be attributed to the ingenious Bavarian court architect François Cuvilliés, one of the leading exponents of the Rococo style in Germany (see the entry for no. 38). His celebrated furniture designs influenced Abraham Roentgen (1711–1793), the greatest German cabinetmaker of the 1750s to the 1770s (see the entry for no. 72).[5] The present commode does not exactly match any of the twelve commodes published in Cuvilliés's *Livre de diferents dessein de commodes* between 1738 and 1742, which have more exaggerated and noticeably bulging contours;[6] however, a "Décoration de Lambris" design by Cuvilliés illustrates a commode with carved bearded heads crowning term volutes at its corners, as seen here.[7] Furthermore, the gilt-gesso decoration on the sides of the Museum's commode, a female bust on an elongated

Fig. 64. Right side of the commode.

Fig. 65. Engraving in François Cuvilliés, *Livre d'ornaments à diverse usages,* 1740s.

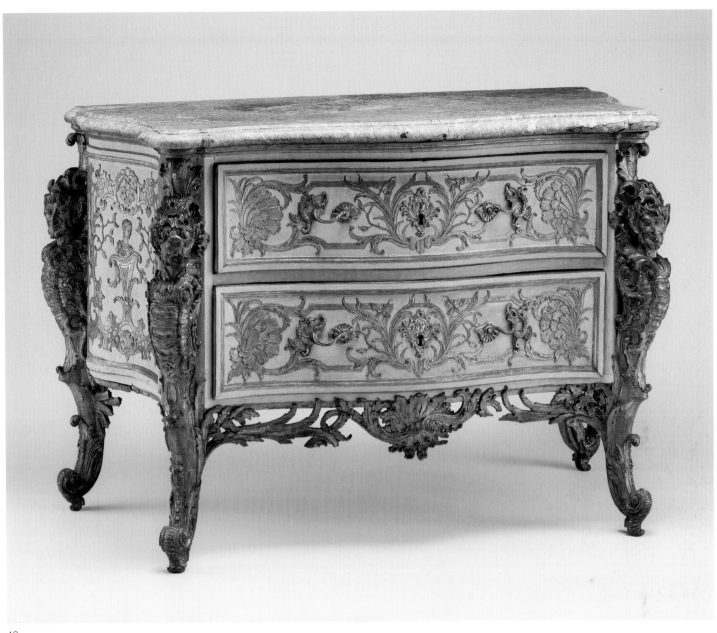

40

C-scroll pedestal framed by scrolled foliage and trelliswork, corresponds closely to an ornamental engraving in the architect's oeuvre (figs. 64, 65).[8] A characteristic Cuvilliés detail is the foot, and especially its curling element, which also appears in the furniture at the Amalienburg hunting lodge at Nymphenburg, designed by Cuvilliés and carved by Johann Joachim Dietrich between 1735 and 1739.[9] Dietrich's name is mentioned in Munich court documents for the first time in 1729. On 14 March 1736, he was named court sculptor and praised for "good workmanship" in his appointment document.[10]

It has been suggested that the construction of this commode should be attributed to Johann Michael Schmidt, but there is no real evidence for this.[11] Adolf Feulner connected the commode with a display cabinet in the Munich Residenz that has comparable ornamental details and proposed that the commode had been made for the counts of Lerchenfeld either for Schloss Kefering, near Regensburg, or the Lerchenfeld Palace in Munich;[12] but this, too, now seems highly unlikely.[13]

In 1928 an advertisement for the commode was placed in *Pantheon* by the Munich firm of L. Bernheimer.[14] This art dealer had bought a closely related pair of commodes of almost the same size in 1918 for a then record amount at the auction of the collection of the Munich writer and publisher Georg Hirth.[15] Two other pairs of commodes, with only minor differences in their measurements and with similar features, are known: one pair, with female corner terms, is in the J. Paul Getty Museum, Los Angeles, and the other is in the Archbishop's Palace in Munich, the former Holnstein Palace, which was commissioned by Count Franz Ludwig von Holnstein and most likely designed by Cuvilliés.[16]

During conservation of the Museum's commode, diverse paint layers were discovered: a lead-white ground without dirt residue, then a blue layer and partial gilding, covered in turn by the present color and gilding. The commode may originally have been colored blue and partially or completely gilded.[17] It probably had a pair, which, if it could be located, might give clues to the original appearance of both and to their original provenance. The top of the Museum's commode is a polished slab of mottled Tegernsee limestone,[18] original to the piece.[CD] WK

I am grateful to Mechthild Baumeister, Conservator, Department of Objects Conservation, Metropolitan Museum, who restored the commode in 1989, for discussing it with me. She contributed much valuable information to the departmental file on this interesting piece. I also thank Afra Schick, Furniture Curator, Staatliche Schlösserverwaltung Berlin-Brandenburg.

1. Mercier 1780, vol. 1, pp. 283–84; quoted in translation in Stürmer 1979a, p. 496.

2. Eighteenth-century inventories describe similar items as furniture "with gilded sculptor's work." See Langer and Württemberg 1996, p. 205.

3. Kreisel and Himmelheber 1983, p. 172.

4. In a conversation with the author, Josef Sieren, head of the painting and gilding workshop, Verwaltung der Staatlichen Schlössern, Nymphenburg, Munich, revealed that a pair of related commodes in the Archbishop's Palace in Munich retain such a finish. Details of this conversation are recorded in a note in the archives of the Department of European Sculpture and Decorative Arts, Metropolitan Museum.

5. Laran 1925, p. 8. Plate 65 shows a design for a writing desk ("secrétaire en tables pour Ecrire") of 1745–55 with a lean-to hinged fall front that could easily be mistaken for a rolltop mechanism.

6. File note of 24 October 1994 by Afra Schick in the archives of the Department of European Sculpture and Decorative Arts; see also Laran 1925, p. 8, pls. 32–35 (commode designs).

7. Laran 1925, pp. 9, 77.

8. Feulner and Remington 1930; Feulner 1931; Schick 1998; and Laran 1925, pl. 22 (left), for a related motif.

9. File note of 24 October 1994 by Afra Schick in the archives of the Department of European Sculpture and Decorative Arts; see also Langer 2000, pp. 130–36.

10. Poser 1975, pp. 123–24.

11. Kreisel and Himmelheber 1983, p. 178; and catalogue of a sale at Sotheby's, London, 13 December 2000, p. 34, lot 36.

12. Feulner 1931, figs. 2, 3. For Schloss Kefering, see Bezirksamt Regensburg 1910, pp. 95–96, fig. 59.

13. Lerchenfeld Palace takes its name not from one of the thirteen different owners this stately home has had during its history but, strangely enough, from

a Lerchenfeld family member who merely lived nearby in the early nineteenth century; Scheibmayr 1989, p. 577.

14. Pantheon 2 (1928), copy of an advertisement in the archives of the Department of European Sculpture and Decorative Arts. It was acquired by the Museum from Adolph Loewi (1888–1977), a Bernheimer relative resident in Venice; on this collector and dealer, see Raggio 1999, pp. 4–7, 180, n. 13.

15. The purchase price was 23,000 reichmarks, according to an annotated copy of the auction catalogue, now in a private New York collection. They were offered again at auction in 2000 and in 2005; catalogues of sales at Sotheby's, London, 13 December 2000, lot 36, and 8 June 2005, lot 33 (the present commode is illustrated in both catalogues). In 1927 the Museum acquired from the Hirth Collection a pair of Rococo doors that may have come from the Munich Residenz (acc. nos. 27.184.2–11).

16. These four commodes are discussed at length in Schick 1998. The pair in the Archbishop's Palace is in an exceptionally good state of preservation; see n. 4 above.

17. On different color schemes for Munich Rococo furniture, see Langer 2000, pp. 130–36, 166, no. 52.

18. Grimm 1990, no. 177.

41.

Fire screen

German (Würzburg), court workshop,
ca. 1736–40
Probably carved by Ferdinand Hundt
(ca. 1704–1758)
Carved and gilded oak; silk panel not original
to the screen
H. 58 in. (147.3 cm), w. 42½ in. (108 cm)
Gift of Louis J. Boury, 1935
35.23.1, 2

Fire screens have been used since the Middle Ages to shield those standing or seated near a fireplace from the excessive heat of the open flames and from flying sparks. Toward the end of the seventeenth century, screens of rectangular shape with a large central panel of colorful fabric or other boldly contrasting material were developed to conceal the dark opening beneath the mantel that otherwise would interrupt the ornamental dado and paneled decoration of the room.[1] The materials used for the frame of these screens ranged from wrought iron or copper to carved wood or even silver, and the panel was often decorated with scenes from the

forge of Vulcan, the Roman god of fire.[2] Especially vulnerable to changing fashions and fire damage, exuberantly carved screens such as the present example have only rarely survived. The purpose of the Museum's screen is suggested by its decoration. At the top, two snake-dragons that seem to breathe fire from their gaping jaws flank the idealized head of a woman in a shell-and-acanthus cartouche.[CD] By turning their heads away from the goddesslike image they protect her complexion from damaging heat, a conceit that conjures the ideal of feminine beauty at the time.

Long thought to be of French origin,[3] this screen in fact represents virtuoso Franconian Rococo carving at its sculptural best.[4] The expressive design and skillful carving suggest that it was one of several screens ordered for the lavishly furnished palace, or Residenz, in Würzburg, the cultural capital of Franconia, by Friedrich Karl von Schönborn (1674–1746). As prince-bishop of Bamberg and Würzburg, this

noble prelate ruled as the spiritual head of the regional Catholic Church and as an independent prince of the Holy Roman Empire, who—in theory—held the emperor as his feudal lord. The office of prince-bishop, a political unicum of the Holy Roman Empire and some neighboring areas, was said to be based on the biblical model of Melchizedek, who is described as high priest and king in the book of Genesis.[5] Since the prince-bishops had to defend the various interests of both church and state, they needed to amass considerable political power and wield it skillfully to allay the tensions that inevitably occurred. Moreover, it was in the interest of the bishops to use their office to increase the influence of their family and to elevate it within the feudal system. None of them understood better the importance of using the visual arts to impress friends and enemies alike with the magnitude of their worldly power than Friedrich Karl von Schönborn. During his tenure, the palace at Würzburg became one

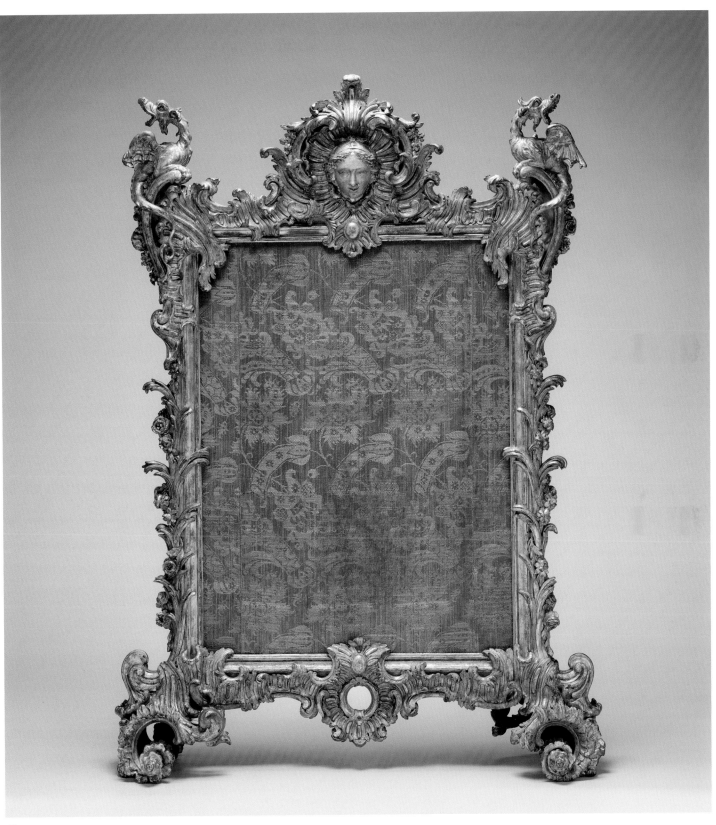

41

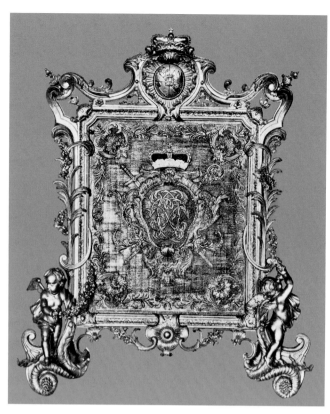

Fig. 66. Detail of the left foot of the fire screen.

Fig. 67. Fire screen by Ferdinand Hundt, 1736. Residenz, Würzburg.

of the most magnificent and splendidly appointed residences of the late Baroque period. Friedrich Karl's architect Balthasar Neumann (1687–1753) hired only the best artisans to decorate it, and Ferdinand Hundt was one of them.

Hundt settled in Würzburg in 1735 and began work the following year in the west wing under the supervision of Neumann, who called him "the best of all ornamental carvers."[6] Closely related to the present example is Hundt's fire screen of 1736 in the Residenz, with a crest incorporating the coat of arms of Friedrich Karl (fig. 67). The exuberantly formed shell feet of that screen are also conceived as scrolls with a C-shaped volute emerging on either side (see fig. 66).[7] Ornamental compositions with surging

rocaille formations, cartouches, and dragon heads characterize Hundt's designs for the carved wood paneling of the audience chamber (ca. 1742).[8] A group of candlestands carved about 1744 by Hundt also relate to the Museum's fire screen in their details, although their outline is unusually restrained. Later, Hundt created fully developed snake-dragons and shell-and-acanthus cartouches for the palace at Bruchsal, built by Cardinal Damian Hugo von Schönborn (1676–1743), prince-bishop of Speyer and a brother of the Würzburg palace's patron.[9] The blue fabric now stretched on a removable panel set within the screen probably replaced a very elaborate decorative panel of silk or lamé embroidered with precious silvered or gilded metal threads.[10] WK

1. Havard 1887–90, vol. 2, cols. 311–27; and Reyniès 1987, vol. 2, pp. 768–74.
2. Baumstark and Seling 1994, vol. 2, pp. 490–93, no. 140 (entry by Gisela Haase).
3. Remington 1935.
4. Nevertheless, the crest motif with the central cartouche and dragons is inspired by French designs, as the similar carved back of an earlier daybed at the Museum documents (acc. no. 22.144); Rogers 1922, p. 260.
5. Genesis 14:18–24.
6. Kreisel and Himmelheber 1983, p. 194; and Fleming and Honour 1989, p. 406.
7. Kreisel and Himmelheber 1983, fig. 521.
8. Ibid., fig. 516.
9. Ibid., figs. 523, 569.
10. Compare Kreisel and Himmelheber 1983, fig. 598; Langer and Württemberg 1996, p. 127, no. 21 (entry by Alexander, Herzog von Würrtemberg); Langer 2000, p. 179, no. 60; and Langer 2002, p. 229, no. 73 (entry by Edgar Bierende).

42.

Commode

French (Paris), ca. 1740–45
Bernard van Risenburgh II (ca. 1696–ca. 1767)
Oak veneered with panels of Chinese
Coromandel lacquer and European black-
lacquered veneer; gilt-bronze mounts; brèche
d'Alep marble top
H. 34 in. (86.4 cm), w. 63 in. (160 cm),
d. 25¼ in. (64.1 cm)
Stamped once on the top of each leg underneath
the marble slab: "B.V.R.B."
The Lesley and Emma Sheafer Collection,
Bequest of Emma A. Sheafer, 1973
1974.356.189

First introduced at the beginning of the eighteenth century, the commode, or chest with drawers, became one of the principal pieces of case furniture in the French interior. Its name, derived from the word *commodité* (convenience), reflects the greater ease with which one could store clothes and finery in the drawers and on the shelves of a commode than in the coffers or trunks commonly used earlier.[1] By the middle of the eighteenth century, commodes were found not only in bedrooms and dressing rooms but also in official reception rooms, often in pairs on opposite walls. Candelabra, busts, and mounted porcelain vases were placed on their marble tops, which may have been selected to match the marble of the mantelpiece in the same room.

Stamped four times with the initials "B.V.R.B.," the Museum's commode was the work of Bernard van Risenburgh II,[2] a cabinetmaker known for exquisite pieces veneered, like this one, with Asian lacquer.[CD] In most cases the lacquer is Japanese, but some of Van Risenburgh's commodes and corner cabinets are decorated with Chinese Coromandel lacquer instead. The latter differs from black and gold Japanese lacquer in that its designs are not painted on the surface but are incised and filled with colored lacquer. Objects decorated in this fashion—especially large multileaf screens—were shipped to Europe by way of the Coromandel coast of southeast India, where the British East India Company had a trading post.

Indicating a certain vogue for this kind of furniture, eight single Coromandel commodes were sold by the dealer in luxury goods Lazare Duvaux (ca. 1703–1758) between November 1748 and August 1753. One of them was purchased by the marquise de Pompadour (1721–1764), mistress

42

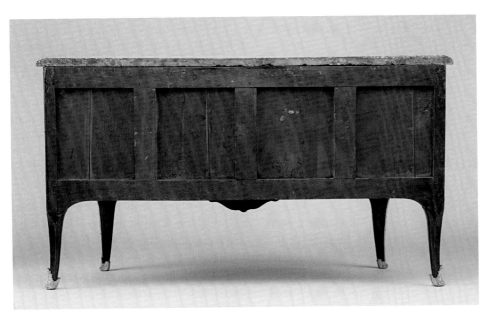

Fig. 68. Back of the commode.

ioned of beveled panels set into a frame, as can be clearly seen on the back of the commode (fig. 68). This type of construction, which allows the wood to expand and contract without cracking, is considered typical of the cabinetmaker's high-quality work.[8]

The Museum's commode, with its colorful *brèche d'Alep* marble top, is very close in size and description to two Coromandel commodes that were sold separately by Duvaux to the same client, a certain M. de La Reynière, in 1748 and 1753.[9] The fact that the Museum's commode can be dated for stylistic reasons to 1740–45, however, makes it unlikely that it was one of them. A nearly identical piece, possibly its pair, is in a private collection.[10] Before its acquisition in 1947 by Mr. and Mrs. Lesley Sheafer of New York, the Museum's commode was in two distinguished Parisian collections, that of Antoine-Alfred Agénor, duc de Gramont (1851–1925),[11] and that of Baron Edmond de Rothschild (1845–1934).[12] D K - G

of Louis XV (1710–1774) and a discerning patron of the arts.[3]

In creating this commode Van Risenburgh must have been guided by the size of the Coromandel lacquer panels available to him as well as by the shape of the gilt-bronze mounts.[4] He seems to have carefully selected pieces of lacquer with an interesting pictorial decoration to use as veneer for both the drawers and the sides. An image with five figures, for instance, was chosen for the center.[CD] This was cut with great difficulty horizontally and bent slightly to fit the drawer fronts. The lacquer is thought to have been derived from a late-seventeenth-century Coromandel chamber screen with panels that were tall rather than wide.[5] This would explain why separate, unrelated figurative scenes, similarly cut and bent, were used to flank the central part. Square pieces of lacquer showing fantastic animals in a landscape setting were chosen for the double-curving sides.[CD] These panels may not have been large enough to cover an entire side since they are surrounded by black-lacquered veneer. This veneer is decorated with a painted frame matching the Chinese lacquer in its colors. Clearly inspired by borders found on Coromandel screens, the floral motifs painted in imitation of a crackled lacquer surface are very realistically rendered.

The elegant scrolling mounts also played an important role. Not only did their curving outline determine the shape of the drawers and the apron but the central cartouche, composed of C-motifs, inverted-C-motifs, and rocailles, also visually divided the facade of the commode into three parts. It seems very likely that Van Risenburgh had these mounts in hand before he completed the commode, or else he owned the bronze models for them (the inventory of furniture and goods drawn up in 1764 and sold to his son and successor, Bernard van Risenburgh III [ca. 1731–1800], included a number of models, molds, and unfinished mounts).[6] He affixed identical mounts to several other commodes decorated with Coromandel lacquer.[7]

The drawers of this commode are not fitted with handles, making it impossible to open them without pulling on the key. This is a rather impractical feature of what was essentially invented as a convenient piece of case furniture. It indicates that commodes had become very fashionable in the mid-eighteenth century and were often considered as display pieces rather than used for actual storage. The carcase is carefully fash-

1. Havard 1887–90, vol. 1, col. 930.

2. Hackenbroch and Parker 1975, no. 1; and Rieder 1994, pp. 37, 39, fig. 13.

3. Duvaux 1873 (1965 ed.), vol. 2, pp. 4, 31–32, 41, 52, 63, 64, 98, 168, nos. 33, 324, 419, 525, 623, 634, 919, 1496.

4. See the discussion of this commode and related ones in Wolvesperges 2000, pp. 186–87, 255, 257, fig. 84.

5. Impey and Kisluk-Grosheide 1994, pp. 55–56, 59, pl. VI, fig. 17.

6. Pradère 1989, p. 199.

7. One of them, in a German private collection, has been considered the pair to the Museum's commode; see Bresinsky 1988, pp. 201, 204–7, figs. 3–5. Another closely related commode is illustrated in Baroli 1957, p. 58. That piece was sold at Christie's, New York, 22–23 October 2003, lot 670.

8. See Wilk 1996, p. 102 (entry by Carolyn Sargentson).

9. The first was described as "une commode à pieds de biche plaquée en vernis de Coromandel, garnie partout de bronze doré d'or moulu, avec son marbre de brèche d'Alep de cinq pieds," and the second as "une commode vernis de Coromandel, de cinq pieds, garnie partout de bronze d'oré d'or moulu, le marbre de brèche d'Alep, 960 Livres"; Duvaux 1873 (1965 ed.), vol. 2, p. 4, no. 33, p. 168, no. 1496.

10. See n. 7 above.

11. Sold from his collection at the Galerie Georges Petit, Paris, 22 May 1925, lot 62.

12. This information comes from the purchase record of Mr. and Mrs. Sheafer in the archives of the Department of European Sculpture and Decorative Arts, Metropolitan Museum.

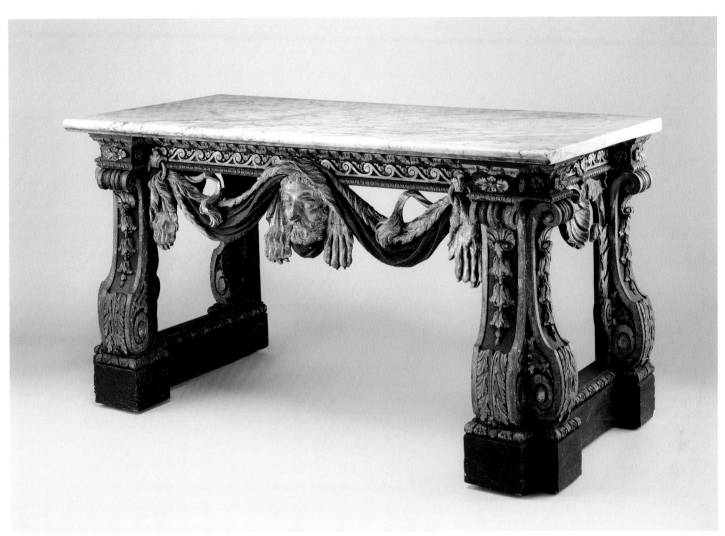

43.

Side table

English, ca. 1740–45
Attributed to Matthias Lock (ca. 1710–1770),
after a design by Henry Flitcroft (1697–1769)
Pine; marble top
H. 35 ¾ in. (90.8 cm), w. 68 ¼ in. (173.4 cm),
d. 34 ½ in. (87.6 cm)
Rogers Fund, 1926
26.45

This boldly carved table, a masterpiece of Palladian design, has legs in the form of large console brackets, and in the center of the frieze is a mask of Hercules draped with the pelt of the Nemean Lion. The frieze is ornamented with a Vitruvian-scroll pattern, and each side is centered with a large concave shell below the frieze. The table was intended for a dining room and has no stretcher or connecting element at the base between the two sides, leaving room for a wine cooler below. It closely corresponds to

a pencil drawing attributed to the furniture designer and carver Matthias Lock in an album of his drawings in the Victoria and Albert Museum, London.[1] It also, however, belongs to a group of very similar tables from houses in most of which the architect Henry Flitcroft worked: Ditchley House in Oxfordshire (a pair of tables now at Temple Newsam House, near Leeds),[2] Wentworth Woodhouse in South Yorkshire, Wimpole Hall in Cambridgeshire,[3] and Shugborough Hall in Staffordshire (a pair of tables belonging to the earl of Litchfield). Flitcroft is recorded in the Ditchley papers as having supplied five designs for table frames there in 1740–41.[4] It has therefore been suggested that this group of tables was designed by Flitcroft and carved by Lock.

The provenance of the present table is unknown during the eighteenth century. It

was acquired at some point during the nineteenth century for Hamilton Palace in South Lanarkshire, Scotland, and after the Hamilton Palace sale in 1919 it was bought by the famous industrialist Viscount Leverhulme (1851–1925), from whom it was acquired by the Metropolitan Museum of Art in 1926. All of the other tables of this model are painted white and have gilt carving, which was probably the original state of this table.

Although Matthias Lock is better known for his many books of designs for furniture in the Rococo style, he also worked in the earlier Palladian fashion, as seen in another design by him in the Victoria and Albert Museum for a side table.[5]

Henry Flitcroft began his career in 1720 as assistant to the architect Lord Burlington (1695–1753) and eventually became known

as "Burlington Harry." He then worked for the crown, continuing in the Office of Works, succeeding William Kent (1685–1748) as master mason and deputy surveyor in 1748, and became comptroller of the works in 1758. He is often regarded as the ablest of the second generation of architects working in the eighteenth century in the Palladian style.[6]

WR

1. Ward-Jackson 1958, p. 40, fig. 48.
2. C. Gilbert 1978a, vol. 2, pp. 353–56, no. 446.
3. Jackson-Stops 1985, pp. 234–35, no. 155 (entry by Gervase Jackson-Stops).
4. Oxford Record Office, DIL.I/9/3a.
5. Coleridge 1968, p. 183, fig. 93.
6. Colvin 1954, pp. 206–9.

44.

Commode

French (Paris), ca. 1745–49
Charles Cressent (1685–1768)
Pine and oak veneered with amaranth and bois satiné; drawer bottoms of walnut, drawer sides of oak, drawer fronts of pine; gilt-bronze mounts; Portor marble top
H. 34½ in. (87.6 cm), w. 55 in. (139.7 cm), d. 22¾ in. (57.8 cm)
The mounts are stamped in several places with the crowned-C mark. Pasted to the top beneath the marble is the trade card of the dealer Jean Rousselot: "Au chasteau de Vincennes, rue de la Monoye, vis à vis la Porte des Balanciers de la Monoye, Rousselot, Marchand-Mercier-Joyalier, Vend Glaces de toutes grandeurs pour les Appartements & Carrosses, Miroirs, Trumeaux & Cheminées de Glace de toutes façons; Bureaux, Commodes, Secretaires, Tables, Coffres, Cabarets, Toilettes & autre Ouvrages de Marqueterie & Ebenisterie de toutes sortes de Bois & Vernis, enrichis de Bronze dorée d'or moulu, ou en couleur; Tables de Marbre sans pieds & avec pieds, & autres Emmeublements de Bois sculptez & dorez; Bras, Feux, Flambeaux & autres Ouvrages de Cuivre dorez d'or ... feuille, argentez, en couleur, ou vernis; Porcelain de la Chine & du Japon, garnies ou non garnies ..."
The Jack and Belle Linsky Collection, 1982
1982.60.56

Among the Parisian cabinetmakers specializing in veneered and marquetried pieces (*ébénistes*), Charles Cressent was an exception. Born in Amiens, he was trained as a sculptor, like his father. His grandfather, however, had been a *menuisier*, or maker of joined furniture. Once in Paris, Charles worked for the cabinetmaker Joseph Poitou (ca. 1682–1718), *ébéniste* to Philippe, duc d'Orléans (1674–1723), the regent of France between 1715 and 1723. By marrying Claude Chevanne, Poitou's widow, in 1719, Cressent was able to continue his master's successful workshop and became, in his turn, cabinetmaker to the regent.[1]

Cressent had other important clients as well, not only in France but also abroad, such as King John V of Portugal (1689–1750) and Charles Albert, Elector of Bavaria (1697–1745), for instance, and was himself a notable art collector. Unlike most cabinetmakers, who worked for the dealers in luxury goods known as *marchands-merciers*, Cressent generally sold his pieces himself and had elegantly furnished showrooms on the second floor of the buildings that accommodated his home and atelier, in the rue Joquelet, a small street between the rue Notre-Dame des Victoires and the rue Montmartre.[2] Working largely in the Régence style, the transitional phase between Baroque and Rococo, Cressent was one of the few cabinetmakers whose name appears in eighteenth-century sale catalogues.[3]

Although Cressent did not sign a single piece of furniture, a considerable body of work has been attributed to him, including the Museum's commode.[4] One of a group of six known commodes of this model, it shows his highly individual and very sculptural manner.[5] The outline of the bowfront facade, of the rounded corners, and of the undulating sides is repeated in the form of the Portor marble top. Supported on four tall legs, the commode is fitted on the front with two drawers that are separated by a horizontal divison, or *traverse*, visible only on either side of a central cartouche. This central section is veneered with amaranth in

Fig. 69. Trade label of the dealer Jean Rousselot, pasted to the top of the commode.

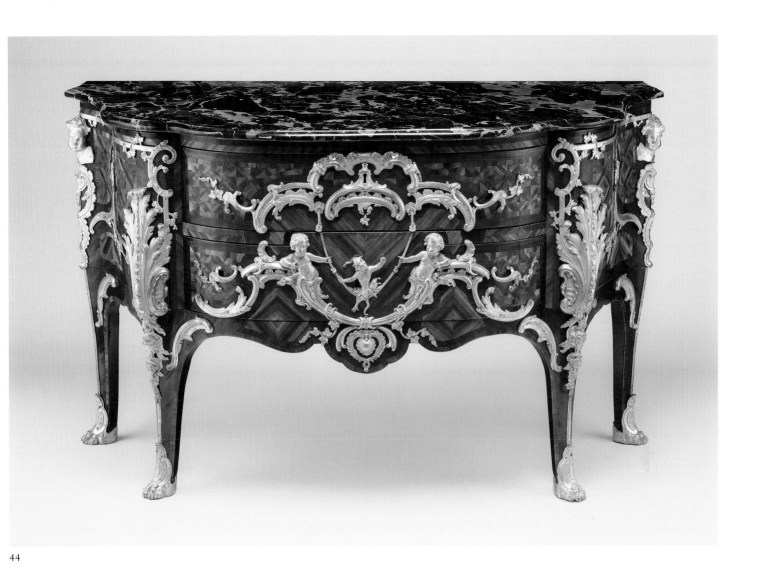

44

a V-shaped pattern. Trelliswork marquetry of *bois satiné* enclosing quartered lozenges of the same wood is used for the rest of the facade and for the sides, each of which has a single door that opens to a cupboard.

Particularly noteworthy are the bold and very decorative gilt-bronze mounts that are such essential elements in Cressent's work. These include Zephyr heads at either side (fig. 70), large scrolling acanthus leaves at the corners, and in the front a charming scene of two boys emerging from acanthus leaves who swing a monkey on a knotted rope.[CD] These gilded bronzes are clearly echoed in the outline of the amaranth veneer on which they are mounted, creating a great harmony in the overall design. As a sculptor, Cressent not only took special interest in the mounts but had them, against guild regulations, cast and finished in his own workshop, which brought him repeatedly into difficulties with the guilds of the *fondeurs-ciseleurs* (casters and chasers) and *ciseleurs-doreurs* (chasers and gilders).

This type of commode with cupboards at the sides and highly original bronzes can be clearly recognized in the detailed descriptions of the sale catalogues for the three auctions that Cressent, when pressed by financial difficulties, organized of his own stock and art collections. The first catalogue, of 1749, in which a pair of such commodes are listed, stressed their extraordinary shape that was said to be different from anything that had been made until then.[6] Except for the tops of Verret marble (also known as Sarrancolin marble or *marbre d'Antin*), which appears to have been a favorite of Cressent's, this description matches the Museum's commode.[7] Also, the crowned-C tax marks on the mounts accord with the date of Cressent's first sale. Imposed by a royal edict of February 1745, this tax mark (the C stands for *cuivre*, or copper, the main ingredient of bronze) was in use until February 1749. Any bronze above a certain weight sold during that period had to be struck with this stamp to show that duty

had been paid.[8] Four commodes of this type, with either brocatelle or Sarrancolin marble tops, were included in Cressent's sale of 1757. Three of them must have been sold because only one commode of this type was listed in the 1765 sale.[9]

The overall shape, the geometrical marquetry (known as parquetry) executed in a combination of amaranth and *bois satiné*, and the inventive bronzes are typical of Cressent's work, and other less easily visible elements are characteristic of his oeuvre as well. The construction of the carcase, for instance, consisting of a combination of oak and pine, is another of this master's trademarks, as is the use of walnut for parts of the drawers.[10] The interior of the side cabinets has been stained red to match the color of the amaranth veneer on the inside of the curving doors.[CD] This feature is repeated in most of the commodes of this group. Typical of commodes by Cressent, which constituted the majority of his oeuvre, is also the fact that he rarely used an escutcheon to

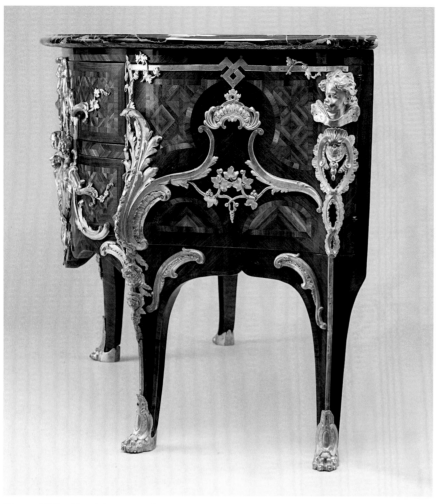

Fig. 70. Right side of the commode.

frame his keyholes but incorporated them in a much larger mount or otherwise sought to hide them. Here the keyhole on the lower drawer is tucked away underneath the monkey's left arm.[CD]

Little is known about the history of this commode, which, particularly in its ornament, shows development toward an advanced Rococo style. Bearing the trade label of Jean Rousselot (fig. 69), this commode appears to have been one of the few pieces by Cressent that passed through the hands of a *marchand-mercier* while the cabi-

netmaker was still alive.[11] Rousselot was active from about 1723 until 1756, and his establishment Au Chasteau de Vincennes, on the rue de la Monnaie, near the rue Saint-Honoré, was located in the center of the Parisian luxury trade, where many antiques dealers are still located today.[12] One of the highlights of the New York collection of Jack and Belle Linsky, who acquired the commode in Paris in 1952,[13] it was lent to the New York "Art Treasures Exhibition" several years later and was given to the Museum in 1982.[14]　　　　　D K - G

1. For biographical information about Charles Cressent, see Pradère 2003. Older sources are Salverte 1962, pp. 71–74; and Honour 1969, pp. 82–89. See also Watson 1966b, pp. 539–41.

2. Pradère 2003, pp. 26–30.

3. A number of these sale catalogue descriptions are quoted in Ballot 1919, pp. 237–48.

4. See Metropolitan Museum of Art 1984, pp. 208–9, no. 127 (entry by William Rieder).

5. Of the other five commodes, one is in the Musée du Louvre, Paris, and two are in the Museu Calouste Gulbenkian, Lisbon. Of the two commodes at Waddesdon Manor, Buckinghamshire, England, one is thought to date to the nineteenth century. Another commode of this model was sold at Sotheby's, New York, 8 November 1985, lot 356; Pradère 2003, pp. 162–63, 282–83.

6. Sale catalogue, 1749, lot 7: "Deux commodes d'un contour extraordinaire à toutes celles qui se sont faites jusqu'à présent, avec deux portes par les côtés, enrichies d'ornemens de bronzes. Il y a sur le devant deux enfans qui balancent un singe, le tout parfaitement bien sizelé; doré d'or moulu, le marbre de Verret du plus beau; elles portent quatre pieds six pouces; les deux tiroirs sont de hauteur"; quoted in Ballot 1919, p. 197.

7. An annotated copy of the 1749 sale catalogue indicates the price was 900 livres, and on this basis Alexandre Pradère has suggested that the pair were sold. In view of the marble, one of them could be the commode now in the collection of the Louvre; Pradère 2003, pp. 162–64, 282.

8. De Bellaigue 1974, vol. 1, pp. 31–35.

9. Ballot 1919, pp. 215, 231; and Pradère 2003, pp. 164, 342–43, no. 70.

10. Langer 1995, pp. 61–62, 65; and Pradère 2003, p. 218.

11. Rousselot's father-in-law, Louis Bosseux, may also have sold pieces by Cressent; Pradère 2003, p. 82. The text of the trade label translates as follows: "[At his shop,] Au Chasteau de Vincennes, on the rue de la Monaye, opposite the Porte des Balanciers de la Monaye, the dealer-jeweler Rousselot sells mirror glass [plates] of all sizes for apartments and carriages, mirrors, pier glasses and overmantel mirrors of all kinds; writing tables, commodes, secretaries, tables, coffers, tables or trays [for coffee or tea services], dressing tables and other marquetried or veneered work of all sorts of wood and varnishes enriched with gilded bronze or laquered [bronze], marble table [tops] with or without [wooden] frame and other furnishings of carved and gilded wood; wall lights, fire dogs, candlesticks and other work of gilded copper . . . leaf [gold], silvered, in color or laquered; porcelain from China and Japan, mounted or unmounted . . ."

12. Ibid.

13. Sold at Galerie Charpentier, Paris, 27 March 1952, lot 92.

14. *Art Treasures Exhibition* 1955, no. 286.

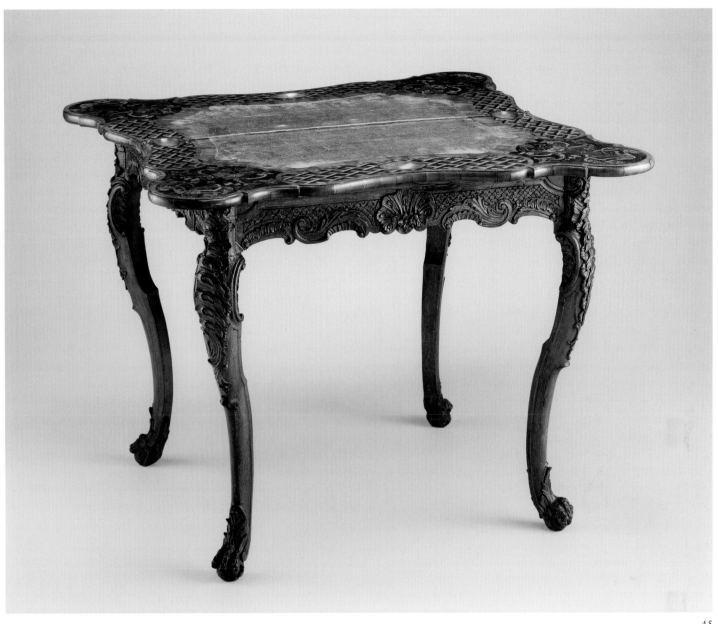

45.

Card table

German (Bamberg?), ca. 1745–50
Carved walnut frame; pine top with marquetry
of walnut, figured walnut, boxwood, alder burl,
birch, olive wood, plum, padauk wood, yew,
green-stained poplar, and other marquetry woods;
lined with modern velvet; iron fittings
H. 29½ in. (74.9 cm), w. 37½ in. (95.3 cm),
d. (closed) 18½ in. (47 cm), d. (opened) 37½ in.
(95.3 cm)
Inscribed in blue on the inside of the frieze:
"v. Zandt."
The Lesley and Emma Sheafer Collection,
Bequest of Emma A. Sheafer, 1973
1974.356.126

Dating to the late 1740s, this folding card table with its serpentine lines comes from Schloss Seehof. Situated north of Bamberg in Franconia, this castle, also known as Marquardsburg, was built during the late seventeenth century as the country seat of the prince-bishop of Bamberg, Marquard Sebastian Schenk von Stauffenberg (1644–1693).[1] It is believed that the Italian architect Antonio Petrini (1624/25–1701) was responsible for the construction of this building with four monumental corner towers arranged around a square courtyard. The interior decoration and the furnishing

of Seehof were carried out by the successive bishops of Bamberg, to whom the estate belonged until church properties were secularized in 1802.

Johann Philipp Anton von Franckenstein (1695–1753), prince-bishop from 1746 to 1753, did much to embellish the castle and its park (see also the entry for no. 61). He commissioned the painter Giuseppe Appiani (1701?–1785/86) to decorate the Weisser Saal (White Hall) with mythological scenes of such deities as Diana, goddess of the hunt; Pomona, goddess of fruit and gardens; and Neptune, god of the waters. These sub-

jects were quite appropriate for a summer residence, where pastimes such as hunting, gardening, and fishing were enjoyed. Franckenstein also engaged the talented Ferdinand Tietz (1708–1777), whom he appointed court sculptor in 1748, to execute a large group of stone figures and benches for the gardens.[2] It is altogether possible that Franckenstein acquired the Museum's card table for Seehof as well.[3]

Four slender cabriole legs ending in leaf-and-paw feet support the rectangular top with rounded forecorners, which can be opened to form a square. Iron hinges allow the frame to extend by concertina action (see the entry for no. 34) and sustain the unfolded top. Hooks on the inside of the frame prevent the table from being folded back once opened, and a locking mechanism does exactly the opposite—it prevents the table from extending once folded.

A carved, solid walnut frame in combination with colorful marquetry is characteristic of furniture originating in southern Germany. This table's carved frieze is embellished on all sides with symmetrical ornament consisting of a central shell flanked by scrolling-leaf and rocaille motifs, and it also displays incised and punched trelliswork. Asymmetrical rocailles, shells, and S-shaped and C-shaped scrolls are carved on the knees and extend down the legs. The top shows fine marquetry decoration of symmetrical shells, strapwork, and scrollwork in both its open and its closed positions (fig. 71). Since the table was presumably more often than not kept folded and placed out of the way against a wall, the marquetry on the inside is particularly well preserved. It still shows striking contrasts between the various native and exotic woods, such as the boxwood and padauk used for the interlaced trelliswork against a walnut ground on two of the four sides, alternating with trelliswork of boxwood and plum on the other two sides.[4] This not only offered a rich variation of tones and textures but also, in a subtle way, identified the partnership of the players seated at opposite ends of the table. In addition to the natural colors of the different timbers, poplar stained green as a result of a natural fungal infestation, and not through the use of dye, is found on the closed top, enhancing its colorful appearance.[5] Giving definition to the leaves, husks, and other ornaments are the engraved details that have been filled with black paste. This engraving is particularly evident on the opened corners, which, oddly, would have been largely invisible when the piece was in use and candlesticks, providing light to the players, were put on top.[6][CD] Since the shallow wells for counters are placed precisely in the center of each side, two of them are cut through in the middle so that the top could be folded over.

Since he is known to have supplied a number of card tables to Schloss Seehof in 1751 and 1758, it has been suggested that the Bamberg court cabinetmaker Nikolaus Bauer (1700–1771) was responsible for this table as well;[7] however, judging by the modest sums Bauer was paid for his work (between three and six gulden), they must have been of a simple nature and are not grounds for attributing this elaborately embellished example to him. The combination of carved decoration and marquetry on the piece suggests not only a south German provenance but also that both a sculptor and a cabinetmaker were involved in its production. Strapwork is not uncommon in Bamberg marquetry, and the Museum's table may well have originated there.[8]

A 1774 inventory taken at Seehof lists no fewer than nineteen tables for card playing and gaming in the main building, indicating the popularity of this diversion at the court.[9] Characterized as "ordinaire," most of them must have been rather plain, per-

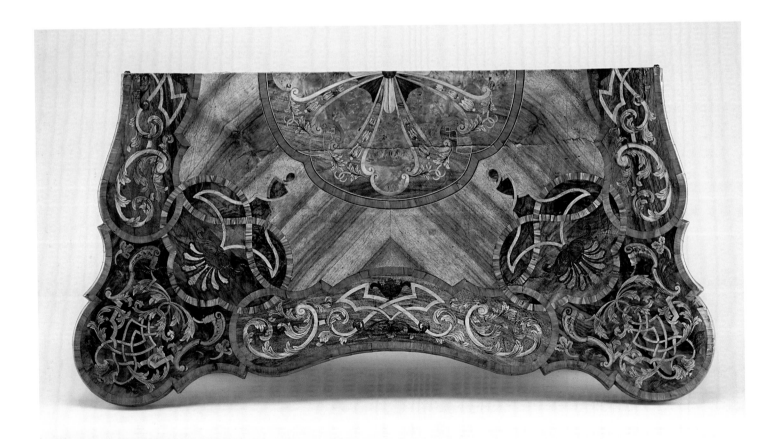

Fig. 71. Top of the closed card table.

haps intended for the servants' use. Two of the tables at Seehof appear to have been of higher quality, but neither of them can be identified with the Museum's table since the decoration as described in the inventory was different and since no folding mechanism is mentioned.[10] In subsequent inventories—of 1817–18 and 1820–21—however, references to "a folding card table with exotic wood and green velvet" could very well pertain to the present example.[11] Even more detailed is a listing of 1829, "one card table, the frame carved and the top partly inlaid and partly covered with velvet," a description that fits the Museum's table perfectly.[12]

Since the card table was not listed in the Seehof inventories of 1774 and 1802,[13] it probably became part of the castle's collections only after the secularization of the ecclesiastical estates. The property was part of the Bavarian royal domain when the inventories of 1817–18, 1820–21, and 1829 were drawn up, and during that time it was rented to various tenants.[14] When the country residence with its furnishings was sold to

Freiherr Friedrich von Zandt in 1842, the table remained there, for the inscription "v. Zandt" on the inside of the frame must refer to him or to one of his descendants. The card table left Seehof, together with many other artworks, after the last male heir of the family died in 1951. Acquired in 1956 by Emma A. Sheafer from the Munich antiques dealer Fischer-Böhler, it was part of the unexpected bequest this New York collector left to the Museum and was included in the exhibition of the highlights of her and her husband's collection in 1975.[15] DK-G

1. For the history of Seehof, see Kämpf 1955; Petzet 1993; and Feldhahn 2003.
2. Lindemann 1989, pp. 94–117, 320–26.
3. Sangl 1990, pp. 105–8, 207–10, no. 20, figs. 77, 78.
4. The veneers have not been officially analyzed. I am grateful to Marijn Manuels, Associate Conservator, Department of Objects Conservation, Metropolitan Museum, who made identifications based on the visual characteristics of the woods as observed with the naked eye and with the use of magnification.
5. For information about this fungus-stained wood and its early use, see Wilmering 1999, pp. 7, 15–16.
6. For an illustration of a card table in use with candlesticks placed at the corners, see Seelig 1995, pl. 64.
7. Kreisel 1970, p. 201, fig. 562; Hackenbroch and Parker 1975, no. 20; Metropolitan Museum of Art 1975, p. 261 (entry by James Parker); and D. Sutton 1982, p. 266. This attribution is disputed in Sangl 1990, pp. 208–10, n. 11.
8. Sangl 1990, p. 208.
9. Staatsarchiv Bamberg, Rep. B24, no. 756, fols. 51, 60, 85.
10. The inventory described them as follows: "1 Fürstlicher Spiehl Tisch mit Cramoisin Sammet überzogen und golden pordieret" and "1 fournirter Spiehl Tisch, in dessen Mitte ein fürstl. Verzogener Rahm" (1 princely game table covered with crimson velvet and gold trim, and 1 veneered game table decorated in the center with a princely coat of arms); Staatsarchiv Bamberg, Rep. B24, no. 756, fol. 85.
11. "Ein Spieltisch zum zusamenlegen mit fremden holz und grünen Sammet"; inventories of 1817–18, p. 2, and 1820–21, no. 25. Transcripts of these inventories are in the archives of Schloss Seehof. See also Kisluk-Grosheide 1989, pp. 100–101, fig. 3.
12. "1 Spieltisch, der Fuss mit Bildhauer-Arbeit, und eingelegter, und theilweise Samet überzogener Platte." At that time this table was placed in the corner dressing room; inventory of 1829, no. 423. A transcript of this inventory is in the archives at Schloss Seehof.
13. A transcript of the 1802 inventory is in the archives at Schloss Seehof.
14. Masching 1991, p. 67.
15. Glueck 1975; and Hackenbroch and Parker 1975, no. 20.

46.

Armchair (*fauteuil à la reine*)

French (Paris), ca. 1749
Attributed to Nicolas-Quinibert Foliot (1706–1776), possibly after a design by Pierre Contant d'Ivry (1698–1777)
Carved and gilded oak; covered in silk velvet with gold trim
H. 43½ in. (110.5 cm), w. 31½ in. (80 cm), d. 27½ in. (69.9 cm)
Incised on the back seat rail under the slip seat: "III." Written in ink twice on the back seat rail under the slip seat: "99." Branded on the underside of the front seat rail and on the wood frame of the slip seat: a crown between "C" and "R" with "4865." Written in ink on a small label: "9969."
Gift of J. Pierpont Morgan, 1906
07.225.57

On 26 August 1739 the eldest and favorite daughter of Louis XV, Madame Louise Élisabeth (1727–1759), was married by proxy in the chapel of Versailles to Don Philip (1720–1765), third son of Philip V, king of Spain. Criticized by some as an extravagant expense,[1] the splendid celebration of this alliance between France and Spain included a nautical fete on the Seine that culminated in spectacular fireworks.[2] Shortly afterward Madame Infante, as the young bride was thence known, departed for Madrid to join her new husband. As he was the youngest son, Don Philip's prospects of inheriting the Spanish crown were slim, but in 1748, by the terms of the Treaty of Aix-la-Chapelle, which concluded the War of the Austrian Succession, he was awarded three duchies in northern Italy: Parma, Piacenza, and Guastalla.

Parma's ducal palace was nothing more than an empty shell at the time, totally unsuitable for the new rulers.[3] Harboring the ambition to create a court that reflected her status, Madame Infante visited Paris before settling in Parma. An annual sum of 200,000 livres granted by her father allowed her to commission and buy furnishings in France.[4] When she left in 1749 after her stay at Versailles—the first of three such

visits—she traveled home to Parma with a convoy of thirty-four wagons loaded with gifts and purchases of tapestries, porcelain, bronzes, and furniture.

It has been suggested that the suite of seat furniture to which the Museum's sumptuously carved armchair belonged was in this first shipment. Two other armchairs of the set, which contained at least four such chairs, are extant, as is a settee.[5] The chairs and settee are thought to have been cut and carved in France and then shipped in pieces to be assembled and completed in Italy. In the absence of documentation and maker's stamps, the set has been attributed for stylistic reasons to Nicolas-Quinibert Foliot, possibly executed after a design by the celebrated architect and designer Pierre Contant d'Ivry.[6] Member of an important family of chairmakers active in mid-eighteenth-century Paris, Foliot, who in 1749 was *maître menuisier* (master joiner) to the Garde-Meuble de la Couronne, the bureau charged

with supplying furniture to the French court, would not have been responsible for the profusion of high-relief carving. Consisting of rocailles, shells, wing motifs, floral garlands, and C-scrolls, this must have been the work of an as yet unidentified carver. The decoration is distributed in an even, balanced manner on the top and front seat rails but is highly asymmetrical on the sides, its exaggerated Rococo ornament masking the joints between the armrests and the seat rails.[CD]

The Museum's armchair, with its pronounced shoulders and inward-scrolling feet, was gilded and upholstered in Parma.[7] The stippled decoration on the rails of the outer back is considered to be typically Italian.[8][CD] One of the other armchairs bears the inscription "Petrus," which most likely refers to Jean-Baptiste Petrus, a French upholsterer working at the court of Louise Élisabeth who may have been responsible for covering the set.[9] The chairs and settee are upholstered *à châssis*, with drop-in seats, removable backs, and arm pads to which the velvet is tacked underneath, making it easy to change the upholstery according to the seasons. The original crimson silk-velvet on the Museum's chair, now very worn, and the broad scalloping border of gold trim—much oxidized today—may have been sent from Paris. The settee has lost its original show cover, but the other two chairs have a more elaborate metal-thread embroidery that echoes the serpentine outline of the frame and complements the carved ornament. Both the passementerie and the embroidery are described in later court inventories as either on crimson velvet or damask-covered seat furniture.[10]

Both types of trim are also recorded in various paintings. A full-length portrait of Maria Luisa of Parma (1751–1819), the third child of Don Philip and Madame Infante, by the French artist Laurent Pécheux (1729–1821), for instance, shows her standing in front of an armchair that clearly belonged to the same set (fig. 72). Its red velvet is embellished with elaborate gold embroidery showing a pattern similar to that known from the other two extant chairs. A cushion in the lower left corner of the canvas, however, has simpler gold passementerie, not unlike that on the Museum's chair. Because the date of the portrait is January 1765, it has been convincingly argued that the setting is the Palazzo Ducale

in Parma, where the duke and his family usually spent the winter months. We know that Pécheux was lodged there at the time, and a contemporary description also mentions red and gold embroidered furniture and hangings in Don Philip's apartment at the palace.[11] All this strongly indicates that the furniture was at the ducal palace in the 1760s.

A series of inventory numbers painted or stamped underneath the frame of the chair tell us something about its subsequent history. The number 99, written in ink, corresponds to an entry in the 1811 inventory of the Palazzo Colorno, one of the ducal summer residences outside Parma.[12] Branded twice on the Museum's chair is an emblem consisting of the number 4865 with the letters *CR* (for Casa Reale, literally, royal house) separated by a crown. Dating to the year 1855, it shows that the chair had been returned to the main palace by that year (see fig. 73).[13] All the artworks and furnishings at the court of Parma were given such marks at the order of Louise-Marie-Thérèse de Bourbon (1819–1864), the last duchess of Parma. The number 9969 written in ink on a small label corresponds to the 1861 inventory of the Palazzo della Pilotta in Parma.[14] The chairs were then in storage on the third floor of that building, located next

to the ducal palace. This inventory was compiled after the departure of Louise-Marie-Thérèse, when the duchy of Parma had become part of Italy. Thereafter, most of the furnishings were transferred to the Palazzo Quirinale in Rome, which served as the residence of the Italian kings, but a few were sold. This chair was acquired at an unknown

Fig. 72. Laurent Pécheux, *Portrait of Maria Luisa of Parma (1751–1819), Later Queen of Spain*, 1765. Oil on canvas, 90⅞ x 64¾ in. The Metropolitan Museum of Art, New York, Bequest of Annie C. Kane, 1926 (26.260.9).

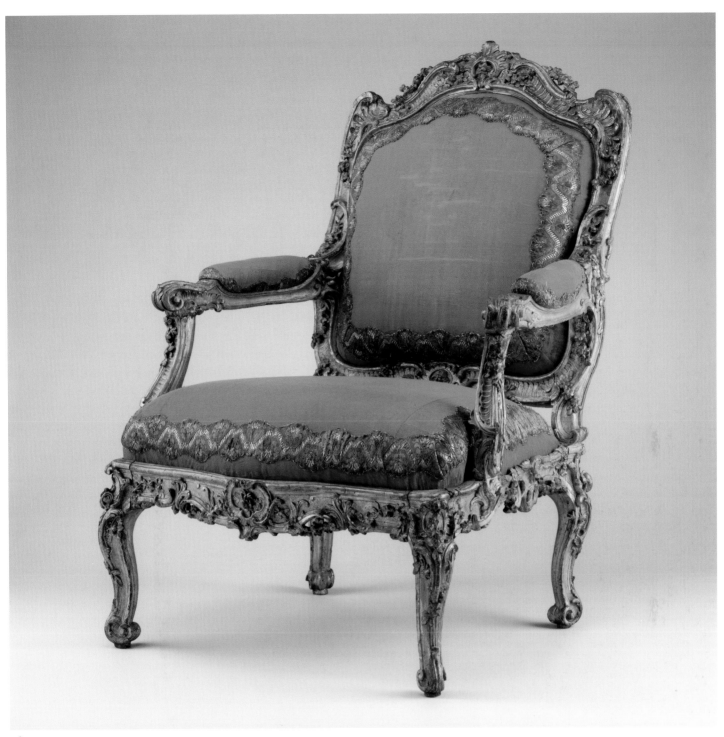

date by the French architect, ceramist, and designer Georges Hoentschel (1855–1915), who had assembled two outstanding collections in a building on the boulevard Flandrin in Paris. One was devoted to medieval and Renaissance art, the other to French decorative arts of the eighteenth century. The chair can be seen in an undated photograph of one of Hoentschel's French decorative-arts galleries (see illustration on page 2).[15] Most of Hoentschel's holdings, including the armchair of Madame Infante, were bought in 1906 by the financier and art collector J. Pierpont Morgan (1837–1913). He donated the French

decorative arts to the Museum the same year, and a special department was created to oversee this gift. At the initiative of Morgan, who served as a Museum trustee and was elected its president in 1904, a new wing was constructed by the firm of McKim, Mead and White to house the Hoentschel collection.[16] Louise Élisabeth's armchair has been on display almost constantly since it arrived at the Museum. DK-G

1. The marquis d'Argenson (1694–1757), who would serve as foreign minister of France from 1744 to 1747, suggested that there were one hundred better

ways to spend the money than to give opulent and ridiculous feasts in honor of the wedding; Argenson 1857–58, vol. 2, p. 31.

2. Parker 1966, pp. 177–78; and Boorsch 2000, pp. 30–31.

3. "le palais de Parme manque de tout, qu'il n'y a ni meubles, ni même d'escalier" (The palace at Parma is destitute of everything; it doesn't have any furniture or even a staircase); Argenson 1857–58, vol. 3, p. 252.

4. Briganti 1965; and Parker 1966, pp. 178–79.

5. One armchair is in the State Hermitage Museum, Saint Petersburg. Another is in a private collection in London, purchased at Sotheby's, Monaco, 21 June 1987, lot 1100. The settee is in the Palazzo Quirinale, Rome.

6. James Parker and Bill Pallot have both attributed the chairs to Foliot. Pallot suggested Contant d'Ivry as designer of the set. See Parker 1966, pp. 179, 182;

Pallot 1987, pp. 132, 134–35, 142–47; and Pallot 1995. Chiara Briganti attributed the settee to Jean Avisse; Briganti 1969, p. 45. Alvar González-Palacios does not exclude the possibility that Jean-Baptiste Tilliard (1685–1766) may have made the set; González-Palacios 1995, p. 167.

7. Alvar González-Palacios suggested that it may have been the work of a well-known gilder by the name of Ramoneda; González-Palacios 1995, p. 167.

8. Pallot 1995, p. 64.

9. Ibid.

10. González-Palacios 1995, p. 167.

11. Parker 1966, pp. 182–84.

12. "Quatre grandes chaises d'appui gravées et dorées avec dossier et fonds garnis en grande etoffe avec un grand galon haut de 60 milimètres et un autre petit d'argent haut de 40 milim" (Four large armchairs carved [?] and gilded, the back[s] and seats upholstered in a luxurious fabric, with a large galloon [trim] sixty millimeters wide and another, small one of silver forty millimeters wide); quoted in González-Palacios 1995, p. 167.

13. Bertini 1982; and González-Palacios 1995, p. 166.

14. "un seggiolone a bracciuoli, pressoché uguale ai due precedenti tranne che questo è guarnito di alto gallone in oro fino festonato" (an armchair almost identical to the previous two, in that it is adorned with a wide gold galloon [trim], finely festooned). The previous entry (9968) describes the two other extant armchairs with their embroidered decoration. See Bertini 1982, p. 52.

15. Hoentschel 1999, p. 179.

16. Tomkins 1989, p. 166.

47.

Armchair (*fauteuil à la reine*)

Southwest German, ca. 1750–60
Carved and gilded beech; covered in eighteenth-century blue damask not original to the armchair
H. 43 ¼ in. (109.9 cm), w. 29 ½ in. (74.9 cm),
d. 23 ½ in. (59.7 cm)
Bequest of George Blumenthal, 1941
41.190.74

The flowing, curvilinear silhouette of this exuberantly carved armchair is close in inspiration to a design attributed to the French ornementist and court goldsmith Juste-Aurèle Meissonier (1695–1750), who was named architect and designer to the king in 1726. Meissonier's chair is characterized by the same overall sweep of the back and cabochon-cartouches heading the legs, and a similar disposition of the armrests. As in the Museum's example, the crest and front rail are centered by an ornamental carving that retains a certain symmetry, although otherwise the Rococo ornament is full-blown.[1] An engraving by Meissonier published in Paris probably about 1735 resembles the drawing in many details and may have contributed to the popularization of the chair design abroad (fig. 74).

Thus, in its general form this German *fauteuil à la reine* is French, but the striking array of C-scrolls at the crest rail and the floral decoration on the central cartouche, as well as the expressive undulation of the side volutes in combination with the dramatic convex moldings of the armrest supports and scroll legs, have transformed the original Gallic conception into something much more dramatic, without compromising the French elegance or comfort.[2] In short, the composition of the frame elements has assumed a much greater importance in the German variation.[3] The gilding

on the front, much of which is presumably original, catches the light, showing off the refinement of the carving. As a whole, the armchair strikes the eye as gracefully light and fancifully stylish, although it is difficult to estimate how the original upholstery and show covers might once have influenced this impression. (The blue eighteenth-century damask covers and the upholstery beneath it date from a conservation project undertaken at the Museum in 1963)[4].

The chair is part of a set, of which three other pieces are known. One was until 1995 in the collection of the grand dukes and margraves of Baden at the castle of Baden-Baden in Germany.[5] The other two entered the Museum in 1974 with the Lesley and Emma Sheafer Collection.[6] Mrs. Sheafer had acquired the pair in 1958 from the Munich art dealer Fischer-Böhler. By that time, they had already been stripped of their gilding or paint and had tapestry show covers. One of them is depicted in a painting by Fritz Bayerlein (1872–1955) of the Green Salon at Schloss Seehof, near Bamberg (see the entry for no. 61),[7] and a photograph thought to date shortly after 1900, taken in the south wing of Seehof, shows the same chair or its twin in situ.[8] Nonetheless, no archival evidence exists to prove that the armchairs were part of the well-documented eighteenth-century furnishings of the castle. Most probably, they were brought to Seehof during the nineteenth century.[9]

The set to which the present chair belongs may be compared with other South German seating furniture, such as the Audience Chair of the Elector of Bavaria at the Munich Residenz, dating to about 1750.[10] In 1958 Fischer-Böhler attributed the design of the pair that Mrs. Sheafer bought to the

Franconian sculptor Ferdinand Tietz (1708–1777) and their manufacture to a workshop in Würzburg, but there is no written or circumstantial evidence for this. The strong French influence and the fact that one chair was formerly in the collection of the grand dukes and margraves of Baden suggest an origin for the set in southwestern Germany, possibly at a court workshop in Mainz, Bruchsal (see the entry for no. 41), Karlsruhe, the Palatinate, Württemberg, or the Baden-Baden region itself.[11] WK

Fig. 74. Juste-Aurèle Meissonier, *Projet d'un trumeau de glace pour un grand cabinet fait pour le Portugal* (detail), ca. 1735. Engraving. The Metropolitan Museum of Art, New York, Rogers Fund, 1918 (18.62.5).

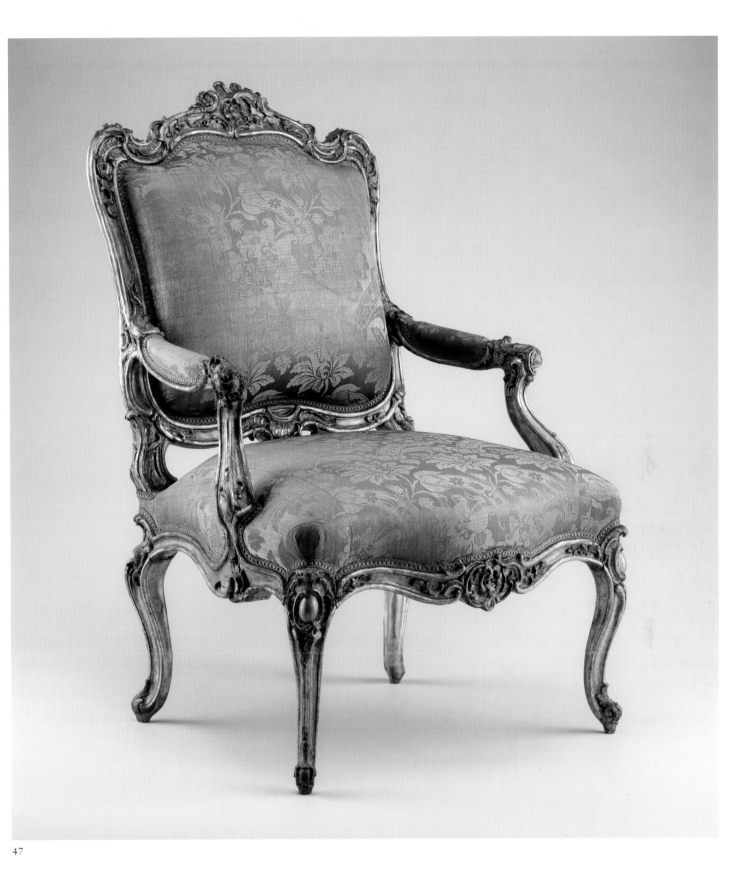

47

1. Fuhring 1999, vol. 2, pp. 360–61, no. 95.

2. For related French models, see Mannheim and Rahir 1907, no. 195; and Bremer-David 1993, p. 64, no. 91.

3. See Pons 1996, p. 217.

4. Archives of the Department of European Sculpture and Decorative Arts, Metropolitan Museum.

5. Catalogue of the Markgrafen von Baden collection sale, Sotheby's, Baden-Baden, 5–21 October 1995, vol. 1, lot 106. That chair was described in the catalogue as nineteenth-century; however, one month before the sale, this author personally exam-

ined it and concluded that the frame was eighteenth-century, with some restoration and several layers of regilding. The chair was auctioned again, at Kunsthandel Hampel, Munich, in 2002.

6. The accession numbers of this pair of chairs are 1974.356.199 and 1974.356.200.

7. Illustrated in Feulner 1929, pl. 45.

8. Langenstein and Petzet 1985, p. 11.

9. Masching 1991, pp. 72, 80, n. 70, figs. 26–28.

10. For the Electoral armchair, see Langer 2002, p. 228, no. 72 (entry by Brigitte Langer). For other exam-

ples, see Kreisel and Himmelheber 1983, figs. 460–65; and the catalogue of a sale at Christie's, Amsterdam, 11 December 2003, lot 214.

11. Kreisel and Himmelheber 1983, figs. 570, 580, 582 (these chairs have stylistically related, flowing, curvilinear ornament), 1058 (the movement of this clock is marked "Frankfurt," but the vividly designed case could have been carved in one of the court workshops mentioned).

48.
Armchair

English, 1751–52
Mahogany; covered in eighteenth-century
Beauvais tapestry not original to the armchair
H. 44 in. (111.7 cm), w. 32 in. (81.3 cm),
d. 28 in. (71 cm)
Gift of Irwin Untermyer, 1964
64.101.990

This armchair is part of a set of furniture that originally consisted of two settees and six armchairs. Three of the armchairs and one settee (fig. 75) are also in the Museum's collection.[1] The set is of particular interest because of its quality and well-documented provenance and because it appears to have been specifically made to carry French tapestry covers. As such, it is a rare example of seat furniture in a French style specially commissioned at this date for a prominent English Georgian house.

Grimsthorpe Castle in Lincolnshire has been the home of the Willoughby de Eresby family since 1516. It incorporates architecture from the early thirteenth century, the Tudor period of the reign of Henry VIII, and a large section, including a new north front, added in 1724 by Sir John Vanbrugh (1664–1726).

Peregrine, third duke of Ancaster (1714–1788), appears to have commissioned this set in the early 1750s as part of the extensive redecoration that he undertook following his marriage in 1750 to the heiress Mary Panton of Newmarket.[2] The set is unusual for English furniture of this period because of its wide proportions and the circular backs of the chairs, which were upholstered with a set of Gobelins coverings entitled *Jeux d'enfants*, after designs by François Boucher (1703–1770).[3] The seats were covered with Gobelins tapestry scenes from the fables of La Fontaine. The settees and chairs were parcel-gilt on the raised areas of carving.[4]

Grimsthorpe descended through the dukes of Ancaster until the death of the fifth duke in 1809, when the dukedom became extinct and the property passed to his niece, Priscilla, baroness Willoughby de Eresby (1761–1828). The set is described in her drawing room in an inventory of about 1813: "Two mahogany and gilt carved Sofas, stuff'd backs and seats cover'd with

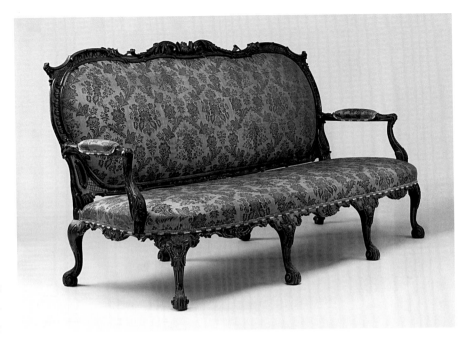

Fig. 75. Settee, English, 1751–52. Mahogany, covered in eighteenth-century lampas not original to the settee; 43¼ x 40½ x 82½ in. The Metropolitan Museum of Art, New York, Purchase, Arthur S. Vernay, Inc. Gift, and Gift of Arthur D. Leidesdorf, by exchange, 1971 (1971.236).

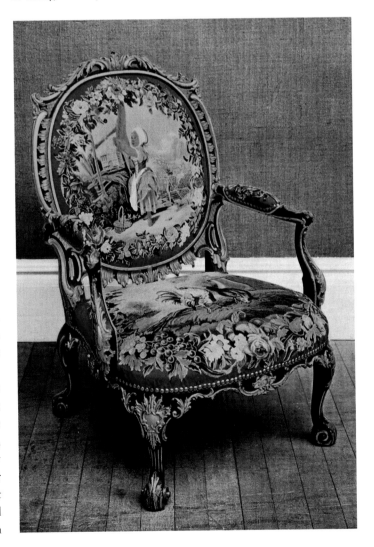

Fig. 76. Armchair from the same suite of furniture photographed at a sale at Sotheby's, London, on 1 May 1934. At that time this chair, which is now also in the collection of the Metropolitan (acc. no. 64.101.988), still had its original parcel gilding and Gobelins tapestry cover.

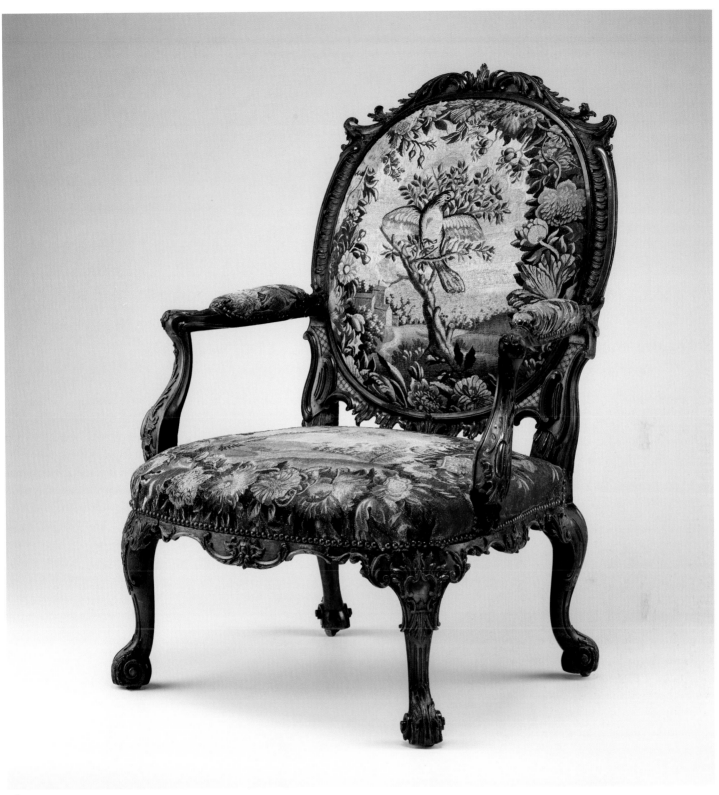

48

Tapestry de Goblins and brass nailed. Six Arm Chairs exactly to correspond with Do."[5] In 1829 the set was put up for sale at Christie's by Priscilla's eldest son and heir, Peter Robert, twenty-first baron Willoughby de Eresby (1782–1865), but it failed to sell and was brought back to Grimsthorpe. The set next appears in the 1867 inventory, but without the two settees, suggesting that they had by that date left the house. The six

chairs appear again in the 1901–3 inventory, where the coverings are described in detail. In 1924 the chairs were in the King James's Drawing Room at Grimsthorpe, seen in a photograph of that room in an article about the house in *Country Life*.[6] The chairs were offered for sale at Sotheby's in London in 1934, when they still had their original coverings (see fig. 76), but again they failed to sell at auction. This time

they were sold privately after the sale. The Gobelins coverings were removed and applied to six modern armchairs, which were bought by Dr. F. Mannheimer of Amsterdam and after World War II given to the Rijksmuseum, where they remain.[7] Judge Irwin Untermyer acquired four of the original chairs in 1949, by which time they had been stripped of their parcel gilding, and he had them upholstered with

their present eighteenth-century Beauvais tapestry.[8]

In 1928 H. Avray Tipping and Christopher Hussey stated that the chairs were "probably by Chippendale," but there is no record of Chippendale's having worked at Grimsthorpe, and there is no stylistic or documentary support for the attribution.[9] Even without an attribution and in their stripped and reupholstered state, the pieces from this set remain an important example of Francophile taste in mid-eighteenth-century England. WR

1. The accession numbers of the Museum's other two armchairs are 64.101.988,989. The other settee and the other two armchairs are in private American collections. The latter were sold most recently at the Arthur D. Leidesdorf sale, Sotheby's, New York, 27 June 1974, lot 31.

2. None of the eighteenth-century expense accounts for the furnishing of Grimsthorpe survive among the Ancaster papers, but the bank account of the third duke at Child's Bank records a considerable project of redecoration in 1751–52. See n. 5 below.

3. Several similar sets are known. For a discussion of these and the Boucher paintings in the Gobelins inventory, see Dauterman, Parker, and Standen 1964, pp. 279–81, no. 70, fig. 37.

4. Three of the chairs with their original upholstery and gilding still intact are shown in the Sotheby's, London, catalogue of 11 May 1934, lot 168, which

is reproduced in Rieder 1978a, p. 184, fig. 6.

5. "An Inventory of the House-Hold Furniture at Grimsthorpe Castle . . . the Property of the Right Honorable Lord Gwydir." The inventory is not dated, but many of the pages are watermarked 1813. The inventories at Grimsthorpe relating to this furniture were studied and transcribed by Colin Streeter.

6. Hussey 1924, p. 653, fig. 7.

7. Rijksmuseum 1952, pp. 330–31, no. 477.

8. Hackenbroch 1958a, p. 31, figs. 143–47, pls. 116–20; and Metropolitan Museum of Art 1977, p. 81, no. 144 (entry by William Rieder).

9. Tipping and Hussey 1928, p. 316, fig. 472, and p. 318. The furniture attributed to Chippendale currently at Grimsthorpe came from Normanton Park, Rutland, in the early 1920s; C. Gilbert 1978b, vol. 1, pp. 248–49.

49.

Standing shelf

English, 1753–54
William Linnell (ca. 1703–1763) and John Linnell (1729–1796)
Pine and mahogany carcase; fretwork panels of English walnut; the whole japanned black, gold, and red
H. 59 in. (149.9 cm), w. 23 in. (58.4 cm), d. 10½ in. (26.7 cm)
Pasted underneath the bottom shelf are two round stickers on which are printed and inscribed, respectively: "Irwin Untermyer Collection"; and "32A" and "F." A third sticker is glued on the inside of the right rear leg.
Gift of Irwin Untermyer, 1964
64.101.1124

"A few years ago everything was Gothic . . . according to the present prevailing whim, everything is Chinese, or in the Chinese taste: or, as it is sometimes more modestly expressed, partly after the Chinese manner," declared the author of an article on taste, the March 1753 issue of the *World*.[1] Dating back to the seventeenth century, chinoiserie, a style consisting of fanciful designs evoking an imaginary China, reached new heights of popularity during the mid-eighteenth century and flourished well past the introduction of Neoclassicism. Pattern books such as the four-part *New Designs for Chinese Temples* (1750–52) by the architects William (d. 1755) and John Halfpenny catered to the craze, as did numerous designs for furniture in the Chinese taste, for example, those published by Thomas Chippendale (1718–1779) in his *Gentleman and Cabinet-Maker's Director* (1754).

The British passion for chinoiserie was well expressed in the bedchamber at Badminton House, Gloucestershire, which was redecorated in 1753–54 for Charles Noel, fourth duke of Beaufort (1709–1756). The walls of this room were hung with Chinese paper, and the London cabinetmaking firm of William Linnell and his son John supplied a set of furniture in the Chinese manner that included four standing shelves, one

pair of which is in the Museum's collection.[2] A preparatory watercolor design for the armchairs by the younger Linnell is the only drawing for the set that has been preserved.[3] No bills for the bedroom furniture exist, but the entire suite may have been included in the duke of Beaufort's large payment of 800 pounds sterling to the firm between 1752 and 1754.[4] Because the account book of the duchess lists certain sums paid to the Linnells,[5]

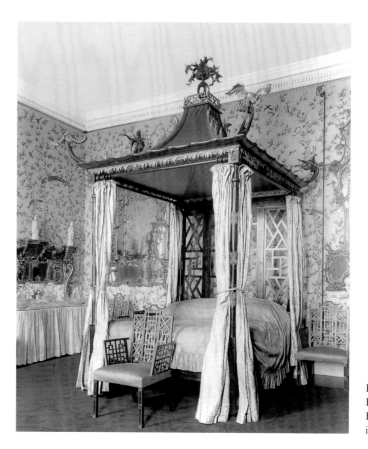

Fig. 77. Chinese Bedchamber at Badminton House in 1908.

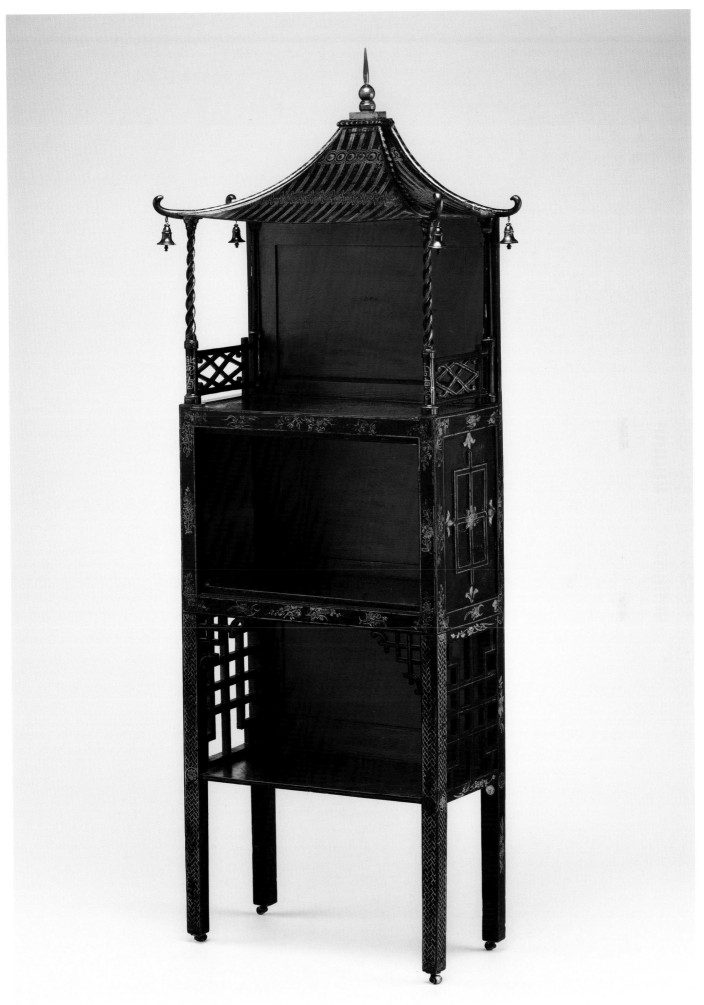

it may have been the duchess rather than the duke who dealt with the cabinetmakers, choosing a design and commissioning this exotic set. Whatever the case may be, the furniture was at Badminton in 1754, when it was described in situ by Dr. Richard Pococke (1704–1765), who visited the house and commented on the "bedchamber finished and furnished very elegantly in the Chinese manner."[6]

The commanding feature of the room was a striking japanned bed with a pagoda-shaped tester, now in the Victoria and Albert Museum, London, that may well have been inspired by the architecture of Chinese temples or garden pavilions.[7] It was originally hung with chintz curtains, which had been replaced when *Country Life* photographed the Badminton bedroom in 1908 (fig. 77). The headboard consists of pierced fretwork panels, which are repeated on other pieces from this set, such as the commode, the armchairs, and the two pairs of standing shelves.[8] Intended for the display of porcelain, the latter are smaller and less elaborate than the designs for china shelves on legs published in Chippendale's *Director*.[9] Fitted with three open compartments, they have open and blind fretwork sides, and pierced latticework balustrades frame the top section. Little bells are suspended from the upturned eaves of the pagoda-shaped roof, which is resting on turned spiral supports in front.

Redecorated and touched up several times, the Museum's standing shelves are currently japanned in black, with flat decoration in gold that includes floral motifs as well as Chinese characters, some of which are imaginary.[CD] The interior is painted red, and there is evidence that other areas were once red as well. In fact, Linnell's drawing suggests that red was the dominant color for the chairs, with highlights executed in blue and yellow. Red and two tones of blue japanning are still present on the headboard of the bed and were originally found on the fretwork of the chairs and possibly also on the commode.[10] In addition, there is yellow paint on the bed, and traces of it are found on the Museum's shelves.[11] Deviating from Linnell's design, the original decoration of the suite may have included black and gold japanning, and if so, not all of it has to be of a later date. The pagoda-shaped tester of the bed and the roofs of the shelves, for instance, may always have been

embellished in this manner. The drawer fronts and top of the commode as well as the central uprights of the chairs' open backs may also originally have been black and gold. Such colorful fretwork was described as "a few laths nailed across each other and made Black, Red, Blue, Yellow, or any other Colour" by the architectural theoretician Robert Morris (ca. 1702–1754), who sweepingly disparaged the whole "Affectation of the (improperly called) *Chinese Taste . . . without Rules or Order*" in his *Architectural Remembrancer* (1751).[12]

Unlike true Asian lacquer, japanning is not very durable, and it is not surprising to learn from the Badminton House records that refurbishing was done in the Chinese Bedroom during the first half of the nineteenth century. Harley and Langs were paid in 1841 "for [supplying] Gold leaf Gilders tools Brass Ornaments Lacquering Furniture . . . for J. Coffey's use." The gilder, polisher, and cabinetmaker John Coffey, active at the house between 1837 and 1848, may, therefore, have refinished the set, but if so, we do not know how much work was involved. Samuel Lang supplied "turned bells for Ornaments to furniture in the Chinese Room" in 1843.[13] These were probably replacements for bells missing from the standing shelves.

Although they were commissioned for the bedchamber, the Museum's pair of shelves, described as "Chinese ornament stands" in the 1835 inventory, were to be found that year in the East Breakfast Room, later known as the Red Room, where they still were in 1913.[14] These records show that other rooms at Badminton were also richly appointed with furniture in the Chinese manner, much of which, including the suite by Linnell, was sold by the ninth duke of Beaufort in 1921.[15] Judge Irwin Untermyer subsequently acquired the present set of standing shelves and placed them in the small porcelain room of his New York apartment.[16] Confounding Robert Morris's assessment of the Chinese taste, the Linnells' design for "ornament stands" proved very popular and has been repeated a number of times during the past 250 years, as recently as the late twentieth century.[17]

D K - G

1. 22 March 1753, *World* (London); reprinted in Fitz-Adam 1782, p. 69. The article is signed with the initials "H.S." The first documented English commission for furnishings in the Chinese manner was from Mrs. Elizabeth Montagu (1720–1800). In 1752 William Linnell supplied various pieces of furniture with latticework decoration for the Chinese Room at Mrs. Montagu's London house; Hayward and Kirkham 1980, vol. 1, p. 108, vol. 2, p. 50, figs. 99, 100.

2. Hayward 1969a, pp. 134, 137, 139, fig. 7. The label on the bottom of the pair to the present shelf is inscribed, possibly, "32B." The accession number of that shelf is 64.101.1125. The second pair of standing shelves is in the Lady Lever Art Gallery, Port Sunlight.

3. Hayward 1969b, pp. 18, 83, fig. 1. The drawing is illustrated in color in Jackson-Stops 1985, p. 437.

4. Hayward and Kirkham 1980, vol. 1, p. 108.

5. Wilk 1996, p. 104 (entry by Tessa Murdoch).

6. Quoted in Hayward and Kirkham 1980, vol. 1, p. 108.

7. See Wilk 1996, pp. 104–5 (entry by Tessa Murdoch).

8. The chintz curtains are mentioned in passing, with no further details, in an unsigned manuscript description of the bedroom at Badminton of 1759, now in an English private collection. The commode is also at the Victoria and Albert Museum, London, as is one pair of armchairs. Another pair of armchairs is in the Bristol Museum and Art Gallery. There may have been other pieces in this set.

9. Chippendale 1762, pls. CXLI–CXLIII.

10. Technical analysis of one of the armchairs in the Victoria and Albert Museum confirms that the original red, blue, and yellow paint layers are present under the black and gold japanned surface. Incidently, blue and red fretwork railings can be seen in eighteenth-century Chinese block-printed and painted paper hangings in the Victoria and Albert Museum (E 412-413-1924).

11. They are on the underside of the latticework that forms part of the railings of the top section. This paint has not yet been analyzed. It has been determined that the yellow paint on the Badminton bed is a chrome yellow, a color not widely available in England until the early nineteenth century and for that reason probably not part of the original color scheme.

12. Morris 1751, postscript.

13. Murdoch 1991, p. 9.

14. Badminton Archives, inventory of 1835 (FmN 5/1/1), fol. 101. Described as pagodas, they were listed as in the Red Room in the inventories of 1849 (RA 1/1/10a), fols. 22–23, and of 1913 (RA 1/1/13). I am grateful to the archivist at Badminton House, Mrs. Margaret Richards, for this information.

15. Catalogue of a sale at Christie's, London, 30 June 1921. The four standing shelves were apportioned into lots 50 and 51 and were acquired by the London dealer Frank Partridge.

16. Hackenbroch 1958a, p. 61, pl. 254, fig. 295. See also Metropolitan Museum of Art 1977, pp. 83–84, no. 150 (entry by William Rieder).

17. Similar shelves have passed through the art market, some of the period, others later copies. Some are fitted with doors, additional fretwork brackets, or more elaborate japanned decoration. See, for instance, the following sale catalogues: Christie's, London, 31 May 1978, lot 280; Christie's, London, 19 November 1981, lot 30; Christie's, London, 24 June 1982, lot 52, and again, Christie's, New York, 19 April 1986, lot 154; Christie's, London, 13 April 1989, lot 135; Christie's, South Kensington, London, 10–11 July 1989, lot 391; Christie's, London, 12 November 1998, lot 235; and Sotheby's, New York, 19–20 April 2001, lot 466.

50.

Armchair (*fauteuil à la reine*)

French (Paris), 1754–56
Nicolas-Quinibert Foliot (1706–1776)
Carved and gilded beech; covered in tapestry made at the Beauvais Manufactory, displaying two ducks on the back and a dog stalking a duck on the seat
H. 41⅞ in. (106.4 cm), w. 30½ in. (77.5 cm), d. 25½ in. (64.8 cm)
Branded inside the back seat rail and inside the slip seat: a crowned G. Incised inside the back seat rail, inside the slip seat, on the slip back, and on the armrests, respectively: "VII," "X," "VIII," and "I" and "VIIII." Written inside the slip seat: "VIII".
Purchase, Martha Baird Rockefeller Gift, 1966 66.60.2 (frame)
Gift of John D. Rockefeller Jr., 1935 35.145.23c–d (arm-pad tapestries), 35.145.25b (seat tapestry), 35.145.26a (back tapestry)

The Danish statesman of German origin Baron Johann Hartwig Ernst Bernstorff (1712–1772) remarked about King Frederick V of Denmark (1723–1766) that he "loved France with a passion."[1] The same could be said of Bernstorff, who was a true Francophile and was credited with speaking the language better than many French people.[2] During his tenure as Danish ambassador at the court of Versailles, from 1744 until 1751, Bernstorff developed a marked preference for the arts of France and lived in a beautifully furnished hôtel in the rue Bourbon in Paris.[3] In 1752, not long after he was recalled to Copenhagen to assume the post of minister of foreign affairs, Bernstorff began building a grand town house in a new part of the city named Frederiksstaden, after the king. Although the exterior of the house, designed by Johann Gottfried Rosenberg (ca. 1709–1776), betrays German influence, the interior decoration was according to the latest French taste.

Particularly beautiful was the tapestry room on the main floor (fig. 78), embellished with four hangings from the series *Les Amours des Dieux* (The Loves of the Gods). Woven of wool and silk at the Beauvais Manufactory in 1754, after designs by the painter François Boucher (1703–1770), these tapestries were commissioned for Bernstorff by his friend the collector Louis-Antoine Crozat, Baron de Thiers (1700–1770), who acted as his representative in France.[4] To complement these tapestries, a set of twelve chair backs, seats, and matching armrests as well as the covers for two settees were woven at the same time.[5] The set of wall hangings and the tapestry-covered seat furniture—two settees and twelve armchairs, including this one—were shipped to Copenhagen and installed in 1756. A marble fireplace and overmantel mirror as well as three pier glasses and three console tables were also made in France for this room, as were the gilt-bronze three-light candelabra signed by François-Thomas Germain (1726–1791) and based on designs by Pierre Contant d'Ivry (1698–1777).[6] The splendid carved and gilded armchairs and settees that were arranged against the walls of the room must have formed an important element of the decoration, which was described by Baron de Thiers as "satisfying our ultimate conception of exquisite luxury."[7]

The frames of the seat furniture were made by the Parisian joiner Nicolas-Quinibert Foliot, who stamped eight of the chairs, but not the one illustrated here, and one of the settees. Established in the rue de Cléry, just like his father, Nicolas Foliot (ca. 1675–1740), whom he succeeded as *menuisier du Garde-Meuble du Roi*, the younger Foliot supplied many pieces to the court. Characteristic of his furniture is the somewhat massive, undulating outline of the chairs in this set, enlivened by symmetrically placed Rococo ornament such as the floral garlands, palm branches, and stylized leaves, which are gadrooned. A prominent shell motif forms the center of the back rail on both the chairs and the settees (fig. 79). Supported on cabriole legs, the feet are elegantly adorned with a large flower head.[CD] The set is upholstered *à châssis*, with removable tapestry seats, armrests, and backs, displaying colorful compositions of birds and animals in landscapes after designs by the painter Jean-Baptiste Oudry (1686–1755), codirector of the Beauvais Manufactory from 1734 until his death.[8] Yellow and brown symmetrical borders of scrolling foliage and rocaille motifs surround these scenes that clearly reflect the outline of the seat furniture, creating a beautiful harmony between the woven covers and the carved and gilded wooden frames.

The tapestry room remained intact until the beginning of the twentieth century, despite the vicissitudes of Bernstorff's house after his death. He bequeathed it to his nephew Andreas Peter Bernstorff (1735–

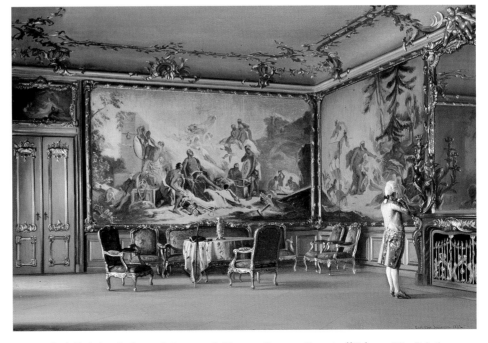

Fig. 78. Carl Christian Andersen (1849–1906), *Tapestry Room at Bernstorff Palace*, 1882. Painting. Current location unknown.

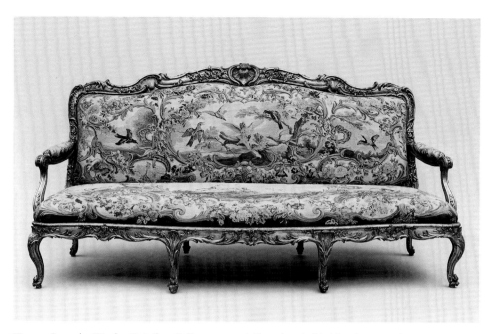

Fig. 79. Settee by Nicolas-Quinibert Foliot, 1754–56. Carved and gilded beech, covered in tapestry woven at the Beauvais Manufactory; 44 x 92½ x 32 in. The Metropolitan Museum of Art, New York, Gift of John D. Rockefeller Jr., 1935 (frame 35.145.1; tapestries 35.145.15a–d).

1797), who, like his uncle, served as foreign minister of Denmark.[9] The property was sold by his son to developers. It was divided and later reunited, and in 1829 became the residence of Prince Frederick Ferdinand (1792–1863) and his bride, Princess Caroline (1793–1881), the eldest daughter of the Danish King Frederick VI. There were renovations to the palace, but the tapestry room was left unaltered and the seat furniture was listed as in situ in the inventory drawn up during that same year.[10] The widowed Princess Caroline remained in the house until the end of her life. The next owner of the Bernstorff palace was King George I of the Hellenes (1845–1913), the second son of King Christian IX of Denmark (1818–1906), who stayed there during visits to his country of birth. It was during this time that the crowned-G mark was branded into the wood of the furniture seats, identifying the pieces as his property.[CD] George I sold the seat furniture and the tapestries separately, early in the twentieth century. By 1902 the American financier and collector J. Pierpont Morgan (1837–1913) had acquired the Foliot chairs and settees from the London dealer Charles Wertheimer.[11] Morgan kept the set with most of the rest of his collection at his London town house to avoid paying United States import duties on artworks more than one hundred years old. Much to their surprise, Queen Alexandra of England (1844–1925) and her sister Dowager Empress Marie of Russia (1847–1928),

both Danish princesses, recognized the seat furniture during a visit in 1908 as having belonged to their brother George I.[12] After the tariff was lifted, the suite was shipped to New York as a loan to the exhibition of Morgan's collection held at the Museum in 1912. Morgan died the next year, and, in 1915, following the exhibition, the furniture was returned to his heirs, who sold the settees and chairs to the New York art dealership Duveen Brothers. Presumably hoping to make a double profit, Joseph Duveen (1869–1939) had the tapestry covers removed from their eighteenth-century frames and fitted on Louis XV–style chairs and settees that were specifically made for this purpose by Carlhian et Cie, the Parisian decorating firm of Paul Carlhian and his brother André.[13] In 1919, assuming he was acquiring antique furniture, one of Duveen's regular clients, the philanthropist John D. Rockefeller Jr. (1874–1960) agreed to purchase, for the staggering sum of 650,000 dollars, what was in fact a set of twelve reproduction chairs and two reproduction settees with the Beauvais covers from the Bernstorff tapestry room.[14] The seat furniture was included in this condition in the Metropolitan Museum's fiftieth-anniversary exhibition the next year.

The original pieces of furniture received modern upholstery, and half of the set was sold; the other half remained with the dealer. Only in 1948 was it discovered that the frames of the seat furniture in the

Rockefeller collection were new, and a thoroughgoing effort was made to locate the eighteenth-century frames. In 1951 six of the original chairs and one settee were found in the Duveen Brothers warehouse, and the remaining half of the set turned up in 1965 at the Gothic Revival–style manor house Lyndhurst, in Tarrytown, New York. The last owner of this house had been Anna, duchess of Talleyrand-Périgord (1875–1961), the youngest daughter of the railroad magnate Jay Gould (1836–1892), who was an avid collector of French furniture.[15] Having subsequently been acquired for the Rockefellers, the entire suite of seat furniture and tapestry covers eventually came into the possession of the Museum.[16] Clothed once again in their original upholstery, the armchairs and settees serve as excellent reminders of the fact that French furniture was widely admired during the eighteenth century and served as elegant furnishings for residences all over Europe.

D K - G

1. "aimait la France à la fureur"; quoted in Reau 1971, p. 55.
2. Luynes 1860–65, vol. 6, p. 452.
3. Rémusat 1917, pp. 398–99.
4. Two of these tapestries—*Vulcan Presenting Arms for Aeneas to Venus* and *Bacchus and Ariadne*—are in the Museum's collection (acc. nos. 22.16.1, 2). See Standen 1985, vol. 2, pp. 534–35, no. 79.
5. The set of furniture consists of two settees and twelve armchairs with Beauvais tapestry covers. Frames: Gift of John D. Rockefeller, Jr., 1935 (35.145.1–7); Gift of Martha Baird Rockefeller, 1966 (66.59.1–5); Purchase, Martha Baird Rockefeller Gift, 1966 (66.60.1–2). Tapestries: Gift of John D. Rockefeller, Jr., 1935 (35.145.15a-d–35.145.28a-d).
6. Parker 1973, pp. 368, 371. Most of these furnishings are still in place. Two tables and a pier glass, still in situ, are illustrated in Pallot 1987, pp. 166–67.
7. "dans le goût de notre dernière volupté"; quoted in Krohn 1922, vol. 1, p. 74.
8. Standen 1985, vol. 2, pp. 484–98, no. 74.
9. The history of the furniture is largely derived from Parker 1973.
10. Rigsarkivet, Copenhagen, Hofmarskallatets Arkiv I. F. 34. An excerpt is in the archives of the Department of European Sculpture and Decorative Arts, Metropolitan Museum.
11. A photograph of two of the armchairs, said to be in the collection of Charles Wertheimer, was published in Molinier 1902a, p. 26.
12. Taylor 1957, p. 24. The seat furniture was in Morgan's bay-windowed back parlor; see Thom 1999, p. 34.
13. See the correspondence of 26 July 1919 between Duveen and Carlhian referring to the making of new chairs and a settee for the "Morgan" tapestries. Carlhian Firm Records 1867–1975, box 386, dossier 9. I am grateful to Charlotte Vignon, Annette Kade Art History Fellow, 2005–2006, Metropolitan Museum, for sharing this information with me.

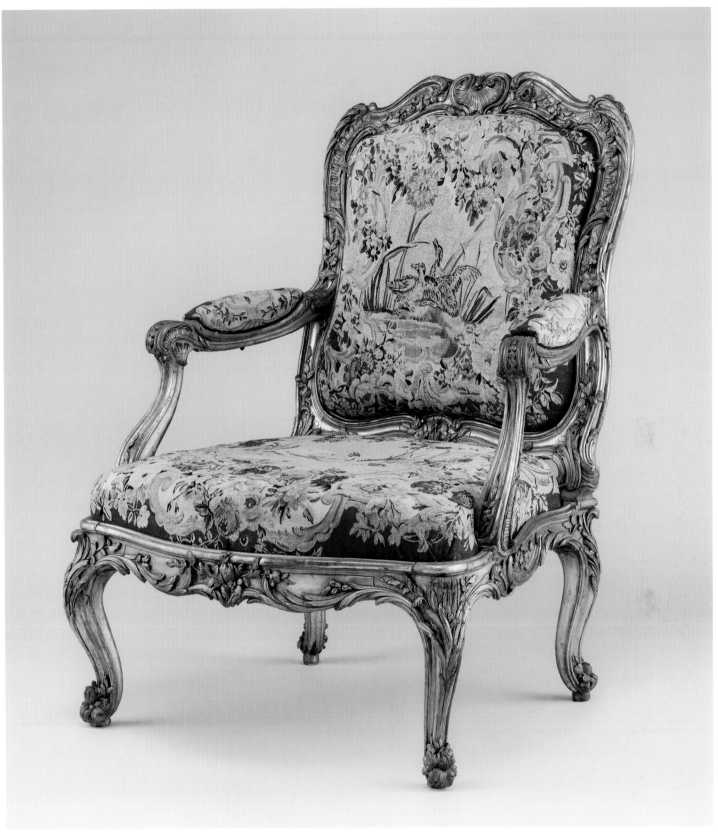

50

14. An agreement was drawn up on 7 July 1919 between John D. Rockefeller Jr. and Duveen Brothers. Rockefeller agreed to buy a set of ten Gobelins tapestries depicting ten months of the year, the Bernstorff tapestry-covered seat furniture said to have been in the possession of the king of Sweden, and the portrait of Lady Dysart by Sir Thomas Lawrence (1769–1830). The transaction was dependent upon delivery of the Lawrence painting. Duveen Brothers Records 1876–1981, Papers and Correspondence, 1901–81, box 504 (microfilm, reel 359). The invoice for the tapestries and seat furniture is dated 31 May 1920. Duveen Brothers Records 1876–1981, Business Records, 1876–1964, Salesbook 2, June 1919–May 1920, box 165 (microfilm, reel 59).

15. Peck 1998, pp. 16–17, 48.

16. Half of the eighteenth-century set has retained some of its original gilding. The gilding on the other half was replaced by gold paint at some point after 1951. See the detailed memorandum by James Parker in the archives of the Department of European Sculpture and Decorative Arts, Metropolitan Museum.

51.

Writing table

French (Paris), ca. 1755
Bernard van Risenburgh II (ca. 1696–ca. 1767)
Oak veneered with tulipwood, kingwood,
amaranth, mahogany, ebony, mother-of-pearl,
and stained horn; the drawers of mahogany and
mahogany veneer on oak; gilt-bronze mounts;
the main writing slide lined with modern velvet
H. 30¾ in. (78.1 cm), w. 38 in. (96.5 cm),
d. 22⅝ in. (57.5 cm)
Stamped beneath the back rail in the center of
the top (partly effaced): "B.V.R.B." and "JME."
Painted inside the left drawer and underneath
the top, respectively: "4762" and "107."
Gift of Mr. and Mrs. Charles Wrightsman, 1976
1976.155.100

Floral marquetry, so fashionable in France during the reign of Louis XIV (1643–1715), fell out of favor during the following decades (see the entry for no. 14). It was reintroduced during the 1740s, with stylized rather than naturalistic flowers, by Parisian cabinetmakers such as Jean-Pierre Latz (ca. 1691–1754) and, especially, Bernard van Risenburgh II.[1] These *ébénistes* experimented successfully with end-cut woods, mostly the exotic Brazilian kingwood—violet colored and with dark, expressive stripes—to simulate the veining of leaves. Harmonizing with the serpentine lines of Rococo furniture, the scrolling flower stems and foliated branches were usually inlaid in a reddish background of quartered *bois satiné* and later of beautifully variegated tulipwood, both also imported from Brazil.[2]

Among the examples of floral marquetry furniture by Van Risenburgh are several elegant writing tables with a curvilinear top supported on cabriole legs.[3] Fitted with a drawer on either end and with three pull-out shelves for composition or for taking dictation, these tables are veneered on top with a scrolling cartouche enclosing floral sprays.[CD] All four sides and the main writing slide in front show similar foliated branches within a shaped frame. Whereas for several of these tables Van Risenburgh used only inlays of end-cut woods, the Museum's example is a richer and more colorful variant, including engraved mother-of-pearl and tinted horn as well (fig. 80).[4] The stems and branches are made of ebony, and green-stained horn was selected for the leaves. The flowers consist of pieces of either red- or blue-stained horn as well as of white translucent mother-of-pearl. There is evidence of replacements and, probably in an attempt to stop further losses and create an even surface, the top was given a thick nitrocellulose finish (now yellowing) before it entered the Museum.

Only a very few pieces of furniture by Van Risenburgh incorporate such natural materials other than wood.[5] It has been suggested that he may have learned this practice from his father, Bernard van Risenburgh I (ca. 1660–1738), an *ébéniste* known for his furniture and clock cases of brass and tortoiseshell in the so-called boulle technique.[6] The inventory drawn up after the latter's death listed a box with burgau and other types of mother-of-pearl, which strongly suggests that he used pieces of iridescent seashell in his work as well.[7]

Very typical of the younger Van Risenburgh's oeuvre are the high-quality gilt-bronze mounts that adorn this table. The moldings running down the hexagonal legs and along the lower edge of the front and back sides emphasize their undulating outline, which is repeated in the amaranth border enclosing the floral marquetry above. The gilt-bronze moldings meet at the center of the front in an elaborate rocaille ornament and at the legs with smaller scrolling leaf motifs.[CD] The knees of the legs are mounted with fine floral pendants. Not only is this table highly unusual in its use of materials, it also has a unique pierced gallery of gilded bronze surrounding the top on three sides and extending partly around the front, showing elaborate Rococo ornament that includes leaves and flowers. This uncommon feature suggests that it was made as a special commission for an unknown but important client.

The piece was later in several distinguished collections, crossing the Atlantic Ocean a number of times before 1976, when it was given by Mr. and Mrs. Charles Wrightsman to the Museum.[8] In the early

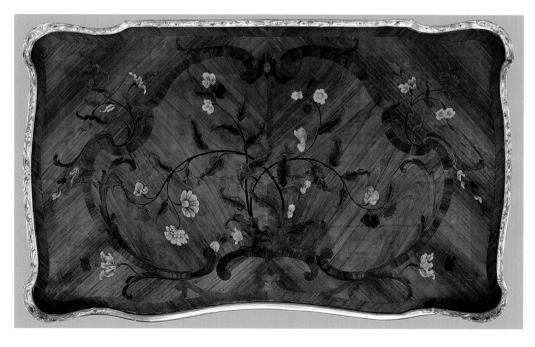

Fig. 80. Top of the writing table.

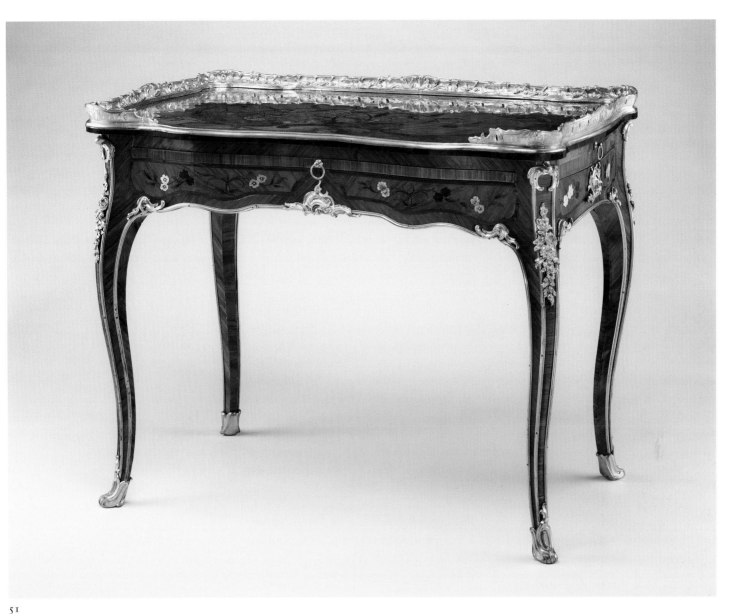

51

1920s Henry Walters (1848–1931), a railroad financier, philanthropist, and important art collector, acquired the graceful table from the Parisian dealer Jacques Seligmann (1858–1923) for his New York residence at 5 East Sixty-first Street.[9] Unlike much of Walters's collection, it did not enter the Walters Art Gallery in Baltimore after his death but remained in New York. It was left, with other important pieces of French eighteenth-century furniture, to his wife, the former Sarah Green, whom he had married in 1922.[10] Two photographs show the table in one of the main rooms of the Walters home with various pieces of sculpture on top.[11] When it was sold by Mrs. Walters at an auction of her property in 1941, the "B.V.R.B." stamp under the back rail was referred to in the catalogue as the mark of an unidentified French cabinetmaker.[12]

Later owned by two notable Brussels art collectors, the banker Baron Jean-Germain-Léon Cassel van Doorn (b. 1882) and his wife, Bertha, the table was sold again, in Paris in 1956, and illustrated in the sale catalogue in color.[13] The stamp under the back rail was then thought to be an abbreviation of the name of a cabinetmaker of Flemish origin, Jacques Vleeschouwer (or Boucher, in French).[14] The riddle of the initials was solved the following year by Jean-Pierre Baroli, who identified them as belonging to the successful Parisian *ébéniste* Bernard van Risenburgh II, whose furniture is considered to be among the finest created during the mid-eighteenth century.[15] DK-G

1. Chastang 2001, p. 57.
2. Pradère 1989, p. 190.
3. One is in the collection of the J. Paul Getty Museum, Los Angeles. It is illustrated in Bremer-David 1993, pp. 52–53, no. 68. Another, formerly in the Paul Dutasta collection, was sold at the Galerie Georges Petit, Paris, 3–4 June 1926, lot 144. Later in the collection of Barbara Piasecka Johnson, it was sold at Sotheby's, New York, on 21 May 1992, lot 84.
4. Watson 1966b, pp. 306–9, no. 151; and Rieder 1994, pp. 34–35, pls. I, II.
5. A table with colored horn, brass, and mother-of-pearl inlay is in the collection of the California Palace of the Legion of Honor in San Francisco. It is illustrated in Baroli 1957, p. 59.
6. Ibid.
7. Pradère 1989, p. 184. A number of pieces with marquetry of tortoiseshell, brass, horn, and mother-of-pearl are attributed to Bernard van Risenburgh I in Ronfort and Augarde 1991.
8. During the nineteenth century it was possibly in the collection of Lord (Thomas Henry?) Foley, and it was later in the possession of the marquis de Juigné.
9. Randall 1970, n.p.
10. Johnston 1999, pp. 114, 172, 198, 200–201.
11. These photographs were reproduced in the catalogue of the Mrs. Henry Walters collection sale, Parke-Bernet Galleries, New York, 30 April–3 May 1941, vol. 1, frontispiece, p. 126.
12. Ibid., vol. 2, lot 1420.
13. Catalogue of the Baronne Cassel van Doorn collection sale, Galerie Charpentier, Paris, 30 May 1956, lot 122.
14. Ibid. See also Salverte 1962, pp. 30–31.
15. Baroli 1957. On the stamp "JME" that appears with Van Risenburgh's initials on this writing table, see the entry for no. 56.

52.

Side chair

English, ca. 1755–60
Mahogany; covered in later needlework
H. 39½ in. (100.3 cm), w. 23 in. (58.5 cm),
d. 19½ in. (49.5 cm)
Gift of Irwin Untermyer, 1964
64.101.983

Whether Thomas Chippendale (1718–1779) invented the "ribband-back" chair is not known, but it is certainly the one chair design most frequently associated with his name. The present example, one of a pair of side chairs in the Museum,[1] is based on a design (fig. 81) that was included in all three editions of his famous book, *The Gentleman and Cabinet-Maker's Director.*[2] The plate illustrates three "ribband back" chairs of similar design. In the first edition, he describes the three chairs without modesty as "the best I have ever seen (or perhaps have ever been made)."[3] In the third edition, he noted that "Several Sets have been made, which have given entire Satisfaction."[4] Little did he know just how many sets would be made by other cabinetmakers, both in London and the provinces, or that ribbonback chairs

would continue to be popular throughout the Chippendale Revival in the nineteenth century and even into the twenty-first century.

In the 1910s and 1920s chairs in this style were usually attributed to Chippendale because of their correspondence to his designs. There followed a period of revisionism among furniture historians (still ongoing) when they realized that because these chairs were executed in such a wide range of quality, an attribution to Chippendale could be sustained only with other documentation. The present chairs have no recorded history before the 1950s. It is only on the basis of their construction, the type of mahogany, and the quality of the carving that they are dated to the years immediately following the publication of *The Director.*

One of the advantages of the design was its flexibility: parts of the ornament could be included or deleted as the cabinetmaker or patron wished. As Chippendale noted in the third edition of his book: "If any of the small Ornaments should be thought superfluous, they may be left out, without spoil-

ing the Design."[5] In the case of the present chairs, the elements thought superfluous by the chairmaker were the ornament at the base of the splat and the entire apron.

The ribbonback design was also executed as a settee. An example with the same design as the present chairs is in the Victoria and Albert Museum, London. It has a two-section back and is accompanied by four chairs.[6]

WR

1. For further discussion of the Museum's two chairs, see Hackenbroch 1958a, p. 30, figs. 137, 138, pls. 110, 111; and Metropolitan Museum of Art 1977, p. 87, no. 155 (entry by William Rieder). The accession number of the second chair is 64.101.984.
2. Thomas Chippendale, *The Gentleman and Cabinet-Maker's Director* (London: privately printed). In the first and second editions, of 1754 and 1755, the chair is illustrated in plate XVI. In the third edition, of 1762, the same plate was renumbered as plate XV.
3. Note to Plate XVI, p. 8, in Chippendale 1754 and Chippendale 1755.
4. Note to Plate XV, p. 3, in Chippendale 1762.
5. Ibid.
6. Coleridge 1968, p. 191, figs. 173, 174.

Fig. 81. Thomas Chippendale, *Ribband back Chairs,* ca. 1750–54. Preparatory drawing for an illustration in *The Gentleman and Cabinet-Maker's Director* (editions of 1754, 1755, and 1762). Black and gray ink and gray wash. The Metropolitan Museum of Art, New York, Rogers Fund, 1972 (1972.581).

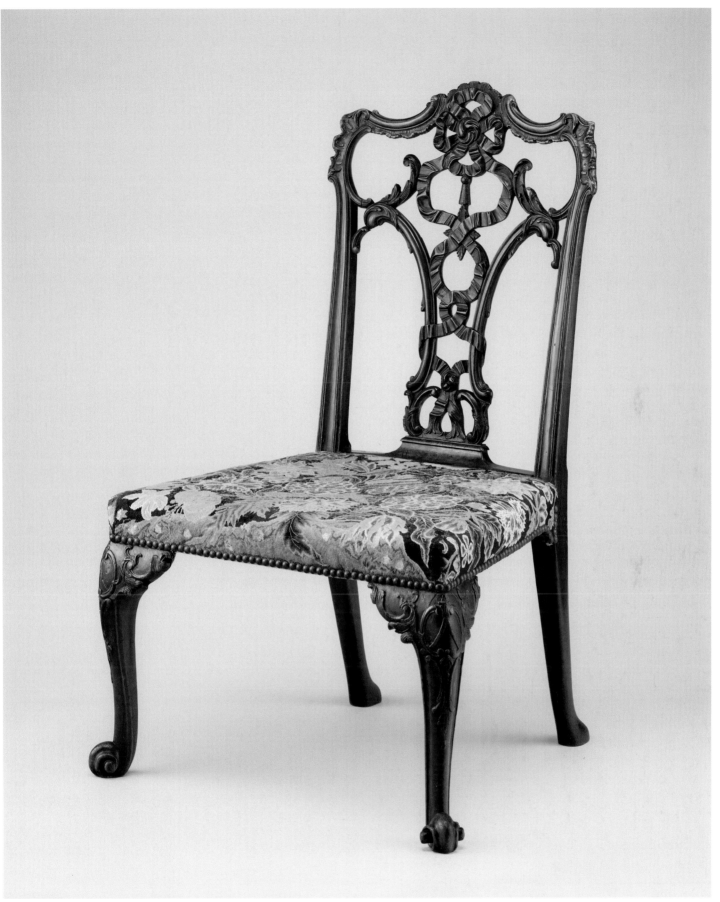

52

53.

Console table

German (Ansbach or Bayreuth), ca. 1755–60
Carved and gilded wood; apron and legs of oak;
double stretcher of linden wood; greenish gray
and reddish brecciated marble top
H. 36 in. (91.4 cm), w. 51½ in. (130.8 cm),
d. 23¼ in. (59.1 cm)
Marked underneath the stretcher: "BB"
The Lesley and Emma Sheafer Collection,
Bequest of Emma A. Sheafer, 1973
1974.356.125

According to Heinrich Kreisel, a distinguished scholar of German furniture, this table and its companion piece, today in the Bayerisches Nationalmuseum in Munich,[1] came from one of the princely castles in Bayreuth. Kreisel based his opinion mainly on the mark "BB" impressed underneath the stretcher of both tables. These he interpreted as an abbreviation of "Brandenburg-Bayreuth," signifying the dynasty of margraves established in Bayreuth during the eighteenth century. Kreisel dated the tables to about 1755–60[2] and attributed their design to Johann Schnegg (1724–1784), a Tyrolian carver working at the court in Bayreuth in the 1750s, together with Georg Dorsch and several other masters and journeymen, all under the supervision of Johann Georg Schleunig (b. ca. 1715), who was in Bayreuth in 1741 and moved to Berlin in 1764. Schnegg seems to have been the most gifted of these artisans. Documentation that would make it possible to untangle the styles of the individual carvers at the Bayreuth court workshop has not been discovered, and neither Kreisel nor any other scholar has yet been able to establish that the tables did originate there.[3] There is a similar console table in the Neues Schloss in Bayreuth[4] and another in the Württembergisches Landesmuseum, Stuttgart. The latter could have been part of the collection of Princess Elisabeth Sophie Friedericke von Bayreuth, who married Duke Karl Eugen von Württemberg (1728–1793) in 1748. Or, the duke could have acquired the table while living in Bayreuth as Prussian governor for several years following his banishment from Montbéliard (Mömpelgard), the Württemberg enclave in eastern France.[5]

There is also a resemblance between the large open-cartouche stretcher of the Sheafer tables and one on a simplified console table model of about 1760 at the Residenz (palace) in Ansbach.[6] [CD] All three of these cartouches are decorated with opening pomegranate buds (Kreisel called them *Krautköpfe,* or cabbage heads), although the one on the Ansbach table is less ornate and not so finely carved as the other two.[7] These striking floral decorations seem to be indebted to designs by Johann Michael Hoppenhaupt the Elder (1709–1778/86), who worked until about 1755 for Frederick the Great (1712–1786) at Berlin and Potsdam.[8]

The Rococo furniture style in Franconia and in particular at the court of Frederick the Great is characterized by utterly fantastic and illogically juxtaposed floral elements. Rocaille ornament both forms and rules the object, an eccentricity found in French Rococo pieces only if they were intended for export to Germany or to the Ottoman Empire, as, for example, was furniture by Jean-Pierre Latz (ca. 1691–1754)[9] and bronzes by Jacques Caffiéri (1678–1755). Exuberantly ornamented show furniture like the Museum's table and its pair in Munich are of high importance, for they anticipate the coming eclipse of the Rococo.

Emma and Lesley Shaefer bought the console tables now in New York and Munich from the Munich firm of Fischer-Böhler, which had close ties with other south German dealers and—what may have been Fischer-Böhler's most important asset—connections with impoverished noble families. Each year the firm was able to show the Sheafers high-quality furniture that appealed to their taste for the south German vernacular. It comes as a surprise that they decided to split up this pair. Perhaps, as the late James Parker, for many years a curator in the Department of European Sculpture and Decorative Arts at the Metropolitan, suggested, there was not enough room for both in the Sheafers' New York apartment.[10] Another influence may have been Mrs. Sheafer's deep affection for the Bayerisches Nationalmuseum, which in 1955 was celebrating its centennial year, or she may have thought the tables would be reunited in Munich after her death through an extensive bequest of objects from the collection she and her husband had assembled.

In the end, however, recognizing the need of the Metropolitan Museum in her beloved New York to represent German art in a wide range of media, and probably also swayed by admiration and personal fondness for Parker, who would be in charge of her collection, Mrs. Sheafer changed her mind and left the vast Sheafer collection to be enjoyed by millions of visitors to the Metropolitan Museum each year.[11] WK

1. The table in Munich is described as follows: linden wood with a gray yellow marble top; h. 94 cm, w. 125 cm, d. 59 cm; marked "BB"; said to have come from a Franconian castle; Jubilee Gift of Mr. and Mrs. Lesley Green Sheafer, New York (inv. no. 55/57). See Müller 1956, pp. 233, 236, fig. 32; and Kreisel and Himmelheber 1983, fig. 708.
2. Written statement signed by Heinrich Kreisel on the back of a photograph of the Museum's table. The photograph bears the stamp "Fischer-Böhler/ Antiquitäten/München 2, Residenzstr. 10/1." Georg Himmelheber, of the Bayerisches Nationalmuseum, stated in a letter dated 1 March 1988 that the pair of console tables "were bought by Fischer-Böhler from Hermann Rothenbücher in Bayreuth (Upper Franconia), who had himself acquired them in Lower Franconia. The provenance of a Bayreuth palace can be assumed but can not yet be proved."
3. Kreisel and Himmelheber 1983, p. 230.
4. Ibid., fig. 709.
5. Müller 1956, p. 233.
6. Pfeil 1999, p. 198, no. 69.
7. Ibid., p. 199, no. 70.
8. Schreyer 1932, pl. 22, figs. 61, 62. For the Berlin Rococo under Frederick the Great, see Eggeling 2003.
9. Hawley 1970.
10. James Parker, conversation with the author, April 1996.
11. The Museum's table is number 19 in Hackenbroch and Parker 1975.

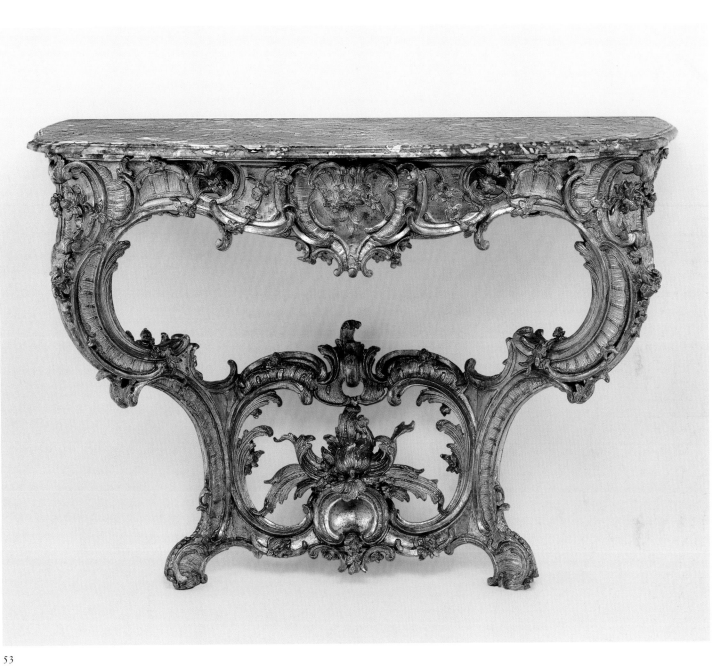

53

54.

Fire screen

English, ca. 1755–60
Panel attributed to Thomas Moore
(ca. 1700–1778)
Mahogany; knotted-pile wool panel not
original to the screen
H. 52½ in. (133.3 cm), w. 37½ in. (95.2 cm),
d. 26¼ in. (66.7 cm)
Gift of Irwin Untermyer, 1964
64.101.1155

Fire screens, made to deflect the heat coming from the hearth, had been a common form of English furniture since the seventeenth century. They often had needlework panels executed by a member of the family. In the quality both of the carving and of the pile knotting, this fire screen is one of the most sophisticated to survive from the middle years of the eighteenth century. Because of its beauty and provenance, it has often been attributed to Thomas Chippendale (1718–1779). It was until the mid-1930s in the collection of the earls of Shaftesbury at St. Giles's House in Dorset, which was refur-nished in the 1750s by the fourth earl of Shaftesbury, whose wife was one of the subscribers to the first edition of Chippendale's design book, *The Gentleman and Cabinet-Maker's Director* (1754). None of Chippendale's designs for fire screens relates closely to this example, however, and no documentation has been found to support his activity at St. Giles's. The fire screen was acquired by Irwin Untermyer (1886–1973) before 1938 and given by him to the Metropolitan Museum in 1964.[1]

The wool panel, which is not original to the frame, is one of a group of panels of similar design, some of which may have been woven at the Savonnerie Manufactory in Paris, and some by workers from that factory who emigrated to England in the early 1750s to work first for the weaver Peter Parisot (1697–1769) in London and then for Thomas Moore, who made knotted-pile carpets and screens at his manufactory in the Moorfields section of west London.[2]

In their production of these panels, both Parisot and Moore were responding to the growing Francophile taste in England. In 1756 Moore advertised that he sold "Chaillot or Royal Velvet Tapestry," meaning knotted-pile carpets and screens in the Savonnerie style.[3] A panel of similar design on a mahogany fire screen at Dumfries House in Ayrshire, Scotland, supplied by Chippendale in 1759, has also been attributed to Thomas Moore.[4] WR

1. Hackenbroch 1958a, fig. 341, pl. 299; and Metropolitan Museum of Art 1977, p. 85, no. 152 (entry by William Rieder).
2. This group of panels is discussed in Standen 1983; and Standen 1985, vol. 2, pp. 740–42, no. 133. Pierre Verlet believed that the panels of French provenance in this group were made in imitation of Savonnerie but not woven there; Verlet 1982b, p. 417, n. 96. On the career of Thomas Moore, see Hefford 1977. On both Parisot and Moore, see Sherrill 1996, pp. 152–58, 171–85.
3. Sherrill 1996, p. 174.
4. C. Gilbert 1969, pp. 671, 674, fig. 47.

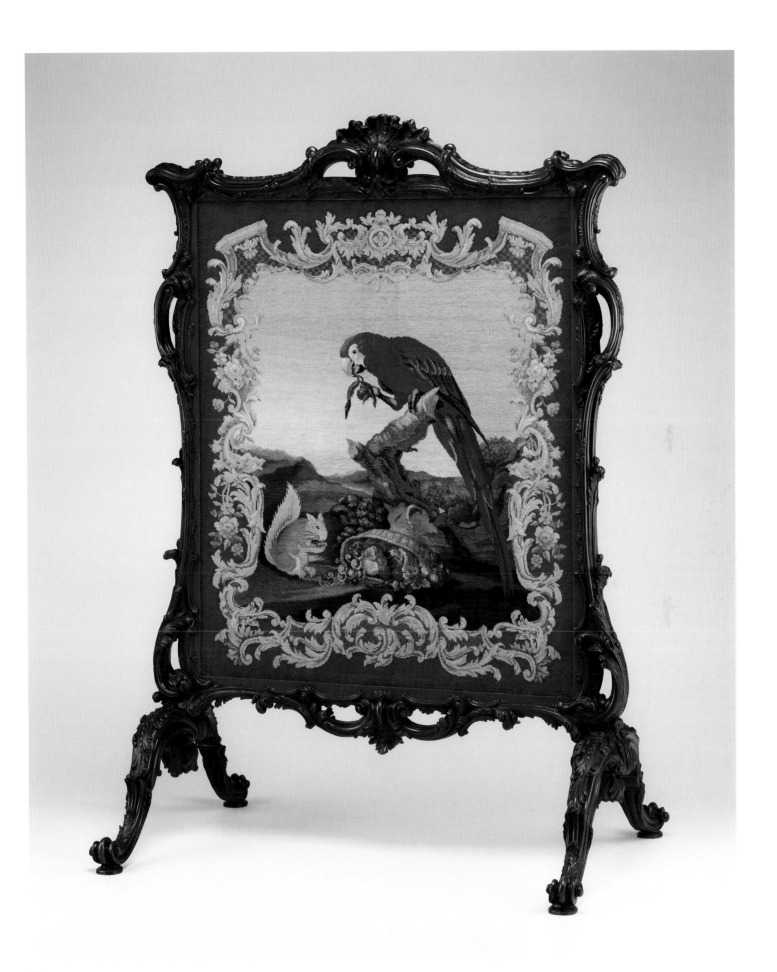

China table

English, ca. 1755–60
Carved mahogany
H. 28¼ in. (71.8 cm), w. 37¾ in. (95.9 cm),
d. 26½ in. (67.3 cm)
Pasted on a block underneath the top is a round
sticker on which are printed and inscribed,
respectively: "Irwin Untermyer Collection";
and "418" and "F."
Gift of Irwin Untermyer, 1964
64.101.1099

Introduced from China early in the seventeenth century, the exotic beverage tea was at first appreciated in England as much for its alleged medicinal qualities as for its taste and mildly stimulating effect. Although the leaves were expensive, tea drinking gradually caught on as a social pastime and became very fashionable during the eighteenth century, when it was enjoyed in public places and after dinner in the drawing rooms of private homes. The custom of brewing and taking tea required new equipment, such as water kettles and their burners, teapots, porcelain bowls from which the hot beverage was sipped, sugar and milk containers, sugar tongs and spoons, and a basin for slops. These implements would be placed together on a tray or table. Tea leaves were generally stored in a box or caddy that could be secured with lock and key.[1]

The earliest tables specifically intended for the tea ceremony were imported from East Asia,[2] but during the eighteenth century, English cabinetmakers started making special furniture for the serving of tea, such as urn and kettle stands, trays, and tables. The latter are generally called silver or china tables because the wares displayed on them were fashioned of silver and porcelain. Many consist of tripod stands supporting a scallop-edged round top that could be tilted when the table was stored out of the way and not in use. Others are oblong in shape and have a pierced gallery, or railing, that prevents the tea things from sliding off the top. The celebrated cabinetmaker Thomas Chippendale (1718–1779) included a plate showing two designs for china tables of the latter type in the first and later editions of his influential *Gentleman and Cabinet-Maker's Director* (1754).[3] The original drawing for the plate is in the Museum's

collection (fig. 82). The caption in the 1754 edition describes the tables as "China or Breakfast Tables" and states that they "will look extremely neat if [they are] well executed." The description of the same tables in the third edition, of 1762, explains that they were designed to hold a set of china, and could also be used for serving tea. With its serpentine lines, slender cabriole legs, scrolled feet, and gracefully curving cross stretchers, the Museum's exquisite table is closely related to one of these designs,[4] although it shows additional, crisply carved details on the aprons and legs and a different floral finial at the crossing of the stretchers. Also, in the manner of fine goldsmith's work, certain details of the leaf ornament at the knees are stippled.[CD] The gallery has very fine openwork carving consisting of Gothic-style tracery, which is unlike the Chinese fretwork suggested in Chippendale's *Director*.[CD] The table's high quality and its resemblance to a plate in *The Director* do not warrant an attribution to Chippendale, however, since the book had already circulated widely among a large audience of cabinetmakers and patrons by 1755, when it appeared in a second edition.

Made of mahogany, a hard, reddish brown timber imported from the West Indies that became a very popular choice for English furniture from the 1730s until the 1770s, this table shows the lustrous quality of the beautifully figured wood at its best. Its shining surface would have magically doubled through reflection a costly tea service placed on top.

Nothing is known about the early history of the Museum's table, but in the memoirs of the English dealer James Henry Duveen (b. 1873) there is an amusing description of its discovery at a country auction in Wales that must have taken place during the early 1890s.[5] According to Duveen, the table had been stored for years in a neglected greenhouse, where it had been overgrown by ivy. Captivated by the most exquisite Chippendale drawing-room table he had ever seen, Duveen bought the little gem for seventy-five pounds sterling and vowed never to part with it; shortly afterward, however, he sold the table for five hundred pounds to the furniture dealer Sydney Letts (d. 1915), who intended to offer it to one of his overseas customers.

During the twentieth century the table was acquired by three notable American collectors of English furniture. The first was Richard Albert Canfield (1855–1914), who ran a famous gambling establishment in

Fig. 82. Thomas Chippendale, *China Tables*, ca. 1750–54. Preparatory drawing for an illustration in *The Gentleman and Cabinet-Maker's Director* (editions of 1754, 1755, and 1762). Black ink and gray wash on blue paper. The Metropolitan Museum of Art, New York, Rogers Fund, 1920 (20.40.2[92]).

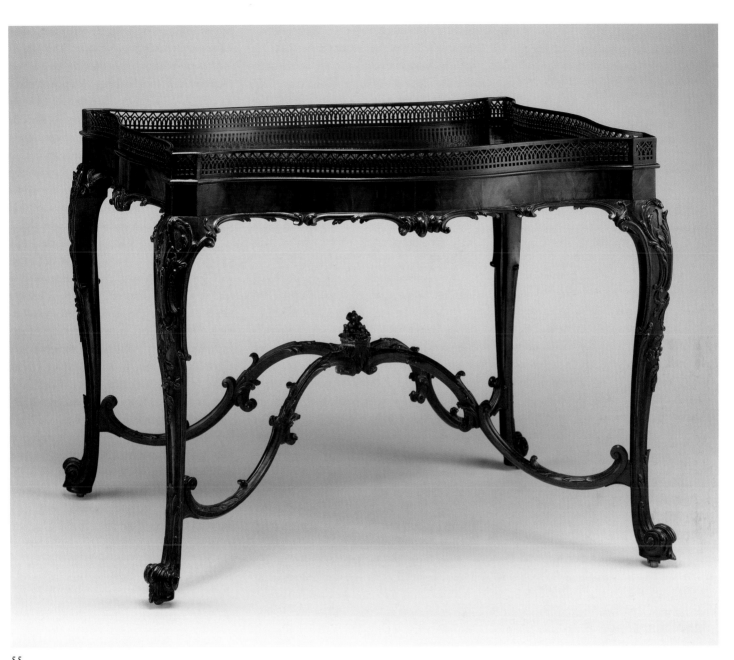

55

New York City and filled his home with eighteenth-century English antiques. The table was photographed there for publication in Eberlein and McClure's *Practical Book of Period Furniture* (1914).[6] The second was Marsden Jaseal Perry (1850–1935), a financier and transportation magnate who bought "the noted Chippendale collection" assembled by Canfield.[7] Perry kept the table in Bleak House, his summer residence in Newport, Rhode Island. Purchased in 1936 for Judge Irwin Untermyer at the auction of Perry's effects, it was illustrated in a 1948 article on Untermyer's collection in the *Magazine*

Antiques.[8] In 1964 the judge gave this splendid and unique china table to the Museum, where it has been on display ever since.[9]

DK-G

1. For instance, in 1683, "One Tea table, carv'd and guilt" as well as "One Japan box for sweetmeats & tea" were listed among the furnishings of the private closet of Elizabeth Dysart, duchess of Lauderdale (ca. 1626–1698) at Ham House in Richmond upon Thames, near London. Quoted in P. Thornton and Tomlin 1980, pp. 83–84.

2. A late-seventeenth-century Javanese lacquer tea table has been preserved at Ham House; illustrated in Tomlin 1986, pp. 38–39.

3. Chippendale 1754, pl. XXXIIII.

4. Hackenbroch 1958a, pp. 52–53, pl. 218, fig. 257; Hackenbroch 1958b, pp. 229–30, figs. 11, 12; and Metropolitan Museum of Art 1977, p. 88, no. 158 (entry by William Rieder).

5. Duveen 1957, pp. 115–19.

6. Eberlein and McClure 1914, pl. XIX.

7. So described on the title page of the catalogue of the Marsden J. Perry collection sale, American Art Association, Anderson Galleries, New York, 3–4 April 1936. The table was lot 246.

8. "European Antiques" 1948, p. 115.

9. No other tables of this model are known to exist. A related table displaying more carving on the apron was formerly in the collection of Marsden J. Perry. It was sold at the American Art Galleries, New York, 29 January 1916, lot 111. A table with similar serpentine top and stretchers but with straight legs is illustrated in Coleridge 1968, p. 195, fig. 214.

56.

Side table (*commode en console*)

French (Paris), ca. 1755–60

Bernard van Risenburgh II (ca. 1696–ca. 1767)

Oak and pine lacquered black and veneered with Japanese black and gold lacquer; gilt-bronze mounts; Sarrancolin marble top

H. 35½ in. (90.2 cm), w. 37½ in. (95.3 cm), d. 21 in. (53.3 cm)

Stamped on top of the carcase at the right rear corner and beneath the carcase to the left of center at the back: "B.V.R.B." and "JME" twice, near each "B.V.R.B." stamp. Painted underneath the top: "176."

Gift of Mr. and Mrs. Charles Wrightsman, 1976

1976.155.101

This table with graceful, curvilinear lines has cabriole legs and is fitted with one drawer in its frieze. Its French name, *commode en console,* indicates that it is, in fact, a combination of a console table, designed to stand against a wall, and a commode, or chest of drawers.[1] A small number of such tables are known today, and they appear to have been in vogue for a short period during the middle of the eighteenth century.[2] Five were sold by the fashionable *marchand-mercier* Lazare Duvaux (ca. 1703–1758) between December of 1753 and February of 1757.[3] They were veneered with tulipwood with the exception of one table, by far the most expensive of all, which was mounted with lacquer. In Duvaux's shop records it was described as a lacquer commode, with console legs, decorated with gilded bronze. It was sold for 1,150 livres on 13 May 1756.[4]

Considered as part of the wall decoration, most console tables were made of carved and gilded wood and were assembled by those joiners, known as *menuisiers,* who specialized in architectural woodwork. This side table, however, with its black-lacquered surface and Japanese lacquer veneer, was the work of an *ébéniste.*

In 1743 it had become mandatory for all members of the furniture-makers' guild to mark their work with their name.[5] The carcase of this table is stamped twice with the initials "B.V.R.B.," identifying its maker as Bernard van Risenburgh II. This talented and prolific artist, the son of the cabinet-maker Bernard I (ca. 1660–1738) and the father of Bernard III (ca. 1731–1800), who succeeded him, was known for his luxurious furniture mounted with end-cut wood, lacquer, or porcelain (see entry for no. 51).[6] He worked almost exclusively for *marchands-merciers,* dealers like Duvaux who specialized in goods for the high end of the market. The stamp "JME," the monogram of the Jurande des Menuisiers-Ébénistes, a committee in charge of maintaining standards of craftsmanship, accompanies Van Risenburgh's initials. Visiting the furniture workshops of guild members four times a year, the committee inspected all pieces and stamped them with their monogram if the quality was acceptable.[7]

During the eighteenth century, imported Japanese lacquer panels, most of which had to be dismantled from cabinets and chests dating to the 1660s and 1670s, were rare and very costly. In addition, the exotic material was difficult to cut and especially to bend in the desired serpentine shapes required for mounting on Rococo furniture without damaging the lacquer surface. For that reason, only the most skilled cabinet-makers—Van Risenburgh, for example—were entrusted with Japanese lacquer by affluent *marchands-merciers* such as Thomas-Joachim Hébert (d. 1773) and Simon-Philippe Poirier (ca. 1720–1785), who obtained it for them at auction or abroad.[8]

The Japanese lacquer on the table's drawer front shows a symmetrical image of small buildings and trees in a landscape setting. Symmetrical decoration is highly unusual in Japanese art, and upon close inspection it turns out that not one single piece of lacquer was used but a combination of two matched pieces with a vertical seam, barely visible, down the middle.[CD] It is likely that these panels were derived from a pair of Japanese cabinets dating to the second half of the seventeenth century.[9] A pair of cabinets was often decorated with an almost identical pictorial design but in mirror image. Although these pieces of furniture were no longer fashionable during the eighteenth century, the lacquer surfaces continued to be highly admired. Part of the left-hand door from one cabinet and part of the right-hand door from the other were probably cut up and combined on the drawer front of this side table. The panels from remaining doors, severely cropped, may have been reused for the sides. The legs as well as the areas surrounding the lacquer on the front and sides have been lacquered black to match, and gilt-bronze mounts cleverly mask the joints. Composed of scrolls, rocaille ornament, floral trails, and foliage, these beautiful mounts have the appearance of being cast as one piece. In fact, they consist of separate elements that overlap, the upper parts having been cut in such a way that they fit over the lower ones.

This *commode en console* is the only example known to exist that is mounted with Japanese lacquer. Possibly it is the one sold in 1756 by Duvaux, but little is known about its early history. During the early twentieth century it was in the possession of the legendary beauty and Parisian society figure Élisabeth de Caraman-Chimay (1860–1922), muse to Marcel Proust (1871–1922) and wife of Comte Henry de Greffulhe (1848–1932). The antiques dealer Paul Cailleux lent the table to the 1955–56 exhibition that was devoted to the most important eighteenth-century Parisian furniture makers.[10] Mr. and Mrs. Charles Wrightsman were the last private owners, and they donated this exquisite piece to the Museum in 1976. DK-G

1. Watson 1966a, pp. 226–29, no. 118; and Rieder 1994, p. 37, pl. III.

2. The earliest example may have been the console table with lacquer ordered in 1744 for Louis XV's bed-chamber at Choisy. The Museum's table has been tentatively connected with this commission. See Pradère 1989, pp. 195–96.

3. Duvaux 1873 (1965 ed.), vol. 2, pp. 180, 279–81, 308, nos. 1590, 2461, 2480, 2714.

4. "une commode de lacq, les pieds à consoles, garnie en bronze doré d'or moulu"; quoted in ibid., p. 281, no. 2480. Sold to M. Masse.

5. Pradère 1989, pp. 12–13.

6. Ibid., pp. 183–99.

7. Ibid., p. 13.

8. Wolvesperges 1998, p. 68; and Wolvesperges 2001, pp. 3–4.

9. Impey and Kisluk-Grosheide 1994, pp. 52–53, figs. 6, 7.

10. *Grands ébénistes* 1955, no. 29, pl. 11.

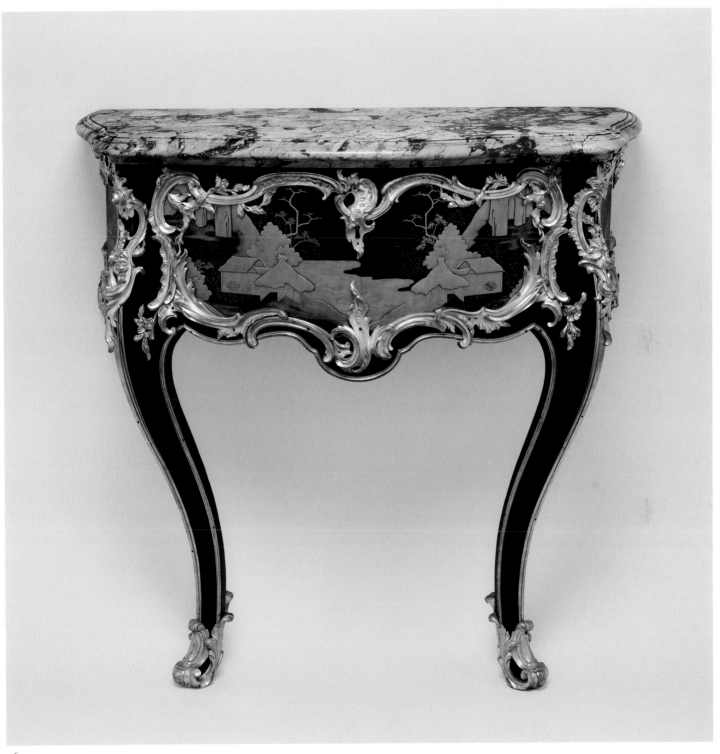

56

57

57.

Writing table (*bureau plat*)

French (Paris), 1759
Gilles Joubert (1689–1775)
Lacquered oak; gilt-bronze mounts; lined with modern leather
H. 31⅞ in. (80.7 cm), w. 69¼ in. (175.9 cm), d. 36 in. (91.4 cm)
Painted underneath the top: "2131" and "202."
Locks stamped twice: "FICHET, A PARIS."
Gift of Mr. and Mrs. Charles Wrightsman, 1973
1973.315.1

The number 2131 painted on this *bureau plat* (fig. 83) corresponds to an entry in the ledger listing new furniture for royal residences, the *Journal du Garde-Meuble de la Couronne*, for 29 December 1759. On that day the *ébéniste* Gilles Joubert delivered "for use in the King's Cabinet at the Château

of Versailles: a red-lacquered writing table equipped with gilt-bronze mounts, with three drawers in front that can be locked with a key, the top covered with black velvet finished with a small gold braid, [the table] measuring 5 *pieds*, 4 *pouces* long, 32 *pouces* wide, and 30 *pouces* high."[1]

Joubert, who had been appointed a cabinetmaker to the Garde-Meuble in 1758 and who in 1763, after the death of Jean-François Oeben (1721–1763), would be named the king's cabinetmaker, had a long and successful career.[2] Between 1748 and 1774 he delivered nearly four thousand pieces of furniture to the crown, many of which he had subcontracted to other cabinetmakers. In 1755 Joubert made two marquetry *encoignures*

(corner cabinets) with elaborate gilt-bronze mounts to match the 1738 medal cabinet by Antoine-Robert Gaudreaus (ca. 1682–1746) for the king's Cabinet Intérieur at Versailles. Four years later, the present writing table,

Fig. 83. Inventory number painted underneath the top of the writing table.

144

one of the very few lacquered pieces supplied by Joubert,[3] was commissioned for use in the same room, the study where Louis XV (1710–1774) did much of his daily work. Located on the first floor (the American second floor), at the corner where the Royal Courtyard meets the Marble Courtyard, the Cabinet Intérieur occupied part of the former picture gallery of Louis XIV and was redecorated in 1753. With its white and gold *boiserie*, or paneling, carved by Jacques Verbeckt (1704–1771), this room was one of the most sumptuous in the king's private apartment.

The writing table, lacquered in brilliant red and with pseudo-Oriental landscape scenes in gold on the sides and the drawer fronts, brought an exotic element to the Rococo room.[CD] This decoration is entirely flat, closely imitating the red Chinese lacquer that first arrived in Europe about the middle of the eighteenth century.[4] The lustrous varnish used is often called *vernis Martin* after the brothers Martin, who developed a high-quality varnish when all fashionable Paris began demanding lacquer in the Chinese or Japanese style. Between March of 1749 and February of 1758, for instance, the Parisian dealer in fine furniture Lazare Duvaux (ca. 1703–1758) sold a number of commodes decorated with either red Chinese lacquer or *vernis Martin* of the same color.[5]

Resting on four cabriole legs, Joubert's table is embellished with exquisite gilt-bronze mounts that enhance its gracious, curving lines. Some of these bold, scrolling mounts have openwork decoration through which the red background is visible (fig. 84).[6]

In 1765 an inkstand of the same red lacquer, with silver-gilt receptacles for the ink, sand, and sponge, was delivered for the king's use.[7] The original black velvet inserted in the tabletop was replaced in 1777 with blue morocco leather.[8] A desk chair also covered in blue leather and listed immediately following the writing table in the 1779 inventory of Versailles was probably used with it.[9] At that time the room also included a folding screen and several pieces of seat furniture upholstered with crimson damask. Made of the same fabric bordered with gold galloon, the curtains beautifully echoed the color scheme of the *bureau plat.*

A year after the table was delivered Louis ordered a marquetry *secrétaire à cylindre* from Oeben. It took almost a decade to complete and was finished by Jean-Henri Riesener (1734–1806) after Oeben's death. Both this famous rolltop desk, which is back at Versailles today, and Joubert's table remained in the room under Louis XV's grandson and successor, Louis XVI (1754–1793), until December 1786, when a new marquetry writing table by Guillaume Benneman (active 1785–92; d. 1811), commissioned as companion to the king's desk, replaced the Museum's red-lacquered one.[10] Joubert's *bureau plat* was passed along to the king's brother, the comte de Provence and future King Louis XVIII (1755–1824), for whom it was restored in 1787. Benneman and Adrien-Antoine Gosselin, who was named *maître*, or master craftsman, in 1772, charged 105 livres for their part of the repairs, which, unfortunately, are not described in detail.[11] In addition, a certain craftsman named Galle charged 72 livres for cleaning and repolishing the mounts. There is evidence that the table was restored more than once at a later date, and it is likely that during one of these restorations the drawer locks, stamped twice *"FICHET, A PARIS,"* were installed. The locksmith Alexandre Fichet (1799–1862), who invented the modern safe and received several patents for safety locks, established a workshop in Paris in 1825.[12]

In 1792 Joubert's writing table was still at Versailles in the Cabinet Intérieur of the comte de Provence, and it was probably among the royal property sold during the Revolution.[13] Nothing is known about its history in the nineteenth and twentieth centuries, until Mr. and Mrs. Charles Wrightsman acquired it in the mid-1960s. They donated it to the Museum in 1973. The writing table has since been described as the "most important piece of French eighteenth-century furniture to be found on the North American continent."[14] DK-G

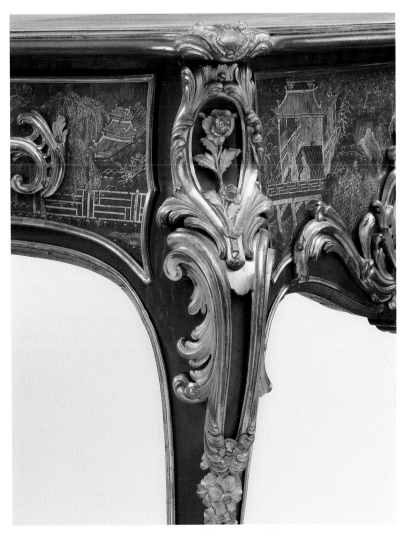

Fig. 84. Mount on the right front corner of the writing table.

1. "pour servir dans le Cabinet du Roy au Château de Versailles: Un bureau de travail de Laque rouge garni d'ornemens de bronze cizelé et doré d'or moulu, ayant trois Tiroirs pardevant fermans a clef, le dessus couvert de velours noir encastré garni d'une petite tresse d'or, ayant 5 pieds 4 pouces de long sur 32 pouces de large et 30 pouces de haut"; Archives Nationales, Paris, O¹ 3317, f. 44. On the writing table, see Watson 1970, pp. 42–51, no. 296; and Verlet 1990, pp. 49–51, no. 6. The *pied* is a unit of length measuring about 12¾ inches (32.4 cm) and consisting of 12 *pouces*. On this, see Havard 1887–90, vol. 4, cols. 304–5, 621.

2. Pradère 1989, pp. 209–19.

3. Wolvesperges 2000, pp. 296–97.

4. Kisluk-Grosheide 2000a, pp. 32–33, pl. V.

5. Duvaux 1873 (1965 ed.), vol. 2, pp. 15, 38, 61, 66, 157, 200, 205, 298, 305, 353, nos. 156, 389, 610, 648, 1415, 1771, 1814, 2606, 2675, 3061.

6. Wolvesperges 2000, pp. 337–38.

7. "écritoire de même lac . . . garnye d'encrier poudrier et cuvette à éponge d'argent doré"; Archives Nationales, Paris, O¹ 3451, f. 19; Versailles inventory of 1765.

8. Archives Nationales, Paris, O¹ 3476-2. The table is described as having been recovered in 1777 in the Versailles inventory of 1779.

9. Archives Nationales, Paris, O¹ 3476-2; inventory of 1779.

10. This writing table is now in the James A. de Rothschild collection at Waddesdon Manor, Buckinghamshire. It has been published in De Bellaigue 1974, vol. 2, pp. 458–65, no. 94.

11. A copy of the bill, dated 4 January 1787, quoted in Verlet 1990, p. 50, reads as follows: "Pour avoir fait restaurer à neuf un bureau en table de 5 p^ds ½ en lacque provenant du Cabinet intérieur du Roy. Benneman, Gosselin. Pour restauration de l'ébénisterie, maroquin neuf avec bordure dorée revenue à . . . 105 [livres]. Pour avoir degressé les bronzes et les avoir repassés à la couleur de l'or moulu et rebrunis à neuf . . . 72 [livres]." (For the restoration of a lacquered writing table measuring 5½ *pieds,* formerly in the inner apartment of the king. Benneman and Gosselin: For the restoration of the woodwork, new moroccan leather with a gold border amounting to 105 [livres]. Galle: For cleaning the bronzes, for a new coat of gilding and [for] repolishing as new . . . 72 [livres]); Archives Nationales, Paris, O¹ 3645, pp. 52–53.

12. On Fichet, see *Grand Larousse* 1989, vol. 6, p. 4248.

13. Archives Nationales, Paris, O¹ 3355, pp. 36; quoted in Verlet 1990, p. 50.

14. Watson 1989, p. 343.

58.

Commode

English, ca. 1760
Attributed to William Vile and John Cobb (active as partners 1751–64)
Pine veneered with mahogany; the drawer linings of mahogany; gilt-bronze handles, leaf plates, and escutcheons
H. 35 in. (89 cm), w. 42 in. (106.6 cm), d. 24¾ in. (62.9 cm)
Gift of Irwin Untermyer, 1964
64.101.1142

This commode was purchased in 1928 from the collection of Earl Howe at Penn House, Amersham, Buckinghamshire, by Irwin Untermyer, who gave it to the Museum in 1964.[1] It is one of a group of commodes that have been attributed to John Cobb (ca. 1715–1778), both during his short-lived partnership with William Vile (ca. 1700/1705–1767) and following Vile's retirement in 1764.[2] Within the group the two commodes most closely related to this one are an example from the collection of Mrs. Venetia Gairdner[3] and another supplied by Cobb to James West at Alscot Park in Warwickshire in 1766.[4] These three commodes have identical gilt-bronze handles, leaf plates, and escutcheons and a similar curved front of *bombé* type. For all the refinement of the fronts of these commodes, the rear feet and aprons of the sides are crudely cut—a curiously anomalous feature. The most significant variation between this commode and the others in this group is in the front legs, which extend forward and then turn inward on scrolled feet.

Commodes of this type with drawers first appeared in France in the early eighteenth century. They had a strong influence on Thomas Chippendale (1718–1779), who acknowledged the French ancestry of his commodes in his design book, *The Gentleman and Cabinet-Maker's Director,* where he titled his versions "French Commode Tables."[5] That term never caught on, and this type of furniture, both in England and in France, has been called "commode" since the eighteenth century. The term is confusing to Americans who tend to call this a "chest of drawers" and think of "commode" as something quite different.

WR

1. The Earl Howe sale was held at Christie's, London, on 13 June 1928, and this chest was lot 30. It has been published in Hackenbroch 1958a, p. 67, fig. 322, pl. 280; Metropolitan Museum of Art 1977, pp. 91–92, no. 165 (entry by William Rieder); and Wood 1994, p. 53, fig. 40.

2. The commodes in this group are identified in Metropolitan Museum of Art 1977, pp. 91–92, no. 165 (entry by William Rieder), and in Wood 1994, pp. 51–53. On Cobb, see Beard and C. Gilbert 1986, pp. 181–84 (entry by Geoffrey Beard).

3. Wood 1994, p. 53, fig. 39. It was sold at Lawrence Fine Art, Crewkerne, Somerset, England, 19 February 1981, lot 215.

4. Ibid., p. 51, fig. 35.

5. See plates LXIV–LXVI and LXIX in Chippendale 1762.

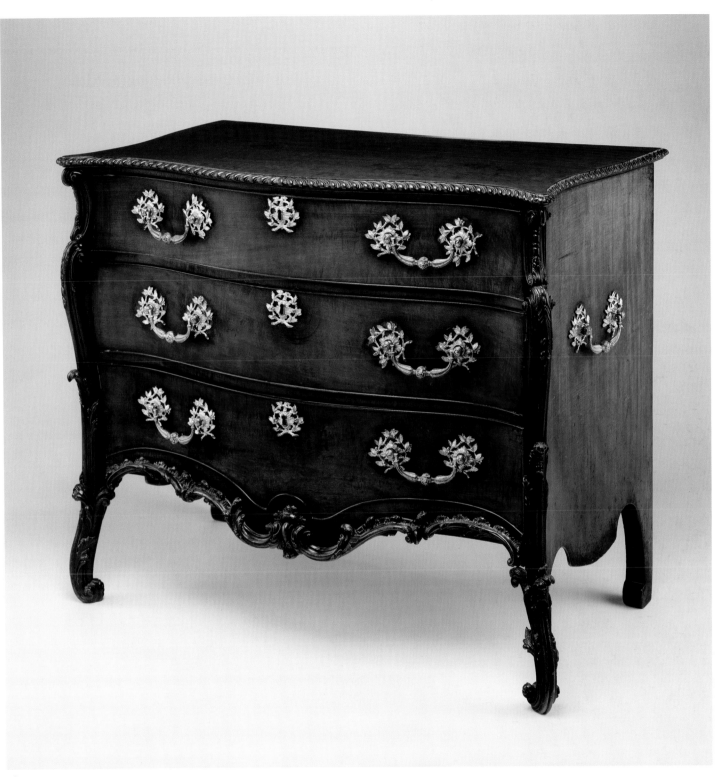

Medal cabinet

English, 1760–61
Attributed to William Vile and John Cobb (active as partners 1751–64)
Mahogany
H. 79 in. (200.7 cm), w. 27 in. (68.6 cm), d. 17¼ in. (43.8 cm)
Fletcher Fund, 1964
64.79

"I will tell you something; the King loves medals," Horace Walpole wrote to Sir Horace Mann in November 1760, shortly after George III acceded to the throne. The present medal cabinet, with 135 shallow drawers that could accommodate more than six thousand coins and medals, is one of two cabinets. Its pair is at present in the British Museum, London, on loan from the Victoria and Albert Museum (fig. 85).[1] They appear to have been commissioned by the future monarch when he was still Prince of Wales; the door of the top section is carved with the star of the Order of the Garter, to which he was elected in 1750.[CD] William Vile (ca. 1700/1705–1767) and John Cobb (ca. 1715–1778) were among the leading cabinetmakers of the period, with a workshop in St. Martin's Lane, then the center of the cabinetmaking district of London.[2]

Both cabinets, each resting on a four-leg stand, may have been the flanking sections of a larger piece of furniture, called His Majesty's Grand Medal Case. A conjectural reconstruction suggests that this may have been of tripartite, breakfront form, the central part of which has not survived, with shelves for books connecting the three parts.[3] The bill for the original medal case has not been found, but a series of entries in the royal accounts of October 1761 describes in detail the alterations made to it by William Vile, the most extensive of which was the filling in of the space between the legs of the end cabinets with drawers and adding "carved doors and Ends and a New plinth to Dº on a frame."[4] Apparently at this time the end sections were also detached from the large cabinet, with the outer side of one part removed and attached as the corresponding side to the other part, leaving one cabinet (Metropolitan Museum) with two carved sides and one cabinet (Victoria and Albert Museum) with plain sides.

In 1761 the medal case was probably in the library of St. James's Palace, London, a range of rooms on the garden side that George III converted for this purpose in 1760. The following year he purchased Buckingham House and began, under the direction of Sir William Chambers (1723–1796), construction of the Great or West Library to contain the newly acquired and celebrated collection of Joseph Smith (1673/74–1770), British consul in Venice from 1740 to 1760, that included an accumulation of books and medals, as well as pictures, statues, and drawings. For this new library William Vile was commissioned to make numerous alterations to bookcases.[5] When in 1825 the books and medals were given by George IV to the British Museum, the pair of medal cabinets appears to have remained at Buckingham Palace. They later went as a royal gift to the second duke of Wellington at Stratfield Saye House in Hampshire. The two medal cabinets were acquired by the Victoria and Albert Museum and the Metropolitan Museum in 1963 and 1964, respectively. WR

1. Wilk 1996, pp. 112–13 (entry by Sarah Medlam).
2. Beard and C. Gilbert 1986, pp. 923–28 (entry by Geoffrey Beard).
3. Shrub 1965.
4. Quoted in ibid., p. 28.
5. H. Roberts 1990, p. 383.

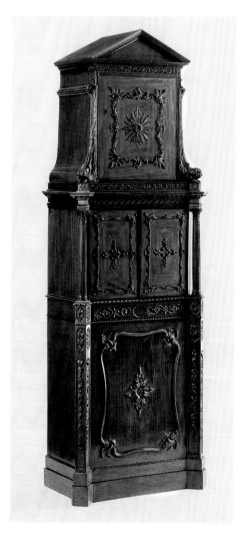

Fig. 85. Medal cabinet attributed to William Vile and John Cobb, 1760–61. Mahogany, 79 x 27 x 17¼ in. Victoria and Albert Museum, London, Bequeathed by Mr. Claude Rotch, London (w.11-1963). On loan to the British Museum.

Fig. 86. Carved lion on the left forecorner of the top section of the medal cabinet.

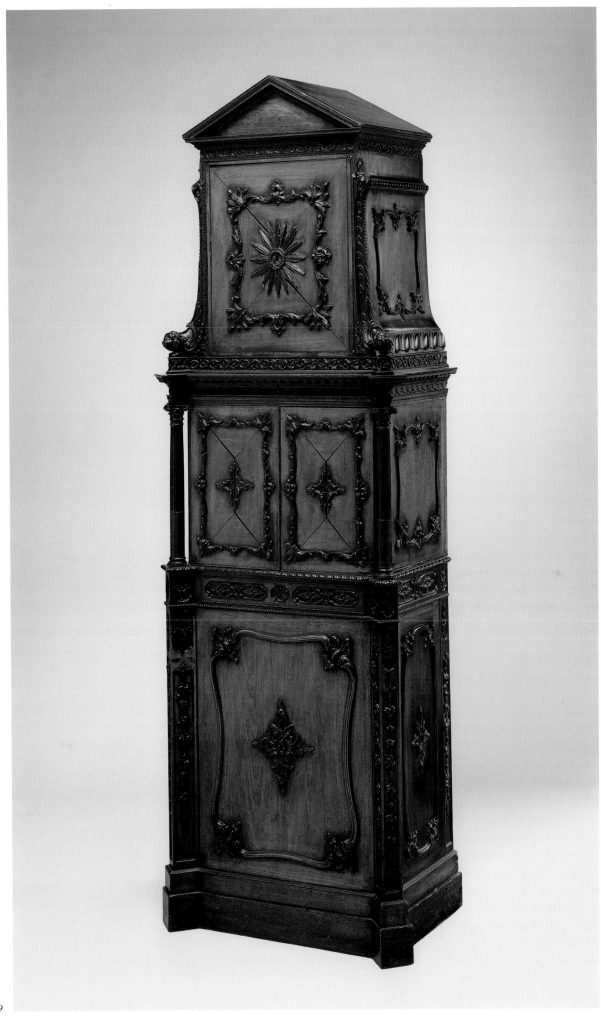

60.

Mechanical table

French, ca. 1761–63
Jean-François Oeben (1721–1763)
Oak veneered with mahogany, kingwood, and
tulipwood, with marquetry of mahogany, rose-
wood, holly, and various other woods; gilt-bronze
mounts; imitation Japanese lacquer; replaced silk
H. 27½ in. (69.8 cm), w. 32¼ in. (81.9 cm),
d. 18⅜ in. (46.7 cm)
Stamped under the back rail on the top:
"J F OEBEN." Stamped under the left rail on
the top: "R.V.L.[C.]" and "JME."
The Jack and Belle Linsky Collection, 1982
1982.60.61

This table has long been recognized as one of the masterpieces of Jean-François Oeben, cabinetmaker to Louis XV (1710–1774).[1] It was made for Oeben's most important client, the king's mistress Madame de Pompadour (1721–1764). The main charge of her coat of arms, a tower, appears at the top of the gilt-bronze mount at each corner.[CD] On the vase at the center of the marquetry top is the ducal coronet (Madame de Pompadour was given the title "duchesse-marquise de Pompadour" in 1752). The top, a tour de force of Rococo design, shows allegorical trophies of her chief interests—architecture, music, painting, gardening, and, last but not least, love—within a scrolling foliate border, executed with dazzling skill in marquetry of etched, stained, and natural mahogany, rosewood, holly, and other woods (fig. 88). Combining an extraordinary design with marquetry of great sophistication, the top is one of the finest panels in all of Oeben's furniture.

Oeben's skills are also apparent in the elaborate mechanism that allows the top to slide back as the large drawer below moves forward. With the drawer open, the table could be used for either reading or writing (fig. 87). A central arched panel, hinged at the front, rises by means of a hidden ratchet support and contains a rectangular panel, which can be rotated and fixed in position so that either side faces forward. One side of this panel is lined with blue moiré silk; the other contains a panel of imitation Japanese lacquer. Flanking this are two flaps, which are inlaid with large tulips overlapping ribbon-bound borders and which cover two shaped compartments veneered

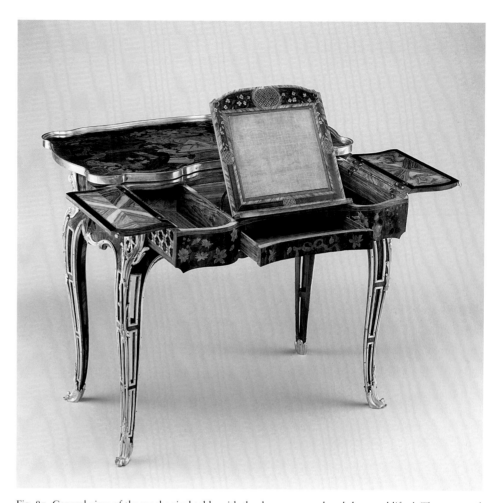

Fig. 87. General view of the mechanical table with the drawer opened and the panel lifted. The covers of the right and left compartments of the drawer are raised.

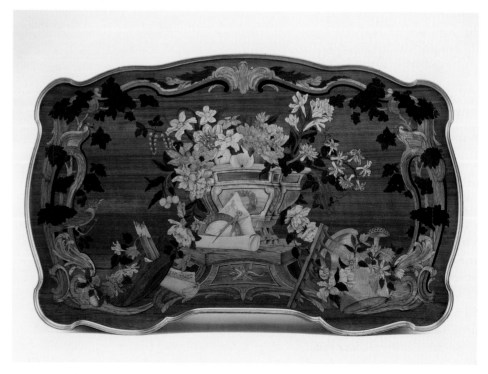

Fig. 88. Top of the mechanical table.

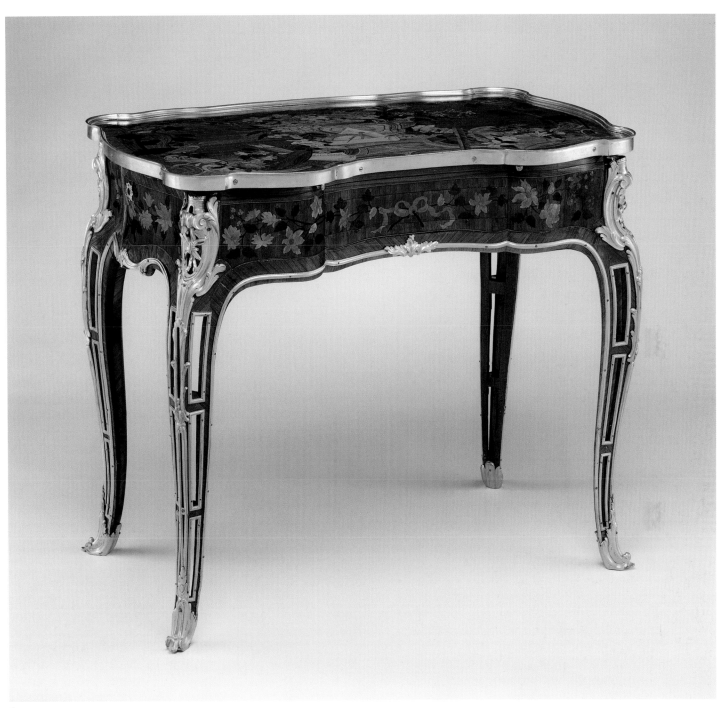

60

with tulipwood.[C] A concealed button releases a shallow drawer below the reading-and-writing panel. One of the most unusual features of this table is the treatment of the legs, each of which is pierced with three openings framed with a gilt-bronze rim. This detail is unique in Oeben's work.

Madame de Pompadour ordered a number of pieces of furniture from Oeben in 1761, but it is not clear that this table was among them. This group was left unfinished on Oeben's death in 1763 and completed by his brother-in-law, Roger Vandercruse (called Lacroix; 1728–1799), whose stamp (R.V.L.C.) along with Oeben's and also "JME," the monogram of the guild, are found on the underside of this table. It cannot be identified in the inventory prepared after Oeben's death, either in the list of ten items awaiting delivery to Madame de

Pompadour or in his large stock of completed and partly completed furniture, mainly because of the brevity of the entries.[2] Madame de Pompadour died in April 1764, and the inventory of her possessions presents the same problem.[3] Whether she ever took possession of this table has not been determined.

Oeben made a number of similar tables with sliding tops and drawers, sometimes

fitted as combination writing and toilette tables. The related tables by Oeben are in the Musée du Louvre, Paris; the J. Paul Getty Museum, Los Angeles; the Huntington Art Gallery, San Marino, California; the National Gallery of Art, Washington, D.C.; the Rijksmuseum, Amsterdam; the Residenzmuseum, Munich; the Victoria and Albert Museum, London; the Bowes Museum, Barnard Castle, Durham; and the Museu Calouste Gulbenkian, Lisbon.

For such a well-known piece of furniture, this table has a surprisingly vague history until the early twentieth century. It may have belonged to Madame de Pompadour's brother and principal heir, the marquis de Marigny, although there is no evidence to support this idea.[4] In the catalogue of the 1928 sale of Judge Elbert H. Gary's collection,[5] a series of previous owners of the table was listed (the marquess of Tullibardine; Mrs. Mary Gavin Baillie-Hamilton; and Lady Harvey, London, from whom it was acquired by the Paris dealers Lewis and Simmons), but in none of these collections has it been documented. In the twentieth century it was sold twice at public auction, both times fetching record prices for a piece of French furniture: at the Gary sale it was acquired by the dealer Joseph Duveen (1869–1939), and at the sale of the Martha Baird Rockefeller collection in 1971, it was acquired by Jack and Belle Linsky.[6] WR

1. For a more detailed discussion of this table and a partial bibliography, see Metropolitan Museum of Art 1984, pp. 210–12, no. 128 (entry by William Rieder). See also Rieder 1997.
2. Guiffrey 1899.
3. Cordey 1939.
4. Freyberger 1969, pp. 12–13.
5. Judge Elbert H. Gary sale, American Art Association, New York, 21 April 1928, lot 271.
6. Martha Baird Rockefeller sale, Sotheby's, New York, 23 October 1971, lot 711.

61.

Settee

German, ca. 1763–64
Carved, painted, and gilded linden wood; modern cotton-velvet squab cushion
H. 43 in. (109.2 cm), w. 54½ in. (138.4 cm), d. 25¼ in. (64.1 cm)
Painted on the outer back: "56B."
The Lesley and Emma Sheafer Collection, Bequest of Emma A. Sheafer, 1973
1974.356.120

Part of a larger set, this remarkable corner settee and its pair, also in the Museum, were commissioned by one of the most powerful figures in eighteenth-century Franconia, Adam Friedrich von Seinsheim (1708–1779). Prince-bishop of Würzburg and, after 1757, also of Bamberg, Seinsheim divided his time between two official residences in those cities and his three summer castles, Veitschöchheim, Werneck, and Seehof.[1] Preferring the country to the city, Seinsheim spent about three months a year outside Bamberg, at Seehof, where he enjoyed walking and hunting. He was fond of gardens and

Fig. 89. Design, attributed to Franz Anton Ermeltraut, for the wall elevation and ceiling of the Audience Chamber (garden room) in the Franckenstein Pavilion, 1761. Gouache over pencil on a gesso ground. Martin von Wagner Museum, Üniversität Würzburg (inv. no. 555/126, 20).

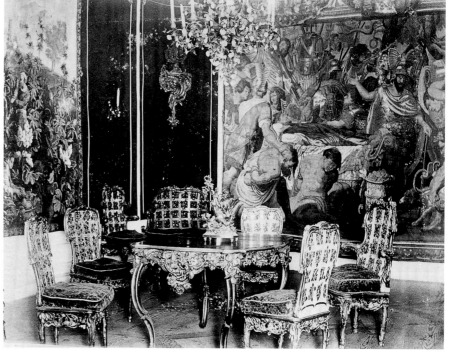

Fig. 90. Undated photograph of the Zandt family dining room at Schloss Seehof. Bayerisches Landesamt für Denkmalpflege, Munich.

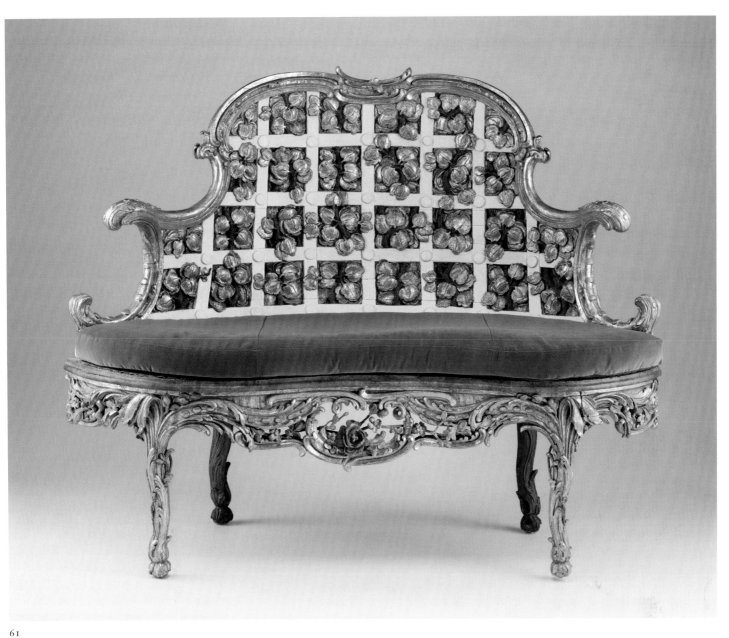

61

did much to embellish the late-seventeenth-century castle and especially its park, where he ordered that a maze, a theater, and a cascade with grotto and trelliswork arcades be constructed.

In 1761 he also resumed work on one of the ancillary buildings at Seehof, the Franckenstein Schlösschen. This garden pavilion at the east end of the orangery and greenhouses had been conceived as a place where the prince could retreat from the strict etiquette at his court. Built by the architect Johann Jakob Michael Küchel (1703–1769) for one of Seinsheim's predecessors, Johann Philipp Anton von Franckenstein, prince-bishop from 1746 to 1753, the Schlösschen had been left unfinished at the time of Franckenstein's death (see the entry for no. 45). Contemporary records indicate that Seinsheim decided to have its two main

rooms, the Saal and the Audience Chamber (also called the Arbor Room, or *berceau*), embellished with frescoes and stuccowork. All four walls of the Audience Chamber were to be decorated as an illusionary arbor with trelliswork and floral festoons. Franz Anton Ermeltraut, court painter at Würzburg, was commissioned to execute a small trompe l'oeil ceiling fresco. It is not known when this was finished because the work was delayed by occasional disputes between the patron and the painter and the latter's frequent illnesses.[2] No description of the room's interior was made when the Franckenstein Pavilion was demolished in the nineteenth century, but a drawing thought to be Ermeltraut's design for the Arbor Room has been preserved, illustrating its intended decoration (fig. 89).[3] Also, an inventory of 1774 at Schloss Seehof mentions a "Grünes

Perceau-zimmer," or Green Trelliswork Room, in the garden pavilion, showing that the room had been completed by then as planned.[4]

Among the furnishings listed were the two settees, together with a pair of matching armchairs and four side chairs that are also in the Museum's collection.[5] In addition, there were four wall brackets hanging in niches, two of which have been preserved as well.[6] These furnishings were described as "von bildhauer Arbeith grün Lassirt," or carved and glazed green.

Both the settees and the matching chairs have serpentine gilded frames consisting of large scrolls of various shapes and open-work aprons decorated with polychrome flowers and foliage. They are supported on slightly curved legs carved with a pattern of reeds, and rest on bun feet that are partly

covered by foliage. Most unusual is the off-white studded latticework intertwined with gilded and painted foliage on the inner backs of the seats; this must have been in total harmony with the original setting of the furniture. The outer backs of the settees and armchairs were left unfinished, as they were intended to stand against the wall; the side chairs, however, have latticework carving on both sides and were meant to be seen in the round.[CD] Corresponding to the inventory description of 1774, traces of a green glaze, originally applied over the gilding, are still present on the furniture.[7] Subsequent inventories offer additional details about the pieces, mentioning their green silk-velvet seat cushions and their placement.[8] Being rather top-heavy and unsteady, the settees stood in two corners of the room and the armchairs are described as being fastened in the other two. Grooves in the outer backs of the settees seem to imply that they too were once secured to the walls of the room.

It is, unfortunately, not known who was the maker of this unique garden-room furniture so expressive of the exuberant Rococo taste. Its sculptural silhouette and elaborate carving, the choice of linden wood, and the unusual construction and simple joinery all make it seem likely that a sculptor or master carver rather than a cabinetmaker was responsible for the set.[9] It has been suggested that Margravine Sophie Caroline von Braunschweig-Wolfenbüttel (1737–1817), of neighboring Bayreuth, presented the suite to Seinsheim.[10] This would explain the absence of bills in Seehof's archival records. The margravine is known to have visited Seinsheim regularly, and pieces of furniture were occasionally exchanged between them. Also in favor of a Bayreuth provenance is the florid style of the pieces: Rococo furniture of Bayreuth was characterized by unrestricted use of naturalistic motifs, such as flowers, foliage, reeds, and birds. There was also a preference in Bayreuth for naturalism in interiors. Several rooms in the more recent of Bayreuth's two castles, the Neues Schloss, were decorated before 1760 in imitation of latticework pavilions, the first examples of their kind in Germany.[11] A complete set of furniture would have been an unusually large gift, however. Since the Museum's suite was in such perfect harmony with its original setting, and given Seinsheim's attention to the smallest details of Seehof's embellishments, it seems more likely that the prince-bishop ordered it himself. With the exception of a corner settee in the Würzburg Residenz, no other pieces known today bear even the slightest resemblance to the Seehof set.[12] For this reason, and in the absence of contemporary documents, it is impossible to attribute the furniture to a specific artist.

The settees, chairs, and wall brackets presumably remained in the Franckenstein Pavilion until it was pulled down, between 1867 and 1870, and were then transferred to the castle itself. Seehof, which was in the possession of the bishopric and then part of the Bavarian royal domain until 1842, had become the private property of Freiherr Friedrich von Zandt and his descendants. Photographs taken at the turn of the century and later show the furniture in the Zandt family dining room (fig. 90).[13] They indicate that large carved flowers, now missing, originally adorned the cresting of the frames. The castle survived World War II intact, but the interior furnishings were sold off after the death in 1951 of the last male heir of the Zandt family.[14] In 1956 the Munich antiques dealer Fischer-Böhler sold this exceptional seat furniture to the New York collector Emma A. Sheafer. At that time the chairs and settees were upholstered in eighteenth-century painted Chinese silk, and only the trelliswork carving on the outer backs of the side chairs was left uncovered. Mrs. Sheafer never knew the full splendor of the furniture that filled the dining room of her New York City apartment. It was with their painted silk show covers that the furniture came to the Museum as part of her bequest in 1973 (see illustration on page 5, above). Once the fabric had been taken off, a conservation campaign was undertaken. This included the reconstruction of the foliage around the inner edge of the frames, which had been cut away to accommodate the upholstery; the removal of later paint layers on the trelliswork; and the manufacture of seat cushions covered in velvet to match the originals.[15] DK-G

1. Much of the information in this entry is taken from Kisluk-Grosheide 1990. See also Sangl 1990, pp. 215–21.

2. Masching 1996, pp. 19–20, A9, p. 23, A16.

3. Roda 1990, pp. 161–68, fig. 3.

4. Staatsarchiv Bamberg, Rep. B24, no. 756, fol. 139.

5. The accession numbers of the pair to the present settee, of the armchairs, and of the four side chairs are, respectively, 1974.356.121; 1974.356.118, 119; and 1974.356.114–117.

6. Accession numbers 1974.356.123,124. They were originally fitted on top with vase-shaped carvings, which are now in the collection of the Bayerische Verwaltung der Staatlichen Schlösser, Gärten und Seen, Munich. The other two brackets and their tops were most likely used to construct a late-nineteenth-century center table to match the seat furniture. This table, which is also in the Museum's collection (acc. no. 1974.356.122), is on long-term loan to Schloss Seehof.

7. Copper was used for this glaze, which would have been applied in a variety of transparent-to-opaque green tones that would allow the gilding to partially shine through. See Gill, Soultanian, and Wilmering 1990, pp. 171–72.

8. See the inventories of 1802, room 57B, and 1817–18, p. 37, no. 2A, transcripts of which are kept in the archives at Schloss Seehof.

9. Linden wood was more often used for sculpture than for furniture during this period. Unusual also is the way that the chairs were constructed. Normally the back supports would have formed one piece with the back legs. Here they were made like stools, with the backs attached separately. See Gill, Soultanian, and Wilmering 1990, p. 169.

10. This was suggested by the Munich dealer Fischer-Böhler (see below).

11. Kisluk-Grosheide 1990, pp. 156–57, fig. 23.

12. Heinrich Kreisel attributed the Würzburg settee to Johann Köhler, an otherwise unknown sculptor, who was paid for "sculptural work [and/or] carving executed in the newly furnished chamber in the princely residence"; Kreisel 1930, pp. 29–30. He ascribed the Seehof set to Köhler, as well; Kreisel 1956, pp. 20–21, 34, n. 28, 38–39, fig. 23.

13. Kisluk-Grosheide 1990, p. 152, figs. 15, 16; and Masching 1991, pp. 67–68, 92, figs. 17, 18.

14. Freiherr Franz Joseph von Zandt died in 1951. His widow remarried the following year, and the Zandt-Hessberg'sche Verwaltung assumed management of the castle; Masching 1991, pp. 68, 77, n. 13.

15. For a description of this conservation work, see Gill, Soultanian, and Wilmering 1990.

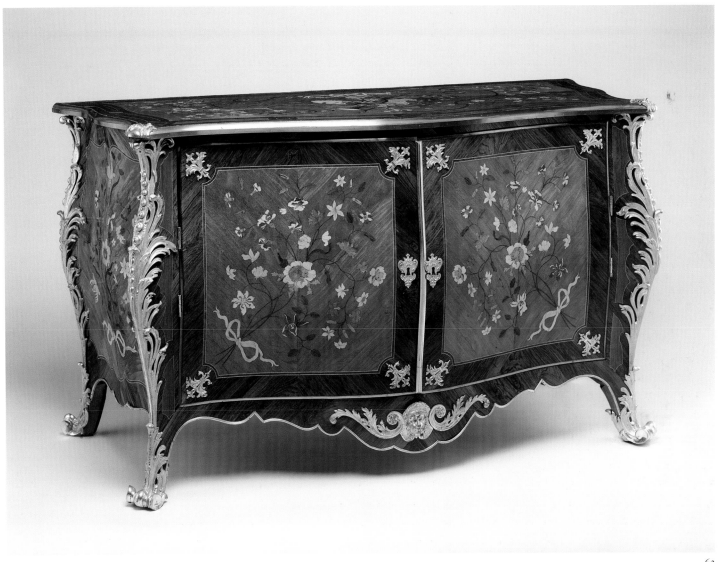

62

62.

Commode

English, 1764

Pierre Langlois (active 1759–81)

Pine and oak veneered with marquetry of satin-
wood, kingwood, and other woods on a
mahogany ground; gilt-bronze mounts

H. 34 in. (86.5 cm), w. 59¾ in. (151.8 cm),
d. 27⅛ in. (69 cm)

Fletcher Fund 1959

59.127

Pierre Langlois was one of the leading cabi-
netmakers in London in the 1760s and
1770s. He produced a wide range of furni-
ture in the French manner, specializing in
commodes in the Louis XV and Louis XVI
styles decorated with floral marquetry and
gilt-bronze mounts. His early marquetry
was closely related to that of the Parisian

ébéniste Jean-François Oeben (1721–1763),
in whose workshop he may have trained.
He shared his London premises with his
son-in-law, the bronze caster and bronze
gilder Dominique Jean, who probably made
the elaborate mounts for his furniture.[1]

This commode is one of his few docu-
mented works. It was supplied to the sixth
earl of Coventry on 20 July 1764 for Croome
Court, Worcestershire, together with a bill
that describes its function: "To the very hon-
orable nobleman the count of Coventry. For
a large commode for placing clothes, inlaid
with flowers of wood native to India and
embellished with gilt bronze at a price of
fifty-five pounds."[2] The wording of the bill
and the interior of the commode, which is

fitted with sliding tray-shelves, indicate that
it was a clothespress intended for a bedroom
or dressing room.[CD] This is the only known
piece of furniture by Langlois that has come
down to us with his trade card pasted to the
back; it describes in both English and French
the range of his products.[3] In the marquetry
trophy of musical instruments on the top
(fig. 91) and the bold foliated corner mounts,
this commode is closely related to one
supplied to the fourth duke of Bedford in
1759, now at Woburn Abbey, Bedfordshire.[4]
Langlois repeated on a number of commodes
the marquetry bunch of flowers seen here on
each front door, tied at the lower outside cor-
ner of the panel and spreading into the space
along a diagonal axis.[5]

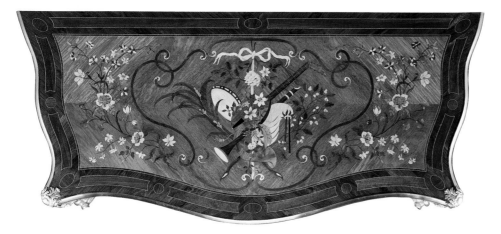

Fig. 91. Top of the commode.

At some point in the nineteenth century the commode was moved to the Tapestry Room at Croome Court, where it appears in an early-twentieth-century photograph.[6] It remained at Croome until 1948, when it was sold by the countess of Coventry at Sotheby's in London.[7] In 1959 it was acquired by the Museum through Frank Partridge and Sons, London, from Bryan Jenks.[8] WR

1. See P. Thornton and Rieder 1971–72; and Beard and C. Gilbert 1986, pp. 526–27 (entry by William Rieder). On Dominique Jean, see "Langlois and Dominique" 1968.

2. "Aux tres Honnorable Mon Segner Le Conte De Conventry. Pour une Grand Commode Pour Mettre Des Abit inscrutée de fleur du bois Natturelle des hinde et ornée de bronze Dorée du prix de L55-0-0." The full text of the bill is quoted in Beard and C. Gilbert 1986, p. 527 (entry by William Rieder).

3. When the commode was purchased by the Museum in 1959, only a fragment of the card remained on the back. Langlois's trade card is illustrated and its full text quoted, in both English and French, in P. Thornton and Rieder 1971–72, pp. 283–84. The trade card states that he could supply commodes, secretaries, clock cases, corner cabinets (encoignures), and other types of furniture decorated with floral marquetry and gilt-bronze mounts. He also advertised "all sorts of fine cabinets"—by which he probably meant carcase furniture generally, as opposed to seat furniture.

4. Ibid., p. 105, fig. 1.

5. Several commodes with similar decoration are illustrated and discussed in ibid., pp. 176, 179–81.

6. Dauterman, Parker, and Standen 1964, p. 33, fig. 9.

7. Sotheby's, London, 25 June 1948, lot 170.

8. Bryan Jenks, Astbury House, Erdington, Shropshire.

63.

Desk (*bonheur-du-jour*)

French (Paris), 1768
Attributed to Martin Carlin (ca. 1730–1785)
Oak veneered with tulipwood, amaranth, and stained sycamore; the small drawers of solid mahogany; mounted with soft-paste Sèvres porcelain plaques; gilt-bronze mounts; lined with modern velvet
H. 32½ in. (82.6 cm), w. 25⅞ in. (65.7 cm), d. 16 in. (40.6 cm)
Twelve plaques bear the date letter for 1768 and the painter's mark of Denis Levé (active 1754–1805); five others have unidentified painter's marks. Underneath the carcase is pasted a round label on which are printed and inscribed, respectively: "Hillingdon Heirlooms" and "103." Also affixed underneath the carcase is a round label with a blue border on which is inscribed: "From Vernon House Aug. 31st 1921."
Gift of Samuel H. Kress Foundation, 1958
58.75.48

The beautiful Marie Jeanne Bécu (1743–1793), who is better known by her married name, Comtesse Du Barry, was introduced to Louis XV (1710–1774) in 1768. After becoming the king's official mistress shortly thereafter, Madame Du Barry began to acquire paintings and furnishings for her apartment at Versailles and later also for her pavilion at Louveciennes. The dealer in luxury furnishings Simon-Philippe Poirier (ca. 1720–1785), who was the principal purchaser of plaques from the Sèvres porcelain manufactory until his partner Dominique Daguerre (d. 1796) succeeded him in 1777, provided her with a variety of porcelain-mounted furniture, which he himself may have helped to design. On 18 November 1768 Poirier delivered the first of these costly pieces to Madame Du Barry at Versailles. It was a low writing desk with a raised section at the back, a so-called *bonheur-du-jour*, for which he charged 1,440 livres.[1] Eleven such *bonheurs-du-jour* are known; four of them are at the Metropolitan Museum.[2] Seven are signed by the cabinetmaker Martin Carlin, and the others have been attributed to him.[3] Born in Freiburg-im-Breisgau, now in southwest Germany, Carlin was established in Paris by 1759, when he married Marie-Catherine Oeben, the sister of the cabinetmaker, or *ébéniste*, Jean-François Oeben (1721–1763). Carlin became a *maître ébéniste* in 1766 and specialized in the production of small, precious pieces of furniture, working mostly for Poirier and later also for Daguerre, who provided him with designs, porcelain plaques, lacquer panels, and gilded bronzes for mounting.[4]

Supported on four slender cabriole legs, this *bonheur-du-jour* is fitted with a single drawer in the frieze, containing on the right a small compartment to hold the inkwell, sponge trough, and a box for sand, now missing. On the left a large part of the drawer has a hinged writing surface, covered with modern green velvet, which could be lifted up to store writing implements underneath.[CD] On the back are one rectangular and two shaped panels framed by gilt-bronze moldings, within which are designs in marquetry of foliated and berried branches (fig. 92). The front, sides, and top—both of the table

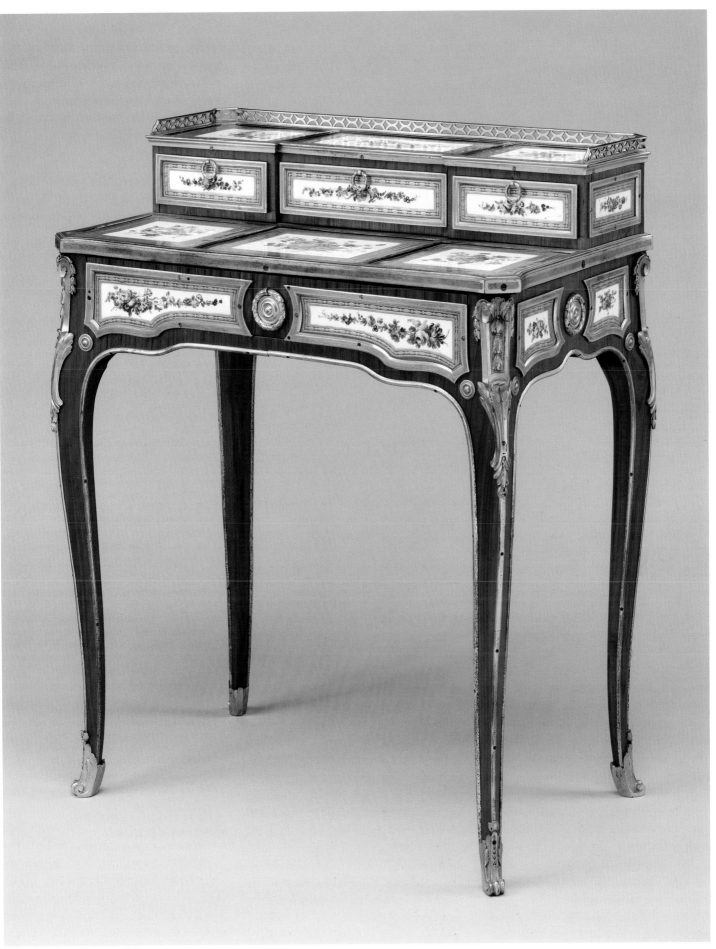

63

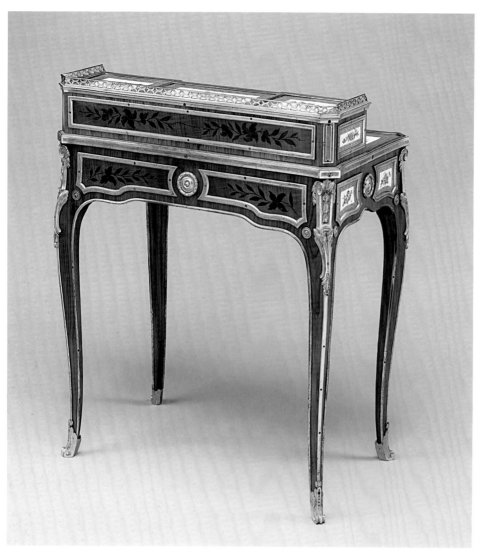

Fig. 92. Back of the desk.

dealers Duveen Brothers. In 1947 a number of artworks from the Hillingdon collection, including seventeen pieces of Sèvres-mounted furniture, were bought from Duveen Brothers by the cultural foundation that had been established by the American businessman and philanthropist Samuel H. Kress (1863–1955). Under the leadership of Samuel's brother Rush H. Kress (1877–1963), the Samuel H. Kress Foundation gave these extraordinary pieces of furniture to the Museum in 1958. D K - G

1. The desk was described in the bill Poirier supplied to Madame Du Barry as "Une table à gradins en porcelaine de France, fond vert et cartouches à fleurs, très richement ornée de bronzes dorés d'or moulu, le dessus du tiroir couvert d'un velours vert et les pièces d'écritoires dorées . . . 1,440 fr. [livres]"; quoted in Vatel 1883, vol. 1, p. 152. See also Baulez 1992, p. 45. At a time when the laboring poor in France earned between 100 and 300 livres per year and a skilled worker between 300 and 1,000 livres, the sum of 1,440 livres that Madame Du Barry paid for this small, elegant desk would have been thought very high by most of Louis XV's subjects. On this and for additional information on standards of living, see Sargentson 1996, p. xi.
 Bonheur-du-jour translates literally as "happiness of the day," and though the origins of the name are not clear, scholars have suggested that it may allude to the joy of letter writing; see Dauterman, Parker, and Standen 1964, p. 134, no. 22.
2. Two are in the Samuel H. Kress Collection, the present one and another one (acc. no. 58.75.49), and two are in the Jack and Belle Linsky Collection (acc. nos. 1982.60.54, 55). See Dauterman, Parker, and Standen 1964, pp. 134–38, nos. 22, 23; and Metropolitan Museum of Art 1984, pp. 217–22, nos. 133, 134 (entries by William Rieder).
3. Pradère 1989, p. 356.
4. Ibid., pp. 343–44.
5. Dauterman, Parker, and Standen 1964, p. 135, no. 22.
6. Jean-Jacques Pierre the younger's mark, a scrolling P (generally recorded as P⁷ or P¹), is different from the mark on the plaques of this writing desk. The painter Philippe Parpette (1736–?1808) is also thought to have marked his work with a scrolling P; Savill 1988, vol. 3, pp. 1055, 1059.
7. There are differences in the gilt-bronze mounts, in the choice of the woods used for the small drawers and for the marquetry panels on the back, as well as in the choice of the veneers used for the underside of the writing flaps. A number of these differences are listed in De Bellaigue 1974, vol. 2, p. 480.
8. Wildenstein 1962, pp. 368–69; De Bellaigue 1974, vol. 2, p. 482; Pradère 1989, p. 356; and Baulez 1992, p. 45.
9. Hughes 1992, pp. 125–26, pl. 76.
10. See Le Roi 1859, pp. 15–16.
11. See Dauterman, Parker, and Standen 1964, pp. 116–19.

and of the raised section with three small drawers—are mounted with Sèvres plaques painted with floral decoration within a green border. Twelve carry the Sèvres date letter for the year 1768 and the mark of the flower painter Denis Levé. The remaining five have been ascribed to Jean-Jacques Pierre the younger (b. 1745/46),[5] another of the factory's flower painters, but this attribution remains questionable.[6] Carlin's other *bonheurs-du-jour* are very similar to this one, varying only in minor details.[7] The plaques mounted on each of the eleven examples range in date between 1765 and 1774, making it relatively easy to establish the sequence in which they were produced.

Given the date on the Sèvres plaques, it has been suggested that the Museum's writing desk was the one supplied to the king's favorite mistress at Versailles in 1768;[8] however, a *bonheur-du-jour* by Carlin now at Boughton House, Northamptonshire, has

several plaques with the same date letter.[9] Since the early history of these pieces is not known, either one could conceivably have belonged to Madame Du Barry. She kept the writing desk in her Cabinet, a small room in her apartment at Versailles, located in the private quarters of the king, which she occupied until May 1774.[10] It is not known what happened to it after Louis XV's death, when part of Madame Du Barry's property was transported to Louveciennes.

Charles Mills (1792–1872), a London banker with a considerable art collection and a penchant for Sèvres porcelain and Sèvres-mounted furniture, purchased the Museum's *bonheur-du-jour* during the nineteenth century.[11] Together with other Sèvres-mounted pieces, this example was at one point in the possession of Mills's descendants, the Lords Hillingdon, at Vernon House, London, from where it was removed in 1921 and later sold to the well-known art

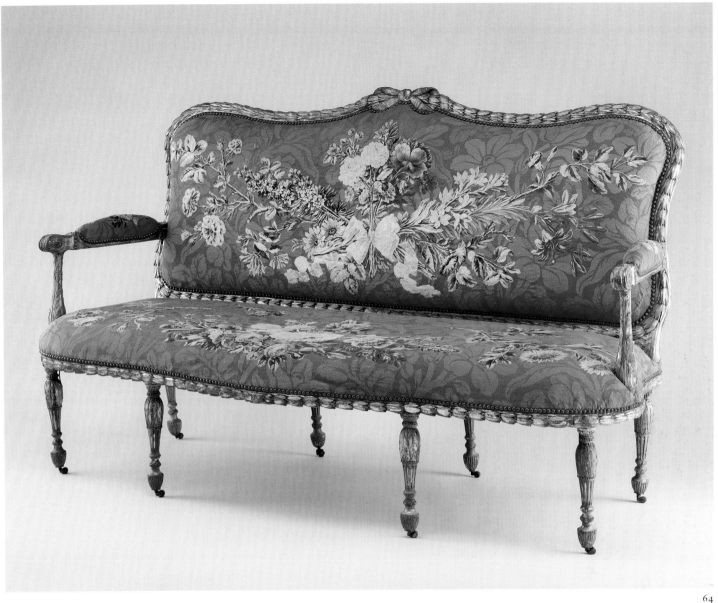

64, 65.

Settee and armchair

English, the frames 1769
John Mayhew (1736–1811) and William Ince
(d. 1804)
Gilded fruitwood; covered in contemporary wool-
and-silk tapestry made at the Gobelins
Manufactory, Paris
Settee: h. 44 in. (111.8 cm), w. 75 in. (190.5 cm),
d. 32½ in. (82.6 cm); armchair: h. 42⅝ in.
(108.3 cm), w. 28½ in. (72.4 cm), d. 26½ in.
(67.3 cm)
Gift of Samuel H. Kress Foundation, 1958
58.75.21,16

The Museum's set of six armchairs and two
settees from the Tapestry Room at Croome
Court, Worcestershire, formerly the seat of
the earls of Coventry, is among the best doc-
umented of all English Neoclassical furni-
ture.[1] It was executed by the leading
London cabinetmakers, John Mayhew and
William Ince,[2] who in 1769 billed the owner
of Croome, George William, the sixth earl
(1721–1809), for "6 Large Antique Elbow
Chairs, with oval Backs, Carv'd with Double
husks & ribbon, knot on top, Gilt in the
Best Burnish'd Gold, Stuff'd with Besthair,
in Linen, Backt with Fine Crimson Tammy,
proper for Covering with Tapistry in the
Country, the patterns included. 2 Settees for
Each Side the Chimney, richly Carv'd &
Gilt, Stuff'd & Cover'd to match the chairs.

10 Setts of Castors, with Screws, & fixing to
the Chairs & Sofas."[3] The floral cartoons
for the furniture covers were executed from
1760 to 1767 at the Gobelins Manufactory in
Paris by Maurice Jacques (1712–1784) and
the decorative artist Louis Tessier (1719/20–
1781).

In England this was the first instance in
which seat covers were designed en suite
with a set of tapestry hangings, which were
intended to be used rather like wallpaper,
covering the walls from chair rail to cornice.
The tapestries had a series of trompe l'oeil
medallions with scenes designed by François
Boucher (1703–1770) representing alle-

gories of the elements: Air, Earth, Fire, and Water. The tapestries were finally installed in June 1771 by Mayhew and Ince: "Three Men's time at Croome putting up the Tapestry." This was the first of several sets of this group of tapestries, called the *Tentures de Boucher,* woven at the Gobelins for English houses, of which the best known are the ones made for Osterley Park, Middlesex; Newby Hall, North Yorkshire; Weston Park, Shropshire; and Moor Park, Hertfordshire (now at Aske, North Yorkshire).

Between 1902 and 1904 the ninth earl of Coventry sold the tapestries and tapestry-covered furniture and re-covered the walls with green damask. Subsequently the original seat covers were acquired by a dealer in Paris, who removed and applied them to a set of modern frames in the Louis XV style. The Tapestry Room from Croome Court was given to the Metropolitan Museum by the Samuel H. Kress Foundation in 1958, together with the modern set of frames (see fig. 93). In the following year the original frames were discovered in a warehouse in Paris. They were purchased by the Kress Foundation and shipped to the Museum, where they were refitted with their original tapestry covers. WR

1. The accession numbers of the entire set are 58.75.15–22.
2. Beard and C. Gilbert 1986, pp. 589–98 (entry by Hugh Roberts and Charles Cator).
3. Quoted in Dauterman, Parker, and Standen 1964, pp. 35–38, no. 2a–h, figs. 11–14. The entry by James Parker contains further quotations of the bills and a bibliography. The best account of this furniture and of the Tapestry Room as a whole, by James Parker and Edith Standen, is found in this volume. See also Rieder 1996.

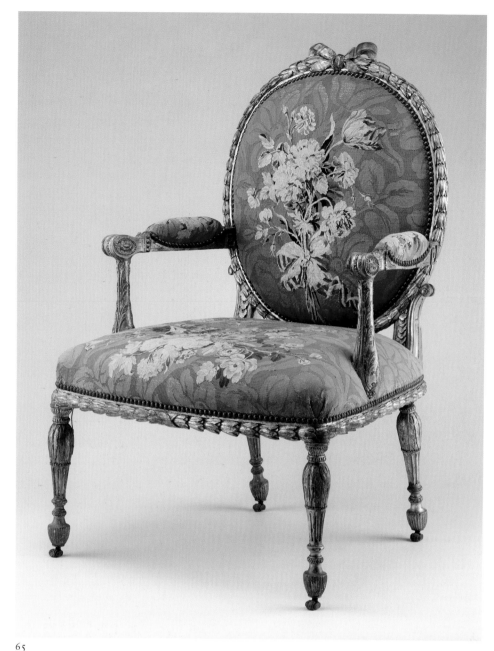

65

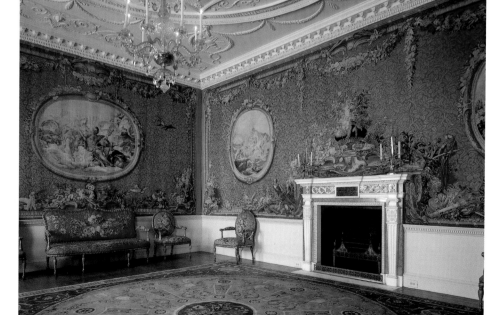

Fig. 93. The Tapestry Room from Croome Court, Worcestershire, 1771, at The Metropolitan Museum of Art. The photograph shows a settee and two chairs from the suite by John Mayhew and William Ince. The Metropolitan Museum of Art, New York, Gift of Samuel H. Kress Foundation, 1958 (58.75.1).

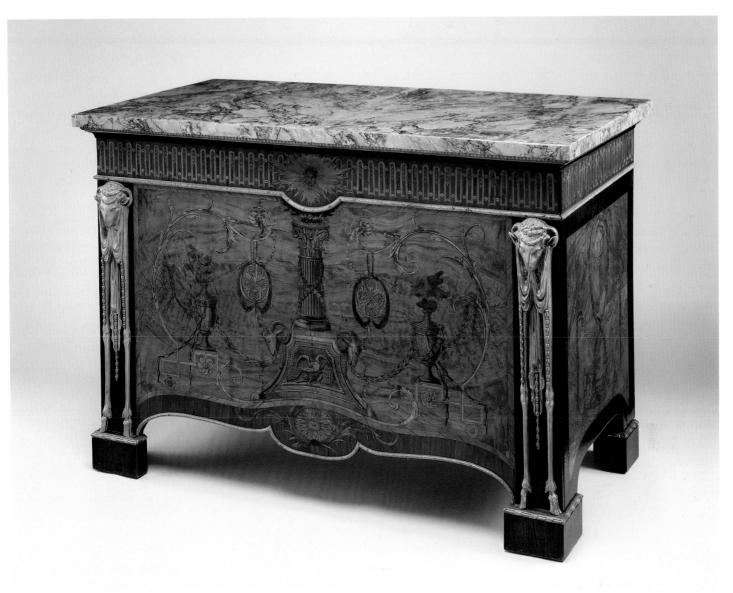

66.

Commode

English, ca. 1770
Attributed to John Mayhew (1736–1811) and
William Ince (d. 1804)
Pine veneered on the front and sides with
marquetry of satinwood, kingwood, holly, rose-
wood, and other woods; the drawer linings of
oak; gilt-bronze mounts; marble top
H. 38 in. (96.5 cm), w. 54 in. (137 cm), d. 28 in.
(71 cm)
Gift of Irwin Untermyer, 1964
64.101.1145

Large, boxlike commodes with a single mar-
quetry panel on the front are rare in English
furniture of the late eighteenth century.
Access to the interior of this one can be
gained only from the sides, each of which
opens to reveal four mahogany drawers (see

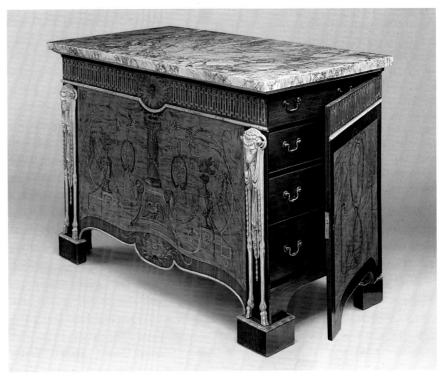

Fig. 94. Three-quarters view of the commode with the right door opened.

fig. 94).[1] This, of course, means that it could only have been placed in front of a pier or in some other position with no furniture nearby. It has all of the aspects of a virtuoso piece. The marquetry of the large front panel is of spectacular quality and unusual design, featuring a Corinthian column on a shaped pedestal with rams' heads terminating with feet at the corners, and an eagle flanked by pendant husks and smoking classical vases.[CD] It has been suggested that the front and side panels are by a Continental artist (one decorative-arts expert, who owned the piece in the 1920s, attributed them to Michelangelo Pergolesi),[2] but in many aspects of its marquetry, this commode is similar to others attributed to Mayhew and Ince, and there is no particular reason to think that the marquetry is not English. A pair of commodes in the Philadelphia Museum of Art displays lions' heads and draped swags closely related to the same elements on the side panels of the present commode and may well have been made by the same shop.[3] Documented furniture by Mayhew and Ince shows a sufficient variety in the style of marquetry to suggest that they may have used panels from independent marqueteurs.

The two corner mounts—each showing a ram's head above elongated legs—are a particularly significant element on this commode. The only other known example occurs on a set of two corner cupboards and two commodes at Burghley House in Lincolnshire, which were provided by Mayhew and Ince to the ninth earl of Exeter in 1767.[4] Much of the furniture at Burghley is described in a Mayhew and Ince bill of 1767–68 and recorded in a daybook of 1770–79.[5] It is only the mounts that make the comparison meaningful, however, for the Burghley commodes and corner cupboards were fitted with reused seventeenth-century marquetry. The commode stood prominently in the hall of Irwin Untermyer's New York apartment (see illustration on page 4, below).

W R

1. A complete bibliography and exhibition history for this piece are given in Metropolitan Museum of Art 1977, pp. 96–97, no. 175 (entry by William Rieder).

2. Mulliner 1924, fig. 52. Pergolesi was active in the second half of the eighteenth century.

3. Their accession numbers are 1976-129-1,2.

4. Hayward and Till 1973, pp. 1605–6, figs. 3–5.

5. The bills and daybook are housed in the Burghley archives (EX 90151 and Estate Books, 1700–1800). See Beard and C. Gilbert 1986, p. 594 (entry by Hugh Roberts and Charles Cator).

67.

Jewel coffer on stand (*coffre à bijoux*)

French (Paris), 1770
Attributed to Martin Carlin (ca. 1730–1785)
Oak veneered with tulipwood, amaranth, stained sycamore, holly, and ebonized holly; mounted with soft-paste Sèvres porcelain plaques; gilt-bronze mounts; lined with modern velvet
H. 37½ in. (95.3 cm), w. 21⅞ in. (55.3 cm), d. 14½ in. (36.8 cm)
One porcelain plaque bears the date letter for 1768, seven the date letter for 1770 and the painter's mark of Jean-Jacques Pierre the younger (b. 1745/46), and one the date letter for 1775 and the painter's mark of Michel-Gabriel Commelin (1746–1802). Underneath the stand is pasted a round label on which are printed and inscribed, respectively: "Hillingdon Heirlooms" and "129." Also affixed underneath the stand is a round label with a blue border on which is inscribed "From Vernon House Aug. 31st 1921."
Gift of Samuel H. Kress Foundation, 1958
58.75.41

This rectangular coffer on stand is one of three closely related pieces in the Museum's collection.[1] Formerly part of the Hillingdon collection, and gift to the Museum of the Samuel H. Kress Foundation (see the entry for no. 63), it is fitted with thirteen porcelain plaques of different shapes that are mounted on three sides and on the hinged top. Most of these plaques are decorated with floral ornament within a narrow green border. Fine gilt-bronze moldings with a stylized leaf pattern—the so-called *feuilles d'eau* motif—hold the porcelain in place and emphasize both the rectilinear form of the casket and the flowing lines of the elegant cabriole-legged stand, which encloses a drawer with a velvet-covered writing panel and a gilt-metal inkwell as well as receptacles for a sponge and sand.[CD] The shaped and undulating plaque on the center front of the coffer is painted with a trophy consisting of various love symbols and framed by a remarkably realistic gilt-bronze imitation of a fringe that lends it the appearance of a lambrequin.[CD] The curving leg-mounts include bearded satyr masks at the top, which protrude slightly from underneath the canted corners of the stand. Interlaced trelliswork marquetry of tulipwood on a stained sycamore ground with tiny dots of the same wood placed at the crossings decorates the back of both the casket and the stand (fig. 95).

In contemporary descriptions these pieces are referred to as *coffres* or *coffres-forts*.[2] For example, in his *L'art du menuisier* (1769–75) André-Jacob Roubo (1739–1791) remarks that since toilette boxes without inside fittings were generally used for the storage of jewelry they were known as coffers, adding that they could be executed in a very sumptuous manner.[3] The presence of the drawer fitted with a writing surface and of the compartment for writing paraphernalia, however, shows that this luxury piece doubled as a small desk.

Dated between 1770 and 1775, nine nearly identical coffers on stand that are either stamped by or attributed to Martin Carlin are known.[4] Between 1766 and 1785 this successful German cabinetmaker working in Paris made more than seventy generally light and elegant pieces of furniture mounted with Sèvres porcelain.[5] These were intended for a fashionable and distinguished clientele, consisting mostly, but not exclusively, of aristocratic ladies.

Marie Antoinette (1755–1793) received a jewel casket on stand by Carlin in 1770, the year of her marriage to the future Louis XVI (1754–1793), and it may well have been the prototype for the other eight examples. That coffer is marked with the double V of Versailles surmounted by the crowned monogram "GR" for G(reniers) des R(écollets), a monastery near the château where the office in charge of the furnishings in Marie Antoinette's residences was located.[6] The plaques are likely to be the ones bought from the Sèvres Manufactory during the

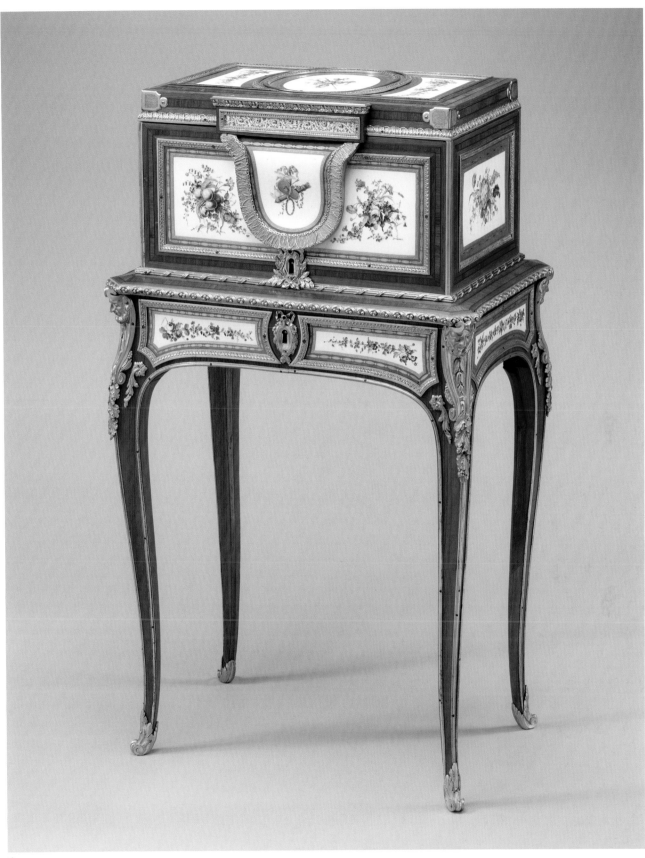

67

first half of 1770 by the *marchand-mercier* Simon-Philippe Poirier (ca. 1720–1785).[7] Later that same year, on 13 December, Poirier, who had a virtual monopoly on the purchase of Sèvres plaques, delivered "a coffer of French porcelain on a green ground with floral cartouches, very richly embellished with gilt bronze [mounts], and its stand" to Madame Du Barry (1743–1793), mistress of Louis XV.[8] Poirier charged 1,800 livres for this coffer on stand, to which he added six livres for shipment to Versailles. Given the fact that seven of the Sèvres plaques on the present example have the date letter *R*, for 1770, painted on their backs, it has been suggested that this, the earliest of the Museum's coffers, may have been the one that was commissioned by Madame Du

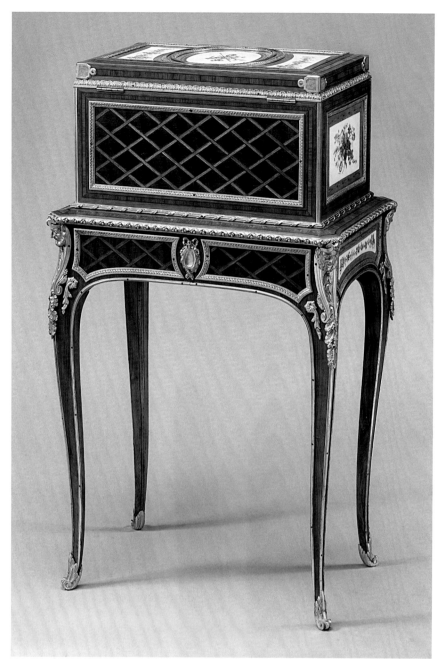

Fig. 95. Back of the jewel coffer on stand.

Fig. 96. *Design for a Jewel Coffer on Stand*, French, ca. 1770–75. Pen and black ink with gray and colored washes. The Metropolitan Museum of Art, New York, Gift of Raphael Esmerian, 1959 (59.611.2).

Barry. The plaque mounted at left on the drawer front, dated 1775 and painted by Michel-Gabriel Commelin, who specialized in floral borders,[9] is likely to be a replacement for an earlier, damaged one. Since the casket on stand is not listed in any of Madame Du Barry's inventories it is possible that she ordered the porcelain-mounted piece as an exquisite present for someone else.

A very similar coffer on stand is the subject of a pen-and-wash drawing in the Museum's collection (fig. 96), one of a series of drawings depicting French furnishings. They were intended for two passionate collectors, Duke Albert von Sachsen Teschen (1738–1822) and his wife, Archduchess Maria-Christine (1742–1798), a sister of Marie Antoinette, who were joint governors of the Austrian Netherlands (today Belgium) from 1780 to 1792. The drawings may either have been a record of furniture in the couple's collection or have served as a catalogue from which they could order fashionable furnishings for the Neoclassical residence built for them in Laeken, near Brussels, now the Belgian royal palace.[10] DK-G

1. Two are part of the Samuel H. Kress Collection (acc. nos. 58.75.41, 42); Dauterman, Parker, and Standen 1964, pp. 126–34, nos. 20, 21. The third is part of the Wrightsman Collection (acc. no. 1976.155.109); Watson 1966a, pp. 140–45, no. 90.

2. Four eighteenth-century descriptions are listed in Dauterman, Parker, and Standen 1964, pp. 129–30.

3. "Il y a de ces dernieres [*boîtes de toilette*] dont l'intérieur est vuide, c'est-à-dire, sans garniture; ces petites Boîtes ne servent, pour l'ordinaire, qu'à serrer les bijoux, & alors elles prennent le nom de *Coffre*. On en fait de très-riches, tant pour la qualité du bois que pour la garniture ou serrure extérieure." Roubo 1769–75, pt. 3, p. 980.

4. The model of the coffer and of the stand is the same for all nine, but there is variation in the decoration of the porcelain plaques, the gilt-bronze moldings, and the marquetry on the back. One coffer is fitted with seven storage trays inside; Detroit Institute of Arts 1996, pp. 55–60, no. 8 (entry by Theodore Dell). Another coffer has a different stand signed by the cabinetmaker Gaspard Schneider; catalogue of the Di Portanova collection sale, Christie's, New York, 20 October 2000, pp. 218–19.

5. Pradère 1989, pp. 344, 356, 358–59.

6. This coffer is now back at Versailles; Baulez 1997.

7. Pradère 1989, p. 360; Roberto Polo collection sale catalogue, Ader-Tajan, Paris, 7 November 1991, lot 153.

8. "un coffre de porcelaine de France fond verd à cartouche de fleurs et très richement orné de bronzes dorés d'or moulu ainsi que son pied"; Wildenstein 1962, p. 375.

9. Savill 1988, vol. 3, p. 1024.

10. Dauterman, Parker, and Standen 1964, pp. 128, 130, fig. 99; Myers 1991, pp. xxi, 195–96, no. 116.

68.

Side chair

English, ca. 1772
Thomas Chippendale (1718–1779)
Mahogany; covered in modern morocco leather
H. 38¼ in. (97.2 cm), w. 22 in. (55.9 cm),
d. 22½ in. (57.2 cm)
Purchase, Lila Acheson Wallace and The
Annenberg Foundation Gifts, Gift of Irwin
Untermyer and Fletcher Fund, by exchange, Bruce
Dayton Gift, and funds from various donors,
1996
1996.426.6

68

About 1772 Thomas Chippendale executed a set of Neoclassical mahogany dining chairs for Goldsborough Hall in North Yorkshire, a large Jacobean country house that belonged to Daniel Lascelles, younger brother of Chippendale's most extravagant patron, Edwin Lascelles (1712–1795), of nearby Harewood House. The set, to which this chair belongs, and which originally included fifteen chairs, remained at Goldsborough until 1929, when it was removed to Harewood House, from where it was sold by the seventh earl of Harewood in 1976.[1]

With their tall backs with arched top-rails and molded sides headed by beaded medallions, or paterae, and leaf finials; their fan-shaped splats with a central patera encircled and flanked by pendant bellflower swags; and their square, tapering paneled legs with pendant husks, the chairs represent one of Chippendale's most elegant designs. He produced five sets of these chairs, with minor variations, for three houses in Yorkshire (Harewood House, Goldsborough Hall, and Newby Hall), one in Hertfordshire (Brocket Hall), and one house in London (Lansdowne House).[2]

Because the Lansdowne House set has not survived, the present set of fourteen chairs was acquired by the Metropolitan Museum in 1996 for a period room, the Dining Room from Lansdowne House, as the closest approximation of what was originally there. On 20 January 1769 Chippendale billed the Lansdowne set to Lord Shelburne, the owner of the house, describing it as a set of "14 Mahogany Chairs with Antique backs and term feet very richly Carvd with hollow seats stuffd and coverd with Red Morocco Leather & double Brass naild L51-9-0 [fifty-one pounds, nine shillings]."[3] The Metropolitan's chairs have been newly upholstered with red morocco leather.

WR

1. C. Gilbert 1978b, vol. 1, p. 258. The set was sold from Harewood at Christie's, London, 1 April 1976, lot 41. It was acquired by the Museum at Christie's, London, 4 July 1996, lot 340. The accession numbers of the entire set are 1996.426.1–14.

2. Ibid., pp. 195–220, 253–54, 258, 264, 266.

3. Ibid., pp. 253, 255.

69.

Athénienne

French, ca. 1773
After a design by Jean-Henri Eberts
Carved and gilded pine; brass and gilt-bronze liner
H. 37¼ in. (94.6 cm), diam. of top 18½ in.
(47 cm)
Gift of Mrs. Charles Wrightsman, in honor of
James Parker, 1993
1993.355.1

The athénienne was a completely new, multifunctional type of French Neoclassical furniture derived from the tripod-shaped perfume burner of classical antiquity. It could be used as a washstand, perfume burner, food warmer, and jardinière. It was invented, probably in 1773, by Jean-Henri Eberts, editor of *Le Monument du Costume* (a series of etchings on the history of French costume in the eighteenth century), and was first advertised in *L'avantcoureur* in September 1773. Only a single engraving of the advertisement, now in the Library of the University of Warsaw, appears to have survived (fig. 97). Eberts stated in his advertisement that the athénienne could be examined and acquired at the shop of the gilder and color-merchant Jean-Félix Watin, the author of a popular handbook on gilding, *L'art du peintre, doreur, vernisseur*. In Eberts's engraving the athénienne is shown as a perfume burner, whereas the present example, which is one of a pair in the Museum's collection, is designed for use as a jardinière.[1]

Several examples of the athénienne have survived.[2] One of the earliest may have been supplied to Madame Du Barry (1743–1793) at Louveciennes in 1774.[3] But the present pair is closest in design to Eberts's engraving. Eberts owned a painting by Joseph-Marie Vien (1716–1809), *La Vertueuse Athénienne*, which includes a tripod that was once thought to be the source of Eberts's design, but because the correspondence is not close, that idea was subsequently played down by French furniture expert Sir Francis Watson: "Nevertheless, since Eberts owned the painting there may well have been some link between the two in his mind."[4]

Fig. 97. Engraved advertisement by Jean-Henri Eberts in *L'avantcoureur*, September 1773. Print Room, Library, University of Warsaw.

Watson suggests that all of the surviving athéniennes may have been made by the same unidentified cabinetmaker. Whether this is the obscure A. P. Dupain who stamped one of the surviving pairs is not known.[5] He may just have specialized in their production. W R

1. The accession number of the second example is 1993.355.2.
2. Eriksen and Watson 1963, p. 111.
3. "Une athéniene de bois sculpté et doré, avec garniture et réchaux à esprit de vin en cuivre bronzé en dehors et argenté dedans" (An athénienne of carved and gilt wood with a fitting for warming spirits of wine made of bronzed copper on the outside and silvered within); quoted in Vatel 1883, vol. 2, p. 488.
4. Watson 1966a, p. 104, no. 71A,B.
5. Watson 1960, p. 151, fig. 226. Dupain is recorded as a *maître menuisier*, or master furniture carver, in 1772.

70.

Table

Italian (Rome), ca. 1775–80
Wood, carved, painted, and partly gilded; black
granite top not original to the table
H. 35⅜ in. (89.9 cm), w. 48⅝ in. (123.5 cm),
d. 23 in. (58.4 cm)
Gift of Robert Lehman, 1941
41.188

Arriving from Dresden in Rome in 1755, the historian of classical art Johann Joachim Winckelmann (1717–1768) stepped into a different, intensely stimulating world. The sophisticated international community settled there was experiencing a rapidly growing fascination with the ancient Mediterranean civilizations. As librarian to the collector Cardinal Alessandro Albani (1692–1779), Winckelmann spent nine productive years in the intense study of Etruscan, Greek, classical Roman, and Egyptian works. He found them "in the galleries, vaults, and gardens of Roman palaces, at Naples, and at the new excavations of Herculaneum."[1] During ancient Roman times, Egyptian monuments, such as obelisks and statues, and precious materials, such as alabaster, that formerly decorated the palaces of the pharaohs and temples on the banks of the Nile (for example, two panels on the Farnese table; see no. 7) were brought as spoils to Rome and were used to embellish public places and the imperial residences. The constant presence of Egyptian art in Italy occasionally inspired artisans of later eras to incorporate its mysterious decorative motifs into their own inventions. Sometimes it was the mere citation of a detail, such as a sphinx's paw used to support a Renaissance *cassone* or cabinet.[2] And because there was no understanding of pharaonic traditions and no knowledge of the land of Egypt or of its ancient writing, European artisans and scholars were unable to distinguish pharaonic originals from imperial Roman copies or interpretations. On a large scale, the frescoes by Raphael and his studio for the Sala dell'Incendio in the Vatican and the Sala Egiziana in the Palazzo Massimo alle Colonne are two of a few grand Italian interior decorations with Egyptianizing details that predate the Egyptomania that seized Europe in the wake of Napoleon's

military campaign along the Nile in 1798 (see the entry for no. 92).[3]

Winckelmann's patron Alessandro Albani was one of the first connoisseurs in early-eighteenth-century Rome to consider in a scholarly manner the nature and significance of Egyptian art. At his villa in Rome he built a salon decorated in the Egyptian style, which he filled with ancient Egyptian and Roman works, creating what was "probably the first such historical reconstruction in modern times."[4] A few years later, the antiquarian, architect, and engraver Giovanni Battista Piranesi (1720–1778) made designs (never executed) for chimneypieces in the Egyptian taste. These extraordinary etchings contained a wealth of Egyptian ornament arranged in an imaginative, purely decorative manner. They became "the ultimate anthology of Egyptian motifs for the remainder of the century."[5] Meanwhile, the archaeologists were continuing to unearth Egyptian works in Rome. Soon European "Neo-classical designers [were drawing] on Egypt in much the same way that Rococo designers had drawn on China."[6]

The design of this table reflects the Neo-Egyptian fashion in Rome in the late 1770s.

The painted finish simulates the beautiful greenish red of Aswan granite. It is highlighted with flecks of gilding that harmonize with the gilded hieroglyphs and the sphinx heads that crown the legs, which terminate in human feet, also gilt. The hieroglyphs and cartouches, some of which are similar to those used by Piranesi in his chimney-piece designs, are identifiable, but their arrangement on the table's aprons and legs does not convey a logical message. These bold details are pulled from their context on ancient monuments and arranged in a merely decorative manner.

Who commissioned this striking piece is not known. The closest connection that can be made is with a table depicted in Laurent Pécheux's attractive 1777 portrait of Margherita Gentili Boccapaduli standing in the room devoted to her natural-history collection and other curiosities.[7] The tabletop in the portrait (fig. 98) incorporates a mosaic of various marbles and other stones, arranged in a way that is typical of souvenirs of a grand tour. It can be assumed that the Museum's table once had a very similar top. Such highly decorative displays of stones, many of which are semiprecious,

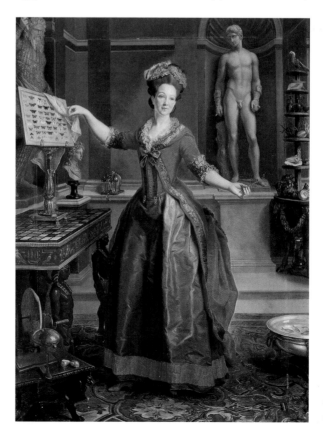

Fig. 98. Laurent Pécheux, *Portrait of the marchesa Margherita Gentili Boccapaduli*, 1777. Oil on canvas, 42⅛ x 31½ in. Private collection.

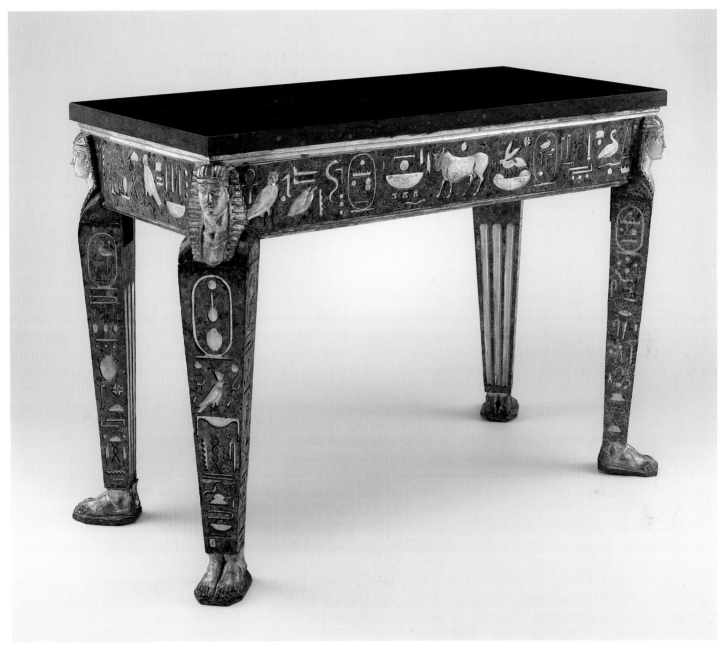

70

later became collector's items in their own right. This may be why the original top of the Museum's table was removed and replaced with one of black granite. There is a related table in a New York private collection, and another was recently recorded on the New York art market.[8]

This intriguing object was among the first gifts that Robert Lehman made to the Metropolitan Museum, which became one of his great interests. In 1975 he bequeathed his collection to the Museum, together with the gift of a new wing to house it. W K

1. Eitner 1970, vol. 1, p. 13. See also Winckelmann 1880.

2. *Der Glanz der Farnese* 1995, p. 55, fig. 5.

3. A passion for the Egyptian style before Napoleon's era was not limited to Italy. Johann M. Dinglinger's *Apis Altar* of 1731 in the Green Vault at Dresden is a rich compendium of ancient Egyptian motifs, surmounted by an obelisk; see Syndram 1999, pp. 60–61. Queen Marie Antoinette adored the style (see the entry for nos. 86–88). And, recognizing the innate appeal of Egyptian objects, David Roentgen, marketing genius *sans pareil* among European cabinetmakers, placed a sphinx, symbol of royal power and feminine wisdom, on either side of the writing surface of a desk that he designed in 1783 with Catherine the Great of Russia specifically in mind; see Fabian 1996, p. 100, no. 213.

4. Pantazzi 1994, p. 39.

5. Humbert, Pantazzi, and Ziegler 1994, p. 69, no. 16 (entry by Michael Pantazzi) and for Piranesi's chimneypiece designs, see pp. 69–74, nos. 16–21 (entries by Michael Pantazzi).

6. Fleming and Honour 1989, p. 275. For chinoiserie, see Gruber 1996.

7. González-Palacios 1991, pp. 141–42, no. 60, pl. XXIV (entry by Alvar González-Palacios). See also Morley 1999, pp. 292–93, and fig. 603 (the present table).

8. For the first, see Humbert, Pantazzi, and Ziegler 1994, pp. 76–77, no. 23 (entry by Michael Pantazzi). The Museum's table is number 42 in that exhibition catalogue (it was shown only at the Paris venue). For the second, see catalogue of a sale at Christie's, New York, 24 September 1998, p. 149, lot 295.

Secretary on stand (*secrétaire à abattant* or *secrétaire en cabinet*)

French (Paris), ca. 1776
Attributed to Martin Carlin (ca. 1730–1785)
Oak veneered with tulipwood, amaranth, holly,
and sycamore; mounted with soft-paste Sèvres
porcelain plaques and plaques of painted tin; gilt-
bronze mounts; white marble shelves; lined with
moiré silk
H. 43½ in. (110.5 cm), w. 40½ in. (102.9 cm),
d. 12⅞ in. (32.7 cm)
The central porcelain plaque bears the date letter
for 1776 and the mark of Edme-François
Bouillat the elder (1739/40–1810). Pasted on
the back is a label inscribed "29617 c/s 5016," a
red-bordered octagonal label inscribed "9," a red-
bordered oval label inscribed "F36," and a red-
bordered octagonal label inscribed "1192" and
"53." Marked on the back: "MN2603," "1017,"
and "M.6501" (partly illegible). Painted under-
neath the stand: "217."
Gift of Mr. and Mrs. Charles Wrightsman, 1976
1976.155.110

In 1795 Grand Duchess Maria Feodorovna (1759–1828) wrote a detailed description of her private rooms at Pavlovsk, near Saint Petersburg, the palace that was built for her and her husband, Grand Duke Paul (1754–1801), by the English Neoclassical architect Charles Cameron (1745–1812). According to the account, her boudoir, leading off the bedchamber, was rectangular and had a vaulted ceiling painted with arabesques. The fireplace, on one of the short walls, was placed opposite the window from where she had a view of the garden and the park. Among the furnishings Maria Feodorovna listed were porphyry-topped tables, carved and gilded seat furniture from Paris, a desk by the cabinetmaker David Roentgen (1743–1807), as well as a porcelain table made in Saint Petersburg. In addition, she mentioned two secretaries mounted with Sèvres porcelain. Standing along one of the long walls of the room, they supported precious objects and knickknacks placed on top.[1]

One of these bowfront upright desks, richly decorated with six variously shaped porcelain plaques and gilt-bronze mounts, is now at the Metropolitan Museum, the gift of Mr. and Mrs. Charles Wrightsman in 1976.[2] The upper section, consisting of a drop front flanked by two open, marble-lined shelves on either side, rests on a stand with a drawer in the frieze, supported on

four tapering legs connected by a marble shelf. Unsigned, the piece has been attributed to the French cabinetmaker of German birth Martin Carlin, who was known for his precious furniture mounted with porcelain (see the entries for nos. 63, 67). He worked almost exclusively for the dealers in luxury goods Simon-Philippe Poirier (ca. 1720–1785) and his partner and successor, Dominique Daguerre (d. 1796). A similar piece, in the collection of the J. Paul Getty Museum, Los Angeles, is actually stamped by Carlin.[3] Several of the gilt-bronze mounts on the Metropolitan's secretary, such as the drapery swags, the border of berried laurel motifs underneath the gallery, or railing, the pendants of flowers and grapes, and the crossed sprigs of oak leaves and acorns, recur regularly on furniture either by or attributed to Carlin. Also typical of his furniture is the lambrequin-shaped porcelain plaque that serves as a handle for the drawer in the stand. It is designed to look as though it partially covers the plaques to the left and right. The curved sides are set with panels of blue and white painted tin, or *tôle peinte*, simulating porcelain.

The large porcelain plaque is decorated with a flower basket suspended from a bow-tied ribbon within a blue-ground border.[CD] Like the lambrequin-shaped plaque below, it appears to overlap two narrow, rectangular flanking plaques, creating a sense of depth. It bears the date letter for the year 1776 and the mark of the Sèvres painter Edme-François Bouillat, who specialized in floral sprays, vases, bouquets, and baskets of flowers.[4] The French word *milieu* (middle) is penciled on the back, indicating the intended placement of the plaque on the secretary's drop front.[5] Pasted on the back of the smaller plaques are tiny rectangular labels printed with the interlaced *L*'s mark of the Sèvres Manufactory. The labels are inscribed with the number 60, and on the back of the larger plaque the number 96 is written in ink. These numbers are probably an indication of the price in livres.

The fall front, lined on the inside with pale blue moiré silk, opens to an interior veneered with tulipwood and fitted with three

pigeonholes, a shelf, and six drawers.[CD] The drawer fronts are beautifully finished with tulipwood and framed in amaranth with stringing of holly and sycamore.

The marble shelves on top, in the open side compartments, and between the legs add a substantial weight to the piece, already laden with porcelain and gilded bronze. With their openwork galleries, these shelves are ideal for the safe display of the small valuables mentioned in the description by its first owner. A black-and-white photograph published in 1907 shows the secretary, still at Pavlovsk, with a variety of porcelain vases, cups, and saucers tucked in the side compartments and on the shelf below, creating what must have been a very colorful sight.[6]

In September of 1781, Paul and Maria Feodorovna, who was born Princess Sophia-Dorothea of Württemberg, had left Saint Petersburg to go on their grand tour, traveling incognito as the comte and comtesse du Nord. For fourteen months they explored Italy and France, acquiring artworks and ordering furnishings for their residence, then under construction at Pavlovsk. While in Paris during the spring of 1782, they visited Daguerre's fashionable shop, À la Couronne d'Or, on the rue Saint-Honoré, where they probably bought this secretary and also commissioned or purchased several other porcelain-mounted pieces of furniture that were later installed at Pavlovsk.

After becoming emperor and empress of Russia in 1796, upon the death of Catherine the Great, Paul and especially Maria—who had a deep affinity for Pavlovsk—continued to make improvements to their former residence and in the park. Maria spent much time there as dowager empress, and she left the palace in 1828 to her youngest son, Grand Duke Michael Pavlovich (1798–1849), stipulating that nothing should be dispersed or changed.[7] After Michael's death, the estate descended to his nephew, Grand Duke Constantine Nicolaievich (1827–1892). Neither Michael nor Constantine apparently ever lived in the palace but kept it as a family museum.[8] Grand Duchess Alexandra Iossif-ovna (1830–1911), Constantine's widow,

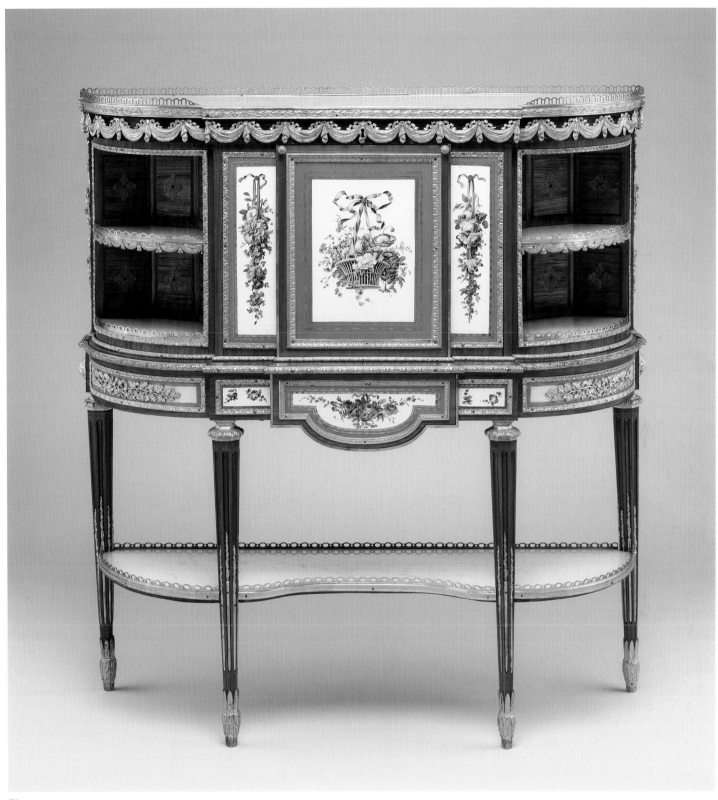

71

became the next owner, and this secretary, together with its companion in Maria Feodorovna's boudoir, are said to have graced her salon.[9] In 1911 she left the palace to her son, Grand Duke Constantine Constantinovich (1859–1915). After the Revolution of 1917, the Soviet government took possession of Pavlovsk and offered works of art from the palace for sale.

Traveling to Russia in 1931, the dealer Joseph Duveen (1869–1939) visited the former imperial residences and acquired French tapestries and porcelain-mounted furniture, including the Museum's secretary.[10] Two years later Duveen Brothers sent the piece to the loan exhibition "French Furnishings of the Eighteenth Century" at the Toledo Museum of Art.[11] It was sold in 1934 to the

Dutch banker and art collector Fritz Mannheimer (1890–1939), together with the second porcelain-mounted secretary from Maria Feodorovna's boudoir at Pavlovsk.[12] Both secretaries were back with Duveen Brothers in 1946, and Charles Wrightsman bought the Museum's piece, number 29617 of the dealer's stock, in 1954.[13] DK-G

1. "deux bureaux assez élevés en porcelaine de Sèvres et bronze, surmontés de petites statues en marbre, de candélabres, de pendules et de petites pièces de cabinet, entre autres d'une petite colonne de lapis lazuli avec deux vases de même, et de babioles semblables"; quoted in Benois 1903, vol. 3, p. 374.

2. Roche 1912–13, vol. 2, pl. LVI; and Watson 1966a, pp. 186–90, no. 105. The second secretary, stamped by Adam Weisweiler (1744–1820), was offered for sale at Christie's, New York, 21 October 1997, lot 256. It is illustrated in Pradère 1989, p. 395, fig. 485.

3. Bremer-David 1993, pp. 41–42, no. 50. It is mounted with porcelain plaques bearing the date letters 1776 and 1777.

4. Savill 1988, vol. 3, pp. 1002–3.

5. Two other plaques have penciled inscriptions on the back that also refer to their placement on the secretary. One reads *droit* (right) and the other *tiroir* (drawer); illustrated in Watson 1966a, p. 189.

6. *Les trésors d'art en Russie* 7 (1907), p. 147, pl. 84.

7. Massie 1990, pp. 110–11.

8. Ibid., p. 111.

9. Benois 1903, p. 374, n. 72.

10. Fowles 1976, pp. 195, 198. A jewel coffer from Maria Feodorovna's bedchamber at Pavlovsk, acquired by Duveen in 1931, now in Detroit, is described in Detroit Institute of Arts 1996, pp. 55–60, no. 8 (entry by Theodore Dell). A writing table, also from Maria's bedchamber and bought by Duveen, is in the J. Paul Getty Museum, Los Angeles; Bremer-David 1993, pp. 58–59, no. 79.

11. *French Furnishings* 1933, no. 41; and "Royal Suite" 1933.

12. Duveen Brothers Records 1876–1981, Papers and Correspondence, 1901–81, box 484, f. 4 (microfilm, reel 339).

13. Duveen Brothers Records 1876–1981, Client Summary Book, 1910–59, I–Z, 17 November 1954 (microfilm, reel 421).

72.

Rolltop desk

German (Neuwied), ca. 1776–78
David Roentgen (1743–1807)
Oak and cherry, veneered with mahogany, maple, kingwood, and various other woods, partly stained; mother-of-pearl; brass, partly gold-lacquered; gilt-bronze mounts; steel and brass operating mechanisms
H. 53½ in. (135.9 cm), w. 43½ in. (110.5 cm), d. 26½ in. (67.3 cm)
Inlaid beneath the keyhole escutcheon on the lower middle drawer: "DR."
Rogers Fund, 1941
41.82

David Roentgen, son of the cabinetmaker Abraham Roentgen (1711–1793),[1] was a legend in his lifetime. Johann Wolfgang von Goethe (1749–1832), who visited Roentgen's workshop in Neuwied on the Rhine in Germany, was so impressed that he himself designed a rolltop desk[2] inspired by "Neuwieder Arbeit," as Roentgen's marvels of technical ingenuity are often called in eighteenth-century inventories.[3]

The Roentgen family belonged to the prosperous Protestant religious group known as Herrnhuter. After being expelled from other settlements, a community of these Moravians accepted the invitation of Johann Friedrich Alexander zu Wied (1706–1791), the count of Neuwied, to settle in his domain. Aiming to strengthen the local economy, Count Wied had wisely granted the internationally connected Brethren religious freedom, partial exemption from local taxes, and unrestricted employment opportunities in their workshops.[4] After a humble beginning under Abraham in 1750, the rapidly expanding Roentgen workshop produced exceptional furnishings of very forward-looking design,

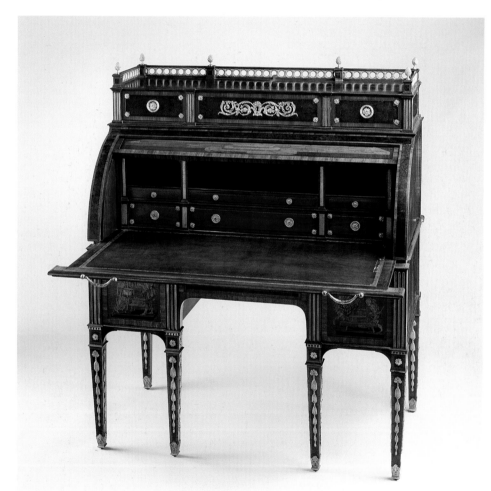

Fig. 99. General view of the desk with the roll top raised and the writing slide extended.

either commissioned by the region's nobility or made for sale at the annual trade fair in Frankfurt am Main. David Roentgen took charge of the manufactory beginning about 1766–67, some years before the "English Cabinetmaker," as Abraham Roentgen called himself, resigned officially.

David perfected his father's innovative practice of prefabricating elements such as drawers and marquetry panels that could be assembled and used to make items of different purpose and appearance. He invented furniture types that soon were in demand throughout the German-speaking cultural

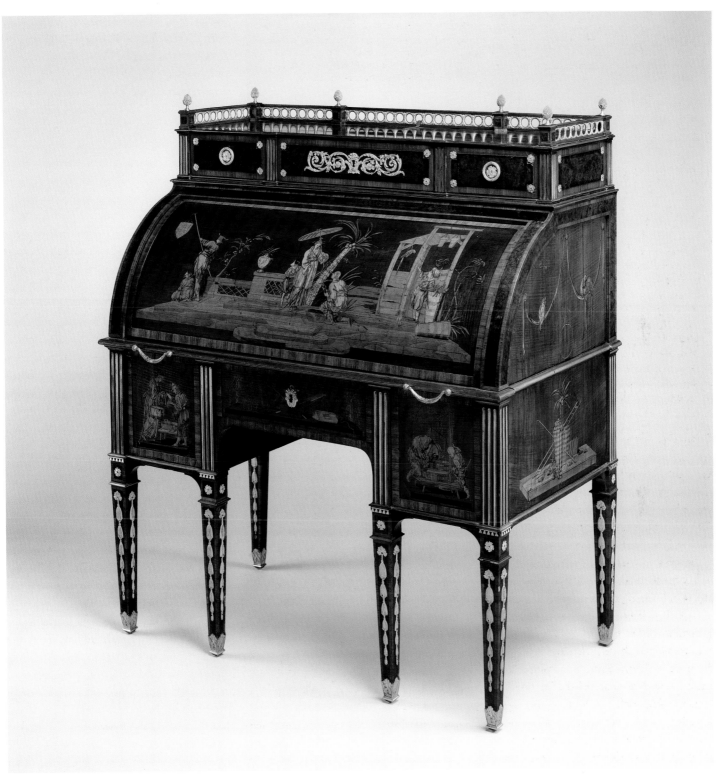

Fig. 100. View of the rolltop desk with the hinged front section of the lower right compartment pulled forward and swung aside.

inlaid *à la mosaique*, . . . This work could be . . . compared to painter's work without any hesitation . . . all the figures are created from wood . . . they are exactly like a painting, one that could be gone over with a plane without losing anything of its beauty."[7] This long-lost piece in Roentgen's oeuvre has recently been identified as a writing desk in the collection of the Danske Kunstindustrimuseum in Copenhagen.[8]

A novelty in the 1770s, the rolltop mechanism was most likely adapted by Roentgen from English and French prototypes.[9] The workshop first used it, about 1773, following an earlier desk model with a slanted fall front possibly inspired by designs of Bavarian Rococo architect François Cuvilliés (1695–1768).[10] A terminus post quem of 1773 is established by a dated rolltop in the Residenz, Munich.[11] The Museum's desk has six legs instead of the usual four,[12] but it is not the most elaborate of all the desks produced at the Roentgen workshop; in many, often at the push of a button, the most amazing mechanical actions take place. Traditionally, however, it is considered a preeminent example of Roentgen's production methods and artistic creativity. Hardly any publication on the history of furniture or ornamental marquetry omits the Museum's masterpiece.[13] The inlaid monogram "DR" on the lower middle drawer is of the utmost rarity.[CD] Its presence demonstrates the master's satisfaction with what he must have considered an exceptionally refined desk. The quality and perfectionism seen here indicate that Roentgen sought recognition for his marquetry and mechanical furniture. His ambition set him apart from most if not all his European competitors.

When the key to the lock in the lower middle drawer is turned to the right, the compartment to the right of the kneehole slides forward, driven by a spring. A button underneath can be pressed to release the front half of the compartment. This swings aside to reveal two drawer panels veneered with exotic kingwood, each with four pulls (fig. 100). Not every pull is functional, however, for the compartment contains only two deep drawers, not four shallow ones. The veneer, which was cut from matching sheets, has a curtainlike look, even though the grain lines are broken by brass moldings.[CD] Pressing in and turning the key to the left opens the compartment to the left of the kneehole; pressing it in halfway and turning

area. Characteristic of Neuwied furniture are sophisticated mechanical devices and a wide range of native and exotic veneers and marquetry surface decorations. Despite their superb quality, the pieces were not all exorbitantly expensive, for the Herrnhuters believed in an "economy of quality," one based on the highest craftsmanship and a just price.[5] Roentgen was able to keep costs down by streamlining production. His innovative measures included the already mentioned prefabrication of case and decorative elements and extended to other efficiencies, such as employing dozens of specialized artisans to work on different parts of his furniture and the use of standardized measurements. The Museum owns two pieces that illustrate the latter practice. One is the present chinoiserie-decorated desk and the other is a slightly earlier rolltop (fig. 101).[6] The latter lacks a superstructure, and its marquetry is a symphony of floral arrangements hanging on ribbon-tied swags by rings and delicately inlaid threads. Astonishingly, the width and depth measurements of both desks are identical. Roentgen's furniture

could also be quickly dismantled for packing and transport, making it easy for him to supply customers from the Atlantic to the Neva: in 1779 he was named furniture maker to Louis XVI and Marie Antoinette of France, and between 1783 and 1789 he sold hundreds of pieces of furniture to the Russian empress Catherine the Great (1729–1796), who became his most important client.

David's reorganization of his father's workshop culminated in a brilliant marketing ploy, the Hamburg furniture lottery of 1769. Debts that had accumulated during the economic depression following the Seven Years' War had to be paid off, and David realized that it would be necessary to cull his stock of outdated items in order to regain financial liquidity. The first prize in this lottery was an imaginative and showy piece especially created to promote the workshop's capabilities by summarizing its latest inventions and technology and to attract lottery-ticket buyers. In the announcement, Roentgen described this piece and its delicate marquetry embellishment as "a desk with top artistically decorated with Chinese figures,

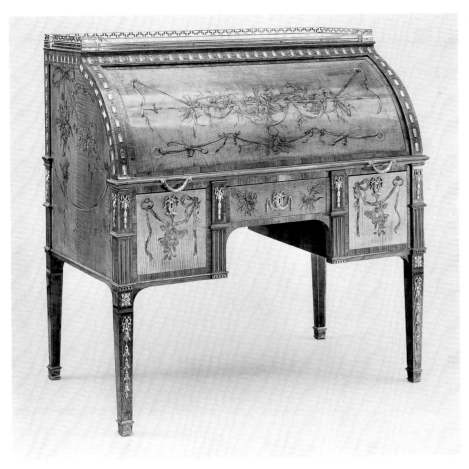

Fig. 101. Rolltop desk by David Roentgen, ca. 1775. Oak, pine, cherry and *bois satiné*, veneered with thuya, tulipwood, satinwood, green- and brown-stained wood, harewood, snakewood, walnut, and amboyna; 45 x 43½ x 26½ in. The Metropolitan Museum of Art, New York, Gift of Samuel H. Kress Foundation, 1958 (58.75.55).

bureau plat (see the entry for no. 57). David Roentgen developed versions that satisfied his large and diverse clientele. The perfection and ingeniousness of these writing desks make them to this day the most collectible of collectibles. W K

I am indebted to Dr. Dietrich Fabian, and Bernd Willscheid, who generously gave me permission to consult the restricted Roentgen archives (part of which is now at the Kreismuseum, Neuwied). Dr. Fabian has entrusted me with the task of continuing the Roentgen Archive Project. I am deeply grateful for his confidence and his continuing advice.

1. An unpublished tea chest by Abraham Roentgen is in the Museum's collection (acc. no. 1999.427); for similar chests, see Koeppe 1997, pp. 105–7, figs. 21–23.
2. On Goethe's rolltop desk design, of about 1779, see Fabian 2001, p. 27.
3. The term may be translated as "Neuwied work" or "of Neuwied craftsmanship." See Fabian 1996, pp. 320–414.
4. Strömer 1988; and L. E. Graf 2004.
5. Nef 1974, p. 132; and Stürmer 1979b, p. 268.
6. On this second rolltop, see Fabian 1996, p. 104, no. 226. Four other pieces made by the workshop under David Roentgen are in the Museum's collection: a commode (see the entry for no. 75); an oval traveling table (acc. no. 58.75.39; see Fabian 1996, p. 49, no. 59); a long-case clock (acc. no. 1975.101; see Fabian 1996, p. 126, no. 288); and a clock given by The Ruth Stanton Family Foundation, in honor of Wolfram Koeppe (acc. no. 2002.237; see "Recent Acquisitions" 2003, pp. 26–27 [entry by Wolfram Koeppe]). On the traveling table, a band-and-bow motif featuring a knife suspended by thin threads may symbolize the important role of the Moravian Brethren in the knife-making industry during the late eighteenth century, a specialty that is still practiced by Moravians in South Africa; my thanks to the Hillwood Museum and Gardens, Washington, D.C., for this information. There is also a questionable side table (acc. no. 1979.356.207; see Fabian 1996, p. 146, no. 338, where it is described as in a private collection).
7. "Ein Bureau mit einem Aufsatz auf das künstlichste, mit Chinuesischen Figuren, a la Mosaique eingelegt, dergestalten dass ich . . . ohne Scheu . . . der Critique eines Kunst-Mahlers frey unterwerfen darf . . . dass alle Figuren von lauter Hölzern gemacht, dass dieselben eine vollkommene Mahlerey präsentiren, welche mit dem Hobel, ohne dadurch etwasan ihrer Schönheit zu verlieren, [überfahren werden können]"; the text is given in full in Fabian 1996, p. 331, doc. no. 2.71.
8. Inv. no. B 36-1921. The present author examined the desk in 1999 and again in June 2005 and identified it as the one described in Roentgen's lottery advertisement. The latter mentions that there was a clavichord (now lost) hidden behind a fall front that looked on the outside like a row of three drawers below the "preciously inlaid" writing compartment. The upper part held two cabinets that were also inlaid with figural Chinese scenes of birds and floral rocaille formations, probably influenced by the prints of Gabriel Huquier (1695–1772); see Gruber 1996, pp. 264, 308, 316, 322. The central jalousie with a figural theater scene (now also lost) was divided and could be rolled sideways like a curtain (as indicated by gaps on both sides) to reveal a gilt-metal musical clock. On the top was a finely worked brass balustrade; see Salverte 1934–35, p. 269; Fabian 1986, pp. 100–101, nos. 197–200; and Fabian 1996, p. 331, doc. no. 2.70.

it to the left disengages the writing surface, which can then be pulled forward by means of the drop-loop handles as one rolls back the curved top to open up the interior. The superstructure encloses a single, wide drawer.

The colorful marquetry on the outside of the desk is set into large panels of maple wood.[CD] As is the case with other Roentgen pieces, these panels may once have been stained with a preparation that turned the maple blue-gray or brown. In this case a gray background would have been exceptionally striking, for the visible grain of the maple would have evoked the bluish gray fabric that was popular in the late 1770s.[14] Like a theater scrim, it would have set off the lively inlaid scenes of Chinese life, confining them within an apparently shallow, three-dimensional space. These vignettes, which the workshop used for numerous pieces, derive from drawings by the German painter Januarius Zick (1730–1797), who worked closely with the artisans at Neuwied.[15] The exotic woods called *bois des Indes* that were used for marquetry of this type (which because of its superb quality was called *pein-*

ture en bois, or "painting in wood") were extremely expensive.[16] With an eye to cutting costs, the canny Roentgen used stained local woods to simulate *bois des Indes* in many areas of this desk.

By the last quarter of the eighteenth century, Parisian cabinetmakers had largely abandoned Rococo marquetry in favor of Neoclassical-style veneer with a beautiful grain.[17] This desk, which must date early in the transitional period, may be a rare example of Roentgen's "market research" into his customers' willingness to purchase pieces executed in the new style. When the roll top is lifted and the dazzling display of chinoiserie disappears, the interior is seen to be entirely Neoclassical, presenting a serene but noble contrast between the richly saturated color of mahogany veneer and the sparkling ormolu and gilded-brass *milleraie* (ribbed) panels and brass moldings, which have preserved some residue of their former gold-lacquered surface (fig. 99).[18]

In the 1770s the rolltop desk became the status symbol par excellence in the libraries of important men, supplanting the Rococo

9. Havard 1887–90, vol. 1, col. 471.

10. Laran 1925, pl. 65; see also Fabian 1996, pp. 95–103, nos. 204, 210, 211, 220, 223. A multi-functional table model by Roentgen (see Fabian 1996, pp. 25–26, nos. 9, 10; and Zinnkann 2005, pp. 26–31) was inspired by the central section of a console table reproduced in an engraving in *L'architecture française* published by J. Mariette about 1730 (see Pradère 2003, p. 159).

11. Fabian 1996, p. 100, no. 214; and Langer and Württemberg 1996, pp. 222–39, nos. 65–67 (entries by Christoph, Graf von Pfeil on three rolltop desks).

12. Fabian 1996, pp. 104–7, nos. 227–33.

13. See, for example, Morley 1999, p. 288, pl. 593. See also Baulez 1996; Gruber 1996, p. 297; and catalogue of a sale at Christie's, London, 7 July 2005, pp. 174–79, lot 400 (the Museum's piece is illustrated on p. 176).

14. I am most grateful to Yannick Chastang for bringing this detail to my attention on 21–23 March 2004, when he, Mechthild Baumeister, Conservator, Department of Objects Conservation, Metropolitan Museum, and I examined the present desk. For the gray stain, see Baumeister et al. 1997, p. 263, fig. 1, p. 266, fig. 2a.

15. Zick's drawings for the Neuwied workshop are based on prints by François Boucher (1703–1770), Jean Pillement (1728–1808), and Gabriel Huquier. Gruber 1996, pp. 256, 275–323; and Reepen and Handke 1996, pp. 54–56.

16. As Michael Stürmer has observed, "*bois des Indes* was an expensive and highly speculative commodity"; Stürmer 1978, p. 800. See also "Marquetrie," in Diderot 1751–65, vol. 10 (1765), pp. 137–43; Roubo 1769–75, pt. 4, p. 1259; and Baulez 1996.

17. Gruber 1996, p. 297.

18. The gilded mounts on the desk are Neoclassical, with the exception of the "Chippendale handles" on the small drawers in the compartments of the lower section, which were part of a sizable purchase that Abraham Roentgen had already made from metal merchants in Birmingham, England. A letter of 1775 from David Roentgen to Karoline Luise, margravine of Baden-Durlach, describes the price differences between mercury-gilded mounts and the gold-lacquered (or polished brass) mounts that the Roentgens imported from England through their Moravian connections in London and Birmingham; see Fabian 1986, pp. 357–58, doc. no. 2.141. For English mounts of different qualities, see N. Goodison 1975; and Koeppe 1989b.

73.

Mechanical table

French, 1778
Jean-Henri Riesener (1734–1806); mechanism
by Jean-Gotfritt Mercklein (1733–1808)
Oak veneered with marquetry of bois satiné,
holly and ebonized holly; amaranth, barberry,
stained sycamore, and green-lacquered wood;
gilt-bronze mounts; velvet; mirror glass
H. 31 in. (78.7 cm), w. 44½ in. (113 cm),
d. 27¼ in. (69.2 cm)
Painted on the underside: "No. 2964."
Rogers Fund, 1933
33.12

For a table to serve Queen Marie Antoinette (1755–1793) during her confinement preceding the birth of her first child—Marie Thérèse Charlotte, Madame Royale, the future duchesse d'Angoulême (1778–1851)—a unique piece of furniture was required. For this occasion Jean-Henri Riesener created a multifunctional table for eating, for the toilette, and for writing in both a standing and a seated position. The mark 2964 identifies it in the archives of French royal furniture, the *Journal du Garde-Meuble de la Couronne:* "A mechanical table of different uses. 1. for eating. 2. for dressing. 3. for writing while standing or seated. The compartments in marquetry of cut mosaic design of mahogany with yellow rosettes inlaid on a yellow ground surrounded with black and white fillets, the top raises to different heights and contains seven compartments. . . ."[1] [CD] It was one of the first of the many important pieces of furniture executed by Riesener for Marie Antoinette. Another detailed contemporary description of the table shows that

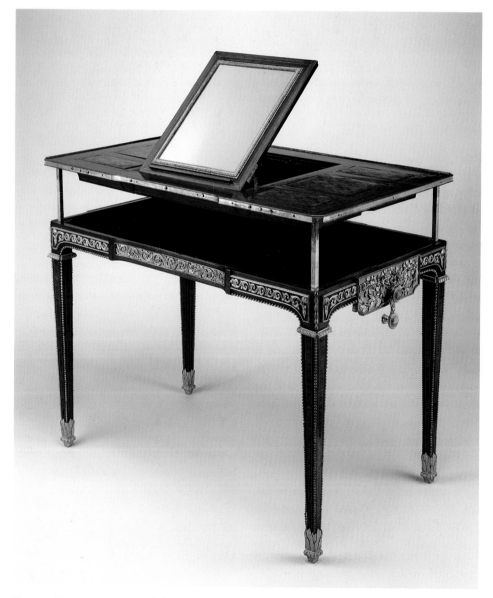

Fig. 102. Three-quarters view of the mechanical table with both the top and the center section raised.

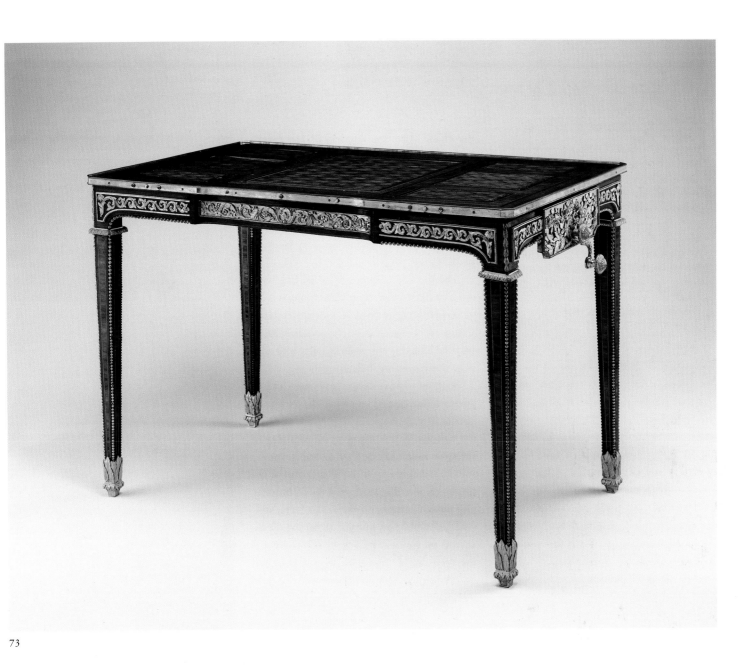

73

Jean-Gotfritt Mercklein, who as *méchanicien de la reine* had the royal warrant for excellence in his trade, made the mechanical fittings.[2]

The top of the table can be raised or lowered by means of the crank at the side (fig. 102). The central panel of the top can be raised for use as a reading desk or reversed to form a dressing-table mirror. At each side of the top are three compartments for cosmetic and writing equipment, whose hinged lids are released by corresponding buttons on the front edge of the table.

Marie Antoinette appears to have been particularly fond of this table and kept it constantly by her side.[3] She did, however, place it at the disposal of Gustavus III, king of Sweden (1746–1792), while he was visit-ing Versailles and the Trianon in the early summer of 1784, as she did with the other mechanical table by Riesener now in the Metropolitan Museum (see the entry for no. 77). Both required some modest restoration by the maker prior to the visit.

When the royal family left Versailles on 6 October 1789, Marie Antoinette had the present table brought to Paris, where it disappeared for more than a century before surfacing in the collection of the duc de Dino. After some short and not well-documented trips to England, in 1932 it was back in Paris, in the Parisian residence of the New York banker George Blumenthal (1858–1941), a trustee of the Metropolitan Museum. It was acquired by the Museum at the Paris sale of his furniture, pictures, drawings, and engravings in December of that year.[4] WR

1. "Dudit jour [12 décembre 1778]. Livré par le S. Riezener. Pour le service de la Reine au château de Versailles. 2964.—Une table mécanique à différents usages, 1° pour manger, 2° pour la toilette, 3° pour écrire debout et assis, en marqueterie à compartimens en mosaïques découpées de bois satiné avec rosettes jaune incrustée sur un fond jaune entouré de filets blanc et noir, le dessus se lève à differents degrés de hauteur contenant 7 cases. . . ." The entry is quoted in full in Verlet 1963, p. 134, no. 17.

2. Ibid., pp. 134–35. See also Lequesne 1997.

3. Verlet 1963, pp. 134–35.

4. It is described in Rubinstein-Bloch 1926–30, vol. 6, pls. XVII, XVIII. In the Blumenthal sale, 1 December 1932, at the Galerie Georges Petit, Paris, it was lot 168.

74.

Armchair (*fauteuil à la reine*)

French (Paris), 1779
Designed by Jacques Gondouin (1737–1818);
made by François Foliot II (1748–?1839);
carving by Mme Pierre-Edme Babel; gilding by
Marie-Catherine Renon
Carved and gilded beech; covered in modern
silk lampas
H. 39 in. (99.1 cm), w. 25½ in. (64.8 cm),
d. 19¾ in. (50.2 cm)
Painted on the webbing underneath the seat:
"Du 13 . . ." and "du No 194/6." and a crowned
double V.
Gift of Susan Dwight Bliss, 1944
44.157.2

This splendid armchair is one of the best-documented pieces of furniture in the Museum's collection. Part of a large set, it was delivered on 20 December 1779 to Marie Antoinette (1755–1793) for use during the winter months in her Grand Cabinet Intérieur, one of the rooms of her private apartment at the Château de Versailles.[1] Evidence of this royal provenance is the crowned double V, the mark for Versailles, on the webbing underneath the seat. The accompanying inventory number "du No 194/6" seems to indicate that this was the sixth of the six armchairs commissioned.[CD]

Detailed accounts pertaining to the design and execution of the garniture reveal the names of most of the artists and craftsmen involved. Named *dessinateur des Meubles de la Couronne* in 1769, the architect Jacques Gondouin (or Gondoin) was responsible for the design of both the furniture and the magnificent white silk-satin brocade that was to be used as wall hangings, curtains, and drapery in the room and for the upholstery of the furniture as well. A colored drawing for the silk-satin brocade has been preserved (fig. 103),[2] and the richness and complexity of the pattern, partly executed in silk chenille to create a sense of depth, is known from surviving lengths.[3] Woven in the Lyons workshops of Jean Charton, the fabric had an elegant arabesque design consisting of floral garlands and foliated branches enclosing applied medallions with six different pastoral trophies.

François Foliot II, member of a well-known family of Parisian joiners, who collaborated regularly with Gondouin, assembled the chair.[4] The fine carving of the frame, with its inverted cornucopias serving as arm supports and its legs with spiraling flutes upholding leaf capitals, was the work of Madame Pierre-Edme Babel. The *reparure*, or the refinement of the carving where it had been dulled by the preparatory layers of whiting; the addition of further detail; as well as the application of the gilding were done by Marie-Catherine Renon, the widow of Gaspard-Marie Bardou. Claude-François Capin (d. 1789), *tapissier ordinaire de sa majesté*, did the upholstering and also supplied dustcovers for the entire set.

Without its luxurious show cover and its comfortable tasseled seat cushion, the chair's appearance is changed. Remnants of original upholstery belonging to other pieces of the same suite indicate that a clear harmony was intended between the decoration of the frame, on the one hand, and the upholstery and passementerie, on the other.[5] The stylized leaf moldings, known as *feuilles d'eau*, carved on the outer back of the chair, for instance, were repeated in the original woven borders that complemented the satin brocade, as well as in the simulated gilded frame surrounding the medallions.[CD] A raised floral trim originally applied along the frame formed a subtle transition between the tiny flowers, so-called *feuilles de refentes*, densely carved on the chair's rails, and the show cover.[6][CD] All the gilded and woven blossoms on this magnificent set of furniture, intended for use during the winter, brought flowers to the queen's surroundings when they were not available in nature.

When in 1783 the decor of the queen's Grand Cabinet Intérieur was altered to include white and gold paneling, the wall hangings and seat furniture were removed. They were later used to furnish a small room on the floor above that had formerly been her billiards room.[7]

The American statesman Gouverneur Morris (1752–1816) purchased the Museum's chair and other pieces of the same set at the sales of the contents of Versailles held during 1793 and 1794.[8] Having served as an unofficial diplomat for President George Washington in Paris since 1789, Morris, a

Fig. 103. Design by Jacques Gondouin for the silk-satin brocade used for the furniture and hangings in the private apartment of Marie Antoinette at Versailles, 1779. Pen over graphite and colored washes. Kunstbibliothek, Berlin (Inv. H.d.z. 5040).

great Francophile, replaced Thomas Jefferson as minister of the United States in France three years later. When he left the country in 1794, Morris received permission to ship these and other furnishings from his hôtel on the rue de la Planche, Paris, to his family home, Morrisania, in the Bronx, New York, to which he returned in 1798. Possibly the first pieces with a royal provenance to enter the United States, they remained with descendants of Morris and were later dispersed. The only side chair of the set, intended for the use of King Louis XVI, for instance, was given to the New-York Historical Society not long after Morris's death. A *bergère* and a fire screen

are now in the collection of the Museum of the City of New York.[9] This armchair, then believed to have been the property of Thomas Jefferson, was acquired by Mr. and Mrs. George T. Bliss of New York at an unknown date and was donated by their daughter to the Museum in 1944. D K - G

1. Verlet 1994, pp. 210–18, 263, no. 30. See also Kisluk-Grosheide 2005, pp. 78–80, figs. 26, 27. The set originally comprised a type of settee known as a *canapé*, also called a *lit de repos à la turc;* six armchairs; two different *bergères,* or armchairs that are upholstered between the arms and seat; a stool; a fire screen, as well as a folding screen with four leaves; a side chair for the king; a bench to be placed in a niche of the room; and a footstool.

2. See also Baulez 2001, p. 30, fig. 2.

3. A length of silk is in the collection of the Musée National des Châteaux de Versailles et de Trianon; see *Soieries de Lyon* 1988, pp. 41, 56–57, 116–17, no. 24.

4. Gautier 1992, p. 60.

5. Fragments of the original upholstery and trim are in the New-York Historical Society, New York, and in the Museum of the City of New York.

6. With generous support from the James Parker Charitable Foundation, the Museum will be able to reupholster the armchair with a modern copy of the silk-satin brocade in the near future.

7. Meyer 1994, pp. 45–48.

8. Schreider 1971; and Fiechter 1983, pp. 444–47.

9. Although commissioned for the queen's Grand Cabinet Intérieur, the *canapé* was apparently never used there. It was not among the purchases of Gouverneur Morris and is now in the collection of the de Young Museum in San Francisco.

75.

Commode

German (Neuwied), ca. 1775–79
Workshop of David Roentgen (1743–1807); designs for the figural marquetry by Januarius Zick (1730–1797); stencil drawings for and stamp-cutting of the marquetry by Elie Gervais (1721–1791) and his workshop; frieze mounts attributed to François Rémond (1747–1812), Paris
Oak, pine, basswood, and cherry wood, veneered with tulipwood, boxwood, amaranth, sycamore, pearwood, and harewood; the drawer linings of mahogany; gilt-bronze mounts; steel and brass operating mechanisms; red brocatelle marble top not original to the commode
H. 35¼ in. (89.5 cm), w. 53½ in. (135.9 cm), d. 27¼ in. (69.2 cm)
Branded twice on the uprights of the back: a double V beneath a crown
The Jack and Belle Linsky Collection, 1982
1982.60.81

During the nineteenth century this important commode was acquired by Baron Mayer Amschel de Rothschild (1818–1874) for his collection at Mentmore Towers, in Buckinghamshire. The grand decoration and furnishings of this palatial residence embodied the "goût Rothschild," a style created by several members of the Rothschild banking dynasty who had turned their attention to art collecting and philanthropy.[1] The commode was displayed in one of the upstairs rooms and remained at Mentmore[2] until 1964, when it made history as the most expensive piece of furniture ever sold at auction.[3] Bought by Mrs. Jack Linsky of New York, the celebrated object entered the Museum with the Jack and Belle Linsky collection in 1982.[4] In addition to the commode's richly decorative appearance and many intriguing hidden compartments,

the possibility that its first owner was Louis XVI (1754–1793) contributes to its renown and its value. Branded twice on the uprights of the back with a double V beneath a crown, which is widely believed to be the château mark of Versailles,[5] the piece was long thought to have been purchased from the great German cabinetmaker and entrepreneur David Roentgen for the private apartments of Louis XVI.[CD] Indeed, the king's expense records mention for 11 April 1779 the payment of 2,400 livres "to the Germans for a big commode."[6] In March of that year the king had already acquired for his pleasure the ultimate multifunctional piece of cabinetmaking from Roentgen, a monumental mechanical writing cabinet with musical clock and sculptural mounts, for the enormous sum of 80,000 livres. That "royal secretary" was publicized all over Europe in newspaper articles celebrating Roentgen's artistic and commercial accomplishments as well as his ingenuity in having created an object that so thoroughly indulged Louis XVI's passion for locksmithing and mechanics. The extraordinary piece, twelve feet high, was dismantled in the 1820s.[7] Also in 1779 Roentgen established a furniture outlet in Paris, and the king named him *Ébéniste-Méchanicien du Roi et de la Reine.* The following year he was inducted into the Parisian cabinetmakers' guild as a master.

The 1792 inventory of the furniture at Versailles mentions a piece that may be the Museum's commode as standing in the king's private apartment in a room called the *pièce du caffé,* off the hall leading to the

Cour des Cerfs.[8] The account describes it as "à 3 vantaux," the term for a commode with three doors concealing the drawer fronts within. The Museum's piece fits the description, except that behind the central door there are shelves, not drawers.[CD] Strictly speaking, then, it is a cross between a *commode à vantaux* and a variation called *commode en bas d'armoire.*[9] Two related examples by Roentgen, one in the Victoria and Albert Museum, London, and the other at the Bayerisches Nationalmuseum in Munich (fig. 104), are similarly designed, and in an inventory of 1795 a commode that sounds much like them is listed in the apartment of the comtesse d'Artois at Versailles.[10]

Although the stamped double V mark on the Museum's commode strongly suggests that it was once used by Louis XVI,[11] there are discrepancies between the 1792 Versailles inventory description and the illusionistic marquetry on the Museum's object. The inventory describes a commode veneered with marquetry "sur les 3 faces avec medaillons à figures." This may describe a commode with figural medallions on all three sides, in which case the Museum's commode is eliminated from consideration, or it may describe a commode decorated in the manner of the ones in Munich and London with two panels (out of five) designed as oval medallions with beaded frames, in the fashionable Neoclassical manner. As we shall see, the Museum's commode may once have had such a decorative scheme on the front.

The *commode à vantaux* in the comtesse d'Artois's apartment was decorated on the

front with scenes from the commedia
dell'arte theater within beaded gilt-bronze
frames. The top was of *bleu turquin* marble,
a blue gray stone streaked with white and
with pale veins and inclusions, of the type
that still graces the tops of the commodes in
Munich and London.[12] This marble very
likely came from a quarry near Leun on the
Lahn River, not far from the Roentgen shop
at Neuwied.[13] It is probable that the Mu-
seum's commode originally had a *bleu
turquin* marble top. It would have comple-
mented the veneer panels beneath the gilded
frieze mounts: those panels were once stained
bluish green, as can be seen when the mounts
are detached.[CD] The present replacement top
is of reddish brocatelle marble from a
Catalonian quarry near Tortosa.[14]

Lion's-head pulls are applied to the small
drawers inside the Museum's commode (see
fig. 105). There are similar pulls on the

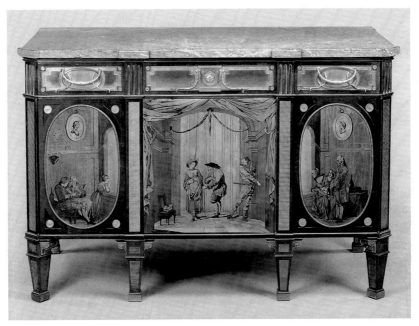

Fig. 104. Commode by David Roentgen, ca. 1775–79. Oak, pine, walnut, mahogany,
boxwood, maple, mother-of-pearl, gilded bronze, and marble; 34½ x 53⅛ x 26⅜ in.
©Bayerisches Nationalmuseum, Munich, Sammlung Fritz Thyssen (90/107).

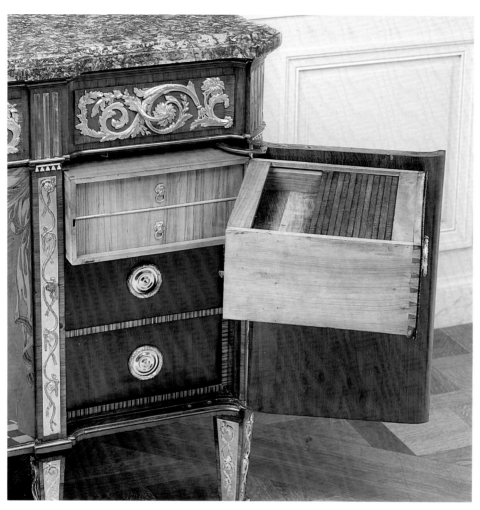

Fig. 105. The lower right door of the commode has been opened and the top compartment pulled forward, or "broken." In this view the released hook and small lion's-head drawer pulls are visible.

drawers of a monumental cabinet that Roentgen supplied to Prince Charles-Alexandre de Lorraine et de Bar (1712–1780) in Brussels in 1776. The prince's cabinet is also embellished with bold lion's-head ormolu mounts at the lower corners.[15] Lions' heads and a relief of Hercules wearing the pelt of the Nemean Lion embellish the most elaborate surviving piece of Roentgen furniture, the secretary of King Frederick William II of Prussia (1744–1797), now in Berlin. It was made in 1779, the same year Louis XVI bought his large writing cabinet. That Roentgen reserved the use of the heraldic animal associated with Herculean power only for the decoration of objects intended for rulers would seem to support a royal provenance for the Museum's commode.[16]

In 1984 William Rieder observed that the scrolling mounts on the frieze of the Museum's commode are replacements; they conceal holes and marks that were made when rectangular mounts like those on the London and Munich commodes were

attached;[17] moreover, they project over the edge of the frieze in some places and clearly were not custom-made for this piece.[CD] They are, however, extremely refined and have been attributed to the Paris maker François Rémond.[18] The mounts on the pilaster strips, decorated with S-scrolls of berried laurel and bow mounts, are typical of Roentgen.[19] The craftsmanship of the moving parts of the interior, such as the sliding tambour tops of the drawers that swing out, reflects Roentgen at his best.

In the summer of 1774 Roentgen had gone on a market-exploration trip to Paris, where he met the German engraver Johann Georg Wille (1715–1808). The latter's memoranda commemorate the meeting: "Mr. Roentgen [the] famous cabinetmaker, . . . visited me with a letter of introduction from Mr. Zick, a painter in Koblenz, an old friend. Because Mr. Roentgen did not know anybody in Paris, I was able to help him with the names of some sculptors and draftsmen, whom he needs."[20]

The painter Januarius Zick, who sent Roentgen to Wille, was certainly responsible for the designs of the delicate marquetry on the Museum's commode. His considerable flair and attention to detail give these subjects a heightened theatricality and visual importance. Like the scenes on the comtesse d'Artois's commode, the center panel on the front illustrates well-known stock characters of the commedia dell'arte, the Italian comedy theater, which enjoyed a revival in Europe during the second half of the eighteenth century.[CD] At right is Harlequin. At left is his sweetheart Columbine ("little dove"), a lady's maid with a flower-decorated straw hat, who in eighteenth-century French comedy became the intrigant, assuming a variety of undefined roles opposite Harlequin. In the center is the beardless Anselmo with a walking stick, who—like Columbine—was long misidentified on this commode.[21]

Zick's designs had to be transformed into stencil drawings, and the seal cutter Elie Gervais was employed to do this. Surviving bills document that Gervais and his workshop were paid, for example, in 1773 "for drawing letters on paper and wood" and "for the drawing and engraving of heads and figures" as well as for "the engraving of a large piece with roses and the costs of the stamp." The 1773 inventory of Gervais's workshop mentions, among decorative mount models and highly refined tools, a long list of "engraving stamps" for figures and ornaments.[22] Could this mean that parts of the famous mosaic marquetry—the celebrated *peinture en bois* (painting in wood) that Roentgen perfected and held a monopoly on—were produced by stamping out especially complicated or minuscule pieces of veneer?[23]

The scene in the Museum's center front panel is nearly identical to those in the center of the London and Munich commodes; however, the composition may be slightly earlier because the chair seen at left has cabriole legs, which had been popular in the Rococo period,[24] whereas the chairs in the Munich and London panels have a Neoclassical design.[25] On the chair in all three panels sits a small long-haired spaniel with drooping ears.

Almost identical to but in reversed position from the ones on the London and Munich commodes are the side panels of the present example. Each depicts a light-

flooded room with a tall, curtainless casement window as a backdrop for two musicians. On the right side, a violinist and a cellist share a trestle stand. Each reads the music from his own sheet, on which the word "allegro" is written. Brass horns hang on the wall. On the left side, two woodwind players rest at a table.[CD] On the wall behind them hang two oboes, and a bassoon leans against the music stand. Two sheets of music most likely for a trio, are propped up on the stand.[26]

The Munich and London commodes have more complicated mechanical operating devices than does the Museum's piece. The other significant difference between them is the composition seen in the panels that flank the one in the center of the front. The London and Munich panels show spectators in theater boxes, whereas the Museum's panels show an empty stage. Josef Maria Greber proposed that two oval marquetry panels in the Musée des Arts Décoratifs in Paris that match the ones to either side of the center panel on the London and Munich commodes were originally the left and right doors of the Museum's piece.[27] This is possible but cannot be confirmed. Parenthetically, it is interesting to note that there are a number of oval panels, either documented or in existence, that show the theater-box scene.[28] This suggests that Roentgen used the design to decorate several different pieces of furniture, as was, in fact, common practice at his shop.

The question why empty stages appear on the side doors of the Museum's commode remains unsolved. They must convey a message: either the actors have departed and the curtain will come down momentarily or we, the audience, wait for new actors to appear suddenly from the back. The fact that the marquetry on the flanking doors is slightly different from that of the central door, as is the choice of veneer woods, suggests another possibility. Could it be that originally these doors were decorated with royal emblems or with medallions depicting Marie Antoinette and Louis XVI, which had to be removed—and were appropriately replaced in a Paris workshop by two empty stages—so that the commode could be sold during the Revolutionary auctions of 1793–94? W K

I thank Mechthild Baumeister, Conservator, Department of Objects Conservation, Metropolitan Museum, for discussing the various problems of this commode so patiently with me over the years. This entry could not have been realized without her enthusiasm.

1. On the "goût Rothschild," see Heuberger 1994.

2. *Mentmore* 1884, vol. 2, p. 187, no. 10, where it is described as by David de Luneville [David Roentgen] and [Pierre] Gouthière (1732–1813/14).

3. *Earl of Rosebery Collection*, catalogue of a sale at Sotheby's, London, 17 April 1964, lot 54. The commode sold for 63,000 pounds sterling (176, 400 dollars).

4. On the commode, see Greber 1980, figs. 537–42; Metropolitan Museum of Art 1984, pp. 223–25, no. 136 (entry by William Rieder); and Fabian 1996, p. 131, no. 299.

5. The stamp has recently been associated with pieces that originally furnished the Petit Trianon at Versailles and not the château; conversation with Yannick Chastang, March 2004.

6. "aux allemands pour une grande commode L 2400"; quoted in Beauchamp 1909, p. 71, and Fabian 1996, p. 347, doc. no. 2.171.

7. Plans to divide it up and readapt sections as smaller, more usable furniture were made as early as 1789 and 1791. Himmelheber 1994, p. 462; Fabian 1996, pp. 164–65, no. 365; and Ramond 2000, vol. 3, pp. 118–29.

8. The description reads as follows: "Une commode plaquée à tableau de bois fond satiné et ombré sur les 3 faces avec medaillons figures en bois de rapport à 3 vantaux. Le dedans à mechanique orné de bronz [sic] à dessus de marque [sic] bleu turquin de 4 pds 2 po de large. 3600 [livres]." Archives Nationales, Paris, O^1 3354, "Inventaire général des meubles de la Famille Royale, Versailles," 1792, p. 52.

9. Havard 1887–90, vol. 1, pl. 54, col. 937; and Fleming and Honour 1989, p. 210.

10. For the Victoria and Albert Museum commode, see Wilk 1996, pp. 128–29 (entry by Sarah Medlam); for the Munich commode, see Himmelheber 1991; for the Versailles inventory information on the comtesse d'Artois commode, see Kisluk-Grosheide 2005, p. 88, and n. 12 below.

11. The double V mark appears on other Museum pieces. Some of them have been questioned; see Kisluk-Grosheide 2005, p. 71, fig. 12, p. 79, fig. 29. In 2003 Mechthild Baumeister examined the back of the London commode, which is not branded with the double V but is constructed in much the same manner as the New York piece. She concluded that the back of the New York piece is original. The two marks on the present commode do not look suspicious, but in the absence of any inventory number we cannot say for sure whether it was ordered for the king's private rooms or some other place at Versailles.

12. "représentant des scènes de comédie ainsi que sur les côtés . . . le tout en bronze doré au mat et encadrement de perles enfilées, à dessus de marbre bleu turquin"; inventory of 1795 of the apartment of the comtesse d'Artois at Versailles, quoted in Molinier 1898, p. 206, n. 2, no. 5, and Kisluk-Grosheide 2005, p. 88. The countess's piece may be identifiable with the commode at the Victoria and Albert Museum in London. Its earlier provenance is unknown. The commode at the Bayerisches Nationalmuseum, Munich, was once part of the collection of the grand dukes of Sachsen Weimar; see catalogue of a sale at Sotheby's, London, 10 June 1932, lot 136. The Weimar and Gotha branch of the Sachse family had early connections with the Roentgen workshop. See Fabian 1996, p. 334, where an entry in the account book of Elie Gervais for 1771 (doc. no. 2.95) is quoted: "David Roentgen owes Elie Gervais . . . for starting [on 21 June] a drawing for a grand commode with six figures, on which I [Gervais] drew the head and hands . . . on 26 [June] I began with even with more care so that it could be sent to Gotha, and on it I drew the head and hands, finished on 29 [June]." This confirms that Gervais worked on the composition's most complicated parts, the heads and hands, by himself.

13. I thank the late Prince Friedrich Wilhelm zu Wied, of Neuwied, and especially his brother Prince Metfried zu Wied, of Runkel, for their advice and permission to consult the archives in the palace at Neuwied. Research on Roentgen's use of local marble from quarries along the Lahn River, some of which were owned by the count of Neuwied, is currently being undertaken by the Roentgen Archive Project.

14. Mielsch 1985, p. 42, nos. 165–67, pl. 5.

15. Fabian 1996, pp. 160–63, no. 364. For the association of a ruler with the head and pelt of the Nemean Lion, see McCormick and Ottomeyer 2004, pp. 110–11, no. 51 (entry by Wolfram Koeppe).

16. Fabian 1996, pp. 166–70, no. 366. There are small lion's-head pulls on the inner drawers of a rolltop desk by Roentgen in the Museum (fig. 101), but if this piece has a royal connection, we do not know what it was. Lion's-head mounts of similar form are illustrated in some furniture-mount trade catalogues from Birmingham, England, where the Roentgens bought prefabricated mounts in huge quantities; T. F. Friedman 1975, pl. 40.

17. Metropolitan Museum of Art 1984, pp. 223–25, no. 136 (entry by William Rieder).

18. Baulez 1996, p. 101.

19. Fabian 1996, p. 111, no. 243; see also p. 166, no. 366 (the corner pilaster strips).

20. Ibid., p. 341, doc. no. 2.133.

21. For a description of the commedia dell'arte subjects in the eighteenth-century decorative arts, see Chilton 2001; on Anselmo, see p. 150. The figures shown on the center panel of the Museum's commode have until now been identified as Harlequin, Pantaloon (who has a pointed beard), and the latter's daughter Isabella.

22. Fabian 1996, pp. 338–41.

23. See Greber 1980, vol. 1, pp. 127–89; and Ramond 2000, vol. 3, pp. 78–133.

24. A similar ladderback chair is depicted on a panel mounted as a tabletop on a stand of later date from the Hodgkins collection that Hans Huth published in 1928; Huth 1928, pl. 54.

25. Roentgen realized this Neoclassical design in life size in a comparable chair group of 1771 in Schloss Wörlitz and as inlaid miniatures in cabinet interiors. Himmelheber 1991.

26. The composition may be by Christoph Willibald Gluck (1714–1787), who wrote pieces for Roentgen's musical devices. I thank Gerhard Croll of the Gluck-Gesamtausgabe, Salzburg, for this information.

27. Greber 1980, vol. 1, p. 216.

28. One is the tabletop from the Hodgkins collection; see n. 24 above. Two others, with Roentgen mounts, are part of a nineteenth-century cabinet; see catalogue of a sale at Sotheby's, New York, 19 November 1993, lot 70 (sold again later on the Paris art market). There is yet another example in a French private collection.

183

76.

Side table

English, ca. 1780
Probably after a design by John Yenn
(1750–1821)
Carved, painted, and gilded pine; painted
mahogany top; gilt-bronze drawer pulls; gilt-copper
molding of later date surrounding the top
H. 32½ in. (82.6 cm), w. 46 in. (116.8 cm),
d. 21 in. (53.3 cm)
Incised and written on the back, respectively:
"G IV R 54" and "2858."
Fletcher Fund, 1929
29.118.1

Fig. 106. Full-size design for a tabletop, attributed to John Yenn, ca. 1780. Pen and ink, pencil, and colored washes. Victoria and Albert Museum, London (E-4988-1910).

The history, date, and authorship of this bowfront side table have long been a subject of debate. Among the few pieces of furniture in the Metropolitan's collection with an English royal provenance (see also no. 59), the Museum acquired this unusual table on the London art market in 1929. Its pair had been given to the Victoria and Albert Museum during the previous year.[1] In view of the English royal inventory monogram "G IV R," for George IV, Rex, incised on the table and its pendant, both pieces were thought to have been ordered by the Prince of Wales, the future George IV (1762–1830), for Carlton House, London.[CD] That residence was remodeled for him by the architect Henry Holland (1745–1806) following the prince's coming of age, in 1783.[2] It is not surprising, then, that Holland was proposed as the designer of the tables;[3] however, as early as 1929, Preston Remington, curator at the Museum, tentatively expressed the possibility that Sir William Chambers (1723–1796), surveyor general and comptroller of the Royal Works, was responsible for the design.[4] Primarily an architect, Chambers, who referred to himself in 1773 as "really a very pretty connoisseur in furniture," was also known for his designs of distinctive architectural furnishings in a heavier, more sculptural manner than the light and elegant style of Robert Adam (1728–1792), his contemporary and rival.[5]

When a third, similar but smaller, table, now in Los Angeles, marked with the same royal inventory monogram, appeared on the art market in 1981, the Chambers attribution was firmly repeated.[6] This assessment was largely based on comparison with a pair of bigger and more monumental tables

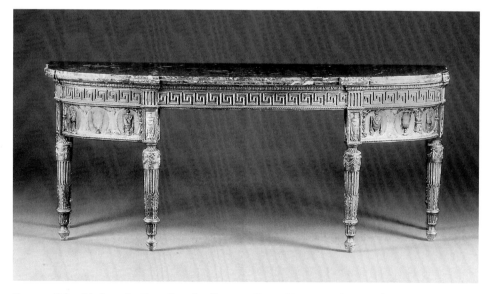

Fig. 107. Side table from the Great Drawing Room at Gower House, London, attributed to Sefferin Alken after a design by William Chambers, ca. 1770. Gilded wood and marble, 35 x 88¼ x 29⅞ in. The Samuel Courtauld Trust, Courtauld Institute of Art Gallery, London (F.1995.XX.1).

known to have been designed by Chambers for the Great Drawing Room at Gower House, London, in the 1760s (fig. 107).[7] Later in the 1980s some scholars argued that if the model for the three monogrammed tables derived from Chambers then their provenance might well be Buckingham House, London, where the architect worked during the 1760s, and their date might be somewhat later, about 1770.[8]

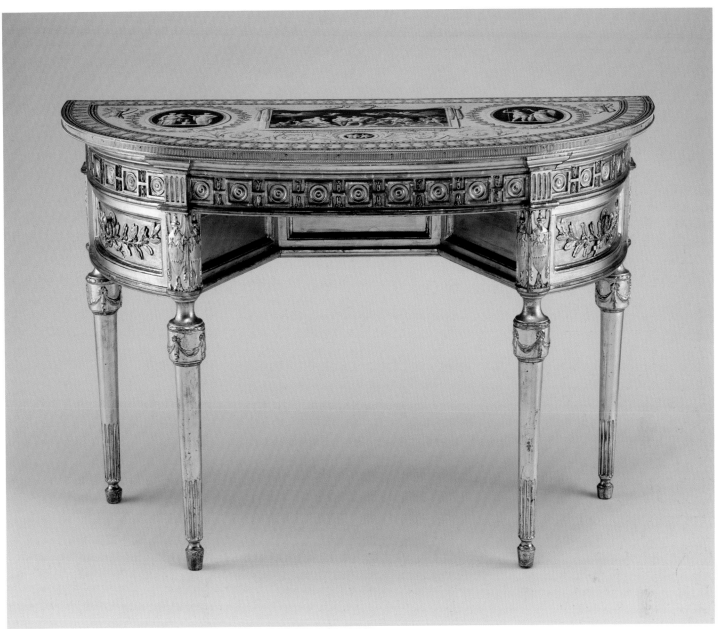

76

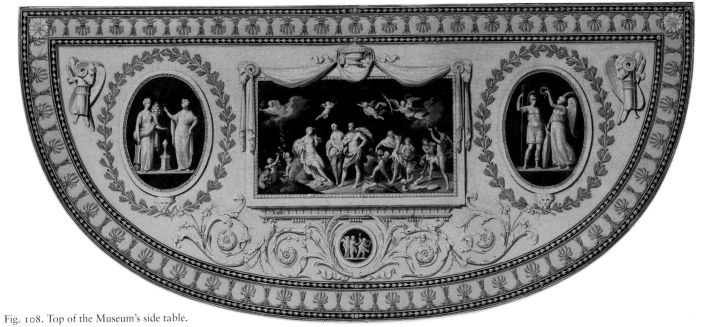

Fig. 108. Top of the Museum's side table.

The discovery of a full-size, partly colored drawing related to the painted decoration on the tops of all three tables, but particularly the smaller one (fig. 106), has brought forward yet another theory. The unsigned drawing, pricked for transfer, is attributed to Chambers's talented pupil and draftsman John Yenn.[9] Yenn appears to have frequently made copies or finished versions of original drawings by Chambers and continued to work in his master's manner after 1771, when he was no longer Chambers's apprentice.[10] Was he the designer of the three monogrammed tables? It seems altogether possible. If so, familiar with Chambers's bold and innovative design for the Gower House tables but working on a different scale, Yenn added lightness and greater refinement to the conception, creating a remarkably different effect.[11]

Since no evidence has been found to date that the tables were either at Carlton House or at Buckingham House, it has been suggested that they were ordered for Queen Charlotte's new Drawing Room at Windsor Castle, for which Yenn did extensive work in 1795.[12] The incised royal marks are in accordance with those used at Windsor in the late 1820s.

The tables may well have left the royal collection at an 1836 sale of surplus furniture and other objects formerly at Carlton House, Windsor Castle, and Buckingham Palace, making it hard to establish their proper provenance. Held at Buckingham Palace, this sale included "a pair of gilt semicircular pier tables, with painted tops" and "a ditto" (referring to a matching one, conceivably the smaller table).[13] The two larger tables were later at Weeting Hall, Norfolk, the seat of the local squire, William Angerstein (1811–1897). They were sold from Weeting Hall with a Carlton House provenance in 1895.[14] The gilded frames of the tables incorporate a trapezoidal recess under the top, not unlike the kneehole space below a desk. This is flanked by convex panels forming simulated drawer fronts that are carved with crossed laurel branches and mounted with gilt-bronze drawer pulls. Some of the carved decoration, such as the drapery swags on the collars of the tapering and partly fluted legs, relate closely to those found on the Gower House tables. The same is true of the slender classical urns directly above the legs, here embellished with bucrania, the ox horns playfully extended into

elongated handles.[CD] Instead of the Greek-key ornament on Chambers's Gower House tables, the friezes are carved with squares enclosing paterae and acanthus ornament.

The tops of the three tables from the royal collection are painted bright yellow and have classical scenes in grisaille against a deep reddish brown background resembling the color of porphyry. Surrounded by a frame of drapery festoons suspended from a classical urn in the center and rams' heads at the corners, the central mythological depiction varies in each case. *The Meeting of Bacchus and Ariadne on the Isle of Naxos* is rendered on the Museum's table (fig. 108) and was based on a composition by the Italian painter Guido Reni (1575–1642). Commissioned and executed in 1637–40 for the bedroom ceiling in Queen's House, Greenwich, residence of Queen Henrietta Maria (1609–1669), the painting met a sad fate not long afterward.[15] In 1650 the apparently prudish widow of the second owner, the Italian financier Michel Particelli d'Emery (1595–1650), comptroller general of France under Cardinal Mazarin, had the painting destroyed because of its excessive nudity; however, it remained known through copies and engravings.[16] An earlier work by the same painter, *Aurora Scattering Flowers for the Chariot of Apollo*, of 1614, served as source for the central scene on the table now in London. The original was a fresco in the garden loggia of Cardinal Scipione Borghese's Palazzo Pallavicini-Rospigliosi in Rome, but the version on the table must have been taken from one of the engravings based on the fresco.[17] It is interesting to note that Chambers had used the same two compositions by Reni in a design for the library ceiling of Woburn Abbey, Bedfordshire, of 1770.[18]

Unlike the scrolling foliage and urn decoration in Yenn's drawing, medallions with classical figures painted in grisaille flank the mythological scenes on the Museum's table and its pair in London. Personifications of Fortune and Victory accompany the *Bacchus and Ariadne,* while Music and Architecture are represented on either side of the *Aurora.* The roundels with putti below the central depiction on both tables signify love. The top of the third table has as its main decoration a composition after *Galatea*, a fresco painted by Raphael (1483–1520) in the Villa Farnesina in Rome in 1512, of which many engraved copies were available.[19]

DK-G

1. Victoria and Albert Museum, London (acc. no. W.42-1928). It has the same "G IV R" mark as the Museum's table, but no number. A later, smaller version of this table was sold at auction at Sotheby's, New York, 12 October 1995, lot 224A.

2. Since the table in the Victoria and Albert Museum has been published more often than the one in the Metropolitan, most of the references that follow pertain to the former: "Gifts to the Nation" 1928, p. 192; National Art-Collections Fund 1929, p. 29, no. 642; M. Harris and Sons 1935, p. 68; Victoria and Albert Museum 1947, p. 15, no. 24; and Remington 1954, pp. 69, 119.

3. They were dated to about 1793 in Fitz-Gerald 1969, no. 115a, b.

4. Remington 1929, pp. 296–98.

5. N. Goodison 1990.

6. Christie's, New York, 17 October 1981, lot 174. This smaller table is now in the collection of the Los Angeles County Museum of Art; Los Angeles County Museum of Art 1983, n.p. It is marked "G IV R 55."

7. See H. Roberts 1996, pp. 169–70, fig. 252. One of these larger tables, formerly at Gower House, is now at the Courtauld Institute of Art Gallery, London. It was auctioned and sold at Christie's, London, 17 November 1994, lot 181.

8. Jervis 1982, pp. 174, 177. See also Beard and J. Goodison 1987, p. 158.

9. This drawing was first mentioned in connection with these tables in Jervis 1982, p. 177. See also Snodin 1996b, p. 203, no. 840 (entry by Stephen Astley et al.).

10. J. Harris 1973, n.p.; Young 1986; Young 1987, p. 399; and H. Roberts 1996, pp. 166–67.

11. H. Roberts 1996, pp. 168–70, 173.

12. Ibid., pp. 170, 173; and H. Roberts 1997, p. 182.

13. Auction conducted by Mr. Phillips at Buckingham Palace, London, 11 August 1836, lots 109, 110. See also H. Roberts 1996, p. 168. It was originally thought that the tables had been removed to the Royal Pavilion in Brighton after the demolition of Carlton House; Remington 1929, p. 296.

14. Christie, Manson, and Woods, London, 5 April 1895, lot 160. The purchaser is recorded as "Davis," and the price was 267 pounds, 15 shillings. They may have been among the artworks acquired earlier by William's grandfather, John Julius Angerstein (1735–1823), who was a wealthy merchant and patron of the arts.

15. Madocks 1984. See also Banta 2004.

16. Pepper 1984, pp. 278–79.

17. Ibid., pp. 228–29.

18. The ceiling, painted in 1771 by the Italian artists Giovanni Battista Cipriani (1727–1785) and Biagio Rebecca (ca. 1735–1808), was later destroyed. See J. Harris 1970, pp. 253–54, no. 145, pl. 90; and Snodin 1996a, pp. 137–39, fig. 196.

19. Bernini Pezzini, Massari, and Prosperi Valenti Rodinò 1985, pp. 149–51.

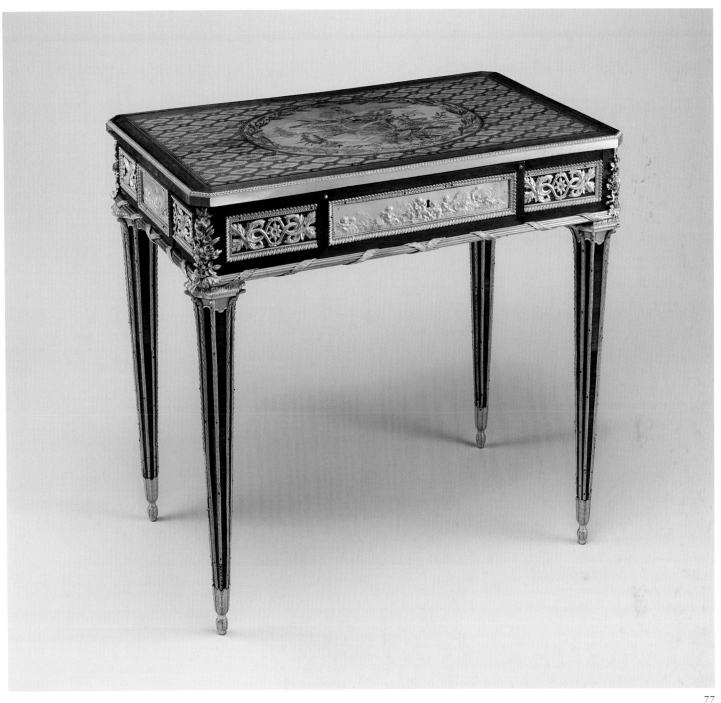

77.

Mechanical table

French, 1780–81
Jean-Henri Riesener (1734–1806)
Oak veneered with mahogany and marquetry of
bois satiné, sycamore, holly, ebonized holly fillets,
and bayberry, the top with an amaranth border;
gilt-bronze mounts; velvet; mirror glass
H. 28½ in. (72.4 cm), w. 30¾ in. (78.1 cm),
d. 19 in. (48.3 cm)
Painted on the underside: "No. 3066."
The Jules Bache Collection, 1949
49.7.117

This particular type of mechanical table, in which the top slides back as the drawer slides forward to reveal a toilette mirror flanked by two compartments, each covered with a hinged flap (fig. 109), was developed and perfected by Jean-François Oeben (1721–1763). Jean-Henri Riesener was apprenticed to Oeben and following Oeben's death took over the direction of his workshop. Riesener continued to make a speciality of mechanical tables.

The number 3066 painted on the underside of the table identifies it in the royal furniture archives, the *Journal du Garde-Meuble de la Couronne*, as the one delivered in January 1781 to Queen Marie Antoinette (1755–1793) at Versailles: "Delivered by Mr. Riesener. For the Cabinet Intérieur of the queen at Versailles. 3066.—A writing table with marquetry compartments of mosaics and rosettes on a mahogany ground,

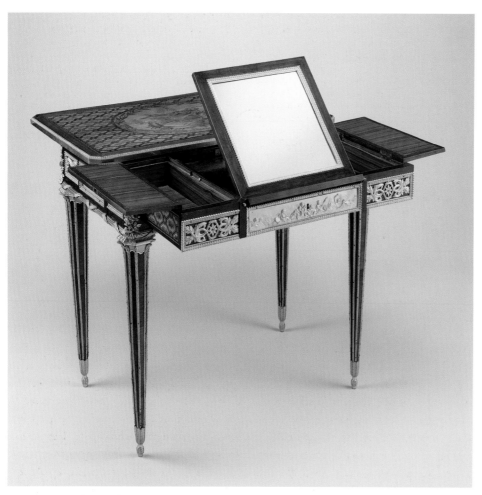

Fig. 109. General view of the mechanical table with the drawer opened and the mirror raised. The flaps of both side compartments are also opened.

The following year it was delivered to the Château de Saint-Cloud for the queen's use in her "dressing room: one writing table . . . the mechanical top veneered with mosaic panels, in the middle an oval medallion with an allegorical trophy with this motto: 'Numine afflatur,' the ground and all the rest of the veneer of this table in amaranth and *bois satiné.* . . ."[3] The contents of Saint-Cloud were sold in the government sales of 1794–95, following the Revolution, but it is not known if this table was included. Its whereabouts in the nineteenth century are unknown, and it next comes to light in the collection of the New York banker Jules S. Bache, who bequeathed it to the Metropolitan Museum in 1949.

The oval marquetry trophy on the top (fig. 110) seems intended to symbolize French supremacy in the worlds of science, commerce, and learning. The motto *Numine afflatur* (Inspired by divine light) on the pennant pertains to Poetry. The Gallic cock is perched on a laurel branch above an astronomical globe, a caduceus (the emblem of peace and commerce), an architect's rule and compass, and a writer's inkstand and books with the wreath and torch of fame.

Riesener repeated a number of the decorative details on other pieces of furniture.

composed of a large body of drawers with mechanical springs making the drawers advance and the top move back. The middle of the top depicts a trophy with the attributes of Poetry and Literature. The hinged stand in the center rises with the touch of a button and has a panel covered on one side with black velvet framed with a small galloon of gold. The gilt-bronze ornaments consist of frames, capitals, stems of plants, friezes, and four bas-reliefs of infants, all chased and gilded with matt gold. . . ."[1]

Already in 1784 the table needed light restoration by Riesener so that it could be placed in the suite of Gustavus III, king of Sweden (1746–1792), during his visit to Versailles and the Trianon in June of that year: "Order of 16 April. Delivered on 29 May to serve the king of Sweden, one mechanical table with marquetry No. 3066. Restore and renew the gilding and the marquetry and furnish several missing pieces of the pearls that decorate the corners and have the mechanism cleaned and adjusted. . . ."[2]

Fig. 110. Detail of the marquetry on the top of the mechanical table.

The marquetry lozenges of *bois satiné* bordered by black and white fillets and containing sunflowers on a *bois jaune* ground are found on several pieces made for Marie Antoinette in the 1780s.[4] The gilt-bronze plaque on the outside of the drawer was used by Riesener on several other pieces of furniture, most notably on the mother-of-pearl cylinder-top desk made for Marie Antoinette's boudoir at Fontainebleau.[5]

WR

1. "Livré par le S. Riézener. Pour servir dans le Cabinet Interieur de la Reine à Versailles. 3066.—Une table à écrire de marqueterie à compartiments de mosaïques et rosettes sur un fond satiné blanc composé d'un grand corps de tiroirs à ressorts mécaniques faisant avancer les tiroirs et reculer le dessus dont le milieu represente un trophée et les attributs de la Poësie et de la Littérature, un pupitre couvert de velours noir encadré d'un petit galon d'or se lève en touchant un bouton, les ornemens en bronze sont composés de cadres, chapiteaux, tiges, frises et de 4 bas reliefs d'enfans, le tout cizelé et doré d'or mat. . . ." Quoted in Verlet 1963, p. 139, no. 19.

2. "Ordre du 16 avril. Livré le 29 may pour servir au Roy de Suede une table mecanique de marqueterie

Nº 3066. Rétably, remis à neuve la dorure et la marquetrie et fourni plusieurs pieces qui manquoient aux perles qui orne les angles et avoir netoyé et ajusté la mecanique. . . ." Ibid.

3. "'Cabinet de toilette.' Une table à écrire . . . le dessus méchanique plaqué à panneaux à mozaïques, le milieu à médaillon ovale représentant un trophée allégorique avec cette devise: 'Numine afflatur,' champs et tout le reste du placage de la ditte table en bois d'amaranthe et satiné. . . ." Ibid.

4. Pradère 1989, pp. 374–75, figs. 451, 452.

5. Watson 1960, p. 117, no. 68.

78.

Armchair (*fauteuil à la reine*)

French (Paris), ca. 1780–85
Georges Jacob (1739–1814)
Carved and gilded walnut; covered in embroidered silk-satin
H. 40¼ in. (102.2 cm), w. 29½ in. (74.9 cm), d. 30⅝ in. (77.8 cm)
On the underside of the back seat rail are stamped, painted, and stenciled, respectively: "G+JACOB" and "279"; "de Pvre Paris Chambre à Balus . . ."; "B125" and the crowned monogram "LPO." Incised on top of each seat rail under the slip seat: "VIII." Inscribed on the slip seat: "Chambre a balustre." Written on the webbing is the crowned monogram "LPO." Attached to the side of the slip seat is a sticker inscribed in ink: "Ouvrard." Affixed under the left seat rail is a modern sticker inscribed: "Duveen Brothers 20-10-19."
Gift of Samuel H. Kress Foundation, 1958
58.75.25

On 31 October 1947 Duveen Brothers sold what the firm called "The Marie Antoinette Set" for 180,000 dollars to Samuel H. Kress (1863–1955).[1] It consisted of three embroidered wall hangings and various pieces of matched seat furniture that originally belonged to two different eighteenth-century suites, with the addition of several later pieces.[2] The wall hangings—chain-stitched embroideries in silk on a white silk-satin ground—show musical instruments, birds' nests, baskets of flowers, and sun hats linked together with swags of flowers. The present armchair and an identical example, as well as a pair of side chairs of the same design, have eighteenth-century show covers that were made to match these embroideries. In order to give the group of seat furniture a unified appearance, the remaining pieces were upholstered with portions cut from

additional embroidered hangings that were sacrificed for this purpose.

It is not entirely clear how such an illustrious provenance became attached to this assembled lot. When the settee, which dates to the nineteenth century, was published in 1927, nothing was said about its origin except, erroneously, that the eighteenth-century *menuisier* Georges Jacob had signed it.[3] In 1934, however, the author of a book on French furniture stated that the set had been made by Jacob for Marie Antoinette (1755–1793), and described it as "one of the most beautiful examples of the talent of this master."[4] Furthermore, he declared that the embroidery was the work of the queen and her ladies and that Marie Antoinette gave the entire set to Louis-Jean-Marie de Bourbon, duc de Penthièvre (1725–1793).[5]

Stamped by Georges Jacob, who supplied much furniture to the court of Louis XVI (1754–1793), this armchair and its pair have straight, rectangular backs, which characterize them as *fauteuils à la reine*. When cutting the walnut frames, Jacob must have carefully taken into consideration the planned decoration, leaving enough wood to allow the unidentified but obviously very skilled carver to execute the designs. Particularly striking are the deeply undercut garlands of myrtle branches spiraling around a straight rod on the seat and back rails (fig. 111).[CD] Trails of berried myrtle branches are carved around the tapering shafts of the cylindrical legs, which are crowned by collars of laurel leaves and berries.[CD] Laurel leaves are also repeated on the front of the curving arm supports

that terminate in acanthus-leaf volutes.[CD] A molding of pearls and twisted-rope motifs carved along the top of the seat rail gives a rhythmical effect not unlike that created by brass upholstery nails—here absent because the chairs are covered *à châssis*. The original slip seat and webbing have been preserved.[CD]

The back panel, edge roll, arm pads, and comfortable down and feather seat cushion are all covered in the original late-eighteenth-century embroidered silk-satin.[6] The back displays floral branches framed by scrolling floral borders. The seat cushion shows a basket of flowers within similar borders. Certain motifs, such as the band of pearls along the fore edge of the seat as well as along the borders of the cushion and of the back, clearly relate to the carving of the wooden frame. The high quality of the once very colorful chain-stitched embroidery clearly identifies it as professional work rather than as the fruit of the queen's pastime. The elegant floral compositions are close to designs by the famed silk manufacturer Philippe de Lasalle (1723–1804/5).

From a series of marks, inscriptions, and inventory numbers on the frames of both armchairs a considerable amount of information can be gleaned.[7] First of all, the incised roman numerals VII and VIII indicate that they were numbers seven and eight of a suite that included both arm- and side chairs, and possibly one or more settees. It was not unusual for a chairmaker to identify the various elements, especially such removable parts as slip seats and arm pads, as belonging to a certain chair, to avoid mixing them up.

The French inscription "de P[enthiè]vre Paris Chambre à Balus[tre]" (and a variation of this) is enlightening as well, showing that the chairs were in the possession of the wealthy duc de Penthièvre, grand admiral of France and a cousin of Louis XVI. The set furnished his Paris residence, the Hôtel de Toulouse, an early-seventeenth-century building on the rue de la Vrillière, near the place des Victoires. By 1719 the architect Robert de Cotte (1656–1735) had renovated the mansion for the duc de Penthièvre's father, the comte de Toulouse.[8] The hôtel had, according to a late-eighteenth-century description, a *chambre des balustres*, or room with balustrade on the ground floor.[9] Used only on special occasions, this room was a *chambre de parade*, or ceremonial bedchamber. A curving balustrade, or *estrade*, seen in a plan by Jacques-François Blondel (1705–1774), closed off a bed alcove separating the state bed from the rest of the room (fig. 112).[10] To have such a balustrade was a privilege, allowed only in the state apartments of dukes, princes, and *grands seigneurs*.[11] The formal nature of the Museum's armchairs as so-called *fauteuils*

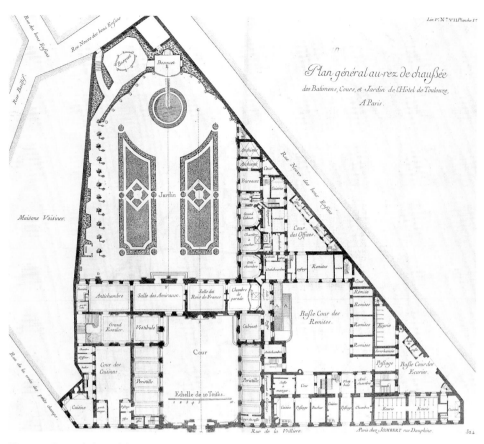

Fig. 112. Ground plan of the Hôtel de Toulouse, Paris, in Jacques-François Blondel, *Architecture françoise* (Paris, 1752–56), vol. 3, chap. 7. The Metropolitan Museum of Art, New York, Gift of Mrs. Alexander McMillan Welch, 1946 (46.52.3.1–.4).

Fig. 111. Detail of the right side of the armchair showing part of the seat rail, right arm support, edge roll, and cushion.

meublants, placed along the wall and considered to be part of the interior decoration, reflects the official function of the room. Given the various other French inscriptions on the frames, it is possible that the chairs were also used in a different part of the house. It has been suggested that the entire set was placed in the first-floor apartment of the duke's widowed daughter-in-law, Marie-Thérèse-Louise, princesse de Lamballe (1749–1792), a friend of Marie Antoinette's.[12]

After the duc de Penthièvre's death his only surviving daughter, Louise-Marie-Adélaïde de Bourbon-Penthièvre (1753–1821), inherited his possessions. Married to the liberal Louis-Philippe-Joseph, duc d'Orléans (1747–1793), who renounced his title and became known as Philippe-Égalité, she was widowed when he was guillotined during the Reign of Terror in 1793. She was exiled from France, and her property including the Hôtel de Penthièvre (Toulouse) was confiscated in 1797. The chairs may then have come into the possession of the banker Gabriel-Julien Ouvrard (1770–1846), whose name is written on stickers affixed to the slip seats. Having amassed a huge fortune in war speculations,

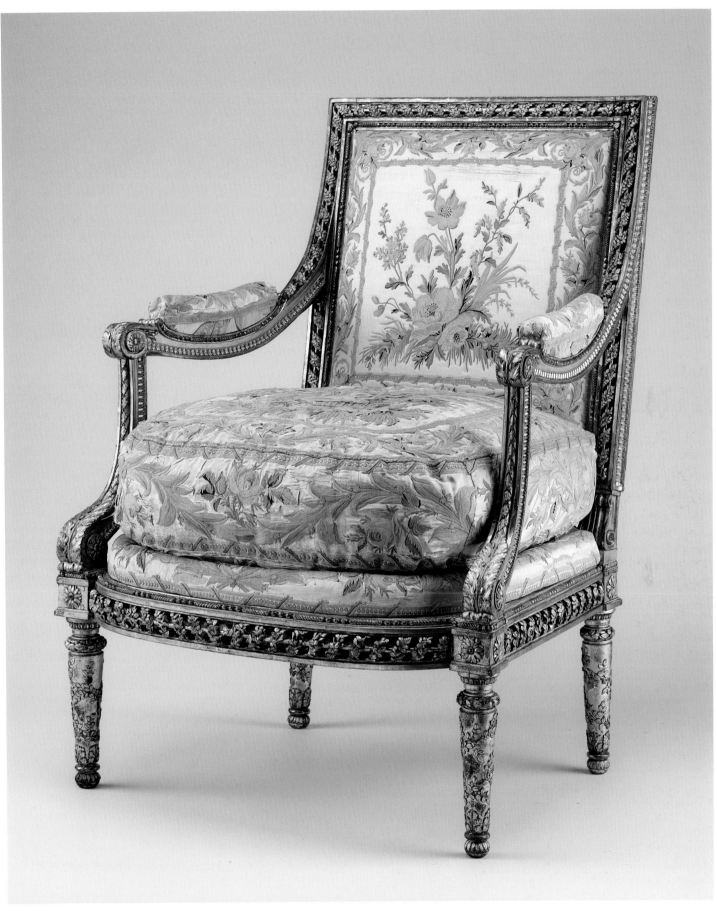

Ouvrard became purveyor to the French navy in 1798. He apparently acquired several of the confiscated estates of the Orléans family that were, however, returned to them in 1814. The "B125" marks on the chairs probably refer to one of these properties, perhaps the eighteenth-century Château de Bizy, in Normandy, where the duc de Penthièvre died and his daughter lived after her return from exile.

An inventory of the Château de Bizy described the Salon de Famille as furnished with hangings of white silk-satin embroidered with floral designs, and it listed a large set of seat furniture in the same room that was upholstered to match. This inventory was drawn up shortly after 1830, when the castle was in the possession of the son of Philippe-Égalité, Louis-Philippe (1773–1850), duc d'Orléans, who became king of France in 1830.[13] The crowned, interlaced monogram "LPO" on the chairs clearly refers to his ownership, and he may have been responsible for uniting the two sets.[CD] It has been said that Louis-Philippe left the assembled seat furniture to his youngest daughter, Marie-Clémentine (1817–1907), who lived in Austria after her marriage to Prince Augustus of Saxe-Coburg.[14] Some years

after her death, in September 1913, Duveen Brothers, the well-known antiques dealership with branches in London, Paris, and New York, acquired this set of furniture.[15]

D K-G

1. Duveen Brothers Records 1876–1981, Papers and Correspondence, 1901–81, box 475, f. 5 (microfilm, reel 330).

2. In 1958 the pieces were a gift of the Samuel H. Kress Foundation to the Museum. They included two armchairs (acc. nos. 58.75.25,26) and two matching side chairs (58.75.33,34) all stamped by Georges Jacob. There were also two similar armchairs (58.75.30,31) and one small settee, or *marquise* (58.75.27), also by Jacob but part of another set. In addition, there were a settee (58.75.24), two armchairs (58.75.29,32), and a second *marquise* (58.75.28) executed at a later date to match the design of accession numbers 58.75.27,30,31. The wall hangings have the accession numbers 58.75.35–37. See Dauterman, Parker, and Standen 1964, pp. 61–75, nos. 7–9.

3. Feulner 1927, p. 675, fig. 600. In this publication the settee is said to be owned by Duveen Brothers.

4. "une des plus belles manifestations du talent de ce maître"; Theunissen 1934, pp. 89–90, pls. XXXIII, XXXIV. In this publication the set is said to be property of Duveen.

5. Ibid., pp. 89–90. This provenance was supposedly based on a *mémoire* of Princesse Marie-Clémentine, daughter of King Louis-Philippe, who inherited the set in the nineteenth century (see below).

6. Dauterman, Parker, and Standen 1964, pp. 70, 74, no. 9.

7. The markings on the matching armchair are very similar to those on the present example. Stamped on the underside of the back seat rail are "G+JACOB" twice and "279"; stenciled are "B125" and the crowned monogram "LPO." Inscribed in ink on a sticker pasted under the back seat rail is "Chambre à Coucher." Incised on the top of each seat rail under the slip seat is the roman numeral VII. Painted on the back rail of the slip seat is "No 7 Chambre . . . Balustre en haut," and pasted there is a sticker on which is written in ink "Ouvrard." The webbing is stenciled with the crowned monogram "LPO." There is a torn Duveen Brothers sticker and another with the number 265818 inscribed on it underneath the left side seat rail.

8. Blondel 1752–56, vol. 3, chap. 7, p. 27; and Parker 1960, pp. 296–301.

9. Thiéry 1787, vol. 1, col. 304.

10. Blondel 1752–56, vol. 3, chap. 7, pl. I.

11. Havard 1887–90, vol. 1, col. 234.

12. Dauterman, Parker, and Standen 1964, p. 66, no. 7a–d.

13. Excerpts from this inventory, which is deposited in the Archives Nationales, Paris, are in the archives of the Department of European Sculpture and Decorative Arts, Metropolitan Museum.

14. Theunissen 1934, p. 89.

15. Duveen acquired a one-third share in the set. Duveen Brothers Records 1876–1981, Business Records, 1876–1964, Paris Stock Book, no. 4, 1913–14, box 100, f. 49 (microfilm, reel 35). The set stayed with Duveen until 1947 and is regularly listed in the records. The Marie Antoinette provenance appeared for the first time in 1935; Duveen Brothers Records 1876–1981, Business Records, 1876–1964, box 26, f. 9 and f. 10 (microfilm, reel 11). I am grateful to Charlotte Vignon, Annette Kade Art History Fellow, 2005–2006, Metropolitan Museum, for this information.

79.

Center table

Russian (Tula), ca. 1780–85
Steel, silver, gilded copper, gilded brass, basswood; replaced mirror glass
H. 27½ in. (69.9 cm), w. 22 in. (55.9 cm), d. 15 in. (38.1 cm)
Branded beneath the top: P below a ducal crown. Pasted beneath the top is a paper label on which is written in ink in Cyrillic abbreviation: "No. 1674"
Purchase, The Annenberg Foundation Gift 2002 2002.115

From 1712, when the imperial armory in the town of Tula, south of Moscow, was founded by Peter the Great (r. 1682–1725), the master armorers regularly enjoyed imperial patronage.[1] During the reign of Empress Elizabeth (1741–61), they began to produce a sideline of cut-steel decorative items and furniture now known as Tula ware. These were richly and elaborately worked using

many different techniques in addition to the faceting that gives them their characteristic diamond-like sparkle. Although in their shapes Tula chairs, tables, and stools resemble traditional wooden furniture, they are chased, blued, chiseled, gilded, pierced, and inlaid like parade weapons. They have come to embody for the eighteenth century the Russian decorative arts, as Fabergé objects have for the decades just before and after 1900.[2] So greatly admired was Tula ware in Western Europe that around 1775 its steel-cut look was imitated in silver and silver-gilt by Augsburg goldsmiths.[3]

In 1785 Empress Catherine the Great, during whose reign (1762–96) the Tula factory flourished, sent two of the armory's most experienced steelworkers to England in order to hone their skills and broaden their creative outlook and ideas; however, English pattern books such as Thomas

Chippendale's *The Gentleman and Cabinet-Maker's Director* (1754) were already in circulation among Russian cabinetmakers.[4] The most imaginative pieces of Tula furniture—objects like the Museum's table—were either delivered directly to Catherine the Great or purchased by her and her family or at the annual Sofia Spring Fair near the palace of Tsarskoye Selo. Made in a cooperative effort by designers and specialist craftsmen, such illustrious pieces were seen as objets d'art and were intended for display and not for daily use. So great was Catherine's passion for these fabulous objects that in 1775 she merged her Tula ware collection of several hundred pieces with some of the crown jewels and placed them together in a special jewelry gallery at the Winter Palace.[5] The empress loved the reflection of light from the thousands of

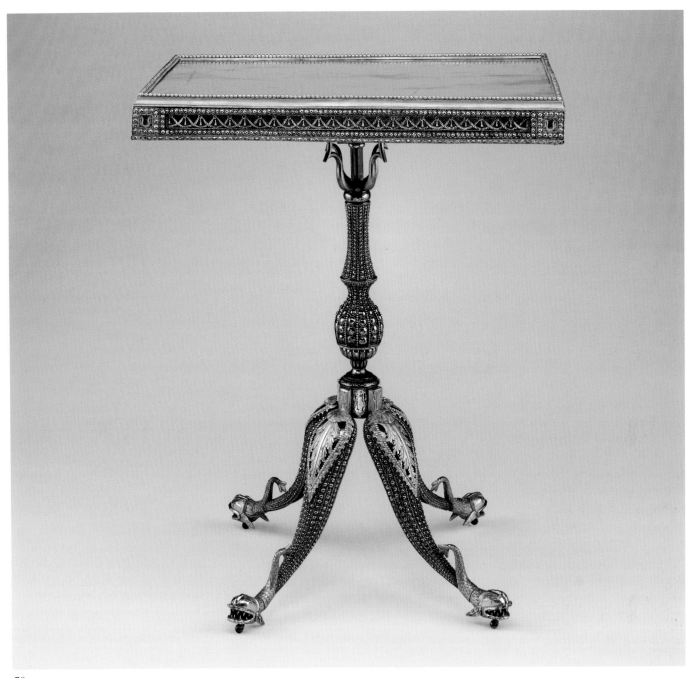

79

cut-steel facets that caught the rays of the sun by day and the flickering light of candles by night.

Catherine's son and successor, Paul I (r. 1796–1801), who disliked his mother's taste in many ways, did, to some extent at least, share her love of Tula ware. As grand duke, he and his second wife, Sophia-Dorothea of Württemberg (1759–1828), called in Russia Maria Feodorovna, ordered "two chandeliers" and "a stool and several other objects" between 14 May and 7 July 1786, from the Tula armorer Simeon Samoelov (Samarin) for Pavlovsk Palace, near Saint Petersburg.[6]

When the Museum's table appeared at auction in 2001, the sale catalogue correctly identified the branded initial "P" as the mark of Duke Peter Friedrich Ludwig of Oldenburg (r. 1785–1829); however, there is one misconception in the catalogue—that Duke Peter might have purchased the table on one of "his visits to his Russian cousins."[7] Tula ware of such high quality was not offered for public sale; rather, such furniture would have left Russia only as a diplomatic gift or as part of an imperial dowry or a present within the imperial family. The Museum's table was most likely acquired by Catherine the Great herself about 1780–85. It is later recorded, together with furniture by Henri Jacob (1753–1824)

and David Roentgen (1743–1807), in an inventory of Pavlovsk Palace in 1801. Among the furnishings in Maria Feodorovna's bedroom is listed "a one-legged table with four whale-feet supporting a rectangular top, with steel diamonds and cut silver."[8] Next to this entry is an annotation in another hand: "Given as a gift to the duke of Golsteen [Holstein] by her Majesty, the Empress."[9] This note contains a crucial clue as to how the imperial table left Russia. Duke Peter and his older brother, Wilhelm August, were born princes of Holstein-Gottorp. Their father's sister, Johanna Elisabeth, was the mother of Catherine the Great, who was born a princess of Anhalt-

Fig. 113. Table, Russian (Tula), ca. 1780–85. Steel, silver, gilded copper, gilded brass, painted tin. Catherine Palace, Tsarskoye Selo.

the sea, supported by golden whales, makes this table a supreme masterpiece.[21] W K

I thank Mechthild Baumeister, Linda Borsch, Olga Kostiuk, Marina Nudel, and Stuart Phyrr for their help with this entry. I am most grateful to H.R.H. Dr. Philipp, duke of Württemberg, for his advice. Special thanks are also due to H.R.H. Christian, duke of Oldenburg, for discussing the history of this table with me and for allowing me to consult Oldenburg family documents at the Staatsarchiv in Oldenburg.

1. Malchenko 1974, p. 5, figs. 5–7.
2. Other typically Russian national arts are stone cutting, associated with the Imperial Glass and Lapidary Works in Saint Petersburg, and the walrus-ivory carving done at Arkhangel'sk. On the latter, see "Recent Acquisitions" 1998, p. 39 (entry by Marina Nudel).
3. A pair of silver candlesticks in the Tula taste by the famous Biller family of Augsburg goldsmiths was shown by the Galerie Neuse, Bremen, at the TEFAF antiques fair, Maastricht, in 1998.
4. Malchenko 1974, pp. 14–16.
5. St. Petersburg Jewellers 2000, p. 8 (showcase at lower left).
6. Archives, State Museum Pavlovsk, doc. A-20/4, pp. 5–6 (for 1786), cited in Kuchumov 2004.
7. Catalogue of a sale at Christie's, London, 13 December 2001, p. 126, lot 500.
8. Archives, State Museum Pavlovsk, inventory of Pavlovsk Palace, 1801, p. 32. See "Recent Acquisitions" 2002, p. 25 (entry by Wolfram Koeppe); Kuchumov 2004, pp. 139–40, n. 10 (in which the table is mentioned); and Koeppe 2005.
9. Kuchumov 2004, p. 140, n. 10.
10. Staatsarchiv, Oldenburg, Best. 7, Urk. 1773, Juli 19/30; see Hülle 1972, p. 45.
11. Following the protocol, the Annual Chronicle of Oldenburg published during these years documents all the public activities of the Russian imperial household before recording local events (reviewed by this author at the Staatsarchiv, Oldenburg).
12. Staatsarchiv, Oldenburg, Best. 6D, no. 25.
13. Herzog Peter Friedrich Ludwig von Oldenburg 1979, pp. 34–37, nos. 15, 16.
14. Hennes 1870 (1971 ed.), p. 524.
15. Herzog Peter Friedrich Ludwig von Oldenburg 1979, pp. 8–9.
16. A detailed estimate provided by the duke's adjutant lists all the transport costs, including money "to bribe the Danish customs" (Staatsarchiv, Oldenburg, restricted Oldenburg family papers). Three pieces by David Roentgen, all bearing the crowned P, were most likely part of the gift; see catalogue of a sale at Christie's, Schloss Anholt, 20–21 November 2001, lots 570–72. One of them, an architect's table, is today in a private collection in New York.
17. Alexeieva 1993, p. 92; and Krieg und Frieden 2001, pp. 342–43, nos. 213–16 (entry by Olga Bashenowa).
18. The table is illustrated in color in Chenevière 1988, p. 247, pl. 266.
19. Krieg und Frieden 2001, p. 343 (on the left).
20. Malchenko 1974, figs. 15, 16.
21. The table was restored in 2003 by Linda Borsch, Conservator, Department of Objects Conservation, Metropolitan Museum. She replaced a thick gilded-wood molding on the top with a beaded frame that was adapted from an original eighteenth-century piece in the Museum's gilt-bronze collection; see the conservation report in the archives of the Department of European Sculpture and Decorative Arts, Metropolitan Museum.

Zerbst, a family not particularly wealthy but ancient and distinguished.

When Wilhelm was killed in an accident at sea, Peter was next in line to rule the dukedom of Oldenburg. The province had been until recently part of the inheritance of Grand Duke Paul. Following the wish of his mother, Catherine, in 1773 Paul transferred Oldenburg to the house of Holstein-Gottorp in order to provide their "poor" cousins "with a solid and suitable estate."[10] Nevertheless, the dukes of Oldenburg had to acknowledge the feudal jurisdiction of the Russian emperor, since he was in theory the head of the state.[11] After the assassination of Paul on 23/24 March 1801, Duke Peter traveled to Russia, doubtless to pay homage to the new czar, Alexander I (r. 1801–25), now head of the imperial family. Peter stayed with Maria Feodorovna at Pavlovsk Palace from 21 May until 26 June 1801.[12] Twenty years earlier he had married Friederike von Württemberg, a sister of Maria Feodorovna's. The marriage, a happy one, was cut short when Friederike died in 1785 after childbirth.[13] In a letter to his sister-in-law dated 23 November 1800, the duke, who never remarried, wrote, "Tomorrow it will be fifteen years since our beloved Friederike left us. I know that your Imperial Majesty will think of us."[14] It seems safe to assume that the dowager empress gave the Museum's table as a personal keepsake to her former brother-in-law during his stay at Pavlovsk. The empress

had herself just become a widow and must have felt gratitude and affection for Peter, who had devoted himself to the upbringing of his two sons, her nephews.[15] In this connection, it is interesting to note that before returning to Oldenburg Duke Peter bought an extra wagon to transport home the things he had acquired during his stay in Saint Petersburg.[16]

The Museum's table belongs to a very small group of Tula furniture embellished with silver inlay, ornamental etching, and gilded applications. It includes a dressing table with chair in the pure Neoclassical taste presented by the town of Tula to Catherine the Great on the occasion of the empress's visit in 1787. She gave it in 1788 to Maria Feodorovna, and it is still preserved in the public rooms at Pavlovsk Palace.[17] Closest in style to the Museum's table is one in Catherine's bedroom at the Catherine Palace in Tsarskoye Selo; its stand still reflects the influence of English Rococo forms, but its top and decoration are Neoclassical (fig. 113).[18] Another example, with a rectangular top and four tapering legs, is in Pavlovsk.[19] Two slightly earlier examples, with round tops in the "Chippendale style," are in the State Hermitage Museum, Saint Petersburg.[20] The table in the Metropolitan is technically the most accomplished and visually the most exciting example. The astonishing disparity between the heavy and recalcitrant materials and the light and airy form that seems to float on the surface of

80.

Candlestand

English, ca. 1780–90
Carved and painted basswood; glass and gilt-
bronze mounts
H. 48 in. (121.9 cm), w. 18½ in. (47 cm), d. 16 in.
(40.6 cm)
Gift of Irwin Untermyer, 1964
64.101.1058a,b

Before the introduction of the Argand oil lamp in 1784 and of later technological innovations such as gas and electric lighting, the artificial illumination of the domestic interior depended largely on candles, made either of rendered animal fat (tallow) or of less smoky and better-smelling beeswax.[1] Given the high cost especially of the wax kind, few candles were used on a daily basis, and once daylight faded the houses were dimly lit. Only at formal entertainments, such as important dinners and balls, would multiple candles—placed in magnificent chandeliers and girandoles—burn in the reception rooms. In addition to these hanging or mounted sources of light, candelabra and candlesticks would be brought in to brighten these rooms, especially in areas that would otherwise remain dark. They might be arranged on tables and mantelpieces and were often placed on tall movable candlestands with flat tops, also known as torchères. During the mid-eighteenth century, English pattern books included pictures of elaborately carved candlestands of spirited Rococo design,[2] which were superseded by others in a more restrained Neoclassical style, such as this elegant example, one of a pair from the Irwin Untermyer collection.[3] With their delightful design and light painted colors, these torchères stood out amid the somber furnishings of the large Oak Room in Judge Untermyer's Fifth Avenue apartment.

Unfortunately, nothing is known about either the maker or the origin of these candlestands. Made of soft basswood, which has a fine texture and even grain very suitable for carving and staining, the torchères have kept their eighteenth-century color scheme of pale gray and light blue, which must have been in harmony with the decor of the interior they were originally commissioned for. Three dolphins descend upon a triangular base, carved with an adaptation

80

Fig. 114. *The Choragic Monument of Lysicrates*, detail of plate XXII in James Stuart and Nicholas Revett, *The Antiquities of Athens*, new ed., vol. 1 (London, 1825).

and the rams' heads with the pendant swags also reveals the influence of Robert Adam (1728–1792), the prominent architect and designer whose sophisticated and elegant style dominated the English arts during the 1770s and 1780s.

Since one side of each base has been left uncarved, these torchères were clearly meant to stand in a niche or to be placed against the wall, probably on triangular bases. Eliminating drafts and protecting passersby from smoke and the wooden stands, which are difficult to clean, from falling wax, the glass shades were both practical and also beautiful when the light was reflected in their shimmering surfaces. Unlike the constant glare of electric light, the dancing flames of candles and the shadows they created must have emphasized—perhaps even exaggerated—the bold carvings of these candlestands and brought the dolphins, albeit temporarily, to life. D K - G

1. For the history of lighting, see Laing 1982; Bourne and Brett 1991; and *Country House Lighting* 1992.

2. Ince and Mayhew 1759–62 (1960 ed.), pls. LXVII–LXIX; Chippendale 1762, pls. CXLIV–CXLVII; and Hayward 1964, pls. 13–15.

3. Hackenbroch 1958a, p. 43, pl. 175, fig. 211; and Metropolitan Museum of Art 1977, p. 99, no. 180 (entry by William Rieder). The accession number of the pair to this candlestand is 64.101.1059a,b.

4. One design by Thomas Chippendale for candlestands was "intended for a Glass Globe, fixed at the Bottom in a Piece of Ornament"; Chippendale 1762, pl. CXLVII.

5. Similar glass globes, but without the griffins or the chains, resting on a tripod base, are placed on candlestands in the saloon of Culzean Castle, Ayrshire, Scotland; Learmont and Riddle 1985, p. 17.

6. Both the design and one of the candlestands based on it are illustrated in Wilk 1996, pp. 110–11 (entry by Catherine S. Hay).

7. Chippendale 1762, pl. CXLV.

8. Stuart and Revett 1825, vol. 1, pl. XXII. The conjectural tripod is known to have inspired a number of perfume burners executed in gilded bronze; N. Goodison 1972, pp. 695–704, figs. 56, 64, 65, 75. The monument is also thought to have inspired Robert Adam's design for a state bed for Robert Child at Osterley Park, Middlesex; Tomlin 1982, pp. 62–64, no. H/1.

of the Vitruvian scroll, which is resting on three fluted, bun-shaped feet. The uplifted tails of the scaly dolphins are lightheartedly twisted and rest against the banded and fluted column that forms the main upright of the stands.[CD] Unlike most torchères, these stands have candleholders on top, inside glass shades that are an intrinsic part of their design.[4] Three rams' heads holding drapery festoons are carved at the corners of a triangular platform that surmounts the shaft.[CD] The shape of these pendant swags is playfully echoed above, in the shape of the gilt-bronze husk festoons hung from rams' heads on the glass globe and also in the chains that are suspended between the griffins above the shade.[5]

Dolphins were a popular decorative motif in mid-eighteenth-century English designs of many kinds, including furniture. Particularly notable examples are the 1758 design for a candlestand by Thomas Johnson (1714–ca. 1778) and the set of four torchères with

two dolphins entwined around their central support, from Hagley Hall, Worcestershire, that are based on it.[6] A simplified design was included in the third edition of *The Gentleman and Cabinet-Maker's Director* by Thomas Chippendale (1718–1779), published in 1762.[7] The architect James Stuart (1713–1788), an early proponent of the Greek Revival style, further propagated the use of the motif through his influential four-volume publication, *The Antiquities of Athens*, with measured drawings by Nicholas Revett (1720–1804). The Choragic Monument of Lysicrates was illustrated in the first volume of 1762 with a reconstruction of its top that included dolphins supporting a tripod stand (fig. 114).[8] It is possible that the unknown maker of the Museum's candlestands was familiar not only with Johnson's overwrought work but also with Chippendale's and with Stuart and Revett's publications. The use of such classically inspired ornaments as the Vitruvian scroll, the husk festoons,

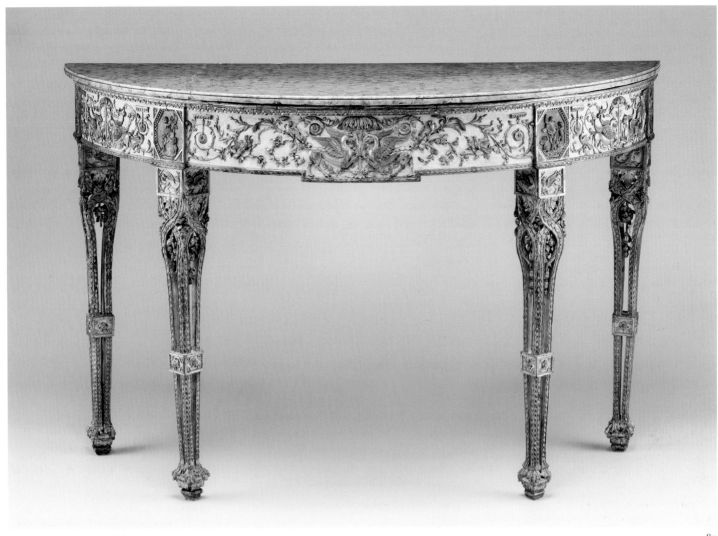

81.

Console table

Italian, 1782–92
Attributed to Giuseppe Maria Bonzanigo
(1745–1820); ornament designs after
Michelangelo Pergolesi (d. 1801)
Carved, painted, and gilded poplar wood;
marble top
H. 36½ in. (92.7 cm), w. 57 in. (144.8 cm),
d. 25½ in. (64.8 cm)
Rogers Fund, by exchange, 1970
1970.4

This elaborate and finely carved console table with pierced legs has occasioned more debate among furniture experts as to the maker and origin than any other piece of Italian furniture in the Museum. The most convincing attribution remains that to the Piedmontese sculptor Giuseppe Maria Bonzanigo, who was appointed in 1787 by Vittorio Amadeo III, duke of Savoy and king of Sardinia (1726–1796), an official

Fig. 115. Detail of the left front leg and frieze of the console table.

wood-carver to the crown. For the royal palaces he made a large quantity of furniture that is notable for the great refinement and delicacy of its design and the extraordinary quality of its carving. His furniture is found chiefly in the Palazzo Reale in Turin and at Stupinigi, the royal hunting lodge just outside the city. Bonzanigo used cameo medallions in a pair of tables at Stupinigi similar to the octagonal panels above the legs on the present table, which simulate cameos carved in relief with figures from classical mythology against a pale blue background. One of the panels on this table depicting Leda and the Swan derives from a 1782 engraving by Michelangelo Pergolesi, the leading Italian master of Neoclassical ornament (fig. 115).

The delicately carved, pierced legs are the tour de force of the table. Their capitals have panels depicting mythological animals. At the top of the beautifully intertwined corners of the legs are carved oak leaves, flowers, and foliage with chains of pendant bellflowers.[CD]

Other suggestions as to the origin of the table are Rome, Naples, and Palermo. In 1913 Seymour de Ricci published it as a console in the style of Giovanni Battista Piranesi (1720–1778), which it most certainly is not, having nothing in common with Piranesi's documented furniture or his designs for furniture in the *Diverse maniere d'adornare i cammini*, his volume of etchings devoted to furniture, clocks, and chimneypieces.[1] Several Italian experts have verbally suggested that the table was made in Naples or Palermo. WR

1. Ricci 1913, p. 69.

82, 83.

Commode and secretary (*secrétaire à abattamt* or *secrétaire en armoire*)

French, 1783
Jean-Henri Riesener (1734–1806)
Oak veneered with ebony and Japanese lacquer; the interiors veneered with tulipwood, amaranth, holly, and ebonized holly; gilt-bronze mounts; replaced velvet; marble tops
Commode: h. 36¾ in. (93.4 cm), w. 56½ in. (143.5 cm), d. 23½ in. (59.7 cm); secretary: h. 57 in. (144.8 cm), w. 43 in. (109.2 cm), d. 16 in. (40.6 cm)
Both stamped on the back with the crowned monogram "MA" within the legend "GARDE MEUBLE DE LA REINE." Both stenciled under the marble top with the inventory mark of the Château de Saint-Cloud and "No. 53."
Bequest of William K. Vanderbilt, 1920
20.155.12,11

Often described as the most famous pieces of eighteenth-century French furniture outside France, this commode and secretary are among the truly great objects made by the cabinetmaker Jean-Henri Riesener.[1] They were part of a suite of three pieces commissioned in 1783 by Queen Marie Antoinette (1755–1793) for her Cabinet Intérieur at Versailles. They are veneered with the queen's prized seventeenth-century Japanese lacquer, which in this case must have been cut from large screens or a Japanese cabinet of about 1660–80.[2]

The basic form of the commode was one that Riesener had been making for at least seven years: a rectangular body with incurved, splayed ends, canted forecorners, and a front with a central, projecting break-front section featuring a distinctive trapezoidal panel.[CD] The piece has two principal drawers and a frieze divided into three shallow drawers. Laurel garlands of gilded bronze are draped across the front. For the en suite secretary, Riesener essentially repeated the commode design for the upper part and added below a cabinet with two doors and a raised, central, rectangular breakfront section, framed with the same gilded bronze as the trapezoidal panel above.

Marie Antoinette was so pleased with the commode and secretary that she asked Riesener to make another pair, this time veneered with pictorial and trellis marquetry. Extensively altered in 1790–91, these later pieces are now in the Frick Collection in New York.[3]

The extraordinary quality of the gilt-bronze mounts has been much discussed in the considerable literature on these pieces. As *ébéniste du roi* (furniture maker to the king), with private accommodations at the Arsenal in Paris, Riesener was exempt from the guild regulations that prohibited *ébénistes* from casting or chasing their own mounts. He employed his own bronze workers, among the most notable of whom was the gilder François Rémond (1747–1812).

Riesener delivered the commode and secretary, together with the third piece in the set, a corner cupboard (*encoignure*), to Versailles on 30 August 1783, when they were all duly recorded in the royal furniture inventory and branded on the back with Marie Antoinette's mark (see fig. 116). They

Fig. 116. Stamped on the back of the commode is the crowned monogram "MA" within the legend "GARDE MEUBLE DE LA REINE."

198

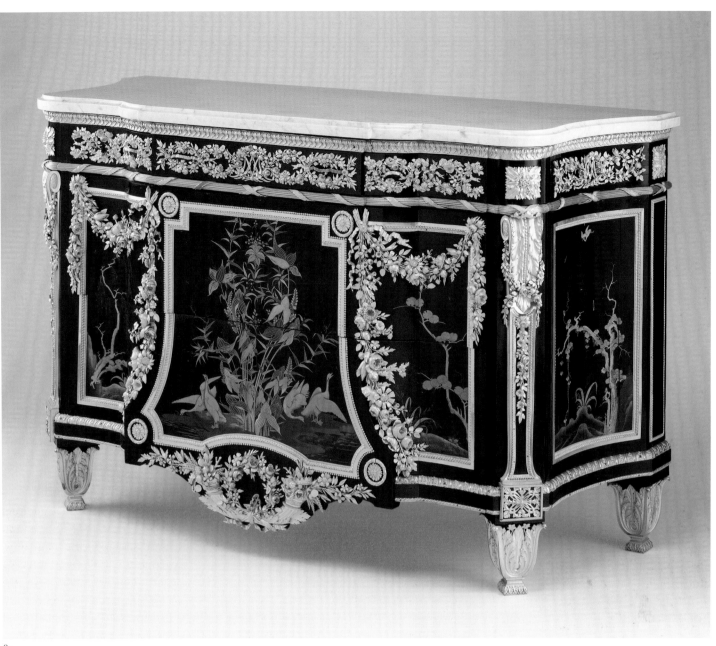

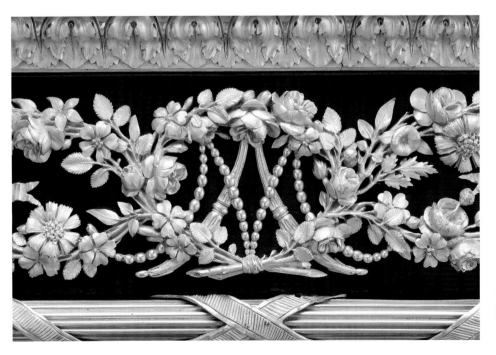

Fig. 117. Detail of the gilt-bronze mounts on the frieze of the secretary. Luxuriant floral sprays encircle the initials of Marie Antoinette. The same initials may be seen on the drawer of the commode (above).

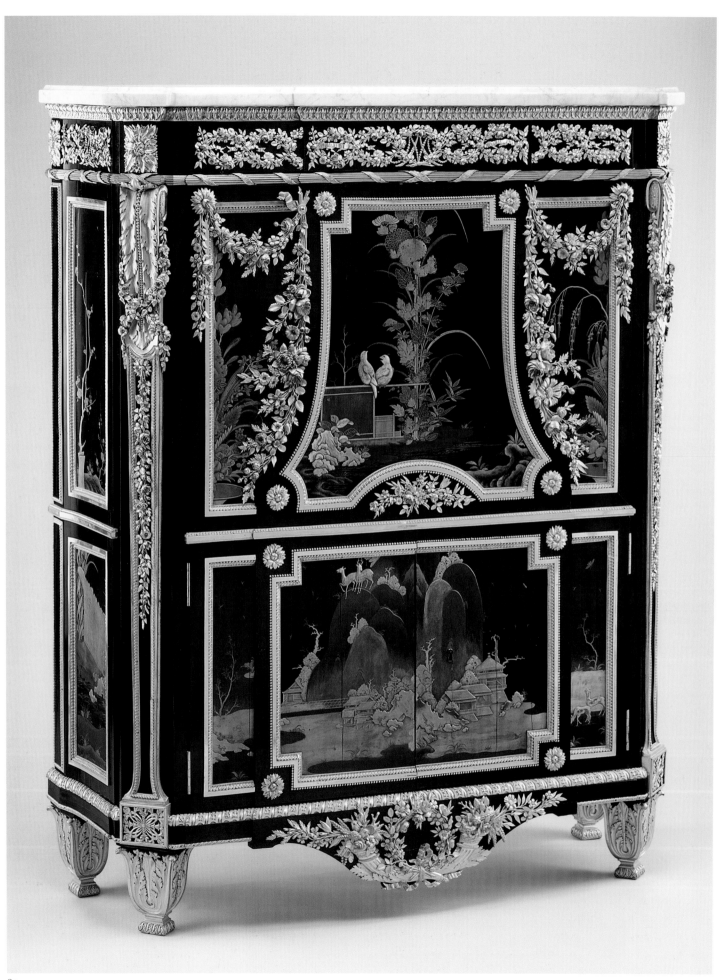

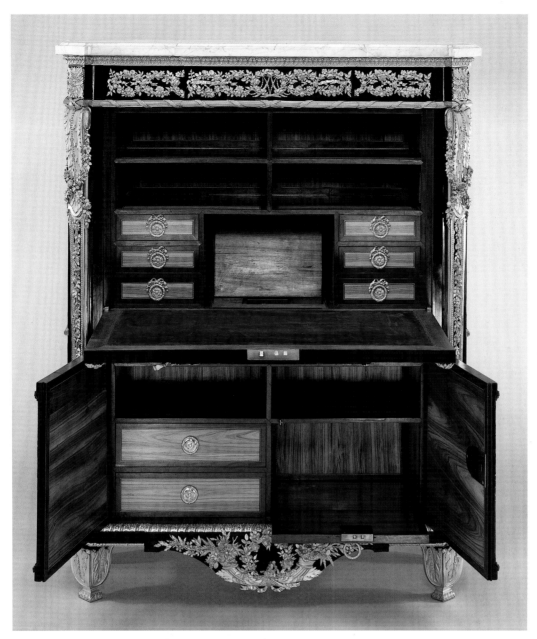

Fig. 118. General view of the secretary with the cabinet doors opened and the fall front lowered. The strongbox compartment is visible on the right side of the cabinet.

remained at Versailles only three years, after which they were moved briefly to the Trianon, where the *encoignure* became separated. In 1787 the commode and secretary were moved again, to the queen's favorite château, the Château de Saint-Cloud, where they were stenciled on the top of the carcase with the inventory mark of Saint-Cloud ("S.C." beneath a crown) and the number 53 and placed in her Cabinet Intérieur.[CD]

The two pieces remained at Saint-Cloud until 1793, when they were set aside from the Revolutionary sales and reserved for the Louvre, where, however, they appear never to have gone. In 1795 they were chosen by

the leading contractor of supplies for the army of the Rhine and Moselle, Abraham Alcan, as partial payment for his services during the Revolution.

The commode and secretary were next recorded in the collection of George Watson Taylor (1770–1841) at his country house, Erlestoke Park, in Wiltshire. At the Erlestoke sale in 1832 they were bought by the London cabinetmaker and agent Robert Hume (active 1808–40), bidding for the duke of Hamilton.

They remained at Hamilton Palace, in South Lanarkshire, Scotland, until 1882, when in the famous Hamilton Palace sale of

that year they were sold to Mrs. William K. Vanderbilt of New York for the house she was building on Fifth Avenue. Following her husband's death in 1920, they were bequeathed to the Metropolitan Museum.

WR

1. This entry is based on Rieder 2002, which summarizes the history and bibliography of these pieces. See also Baulez 2001, pp. 32–33, figs. 5, 6.
2. The lacquer has been extensively studied in Impey and Kisluk-Grosheide 1994.
3. Dell 1992b, pp. 71–91.

84.

Side chair (*chaise à la reine*)

French (Paris), 1784
Georges Jacob (1739–1814); carving by Jules-Hugues
Rousseau (1743–1806) and Jean-Siméon Rousseau
de la Rottière (1747–1820); gilding by Presle
Carved and gilded walnut; covered in silk-moiré
damask not original to the chair
H. 34 in. (86.4 cm), w. 18½ in. (47 cm), d. 18 in.
(45.7 cm)
Painted inside the seat rail: "26A."
Gift of Mr. and Mrs. Charles Wrightsman, 1977
1977.102.13

In his 1966 study of the furniture in the Wrightsmans' collection Francis Watson said that the exceptional quality of the carving and the use of two-toned gilding on this chair and its pair, also in the Museum, suggested the work of a major craftsman, such as the talented *menuisier* Georges Jacob; he added that the chairs probably formed part of an important commission as well.[1] All these suggestions were proven to be true when records were discovered showing that the chairs had been ordered in 1784 for the use of Queen Marie Antoinette (1755–1793) in her boudoir at the Château des Tuileries.[2] These records from the Garde-Meuble de la Reine, the bureau under the direction of Bonnefoy Duplan that commissioned furnishings for the private apartments of the queen, offer interesting information about the work done by the artists and craftsmen involved in the project.

Jacob, the first in a three-generation dynasty of well-known chairmakers, and later also cabinetmakers, became a master in 1765. Soon he had a fashionable clientele and was busy supplying seating furniture to a number of the royal palaces.[3] He charged sixty-four livres for this pair.[4] They were described as "two side chairs of a new shape made of walnut."[5] The "new shape" may refer to the horseshoe- or balloon-shaped seat, a feature that Jacob was to repeat for side chairs of other important sets,[6] or, possibly, to the arched top rails of the rectangular backs, or to both.

Once the basic framework was finished, the chairs were carved by the brothers Rousseau—Jules-Hugues and Jean-Siméon, who called himself de la Rottière, to distinguish himself from his older sibling.[7] In the Rousseaus' 1784 *mémoire* (memorandum) the chairs can easily be recognized, given the very detailed description of their work done on the different parts, sometimes with a kind of justification for the sums charged.[8] For the columnar back stiles, for instance, which consist of bundles of thirty-two rods each, tied with crossed ribbons, the Rousseau brothers charged nine livres per upright, explaining that it was very difficult to align the rods. Of the unusual finials surmounting the back stiles they said, "the two small balloons on top covered with their strings [are] carefully detailed" (fig. 119).[9] The finials cost six livres each. The seat rail, according to the account, was carved to show five rods tied together in a bundle with myrtle branches that were "very precisely rendered" (*très précieusement faits*). Given the challenge to the artists of carving the rods with regularity, especially where they appear from underneath the branches, the work was assessed at eight livres per *pied*,[10] which added up to thirty-two livres for the seat rails of each chair. The account also specified the different decorations on the legs, which are shaped like fluted quivers, embellished with floral swags, and filled with arrows, of which only the feathered ends are showing.[CD] The Rousseaus charged the total sum of 141 livres and 17 sols for each chair.[11]

The side chairs were next prepared for gilding, which involved many steps, including washing the wood and applying numerous coats of whiting. This was followed by the so-called *reparure*, the refreshment of the carved elements lost under the preparatory layers of whiting and the addition of extra details to the decoration. This work and the actual gilding afterward were done by Presle, "painter and gilder to the king," whose shop was on the rue Poissonnière in Paris.[12] Given the richness and the perfection of the work, according to the account, Presle charged 210 livres for each chair. Interestingly enough, the *mémoire* does not specify the use of two-toned gilding, only mentioning "d'or jaune bruni avec la plus grand soin" (yellow gold burnished with the greatest care). Certain details of the carving, such as the myrtle branches on the seat rails, for instance, show an unmistakenly green hue. This was not produced by a different gold, according to descriptions given by Jean-Félix Watin in his popular manual *L'art du peintre,*

Fig. 119. Detail of the left side of the chair back, showing the balloon-shaped finial.

Fig. 120. *À l'Honneur de Messieurs Charles et Robert*, etching and engraving, published by Le Noir, Paris, ca. 1783. Gimbel Collection, U. S. Air Force Academy Library, Colorado (1128).

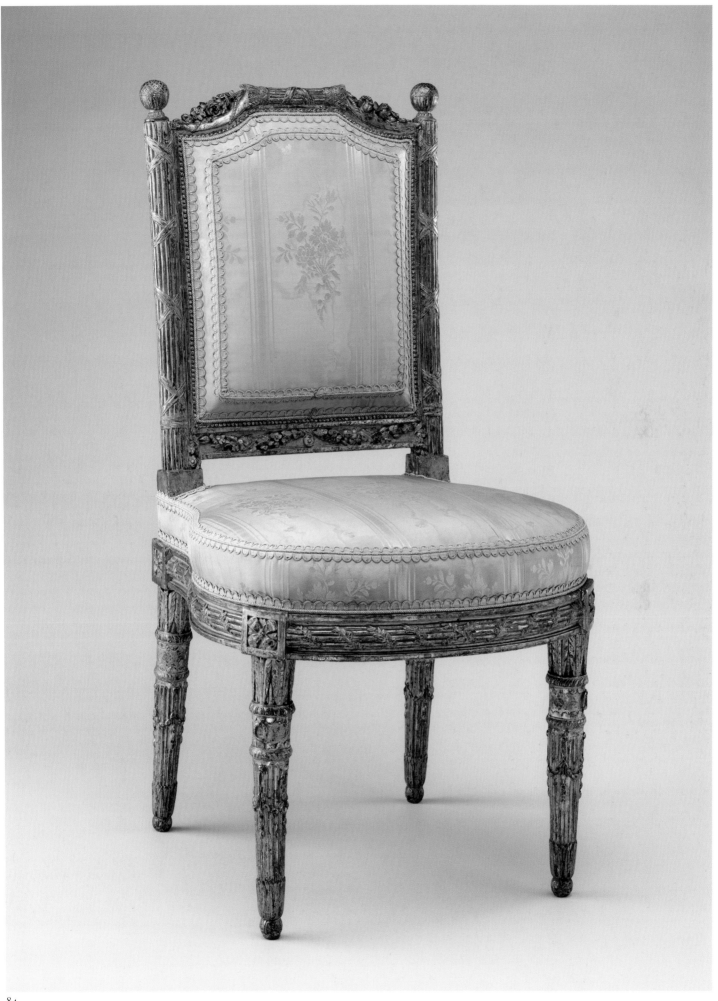

doreur, vernisseur (1773), but by a different colored ground underneath the gold.[13] Whereas for ordinary gilding (*d'or jaune*) the gold should be applied over a yellow coating made of whiting mixed with finely ground ocher, for greenish gold (*d'or vert*) a layer of whiting mixed with some Prussian blue should be applied.

It is unfortunately not known how the chairs were originally upholstered. A bill from the silk painter Jacques-Claude Cardin (b. ca. 1721) for various designs that he made for the queen's private apartment at the Tuileries in 1784 indicates that the chairs were intended to have show covers embroidered to match the brocaded fabric in the boudoir.[14]

Historic events are rarely commemorated in the decoration of furniture, but the small balloon finials of these chairs clearly celebrate the successful aeronautic experiments of 1783, which caused much popular excitement and stirred great interest in the science of aviation.[15] The Montgolfier brothers, Joseph-Michel (1740–1810) and Jacques-Étienne (1745–1799), released a hot-air balloon on 5 June 1783 from the town square in Annonay, near Lyons. On 19 September 1783 they launched another balloon, carrying a sheep, a duck, and a rooster, from the park of Versailles before a large audience that included Louis XVI and Marie Antoinette. Other experiments quickly

followed, such as the release of a hydrogen balloon by the French physicist Jacques-Alexandre-César Charles (1746–1823) from the Champ de Mars in Paris on 27 August 1783. Later that same year, on 1 December, Charles himself manned the gondola of a hydrogen balloon together with Marie-Noël Robert, who had assisted in its design and construction. They had a successful takeoff from the Tuileries gardens. The netting draped over the upper half of the chairs' balloon-shaped finials characterize them as hydrogen rather than hot-air balloons, and it is likely that Charles and Robert's successful ascension from the Tuileries park, illustrated in contemporary prints, served as the inspiration for the finials (fig. 120).

Little is known about the later history of these exceptional side chairs, only that they were for a time in the collection of Baroness Renée de Becker in New York. Mr. and Mrs. Charles Wrightsman, also of New York, acquired them in 1958 and gave them to the Museum in 1977. D K - G

1. Watson 1966a, p. 50, no. 36A, B. The accession number of the matching side chair is 1977.102.14. Painted inside the seat rail is "26B."

2. This provenance was first published in Baulez and D. Ledoux-Lebard 1981, p. 20, fig. 23. The memorandum is Archives Nationales, Paris, O¹ 3629, dossier 4, 1784.

3. Information about Georges Jacob is given in Pallot 1993, pp. 194–96.

4. It is difficult to estimate what 64 livres would be worth today. To get a sense of the cost of these chairs, it is helpful to know that in France between 1726 and 1790 the laboring poor would earn between 100 and 300 livres a year, and a skilled worker between 300 and 1,000 livres. This and other figures are given in Sargentson 1996, p. xi.

5. "deux chaises de forme nouvelle; faites en bois de noyer"; Archives Nationales, Paris, O¹ 3629, dossier 4, 1784. Quoted in Lefuel 1923, p. 155.

6. Several related side chairs with horseshoe-shaped seats by Jacob of about 1785 are known. Four are in the Jones Collection in the Victoria and Albert Museum, London; P. Thornton 1972, pp. 173–74, fig. 20. Another, different, one was sold in Paris; catalogue of the Comte de Greffulhe collection sale, Binoche, Hôtel Drouot, Paris, 6 March 2000, lot 115. A set of furniture supplied by Jacob in 1787 for Marie Antoinette's bedchamber at the Petit Trianon, Versailles, also included similar side chairs; see Meyer 2002, pp. 274–81, no. 71.

7. Their father, Jules-Antoine Rousseau (1710–1782), was responsible for decorative carving in the interiors of many French palaces. See Brière 1924; and Bénézit 1999, vol. 12, p. 32.

8. Archives Nationales, Paris, O¹ 3629, dossier 4, 1784.

9. "les 2 petits ballons au dessus et couverts de leurs filets très soigneusement détaillés"; ibid.

10. A *pied* is an old French length measurement of about 12¾ inches (32.4 cm); Havard 1887–90, vol. 4, cols. 304–5, 621.

11. Twenty sols make one livre.

12. Archives Nationales, Paris, O¹ 3629, dossier 4, 1784.

13. Watin 1828, pp. 215, 221–22.

14. "Avoir fait des desseins d'après les étoffes broché du petit boudoir pour les deux chaises en dessiné sur les differentes parties des dittes chaises pour être brodé pour ce valué a . . . 18 livres"; Archives Nationales, Paris O¹ 3631, semester 2, 1784. Cardin became a master painter and member of the Académie de Saint Luc in 1761, and he did much work for the French court; see Coural 1972. I am grateful to Christian Baulez for this reference.

15. *Balloon* 1983, pp. 15, 74.

85.

Secretary (*secrétaire à abattant* or *secrétaire en armoire*)

French, 1786–87
Guillaume Benneman (active 1785–92; d. 1811); bronze ornaments possibly by Gilles-François Martin (ca. 1713–1795); gilt-bronze mounts modeled by Louis-Simon Boizot (1743–1809) and others; mercury gilding by Galle
Oak veneered with partly stained kingwood, ebony, rosewood, holly, and mahogany; gilt-bronze mounts; brèche d'Alep marble top not original to the secretary; the writing surface lined with leather not original to the secretary
H. 63½ in. (161.3 cm), w. 32 in. (81.3 cm), d. 15 in. (38.1 cm)
Stamped vertically on the upper part of the back, at left: "G. BENEMAN." Painted in black on the upper center of the back and again, larger, below: "No. 13."
Gift of Mr. and Mrs. Charles Wrightsman, 1971
1971.206.17

This desk entered the Museum's furniture collection in 1971, one of many gifts that reflect the great generosity of Mr. and Mrs. Charles Wrightsman toward the Metropolitan Museum. Its beauty and workmanship are outstanding, and its provenance is extraordinary. A receipt dated 25 May 1787 indicates it was placed for Louis XVI's use in the Cabinet Intérieur at the Palais de Compiègne.[1] Through a contradictory twist of fate, it was confiscated after the Revolution and used by the directors of the first formally constituted French republic at the Palais du Luxembourg in Paris—despite the fact that it was a relic of Bourbon ostentation.[2] During the first Empire it was sent to

the Hôtel d'Elbeuf for the use of Archchancellor Jean-Jacques Régis de Cambacérès (1753–1824), to whom Napoleon gave it in 1808.[3] It was recorded in the duke's collection in 1824 and was subsequently owned by Henri de Rothschild, by Edith Chester Beatty in London, and by Guedes de Souza in Lisbon.[4]

One of the few precisely documented pieces of Parisian furniture made for the court in the 1780s, the desk exemplifies the extreme luxury and lavish expenditure that characterized the ancien régime just before the furious class upheaval that brought it down. In regard to the commissioning and delivery of royal furniture under Louis XVI,

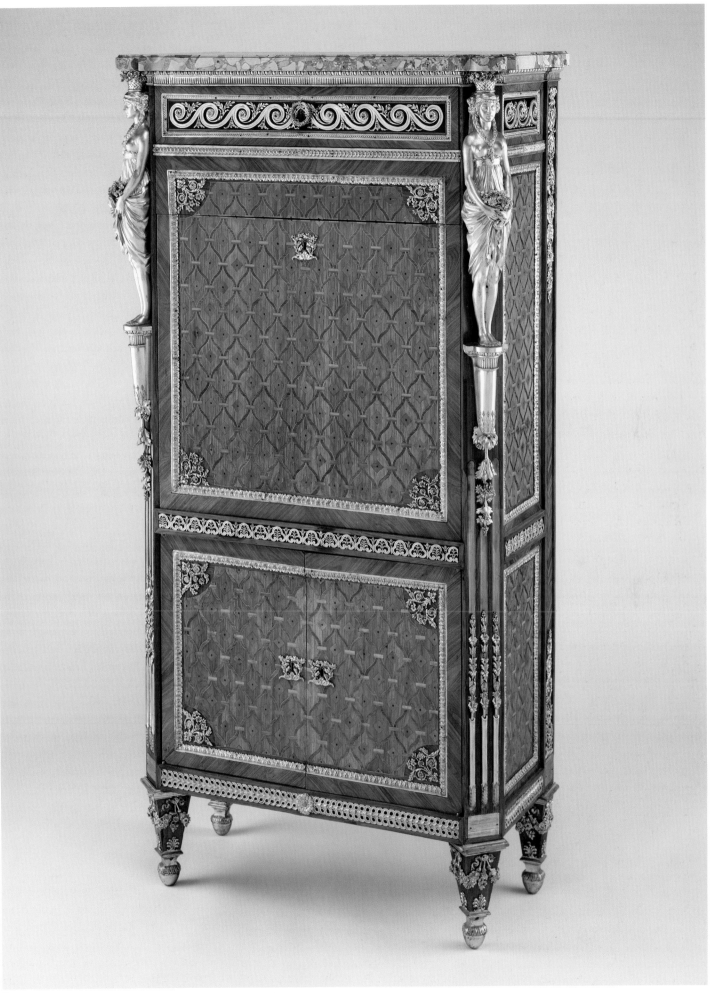

Fig. 121. General view of the secretary with the fall front lowered.

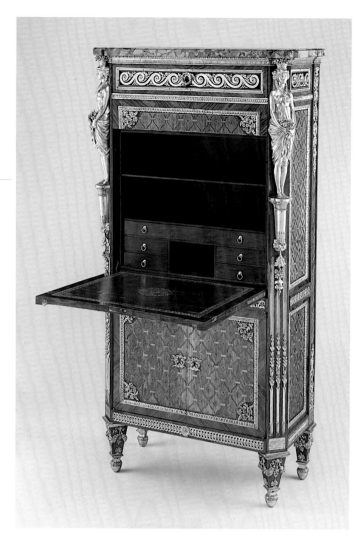

results in a shift of attention toward the woodwork and clearly distorts the original appearance of the desk. The marquetry technique alone commands highest respect, however, and reflects the considerable abilities of the Benneman workshop. The vertical, curving, dark kingwood lines were cut out with a shoulder knife from large pieces of veneer with such a precision that the final result is a true masterwork.[8] [CD] This kind of desk, called *secrétaire à abattant*, derived from a portable writing cabinet with a fall front. When the cabinet stood open, the latter would serve as the writing surface, and when closed, it would conceal the interior drawers and other storage compartments. The type seen here (*secrétaire en armoire*), with a lower cabinet closed by doors and an upper cabinet with a fall front, was fully developed by the second half of the sixteenth century (fig. 121).[CD] Many examples are virtuoso show pieces with sculptural corner figures of highly expressive design.[9] Such lavish, flamboyant furniture maintained the glory of the French crown and the country's hegemony in the production of luxury goods. In 1780 Louis-Sébastien Mercier noted that in France in the decade just past, "six hundred mansions were built that in the inside looked like a fairyland; because [human] imagination does not go beyond a luxury so exquisite."[10] Their owners lavished more attention and money on the furniture than on any other aspect of the interior decor. Louis XVI's furniture commissions were intended to demonstrate the sound state of the exchequer and to convince the rest of Europe of France's financial stability; however, in the face of a rapidly growing public debt, swollen by wars and an inadequate tax system, the king's advisers were in the end unable to ward off financial disaster and political revolution. It is astonishing that this situation should have initiated the commissioning of some of the finest furniture ever made, including this secretary by Benneman, one of the most prolific and original of French cabinetmakers.

W K

the secretary is also an excellent example. It was made by one of the great Parisian *ébénistes*, in this case, Guillaume Benneman,[5] who in 1785 succeeded Jean-Henri Riesener (1734–1806) as royal cabinetmaker, working in collaboration with a team of artisans, all under the direction of Jean Hauré (active 1774–96), who supervised the making of furniture for the crown. (Benneman, who was born and trained in Germany, moved to Paris and received his first royal commission in 1784.) Hauré ordered the secretary and two other pieces, a *commode en console* and a *bureau plat*, to complement a commode that had been delivered to Versailles by Gilles Joubert (1689–1775) in 1770–71 and that was restored in 1786. These case pieces and an additional suite of seat furniture[6] were all intended for the king's use. For the Museum's piece Benneman assembled the mounts, which had been modeled by Louis-Simon Boizot and two other sculptors, one named Martin (possibly Gilles-François Martin) and the other named Michaud. The bronze worker Forestier (probably Étienne-Jean Forestier or his brother Pierre-Auguste)

was paid for the cast, and either Étienne-Jean Thomire or Pierre-Philippe Thomire (1751–1843) as well as Bardin, Tournay, and others, were paid for the chiseling. Galle did the mercury gilding. Even the small gilded rosettes that formerly decorated the "eyes" of the stylized trellis-formed marquetry, covering the colorfully contrasting inlay like a net with golden knots, are mentioned (*petites rosaces en cuivre doré*).[CD] The original marble top was supplied by Jean-Pierre Lanfant (who became a master in 1785), but it has since been replaced.[7]

In comparison with the bold, stylish mounts, of which the superb classicizing caryatids are masterfully conceived statuettes in their own right, the delicate trellis marquetry of intertwined hearts and lozenges seems rather old-fashioned. The king's desire to economize by "updating" older pieces of furniture and commissioning matching items led to this development. Nevertheless, the cabinetry and especially the mounts are some of the best that Parisian artisans ever invented. The unfortunate loss of the small gilded rosettes

1. According to a note in the archives of the Department of European Sculpture and Decorative Arts, Metropolitan Museum, an inventory label with the mark "CP," for the Palais de Compiègne, was attached to this piece until 1953.

2. Augarde 1989, p. 145, fig. 4, and pp. 146–47.

3. Christian Baulez, Conservateur at the Château de Versailles, to James Parker, 29 June 1984, in the

archives of the Department of European Sculpture and Decorative Arts.

4. Verlet 1963, pp. 155–57, colorpl. III; Watson 1966a, pp. 195–201, no. 107; and Metropolitan Museum of Art 1975, p. 258 (entry by Penelope Hunter-Stiebel).

5. Pradère 1989, pp. 404–11.

6. Meyer 2002, pp. 158–63, no. 41.

7. Watson 1966a, pp. 195–201, no. 107. Hauré's detailed account of the work done on the piece by each craftsman is given in Watson 1966a, p. 198.

8. Chastang 2001, no. 6, fig. 34. I thank Yannick Chastang for bringing this detail to my attention during an examination of the secretary in the company of Mechthild Baumeister, Conservator, Department of Objects Conservation, Metropolitan Museum, in

March 2004. The pinholes in the rosettes are filled with ebony; this and the lack of any denting in these areas testify to an extensive reworking of the surface.

9. Koeppe 1994a.

10. Mercier 1780, vol. 1, pp. 283–84, vol. 4, p. 121, quoted in translation in Stürmer 1979a, p. 497.

86, 87, 88.

Daybed (*lit de repos* or *sultane*), armchair (*bergère*), and fire screen (*écran*)

French (Paris), 1788
Jean-Baptiste-Claude Sené (1748–1803);
painting and gilding by Louis-François Chatard
(ca. 1749–1819)
Carved, painted, and gilded walnut; daybed and armchair covered in modern silk-satin damask, fire screen covered in modern silk-satin weave
Daybed: h. 36½ in. (92.7 cm), w. 69 in. (175.3 cm), d. 31½ in. (80 cm); armchair: h. 39 in. (99.1 cm), w. 27¼ in. (69.2 cm), d. 25¼ in. (64.1 cm); fire screen: h. 44¼ in. (112.4 cm), w. 27¾ in. (70.5 cm), d. (base) 17 in. (43.2 cm)
Gift of Ann Payne Blumenthal, 1941
41.205.1–3a,b

After Louis XVI (1754–1793) bought the Château de Saint-Cloud from the duc d'Orléans, on 19 February 1785, it was provisionally furnished so that Marie Antoinette (in whose name the king purchased it) could stay there during the month of September that same year. Being in need of renovation, the seventeenth-century palace was subsequently altered and enlarged by the architect Richard Mique (1728–1794), and appropriate furnishings were commissioned for the

queen, who planned to spend the summers there with her children.[1] Much of this furniture was ordered from Jean-Baptiste-Claude Sené, member of an important dynasty of Parisian chairmakers of that name, who became a *maître menuisier* in 1769 and was appointed chairmaker to the crown in 1784.[2] A *mémoire* by Sené of 1788 describes the daybed, fire screen, and *bergère* (a comfortable armchair upholstered between the arms and the seat), together with four matching

86

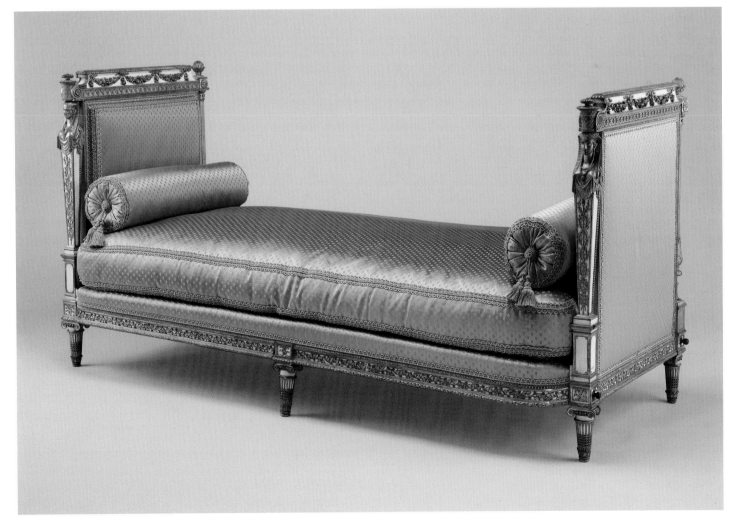

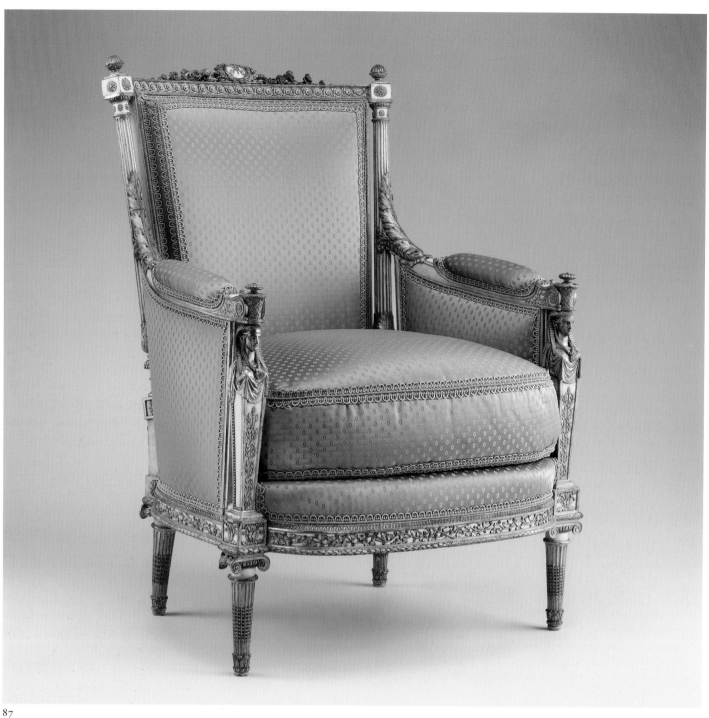

87

armchairs (*fauteuils*) and a *tabouret* (stool) that were intended for the queen's Cabinet Particulier, one of the rooms in her private apartment at Saint-Cloud.[3]

The daybed, referred to in Sené's account as "une sultane," meaning a low settee without a back, is described in great detail, which permits easy identification because of its carved ornament.[4] The curving front rail is embellished with ivy; the feet carry Ionic capitals; the isolated columns at the back are surmounted by Doric capitals; the frieze running along the top at either end has sun motifs and flowers; and there are garlands of roses along the crest rails.[CD] Interesting

are the female half figures with Egyptian headdresses carved on tapering supports that are decorated with interlaced myrtle branches.[CD] Sené simply calls them caryatids, without making a specific reference to their exotic headgear. He charged 700 livres for this daybed.

The *bergère* was decorated in a similar manner and has a medallion with Marie Antoinette's initials flanked by rose branches on its top rail.[CD] Sené charged 270 livres for this chair. The fire screen differs somewhat in that it does not have Egyptian caryatids but instead seated female figures on the feet and a reclining woman, originally holding a

cornucopia, on top.[CD] The work on the screen amounted to 400 livres. In addition, 72 livres was charged for the fabrication of two, not further specified, wax models, presumably for the furniture, probably the work of a sculptor.[5]

Although Sené's name is the only one on the account, he was most certainly not responsible for the elaborate decoration. This must have been left to a specialized carver, who, very likely, collaborated closely with Sené so that the latter could provide wooden frames of the right shape and thickness for carving.[6] The surface treatment was done by Louis-François Chatard, whose

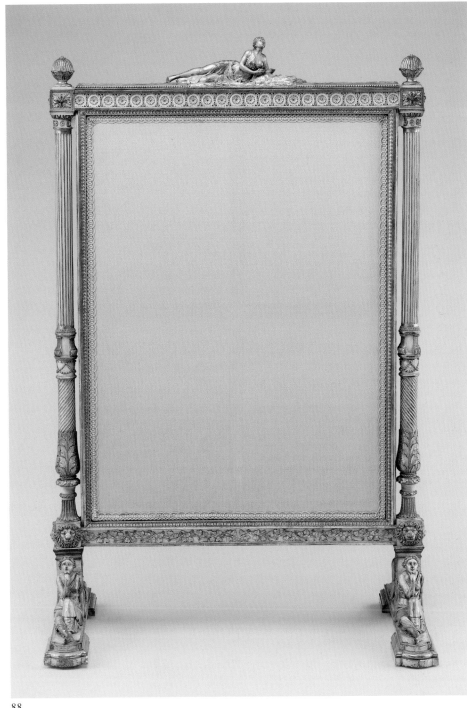

88

lated corded borders that frame the panel. White and various tones of yellow, blue, and green were chosen for the flowers, and for the corded borders several shades of pink and a deep brown. This matt cotton fabric with its floral needlepoint in a shiny silk floss would have been in perfect harmony with the dull off-white paint and the lustrous gilding of the furniture frames and was very suitable for use during the summer.[12]

A ground plan of Saint-Cloud in 1788 shows the new layout of the royal apartments created by Mique on the first floor (the American second floor) of one of the lateral wings.[13] The private rooms of the king faced the garden and those of the queen the courtyard. Both sets of rooms were *en enfilade*, with the doors aligned so that one could pass from one to the next in a straight line. Marie Antoinette's dressing room had two windows and four doors, two of which were in the short walls opening to the rooms on either side, the bedchamber and the Cabinet Intérieur. Since the dressing room did not have a niche, the daybed, an increasingly popular piece of furniture during the eighteenth century, stood, in all likelihood, along the wall opposite the windows, flanked by doors giving access to the *garderobe,* or closet, and a private staircase behind the room. In addition to this set of furniture, the dressing room was furnished in 1789 with a dressing table and a commode, both of mahogany, a *fauteuil de toilette,* as well as a mechanical writing table by Jean-Henri Riesener (1734–1806), now also in the Museum's collection (see no. 77).[14] Unlike the daybed and the *bergère,* none of these other pieces or the gilt-bronze wall brackets in the room had any ornament derived from ancient Egyptian art. Nevertheless, Marie Antoinette seems to have been one of the propagators of this novel form of decoration in the Egyptian taste, since she commissioned and bought a number of furnishings embellished with sphinxes or figures with an Egyptian headdress.[15]

The contents of Saint-Cloud were sold in 1794–95, and the furniture from Marie Antoinette's dressing room may have been included in the sale. Nothing further is known about the history of the daybed, *bergère,* and fire screen until 1911, when they were twice offered for sale in Paris at the Hôtel Drouot.[16] Attributed to Georges Jacob, they were in the possession of the marquis de Casaux until 1923[17] and then

mémoire describes it as "gilding, burnishing, and setting off in white"; for this he received 2,392 livres, which included packing the furniture and shipping it to Saint-Cloud.[7]

According to the 1789 inventory of the château, in which the furniture is listed as in Marie Antoinette's dressing room, the set had show covers of white twilled-cotton weave, embroidered in satin stitch with rows of small detached bouquets in shaded silk framed by borders of various widths.[8] The queen, who is known to have worked on needlepoint projects until the end of her life, was herself responsible for this embroidery.[9] Photographs of the pieces taken early in the twentieth century show that the original upholstery was embroidered with small individual flowers, not unlike the designs on the printed cotton fabrics known as calico.[10] These show covers were no longer on the furniture when it entered the Museum's collection in 1941, with the exception of the fire screen, whose front panel has been preserved.[11] CD Although the natural cotton ground is discolored, the silk embroidery, executed in satin stitch, is in a remarkably good condition. It consists of floral ornament and in the center the interlaced initials of Marie Antoinette, composed of cornflowers and other blossoms, all within simu-

acquired by the financier George Blumenthal (1858–1941), who was for many years a trustee, and from 1934 to 1941 president, of the Museum.[18] D K - G

1. Meyer 1965.
2. Pallot 1993, pp. 199–200.
3. Archives Nationales, Paris, O¹ 3646, semester 1, 1788, 3 May, no. 157; see Verlet 1994, pp. 244–51, 265, no. 39. The whereabouts of the *tabouret* are not known. The four armchairs are thought to be dispersed among three collections. Two are at the Victoria and Albert Museum, London; illustrated in Watson 1960, pp. 140–41, no. 169. One, formerly in the Rothschild collections, is now at Versailles; Arizzoli-Clémentel 2002, pp. 294–95, no. 105. The fourth armchair was sold at auction at Sotheby's, New York, 25 April 1998, lot 339, and again, at Sotheby's, New York, 22 October 2005, lot. 78.
4. "Une sultanne de 9 pieds de long à deux dossier, le devant bombé, la cinture orné d'une frisse de lierre, d'une tore de mirtre et feuilles d'eaux, les pieds orné d'un chapiteaux ionique et de 16 calenure avec graines et d'un culot au bas, les montant de devant composé d'une cariatides en guaines sur un pieds d'estal, la guaine orné d'une perle et branche de mirte entrelassé et d'un tirce au milieu, le derriere à collonne isolé orné du chapiteaux dorique taillies d'ove et rosette calené au deux tierre avec feuille d'acante entique et d'une basse composé, les traversse des dossier orné d'une frisse à soleil et fleurond et feuille d'aux au bas pour encadrement au desus une

atique orné de guirlande de rose, avec gaudron et perle au desus, le tout fait avec soins et preparé en bois de noyer, pour ce . . . 700 [livres]."; Archives Nationales, Paris, O¹ 3646, semester 1, 1788, 3 May, no. 157; quoted in Verlet 1994, p. 244.
5. Pallot 1987, pp. 40, 42.
6. The document Archives Nationales, Paris, O¹ 3290, fols. 131r–132v, Order of 3 May 1788, no. 157, refers to this set as made by Sené, "le tout en bois pour être sculpté"; Verlet 1994, p. 247.
7. "la dorure d'or bruni et rechampie en blanc"; Archives Nationales, Paris, O¹ 3646, semester 2, 1788, 3 May, no. 157; quoted in Verlet 1994, p. 245. For information about Chatard, see Boudry 2004.
8. "bazin des Indes de fond blanc, brodé au passé à petite bouquets détachés encadré de bordures de 2, 3, 4 et 9 pouces: le tout en soie nuée"; Archives Nationales, Paris, O¹ 3428, p. 156; 1789 inventory of Saint-Cloud.
9. "St Cloud, Cabinet particulier: un meuble de bazin brodé par la reine, composée de 4 rideaux de croisé, 1 sultanne, 4 fauteuils, 1 bergere et 1 tabouret, 1 écran"; Archives Nationales, Paris, O¹ 3544, Garde-Meuble, summary of accounts for furniture produced from 1784 to 1790, p. 385 (1788). See Standen 1966, p. 23.
10. The *bergère* with its original upholstery is illustrated in Guérinet n.d. (ca. 1910), pl. 89.
11. Accession number. 41.205.3c. This panel was mounted on the back of the fire screen when it entered the Museum's collection in 1941, although the queen's cipher indicates that it was originally the front panel. The front had been reupholstered. In 1991 an exact copy of the fire screen was sold at auction with an

embroidered front panel showing individual flowers; it may well have been the original back panel of this screen; see Christie's, London, 13 June 1991, lot 47.
12. The Metropolitan Museum is currently working on the re-creation of the embroidered covers.
13. Archives Nationales, Paris, N III (Seine-et-Oise) 188¹. It is illustrated in Meyer 1965, p. 229.
14. Supplied to the queen's Grand Cabinet Intérieur at Versailles in 1781, it was later transferred to Saint-Cloud; Kisluk-Grosheide 2005, pp. 79–82, figs. 28–32.
15. Humbert, Pantazzi, and Ziegler 1994, pp. 127–28, no. 52 (entry by Jean-Marcel Humbert). In her Cabinet Intérieur at Saint-Cloud, for instance, there was a table, now at the Louvre, mounted with gilt-bronze sphinxes and supported on caryatid legs. It is described in the 1789 inventory as a "figure de femme terme ou cariatide, drapée dans le style Egyptien"; Archives Nationales, Paris, O¹ 3428, p. 168.
16. First on 2 June, held for 1,000,000 francs and then withdrawn; second on 17 June, sold to an unknown buyer for 135,000 francs. "Trois meubles qui ont probablement appartenu à Marie-Antoinette" 1924.
17. Sold from the marquis de Casaux collection, Hôtel Drouot, Paris, 21 December 1923, lots A–C. The illustrations in the sale catalogue show the three pieces with the original embroidered show covers largely intact.
18. Rubinstein-Bloch 1926–30, vol. 6, pls. XXXVII, XXXVIII. The pieces were given after Blumenthal's death in 1941 to the Museum by his second wife, Ann Payne Blumenthal.

89.

Secretary on stand (*secrétaire à abattant* or *secrétaire en cabinet*)

French (Paris), ca. 1790
Adam Weisweiler (1744–1820)
Oak veneered with ebony, amaranth, holly, ebonized holly, satinwood, and Japanese and French lacquer panels; gilt-bronze mounts; brocatelle marble top not original to the secretary; steel springs; lined with modern morocco leather
H. 52⅜ in. (133 cm), w. 34 in. (86.1 cm), d. 16½ in. (41.9 cm)
Stamped on the back above the right-hand rear leg: "A. WEISWEILER." Painted underneath the stand: "151B."
Gift of Mr. and Mrs. Charles Wrightsman, 1977
1977.1.13

"Daguerre is [fleecing] the K[ing] of Naples at a shameful rate. I saw yesterday a secretaire (price 19000 livres) of most hideous taste, with a tremendous deal of bronze ornament wretchedly executed," wrote the well-known collector William Beckford (1760–1844) from Paris to his cousin Sir William Hamilton (1730–1803), the English envoy in Naples, on 27 February 1792. This not

very flattering remark pertained to one of a pair of secretaries, which are both now in the Museum's collection together with a matching *commode à vantaux* (fig. 122). These pieces and a rolltop desk (fig. 123) were bought by Ferdinand IV, king of Naples (1751–1825), for his study at Caserta.[1]

The history of this furniture began two years earlier, when Ferdinand and many other members of the royalty and nobility of Europe were gathered in Frankfurt to attend the coronation of Leopold II (1747–1792) as the Holy Roman Emperor. Married to the newly crowned sovereign's sister Maria Carolina (1752–1814), Ferdinand was the brother-in-law of both Leopold and Marie Antoinette (1755–1793).

Hoping to profit from this important event by selling works of art they had brought with them and to secure other commissions, the Parisian *marchands-merciers* Dominique Daguerre (d. 1796) and Martin-

Eloi Lignereux (1750–1809), Daguerre's business partner since 1789, also went to Frankfurt. A bill of 20 September 1790 indicates that they achieved their goal by selling an impressive list of luxury goods to the court of Naples. This included a "very beautiful commode with Chinese lacquer, richly adorned with figures and other chiseled bronzes, gilded with real gold but not burnished, with a top of brocatelle marble" and a secretary with similar mounts en suite.[2] Two years later a matching rolltop lacquer desk, now in a private collection, and a second secretary also bought from Daguerre and Lignereux joined the set. They were acquired for the king's study in the royal palace at Caserta.[3] The second secretary was described in detail in the bill of 21 March 1792: "a cabinet in the form of a secretaire, also with the most beautiful Chinese varnish, and veneered in ebony, with feet like fluted columns in bronze and

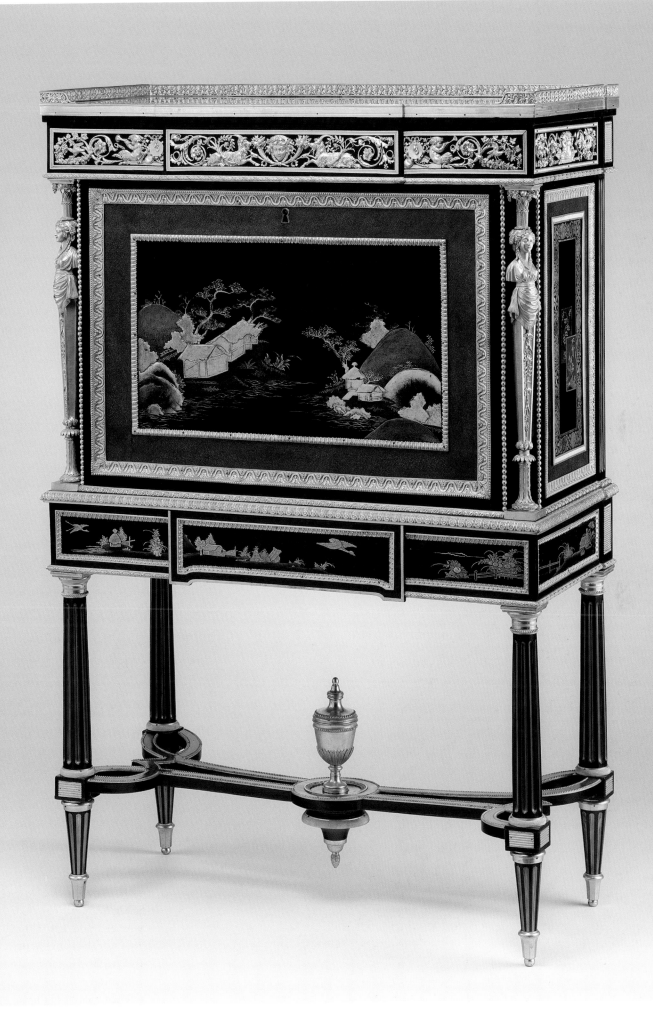

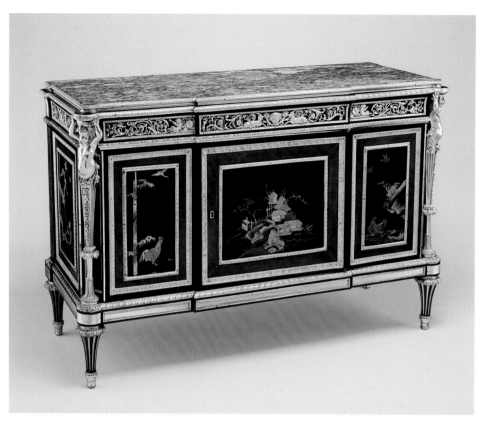

Fig. 122. Commode by Adam Weisweiler, ca. 1790. Oak veneered with ebony and mahogany and with panels of Japanese and French lacquer; gilt-bronze mounts; marble top; 38⅜ x 58⅝ x 22¼ in. The Metropolitan Museum of Art, New York, Gift of Mr. and Mrs. Charles Wrightsman, 1977 (1977.1.12).

Daguerre probably submitted designs to Weisweiler and provided him with the lacquer panels and the exquisite gilt-bronze mounts called for in the designs.

Weisweiler made a number of secretaries on stand, often with slender fluted legs connected by interlaced stretchers of an intricate design and supported on short *toupie* (peg-top) feet. Despite the fact that they were called "Chinese" in Daguerre's and Lignereux's accounts, the exteriors of both of the Museum's secretaries are decorated with a combination of Japanese and French lacquer panels.[7] The vertical side panels, embellished with rectangular, cardlike ornaments with borders of *mon* symbols and scrollwork incorporating some mother-of-pearl, are Japanese and can be dated to 1630–50.[CD] The large panel mounted on each fall front was decorated in France.[8] The surrounding borders—metal painted in imitation of speckled aventurine lacquer—are also European.

Most beautiful are the decorative mounts that are such an important aspect of Weisweiler's work. The frieze, consisting of

the legs . . . worked above the feet; this piece is embellished with friezes, entablatures, panels, and other ornaments in chiseled and gilded bronze without burnishing; the interior is inlaid with yellow wood, with small shelves for writing fitted about an inch apart so that their position can be changed at will; the fall front is covered with green morocco leather, edged with a border of gilt galloon. This piece of furniture makes a symmetrical pair with the secretaire that H. M. bought in Frankfurt."[4] Alabaster tops were ordered from Rome for the pieces, which, with the exception of the commode, were delivered without marble slabs.[5]

Although the name of the cabinetmaker is not mentioned in the bills, a stamp on this secretary identifies it as the work of Adam Weisweiler. One of a number of eighteenth-century cabinetmakers born in the Rhineland but established in France, Weisweiler had a long and successful career in Paris.[6] He worked almost exclusively for *marchands-merciers*, most notably Daguerre, who supplied his light and elegant furniture, decorated with lacquer, porcelain, *pietre dure*, or beautifully figured veneer, rather than with marquetry, to the French and foreign courts.

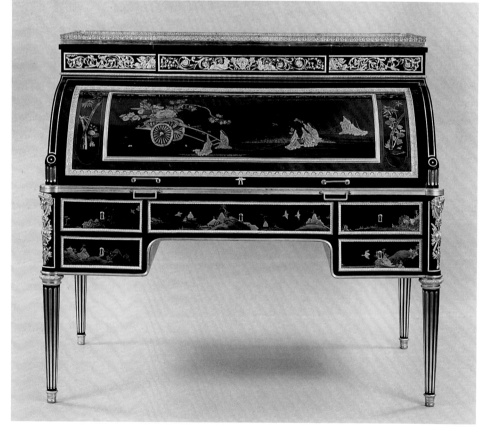

Fig. 123. Rolltop desk by Adam Weisweiler, 1792. Oak veneered with ebony, mahogany, and satinwood and with panels of Japanese and French lacquer; gilt-bronze mounts; marble top; 53½ x 59 x 23⅝ in. Private collection. Since the back as well as the front and sides of the desk are veneered with lacquer panels, it was intended to be freestanding.

separate panels of an almost jewel-like quality, is invisibly mounted by means of lugs fastened either on top of the three drawer fronts or from behind. Much of this ornament, such as the central mask flanked by cornucopias, goats, scrolling foliage, and trumpeting fauns, is typical of Weisweiler's furniture. The same is true of the female term figures carrying a basket of flowers placed in a recess at the front corners.[CD] Because of their perfection, these wonderful mounts have traditionally been attributed to the gifted bronze worker and gilder Pierre Gouthière (1732–1813/14), who often worked for Daguerre.[9] François Rémond (1747–1812), however, may also have been involved, since he is known to have gilded, and sometimes cast and finished, similar mounts for Daguerre, who most likely owned the models.[10]

In contrast to the lustrous and dark exterior, the interior, fitted with a shelf, pigeonholes, and narrow drawers, is much lighter in color, being veneered with satinwood.[CD] The drawer fronts have, in addition, amaranth borders and small fillets of holly and ebonized holly as well.[11] There is a set of steel springs, connected to struts, that counterbalance the weight of the fall front; the mechanism is repeated in other examples of Weisweiler's work.[12] An inscription on these springs announces that they were made in the German town of Solingen, well known for the production of weapons and steel tools. The drawers of the frieze, fitted with spring catches at the back, are released by pressing buttons in the interior, underneath the top. The drawer in the stand can be opened in a similar manner by pressing a button underneath, making a lock and keyhole unnecessary.[13] A steel rod, partially threaded, keeps the slender legs in place and gives them additional strength and stability. This practical feature allows the feet and legs to be removed and the stretcher to be detached, making it possible to move the secretary in a disassembled state, decreasing the risk of damaging its delicate legs. Given

the history of the piece, this must have proved truly useful.

In 1792 the architect Carlo Vanvitelli (1739–1821) changed the decor of King Ferdinand's study at Caserta from the Rococo to the more fashionable Neoclassical style. It seems, in fact, that its new color scheme was inspired by the purchase of Weisweiler's commode and secretary two years earlier. The British architect Sir Robert Smirke (1781–1867), who visited Caserta early in the nineteenth century, gave the following account of the redecorated room: "A small Cabinet for the King is handsomely finished with deep green[,] painted in panels bordered with black—next [to] this is a small gilt moulding and beyond a broad stripe painted in imitation of venturino. . . . The Base and Surbase is of red porphyry."[14]

The room has kept its late-eighteenth-century decor until today. The furniture, however, was removed in 1806, when the royal couple fled to Sicily after Napoleon's forces had occupied Naples.[15] With the Restoration of 1815, the furnishings were returned to Caserta, where they probably stayed until the unification of Italy in 1860, when the Kingdom of Naples was abolished. It is not known when these superb French pieces were sold and replaced with the poor copies that are still in the room. In 1920 Charles Terrasse described the secretaries, the commode, and the rolltop desk in detail in a catalogue that was probably published as a form of advertisement when the pieces were in the possession of a Parisian dealer.[16] Having been in a private collection in Argentina, the secretaries and commode were back in Paris in 1950, where Mr. and Mrs. Charles Wrightsman acquired them.[17]

DK-G

1. The author is indebted to Alvar González-Palacios for his recent research on all four pieces. Much of it was published in González-Palacios 2003. William Beckford's letter is quoted on p. 434 of his article. The accession number of the second secretary is 1977.1.14.

2. "Una bellissima comoda con vernice della Cina,

riccamente adornata con figure, ed altri bronzi intagliati, ed indorati in oro, senza essere imbruniti, colla coperta di Marmo broccatello. Un Segretario con suoi fornimenti sudetti bronzi." Quoted in González-Palacios 2003, p. 442, doc. no. 1.

3. Ibid.

4. "Un'altro mobile componendo armario a guisa di Segretario, anche di belliss.ma vernice della Cina, ed impiallicciato in legno di Ebano, con piedi fatti a colonne scannellati in rame, i fra mezzi delle gambe tagliuzzati ne' piedi, il detto mobile adornato di freggi, cornici, quadri, ed altri ornamenti in bronzo molto bene intagliati, ed indorati, senza imbrunitura, l'interno foderato di legno giallo, con tavolini per scrivere con incastratura ad un dito pollice di distanza l'uno dall'altro, per cangiare li detti tavolini a piacere, il pezzo che casca giù coperto di marocchino verde, con merletto in oro. Questo mobile serve a far semetria con un Segretario, che S.M. comprò a Francfort." Quoted in ibid., pp. 434-35, 442, doc. no. 2.

5. Ibid., pp. 439-40.

6. For information about Weisweiler's life and work, see Lemonnier 1983; De Bellaigue 1974, vol. 2, pp. 883-84; and Pradère 1989, pp. 389-403.

7. Some of these panels have been replaced or put back differently since the pieces were published in 1920. Compare the photographs in Terrasse 1920, between pp. 14-15 and 18-19.

8. According to Oliver Impey (notes in the archives of the Department of European Sculpture and Decorative Arts, Metropolitan Museum), the decoration of the fall front on both secretaries is all European but possibly on Japanese black lacquer panels. The lacquered decoration on the front and sides of the present stand is entirely European, while that on its pair is Japanese with European additions. The fact that the two secretaries were made at different times may explain some of the differences in their construction.

9. See, for instance, Terrasse 1920, p. 6; Watson 1966a, pp. 134-37, no. 88; and Watson 1966b, pp. 568-69.

10. Rémond is known to have gilded similar bronzes for Daguerre to be mounted on furniture by Weisweiler; Baulez 1995, pp. 84-85. See also Verlet 1999, p. 320.

11. The interior of the other secretary has been reworked. It is fitted with two movable shelves for papers, not unlike those described in the bill of 1792, that rest on horizontal slots of satinwood.

12. A related secretary by Weisweiler in the collection of the Rijksmuseum, Amsterdam, used to have similar springs, for instance. Only the attachment pieces of those springs, inscribed "Fait a Solingen," are still in place. I am grateful to Mechthild Baumeister, Conservator, Department of Objects Conservation, Metropolitan Museum, for this information.

13. Again, I thank Mechthild Baumeister for this information.

14. Quoted in González-Palacios 2003, p. 435.

15. In an inventory of 1800 the furniture was described as being damaged; ibid.

16. Terrasse 1920.

17. Watson 1966a, p. 134, no. 88.

90.

Side chair

Italian (Sicily), ca. 1790–1800
Carved, gilded, and painted walnut; reverse-
painted glass (verre églomisé); covered with
cut and voided seventeenth-century silk velvet
probably not original to the side chair
H. 38⅝ in. (98.1 cm); w. 21⅝ in. (54.9 cm);
d. 20 in. (50.8 cm)
In the center of the top of the back, in gilded
wood: "PPL"
Gift of John P. Richardson, 1992
1992.173.2

The gilded moldings and carved decoration on this chair and a matching settee (fig. 124) frame reverse-painted glass panels, which imitate in different colors the hardstones agate, marble, and lapis lazuli. Close inspection reveals the high quality and intriguingly delicate structure of the paint and the fragility of the panels, which is not evident at first glance. That the chair and settee have survived in such good condition is testimony to the technical skills of the maker, who provided a sound base for the heavy glass strips, preventing them from peeling away over time. Nevertheless, these are display pieces that were clearly not intended for regular use. The smallest body movement of a user or any attempt to shift or lift the heavy objects puts divergent forces and pressure on their ostentatious "skin."

The Museum's chair and settee are part of a large suite that originally consisted of at least four settees and twenty side chairs.[1] Early in the twentieth century the set was in the collection of the earl of Derby, at Derby House, London, from where it was sold in 1940 to Mrs. Violet van der Elst, also of London. The pieces were dispersed in 1948.[2] At that time, all items of the suite were covered with the bold red and gold baroque-cut velvet that still decorates the Museum's pieces. For many years it was assumed that the initials "PPL" displayed in a medallion on the backs referred to the Villa Palagonia in Bagheria, near Palermo, and, more specifically, to a member of the illustrious Gravina family as a patron;[3] however, as James David Draper pointed out, although "the peculiarly Sicilian penchant for fashioning an overall look out of glass was most memorably given free rein at

the Villa Palagonia, . . . the initials 'PPL' . . . do not correspond with those of any prince of Palagonia and in truth the pieces have a much more pronounced neo-classical severity than the Villa Palagonia ballroom."[4]

John Richardson, the donor of the Museum's pieces, which he had acquired on the London art market, kept them at one point in the Château de Castille in Provence, the home of the Cubist scholar Douglas Cooper,[5] who himself owned at least three chairs from the set.[6] For the moment, the original location of the suite remains a mystery, although the preciousness and labor-intensive nature of the work narrows the source of the commission to one of the great, prosperous, aristocratic families of Sicily.

The back of the settee is tripartite; the medallion with initials appears at the top of the center section, but in the same place on the side sections there is a military trophy in the form of a helmet superimposed on a saber.[CD] There is a gilded openwork frieze of overlapping ellipses along the top of the back of both the chair and the settee; this appears also along the bottom of the back of the settee but not on the Museum's chair. These ellipses, rather freely adapted from ancient vase paintings, reflect the so-called Etruscan

fashion of the last third of the eighteenth century.[7] A very similar pair of chairs, each, however, with an octagonal *verre églomisé* panel set into the back in place of upholstery, is part of the collection of Juan March Ordinas at Palau March in Palma de Mallorca.[8] That those panels show a mythological chariot in the manner of an ancient vase painting is also very much in the "Etruscan" style. The incorporation of glass panels in the center of the backs makes the March chairs even more fragile than the Derby House suite.[9]

Other pieces from this suite are preserved in the Art Institute of Chicago (two chairs),[10] the Ringling Museum of Art, Sarasota, Florida (two settees and two chairs),[11] and the Museum für Kunsthandwerk, Frankfurt am Main (one chair),[12] as well as in various private collections. Some of them have been re-covered in shell pink or blue gray fabric with the intention of intensifying the effect of the same shades painted on the glass.

W K

1. Catalogue of a sale at Christie, Manson, and Woods, London, 26 July 1940, lot 41 (sold to Mrs. Violet van der Elst).
2. Catalogue of the Violet van der Elst collection sale, Christie, Manson, and Woods, London, 8 April 1948, lot 114 (ill.).

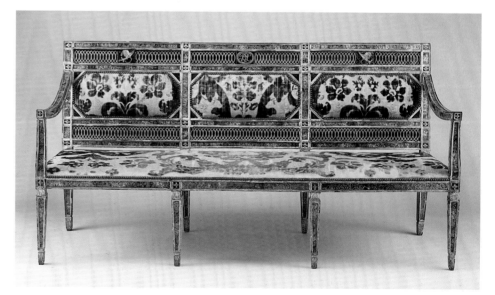

Fig. 124. Settee, Italian (Sicily), ca. 1790–1800. Carved, gilded, and painted walnut; reverse-painted glass (*verre églomisé*); covered in cut and voided seventeenth-century silk velvet probably not original to the settee; 38¾ x 78⅜ x 26 in. The Metropolitan Museum of Art, New York, Gift of John P. Richardson, 1992 (1992.173.1).

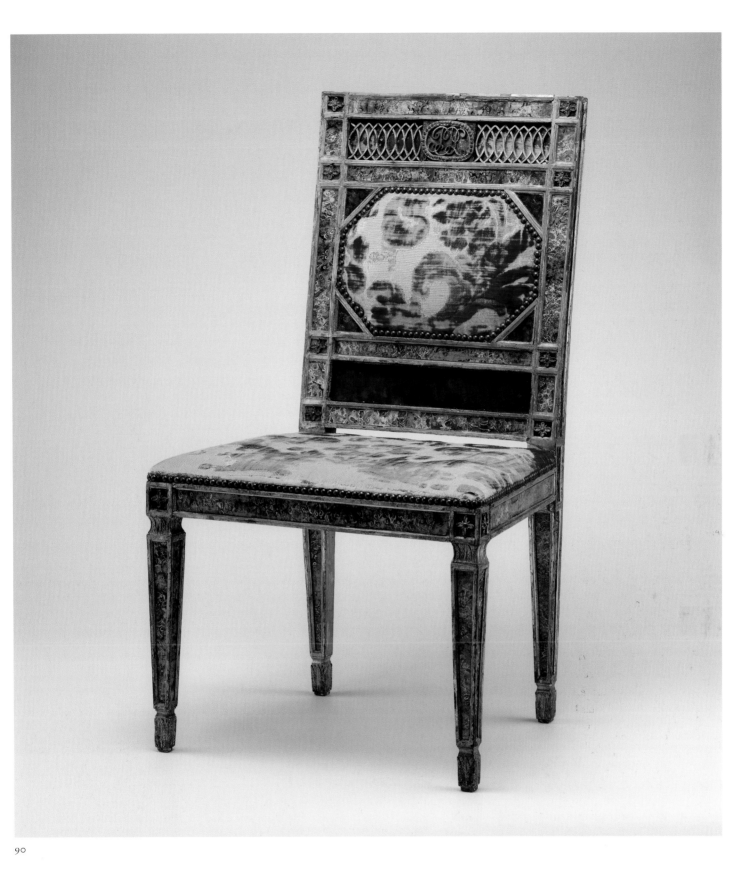

90

3. Wardwell 1967, p. 520.

4. Draper 1994, p. 23. On the Villa Palagonia and its glass decorations and furniture, see González-Palacios 1971. González-Palacios quotes (p. 456) an English visitor to the villa in 1770, Patrick Brydone, who called it an "enchanted castle," in which some of the ceilings "instead of plaster or stucco, are composed entirely of large mirrors, nicely joined together. The effect that these produce (as each of them make a small angle with the other), is exactly that of a multiplying glass, so that when three or four people are walking below, there is always the appearance of three or four hundred walking above." Goethe, who visited the villa in 1787, described it as "the Palagonian madhouse." See also González-Palacios 1984, vol. 1, p. 385, vol. 2, p. 275, fig. 629; and Giarrizzo and Rotolo 1992, p. 124, pl. 78.

5. Mentioned to me by Walter E. Stait, in 1993.

6. Richardson 1984, pp. 56–57.

7. Morley 1999, pp. 202–8, pl. 386.

8. Junquera y Mato 1992, p. 269.

9. Unfortunately, I have not had the opportunity to examine the chairs in question and have no idea what their state of preservation is. The Derby House set was copied in the early twentieth century; see catalogue of a sale at Christie's, London, 27 May 1993, lot 181.

10. Wardwell 1967, p. 520.

11. Duval 1981, p. 157, no. 153.

12. Bauer, Märker, and Ohm 1976, pp. 112, 145–46, no. 201; see also catalogue of a sale at Sotheby's, New York, 28 April 1990, lots 175–77 (three pairs of side chairs).

Athénienne

French (Paris), ca. 1800–1814
Design attributed to Charles Percier
(1764–1838); made by the firm of Martin-
Guillaume Biennais (1764–1843; retired 1819)
Legs, base, and shelf of yew wood; gilt-bronze
mounts; iron plate beneath the shelf
H. 36⅜ in. (92.4 cm), d. 19½ in. (49.5 cm)
Bequest of James Alexander Scrymser, 1918
26.256.1

The form of this elegant washstand ultimately derives from the ancient Greco-Roman three-legged perfume burner or brazier, of which the designer Charles Percier had made some study. The decoration reflects his familiarity with the wall decorations in the emperor Nero's Golden House and their adaptation in Raphael's Logge in the Vatican. A reappreciation during the Renaissance of the tripod as a luxury item of the utmost refinement is documented as early as 1499 by an example illustrated in Francesco Colonna's *Hypnerotomachia Poliphili*, published in Venice that year.[1] A further not-to-be-underestimated influence on Percier was Neoclassical paintings illustrating ancient Greek mythology, such as *The Loves of Paris and Helen*, commissioned from Jacques-Louis David (1748–1825) by the comte d'Artois in 1788.[2] The designer was also familiar with the richly illustrated seven-volume *Recueil d'antiquités* (1752–67) by the comte de Caylus (1692–1765),[3] and the *Recueil et parallèle des édifices* by Jean-Nicolas-Louis Durand (1760–1834), published between 1799 and 1801 in Paris, in which plate 25 was devoted to tripod forms, among other types of Roman objects.[4]

The shape of the base and of the shelf—triangular with canted sides—can be traced back to a famous antique Roman tripod named after the French antiquarian Nicolas-Claude Fabri de Peiresc (1580–1637).[5] Percier was probably also acquainted with the athénienne designed about 1773 by Jean-Henri Eberts (no. 69 in this book), which has the same type of base.

The long-accepted attribution of the design of this athénienne to Charles Percier, the imaginative friend of Pierre-François-Léonard Fontaine (1762–1853), who in partnership with Fontaine dominated inte-

rior design in France during the Empire period, is based on its close similarity to a large colored drawing ascribed to Percier now in the Musée des Arts Décoratifs in Paris (fig. 125).[6] The maker of the Museum's piece, Martin-Guillaume Biennais, was perhaps the most accomplished goldsmith and entrepreneur of his time in France (see also the entry for no. 92). He owed his economic success to the dissolution of the mighty Parisian guilds, the *grandes corporations*, which had controlled the activity of all craftsmen and artisans during the ancien régime. Like other skillful young goldsmiths he found himself free after the Revolution to explore business opportunities without corporate obstacles and turned his back on the outdated privileges and jealousies of the habitually conservative former guild masters. One of seven children, Biennais was born into a simple laboring family in 1764. Four decades later, he headed the most important goldsmith's and jeweler's firm in

continental Europe. His inventive traveling sets and ostentatious tableware found favor not only with the emperor and his entourage but also with the swarm of nouveaux riches and self-made men who flourished in prosperous post-Revolutionary France.[7] Biennais's products were smartly promoted on his business card of 1806. It shows at the left in an architectural niche a fashionable tripod, most likely a perfume burner or brazier, crowned by a swan with spread wings.[8]

There is an iron plate on the underside of the triangular shelf between the legs of the Museum's example. This served as an attachment for a lost, hanging bell-shaped ornament decorated with a stylized acanthus-and-acorn motif. How the bell hung down over the stand can be seen in another version of this model in Fontainebleau.[9] The unusually formed, bold ormolu mount would have shifted the eye slightly toward the gilt-metal parts below, creating a better balance between the warm-colored wood and gilded bronze

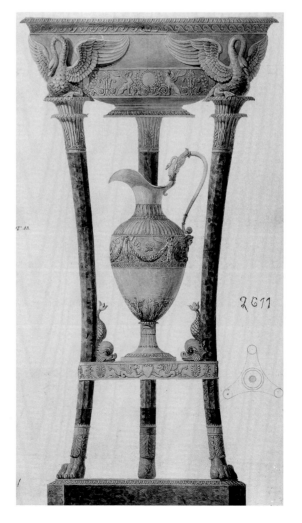

Fig. 125. Design for an athéniénne, attributed to Charles Percier. Graphite and wash drawing. Museé des Arts Décoratifs, Cabinet des Arts Graphiques, Paris (10424).

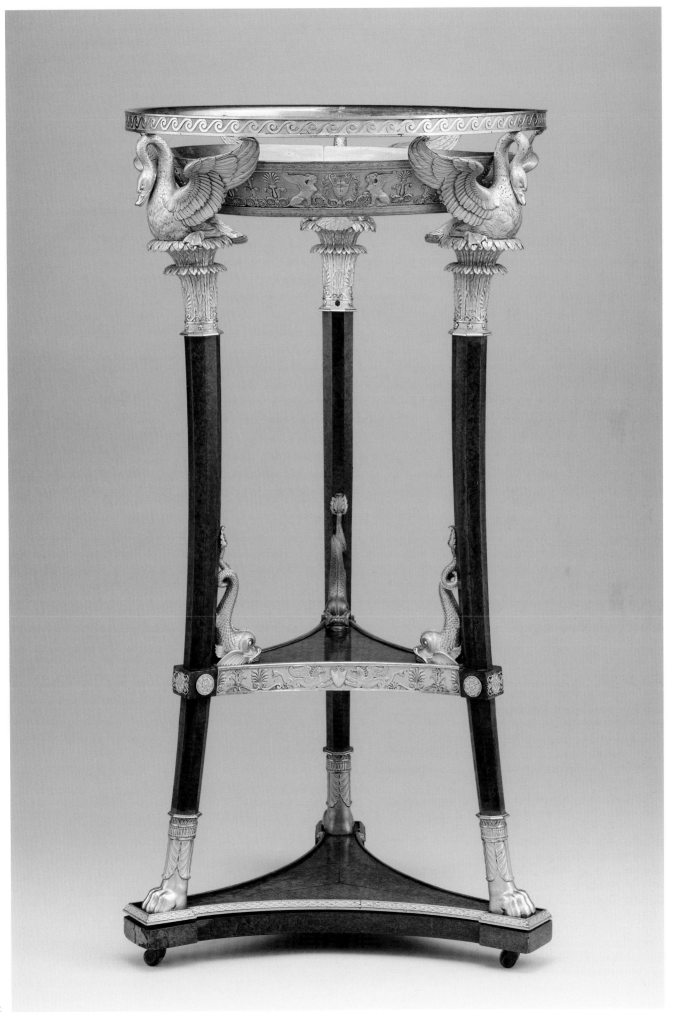

mounts and the sparkling, moonlight-cold look of the silver basin and ewer (both missing from the Museum's piece). Several simpler washstands are recorded in inventories of Napoleon's palaces.[10]

Percier's athénienne is known in three versions: the above-mentioned example at Fontainebleau, which has a probably not original dark, patinated metal basin (the ewer is lost); the present piece; and the famous personal washstand of Napoleon, today at the Musée du Louvre, Paris.[11] Napoleon kept it in his bedroom at the Palais des Tuileries, where he settled early in 1800, the year in which he commissioned the stand. It was one of the few personal luxury items that accompanied the emperor into exile at Saint Helena.

Like Napoleon's washstand, this example is decorated with masterfully executed dolphins and swans, both graceful allusions to Napoleon as the rightful successor of the Sun King, Louis XIV. The firstborn son of each French ruler was called the "Dauphin," a word that also means dolphin. That jolly sea-dweller and also the winged sea creatures on the frieze around the triangular shelf suggest the Mediterranean, which forms the southern border of France and surrounds the island of Corsica, the birthplace of Napoleon.[12] CD The swan, which was believed to utter a beautiful song at the time of its death, was associated with Apollo, god of music, with whom Louis XIV identified himself. The swan is also a symbol of beauty and of parental solicitude. At the approach of danger, with feathers puffed up and anxiously hissing, these birds protect their young within the wall of their white wings. Napoleon's consort, Josephine, and her children were frequently compared to a swan and its cygnets.[13] The swan was chosen as her symbol by Claude, wife of Francis I, the French Renaissance king whom Napoleon greatly admired.

The Museum's athénienne was certainly made for a close friend or relative of the emperor. It is a superior example of the new Empire style, through which Napoleon, with the aid of leading artisans, tried to emulate the lavish decors of the ancien régime, modified by the classical restraint and formality of the art of the caesars of ancient Rome. Empire furniture of such superbly calculated plan and proportions may express better than anything else the confidence, fresh ideas, and energy of the age.

WK

1. P. Thornton 1991, p. 212, pl. 240.
2. *Jacques-Louis David* 1989, pp. 184–88, no. 79; and Dion-Tenenbaum 2003, p. 20, fig. 9.
3. Paolini, Ponte, and Selvafolta 1990, p. 30.
4. Morley 1999, p. 17, fig. 10 (dated 1802); and *D'après l'antique* 2000, p. 345, no. 159 (entry by Anne Dion-Tenenbaum).
5. For the Peirese tripod, see Morley 1999, p. 25, fig. 27.
6. Dion-Tenenbaum 2003, pp. 19–20, no. 2; in this excellent study Dion-Tenenbaum discusses the evolution of the tripod form in great detail.
7. Ibid., pp. 11–17.
8. Ibid., p. 14, fig. 3.
9. The third known version of this model, in the Musée du Louvre, Paris, has an identical iron plate, but the pendent bell ornament has been lost. On this washstand, see below at n. 11. For the second version, at Fontainebleau, see Dion-Tenenbaum 2003, pp. 23–24, no. 4.
10. For example, "une athénienne dorée beau bois d'acajou, pot et jatte dorés" (a gilded athénienne of mahogany, the ewer and bowl gilded) and another with gilded ewer and bowl decorated with palmettes; Archives Nationales, Paris, O^2 55.
11. For Napoleon's washstand, see R., G., and C. Ledoux-Lebard 1953, p. 200, no. 872; *D'après l'antique* 2000, pp. 346–47, no. 160 (entry by Anne Dion-Tenenbaum); Dion-Tenenbaum 2003, pp. 21–22, no. 3; Feigenbaum 2003, p. 71, no. 47 (entry by David O'Brien); and Pastré 2003, p. 2109, fig. 4.
12. A Greek mosaic found on the island of Delos is decorated with dolphins and the same wavelike Vitruvian scroll ornament that encircles the upper ring of the basin holder of the Museum's washstand. For the mosaic, see Arizzoli-Clémental 1994, p. 62.
13. Draper 1978, p. [4]. On the symbolism of swans, see Hall 1979, p. 294.

92.

Medal cabinet

French (Paris), ca. 1809–19
Designed and drawn by Charles Percier (1764–1838), probably following instructions from Baron Dominique-Vivant Denon (1747–1825); made by François-Honoré-Georges Jacob-Desmalter (1770–1841); silver decorations by the firm of Martin-Guillaume Biennais (1764–1843; retired 1819)
Mahogany; applied and inlaid silver
H. 35 ½ in. (90.2 cm), w. 19 ¾ in. (50.2 cm), d. 14 ¾ in. (37.5 cm)
Engraved above each keyhole: "Biennais." Marked on one wing of each winged disk: the letter B surmounted by a crouching monkey, pellet on each side, within a lozenge [the maker's mark]; a rooster and the number 1 in an octagon [the Paris assay mark for first-standard silver, 1809–19]; a helmeted head in a circle [the Paris medium excise mark for silver, 1809–19]. Marked on the other wing of each winged disk: a classical head and the letter P in an oval [the standard mark, 1793–94]
Bequest of Collis P. Huntington, 1900
26.168.77

The design, medium, and execution of this extravagant medal cabinet are as impressive and eccentric as the man who probably commissioned it, Napoleon, Emperor of the French (1769–1821), who at the time of its making was a step away from abdication and exile.[1] The first significant contemporary reference to it has been published by Antony Griffiths: "The most interesting record, however, is an account submitted in February 1814 by [the goldsmith] Biennais for 3600 francs, for what is described as the 'médailler du Roi.'" In Biennais's account, Griffiths continues, this medal cabinet for the king is described as "in the form of an Egyptian pedestal, containing 44 mahogany drawers with silver mounts, and meant to serve as a stand for the emperor's old medal cabinet."[2]

Napoleon was interested in medals. While campaigning in Egypt in the 1790s, he found a medal of the Roman general Julius Caesar, and in 1803 when he was considering an invasion of England, some coins of William the Conqueror were uncovered at Ambleteuse. Both discoveries were considered extremely propitious.[3] He developed the practice of distributing medals on state occasions to commemorate the high points of his career, and he also had special editions struck in precious metals and sent to foreign allies. The first fully documented owner of this cabinet, Napoleon's Director General of Museums, Baron Dominique-Vivant Denon, was no less an enthusiast. When his estate was sold after his death, three thousand contemporary medals alone were listed in the inventory.[4]

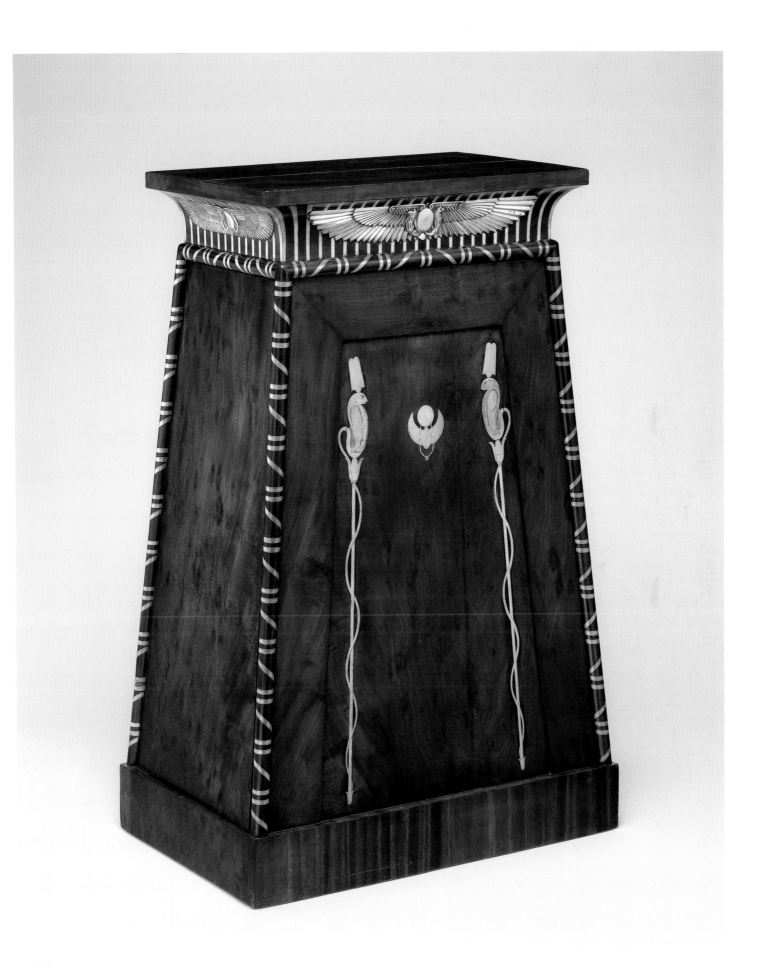

Fig. 126. Charles Percier, *Design for a Medal Cabinet*. Drawing. Musée des Arts Décoratifs, Cabinet des Arts Graphiques, Paris (CD 3240 [GF 9]).

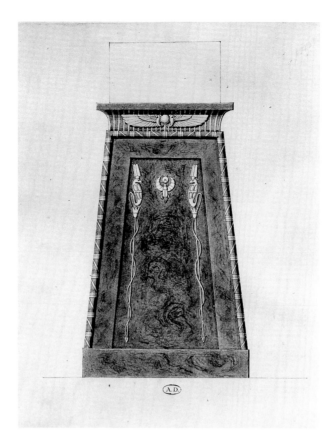

Denon had accompanied Napoleon on his Egyptian campaign in 1798–99 as a recording draftsman. The book he wrote based on his experiences and observations along the Nile, *Voyage dans la basse et la haute Égypte* (1802), brought ancient Egypt to life for his readers and whipped up to a frenzy the European craze known as Egyptomania. Napoleon later appointed Denon director of the Musée Napoléon (now the Musée du Louvre). He was also for a time in charge of the medals mint (Monnaie des Médailles) and designed the ceremonial necklace of the Legion of Honor, a special badge with a chain, made by the French firm of Biennais, which Napoleon gave to distinguished members of his immediate entourage.[5]

Denon may have instructed the designer Charles Percier regarding the details of this splendid cabinet (see Percier's design, fig. 126).[6] The pylon (gateway) at Apollonopolis Parva (now Ghoos) in Upper Egypt,

Fig. 127. General view of the medal cabinet. Several drawers have been opened by pulling the hinged wings of the silver scarablike insects inlaid in the front.

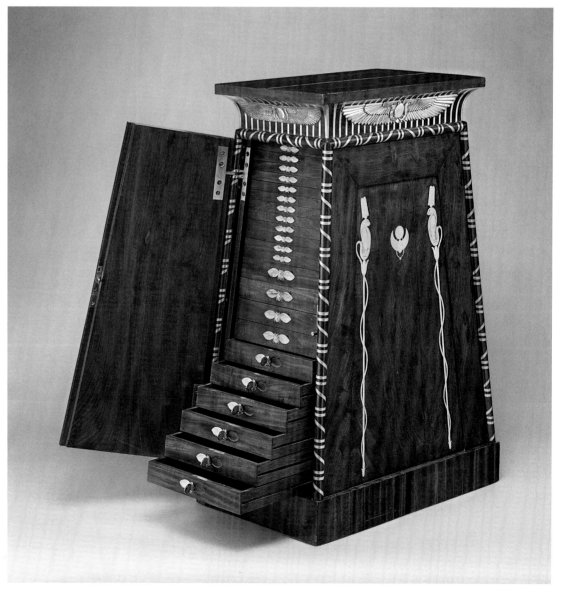

which Denon recorded in his book, served as the inspiration for the top section.[7] The piece was made by the Parisian firm of François-Honoré-Georges Jacob-Desmalter, who in 1807 employed as many as 350 specialist craftsmen. His furniture is characterized by superb quality, classical severity, and functional perfection. Whether or not the cabinet was commissioned by Napoleon, it would have appealed to him. The emperor once compared his own perfectly orderly mind to "a chest of drawers, which he could open or close at will, forgetting any subject when its drawer was closed, and finding it ready with all necessary detail when its drawer was opened."[8]

Like other grand furniture of the Empire period, the cabinet is decorated with applied and inlaid metal, but here the patron demanded something out of the ordinary: the fittings are of the finest silver (having a purity of 950/1,000) rather than the usual gilded bronze. The famous goldsmith's shop of Martin-Guillaume Biennais was selected to make them. Beneath the cornice at the top there are inlaid silver bands surmounted by an Egyptianizing winged disk and two *uraei*, the sacred cobra symbol of ancient Egyptian kings. Inlaid on the front and the back panel of the cabinet is a winged scarab between *uraei* astride lotus stalks. The eye of each *uraeus* is a catch; when a silver stick that accompanies the keys to the cabinet is inserted in the pupil, the body of the snake falls forward to reveal the keyhole that opens one of the two side doors.[CD] Then the function of the cabinet is revealed. Each cupboard contains twenty-two drawers of graduated size, formerly fitted to hold medals and coins (the number of each drawer is engraved on an octagonal silver plaque affixed to the top edge). In the center of each drawer front is inlaid a silver scarab-like insect, whose right wing is hinged to provide a pull (fig. 127). In addition to his maker's mark on one wing of each winged disk, Biennais had his name engraved above each keyhole so that no one opening the cupboards could miss it.[CD]

As Jean-Marcel Humbert has observed, "The originality and variety of its decoration make this piece an excellent illustration of the taste for things Egyptian at the beginning of the nineteenth century. At the same time, it is the very essence of Egyptomania: the adaptation of antique forms and decorations, in dimensions as well as materials, to a type of object and function completely different from those associated with these symbols in Antiquity."[9] WK

1. On the design, medium, and execution of the cabinet, see *Dominique-Vivant Denon* 1999, p. 425, no. 492 (entry by Anne Dion-Tenenbaum). For the silver marks, see Carré 1931, p. 202 (Paris mark for first-standard silver), p. 203 (Paris medium excise mark); Beuque and Frapsauce 1929, p. 281, no. 2493; and Nocq 1926–31, p. 195 (standard marks described, dated 1797). Other recent literature on the cabinet includes the following: *Napoléon* 1969, pp. 105–6, no. 289 (entry by Serge Grandjean); *Age of Neo-Classicism* 1972, no. 1609 (entry by William Rieder); Kjellberg 1978–80, vol. 2, p. 151, fig. 143; Koeppe 1993, p. 43; Arizzoli-Clémental 1994, p. 67; and Humbert, Pantazzi, and Ziegler 1994, pp. 206–8, no. 107 (entry by Jean-Marcel Humbert).

2. "en forme de piédestal égyptien, contenant 44 tiroirs en bois d'acajou avec ornemens incrustés en argent, et destiné à supporter l'ancien médaillier de l'Émpereur." Griffiths 1991, pp. 47–49, fig. 17.

3. Draper 1978, no. 14, fig. 5.

4. Dubois 1826, p. 191, no. 835; and *Dominique-Vivant Denon* 1999.

5. Dion-Tenenbaum 2003, pp. 102–4, no. 67.

6. On Percier as the designer of this cabinet, see Humbert, Pantazzi, and Ziegler 1994, pp. 206–8, no. 107 (entry by Jean-Marcel Humbert). For other aspects of his career, see the entry for no. 91.

7. Denon 1802 (1989–90 ed.), vol. 2, pl. LXXX, fig. 1; and Kjellberg 1978–80, vol. 2, p. 151, fig. 143.

8. Palmer 1963, p. 370.

9. Humbert, Pantazzi, and Ziegler 1994, pp. 206–8, no. 107 (entry by Jean-Marcel Humbert).

93.

Side chair

Austrian (Vienna), ca. 1815–20
Designed and made at Danhauser's K. K. Priv. Möbel-Fabrik, Vienna
Beech and pine veneered with cherry; ebonized mahogany framing strips; covered in silk not original to the chair
H. 37⅛ in. (94.3 cm); w. 22⅛ in. (56.2 cm); d. 19 in. (48.3 cm)
Purchase, Friends of European Sculpture and Decorative Arts Gifts, 1996
1996.417.1

The years between 1815 and 1848 in Germany and Austria were characterized by a conservative political and cultural climate. The period and its style of interior decoration are both called Biedermeier, after a fictional character invented by the poet Ludwig Eichrodt (1827–1892) in the 1850s. Although the term invokes qualities typical of the German bourgeoisie (unpretentiousness, thrift, domesticity), the origin of the Biedermeier furniture style was totally aristocratic. The simple, elegant forms with their clean lines and light-colored wood veneer derived from the ornamentally restrained furniture that had been made for the royal and princely households of Germany, Austria, and France beginning in the late eighteenth century.[1] For this market, even Parisian *ébénistes*, such as Canabas, Saunier, Jacob, and Molitor,[2] produced simple mahogany pieces that were set apart only by their excellent materials and outstanding craftsmanship.[3] Berlin, Munich, and Viennese cabinetmakers followed suit, creating similar, refined furniture.[4]

Contemporary watercolors document that Biedermeier interiors were characterized by the use of strong colors for paint, wallpaper, and fabrics.[5] Consequently, the upholstery specialist of the Metropolitan Museum's Objects Conservation Department was delighted but not surprised to discover some silk threads of a strong aquamarine color beneath the former show covers on the present chair and its pair, which is also in the Museum's collection.[6] An appropriate fabric was acquired and dyed to match these

remnants of the earliest upholstery. Seldom are curators and conservators given such a splendid opportunity to re-create the original appearance of a piece of furniture and to do it with the correct material, in this case, precious silk. The spring upholstery on the drop-on seats is original, as are large parts of the surface finish.[7] The quest for truly comfortable seating furniture characterized the Biedermeier period: in 1822 Georg Junigl obtained a patent in Vienna "for his improvement on contemporary methods of furniture upholstery which, by means of a special preparation of hemp and with the assistance of iron springs, he renders so elastic that it is not inferior to horsehair upholstery."[8]

The Museum's side chairs, originally part of a set of six, can be attributed to the firm of Josef Ulrich Danhauser (1780–1829), the leading furniture manufacturer in Vienna.[9] He had many royal patrons, including Archduke Karl von Sachsen Teschen (1771–1847) and Duke Albert von Sachsen Teschen (1738–1822). The Danhauser factory produced some items in large quantities, and these pieces established the firm's reputation throughout Central Europe and Northern Italy.[10] W K

1. Folnesics 1922; and Himmelheber 1989.

2. Joseph Gegenbach, called Canabas (1712–1797); Claude Charles Saunier (1735–1807); Georges Jacob (1739–1814); Bernard Molitor (d. 1833).

3. Reyniès 1987, vol. 1, pp. 42–45, 205; and Pfeil 1999, p. 235.

4. Ottomeyer 1987; and Stiegel 2003.

5. Gere 1989, pp. 188–93; Völker 1996, pp. 12, 69, figs. 6, 61; Arrizoli-Clémental 1994, p. 47.

6. "Recent Acquisitions" 1997, p. 50 (entry by Wolfram Koeppe).

7. Out of the set of six (see below), the Museum was allowed to choose the two chairs in the best state of preservation. They were examined and conserved by Mechthild Baumeister and Nancy C. Britton, Conservators, in the Museum's Sherman Fairchild Center for Objects Conservation in 1998. The accession number of the second chair is 1996.417.2.

8. Fleming and Honour 1989, p. 842. The technique had been in existence for some time, however; see Fabiankowitsch and Witt-Dörring 1996.

9. "Danhauser's K. K. Priv. Möbel Fabrik" translates as Danhauser's Privileged Imperial and Royal Furniture Manufactory. For similar chairs, see *Vienna in the Age of Schubert* 1979, p. 29, fig. 6, p. 41, fig. 15; Griffo 1984, p. 38; Himmelheber 1973, fig. 380; Wilkie 1987, p. 71, fig. 54, pp. 137–38, 148, fig. 138; Himmelheber 1989, pp. 112, 214, nos. 121, 122; Paolini, Ponte, and Selvafolta 1990, p. 210; and Wardropper and L. S. Roberts 1991, pp. 98, 137–38.

10. Himmelheber 1989; and Fabiankowitsch and Witt-Dörring 1996.

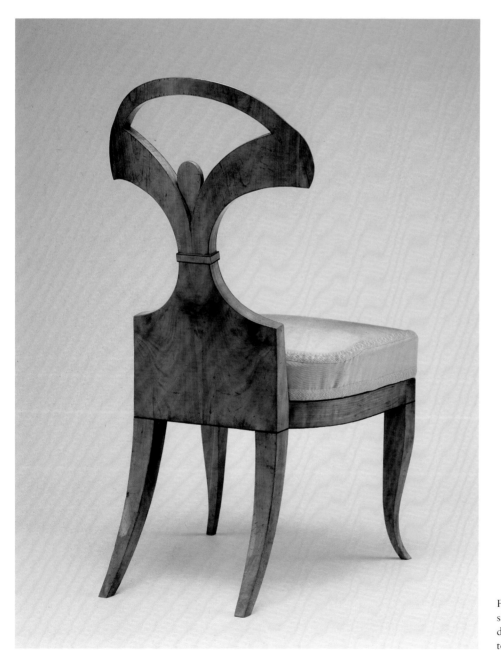

Fig. 128. This view of the side chair from behind shows not only the sculptural quality of the design but the way in which the chair back curves to support the human back with comfort.

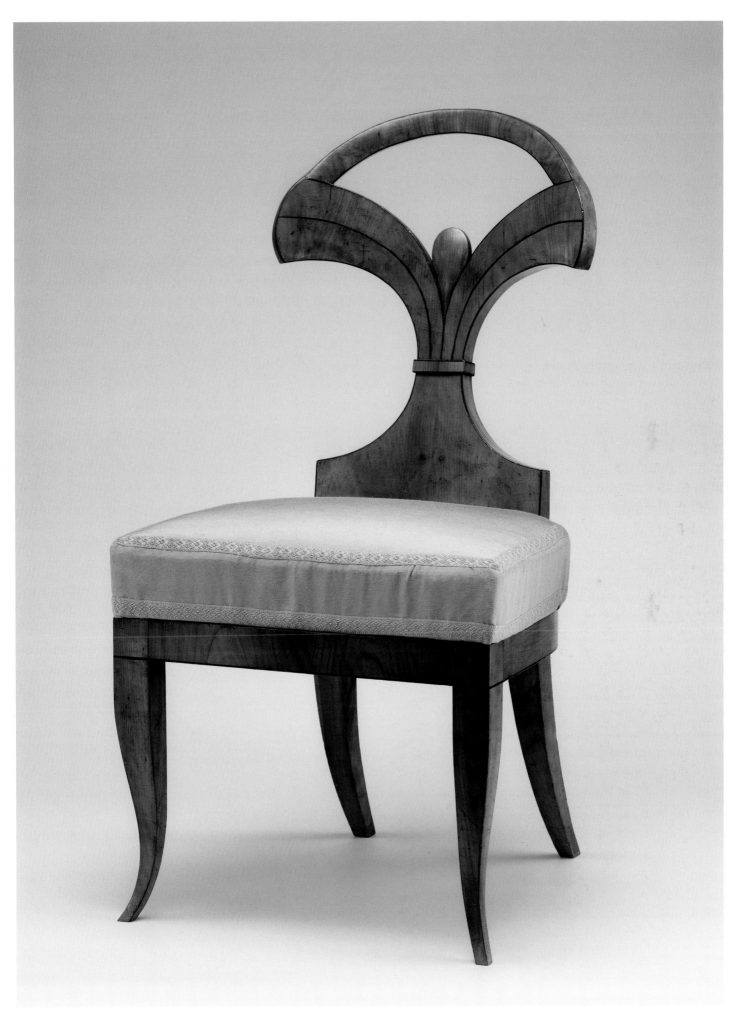

94.
Vase

Lapidary work Italian (Florence), the mounts
and pedestal French (Paris), 1819
Mounts and pedestal by Pierre-Philippe Thomire
(1751–1843)
Russian malachite, composite filling material;
gilt-bronze mounts; bronze pedestal
H. (with pedestal) 9 ft. 2 in. (279.4 cm), h. (vase
alone) 5 ft. 7½ in. (171.5 cm)
Incised on the pedestal: "THOMIRE A PARIS
1819."
Purchase, Admiral Frederic R. Harris Gift, 1944
44.152 a,b

As early as 4000 B.C. malachite was used by
the Egyptians to produce precious contain-
ers for sacred oils and cosmetics. The min-
eral is a hydrated copper carbonate that
forms by chemical alteration in the copper
ores. It "grows in layers of tiny crystals, and
its colors correlate with different crystal
sizes: smaller crystals form light green bands
and larger crystals make darker ones."[1]
Today the main source of gem malachite
with intricate patterns and layers is Zaire, in
equatorial Africa; however, in the eigh-
teenth and nineteenth centuries, malachite
was mostly mined in Russia, and working it
was considered a typically Russian art, like
the crafting of cut-steel furniture at Tula
(see the entry for no. 79). A schistoid mate-
rial, malachite is brittle and cannot be used
to make big, monolithic objects, although
items of limited size can sustain themselves.
For large pieces, malachite has to be used as
veneer attached to a firm structure. The
flamboyance of cut-steel and malachite
objects puts these Russian creations in a
unique category within the European deco-
rative arts. It seems curiously appropriate
that the early history of the two crafts
should have been intertwined with the life
of the same man, Akinfi Nikitich Demidov
(1678–1745).

Early in the eighteenth century this skill-
ful blacksmith in Tula who specialized in
refined parade weaponry, attracted the
attention of Peter the Great (1672–1725).
The Russian emperor granted him certain
privileges, and he was later given land near
Moscow on which to establish forges. When
these turned out to be highly successful
enterprises, Demidov was granted undevel-
oped territories in the Ural Mountains.[2]
Two generations later, the Demidov family

discovered iron, platinum, and precious and
semiprecious stones there. They also searched
for copper[3] and found large deposits of
malachite nearby. The Demidovs used the
unusual stone to decorate a room in one of
their residences, and this became the proto-
type of the Malachite Room in the Winter
Palace in Saint Petersburg.[4]

The first imperial lapidary factory was
founded at Peterhof, near Saint Petersburg,
in 1723. Here the Russian techniques of
making malachite mosaics were first per-
fected. Covering whole wall panels with a
finely patterned mosaic of malachite pieces
required great skill. The stone had to be cut
in thin slabs, mounted on a special plaster
or stone backing, and arranged to form
designs.[5] A second factory was established,
in 1726, at Ekaterinburg. It specialized in
producing huge malachite, lapis lazuli, and
jasper vases with gilded bronze handles to
stand on grand staircases or fill alcoves in
the reception rooms of the Saint Petersburg
palaces. Most of the malachite came from
the Demidov mines. Malachite became even
more fashionable in the nineteenth century,
when new and richer lodes were discovered
on the western slopes of the Ural Mountains,
making it possible to carry out such projects
as the one for Saint Isaac's Cathedral in Saint

Petersburg, with its ten thirty-foot-tall
malachite mosaic columns.[6]

The Museum's vase is of the so-called
Medici type, based on an ancient Roman form
admired in the early nineteenth century.[7] It was
commissioned by Count Nikolai Demidov
(1773–1828) for his villa at San Donato, near
Florence. From a distance the malachite
veneer is perfection itself. A closer look
reveals an uneven—and in some areas an
almost clumsy—use of the stone, by compari-
son with important malachite objects of
known Russian manufacture. For example,
large areas of the surface are composed of
small malachite particles mixed with a filling
substance. It thus seems likely that the veneer
was not applied by the extraordinarily skilled
Russian master mosaicists. Instead, Demidov
probably had the raw malachite—a symbol
of his fortune—transported from the family-
owned mines to Florence. There it would
have been shaped and finished by local artists,
perhaps at the famous stone-working factory
Opificio delle Pietre Dure, and then sent on to
Paris to be fitted with its gilt-bronze mounts
and set on its bronze pedestal.

The winged female figures attached to
the body of the vase represent Fame.[CD] Their
trumpet-attributes are teasingly shaped like
handles, suggesting the possibility of lifting

Fig. 129. Inscription on
the vase's pedestal giv-
ing the surname of the
mount maker Pierre-
Philippe Thomire and
the date 1819.

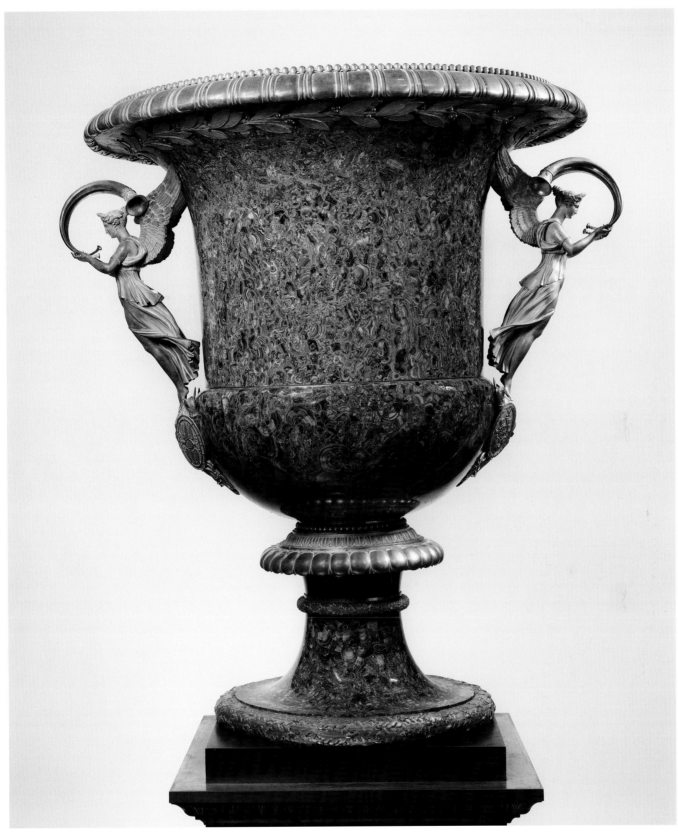

the monumental object like a loving cup. Both figures stand on military trophies and wear laurel crowns, the symbols of victory. A garland of laurel runs prominently under the lip mount. This evergreen plant, *Laurus nobilis*, was an emblem adopted by Lorenzo de' Medici (1448–1492) together with the motto "Ita ut virtus," which means "Thus is virtue," that is to say, virtue is evergreen, like the color of the precious stone that embellishes this vase.[8] Lorenzo, wealthy patron of the arts, was called "the Magnificent." Did Count Demidov want to evoke a comparison between his own family's "evergreen" fortune and that of the Florentine Medici dynasty?

The vase's foot is firmly established on an ormolu roundel covered with oak leaves and acorns, the traditional symbols of strength and continuity that were part of the heraldic devices of several noble families in Renais-

sance Tuscany (fig. 129). These and the other mounts by the famous Thomire ormolu factory in Paris are of superb quality. Pierre-Philippe Thomire was known throughout Europe for his bronze decorations and sculpture. He established a reputation about 1780 with his beautiful mounts for Sèvres porcelain vases. In 1804 he founded a workshop that produced furniture as well as luxury bronzes. After Thomire brilliantly executed large commissions for the imperial palaces, Napoleon granted his firm the title *fournisseur de leurs Majestés*.[9]

Count Demidov displayed this vase, which is still in the Empire style,[10] at the Villa San Donato, together with his important art collection, until his death. His heir, Prince Anatole Demidov (1812–1870), enlarged the villa and commissioned and purchased many paintings, sculptures, and decorative objects to fill it.[11] In the winter of 1874–75, while a student at Florence, the American sculptor Daniel Chester French (1850–1931) described the interior of the Demidov Palace and made special note of the numerous objects of malachite that were there, including "great malachite vases five feet high." He added, "The Demidov Family, it seems, owned all the malachite mines in the world."[12] At the time of the sale of parts of the prince's collection in 1880, this vase was described in the catalogue as supporting a gilt-bronze candelabrum with nineteen branches in the form of fluted, leafy stalks arranged in a lower tier of twelve surmounted by a central cluster of seven branches. Today wooden blocks fitted around the interior of the rim and pierced with twelve holes remain. These holes presumably were made to hold the twelve branches of the first tier of the candelabrum as mentioned in the sale catalogue.[13]

William Henry Vanderbilt (1821–1885) purchased the vase at the 1880 Demidov sale for his residence at 640 Fifth Avenue, New York City.[14] In an annotated catalogue of the sale, the name Crosby appears with the entry for lot 1019, the Museum's vase. John Schuyler Crosby (1839–1914) and James Jackson Jarves (1818–1888) apparently acted as Vanderbilt's agents, which is surprising, given the importance of their official positions. They were at that time, respectively, American consul and vice-consul in Florence.[15]

Comparable in size and shape but set with mounts in a different style is a malachite vase in the Royal Collection at Windsor Castle. It was presented by Nicholas I of Russia (1796–1855) to Queen Victoria when he stayed at Windsor in 1844.[16] WK

I am grateful to Marina Nudel, Senior Research Associate, Department of European Sculpture and Decorative Arts, for helping me with this entry.

1. Post 1997, pp. 132–33.
2. Kennett 1973, p. 41.
3. For copper objects made at the Demidov factories, see Kugel 1998, p. 30, no. 90.
4. Kennett 1973, p. 41.
5. Ibid.; and Chenevière 1988, pp. 264–66.
6. Hare 1965, p. 261; and Chenevière 1988, pp. 259–64.
7. Héricart de Thury 1819, p. 80, no. 1; see also Ottomeyer 2004, p. 16.
8. Hall 1979, p. 190.
9. Cohen 1986; and the entry on Pierre-Philippe Thomire by Martin Chapman in *Dictionary of Art* 1996, vol. 30, p. 747.
10. Draper 1978, no. 182.
11. For the Demidovs as collectors, see *The Contents of Villa Demidoff, Pratolino, near Florence*, catalogue of a Sotheby's of London sale at the Villa Demidoff, 21–24 April 1969, p. ix; and *Anatole Demidoff* 1994.
12. Note of 7 August 1945 by Mrs. Margaret French Cresson, his daughter, in the archives of the Department of European Sculpture and Decorative Arts, Metropolitan Museum.
13. File note by Clare Vincent dated 16 August 1963, in the archives of the Department of European Sculpture and Decorative Arts.
14. Strahan 1883–84, vol. 1, p. 14; and Crowninshield 1941, p. 39.
15. The annotated copy is in the New York Public Library, New York City, given by the Estate of Samuel Isham. For the careers of Crosby and Jarves, see *American National Biography* 1999, vol. 5, pp. 782–83 (entry by Thomas A. McMullin), and vol. 11, pp. 875–76 (entry by Rhoda E. A. Hackler).
16. For the vase in Windsor, see Hare 1965, pp. 261–62, fig. 155A.

95.

Armchair

German (Berlin), 1828
Designed by Karl Friedrich Schinkel (1781–1841); probably made by Johann Christian Sewining (d. 1836) and Karl Wanschaff (1775–1878)
Mountain ash, gilded; brass mounts and casters; modern upholstery
H. 35½ in. (90.2 cm), w. 24¼ in. (61.5 cm), d. 23¼ in. (59.1 cm)
Purchase, Gifts of Mr. and Mrs. William Randolph Hearst Jr., Irwin Untermyer, and John D. Rockefeller Jr., by exchange, and Bequest of John L. Cadwalader, by exchange, 1996
1996.30

Between 1826 and 1828, at the height of his influence as Germany's leading architect and most sought-after designer, Karl Friedrich Schinkel was commissioned by Prince Karl of Prussia (1801–1883) to remodel the prince's Berlin palace (destroyed in World War II). It seemed appropriate that Karl, a son of King Frederick William III of Prussia (1770–1840) and the younger brother of King Frederick William IV (1795–1861) and Emperor William I (1797–1888), would engage the court architect Schinkel to draw up the plans. For the Marble Hall (or Reception Hall) Schinkel designed a luxurious suite of gilded furniture, comprising two sofas and eight armchairs, one of which is the present piece.[1] Many of the details reflect the designer's sensitivity to all aspects of the room's decor. One of the most intriguing of these is the similarity between the sides of the sofas and the pattern of the inlaid border of the wooden floor.[2] Like most display furniture, all ten pieces would have been placed against a wall. The details of the show covers and the ornaments on the front, such as the sphinxes looking forward from the arm supports and the lion mascarons on the armrests, give the furniture a ponderous grandeur; however, the chairs, which are indeed extremely heavy,

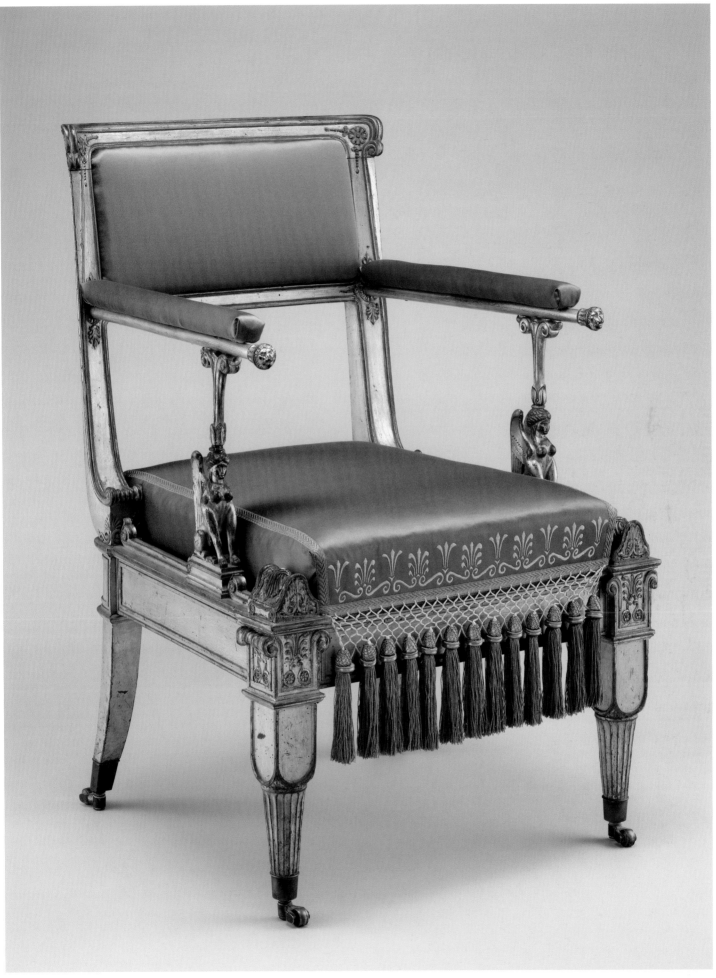

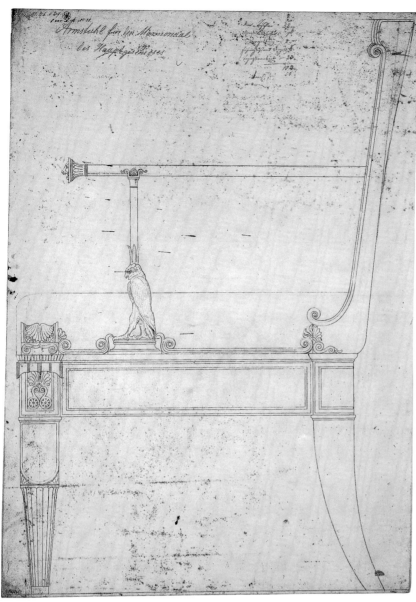

Fig. 130. Design by Karl Friedrich Schinkel for the Museum's armchair, 1826–28. Pen and ink drawing. Kupferstichkabinett, Berlin.

the other pieces in the suite.[8] As the chair prototype was one of the most expensive ever produced,[9] this was clearly done in order to simplify production and reduce costs. The use of different materials for the decorative parts of the later chairs reflects Schinkel's passion for exploring new production methods.

Schinkel's design for the prototype is based on an ancient Roman chair depicted in wall paintings that had been excavated in Herculaneum in the eighteenth century.[10] The sketch of a related but bolder chair in the Egyptian taste appears in plate 29 of Charles Percier and Pierre-François-Léonard Fontaine's *Recueil de décorations intérieures,* of 1801.[11] A closer comparison, however, is provided by plate 59, fig. 1, in Thomas Hope's *Household Furniture and Interior Decoration,* of 1807, a publication well known to the German architect. Hope's and Schinkel's interpretations clearly follow the ancient paintings, even to the extravagantly conceived but structurally weak armrests. If Schinkel's chairs are picked up by the arms rather than moved on their casters, the thin armrests and their fragile supports may break. A regilding of the repaired areas is then inevitable. This must have happened to the Museum's example before it was acquired.[12]

Schinkel made no fewer than 252 design drawings for Prince Karl's furnishings.[13] He chose the cabinetmakers Karl Wanschaff and Johann Christian Sewining to execute them.[14] Two preparatory drawings for the chair—a silhouette and a frontal view—have survived (see fig. 130). They show that Schinkel had originally planned to use owls, symbols of wisdom in ancient Greece and attributes of Athena, as armrest supports; however, he later substituted sphinxes. These half-human, half-leonine creatures were in antiquity often depicted in monumental and funerary contexts. Regarded as repositories of arcane wisdom in ancient Greek mythology, they were believed also to be monstrous and bloodthirsty.[15] Gradually they lost their aura of malevolence and were envisaged as enigmatic creatures. In postclassical art they have beautiful female faces and breasts, as on this chair.[CD] The motif reflects Schinkel's obsession with the ancient Greek world. His working drawings include detailed views of the coverings and other textile ornamentation, enabling the Museum's Objects Conservation Department, under the supervision of Nancy C. Britton, to re-create the sumptuous upholstery in 1997–98.[16]

have casters and can be moved—belying their monumentality and very much to the astonishment of the viewer, who can thus appreciate them from all sides.

Until recently there was much confusion as to how many examples of the chairs of the former suite were still in existence.[3] The situation is now thought to be as follows. The Stiftung Preussische Schlösser und Gärten Berlin-Brandenburg currently displays two chairs in the Schinkel Pavilion at Schloss Charlottenberg, Berlin,[4] and there is a further example in storage at Schloss Charlottenburg.[5] The Kunstgewerbemuseum in Berlin owns two chairs, and there is another example, which has possibly retained much of its original upholstery under a later

show cover, in the Danske Kunstindustrimuseum in Copenhagen.[6] Therefore, it seems that seven chairs (including the Museum's piece) have survived, leaving one example as well as the pair of sofas unaccounted for.

It is generally acknowledged that the Museum's chair is the prototype for the series and was made under the architect's supervision.[7] It retains most of its original gilding and the original casters, and, in addition, the decorative parts, such as the fully three-dimensional sphinxes and the flat relief ornamentation, are carved in wood following traditional chairmaking techniques. Molds were later made of these elements in lead, zinc, iron, and composite mass in order that casts might be applied to

Prince Karl must have appreciated the beauty and extraordinary design of the set, for in 1872 he donated one example to the Hohenzollernmuseum (today, with a different show cover, it is in the Kunstgewerbemuseum, Berlin).[17] After his death, in 1883, much of the rest of the palace's contents was dispersed. The Museum's chair was acquired by a member of the Puttkammer family of Prussia, and it presumably stayed in the hands of that collector's descendants until about 1995. The following year, the Museum was fortunate enough to acquire it. This famous and fully documented chair model is rightly considered one of Schinkel's most accomplished pieces of furniture as well as a superb example of the late German Empire style.[18] WK

1. Sievers 1942, pp. 213–14, 218; Sievers 1950, p. 36, fig. 39; Hampel 1989, pp. 22–23, 282, nos. 55–58; "Recent Acquisitions" 1999, p. 43 (entry by Wolfram Koeppe); and Stiegel 2003, figs. 91 (drawing), 92 (armchair), and p. 556, no. 248.

2. Hedinger and Berger 2002, pp. 172–74, no. 46, figs. 1, 2 (entry by Julia Berger).

3. Even the catalogue of the recent Schinkel furniture exhibition did not clear up this problem. See ibid.

4. *Age of Neo-classicism* 1972, pp. 765–66, no. 1633 (entry by William Rieder); *Karl Friedrich Schinkel* 1981, pp. 86, 299, no. 242 (entry by Winfried Baer); and Paolini, Ponte, and Selvafolta 1990, p. 203.

5. I am grateful to Mechthild Baumeister, Conservator, Department of Objects Conservation, Metropolitan Museum, for bringing this unpublished example in Schloss Charlottenburg to my attention. I also thank Burkhardt Göres for examining the two chairs at the Kunstgewerbemuseum, Berlin, with me in 1997.

6. Conservator Mechthild Baumeister and I thank Vibeke Woldbye of the Danske Kunstindustrimuseum for allowing us (on separate occasions in 1999 and 2000) to examine the Copenhagen chair.

7. "Recent Acquisitions" 1999, p. 43 (entry by Wolfram Koeppe); and Hedinger and Berger 2002, pp. 172–74, no. 46 (entry by Julia Berger).

8. Mechthild Baumeister and I have examined the two chairs in the Schinkel Pavilion as well as the pieces at the Kunstgewerbemuseum, Berlin. They all incorporate prefabricated elements.

9. Stiegel 2003, p. 125.

10. Published in the *Antichità di Ercolano* 1757–92, vol. 4, pl. 44.

11. Hedinger and Berger 2002, p. 174, fig. 4.

12. Conservation report by Mechthild Baumeister, January 1996, in the archives of the Department of European Sculpture and Decorative Arts, Metropolitan Museum.

13. Sievers 1942, p. 175.

14. Ibid., p. 180.

15. Edmunds 1981.

16. On the restoration of the upholstery on the two chairs in the Schinkel Pavilion, see Arenhövel 1979, p. 288, no. 571 (entry by Dietmar Jürgen Ponert); and *Karl Friedrich Schinkel* 1980, pp. 237–38, no. 382 (entry by Burkhardt Göres).

17. Schmitz 1923, p. 184.

18. The chair type was first published in 1836; see Lohde 1836, no. 264. On Schinkel's furniture, see Göres 1980; and W. Baer 1981.

96.

Porcelain table

German (Berlin), ca. 1833–34
Probably designed by Karl Friedrich Schinkel (1781–1841); made by the Königliche Porzellan-Manufaktur, Berlin; Helios and zodiac designs for the center of the top painted by August von Kloeber (1793–1864), design for the garland painted by Gottfried Wilhelm Voelker (1772–1849); bronze and metal mounts by Bronzeure Werner und Neffen, Berlin
Hard-paste porcelain, gilded bronze, and yellow metal; iron and wood as support materials
H. 35½ in. (90.2 cm), diam. of top 26 in. (66 cm), diam. of top including frame 31 in. (78.7 cm)
Impressed on the underside of the torus molding with curling-leaf decoration between the paws on the base: "16." Incised twice on the shaft: "XII."
Wrightsman Fund, 2000
2000.189

This dazzling table is made entirely of porcelain with the exception of the reeded gilt-metal rim with concave moldings around the circular porcelain top, the canted triangular gilt-metal base with low feet, and the gilt-bronze beaded molding encircling the porcelain curling-leaf decoration on top of the base. There is also an iron column that acts as a spine, disguised by four porcelain acanthus-leaf sleeves fitted one above the other, set off by gilded metal moldings.[CD] The gilding of the porcelain surface of the stand is daringly finished in different techniques that create delicate matt and brightly polished areas, producing the trompe l'oeil effect of a gilded cast-bronze support.[1]

The fabrication of the Museum's spectacular table was made possible by new production and color technologies that were developed after 1832 at the Royal Porcelain Manufactory, Berlin, to attract royal patronage.[2] The catalogue of the Academy Exhibition of 1834 mentions "a round table with porcelain top and porcelain foot."[3] Since porcelain tabletops were usually fitted with supports of metal or carved wood, this piece would have been a novelty and of great interest to the public. A Berlin newspaper devoted much space to the subject in November of that year: "The porcelain table with a twenty-six-inch circular top displayed at the current exhibition in the rooms of the Royal Academy is characterized not only by excellent color, gilding, and painting but by a beautifully smooth top . . . [and this] can also be said of the gilded table foot. Only the triangular base of the piece is of gilded bronze: all other [parts], even those that are difficult to make, such as the ancient griffins feet, are of porcelain, and [they] tes-tify to the skill of the modelers employed by the manufactory, and to their good fortune in overcoming the difficulties encountered during the firing of the porcelain."[4]

It is tempting to identify the table mentioned in the *Berlinische Nachrichten* with the Museum's example. Very likely only two tables of this size with a porcelain foot were produced at the manufactory. One was given by King Frederick William III of Prussia (1770–1840) to the grand duchess of Weimar in 1838. It is described in the king's privy-purse account as having a "top 25 inches in diameter on a porcelain foot with figural painting."[5] The same account book, which the king began to keep in 1811 to record royal gifts within his family (and their value) as well as diplomatic presents to foreign dignitaries, mentions in much more detail an earlier gift by the monarch to Grand Duchess Helena Pavlovna of Russia (1807–1873). In an entry of 1 June 1835, the Museum's table is described as follows: "For Her Royal Highness the Grand Duchess Helene, 1. Tabletop, circular, 25 inches in diameter, with colored figures, the subject Helios, on a blue background, surrounded by a zodiac border in brown and gold on matt gold, the whole background

polished gold, on which colored fruits and flower garlands are intertwined with a blue band, also colored butterflies and insects."[6] The price (1,200 taler) was very high, surpassed only by that of the monumental vases the king commissioned as gifts for the Russian court.[7] The top (fig. 131) is richly decorated with a central tondo in which Helios, the sun god, is seen rising up to heaven from the eastern Ocean in a carriage pulled by four white horses. "Iconographically the signs of the . . . zodiac [in the band around the tondo] belong to the triumph of light during the course of the seasons."[8] The latter are represented by garlands of the fruits and flowers that flourish as the year progresses, and these are displayed on a wreath of vine leaves, autumn's bounty. The exotic fruits, such as pineapples and pomegranates, possibly symbolize winter, when they would have been cultivated in the fashionable and expensive greenhouses of the period, a luxury as extravagant as a table made almost completely out of porcelain.

As unusual as this lavish present was the character of the recipient, Helena Pavlovna. Born Princess Charlotte of Württemberg, she married, in 1824, Grand Duke Michael Pavlovitch, the youngest brother of Alexander I of Russia (1777–1825). She was one of the most fascinating personalities of the period, always a little ahead of her time. Socially and politically concerned with Russia's future, she was a most outspoken advocate of the abolition of serfdom, setting a courageous example on her own estates. In 1859, two years before Alexander II (1818–1881) officially abolished serfdom, the grand duchess freed more than fifteen thousand people living on her estates in the Ukraine.[9] During the Crimean War, this mother of five daughters established a nursing unit, a step that was aggressively opposed by leading military figures. This was the first war in which medically trained women served on the battlefield, saving the lives of thousands of soldiers. The salon of her residence, the Mikhail Palace—designed by Karl Rossi (1775–1849) and the finest example of architecture in the Russian Empire style— was one of the cultural centers of Saint Petersburg. The palace now houses the State Russian Museum. Beginning in 1852, the gifted pianist Anton Rubinstein (1829– 1894) was part of the grand duchess's

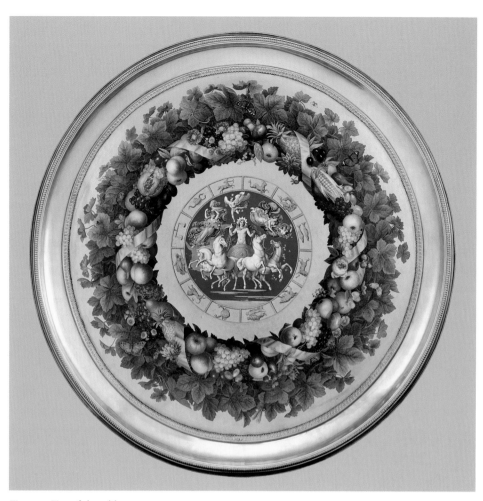

Fig. 131. Top of the table.

artistic entourage. She firmly supported Rubinstein's ambition to found Russia's first musical conservatory, whose most famous student would be the composer Peter Ilyich Tchaikovsky (1840–1893).[10]

The Museum's table can be attributed to Karl Friedrich Schinkel, Germany's most important nineteenth-century architect, who was also a gifted interior designer (see the entry for no. 95). Schinkel's tables are distinguished by their strong compositions and inventive interpretations of ancient models, especially the tripod form.[11] Closely related shaft designs with highly stylized acanthus leaves arranged in tiers can be seen on the monumental candelabra of 1831–32 in the Schinkel Pavilion at Schloss Charlottenburg, Berlin.[12] It seems that during this period in Berlin only Schinkel could coordinate many different craftsmen in the production of a large and complex object that looks magnificent when seen from a distance and withstands the close scrutiny of a connoisseur in its refined details. These qualities, rarely seen in furniture, characterize this extraordinary table. W K

I am very grateful to Achim Stiegel, of the Kunstgewerbemuseum, Berlin, who researched this table extensively before the Museum acquired it. His unpublished notes made it possible to confirm previously vague attributions to the various artists involved. I am also grateful to Ilse Baer and Winfried Baer, for their generous help with archival information.

1. See "Recent Acquisitions" 2000, pp. 40–41 (entry by Clare Le Corbeiller); and I. Baer 2001, pp. 17–18, fig. 9.

2. Kolbe 1862, p. 254.

3. "Ein runder Tisch mit Porzellan Platte und Fuss." Börsch-Supan 1971, vol. 2, no. 1164 (for 1834).

4. "Schon der auf der irzigen Ausstellung in den Sälen der k. Akademie aufgestellte Porzellan-Tisch mit einer runden Tischplatte von sechs und zwanzig Zoll Durchmesser, zeichnet sich nicht allein durch ausgezeichnete Farben, Vergoldung und Malerei [aus], . . . was ebenfalls von dem, grösstenteils in Biscuit-Porzellen sauber gearbeiteten, vergoldeten Tischfüsse gilt. Nur der dreikantige Sockel an demselben ist von vergoldeter Bronze; alles übrige, selbst die, so schwierig auszuführenden, antiken, gebogenen Greifsfüsse sind von Porzellan, und zeugen für die Kunstfertigkeit der bei der Porzellan-Manufactur beschäftigten Modelleure, und wie glücklich man Schwierigkeiten beim Garbrennen des Porzellans zu überwinden weiss." "Königl. Porzellan-Manufactur" 1834. Achim Stiegel kindly drew my attention to this review.

5. "Platte mit 25 Zoll Durchmesser auf einem porzellan Stand figürlicher Malerei." Account book, Geheimes Staatsarchiv, BRH Rep. 49, G, no. 33.

6. "1. [Eine] Tischplatte rund 25 Zoll im Durchmesser, mit coul. Figuren Sujet Helios, auf blauem Fonds,

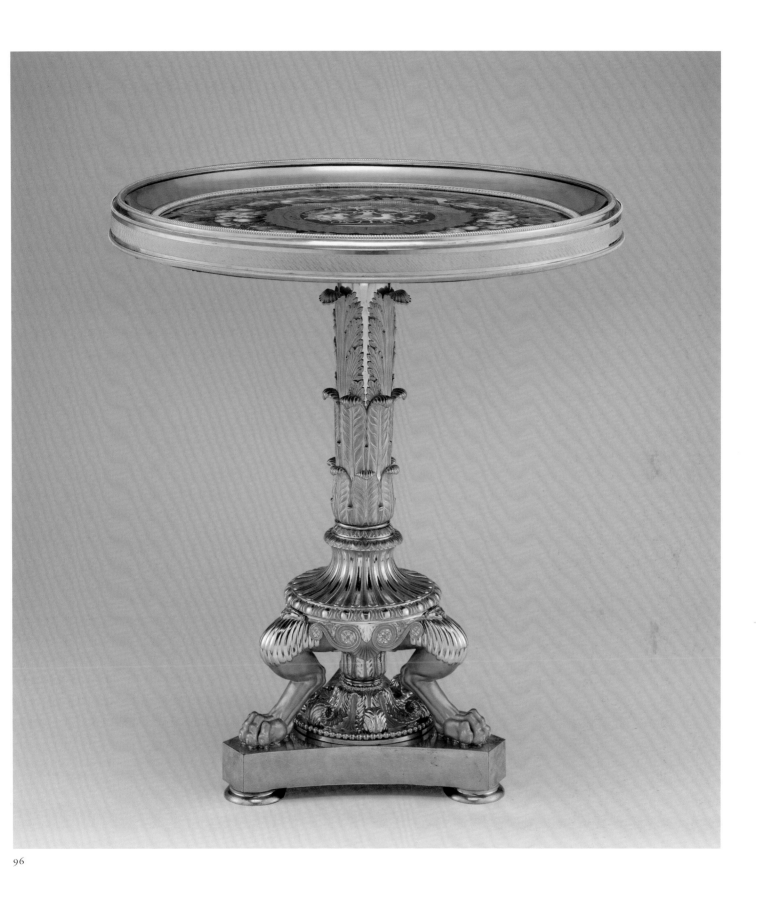

umgeben als Medaillon die Himmelszeichen aus Braun & Gold auf mattem Golde, der ganze fond Glanzgold, darauf coul. Früchte, u. Blumen guirl. Mit blauem Bande durchwunden, nebst coul. Schmetterlinge u. Insekten." Ibid., no. 213, p. 88.

7. W. Baer and I. Baer 1983.

8. I. Baer 2001, p. 17.

9. *Das Haus Württemberg* 1997, pp. 326–27 (entry by Hans-Martin Maurer); and Willscheid 2002.

10. *Das Haus Württemberg* 1997, p. 327 (entry by Hans-Martin Maurer).

11. On Schinkel's tables, see Hampel 1989; Hedinger and Berger 2002, pp. 108–16, nos. 21–24 (entries by Elke Katharina Wittich), pp. 214–15, no. 59 (entry by Franziska Fuchsius); Himmelheber 2002, p. 938, fig. 2; and Stiegel 2002. There are well-known examples in the Thurn und Taxis Museum, Regensburg, and in the Kunstgewerbemuseum and the Schinkel Pavilion, Berlin. For a newly discovered table with a porcelain top by the Königliche Porzellan-Manufaktur, Berlin, see the catalogue of the Leo Spik sale, Berlin, 27–29 March 2003, lot 604.

12. *Karl Friedrich Schinkel* 1981, p. 315, no. 275 (entry by Winfried Baer); see also Schinkel's signed candelabra design in Sievers 1950, fig. 227. For a stand by Schinkel with a similar design, see Sievers 1950, fig. 58.

97, 98.

Sofa and armchair

Italian (Piedmont), ca. 1835
Designed by Filippo Pelagio Palagi (1775–1860);
made by Gabrielle Cappello (1806–1876)
Mahogany veneered with maple and mahogany;
covered in modern silk brocade
Sofa: h. 42½ in. (108 cm), w. 90 in. (228.6 cm),
d. 31⅛ in. (79.1 cm); armchair: h. 43 in. (109.2
cm), w. 27½ in. (70 cm), d. 24 in. (61 cm)
Inscribed in pencil on the frame of the sofa seat:
"Racconigi Camera da letto degli Augusti Sposi."
Stenciled in green on the back of the frame of the
chair are marks that reflect the last inventory
made at the Castello di Racconigi, in 1900:
"3425," with traces of the letters "PPR," erased.
The chair bears the incised stamp "PPR 3425."
Purchase, Gift of J. Pierpont Morgan, by
exchange, 1987
1987.62.1,3

The Museum's sofa and two armchairs, one of which is illustrated here, are from a suite of twelve pieces of furniture—consisting of a daybed (fig. 132), sofa, four armchairs, and six side chairs—made for the royal bedroom and adjacent drawing room at Racconigi, the summer palace of the kings of Sardinia, later to become kings of Italy, near Turin.[1] The inscription on the sofa translates literally as "Racconigi Bedroom of the August Married Couple," that is, the Royal Bedroom.

The set was designed by Filippo Pelagio Palagi, who trained as a painter in Bologna. After working in Rome and Naples, in 1818 he opened a private art school in Milan. In 1832 he was summoned to Turin by King Carlo Alberto I of Sardinia (r. 1831–49) to direct the Scuola di Ornato of the newly founded Accademia Albertina di Belle Arti and charged with the renovation and redecoration of the royal palaces: the Palazzo Reale and Racconigi. Palagi designed not only major features such as ceilings, floors, and furniture but also candelabra, chandeliers, and curtain rods, achieving a decorative unity that blended architecture with the ornamentation and furnishing. The style of this suite, which might best be called Italianate Late Empire, incorporates motifs from as far afield as Etruscan bronzes, ancient Greek vases, and Biedermeier furniture. In his eclecticism, Palagi announces the oncoming historicism of the revival styles.

His furniture for the royal palaces represents Italian craftsmanship of the period at its highest level. This suite was executed by Gabrielle Cappello, known as Moncalvo, with the assistance of Carlo Chivasse. Moncalvo, who executed many of Palagi's designs for Racconigi, was a master of inlay and veneer and headed a large workshop. He was awarded a medal at the 1851 Great Exhibition of the Works of Industry of All Nations in London for a set of furniture from the Etruscan Study at Racconigi.

Other pieces from this suite have been acquired by the J. Paul Getty Museum, Los Angeles (the daybed),[2] the Art Institute of Chicago (two side chairs),[3] the Minneapolis Institute of Arts (two armchairs), the Detroit Institute of Arts (side chair), the Virginia

97

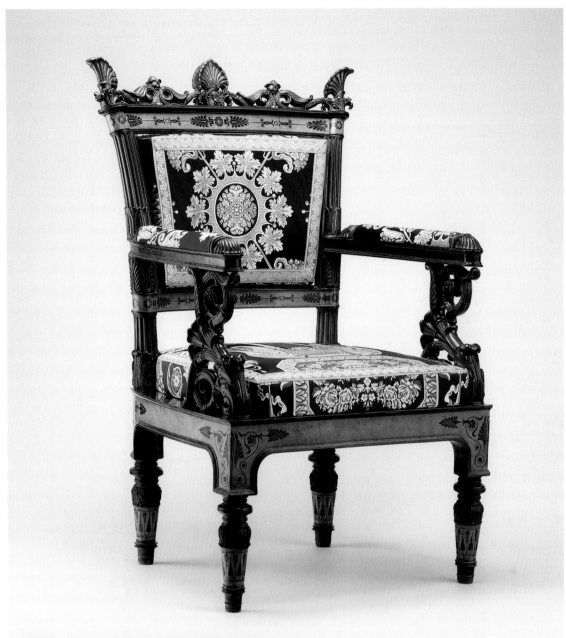

98

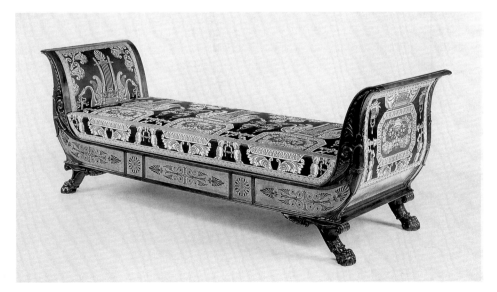

Fig. 132. Daybed designed by Filippo Pelagio Palagi and made by Gabrielle Cappello, ca. 1835. Mahogany veneered with maple and mahogany, covered in modern silk brocade; 31½ x 88⅛ x 27⅛ in. The J. Paul Getty Museum, Los Angeles, copyright © The J. Paul Getty Museum.

Museum of Fine Arts, Richmond (side chair),[4] and the Victoria and Albert Museum, London (side chair).[5] The sofa and two armchairs were acquired by the Metropolitan Museum in 1980 from Heim Gallery, Ltd., London, together with fragments of the original blue and silver silk brocade upholstery, which allowed several of these museums to collaborate in commissioning new upholstery from the firm that made the original fabric: Prelle in Lyons. WR

1. The accession number of the Museum's second armchair is 1987.62.2.

2. "Acquisitions" 1987, p. 218, no. 118.

3. Zelleke 2002, pp. 55–56, no. 27.

4. Gustafson 1989, p. 414.

5. Wilk 1996, pp. 146–47 (entry by James Yorke).

99.

Cabinet

English (London), 1861–62
Designed by Philip Webb (1831–1915);
decorated by Sir Edward Burne-Jones
(1833–1898); executed by Morris, Marshall,
Faulkner and Company, London
Painted and gilded pine; painted leather; copper
hardware; painted iron hinges
H. 73 in. (185.4 cm), w. 45 1/8 in. (114.6 cm),
d. 21 1/8 in. (53.7 cm)
Rogers Fund, 1926
26.54

At the London International Exhibition of 1862 this remarkable cabinet was part of the first public showing by the newly established firm of Morris, Marshall, Faulkner and Company.[1] It was one of six pieces of painted furniture by the firm included in the Medieval Court of the exhibition, where a range of objects in an eclectic mixture of Gothicizing styles was on display. Forming the "most conspicuous feature of the Court," according to William Burges (1827–1881),[2] these exhibits reflected a contemporary interest in painted furnishings and in particular the influence of Burges himself.[3] He was an architect and designer with a passion for medieval forms and techniques, and his studies resulted in carefully constructed furniture with integral painted scenes.[4] Burges praised the pieces by Morris, Marshall, Faulkner and Company shown at the 1862 exhibition,[5] but they were not generally admired. The *Ecclesiologist* for June 1862 observed: "Some painted and japanned furniture, exhibited by Messrs. Morris, Marshall, and Co., is simply preposterous. We believe that it is meant to be inexpensive; but some of the affixed prices scarcely bear out the assertion. We must totally decline to praise the design or execution of these specimens. The colouring in particular is crude and unpleasing, while the design is laboriously grotesque."[6] According to a description in the *Building News* for 8 August of that year, the two doors of the Museum's lacquered cabinet were beautifully painted with single figures on a punctured gilt background. These pictures were said to be "decidedly the best of Messrs. Morris, Faulkner, & Marshall's work," but, the critic added, "if we possessed the cabi-

net we should cut them out and frame them, and put the rest behind the fire, *because* it gives us perfectly the rude execution and barbarous ornament of centuries ago."[7]

The versatile William Morris (1834–1896), one of the leading artists and theorists of the late Victorian era, is generally not known for his furniture and, with exception of a few pieces for his own use, he designed very little of it.[8] He relied largely on the talent of his friend the architect Phillip Webb, who designed furniture for the Red House in Bexleyheath that he built for Morris and his bride, Jane Burden (1839–1914). The painter Edward Burne-Jones decorated some of these early furnishings, and others were embellished by Morris himself. The fruitful collaboration between various architects and Pre-Raphaelite painters on the interior decoration of the Red House, combined with the need that they felt to reform the minor arts, which were, according to Morris, "in a state of complete degradation,"[9] led them to establish their own firm in 1861.

Webb was also the mastermind behind the Museum's cabinet—his accounts with the firm recorded an 1861 payment of one pound, ten shillings for the design of the "chess player" cabinet.[10] Medieval in spirit, with a refreshingly simple rectilinear shape, stylized finials, and honest construction, the

cabinet served as a perfect vehicle for the painting by Burne-Jones. Executed on leather that has been fastened with brass tacks to the wooden carcase, the composition shows a backgammon-playing couple in a garden. For this, two preparatory drawings and a watercolor are known (see fig. 133).[11] It has been suggested that the striking redhead Fanny Cornforth (1824–1906), mistress of the painter Dante Gabriel Rossetti (1828–1882), served as model for the female figure.[12]

The technique used here of applying several coats of tinted varnish over silver foil, creating an almost iridescent effect, was already known in the Middle Ages. Burges is credited with having reintroduced this method of decorating furniture, which was first written up by Theophilus in his treatise *De Diversis Artibus*.[13] This twelfth-century monk also described how to cover altar and door panels with animal hides, and it is quite possible that the idea of painting on leather, regularly practiced by Morris, Marshall, Faulkner and Company, was also generated by this medieval manuscript.[14]

The structural members of the cabinet provide a decorative frame, as it were, for the scene on the doors. They are—just as are also the cabinet's sides and interior—embellished with rhythmical patterns of

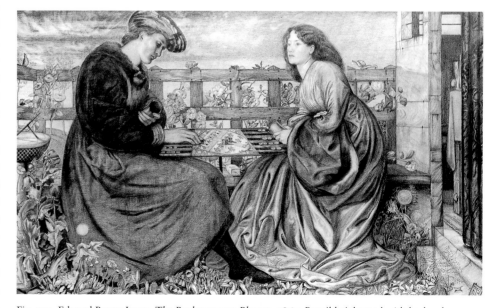

Fig. 133. Edward Burne-Jones, *The Backgammon Players*, 1861. Pencil heightened with bodycolor. Fitzwilliam Museum, University of Cambridge (2004).

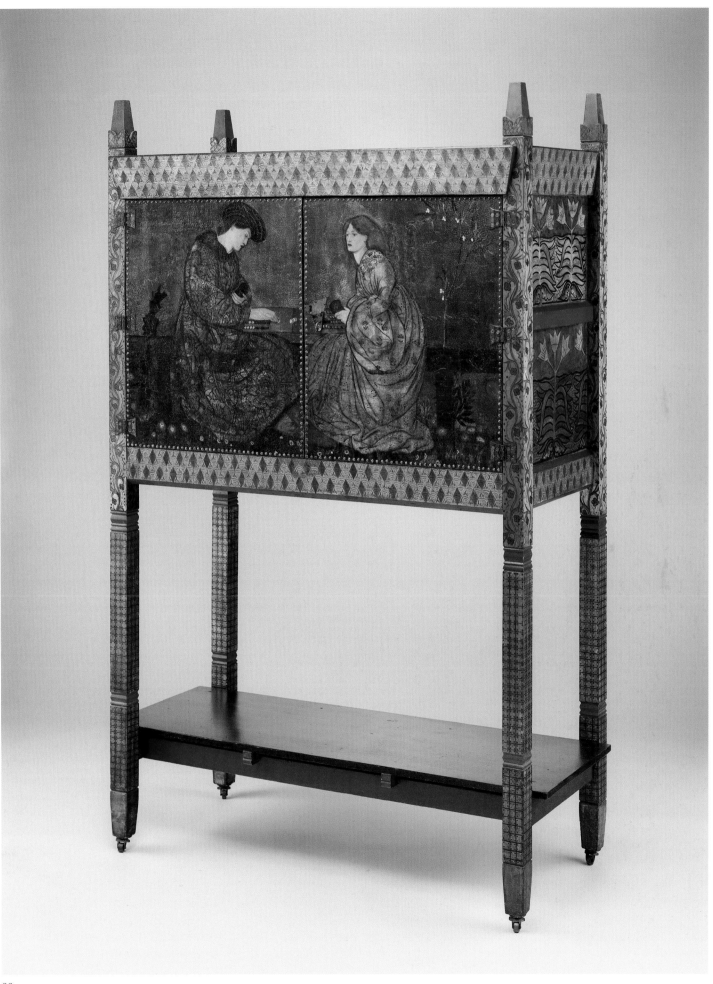

geometric shapes or of two-dimensional floral ornament that clearly foreshadow the future wallpaper and textile designs produced by the firm. Although the company remunerated Webb during the early years of its existence for painting and lacquering leather panels and woodwork,[15] it has been suggested that Burne-Jones may have been partly responsible for the decorative work on the Museum's cabinet. An entry in his account book with the firm, dating to the first months of 1862, listed "Gold cabinet: woodwork £5 painting £10."[16] The copper pulls on the inner drawers, remarkably modern, are identical to those found on a cabinet designed by Webb and painted by Morris, which was also shown at the 1862 exhibition.[17] CD

Priced at thirty guineas,[18] the cabinet was sold at the time of the exhibition to the politician Henry Labouchère, later Baron Taunton (1798–1869). In correspondence of 11 December 1862, Morris, Marshall, Faulkner and Company explained that there was a delay in delivering the cabinet to its new owner due to minor damage that had occurred during its transportation to and from the exhibition. In addition, the painted surfaces had suffered from dampness during the exposition, which the company "felt bound to repair . . . though they are of slight account in themselves yet it takes some time for the paint & varnish to dry properly."[19] The cabinet remained with the descendants of Lord Taunton until 1926, when his grandson decided to offer it for sale. A farsighted and important acquisition, it was purchased that year by the Museum through the London dealer R. Langston Douglas. DK-G

1. Wildman and Christian 1998, pp. 74–76, no. 18; and Gere 1999, p. 27.
2. Burges 1862, p. 4.
3. Crook 1981, pp. 294–300.
4. Wilk 1996, pp. 154–55 (entry by Frances Collard).
5. Burges 1862, pp. 4–5; and Burges 1865, p. 76.
6. "International Exhibition" 1862, p. 171.
7. "Mediaeval Court" 1862, p. 99.
8. Collard 1996, p. 155; and Parry 1996b, p. 165, nos. J.3, J.4 (entries by Frances Collard).
9. Written by Morris in a letter of September 1883 to the model-maker and gilder Andreas Scheu (1844–1927), who was one of the pioneers of the Austrian Social Democratic movement. Quoted in Wildman 1984, p. 126. See also Parry 1996a, p. 138.
10. Lethaby 1935, pp. 40–41.
11. One of the drawings, in the Fitzwilliam Museum, Cambridge, is illustrated here. The watercolor is in the Birmingham Museums and Art Gallery; it is illustrated in Wildman and Christian 1998, pp. 73–74, no. 17. The other preliminary drawing, in a private collection, is illustrated in Harrison and Waters 1989, p. 49, no. 54.
12. Wildman and Christian 1998, pp. 73, 76, nos. 17, 19. Jane Morris was previously said to have been the model; Johnson 1979, p. 53, no. 29.
13. Collard 1996, p. 156; Parry 1996b, pp. 172–74, nos. J.18, J.19 (entries by Frances Collard).
14. Theophilus 1979, p. 26.
15. Lethaby 1935, p. 41.
16. Wildman and Christian 1998, p. 75, no. 18.
17. Wilk 1996, pp. 158–59 (entry by Frances Collard).
18. Burges 1862, p. 4.
19. This letter is in the Archives of the Metropolitan Museum. The cabinet stood in the corridor at Quantock Lodge, Somersetshire, the house built by Lord Taunton in 1857. It was inherited by his daughter, Mrs. Stanley, and sold by his grandson, Captain Stanley. A statement by Captain Stanley providing this information is also in the Metropolitan's Archives.

100.

Table

Tabletop: Italian (Florence), ca. 1855–60; stand: Austrian (Vienna), ca. 1865
Designed by Theophil Hansen (1813–1891); the top executed at the Opificio delle Pietre Dure, Florence; the stand executed by Heinrich Dübell (active ca. 1853–80); the carved elements and the models for the bronze sculptures made by Josef Dollischek (active 1865–72) and cast by the firm of Hagenmeyer
Tabletop: Belgian black marble, semiprecious stones; stand: painted pine, ebonized fruitwood; brass; gilt-bronze mounts
Diam. of top 51 in. (129.5 cm); h. of stand 30½ in. (77.5 cm)
Gift of Mr. and Mrs. Nathaniel Spear Jr., 1982 1982.168 a,b

When this table arrived at the Metropolitan, it was thought to have been made in Florence about 1880; however, Museum curator James Parker pointed out that the "stand for the table top, which does not resemble [1880s] Italian work, was probably made at about the same time in Vienna, where both table top and stand were in the early years of the twentieth century."[1]

Recent research has focused on the stand; the quality of its design and the subtle execution point to Theophil (Theophilus Edvard) Hansen, one of the most important architects of the second half of the nineteenth century. After studying at the Academy in Copenhagen, Hansen won a scholarship in 1838 and traveled to Berlin, where he became an admirer of architect and designer Karl Friedrich Schinkel's work (see the entries for nos. 95, 96). Following a stay in Munich, Hansen embarked on a study tour of Italy and Greece, before settling in Vienna in 1846. There he helped construct several public buildings, including the museum of arms and armor at the Viennese arsenal. Hansen soon became one of the most sought-after architects in the Austrian capital.

Together with Friedrich von Schmidt and Heinrich von Ferstel, he was part of the triumvirate that dominated Viennese architecture in the 1860s and 1870s.[2] During these years he created the Wiener Stil (Vienna Style), a distinguished and elegant interpretation of High Renaissance art. He also helped design the famous boulevard known as the Ringstrasse. After the Austrian Parliament (1873–83), Hansen's best-known creation may be the imposing Golden Hall at the Vienna Musikverein, of 1867–69, in which the Vienna Philharmonic performs its annual concert on New Year's Day, an event that has been televised around the world for decades and has acquainted millions of music lovers with Hansen's magnificent architecture.

During the 1860s Hansen was mainly concerned with the interior decoration of two grand Viennese houses, the Palais Todesco and the Palais Epstein and Ephrussi.

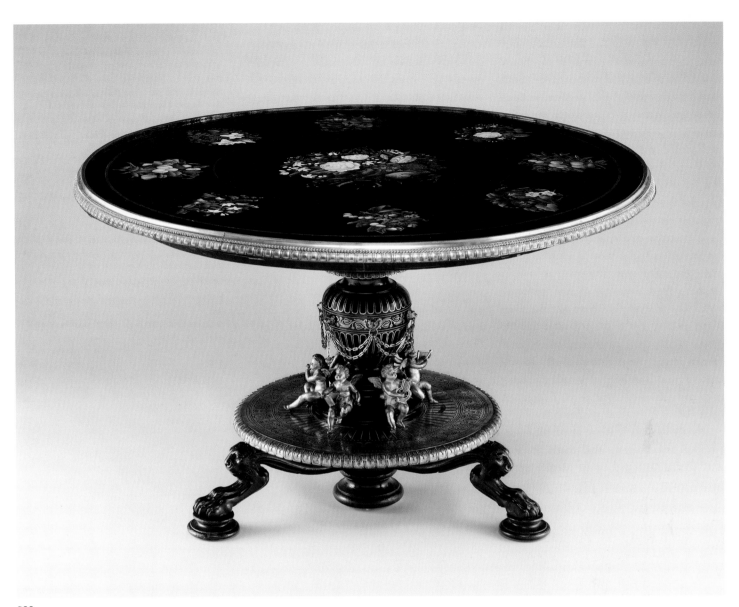

His patrons were wealthy men who wanted to showcase their possessions (which symbolized their accomplishments) in the artistically decorated reception rooms of their splendid mansions.[3] The owner of the Palais Todesco, like his colleagues S. M. von Rothschild and Baron Jonas Königswarter, was a powerful Austrian banker and member of the Vienna stock exchange.[4] These elites moved in what has been called a "second society,"[5] a different world from that of the old Austrian aristocracy. Wealth was its basis, and its lifeblood was the practice of unregulated capitalism. In the private office of Eduard Todesco, directly over his desk, was a fresco, *The Allegory of Trading*. For this sophisticated patron of art, wealth was not only the means to acquire the beautiful things that he wanted but an aspect of his identity.[6]

The Museum's table stood in one of the most important public rooms in the Palais

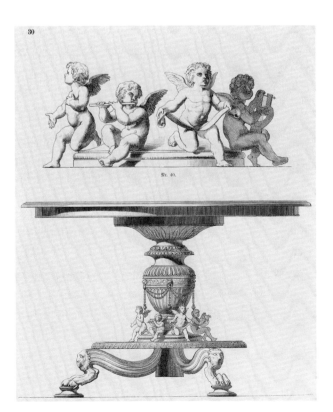

Fig. 134. Theophil Hansen, *Design for a Table in the Salon of the Palais Todesco*, ca. 1865. Engraving in *Gewerbehalle* (Stuttgart), no. 2 (1866).

Todesco, the Salon, which was located between the Ballroom and the much smaller Boudoir.[7] The Salon was the scene of intimate concerts, as is suggested by the music-making putti on the table's base, and on occasion served as a drawing room where the ladies played cards and socialized while the gentlemen visited the Billiards Room to enjoy smoking, alcoholic beverages, and other amusements. The eight floral compositions on the tabletop probably marked the places of participating card players.[CD] The table is part of an ensemble that was specifically created for the Salon by Hansen (see fig. 134). In 1866 the suite was described as one of Hansen's finest creations in the "modern" style.[8] The unifying elements are the vase-shaped legs of the chairs and table and the bronze figures decorating them.[9] Not much is known about the Viennese court cabinetmaker Heinrich Dübell, who made the stand; some very diverse furniture by him exists, documenting his workshop's flexibility.[10]

The Opificio delle Pietre Dure, the stoneworkers' manufactory that made the top, was founded in 1588 by the Medici family in Florence. Late Renaissance tables by the Opificio with *pietre dure* (hardstone mosaic) tops supported on carved-wood vase-shaped stands with putti decoration could have influenced Hansen.[11] The 1860s, when the table is first recorded, were years of dramatic political change on the Italian peninsula. Tuscany had been ruled by the house of Hapsburg-Lorraine since 1765. After the uprising under Giuseppe Garibaldi (1807–1882), Grand Duke Ferdinand IV of Hapsburg-Toscana had to leave Tuscany, which became part of a unified Italy. It is likely that this tabletop was bought shortly before 1860, possibly as a souvenir of some northern visitor's grand tour; many travelers purchased the famous *pietre dure* panels and had them mounted on stands as console or center tables by cabinetmakers at home. A similar eclectic table is depicted in a portrait of Emperor Francis I of Austria (1768–1835) by Friedrich von Amerling (1803–1887),[12] and there exist several examples of *pietre dure* tops on later stands in the Chinese (Blue) Salon at Schönbrunn Palace, in Vienna.[13] W K

1. Metropolitan Museum of Art 1983, p. 36 (entry by James Parker). Parker was following a remark of the donor to Olga Raggio, then the chairman of the Department of European Sculpture and Decorative Arts.
2. Niemann and Fellner von Feldegg 1893, p. 114. See also Wagner-Rieger and Reissberger 1980.
3. Ottillinger and Hanzl 1997, p. 357.
4. Wagner-Rieger and Reissberger 1980, pp. 240–41.
5. Ottillinger and Hanzl 1997, p. 357.
6. Wagner-Rieger and Reissberger 1980, p. 241.
7. Ibid., p. 219.
8. *Gewerbehalle* (Stuttgart), no. 2 (1866); cited in Ottillinger and Hanzl 1997, pp. 357, 359.
9. Ottillinger and Hanzl 1997, pp. 356, 357, figs. 211–13.
10. On Dübell, see Himmelheber 1983, p. 281, n. 484, figs. 708, 711, 848, 850, 879, 894. For the sculptor Josef Dollischek, see Kieslinger 1972.
11. *La collezione Chigi Saracini* 2000, p. 145.
12. Kugler 1995, p. 66.
13. Ibid., pp. 110–11; for similar *pietre dure* compositions, see Giusti, Mazzoni, and Pampaloni Martelli 1978, figs. 19, 22, 24, 27, 28, 29–31, 34–37, 197–221; and Paolini, Ponte, and Selvafolta 1990, p. 452.

101.

Cabinet (*armoire*)

French (Paris), 1867
Designed by Jean Brandely (active 1855–67);
made by Charles-Guillaume Diehl (1811–
ca. 1885); mounts and large central plaque by
Emmanuel Frémiet (1824–1910)
Oak veneered with cedar, walnut, ebony, and
ivory; silvered bronze mounts
H. 93¾ in. (238 cm), w. 59½ in. (151 cm),
d. 23⅝ in. (60 cm)
Incised at the bottom edge and at the lower left
of the large plaque, respectively: "BRANDELY
DIEHL FREMIET" and "E. FREMIET."
Purchase, Mr. and Mrs. Frank E. Richardson
Gift, 1989
1989.197

When the prototype for this cabinet, now in the collection of the Musée d'Orsay, Paris, was exhibited at the Exposition Universelle in 1867, the reaction of the British Royal Commission was not at all favorable: "Some heavy work by Diehl, containing metal bas-reliefs by Fremiet, is an invention, though, probably, the visitor will not care to see such work repeated."[1] Perhaps the public would not have liked to see more of this kind of furniture, but Diehl must have been very pleased with the results because he ordered a second, nearly identical, cabinet for himself, the present example, now in the Museum's collection.[2]

Born in Steinbach, Hesse, Diehl moved to Paris in 1840. There he started a workshop that expanded into a large and thriving establishment specializing in the production of luxury objects and small pieces of furniture decorated with boulle marquetry, mounted with porcelain and bronzes, or veneered with costly woods.[3] Diehl participated in numerous international exhibitions, where his work was usually well received, and he was awarded many medals.

For the realization of an ambitious model that he intended to submit to the

Fig. 135. Detail of the projecting underside of the central plaque on the cabinet, inscribed with the names of the artists.

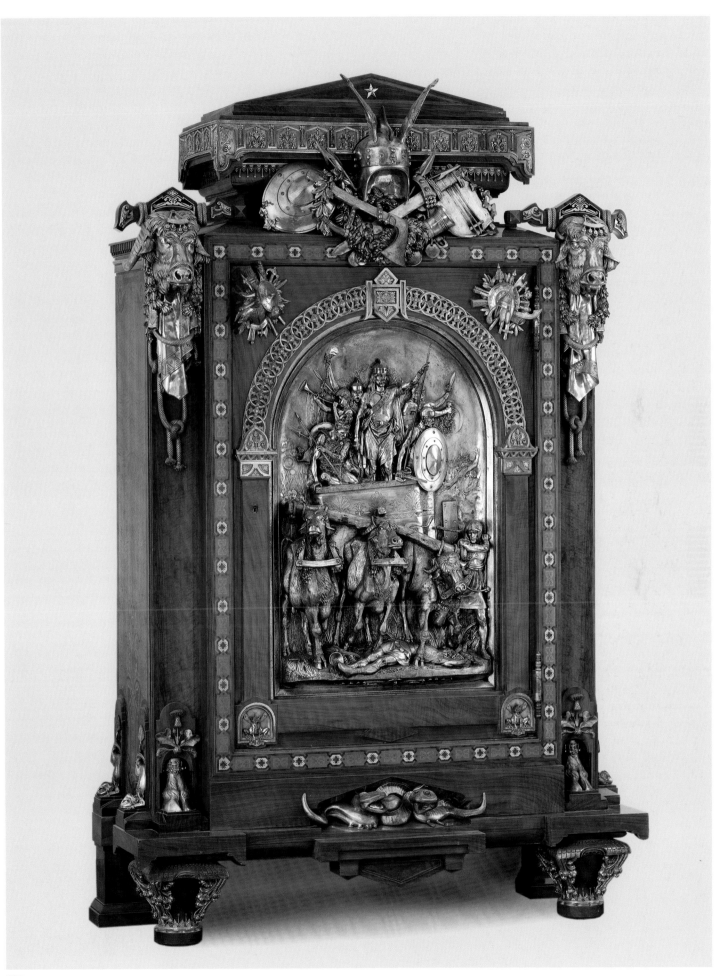

Paris exposition of 1867, Diehl enlisted the help of the industrial designer Jean Brandely and the sculptor Emmanuel Frémiet. Unlike much furniture of the period, which was executed in various revival styles, this piece is truly unconventional in shape. Unexpected, too, is its strong expression of French nationalism.[4] Beneath a sarcophagus-like top and above two front legs reminiscent of capitals, the armoire's central plaque of silvered bronze evokes a legendary past. It depicts the return of King Merovech (d. 458), leader of the Salian Franks, after defeating Attila at the battle of the Catalaunian Fields in 451 and thereby saving Western Europe from the marauding Huns. Surrounded by armed warriors, Merovech stands atop an ox-drawn chariot while the driver urges the three hesitant oxen to step over the body of a fallen enemy.

Clearly serving as a triumphal arch, an openwork frieze frames the round-topped central plaque and is supported at each side by cedar-veneered pilasters. Trophies of Frankish arms and armor, corner mounts of yoked ox heads, hooves, and fantastic animals further strengthen the sculptural character of this highly unusual piece.[CD] The talented sculptor Frémiet, known for his vivid representations of animals and equestrian sculptures of historical figures in bronze, created these mounts as well as the central relief, on which his name appears twice (see fig. 135). The artist's fascination with natural history is clearly expressed in this work.

Diehl may well have made the first version of this model, which is fitted with fifty interior drawers for the storage of medals, with Emperor Napoleon III (1808–1873) in mind.[5] The victory of King Merovech, founder of the Merovingian dynasty of Frankish kings, was a source of national pride to the French, and a special section devoted to the Merovingian era was included in the

Musée des Souverains established in Paris by Napoleon III in 1852.[6] A decade later the emperor decided to install a Gallo-Roman museum in the old château at Saint-Germain-en-Laye, subsequently known as the Musée des Antiquités Nationales. Despite the overt reference to a decisive moment in early French history, Napoleon III was not interested, and the cabinet remained unsold. Diehl was awarded only a bronze medal in the category of furniture by the jury of the exhibition, and considering this an offense, he refused to accept the award.[7]

Not all the criticism, however, was negative. The precisely executed marquetry border framing the door as well as the arabesques on the sides were praised as magnificent,[8] and the large relief was called "truly artistic."[9] Particularly positive was the description by Jules Mesnard in his *Les merveilles de l'Exposition Universelle de 1867*.[10] After commenting favorably on Diehl's extreme originality, the author expounded on the Merovingian style of the piece, wondering how the artist found models for it since the art, and especially the furniture, of this period was practically nonexistent. Mesnard went on to say that Diehl did not create a cabinet in the Merovingian manner but in the spirit, style, and taste of that era. Praising the correctness of the chariot and its decoration, the costumes, and the arms and armor, Mesnard described Frémiet, who had made equestrian sculptures of a Gallic chief and a Roman horseman in 1866 for the Musée des Antiquités Nationales,[11] as famous for his archaeological veracity. The author also commented on the unusual hidden hinges that are enclosed inside the cabinet once the door is shut. In 1873 the armoire was sent to the international exhibition in Vienna, where again it failed to find a buyer. Not until a century had passed did the French government finally acquire it for the national collections.

This version of the *armoire*, which Diehl commissioned for his own use, differs in some aspects from its prototype. The interior is fitted as a regular *armoire* rather than as a medal cabinet. On the exterior Diehl made several changes as well, enriching it with extra mounts, also by Frémiet, in the shape of trophies of arms placed in the spandrels of the arch as well as with the fantastic, almost froglike creatures in the corners below.[CD] Diehl kept the piece at his country house at Lagny, east of Paris, until his death, whereupon Albert Dubosc (1874–1956), a collector of works by Frémiet, acquired it for his residence La Roseraie at Sainte-Adresse.[12] Dubosc must have counted himself lucky to acquire this cabinet with dramatized central plaque and its innovative mounts, for it is among a handful of pieces of furniture that incorporate work by Frémiet.[13] The Museum purchased it from descendants of Dubosc, becoming only the third owner of this most compelling armoire.

DK-G

1. *Reports on the Paris Universal Exhibition* 1868, p. 284, quoted in Hunter-Stiebel 1989, p. 40.
2. "Recent Acquisitions" 1990, pp. 33–34 (entry by James Parker).
3. D. Ledoux-Lebard 1984, pp. 164–67.
4. Hunter-Stiebel 1989, p. 38.
5. Vitry 1898, p. 67, n. 1.
6. The Musée des Souverains was located in the Musée du Louvre, in the rooms behind Claude Perrault's colonnade on the east facade; *Second Empire* 1978, p. 104, no. II-23 (entry by Daniel Alcouffe).
7. Hunter-Stiebel 1989, p. 40.
8. *Rapports des délégations ouvrières* 1869, p. 12.
9. *Universal Exhibition* 1867–68, p. 151.
10. Mesnard 1867, vol. 1, pp. 178–81.
11. Chevillot 1988, pp. 107, 116–19, nos. 90, 92.
12. Biez 1910, pp. 268, 280, ill. facing p. 252.
13. A smaller cedarwood and walnut humidor cabinet, incorporating similar mounts by Frémiet, appeared on the Paris art market in 1990. Additional small boxes for cigars with Frémiet mounts were on the Paris art market in 2003. Photographs of these pieces are in the archives of the Department of European Sculpture and Decorative Arts, Metropolitan Museum.

Frame

Italian (Florence), 1870

Egisto Gajani (1832–1890)

Carved and partially gilded walnut; modern mirror glass backed with oak

H. 30¾ in. (78.1 cm), w. 22¾ in. (57.9 cm), d. 3⅝ in. (9.2 cm)

Incised on the frame below the glass: "EGISTO GAJANI FECE/ FIRENZE 1870."

Gift of James Parker, in memory of Alfreda Huntington, 1992

1992.317

At the Exposition Universelle of 1867 in Paris, Egisto Gajani showed various examples of his talent, including two sumptuously sculptured frames that had taken nearly a year to complete.[1] Reproduced in *The Illustrated Catalogue of the Universal Exhibition,* one of these oval frames was largely composed of luxuriant openwork acanthus scrolls and the other was nearly identical to the Museum's object (fig. 136).[2] Gajani's works were, according to the commentary, "of rare excellence in execution, and in design prominent among the best of Italy."[3]

Gajani was one of a small group of virtuoso carvers active in Florence and Siena during the second half of the nineteenth century. In search of a national style after the unification of Italy in 1861, they worked

Fig. 136. A closely related mirror by Egisto Gajani shown at the Paris Exposition Universelle of 1867, in *The Illustrated Catalogue of the Universal Exhibition* (London and New York, 1867–68).

to fourteen craftsmen in 1867.[4] Working frequently for foreign clients, the artist designed and executed entire room decorations—furniture as well as smaller objects. Between 1865 and 1887 he was a regular participant in the international exhibitions, where he received a number of awards. Together with his distinguished colleague Luigi Frullini (1839–1897), Gajani issued an undated album of photographs entitled *Panneaux et ornements en bois sculptés.*[5] These images show that although the artists at times adopted a very similar manner, Frullini's work was predominantly characterized by its graceful tendrils and minute renderings of plants and birds. Gajani's art, on the other hand, was generally executed in a bolder style that translated well into the decoration of larger pieces of furniture as well as of monumental mantelpieces.

The Museum's oval frame, now fitted as a mirror, has a winged putto in a contrapposto pose standing in a scallop shell as crest decoration.[6] CD Cords strung with clusters of various fruits and pinecones, carved almost in the round, descend from the raised arms of this naked *amorino* along the upper edges of the frame. Beautifully contrasting with the punched and gilded background, the high-relief decoration consists further of a grotesque mask, coiling acanthus leaves and flowers, as well as fantastic dragon-headed creatures with birdlike bodies. A strapwork cartouche below, incised with the name of the artist and place and date of origin, shows this frame to be a later

variation of the one exhibited in Paris in 1867.CD The sensuality of the putto, combined with the fruit garlands that are somewhat reminiscent of the ceramic wreaths by the Della Robbia family, and the fanciful creatures and plant ornament, lend the frame an unmistakably nineteenth-century flavor. They illustrate clearly that rather than being a mere copyist, Gajani was a talented artist who possessed a spirited imagination.

Not only did Gajani use this model, albeit slightly changed, at least twice but the Sienese artists Arturo Guidi (1844–1911), Angelo Querci (1838–1900), and Gaetano Gosi (1835–after 1892) executed a similar frame in 1870, signaling a certain vogue for this kind of richly sculptured decorative object in a Renaissance-inspired style.[7]

The frame was the gift of James Parker, an authority on European furniture, curator at the Museum for four decades, and a cherished colleague, in memory of a close Anglo-American friend and a wonderful hostess, Alfreda Huntington, in 1992.[8] DK-G

1. Chiarugi 1994, vol. 2, p. 478.
2. *Universal Exhibition* 1867–68, pp. 125, 210.
3. Ibid., p. 210.
4. Chiarugi 1994, vol. 2, p. 478. See also *Esposizione Universale* 1867, pp. 37–38; Gubernatis 1889, pp. 211–12.
5. The album consists of twenty-six sheets of photographs. A copy is in the Thomas J. Watson Library at the Metropolitan Museum.
6. Gere 1999, p. 35.
7. Chiarugi 1994, vol. 1, p. 306, fig. 413.
8. Draper 1994, p. 24.

in a manner that was derived from the Italian Renaissance, and it quickly found favor all over Europe and also in America. Trained in Florence, first under Angiolo Barbetti (1805–1873) and subsequently under Francesco Morini (1822–1899), Gajani opened his own workshop in Florence in the early 1860s. It was to become one of the most esteemed in the city, employing twelve

103.

Settee

English (London), 1885
Designed by Sir Lawrence Alma-Tadema (1836–1912); made by Johnstone, Norman and Company, London
Ebony, boxwood, sandalwood, cedarwood, ebonized mahogany, ivory, mother-of-pearl, and brass; covered in modern silk, colored trim
H. 35½ in. (90.2 cm), w. 58¼ in. (148 cm), d. 28 in. (71.1 cm)
Bequest of Elizabeth Love Godwin, 1975
1975.219a

In 1881 Henry Gurdon Marquand (1819–1902), a wealthy banker, Museum benefactor, and collector, commissioned his friend the eminent architect Richard Morris Hunt (1827–1895) to design a residence for him in New York City.[1] Located at the northwest corner of East Sixty-eighth Street and Madison Avenue, Hunt's four-story mansion in a French transitional style was finished in 1884. Its interiors, the collabora-

tive work of several American and European artists working under Hunt's direction, took until 1888 to complete. For each of the rooms a different historical style was chosen, with Marquand's art collection as an integral part of the decoration.

One of the most beautiful and best documented rooms of the house was the Greek Parlor, or Music Room, on the main floor, for which the Dutch-born English painter

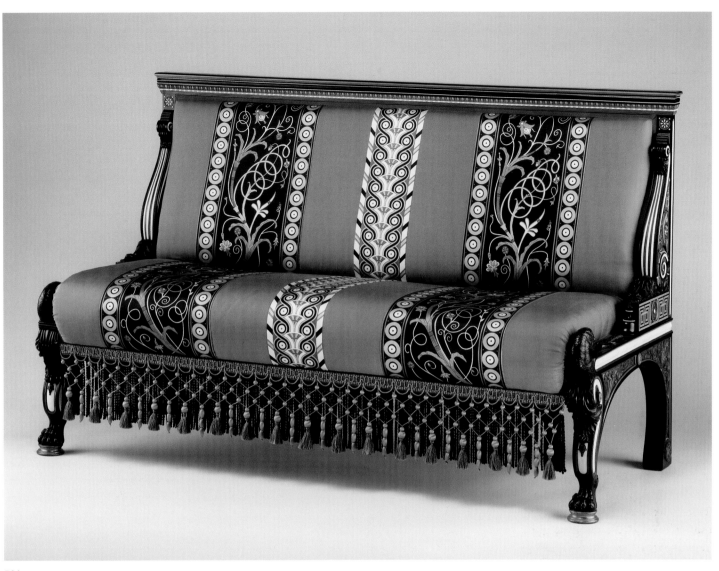

103

Fig. 137. Undated photograph of the Music Room at the Marquand residence, New York City. Nassau County Museum of Art, Roslyn Harbor, New York.

Sir Lawrence Alma-Tadema designed the classicizing furnishings. Although his artistic reputation was based on his genre paintings of the ancient world, this was not the only time Alma-Tadema was to act as designer, for he also created the interiors of his two homes in London, noted for their highly original and eclectic decoration.[2]

The Museum's unusual settee was part of the seating furniture made for the Marquand Music Room, which comprised a second, identical, settee, two smaller ones with curved backs to be placed in the alcove, a pair of tub-shaped armchairs, and four side chairs. These pieces were all similarly carved with ducks' heads and decorated with scrolling tendrils, rosettes, stylized palmettes, and adaptations of the Greek-key motif. The owner's monogram was inlaid in the outer backs of the chairs. In addition there were two round onyx-topped tables, a music cabinet, and a pair of corner display cabinets, as well as the grand piano with its matching stools.

Alma-Tadema selected the London firm of Johnstone, Norman and Company to execute his designs. In a letter to Marquand in March 1884 he advised: "I have asked the people who work generally for me & understand my wishes Messrs. Johnston [sic] Norman & Co. who do every thing amongst others for the Prince of Wales, if such be a recommendation [sic], to write to you on the subject of your drawing room. They will execute the things under my direction & according to my sketches if you allow me to mix up with it. I offer this as no firm will be able to do the thing good enough without the advice of a specialist."[3] W. C. Codman provided working drawings for the carving, inlay, and embroidery, under Alma-Tadema's supervision. The artist kept his patron regularly abreast of the progress made. In September 1884 he communicated to Marquand that "the furniture progresses. I have looked at it several times. We have succeeded in making the corner of [the] sofa most comfortable as also the easy chair & I am convinced that it will turn out a success, which is of course necessary."[4] In April of the following year Alma-Tadema's correspondence with Marquand in New York included the news that the furniture was "progressing favorably" as well as that "[Johnstone, Norman and Company] seem to be pleased with it & as workmanship I really believe you could not get anything better. I hope for goodness

Fig. 138. Portiere from the Music Room at the Marquand residence, New York City, ca. 1885. Ribbed silk with satin- and stem-stitch embroidery in silk and silk-satin appliqués; 102¼ x 41 in. The Metropolitan Museum of Art, New York, Rogers Fund, 1996 (1996.330).

sake that it will please you."[5] By the summer of 1885 the set of furniture, with the exception of the grand piano, was completed. Exhibited in July of that year at Johnstone's New Bond Street showroom, the suite, considered befitting "a fairy palace," was positively reviewed in various contemporary journals.[6] It was praised as much for the "quaintness of its design" as for the high quality of the workmanship and the richness of the materials used.[7]

With its wonderful carved detail and colorful inlays, the furniture clearly reflected Alma-Tadema's interest in and study of classical archaeology. In 1863 the artist had traveled on his honeymoon to Italy, visiting Rome, Naples, and the excavations at Pompeii. Not only did Alma-Tadema make measured drawings while in Italy, but over the years he also built up an extensive photographic documentation of both Roman and Greek buildings and architectural details

that served him for his paintings.[8] Undoubtedly, Alma-Tadema drew inspiration from his photographic archives for the Marquand furnishings as well. For instance, the shape of the armchairs (see fig. 137) is freely derived from stone seats in ancient Greece of which he owned photographs,[9] while the ovolo-and-beaded border along the top rail of the settee and around the top of the grand piano case is closely related to an image of an architectural fragment also in Alma-Tadema's collection.[10] Even more striking is the resemblance of the piano's heavy front legs, shaped like winged lions, to Roman marble table supports known as *protomes*. The painter may have seen these during his journeys to Italy, and his photograph archives included at least two similar images—one from the House of Gaius Cornelius Rufus and another from the House of Meleager, both in Pompeii.[11] The graceful, curving wing and the muscular body of the lion sheathed by acanthus leaves can be clearly recognized from this type of *protome*. The flowing scrolls and tendrils, the anthemia and bellflowers, and the corded, ribbed stalks emerging from acanthus leaves embellishing the case of the piano and the pieces of seating furniture can be traced to the same source. Similar patterns, executed in silk embroidery and appliqué on green gray rep silk, were used for the upholstery, curtains, and portieres in the same room (fig. 138). The colors of the fabric, with its floral ornament, rosettes, and Greek-key motifs, clearly reflected those of the various woods, coral, and mother-of-pearl of the furniture and piano frames.

Green gray silk, decorated with scrolls and stylized leaves in gold, also covered the walls above the marble dado.

Paintings and painted decoration were an important aspect of the room. Alma-Tadema had asked Frederic, Lord Leighton (1830–1896), the best-known classicizing painter of the day in Great Britain, to create a painting for the ceiling, and two of Alma-Tadema's own works were hung on the walls. In addition Alma-Tadema commissioned Sir Edward Poynter (1836–1919) to paint the inside lid of the piano, for which the artist produced *The Wandering Minstrels* in 1887.

Widely considered a New York landmark in its day, the mansion did not survive its owner for very long, as it was torn down in 1912. Even earlier, following Marquand's death, his art collection was disposed of at a very successful auction in January 1903 that included the furnishings of the Music Room.[12] As a result, the furniture and piano are now divided among various private and public collections.[13] Although the entire suite was offered for sale, one of the settees remained in the possession of the family, and it came to the Museum in 1975 as a bequest of Marquand's granddaughter Elizabeth Love Godwin. At the time it no longer retained its original show covers or trimmings, but the materials of the understructure remained intact. The location and width of the original embroidered panels were clearly visible on the inner back, denoted by pencil lines and the discoloration of the cotton filler cover.[CD] In an attempt to supply the settee with covers that

were close to Alma-Tadema's designs, the Museum had it reupholstered in green gray silk, with silk-screened panels replacing the original embroideries, and provided with a deep fringe as seen in old photographs.[14]

DK-G

1. Most of the information in this entry is derived from Kisluk-Grosheide 1994.
2. On the interiors at Townshend House, near Regent's Park, where Alma-Tadema lived between 1870 and 1886, as well as those of his house at 17 Grove End Road, where he subsequently lived, see Treuherz 1997, pp. 45–49, 51–56.
3. Alma-Tadema to Marquand, 2 March 1884; Allan Marquand Papers, Manuscripts Division, Department of Rare Books and Special Collections, Princeton University Library.
4. Alma-Tadema to Marquand, 29 September 1884; Archives of the Metropolitan Museum.
5. Alma-Tadema to Marquand, 10 April 1885; Allan Marquand Papers.
6. "Classic Furniture" 1885.
7. "Furniture" 1885. See also "Art in August" 1885, p. xliii; "Art Notes" 1885, p. 290; and "Furniture for New York Millionaires" 1885.
8. Tomlinson 1991, pp. 1–6; and Pohlmann 1997, pp. 111–18.
9. Tomlinson 1991, p. 121; Treuherz 1997, pp. 50–51, figs. 34, 35.
10. Pohlmann 1997, p. 115, fig. 107.
11. Kisluk-Grosheide 2000b, pp. 54, 56, figs. 10, 11.
12. Catalogue of the Henry G. Marquand collection sale, American Art Association, Anderson Galleries, New York, 23–31 January 1903. The Alma-Tadema furniture was offered as lot 1364a–f.
13. The armchairs are divided between the collection of the Victoria and Albert Museum, London, and the National Gallery of Victoria, Melbourne. See Wilk 1996, pp. 176–77 (entry by Frances Collard). The music cabinet is in the Chrysler Museum of Art, Norfolk, Virginia, and the piano is in the Sterling and Francine Clark Art Institute, Williamstown, Massachusetts.
14. Gill 2001, pp. 33–43, fig. 2.4.

Glossary

Rose Whitehill

Cross-references are indicated by the use of SMALL CAPITALS.

acanthus: an ornament derived from the spiky leaves of the acanthus plant. It appears on the Corinthian capital and was a very popular motif in Renaissance and Baroque carving.

à châssis: a French term used to describe seat furniture with a removable back, seat, and arm pads.

aedicula: a structure resembling a small building, with columns and PEDIMENT suggesting a shrine.

amaranth: a dense purple-red wood from Guyana and South America used for VENEER and MARQUETRY and especially popular during the eighteenth century. It is also known as purpleheart or purplewood.

apron: a shaped horizontal element beneath the seat RAIL of a chair or settee or under a tabletop.

arabesque: a carved or painted decoration consisting of interlaced and scrolling FOLIATE lines.

athénienne: a small decorative table resembling an antique tripod, used as a brazier, plant stand, or washstand.

atlas: a nude or seminude male figure used as a supporting column.

auricular: in a curving, amorphous style characteristic of Dutch Mannerism, evoking the shapes of a shell's interior or the lobe and folds of the human ear.

baluster: a pillar of vaselike outline usually supporting a railing. A series of these shafts is called a balustrade.

bergère: a French term for an armchair upholstered between the arms and the seat.

bluing: a technique of ornamenting steel involving heat, used mainly in the manufacture of swords and armor.

bois satiné: a South American wood of a deep red hue popular for VENEER and MARQUETRY especially during the eighteenth century.

bombé: a French term meaning thrust out; a rounded or bulging silhouette on the front or sides of CASE FURNITURE.

boulle work: a type of MARQUETRY perfected by André-Charles Boulle (1642–1732) in which identically thin sheets of tortoiseshell and brass are glued and then cut together in a design; the layers are then combined and applied to the CARCASE of a piece of furniture. If the brass design is inlaid in the tortoiseshell, the work is called *première partie*, and if the tortoiseshell design is inlaid in the brass ground, the work is called *contre partie*.

breakfront: descriptive of a piece of CASE FURNITURE in which the central section projects beyond the side sections.

brecchiated marble: a fine-grained limestone in which sharp fragments of rock are embedded, forming a variegated pattern. It is often used for the tops of tables and COMMODES.

bucranium: a decorative motif of ox skulls, often with garlanded horns.

bun foot: a flattened ball foot.

bureau brisé: a French term (meaning literally, "broken desk") for a writing table with a hinged top that opens or "breaks" across the middle to reveal a writing surface inside. Fashionable during the last three decades of the seventeenth century, this type of desk was supplanted by the BUREAU PLAT during the early eighteenth century.

bureau plat: the French term for a writing table with a flat, often leather-covered top and with drawers in the FRIEZE.

burl or **burr:** an abnormal growth on a tree. Its irregular grain makes it desirable for use as VENEER.

cabochon: a convex oval or round sculpted ornament resembling an unfaceted gemstone. It is often set among carved ACANTHUS foliage.

cabriole leg: a furniture leg that curves outward at the knee, then inward, ending in a scrolled foot.

canapé: a French term for a settee or sofa.

caning: rattan wickerwork used for the seat and back of chairs.

canted: descriptive of an edge or corner that is beveled or oblique.

carcase: the framework or body of a piece of furniture.

cartoon: a full-scale design used as a model or pattern.

cartouche: an ornament resembling a partly unrolled sheet of paper or scroll; sometimes an oval tablet bearing an inscription or armorial device.

caryatid: a female figure used as a support for a capital or an entablature.

case furniture: a category that includes bureaus, bookcases, and any other cabinet piece intended to contain something.

chasing: the decoration of metal by punching relief patterns in the surface; the removal of surface blemishes from metal by tooling.

chinoiserie: European imitations of, for the most part, Chinese art. They are usually more evocative than accurate.

ciselure: the French term for the CHASING and finishing given to bronze sculptures and bronze furniture MOUNTS. The specialist in this work was called a *ciseleur*; see also FONDEUR-CISELEUR.

coffer: a small chest usually intended to hold papers or precious items; also a recessed panel in a ceiling, usually one of many—hence the term "coffered ceiling."

commode: a French term for a low chest of drawers often made in pairs. It was introduced during the early eighteenth century.

commode à vantaux: a variant of the COMMODE. Its drawers are enclosed by doors.

commode en console: a cross between a CONSOLE TABLE and a COMMODE, it is fitted with one drawer and supported on two CABRIOLE LEGS. Designed to be attached to the wall, it usually stands underneath a mirror.

console table: a table placed against or fixed to a wall, usually without legs in back, and often set beneath a mirror.

contre partie: see BOULLE WORK.

diaper: a repeated, allover pattern of diamond or rectangular shapes.

drop front: see FALL FRONT.

ébéniste: the French name for a cabinetmaker specializing in VENEERED furniture.

écran: a French term for a screen, especially a fire screen.

encoignure: the French term for a type of low corner cupboard, often made in pairs.

en suite: a term designating a set of matching furniture; an ensemble.

escutcheon: a shield or shield-shaped ornament bearing an emblem or coat of arms; also a metal plate, often of gilded bronze, used to protect a keyhole and the surrounding surface of a piece of furniture.

fall front or **drop front:** a hinged panel on the front of a piece of CASE FURNITURE that can be lowered to form a writing surface. The French term for fall-front pieces is *à abattant*.

fauteuil: the French term for an open armchair with an upholstered back and seat. A version of this with a straight back is called a *fauteuil à la reine*. When the back is curved, such a chair is called a *fauteuil en cabriolet*.

247

fauteuil meublant: the French term for a formal armchair meant to stand against the wall.

festoon: a representation of a floral garland gathered up at either end and bound with ribbons.

fillet: in cabinetwork, a plain, very narrow band, usually a strip of VENEER.

finial: a small ornamental sculpture, often in the form of an acorn, urn, or flame, placed on top of furniture or on the cover of a vase.

foliate: in the shape of a leaf.

fondeur-ciseleur: the French name for a specialist in casting and chasing metal. The members of the guild of *fondeurs-ciseleurs* made the bronze MOUNTS that distinguish much elegant eighteenth-century French furniture.

fretwork: a decorative band of intersecting horizontal and vertical lines, forming a Greek-key or meander pattern.

frieze: a continuous, flat, rectangular band underneath a cornice or tabletop.

gadrooning: a series of oval beads, lobes, or flutes used to decorate an edge.

galloon: a braidlike upholstery trim.

gesso: a mixture of plaster of paris, sizing, and/or glue used to make a base for carved and painted or gilded ornamentation.

girandole: an elaborate branched candlestick or candelabrum, in some cases portable, in others mounted as a wall bracket.

Greek-key pattern: see FRETWORK.

grisaille: decorative painting in monochrome, usually whites or grays, giving the illusion of relief sculpture.

gros point: the French term for cross-stitch embroidery worked on canvas or similar material on a larger scale than PETIT POINT.

grotesque: a classically inspired ornament that features fantastic beasts, birds, and humans set amid scrolling FOLIATE motifs.

guilloche: a braidlike ornament in which two bands twist in opposite directions around a central circle or rosette.

hardware: furniture parts or fittings made of metal.

harpy: a monstrous creature with a woman's head and breasts and a bird's claws and wings.

husk: an ear of wheat, often portrayed strung or suspended in a garland.

inlay: a decorative technique whereby small, shaped pieces of contrasting wood, ivory, or metal are set into the wooden CARCASE or frame of furniture. It differs from MARQUETRY, a VENEER-ING technique in which the whole surface of the furniture is covered.

jardinière: a French term for a table or stand intended to hold flowers or plants.

joiner: a craftsman who constructs pieces of furniture from solid wood—such as chairs, tables, and beds—to be decorated with carving rather than VENEER.

lambrequin: a carved or painted ornament imitating draped cloth with tassel or fringe embellishment.

latticework: see TRELLISWORK.

lobing: see GADROONING.

lozenge: a diamond-shaped figure.

marchands-merciers: eighteenth-century Parisian dealer-decorators. They not only sold but ordered and may also have helped to design luxury furnishings, frequently becoming catalysts in the development of new fashions and decorating trends.

marquetry: a decorating technique whereby small pieces of wood or other precious materials (e.g., ivory or metal) are arranged on the surface of a piece of furniture to form a decorative VENEER. The patterns may include floral or figurative designs, but if a geometric design is employed, the technique is called parquetry.

menuisier: a French term for JOINER.

mercer: a dealer in textiles and trim.

mercury gilding: a method of decorating bronze and other metals with gold. Ground gold (see ORMOLU) was mixed with mercury and applied to the base metal, which was then heated over an open fire. The gold would adhere to the base metal but the mercury would evaporate. The process was repeated several times until a sufficiently thick layer of gold had been formed. The gilded product might be burnished or was left matt.

modillion: a small console or bracket, usually in a series, supporting a cornice.

monochrome: painting in a single hue or color (see GRISAILLE).

mount: a decorative and sometimes also functional metal attachment to a piece of furniture.

ormolu: a French term (*or moulu*) meaning ground gold; the gilded bronze used for decorative objects and furniture mounts.

Palladian: influenced by the classical style of the Italian architect Andrea Palladio (1508–1580). Palladian furniture is characterized by the use of such motifs as masks, SWAGS, and PEDIMENTS.

parcel gilding: a technique of gilding furniture whereby only the carved ornamentation is gilded.

parquetry: see MARQUETRY.

passementerie: a French term for the trim in gold or silver lace or braid used to decorate textiles and upholstery.

patera: a small circular ornament decorated in low relief, often with a floral or ACANTHUS motif in the center.

pediment: a triangular structure set above the cornice of bookcases or cabinets, imitating the gable over the portico of a classical temple.

petit point: the French term for a diagonal embroidery stitch called tent stitch, worked on a smaller scale than GROS POINT.

pier glass: a tall mirror placed on the pier or wall between two windows.

pietre dure: an Italian term meaning hard stones; the use of semiprecious stones or colored marble to create large-scale objects such as vases and sculpture, or in mosaic form to decorate tabletops and furniture panels.

plinth: a usually square base for a pilaster or column.

première partie: see BOULLE WORK.

rail: a horizontal element in the framework of a chair.

reparure: a French term for the work that is done to refine the carved decoration on a piece of furniture intended for gilding, after several preparatory coats of whiting have dulled the carving. It also includes the addition of new details before the gold leaf is applied.

repoussé work: the ornamentation of a sheet of metal produced by hammering it from the underside, creating a design in relief.

rinceau: a scrolling-foliage motif.

ripple molding: a continuous band of small grooves placed close together to produce an undulating effect.

rocaille: a French term meaning rockwork. It originally designated the natural materials used in grotto and garden decoration, such as shells and stones. Their irregular, asymmetrical contours became an important feature of the Rococo style, with its emphasis on C-curves and fantastic shapes.

scroll foot: a furniture foot carved into a scroll or tight S-shape.

show cover: the decorative and often costly top layer of upholstery on a piece of furniture. Unlike the UNDER UPHOLSTERY, it is meant to be seen.

slip seat: a seat that can be dropped into and removed from a chair frame.

splat: the vertical central panel of a chair back extending from the top RAIL to the seat rails.

splayed: curving or extending outward.

stile: an upright supporting post on a piece of seating furniture, extending from the foot to the top RAIL.

stippling: ornament creating by punching small dots on a surface.

strapwork: ornament consisting of narrow interlaced bands.

stretcher: a crosspiece that joins the legs of a table or chair, providing extra support.

swag: a representation of a length of cloth suspended and tied up in a loop at each end.

tambour top: in cabinetwork, a type of flexible shutter made of thin strips of wood glued to a fabric backing; often used for the roll tops on desks.

tester: the canopy over a bed. Made of cloth or wood, it is generally supported on four posts.

trelliswork or **latticework:** an arrangement of strips of wood or metal in a woven crisscross pattern.

trompe l'oeil: a French term meaning "fool the eye"; giving a three-dimensional effect in a two-dimensional medium.

trophy: originally, a pile of armor and other spoils of war commemorating a victory. Later, the attributes of the arts, sciences, love, pastoral life, and music might be painted or carved in a similar way as a purely decorative motif.

under upholstery: that part of the upholstery of a chair or sofa concealed by a SHOW COVER.

veneer: a thin layer of a superior wood applied to the CARCASE of a piece of furniture. The carcase is usually made of a secondary, less fine wood, such as oak or pine.

verdigris: a blue green pigment, consisting of copper acetate, which is often dissolved and used as a stain.

verre églomisé: a plate of glass decorated on the back with an unfired painted design or gilding.

Vitruvian scroll: a classical ornament consisting of running scrolls that resemble waves. It is usually used to decorate the FRIEZE of a table or other edge.

volute: a spiral, scrolling form, found, for example, on either side of the Ionic capital.

webbing: wide strips of usually woven material interlaced and tacked to a chair frame; part of the invisible UNDER UPHOLSTERY that with the linen sackcloth on top forms the foundation for the stuffing of the seat or for the seat cushion.

Bibliography

"Acquisitions" 1987
"Acquisitions/1986." *J. Paul Getty Museum Journal* 15 (1987), pp. 151–238.

Age of Neo-Classicism 1972
The Age of Neo-Classicism. Exh. cat., Royal Academy of Arts and Victoria and Albert Museum. London, 1972.

Alcouffe 2002a
Daniel Alcouffe. "Le décor peint des cabinets d'ébène." *Dossier de l'art,* no. 86 (May 2002), pp. 16–23.

Alcouffe 2002b
Daniel Alcouffe. "La naissance de l'ébénisterie: Les cabinets d'ébène." In *Un temps d'exubérance* 2002, pp. 212–17.

Alcouffe and De Bellaigue 1981
Daniel Alcouffe and Geoffrey De Bellaigue. *Il mobile francese dal Rinascimento al Luigi XV.* I quaderni dell'antiquariato. Collana di arti decorative 9, year 1. Milan, 1981.

Alexeieva 1993
Alexandra Vassilievna Alexeieva. "Furniture." In *Pavlovsk,* ed. Emmanuel Ducamp, vol. 2, *The Collections,* pp. 92–115. Paris, 1993.

Alfter 1986
Dieter Alfter. *Die Geschichte des Augsburger Kabinettschranks.* Schwäbische Geschichtsquellen und Forschungen 15. Augsburg, 1986.

Alonso Pedraz 1986
Martín Alonso Pedraz. *Diccionario medieval español: Desde las Glosas Emilianenses y Silenses (s. X) hasta el siglo XV.* 2 vols. Salamanca, 1986.

American National Biography 1999
American National Biography. Ed. John A. Garraty and Mark C. Carnes. 24 vols. New York, 1999.

Anatole Demidoff 1994
Anatole Demidoff: Prince of San Donato (1812–70). Exh. cat., Wallace Collection. Collectors of the Wallace Collection 1. London, 1994.

Angelmaier, Freyer, and Huber 2004
Ursula Angelmaier, Ulli Freyer, and Andreas Huber. *Der Kabinettschrank des Würzburger Fürstbischofs Johann Gottfried von Guttenberg von Johann Daniel Sommer.* Künzelsau, 2004.

Antichità di Ercolano 1757–92
Le antichità di Ercolano esposte. 8 vols. Naples, 1757–92.

Aprà 1972
Nietta Aprà. *The Louis Styles: Louis XIV, Louis XV, Louis XVI.* London, 1972.

Arenhövel 1979
Willmuth Arenhövel, ed. *Berlin und die Antike: Architektur, Kunstgewerbe, Malerei, Skulptur, Theater und Wissenschaft vom 16. Jahrhundert bis heute.* 2 vols. Exh. cat., Schloss Charlottenburg. Berlin, 1979.

Argenson 1857–58
René-Louis de Voyer, marquis d'Argenson. *Mémoires et journal inédit du marquis d'Argenson, ministre des affaires étrangères sous Louis XV.* 5 vols. Paris, 1857–58.

Arizzoli-Clémentel 1994
Pierre Arizzoli-Clémentel. "Néoclassicisme." In *L'art décoratif en Europe,* ed. Alain Gruber, vol. 3, *Du Néoclassicisme à l'Art Déco,* pp. 21–127. Paris, 1994.

Arizzoli-Clémentel 2002
Pierre Arizzoli-Clémentel. *Versailles: Furniture of the Royal Palace, Seventeenth and Eighteenth Centuries.* Vol. 2. Trans. Ann Sautier-Greening. Dijon, 2002.

"Art in August" 1885
"Art in August." *Magazine of Art* 8 (August 1885), pp. xli–xliv.

"Art Notes" 1885
"Art Notes and Reviews." *Art-Journal,* September 1885, pp. 289–92.

Art Treasures Exhibition 1932
Art Treasures Exhibition, 1932. Exh. cat., Christie, Manson & Woods. London, 1932.

Art Treasures Exhibition 1955
Art Treasures Exhibition. Exh. cat., Parke-Bernet Galleries. New York, 1955.

Ash 1965
Douglas Ash. "Gothic." In *World Furniture: An Illustrated History,* ed. Helena Hayward, pp. 26–34. New York, 1965.

Augarde 1989
Jean-Dominique Augarde. "L'ameublement du palais directorial du Luxembourg." In *De Versailles à Paris: Le destin des collections royales,* ed. Jacques Charles, pp. 141–48. Paris, 1989.

Baarsen 1988a
Reinier Baarsen. "The Court Style in Holland." In Baarsen et al. 1988, pp. 12–35.

Baarsen 1988b
Reinier Baarsen. "Mix and Match Marquetry." *Country Life* 182 (October 13, 1988), pp. 224–27.

Baarsen 1993a
Reinier Baarsen. *Nederlandse meubelen, 1600–1800/Dutch Furniture, 1600–1800.* Rijksmuseum, Amsterdam. Amsterdam and Zwolle, 1993.

Baarsen 1993b
Reinier Baarsen. "Twee meubelen uit 1622." *Antiek* 28 (December 1993), pp. 204–11.

Baarsen 1996
Reinier Baarsen. "Herman Doomer: Ebony Worker in Amsterdam." *Burlington Magazine* 138 (November 1996), pp. 739–49.

Baarsen 2000a
Reinier Baarsen. "Een Augsburgs pronkkabinet." *Bulletin van het Rijksmuseum* 48 (Summer 2000), pp. 3–17.

Baarsen 2000b
Reinier Baarsen. *Seventeenth-Century Cabinets.* Rijksmuseum Dossiers. Zwolle and Amsterdam, 2000.

Baarsen 2002
Reinier Baarsen. "Newark and Denver: Dutch Interiors." Review of the exhibition "Art & Home: Dutch Interiors in the Age of Rembrandt." *Burlington Magazine* 144 (March 2002), pp. 189–91.

Baarsen et al. 1988
Reinier Baarsen, Gervase Jackson-Stops, Phillip M. Johnston, and Elaine Evans Dee. *Courts and Colonies: The William and Mary Style in Holland, England, and America.* Exh. cat., Cooper-Hewitt Museum, New York. New York, 1988.

Baarsen et al. 2001
Reinier Baarsen et al. *Rococo in Nederland.* Exh. cat., Rijksmuseum, Amsterdam. Waanders and Amsterdam, 2001.

Bachtler 1978
Monika Bachtler. "Die Nürnberger Goldschiedefamilie Lencker." *Anzeiger des Germanischen Nationalmuseums,* 1978, pp. 71–122.

C. H. Baer 1912
Casimir Hermann Baer. *Deutsche Wohn- & Festräume aus sechs Jahrhunderten.* Bauformen-Bibliothek 6. Stuttgart, 1912.

I. Baer 2001
Ilse Baer. "Table Tops from the Berlin Porcelain Manufactory (KPM) from the First Half of the Nineteenth Century." In *The International Ceramics Fair and Seminar Handbook,* 2001, pp. 11–18.

W. Baer 1981
Winfried Baer. "Möbel nach Schinkelentwürfen und ihre Vorbilder." In *Karl Friedrich Schinkel* 1981, pp. 290–92.

W. Baer and I. Baer 1983
Winfried Baer and Ilse Baer. *Auf allerhöchsten Befehl: Königsgeschenke aus der Königlichen Porzellan-Manufaktur.* Exh. cat., Haus an der Redoute, Bonn-Bad Godesberg; Hetjens-Museum, Düsseldorf; and Schloss Charlottenburg, Berlin. Veröffentlichung aus dem KPM-Archive der Staatlichen Porzellan-Manufaktur Berlin, KPM 1. Berlin and Arenhövel, 1983.

Baetjer 1995
Katharine Baetjer. *European Paintings in The Metropolitan Museum of Art by Artists Born before 1865: A Summary Catalogue.* New York, 1995.

Baetjer et al. 1986
Katharine Baetjer et al. "The Jack and Belle Linsky Collection in The Metropolitan Museum of Art: Addenda to the Catalogue." *Metropolitan Museum Journal* 21 (1986), pp. 153–84.

Balboni Brizza 1995
Maria Teresa Balboni Brizza, ed. *Stipi e cassoni.* Le guide del museo. Museo Poldi-Pezzoli, Milan. Turin, 1995.

Baldini, Giusti, and Pampaloni Martelli 1979
Umberto Baldini, Anna Maria Giusti, and Annapaula Pampaloni Martelli, eds. *La Cappella dei Principi e le pietre dure a Firenze.* Gallerie e musei di Firenze. Milan, 1979.

Balloon 1983
The Balloon: A Bicentennial Exhibition. Exh. cat., University Art Museum, University of Minnesota. Minneapolis, 1983.

Ballot 1919
Marie-Juliette Ballot. "Charles Cressent: Sculpteur, ébéniste, collectionneur." *Archives de l'art français*, n.s., 10 (1919). Repr., Paris, 1969.

Banta 2004
Andaleeb Badiee Banta. "A 'Lascivious' Painting for the Queen of England." *Apollo* 159 (June 2004), pp. 66–71.

Baroli 1957
Jean-Pierre Baroli. "Le mystérieux B.V.R.B. enfin identifié." *Connaissance des arts*, no. 61 (March 1957), pp. 56–63.

Bassett and Fogelman 1997
Jane Bassett and Peggy Fogelman. *Looking at European Sculpture: A Guide to Technical Terms.* J. Paul Getty Museum. Los Angeles, 1997.

Bauer, Märker, and Ohm 1976
Margrit Bauer, Peter Märker, and Annaliese Ohm. *Europäische Möbel von der Gotik bis zum Jugendstil.* Museum für Kunsthandwerk. Frankfurt am Main, 1976.

Baulez 1992
Christian Baulez. "Sèvres: Commandes et achats de Madame Du Barry." *L'estampille/L'objet d'art*, no. 257 (April 1992), pp. 34–53.

Baulez 1995
Christian Baulez. "'Toute l'Europe tire ses bronzes de Paris.'" In *Bernard Molitor, 1755–1833: Ébéniste parisien d'origine luxembourgeoise*, pp. 77–101. Exh. cat., Villa Vauban. Luxembourg, 1995.

Baulez 1996
Christian Baulez. "David Roentgen et François Rémond: Une collaboration majeure dans l'histoire du mobilier européen." *L'estampille/L'objet d'art*, no. 305 (September 1996), pp. 96–118.

Baulez 1997
Christian Baulez. "Le coffre à bijoux (1770) de Marie-Antoinette revient à Versailles." *Revue du Louvre/La revue des musées de France*, June 1997, pp. 17–19.

Baulez 2001
Christian Baulez. "Le grand cabinet intérieur de Marie-Antoinette: Décor, mobilier et collections." In Monika Kopplin, *Les laques du Japan: Collections de Marie-Antoinette*, pp. 28–41. Exh. cat., Musée National des Châteaux de Versailles et de Trianon, and Museum für Lackkunst, Münster. Paris, 2001.

Baulez and D. Ledoux-Lebard 1981
Christian Baulez and Denise Ledoux-Lebard. *Il mobile francese dal Luigi XVI all'Art Déco.* I quaderni dell'antiquariato. Collana di arti decorative 7, year 1. Milan, 1981.

Baumeister and Rabourdin forthcoming
Mechthild Baumeister and Stéphanie Rabourdin. "A Seventeenth-Century Parisian Ebony Cabinet Restored by Herter Brothers." In *Postprints of the Wooden Artifacts Group Presented at the 33rd Annual Meeting of the American Institute for Conservation, Minneapolis, Minnesota, June 2005.* Forthcoming.

Baumeister et al. 1997
Mechthild Baumeister, Jaap Boonstra, Robert A. Blanchette, Christian-Herbert Fischer, and Deborah Schorsch. "Gebeizte Maserfurniere auf historischen Möbeln/Stained Burl Veneer on Historic Furniture." In Katharina Walch and Johann Koller, with contributions by Mechthild Baumeister et al., *Lacke des Barock und Rokoko/Baroque and Rococo Lacquers*, pp. 251–96. Arbeitsheft (Bayerisches Landesamt für Denkmalpflege) 81. Munich, 1997.

Baumgärtel and Neysters 1995
Bettina Baumgärtel and Silvia Neysters, eds. *Die Galerie der starken Frauen/La galerie des femmes fortes: Regentinnen, Amazonen, Salondamen.* Exh. cat., Kunstmuseum Düsseldorf and Hessisches Landesmuseum, Darmstadt. Munich and Berlin, 1995.

Baumstark and Seling 1994
Reinhold Baumstark and Helmut Seling, eds. *Silber und Gold: Augsburger Goldschmiedekunst für die Höfe Europas.* 2 vols. Exh. cat., Bayerisches Nationalmuseum. Munich, 1994.

Beard 1997
Geoffrey Beard. *Upholsterers and Interior Furnishing in England, 1530–1840.* Bard Studies in the Decorative Arts. New Haven and London, 1997.

Beard and C. Gilbert 1986
Geoffrey Beard and Christopher Gilbert, eds. *Dictionary of English Furniture Makers, 1660–1840.* Leeds, 1986.

Beard and J. Goodison 1987
Geoffrey Beard and Judith Goodison. *English Furniture, 1500–1840.* Christie's Pictorial Histories. Oxford, 1987.

Beauchamp 1909
Comte de Beauchamp. *Comptes de Louis XVI.* Preface by Gaston Schéfer. Paris, 1909.

Behling 1942
Lottlisa Behling. *Der Danziger Dielenschrank und seine holländischen Vorläufer.* Veröffentlichungen des Stadtmuseums und Gaumuseums für Kunsthandwerk zu Danzig. Danzig, 1942.

Bencard 1992
Mogens Bencard. *Silver Furniture.* Trans. Martha Gaber Abrahamsen. Copenhagen, 1992.

Bénézit 1999
Emmanuel Bénézit. *Dictionnaire critique et documentaire des peintres, sculpteurs, dessinateurs et graveurs de tous les temps et de tous les pays.* New ed. Ed. Jacque Busse. 14 vols. Paris, 1999.

Benois 1903
Alexandre Benois. "Description du Grand Palais de Pavlovsk, rédigée et écrite par la grande-duchesse Marie Féodorovna en 1795." *Les trésors d'art en Russie* 3, pp. 371–82.

Bergvelt and Kistemaker 1992
Ellinoor Bergvelt and Renée Kistemaker, eds. *De wereld binnen handbereik: Nederlandse kunst- en rariteitenverzamelingen, 1585–1735.* Exh. cat., Amsterdams Historisch Museum. Zwolle and Amsterdam, 1992.

Berliner and Egger 1981
Rudolf Berliner and Gerhart Egger. *Ornamentale Vorlageblätter des 15. bis 19. Jahrhunderts.* 3 vols. 2nd ed. Munich, 1981.

Bernini Pezzini, Massari, and Prosperi Valenti Rodinò 1985
Grazia Bernini Pezzini, Stefania Massari, and Simonetta Prosperi Valenti Rodinò. *Raphael Invenit: Stampe da Raffaello nelle collezioni dell'Istituto Nazionale per la Grafica.* Rome, 1985.

Bertini 1982
Giuseppe Bertini. "Inventari e punzonature degli arredi ducali parmensi al tempo dei secondi Borbone." In *Saggi e testimonianze in onore di Francesco Borri*, pp. 47–55. Parma, 1982.

Bettag 1998
Alexandra Bettag. *Die Kunstpolitik Jean Baptiste Colberts: Unter Berücksichtigung der Académie Royale de Peinture et de Sculpture.* Weimar, 1998.

Beuque and Frapsauce 1929
Émile Beuque and Marcel Frapsauce. *Dictionnaire des poinçons de maîtres-orfèvres français du XIVe siècle à 1838.* Paris, 1929.

Bezirksamt Regensburg 1910
Bezirksamt Regensburg. Kunstdenkmäler von Oberpfalz & Regensburg 21. Munich, 1910.

Biez 1910
Jacques de Biez. *E. Frémiet.* Paris, 1910.

Blok 1918
Ima Blok. "De fontein op de Vischmarkt te Leiden." *Oud Holland* 36 (1918), pp. 247–55.

Blondel 1752–56
Jacques-François Blondel. *Architecture françoise; ou, Recueil des plans, élévations, coupes et profiles des églises, maisons royales, palais, hôtels & édifices les plus considérables de Paris.* 4 vols. Paris, 1752–56.

Bober and Rubinstein 1987
Phyllis Pray Bober and Ruth Rubinstein, with Susan Woodford. *Renaissance Artists and Antique Sculpture: A Handbook of Sources.* London and New York, 1987.

Boccaccio 1930
Giovanni Boccaccio. *The Decameron of Giovanni Boccaccio.* Trans. James Macmullan Rigg. 2 vols. Everyman's Library. London, 1930.

Boccaccio 1982
Giovanni Boccaccio. *The Decameron.* Trans. Mark Musa and Peter E. Bondanella. New American Library. New York, 1982.

Bodart 1975
Didier Bodart. "Une description de 1657 des fresques de Giovanni Francesco Romanelli au Louvre." *Bulletin de la Société de l'Histoire de l'Art Français,* 1974 (pub. 1975), pp. 43–50.

Bohr 1993
Michael Bohr. *Die Entwicklung der Kabinett-schräncke in Florenz.* Europäische Hochschulschriften, ser. 38, Kunstgeschichte 182. Frankfurt am Main, 1993.

Boorsch 2000
Suzanne Boorsch. "Fireworks! Four Centuries of Pyrotechnics in Prints and Drawings." *The Metropolitan Museum of Art Bulletin* 58, no. 1 (Summer 2000).

Börsch-Supan 1971
Helmut Börsch-Supan, ed. *Die Kataloge der Berliner Akademie-Ausstellungen, 1786–1850.* 2 vols. Quellen und Schriften zur bildenden Kunst 4. Berlin, 1971.

Boudry 2004
Sébastien Boudry. "Chatard: Peintre doreur du Garde-Meuble." *L'estampille/L'objet d'art,* no. 387 (January 2004), pp. 66–77.

Bourne and Brett 1991
Jonathan Bourne and Vanessa Brett. *Lighting in the Domestic Interior: Renaissance to Art Nouveau.* London, 1991.

Bowett 1999
Adam Bowett. "The English 'Horsebone' Chair, 1685–1710." *Burlington Magazine* 141 (May 1999), pp. 263–70.

Bowett 2002
Adam Bowett. *English Furniture, 1660–1714: From Charles II to Queen Anne.* Woodbridge, Suffolk, England, 2002.

Boyce 1910
Cecil Boyce. "The British Losses at the Brussels Exhibition." *Connoisseur* 28 (October 1910), pp. 135–46.

Brandner et al. 1976
Willi Brandner, Johann Michael Fritz, Wolfgang Knobloch, and Rosemarie Stratmann. "Die Restaurierung einer Garnitur Augsburger Prunkmöbel." *Jahrbuch der Staatlichen Kunstsammlungen in Baden Württemberg* 13 (1976), pp. 55–64.

Braun 1988
Albrecht Braun. "Zwei Gewehrkolben mit Reliefdekor von Johann Eberhart Sommer." In *Die Künstlerfamilie Sommer: Neue Beiträge zu Leben und Werk,* pp. 141–50. Sigmaringen, 1988.

Breck 1918
Joseph Breck. "English Furniture in the Palmer Collection." *Bulletin of The Metropolitan Museum of Art* 13 (December 1918), pp. 274–82.

Bremer-David 1993
Charissa Bremer-David, with Peggy Fogelman, Peter Fusco, and Catherine Hess. *Decorative Arts: An Illustrated Summary Catalogue of the Collections of the J. Paul Getty Museum.* Rev. ed. Malibu, 1993.

Bresinsky 1988
Hermann Bresinsky. "Montierter Lack: Französische Möbel des 18. Jahrhunderts hergestellt unter Verwendung ostasiatischer Lackarbeiten." *Restauro* 94 (July 1988), pp. 195–210.

Brière 1924
Gaston Brière. "Documents sur Jules-Antoine Rousseau et ses fils sculpteurs décorateurs." *Bulletin de la Société de l'Histoire de l'Art Français,* 1924, pp. 180–88.

Briganti 1965
Chiara Briganti. "Comment Madame Infante, fille ainée de Louis XV, à meublé sa résidence princière de Parme." *Connaissance des arts,* no. 161 (July 1965), pp. 48–59.

Briganti 1969
Chiara Briganti. *Curioso itinerario delle collezioni ducali parmensi.* [Parma], 1969.

Britton 2001
Nancy C. Britton. "Reconciling Conservation and Interpretation: Strategies for Long-Term Display of a Late Seventeenth-Century Bed." In Kathryn Gill and Dinah Eastop, *Upholstery Conservation: Principles and Practice,* pp. 61–73. Butterworth-Heinemann Series in Conservation and Museology. Oxford, 2001.

Brooke 1992
Xanthe Brooke. *The Lady Lever Art Gallery: Catalogue of Embroideries.* Stroud, Gloucestershire, England, 1992.

Brunhammer 1964
Yvonne Brunhammer, ed. *Cent chefs-d'oeuvre du Musée des Arts Décoratifs.* Exh. cat., Pavillon de Marsan, Palais du Louvre. Paris, 1964.

Buckland 1983
Frances Buckland. "Gobelins Tapestries and Paintings as a Source of Information about the Silver Furniture of Louis XIV." *Burlington Magazine* 125 (May 1983), pp. 271–83.

Buckland 1989
Frances Buckland. "Silver Furnishings at the Court of France, 1643–1670." *Burlington Magazine* 131 (May 1989), pp. 328–36.

Buffa 1984
Sebastian Buffa, ed. *Italian Masters of the Sixteenth Century: Antonio Tempesta.* The Illustrated Bartsch 37. New York, 1984.

Buffet-Challié 1965
Laurence Buffet-Challié. "The Seventeenth Century: France." In *World Furniture: An Illustrated History,* ed. Helena Hayward, pp. 76–85. New York, 1965.

Burges 1862
William Burges. "The International Exhibition." *Gentleman's Magazine* 213 (July 1862), pp. 3–12.

Burges 1865
William Burges. *Art Applied to Industry: A Series of Lectures.* Oxford, 1865.

Burr 1964
Grace Hardendorff Burr. *Hispanic Furniture from the Fifteenth through the Eighteenth Century.* 2nd ed. The Hispanic Society of America. New York, 1964.

Callmann 1980
Ellen Callmann. *Beyond Nobility: Art for the Private Citizen in the Early Renaissance.* Exh. cat., Allentown Art Museum. Allentown, Pa., 1980.

Callmann 1999
Ellen Callmann. "William Blundell Spence and the Transformation of Renaissance Cassoni." *Burlington Magazine* 141 (June 1999), pp. 338–48.

Carlhian Firm Records 1867–1975
Carlhian Firm Records, 1867–1975. Getty Research Institute, Los Angeles.

Carré 1931
Louis Carré. *A Guide to Old French Plate.* London, 1931.

Castelluccio 2002
Stéphane Castelluccio. *Le style Louis XIII.* De styles. Paris, 2002.

Castelnuovo 1990
Enrico Castelnuovo. "Tapezzerie bellissime in figure." In *Gli arazzi del cardinale: Bernardo Cles e il Ciclo della Passione di Pieter Van Aelst,* ed. Enrico Castelnuovo, pp. 11–17. Storia dell'arte e della cultura. Trent, 1990.

Cecchini 1976
Norma Cecchini. *Dizionario sinottico di iconologia.* Scienze storico-ausiliarie 1. Bologna, 1976.

Chapuis 1992
Jean-Baptiste Chapuis. "Le Cabinet Fouquet: Restauration d'un prestigieux cabinet français du XVIIᵉ siècle." *L'estampille/L'objet d'art,* no. 259 (June 1992), pp. 72–81.

Chastang 2001
Yannick Chastang. *Paintings in Wood: French Marquetry Furniture.* Exh. cat., Wallace Collection. London, 2001.

Chefs-d'oeuvre de la curiosité du monde 1954
Chefs-d'oeuvre de la curiosité du monde. Exh. cat., Musée des Arts Décoratifs. Paris, 1954.

Chenevière 1988
Antoine Chenevière. *Russian Furniture: The Golden Age, 1780–1840.* London, 1988.

Chevillot 1988
Catherine Chevillot. *Emmanuel Fremiet, 1824–1910: La main et le multiple.* Exh. cat.,

Musée des Beaux-Arts, Dijon, and Musée de Grenoble. Dijon and Grenoble, 1988.

Chiarugi 1994
Simone Chiarugi. *Botteghe di mobilieri in Toscana.* 2 vols. Florence, 1994.

Chilton 2001
Meredith Chilton. *Harlequin Unmasked: The Commedia dell'Arte and Porcelain Sculpture.* New Haven and London, 2001.

Chippendale 1754
Thomas Chippendale. *The Gentleman and Cabinet-Maker's Director: Being a Large Collection of the Most Elegant and Useful Designs of Household Furniture, in the Gothic, Chinese and Modern Taste.* London, 1754.

Chippendale 1755
Thomas Chippendale. *The Gentleman and Cabinet-Maker's Director: Being a Large Collection of the Most Elegant and Useful Designs of Household Furniture, in the Most Fashionable Taste; Including a Great Variety of Chairs, Sofas, Beds, and Couches.* 2nd ed. London, 1755.

Chippendale 1762
Thomas Chippendale. *The Gentleman and Cabinet-Maker's Director: Being a Large Collection of the Most Elegant and Useful Designs of Household Furniture, in the Most Fashionable Taste; Including a Great Variety of Chairs, Sofas, Beds, and Couches.* 3rd ed. London, 1762.

Ciechanowiecki 1965
Andrew Ciechanowiecki. "Renaissance: Spain and Portugal." In *World Furniture: An Illustrated History,* ed. Helena Hayward, pp. 61–65. New York, 1965.

"Classic Furniture" 1885
"Classic Furniture for an American Mansion." *Furniture Gazette,* n.s., 23 (August 1, 1885), p. 355.

Cohen 1986
David Harris Cohen. "Pierre-Philippe Thomire: Unternehmer und Künstler." In Hans Ottomeyer and Peter Pröschel, *Vergoldete Bronzen: Die Bronzearbeiten des Spätbarock und Klassizismus,* vol. 2, *Beiträge zur Geschichte und Technik der Bronzearbeiten, zu Künstlern und Werkstätten,* pp. 657–65. Munich, 1986.

Coleridge 1965
Anthony Coleridge. "The Seventeenth Century: England, 1660–1715." In *World Furniture: An Illustrated History,* ed. Helena Hayward, pp. 86–96. New York, 1965.

Coleridge 1968
Anthony Coleridge. *Chippendale Furniture— the Work of Thomas Chippendale and His Contemporaries in the Rococo Taste: Vile, Cobb, Langlois, Channon, Hallett, Ince and Mayhew, Lock, Johnson and Others, circa 1745–1765.* Faber Monographs on Furniture. London, 1968.

Collard 1996
Frances Collard. "Furniture." In Parry 1996b, pp. 155–63.

Colle 1997
Enrico Colle, ed. *I mobili di Palazzo Pitti.* [Vol. 1], *Il periodo dei Medici, 1537–1737.* Palazzo Pitti, Florence, Museo degli Argenti 7. Centro Di cat. 295. Florence, 1997.

La collezione Chigi Saracini 2000
La collezione Chigi Saracini di Siena: Per una storia del collezionismo italiano. Exh. cat., Palazzo del Te, Mantua. Florence, 2000.

Colvin 1954
Howard Montagu Colvin. *A Biographical Dictionary of English Architects, 1660–1840.* London, 1954.

Cordey 1939
Jean Cordey. *Inventaire des biens de Madame de Pompadour: Rédigé après son décès.* Paris, 1939.

Corkhill 1989
Thomas Corkhill. *The Complete Dictionary of Wood.* New York, 1989.

Cormack 1985
Malcolm Cormack. *A Concise Catalogue of Paintings in the Yale Center for British Art.* New Haven, 1985.

Cornforth 1973
John Cornforth. "Hampton Court, Herefordshire: The Property of Captain the Hon. Philip Smith." *Country Life* 153 (February 22, March 1, and March 8, 1973), pp. 450–54, 518–21, 582–85.

Country House Lighting 1992
Country House Lighting, 1660–1890. Temple Newsam Country House Studies 4. Leeds, 1992.

Country House Portrayed 1973
A Country House Portrayed: Hampton Court, Herefordshire, 1699–1840. Exh. cat., Sabin Galleries Ltd. London, 1973.

Coural 1972
Jean Coural. "Restitution du Cabinet du Conseil du Roi." *Le petit journal des grandes expositions,* 1972, unpaginated.

Cröker 1743
Johann Melchior Cröker. *Der wohlanführende Mahler.* Jena, 1743.

Crook 1981
Joseph Mordaunt Crook. *William Burges and the High Victorian Dream.* Chicago, 1981.

Crowninshield 1941
Frank Crowninshield. "The House of Vanderbilt." *Vogue,* November 15, 1941, pp. 39–53, 90, 93–94, 96–97, 100.

"Curious Suit" 1882
"A Curious Suit." *Philadelphia Inquirer,* December 25, 1882.

Dal Prà 1993
Laura Dal Prà, ed. *I Madruzzo e l'Europa, 1539–1658: I principi vescovi di Trento tra Papato e Impero.* Exh. cat., Castello del Buonconsiglio, Trent, and Chiesa dell'Inviolato, Riva del Garda. Milan, 1993.

Dann 1988
Ingrid Dann. "Walther Ryff." In Günther 1988, pp. 79–88.

D'après l'antique 2000
D'après l'antique. Exh. cat., Musée du Louvre. Paris, 2000.

Dauterman, Parker, and Standen 1964
Carl Christian Dauterman, James Parker, and Edith Appleton Standen. *Decorative Art from the Samuel H. Kress Collection at The Metropolitan Museum of Art: The Tapestry Room from Croome Court, Furniture, Textiles, Sèvres Porcelains, and Other Objects.* Complete Catalogue of the Samuel H. Kress Collection. London, 1964.

De Bellaigue 1974
Geoffrey De Bellaigue. *Furniture, Clocks, and Gilt Bronzes.* 2 vols. The James A. de Rothschild Collection at Waddesdon Manor. Fribourg, 1974.

De Bellaigue 1975
Geoffrey De Bellaigue. "Edward Holmes Baldock." *Connoisseur* 190 (September 1975), pp. 18–25.

Dee 1988
Elaine Evans Dee. "Printed Sources for the William and Mary Style." In Baarsen et al. 1988, pp. 80–85.

Dell 1992a
Theodore Dell. "French Furniture: Eighteenth and Nineteenth Centuries (Part 1)." In Frick Collection, *The Frick Collection: An Illustrated Catalogue,* vol. 5, *Furniture: Italian and French,* ed. Joseph Focarino, pp. 187–384. New York, 1992.

Dell 1992b
Theodore Dell. "French Furniture: Eighteenth and Nineteenth Centuries (Part 2)." In Frick Collection, *The Frick Collection: An Illlustrated Catalogue,* vol. 6, *Furniture and Gilt Bronzes: French,* ed. Joseph Focarino, pp. 3–240. New York, 1992.

Denon 1802 (1989–90 ed.)
Dominique-Vivant Denon. *Voyage dans la Basse et la Haute Égypte pendant les campagnes du Général Bonaparte.* 2 vols. Paris, 1802. New ed.: Ed. Jean-Claude Watin. Paris, 1989–90.

Detroit Institute of Arts 1996
Detroit Institute of Arts. *The Dodge Collection of Eighteenth-Century French and English Art in the Detroit Institute of Arts.* New York, 1996.

Di Castro, Peccolo, and Gazzaniga 1994
Alberto Di Castro, Paola Peccolo, and Valentina Gazzaniga. *Marmorari e argentieri a Roma e nel Lazio tra Cinquecento e Seicento: I committenti, i documenti, le opere.* L'universo barocco. Rome, 1994.

Dictionary of Art 1996
The Dictionary of Art. Ed. Jane Turner. 34 vols. New York, 1996.

Diderot 1751–65
Denis Diderot. *Encyclopédie; ou, Dictionnaire raisonné des sciences, des arts et des métiers.* 17 vols. Paris, 1751–65.

Dion-Tenenbaum 2003
Anne Dion-Tenenbaum. *L'orfèvre de Napoléon: Martin-Guillaume Biennais.* Exh. cat., Musée du Louvre. Les dossiers du Musée du Louvre. Paris, 2003.

Dolci 2003
Enrico Dolci. "La cultura del marmo." In *Eternità e nobiltà di materia: Itinerario artistico fra le pietre policrome*, ed. Annamaria Giusti, pp. 105–38. Opificio delle Pietre Dure. Florence, 2003.

Dominique-Vivant Denon 1999
Dominique-Vivant Denon: L'oeil de Napoléon. Exh. cat., Musée du Louvre. Paris, 1999.

Draper 1978
James David Draper, with Clare Le Corbeiller. *The Arts under Napoleon: An Exhibition of the Department of European Sculpture and Decorative Arts, with Loans from the Audrey B. Love Foundation and Other New York Collections.* Exh. cat., The Metropolitan Museum of Art. New York, 1978.

Draper 1994
James David Draper. "A Life at the Met: James Parker and the Collecting of Italian Furniture." *Apollo* 139 (January 1994), pp. 20–24.

Drossaers and Lunsingh Scheurleer 1974
Sophie W. A. Drossaers and Theodoor H. Lunsingh Scheurleer. *Inventarissen van de inboedels in de verblijven van de Oranjes en daarmede gelijk te stellen stukken, 1567–1795.* Vol. 1, *Inventarissen Nassau-Oranje, 1567–1712.* The Hague, 1974.

Dubois 1826
L. J. J. Dubois. *Description des objets d'arts qui composent le cabinet de feu M. le baron V. Denon: Monuments antiques, historiques, modernes; ouvrages orientaux, etc.* Paris, 1826.

Duval 1981
Cynthia Duval. *Five Hundred Years of Decorative Arts from the Ringling Collections, 1350–1850.* Exh. cat., John and Mable Ringling Museum of Art. Sarasota, Fla., 1981.

Duvaux 1873 (1965 ed.)
Lazare Duvaux. *Livre-journal de Lazare Duvaux, marchand-bijoutier ordinaire du Roy, 1748–1758.* 2 vols. Paris, 1873. Repr., 1965.

Duveen 1957
James Henry Duveen. *The Rise of the House of Duveen.* New York, 1957.

Duveen Brothers Records 1876–1981
Duveen Brothers Records, 1876–1981. Getty Research Institute, Los Angeles. Microfilm, Thomas J. Watson Library, The Metropolitan Museum of Art, New York.

Eberlein and McClure 1914
Harold Donaldson Eberlein and Abbot McClure. *The Practical Book of Period Furniture: Treating of Furniture of the English, American Colonial and Post-Colonial and Principal French Periods.* Lippincott's Practical Books for the Enrichment of Home Life. Philadelphia and London, 1914.

Edmunds 1981
Lowell Edmunds. *The Sphinx in the Oedipus Legend.* Beiträge zur klassischen Philologie 127. Königstein, 1981.

Edwards 1964
Ralph Edwards. *The Shorter Dictionary of English Furniture from the Middle Ages to the Late Georgian Period.* London, 1964.

Edwards and Jourdain 1955
Ralph Edwards and Margaret Jourdain. *Georgian Cabinet-Makers, c. 1700–1800.* Rev. ed. London, 1955.

Eggeling 2003
Tilo Eggeling. *Raum und Ornament: Georg Wenceslaus von Knobelsdorff und das friderizianische Rokoko.* 2nd ed. Regensburg, 2003.

Eikelmann 2002
Renate Eikelmann, ed. *Der Mohrenkopfpokal von Christoph Jamnitzer.* Exh. cat., Bayerisches Nationalmuseum. Munich, 2002.

Eitner 1970
Lorenz Eitner. *Neoclassicism and Romanticism, 1750–1850: Sources and Documents.* 2 vols. Englewood Cliffs, N.J., 1970.

Eriksen and Watson 1963
Svend Eriksen and Francis J. B. Watson. "The 'Athénienne' and the Revival of the Classical Tripod." *Burlington Magazine* 105 (March 1963), pp. 108–12.

Esposizione Universale 1867
Dei prodotti di varie arti ed industrie inviati all'Esposizione Universale del 1867 in Parigi. Florence, 1867.

"European Antiques" 1948
"European Antiques in an American Collection." *Magazine Antiques* 53 (February 1948), pp. 114–15.

Fabian 1986
Dietrich Fabian. *Roentgenmöbel aus Neuwied: Leben und Werk von Abraham und David Roentgen.* Bad Neustadt, 1986.

Fabian 1996
Dietrich Fabian. *Abraham und David Roentgen: Das noch aufgefundene Gesamtwerk ihrer Möbel- und Uhrenkunst in Verbindung mit der Uhrmacherfamilie Kinzing in Neuwied. Leben und Werk, Verzeichnis der Werke, Quellen.* Bad Neustadt, 1996.

Fabian 2001
Dietrich Fabian. *Goethe—Roentgen: Ein Beitrag zur Kunstmöbelgeschichte des 18. Jahrhunderts.* 5th ed. Bad Neustadt, 2001.

Fabiankowitsch and Witt-Dörring 1996
Gabriele Fabiankowitsch and Christian Witt-Dörring. *Genormte Fantasie: Zeichenunterricht für Tischler, Wien, 1800–1840.* Exh. cat., Geymüllerschlössel. Vienna, 1996.

Fabri 1989
Ria Fabri. *Meubles d'apparat des Pays-Bas méridionaux, XVIe–XVIIIe siècle.* Exh. cat. Organized by the Generale Bank, Belgium. Brussels, 1989.

Fabri 1991
Ria Fabri. *De 17de-eeuwse Antwerpse kunstkast: Typologische en historische aspecten.* Verhandelingen van de Koninklijke Academie voor Wetenschappen, Letteren en Schone Kunsten van België, Klasse der Schone Kunsten 53. Brussels, 1991.

Fagiolo dell'Arco 1983
Maurizio Fagiolo dell'Arco, ed. *The Art of the Popes from the Vatican Collection: How Pontiffs, Architects, Painters, and Sculptors Created the Vatican.* Milan, 1983.

Farmer 1978
John David Farmer. *Rubens and Humanism.* Exh. cat., Birmingham Museum of Art, Birmingham, Alabama. Birmingham, 1978.

Feduchi 1969
Luis M. Feduchi. *Estilos del mueble español.* Madrid, 1969.

Feigenbaum 2003
Gail Feigenbaum. *Jefferson's America and Napoleon's France: An Exhibition for the Louisiana Purchase Bicentennial.* Exh. cat., New Orleans Museum of Art. New Orleans, 2003.

Feldhahn 2003
Ulrich Feldhahn. "Le château de Seehof: Renaissance d'une résidence baroque." *L'estampille/L'objet d'art*, no. 382 (July–August 2003), pp. 36–43.

Fenaille 1903–23
Maurice Fenaille. *État général des tapisseries de la Manufacture des Gobelins depuis son origine jusqu'à nos jours, 1600–1900.* 5 vols. Paris, 1903–23.

Fernández 1999
Henry Dietrich Fernández. "The Papal Court at Rome, c. 1450–1700." In *The Princely Courts of Europe: Ritual, Politics and Culture under the Ancien Régime, 1500–1750*, ed. John Adamson, pp. 141–63. London, 1999.

Ferrandis Torres 1940
José Ferrandis Torres. "Muebles hispanoárabes de taracea." *Al-Andalus* 5 (1940), pp. 459–65.

Feulner 1927
Adolf Feulner. *Kunstgeschichte des Möbels.* 3rd ed. Berlin, 1927.

Feulner 1929
Adolf Feulner. *Historic Interiors in Colour: Eighty Coloured Views from Castles and Private Houses.* New York, 1929.

Feulner 1931
Adolf Feulner. "Eine Kommode nach Entwurf von Cuvilliés." In *Festschrift zum sechzigsten Geburtstage von E. W. Braun*, pp. 167–69. Anzeiger des Landesmuseums in Troppau 2. Augsburg, 1931.

Feulner 1980
Adolf Feulner. *Kunstgeschichte des Möbels.* Propyläen Kunstgeschichte, Supplement- und Sonderbände 2. Frankfurt am Main, Berlin, and Vienna, 1980.

Feulner and Remington 1930
Adolf Feulner and Preston Remington. "Examples of South German Woodwork in the Metropolitan Museum." In *Metropolitan Museum Studies* 2, pt. 2 (1930), pp. 152–70.

Fiechter 1983
Jean-Jacques Fiechter. *Un diplomate américain sous la Terreur: Les années européennes de Gouverneur Morris, 1789–1798.* Paris, 1983.

Fitz-Adam 1782
Adam Fitz-Adam [pseud.]. *The World*. Vol. 1.
New ed. London, 1782.

Fitz-Gerald 1969
Desmond Fitz-Gerald, ed. *Georgian Furniture*.
Rev. ed. Victoria and Albert Museum. London,
1969.

Fleming and Honour 1989
John Fleming and Hugh Honour. *The Penguin
Dictionary of Decorative Arts*. New ed. London
and New York, 1989.

Flemming 1992
Dorothee von Flemming. "44. Alte Kunst- und
Antiquitätenmesse in Delft." *Weltkunst* 62
(September 15, 1992), pp. 2370–73.

Fock 1989
C. Willemijn Fock. "Leidse beeldsnijders en hun
beeldsnijwerk in het interieur." In Theodoor H.
Lunsingh Scheurleer, C. Willemijn Fock, and A. J.
van Dissel, *Het Rapenburg: Geschiedenis van een
Leidse gracht*, vol. 4a, *Leeuwenhorst*, pp. 7–78.
Leiden, 1989.

Fock 1992
C. Willemijn Fock. "Kunst en rariteiten in het
Hollandse interieur." In Bergvelt and Kistemaker
1992, pp. 70–91.

Fock 1994
C. Willemijn Fock. "Snakerijen, festoenen en
Jeruzalemsveren: Enkele 17de-eeuwse meubels
van beeldsnijders in Leiden." *Antiek* 29, no. 3
(October 1994), pp. 35–41.

Folnesics 1922
Josef Folnesics. *Innenräume und Hausrat der
Empire- und Biedermeierzeit in Österreich-
Ungarn*. 5th ed. Vienna, 1922.

Forssman 1956
Erik Forssman. *Säule und Ornament: Studien zum
Problem des Manierismus in den nordischen
Säulenbüchern und Vorlageblättern des 16. und 17.
Jahrhunderts*. Acta Universitatis Stockholmiensis.
Stockholm Studies in History of Art 1. Stockholm,
1956.

Fowler and Cornforth 1974
John Fowler and John Cornforth. *English
Decoration in the Eighteenth Century*.
London, 1974.

Fowles 1976
Edward Fowles. *Memories of Duveen Brothers*.
London, 1976.

Freiberg 1995
Jack Freiberg. *The Lateran in 1600: Christian
Concord in Counter-Reformation Rome*.
Cambridge and New York, 1995.

French Furnishings 1933
French Furnishings of the Eighteenth Century. Exh.
cat., The Toledo Museum of Art. Toledo, 1933.

Freyberger 1969
Ronald Freyberger. "The Judge Elbert H. Gary
Sale." *Auction* 2, no. 10 (June 1969), pp. 10–13.

Frick Collection 2003
Frick Collection. *The Frick Collection: An
Illustrated Catalogue*. Vol. 9, *Drawings, Prints,
and Later Acquisitions*. New York, 2003.

J. Friedman and Caracciolo 1993
Joe Friedman and Marella Caracciolo. *Inside
Rome: Discovering Rome's Classic Interiors*.
London, 1993.

T. F. Friedman 1975
Terry F. Friedman. "Two Eighteenth-Century
Catalogues of Ornamental Pattern Books."
Furniture History 11 (1975), pp. 66–75.

Fuhring 1989
Peter Fuhring. *Design into Art—Drawings for
Architecture and Ornament: The Lodewijk
Houthakker Collection*. 2 vols. London, 1989.

Fuhring 1994
Peter Fuhring. "Armoire 'au char d'Apollon'
attribuée à André-Charles Boulle." In *L'armoire
"au char d'Apollon" par André-Charles Boulle*,
pp. 8–47. Exh. cat., Galerie J. Kugel. Paris, 1994.

Fuhring 1999
Peter Fuhring. *Juste-Aurèle Meissonnier: Un génie
du Rococo, 1695–1750*. 2 vols. Archives d'arts
décoratifs. Turin and London, 1999.

"Furniture" 1885
"Furniture: Designed by L. Alma-Tadema, R.A."
Building News 49 (July 24, 1885), p. 122.

"Furniture for New York Millionaires" 1885
"Furniture for New York Millionaires."
Cabinet Making and Upholstery, September 1885,
p. 104.

Gaehtgens 1995
Barbara Gaehtgens. "Macht-Wechsel oder die
Übergabe der Regentschaft." In Baumgärtel and
Neysters 1995, pp. 64–78.

Gaillemin 2002
Jean-Louis Gaillemin. "Louis XIII: Portes ouvertes."
Connaissance des arts, no. 593 (April 2002),
pp. 66–73.

Gautier 1992
Jean-Jacques Gautier. "Jacques Gondouin:
Architecte et dessinateur du Garde-Meuble de la
Couronne." *L'estampille/L'objet d'art*, no. 263
(November 1992), pp. 58–66.

Gébelin 1927
François Gébelin. *Les châteaux de la Renaissance*.
Paris, 1927.

Gere 1989
Charlotte Gere. *Nineteenth-Century Decoration:
The Art of the Interior*. New York, 1989.

Gere 1999
Charlotte Gere. "European Decorative Arts at the
World's Fairs, 1850–1900." *The Metropolitan
Museum of Art Bulletin* 56, no. 3 (Winter 1998–99).

Germer 1997
Stefan Germer. *Kunst, Macht, Diskurs: Die
intellektuelle Karriere des André Félibien im
Frankreich von Louis XIV*. Munich, 1997.

Giarrizzo and Rotolo 1992
Mario Giarrizzo and Aldo Rotolo. *Mobile e
mobilieri nella Sicilia del Settecento*. Palermo, 1992.

"Gifts to the Nation" 1928
"Antique Dealers' Gifts to the Nation."
Connoisseur 81 (July 1928), pp. 191–92.

C. Gilbert 1969
Christopher Gilbert. "Thomas Chippendale at
Dumfries House." *Burlington Magazine* 111
(November 1969), pp. 663–77.

C. Gilbert 1971
Christopher Gilbert. "Furniture by Giles Grendey
for the Spanish Trade." *Magazine Antiques* 99
(April 1971), pp. 544–50.

C. Gilbert 1978a
Christopher Gilbert. *Furniture at Temple Newsam
House and Lotherton Hall: A Catalogue of the
Leeds Collection*. Vols. 1 and 2. London, 1978.

C. Gilbert 1978b
Christopher Gilbert. *The Life and Work of
Thomas Chippendale*. 2 vols. London, 1978.

C. Gilbert 1998
Christopher Gilbert. *Furniture at Temple Newsam
House and Lotherton Hall: A Catalogue of the
Leeds Collection*. Vol. 3. Bradford and London,
1998.

C. E. Gilbert 1988
Creighton E. Gilbert. *L'arte del Quattrocento
nelle testimonianze coeve*. Bibliotheca Artibus et
Historiae. Florence, 1988.

Gill 2001
Kathryn Gill. "The Lawrence Alma-Tadema
Settee, Designed c. 1884–85: The Challenges of
Interpretation and Replication." In Kathryn Gill
and Dinah Eastop, *Upholstery Conservation:
Principles and Practice*, pp. 33–43. Butterworth-
Heinemann Series in Conservation and
Museology. Oxford, 2001.

Gill, Soultanian, and Wilmering 1990
Kathryn Gill, Jack Soultanian, and Antoine M.
Wilmering. "The Conservation of the Seehof
Furniture." *Metropolitan Museum Journal* 25
(1990), pp. 169–73.

Ginzburg Carignani 2000
Sylvia Ginzburg Carignani. *Annibale Carracci a
Roma: Gli affreschi di Palazzo Farnese*. Saggi.
Arti e lettere. Rome, 2000.

Gismondi and Richard 1988
Jean Gismondi and Isabelle Richard. "Le Corail:
Symbole antique, fétiche populaire et joyau
baroque." In *Les Antiquaires . . . au Grand Palais:
XIVe Biennale Internationale, 22 septembre–
9 octobre 1988*, pp. 87–99. Paris, 1988.

Giusti, Mazzoni, and Pampaloni Martelli 1978
Anna Maria Giusti, Paolo Mazzoni, and Annapaula
Pampaloni Martelli. *Il Museo dell'Opificio delle
Pietre Dure a Firenze*. Gallerie e musei di Firenze.
Milan, 1978.

"La glace la plus extraordinaire" 1954
"La glace la plus extraordinaire." *Connaissance
des arts*, no. 32 (October 15, 1954), pp. 66–67.

Der Glanz der Farnese 1995
*Der Glanz der Farnese: Kunst und Sammel-
leidenschaft in der Renaissance*. Exh. cat., Palazzo
Ducale di Colorno, Parma; Haus der Kunst,

Munich; and Galleria Nazionale di Capodimonte, Naples. Munich, 1995.

Glueck 1975
Grace Glueck. "$7.3-Million Gift Surprises Met Museum." *New York Times*, April 2, 1975, p. 41.

Gobiet 1984
Ronald Gobiet. *Der Briefwechsel zwischen Philipp Hainhofer und Herzog August d. J. von Braunschweig-Lüneburg.* Forschungshefte (Bayerisches Nationalmuseum, Munich) 8. Munich, 1984.

Gombrich 1985
Ernst H. Gombrich. "Apollonio di Giovanni: A Florentine Cassone Workshop Seen through the Eyes of a Humanist Poet." In *Gombrich on the Renaissance*, vol. 1, *Norm and Form*, pp. 11–28. 4th ed. Studies in the Art of the Renaissance 1. London, 1985.

Gontar 2003
Cybèle Trione Gontar. "The Campeche Chair in The Metropolitan Museum of Art." *Metropolitan Museum Journal* 38 (2003), pp. 183–212.

González-Palacios 1971
Alvar González-Palacios. "The Prince of Palagonia, Goethe and Glass Furniture." *Burlington Magazine* 113 (August 1971), pp. 456–60.

González-Palacios 1982
Alvar González-Palacios. *Mosaici e pietre dure: Firenze, paesi germanici, Madrid.* I quaderni dell'antiquariato. Collana di arti decorative 21, year 2. Milan, 1982.

González-Palacios 1984
Alvar González-Palacios. *Il tempio del gusto—Roma e il regno delle Due Sicilie: Le arti decorative in Italia fra classicismi e barocco.* 2 vols. Marmi 136. Milan, 1984.

González-Palacios 1991
Alvar González-Palacios, ed. *Fasto romano: Dipinti, sculture, arredi dai palazzi di Roma.* Exh. cat., Palazzo Sacchetti. Rome, 1991.

González-Palacios 1995
Alvar González-Palacios, with Roberto Valeriani. *Gli arredi francesi.* Il patrimonio artistico del Quirinale. [Rome], 1995.

González-Palacios 2003
Alvar González-Palacios. "Daguerre, Lignereux and the King of Naples's Cabinet at Caserta." *Burlington Magazine* 145 (June 2003), pp. 431–42.

N. Goodison 1972
Nicholas Goodison. "Mr Stuart's Tripod." *Burlington Magazine* 114 (October 1972), pp. 695–704.

N. Goodison 1975
Nicholas Goodison. "The Victoria and Albert Museum's Collection of Metal-Work Pattern-Books." *Furniture History* 11 (1975), pp. 1–30.

N. Goodison 1990
Nicholas Goodison. "William Chambers's Furniture Designs." *Furniture History* 26 (1990), pp. 67–89.

Göres 1980
Burkhardt Göres. "Entwürfe und Ausführung von Möbeln und anderem Kunsthandwerk." In *Karl Friedrich Schinkel* 1980, pp. 221–49.

H. Graf 1989
Henriette Graf. "Boullemöbel aus München." *Weltkunst* 59 (August 15, 1989), pp. 2237–41.

L. E. Graf 2004
Lanie E. Graf. "Moravians in London: A Case Study in Furniture-Making, *c.* 1735–65." *Furniture History* 40 (2004), pp. 1–52.

Grand Larousse 1989
Grand Larousse universel. Rev. ed. 15 vols. Paris, 1989.

Grands ébénistes 1955
Grands ébénistes et menuisiers parisiens du XVIIIᵉ siècle, 1740–1790. Exh. cat., Musée des Arts Décoratifs. Paris, 1955.

Greber 1956
Josef Maria Greber. *Die Geschichte des Hobels von der Steinzeit bis zum Entstehen der Holzwerkzeugfabriken im frühen 19. Jahrhundert.* Zurich, 1956.

Greber 1980
Josef Maria Greber. *Abraham und David Roentgen: Möbel für Europa—Werdegänge, Kunst und Technik einer deutschen Kabinett-Manufaktur.* 2 vols. Starnberg, 1980.

Griffiths 1991
Antony Griffiths. "The End of Napoleon's *Histoire Métallique.*" *Medal,* no. 18 (Spring 1991), pp. 35–49.

Griffo 1984
Massimo Griffo. *Il mobile dell'Ottocento: Altri paesi europei.* Novara, 1984.

Grimm 1990
Wolf-Dieter Grimm. *Bildatlas wichtiger Denkmalgesteine der Bundesrepublik Deutschland.* With contributions by Ninon Ballerstädt et al. Arbeitsheft (Bayerisches Landesamt für Denkmalpflege) 50. Munich, 1990.

Grivel and Fumaroli 1988
Marianne Grivel and Marc Fumaroli. *Devises pour les tapisseries du Roi.* Paris, 1988.

Gruber 1994
Alain Gruber. "Interlace." In *The History of Decorative Arts: The Renaissance and Mannerism in Europe*, ed. Alain Gruber, pp. 21–111. Trans. John Goodman. New York, 1994.

Gruber 1996
Alain Gruber. "Chinoiserie." In *The History of Decorative Arts: Classicism and the Baroque in Europe*, ed. Alain Gruber, pp. 225–323. Trans. John Goodman. New York, 1996.

Grünenwald 1951–52
Elisabeth Grünenwald. "Die Künstlerfamilie Sommer aus Künzelsau." *Württembergisch Franken*, n.s., 26–27 (1951–52).

Gubernatis 1889
Angelo de Gubernatis, ed. *Dizionario degli artisti italiani viventi: Pittori, scultori e architetti.* Florence, 1889.

Guérinet n.d. (ca. 1910)
Armand Guérinet, ed. *Les sièges des palais et musées nationaux.* 1st ser. Paris, n.d. [ca. 1910].

Guidobaldi 2003
Federico Guidobaldi. "*Sectilia pavimenta* e *incrustationes*: I rivestimenti policromi pavimentali e parietali in marmo o materiali litici e litoidi dell'antichità romana." In *Eternità e nobiltà di materia: Itinerario artistico fra le pietre policrome*, ed. Annamaria Giusti, pp. 15–75. Opificio delle Pietre Dure. Florence, 2003.

Guiffrey 1881–1901
Jules Guiffrey. *Comptes des Bâtiments du Roi sous le règne de Louis XIV.* 5 vols. Collection de documents inédits sur l'histoire de France, 3rd ser., Archéologie. Paris, 1881–1901.

Guiffrey 1885–86
Jules Guiffrey. *Inventaire général du mobilier de la couronne sous Louis XIV (1663–1715).* 2 vols. Paris, 1885–86.

Guiffrey 1899
Jules Guiffrey, ed. "Inventaire de Jean-François Oeben." *Nouvelles archives de l'art français*, 3rd ser., 15 (1899), pp. 298–367.

Günther 1988
Hubertus Günther. *Deutsche Architekturtheorie zwischen Gotik und Renaissance.* With contributions by Michael Bode et al. Darmstadt, 1988.

Gustafson 1989
Eleanor H. Gustafson. "Museum Accessions." *Magazine Antiques* 135 (February 1989), pp. 414, 418, 422.

Haags Gemeentemuseum 1975
Haags Gemeentemuseum. *Meubelen, 1600–1800/Furniture, 1600–1800, Haags Gemeentemuseum.* The Hague, 1975.

Hackenbroch 1958a
Yvonne Hackenbroch. *English Furniture, with Some Furniture of Other Countries in the Irwin Untermyer Collection.* The Irwin Untermyer Collection 3. The Metropolitan Museum of Art, New York. Cambridge, Mass., 1958.

Hackenbroch 1958b
Yvonne Hackenbroch. "Pattern Books and Eighteenth-Century Furniture Design." *Magazine Antiques* 74 (September 1958), pp. 225–32.

Hackenbroch and Parker 1975
Yvonne Hackenbroch and James Parker. *The Lesley and Emma Sheafer Collection: A Selective Presentation.* Exh. cat., The Metropolitan Museum of Art. New York, 1975.

Hall 1979
James Hall. *Dictionary of Subjects and Symbols in Art.* Rev. ed. New York, 1979.

Hampel 1989
Frithjof Detlev Paul Hampel. *Schinkels Möbelwerk und seine Voraussetzungen.* Beiträge zur Kunstgeschichte 4. Witterschlick and Bonn, 1989.

Hamperl and Rohner 1984
Wolf-Dieter Hamperl and Aquilas Rohner. *Böhmisch-Oberpfälzische Akanthusaltäre.* Grosse Kunstführer 123. Munich and Zurich, 1984.

Hare 1965
Richard Hare. *The Art and Artists of Russia*. London, 1965.

Hargrave 1930
Catherine Perry Hargrave. *A History of Playing Cards and a Bibliography of Cards and Gaming*. Boston and New York, 1930.

J. Harris 1970
John Harris. *Sir William Chambers: Knight of the Polar Star*. With contributions by Joseph Mordaunt Crook and Eileen Harris. Studies in Architecture 9. London, 1970.

J. Harris 1973
John Harris. *John Yenn, Draughtsman Extraordinary: Drawings from the Royal Academy of Arts*. Exh. cat., Heinz Gallery. London, 1973.

M. Harris and Sons
Listed under the letter M.

Harrison and Waters 1989
Martin Harrison and Bill Waters. *Burne-Jones*. 2nd ed. London, 1989.

Das Haus Württemberg 1997
Das Haus Württemberg: Ein biographisches Lexikon. Stuttgart, 1997.

Havard 1887–90
Henry Havard. *Dictionnaire de l'ameublement et de la décoration depuis le XIII^e siècle jusqu'à nos jours*. 4 vols. Paris, [1887–90].

Hawley 1970
Henry H. Hawley. "Jean-Pierre Latz: Cabinetmaker." *Bulletin of the Cleveland Museum of Art* 57 (September–October 1970), pp. 203–59.

Hayward 1964
Helena Hayward. *Thomas Johnson and English Rococo*. London, 1964.

Hayward 1969a
Helena Hayward. "Chinoiserie at Badminton: The Furniture of John and William Linnell." *Apollo* 90 (August 1969), pp. 134–39.

Hayward 1969b
Helena Hayward. "The Drawings of John Linnell in the Victoria and Albert Museum." *Furniture History* 5 (1969), pp. 1–118.

Hayward and Kirkham 1980
Helena Hayward and Pat Kirkham. *William and John Linnell: Eighteenth Century London Furniture Makers*. 2 vols. New York, 1980.

Hayward and Till 1973
Helena Hayward and Eric Till. "A Furniture Discovery at Burghley." *Country Life* 154 (June 7, 1973), pp. 1604–7.

Hedinger and Berger 2002
Bärbel Hedinger and Julia Berger, eds. *Karl Friedrich Schinkel: Möbel und Interieur*. Exh. cat., Jenisch Haus, Altonaer Museum, Hamburg. Munich and Berlin, 2002.

Hefford 1977
Wendy Hefford. "Thomas Moore of Moorfields." *Burlington Magazine* 119 (December 1977), pp. 840–48.

Heilmeyer 2001
Marina Heilmeyer. *The Language of Flowers: Symbols and Myths*. Munich and New York, 2001.

Hennes 1870 (1971 ed.)
Johann Heinrich Hennes. *Friedrich Leopold, Graf zu Stolberg, und Herzog Peter Friedrich Ludwig von Oldenburg: Aus ihren Briefen, und anderen archivalischen Quellen*. Mainz, 1870. Repr., Bern, 1971.

Van Herck 1972
Jan van Herck. *Il mobile fiammingo*. Gli stili dei mobile. Milan, 1972.

Héricart de Thury 1819
Louis-Étienne-François Héricart de Thury. *Rapport du Jury d'Admission des Produits de l'Industrie du Département de la Seine, à l'Exposition du Louvre, comprenant une notice statistique sur ces produits*. [France], 1819.

Hernmarck 1953
Carl Hernmarck. "Claude Ballin et quelques dessins de pièces d'argenterie du Musée National de Stockholm." *Gazette des beaux-arts*, 6th ser., 41 (February 1953), pp. 103–18.

Herter Brothers 1994
Herter Brothers: Furniture and Interiors for a Gilded Age. Exh. cat., Museum of Fine Arts, Houston; High Museum of Art, Atlanta; and The Metropolitan Museum of Art, New York. New York and Houston, 1994.

Herzog and Ress 1958
Erich Herzog and Anton Ress. "Elfenbein, Elfenbeinplastik." In *Reallexikon zur deutschen Kunstgeschichte*, vol. 4, cols. 1307–62. Stuttgart, 1958.

Herzog Peter Friedrich Ludwig von Oldenburg 1979
Herzog Peter Friedrich Ludwig von Oldenburg (1755–1829). Exh. cat., Landesmuseum Oldenburg. Veröffentlichungen der Niedersächsischen Archivverwaltung, suppl. 22. Göttingen, 1979.

Heuberger 1994
Georg Heuberger, ed. *The Rothschilds: A European Family*. 2 vols. Exh. cat., Jewish Museum, Frankfurt am Main. Sigmaringen, 1994.

Hill 1930
George Francis Hill. *A Corpus of Italian Medals of the Renaissance before Cellini*. 2 vols. London, 1930.

Himmelheber 1973
Georg Himmelheber. *Die Kunst des deutschen Möbels: Möbel und Vertäfelungen des deutschen Sprachraums von den Anfängen bis zum Jugendstil*. Vol. 3, *Klassizismus, Historismus, Jugendstil*. Munich, 1973.

Himmelheber 1975
Georg Himmelheber. "Ulrich and Melchior Baumgartner." *Pantheon* 28 (April–June 1975), pp. 113–20.

Himmelheber 1983
Georg Himmelheber. *Die Kunst des deutschen Möbels: Möbel und Vertäfelungen des deutschen Sprachraums von den Anfängen bis zum Jugendstil*. Vol. 3, *Klassizismus, Historismus, Jugendstil*. 2nd ed. Munich, 1983.

Himmelheber 1988
Georg Himmelheber. "Die Möbel des Johann Daniel Sommer." In *Die Künstlerfamilie Sommer: Neue Beiträge zu Leben und Werk*, pp. 121–40. Sigmaringen, 1988.

Himmelheber 1989
Georg Himmelheber. *Biedermeier, 1815–1835: Architecture, Painting, Sculpture, Decorative Arts, Fashion*. Munich, 1989.

Himmelheber 1991
Georg Himmelheber. "Roentgenmöbel in Münchner Museen. XI., Kommode, um 1779, Bayerisches Nationalmuseum." *Weltkunst* 61 (October 15, 1991), pp. 3012–15.

Himmelheber 1994
Georg Himmelheber. "Roentgens Prunkmöbel für Ludwig XVI." *Zeitschrift für Kunstgeschichte* 57 (1994), pp. 462–73.

Himmelheber 2002
Georg Himmelheber. "Karl Friedrich Schinkel: Metall für Möbel." *Weltkunst* 72 (June 2002), pp. 938–41.

Hinckley 1971
F. Lewis Hinckley. *A Directory of Queen Anne, Early Georgian, and Chippendale Furniture; Establishing the Preeminence of the Dublin Craftsmen*. New York, 1971.

Hoentschel 1999
Nicole Hoentschel. *Georges Hoentschel*. Saint-Rémy-en-l'Eau, 1999.

Honour 1965a
Hugh Honour. "The Eighteenth Century: Italy." In *World Furniture: An Illustrated History*, ed. Helena Hayward, pp. 154–59. New York, 1965.

Honour 1965b
Hugh Honour. "The Seventeenth Century: Italy." In *World Furniture: An Illustrated History*, ed. Helena Hayward, pp. 66–71. New York, 1965.

Honour 1969
Hugh Honour. *Cabinet Makers and Furniture Designers*. Great Craftsmen. New York, 1969.

Hughes 1992
Peter Hughes. "The French Furniture." In *Boughton House: The English Versailles*, ed. Tessa Murdoch, pp. 118–27. London, 1992.

Hughes 1996
Peter Hughes. *The Wallace Collection: Catalogue of Furniture*. 3 vols. London, 1996.

Hülle 1972
Werner Hülle. "Die Erhebung der Grafschaften Oldenburg und Delmenhorst zum Herzogtum und Thronlehen durch Kaiser Joseph II." *Oldenburger Jahrbuch* 72 (1972), pp. 45–59.

Humbert, Pantazzi, and Ziegler 1994
Jean-Marcel Humbert, Michael Pantazzi, and Christiane Ziegler. *Egyptomania: Egypt in Western Art, 1730–1930*. Exh. cat., Musée du Louvre, Paris; National Gallery of Canada,

Ottawa; and Kunsthistorisches Museum, Vienna. Ottawa and Paris, 1994.

Hunter-Stiebel 1989
Penelope Hunter-Stiebel. *Of Knights and Spires: Gothic Revival in France and Germany.* Exh. cat., Rosenberg & Stiebel. New York, 1989.

Hussey 1923
Christopher Hussey. "Walnut Furniture at Burley-on-the-Hill." *Country Life* 53 (February 24, 1923), pp. 254–57.

Hussey 1924
Christopher Hussey. "Grimsthorpe Castle, Lincolnshire—III: The Seat of the Earl of Ancaster." *Country Life* 55 (April 26, 1924), pp. 650–57.

Huth 1928
Hans Huth. *Abraham und David Roentgen und ihre Neuwieder Möbelwerkstatt.* Berlin, 1928.

Huth 1965
Hans Huth. "Renaissance: Germany and Scandinavia." In *World Furniture: An Illustrated History,* ed. Helena Hayward, pp. 47–52. New York, 1965.

Huth 1971
Hans Huth. *Lacquer of the West: The History of a Craft and an Industry, 1550–1950.* Chicago and London, 1971.

Impey and Kisluk-Grosheide 1994
Oliver R. Impey and Daniëlle Kisluk-Grosheide. "The Japanese Connection: French Eighteenth-Century Furniture and Export Lacquer." *Apollo* 139 (January 1994), pp. 48–61.

Ince and Mayhew 1759–62 (1960 ed.)
William Ince and John Mayhew. *The Universal System of Household Furniture.* London, 1759–62. Repr., 1960.

"International Exhibition" 1862
"The International Exhibition." *Ecclesiologist,* n.s., no. 114 (June 1862), pp. 168–76.

Irmscher 1988
Günter Irmscher. "Christoph Jamnitzer als Plastiker." *Weltkunst* 58 (October 15, 1988), pp. 3065–67.

Italian Cassoni 1983
Italian Cassoni from the Art Collections of Soviet Museums. Trans. Arthur Shkarovsky-Raffé. Leningrad, 1983.

J. Paul Getty Museum 1998
J. Paul Getty Museum. *Masterpieces of the J. Paul Getty Museum: European Sculpture.* Los Angeles, 1998.

Jackson-Stops 1985
Gervase Jackson-Stops, ed. *The Treasure Houses of Britain: Five Hundred Years of Private Patronage and Art Collecting.* Exh. cat., National Gallery of Art, Washington, D.C. Washington, D.C., New Haven, and London, 1985.

Jacques-Louis David 1989
Jacques-Louis David, 1748–1825. Exh. cat., Musée du Louvre, Paris, and Musée National du Château, Versailles. Paris, 1989.

Jervis 1968
Simon Jervis. "A Tortoiseshell Cabinet and Its Precursors." *Victoria and Albert Museum Bulletin* 4 (October 1968), pp. 133–43.

Jervis 1974a
Simon Jervis. "'A Great Dealer in the Cabinet Way': Giles Grendey (1693–1780)." *Country Life* 155 (June 6, 1974), pp. 1418–19.

Jervis 1974b
Simon Jervis. *Printed Furniture Designs before 1650.* Leeds, 1974.

Jervis 1982
Simon Jervis. "The Burlington House Fair at the Royal Academy: Furniture." *Burlington Magazine* 124 (March 1982), pp. 172–77.

Jestaz 1995
Bertrand Jestaz. "Le collezioni Farnese di Roma." In *I Farnese: Arte e collezionismo,* ed. Lucia Fornari Schianchi and Nicola Spinosa, pp. 49–67. Exh. cat., Palazzo Ducale di Colorno, Parma; Haus der Kunst, Munich; and Galleria Nazionale di Capodimonte, Naples. Milan, 1995.

Johnson 1979
Diana L. Johnson. *Fantastic Illustration and Design in Britain, 1850–1930.* Exh. cat., Museum of Art, Rhode Island School of Design. Providence, 1979.

Johnston 1999
William R. Johnston. *William and Henry Walters: The Reticent Collectors.* Baltimore, 1999.

Jourdain 1919
Margaret Jourdain. "Sutton Scarsdale, Derbyshire: The Seat of Mr. William Arkwright." *Country Life* 45 (February 15, 1919), pp. 166–73.

Joy 1982
Edward T. Joy. *Gaming.* The Arts and Living. Victoria and Albert Museum. London, 1982.

Junquera y Mato 1992
Juan José Junquera y Mato. *Spanish Splendor: Great Palaces, Castles, and Country Houses.* New York, 1992.

Jutzi and Ringger 1986
Volker Jutzi and Peter Ringger. "Die Wellenleiste und ihre maschinelle Herstellung." *Maltechnik Restauro* 92 (April 1986), pp. 34–62.

Kämpf 1955
Margarete Kämpf. *Das fürstbischöfliche Schloss Seehof bei Bamberg.* Würzburg, 1955.

Karl Friedrich Schinkel 1980
Karl Friedrich Schinkel, 1781–1841. Exh. cat., Altes Museum. Berlin, 1980.

Karl Friedrich Schinkel 1981
Karl Friedrich Schinkel: Architektur, Malerei, Kunstgewerbe. Exh. cat., Schloss Charlottenburg. Berlin, 1981.

Katalog der Ornamentstich-Sammlung 1894
Katalog der Ornamentstich-Sammlung des Kunstgewerbe-Museums. Leipzig, 1894.

Kemp 1992
Martin Kemp. "The Mean and Measure of

All Things." In *Circa 1492: Art in the Age of Exploration,* ed. Jay A. Levenson, pp. 95–111. Exh. cat., National Gallery of Art, Washington, D.C. Washington, D.C., New Haven, and London, 1992.

Kennett 1973
Audrey Kennett. *The Palaces of Leningrad.* New York, 1973.

Kieslinger 1972
Alois Kieslinger. *Die Steine der Wiener Ringstrasse: Ihre Technische und Künstlerische Bedeutung.* Die Wiener Ringstrasse, Bild einer Epoche 4. Wiesbaden, 1972.

Kirkham 1980
Pat Kirkham. "Inlay, Marquetry and Buhl Workers in England, c. 1660–1850." *Burlington Magazine* 122 (June 1980), pp. 415–19.

Kisluk-Grosheide 1989
Daniëlle O. [Kisluk-]Grosheide. "Richesses de l'Europe centrale: Le mobilier." *Connaissance des arts,* no. 453 (November 1989), pp. 100–103.

Kisluk-Grosheide 1990
Daniëlle O. Kisluk-Grosheide. "The Garden Room from Schloss Seehof and Its Furnishings." *Metropolitan Museum Journal* 25 (1990), pp. 143–60.

Kisluk-Grosheide 1991
Daniëlle O. Kisluk-Grosheide. "A Group of Early Eighteenth-Century 'Augsburg' Mirrors." *Furniture History* 27 (1991), pp. 1–18.

Kisluk-Grosheide 1994
Daniëlle O. Kisluk-Grosheide. "The Marquand Mansion." *Metropolitan Museum Journal* 29 (1994), pp. 151–81.

Kisluk-Grosheide 1996
Daniëlle O. Kisluk-Grosheide. "'Cutting up Berchems, Watteaus, and Audrans': A *Lacca Povera* Secretary at The Metropolitan Museum of Art." *Metropolitan Museum Journal* 31 (1996), pp. 81–97.

Kisluk-Grosheide 2000a
Daniëlle O. Kisluk-Grosheide. "The (Ab)Use of Export Lacquer in Europe." In *Ostasiatische und europäische Lacktechniken: Internationale Tagung des Bayerischen Landesamtes für Denkmalpflege und des Deutschen Nationalkomitees von ICOMOS in Zusammenarbeit mit dem Tokyo National Research Institute of Cultural Properties, München 11.–13. März 1999/East Asian and European Lacquer Techniques: International Conference of the Bavarian State Department of Historical Monuments and the German National Committee of ICOMOS Together with the Tokyo National Research Institute of Cultural Properties, Munich, 11–13 March 1999,* ed. Michael Kühlenthal, pp. 27–42. Arbeitsheft (Bayerisches Landesamte für Denkmalpflege) 112. ICOMOS, Hefte des Deutschen Nationalkomitees 35. Munich, 2000.

Kisluk-Grosheide 2000b
Daniëlle O. Kisluk-Grosheide. "A Piano for a New York Millionaire." *CAI* (Sterling and Francine Clark Art Institute, Williamstown, Massachusetts), 2000, pp. 48–57.

Kisluk-Grosheide 2005
Daniëlle O. Kisluk-Grosheide. "Versailles au Metropolitan Museum de New York." *Versalia*, no. 8 (2005), pp. 66–93.

Kisluk-Grosheide 2006
Daniëlle O. Kisluk-Grosheide. "French Royal Furniture in the Metropolitan Museum." *The Metropolitan Museum of Art Bulletin* 63, no. 3 (Winter 2006).

Kjellberg 1978–80
Pierre Kjellberg. *Le mobilier français.* Vol. 1, *Du Moyen Âge à Louis XV.* Vol. 2, *De la transition Louis XV–Louis XVI à 1925.* Paris, 1978–80.

Knothe 2002
Florian Knothe. "*Les Artisans du Roi:* A Family of Craftsmen." Master's thesis, Courtauld Institute of Art, University of London, 2002.

Koeppe 1989a
Wolfram Koeppe. "'. . . alles in vergüldt Silber gefasst': Über einen Nürnberger Turboschneckenpokal des späten Manierismus." *Kunst & Antiquitäten,* 1989, no. 1, pp. 34–42.

Koeppe 1989b
Wolfram Koeppe. "'. . . mit feiner Bildhauer-Arbeit verfertigte Stücke': Zu einem bislang unbekannten Schreibmöbeltypus der Roentgen-Werkstatt." *Kunst & Antiquitäten,* 1989, no. 4, pp. 32–38.

Koeppe 1991a
Wolfram Koeppe. "Ein Girandolenpaar des Albrecht Biller: Addenda zum Einfluss französischer Ornamentformen auf die Augsburger Goldschmiedekunst um 1700." *Jahrbuch des Museums für Kunst und Gewerbe Hamburg,* n.s., 8 (1989; pub. 1991), pp. 63–76.

Koeppe 1991b
Wolfram Koeppe. "Vergessene Meisterwerke deutscher Möbelkunst: Die Meisterstücke der Breslauer Schreinerzunft im 18. Jahrhundert." *Kunst & Antiquitäten,* 1991, no. 4, pp. 38–45.

Koeppe 1992
Wolfram Koeppe. *Die Lemmers-Danforth-Sammlung Wetzlar: Europäische Wohnkultur aus Renaissance und Barock.* Heidelberg, 1992.

Koeppe 1993
Wolfram Koeppe. "Quo Vadis Möbelliteratur?" *Kunst & Antiquitäten,* 1993, no. 9, pp. 42–43.

Koeppe 1994a
Wolfram Koeppe. "Der antike Verpflichtet: Ein Beispiel römischen Möbelkunst des 16. Jahrhunderts—der 'Cesarini Schreibschrank.'" *Kunst & Antiquitäten,* April 1994, pp. 28–31.

Koeppe 1994b
Wolfram Koeppe. "French and Italian Renaissance Furniture at The Metropolitan Museum of Art: Notes on a Survey." *Apollo* 138 (June 1994), pp. 24–32.

Koeppe 1995
Wolfram Koeppe. "The Chest in the Italian and Central European Bedchamber from the Fifteenth to the Seventeenth Century." In *The Bedroom from the Renaissance to Art Deco,* comp. and ed. Meredith Chilton, pp. 13–24. Toronto, 1995.

Koeppe 1996
Wolfram Koeppe. "Möbel und Schaustücke." In *Liselotte von der Pfalz: Madame am Hofe des Sonnenkönigs,* ed. Sigrun Paas, pp. 179–88. Exh. cat., Heidelberger Schloss. Heidelberg, 1996.

Koeppe 1997
Wolfram Koeppe. "Kästchen aus der Werkstatt von Abraham Roentgen in amerikanischen Sammlungen." In *Zwischen Askese und Sinnlichkeit: Festschrift für Norbert Werner zum 60. Geburtstag,* ed. Carolin Bahr and Gora Jain, pp. 98–110. Giessener Beiträge zur Kunstgeschichte 10. Dettelbach, 1997.

Koeppe 2004
Wolfram Koeppe. "Exotica and the Kunst-kammer: 'Snake Stones, Iridescent Sea Snails, and Eggs of the Giant Iron-Devouring Bird.'" In Syndram and Scherner 2004, pp. 80–89.

Koeppe 2005
Wolfram Koeppe. "The Oldenburg Table." *Weltkunst* 75 (2005), pp. 188–92. 75th anniversary issue, pt. 1.

Koeppe and Lupo 1991
Wolfram Koeppe and Michelangelo Lupo. "Lo *Heiltumsaltar* nella sacrestia della cattedrale di Trento." In *Ori e argenti dei santi: Il tesoro del Duomo di Trento,* ed. Enrico Castelnuovo, pp. 35–56. Storia dell'arte e della cultura. Trent, 1991.

Kolbe 1862
Georg Kolbe. *Geschichte der Königlichen Porcellanmanufactur zu Berlin nebst einer einleitenden Übersicht der geschichtlichen Entwickelung der ceramischen Kunst.* Berlin, 1862.

"Königl. Porzellan-Manufaktur" 1834
"Ueber den gegenwärtigen Zustand der porzellan-Malerei und Formerei in Berlin, namentlich in Bezug auf die Königl. Porzellan-Manufaktur." *Berlinische Nachrichten,* no. 260 (November 6, 1834).

Kootte 1991
T. G. Kootte, ed. *De bijbel in huis: Bijbelse verhalen op huisraad in de zeventiende en achttiende eeuw.* Exh. cat., Rijksmuseum Het Catharijneconvent, Utrecht. Zwolle and Utrecht, 1991.

Kraut 1988
Stefan Kraut. "Die Familie Sommer im Überblick." In *Die Künstlerfamilie Sommer: Neue Beiträge zu Leben und Werk,* pp. 35–38. Sigmaringen, 1988.

Kreisel 1930
Heinrich Kreisel. *Die Kunstschätze der Würzburger Residenz.* Würzburg, 1930.

Kreisel 1956
Heinrich Kreisel. *Fränkische Rokokomöbel.* Wohnkunst und Hausrat, Einst und Jetzt 26. Darmstadt, 1956.

Kreisel 1968
Heinrich Kreisel. *Die Kunst des deutschen Möbels: Möbel und Vertäfelungen des deutschen Sprachraums von den Anfängen bis zum Jugendstil.* Vol. 1, *Von den Anfängen bis zum Hochbarock.* Munich, 1968.

Kreisel 1970
Heinrich Kreisel. *Die Kunst des deutschen Möbels: Möbels und Vertäfelungen des deutschen Sprachraums von den Anfängen bis zum Jugendstil.* Vol. 2, *Spätbarock und Rokoko.* Munich, 1970.

Kreisel and Himmelheber 1981
Heinrich Kreisel. *Die Kunst des deutschen Möbels: Möbel und Vertäfelungen des deutschen Sprachraums von den Anfängen bis zum Jugendstil.* Vol. 1, *Von den Anfängen bis zum Hochbarock.* 2nd ed. Rev. by Georg Himmelheber. Munich, 1981.

Kreisel and Himmelheber 1983
Heinrich Kreisel. *Die Kunst des deutschen Möbels: Möbel und Vertäfelungen des deutschen Sprachraums von den Anfängen bis zum Jugendstil.* Vol. 2, *Spätbarock und Rokoko.* 2nd ed. Rev. by Georg Himmelheber. Munich, 1983.

Krieg und Frieden 2001
Krieg und Frieden: Eine deutsche Zarin in Schloss Pawlowsk. Exh. cat., Haus der Kunst, Munich. Munich and Hamburg, 2001.

Krohn 1922
Mario Krohn. *Frankrigs og Danmarks kunstneriske forbindelse i det 18. aarhundrede.* 2 vols. Copenhagen, 1922.

Kuchumov 2004
Anatolii Mikhailovich Kuchumov. "Tul'skie stal'nye izdeliia v urbranstve Pavlovskogo dvortsa (Works in steel from Tula in the interiors of Pavlovsk Palace). In Anatolii Mikhailovich Kuchumov, *Stat'i, vospominaniia, pis'ma* (Essays, memoirs, letters), pp. 136–42. Pavlovsk: Istoriia i sud'by. Saint Petersburg, 2004.

Kugel 1998
Alexis Kugel. *Trésors des tzars: La Russie & l'Europe de Pierre le Grand à Nicolas I^er/ Treasures of the Czars: Russia and Europe from Peter the Great to Nicholas I.* Exh. cat., Jacques Kugel. Paris, 1998.

Kugler 1995
Georg Kugler. *Schloss Schönbrunn: Die Prunkräume.* Vienna, 1995.

Kunst- und Werck-Schul 1707
Kunst- und Werck-Schul. Rev. ed. Vol. 2. Nuremberg, 1707.

Laing 1982
Alastair Laing. *Lighting.* The Arts and Living. Victoria and Albert Museum. London, 1982.

Langedijk 1981–87
Karla Langedijk. *The Portraits of the Medici, Fifteenth–Eighteenth Centuries.* 3 vols. Florence, 1981–87.

Langenstein and Petzet 1985
York Langenstein and Michael Petzet. *Seehof: Baugeschichte und Restaurierung von Schloss und Park.* Bayerisches Landesamt für Denkmalpflege. Munich, 1985.

Langer 1995
Brigitte Langer. *Französischen Möbel des 18. Jahrhunderts.* Vol. 1 of *Die Möbel der Residenz München,* ed. Gerhard Hojer and Hans Ottomeyer. Kataloge der Kunstsammlungen/

Bayerische Verwaltung der Staatlichen Schlösser, Gärten und Seen. Munich and New York, 1995.

Langer 2000
Brigitte Langer. *Die Möbel der Schlösser Nymphenburg und Schleissheim*. Munich, London, and New York, 2000.

Langer 2002
Brigitte Langer, ed. *Pracht und Zeremoniell: Die Möbel der Residenz München*. Exh. cat., Residenz, Munich. Organized by the Bayerische Verwaltung der Staatlichen Schlösser, Gärten und Seen. Munich, 2002.

Langer and Württemberg 1996
Brigitte Langer and Alexander Herzog von Württemberg. *Die deutschen Möbel des 16. bis 18. Jahrhunderts*. Vol. 2 of *Die Möbel der Residenz München*, ed. Gerhard Hojer and Hans Ottomeyer. Kataloge der Kunstsammlungen/Bayerische Verwaltung der Staatlichen Schlösser, Gärten und Seen. Munich and New York, 1996.

"Langlois and Dominique" 1968
"Langlois and Dominique." *Furniture History* 4 (1968), pp. 105–6.

Laran 1925
Jean Laran. *François de Cuvilliés: Dessinateur et architecte*. Les grands ornemanistes. Oeuvres choisies. Paris, 1925.

Latham 1904–9
Charles Latham. *In English Homes: The Internal Character, Furniture and Adornments of Some of the Most Notable Houses of England*. 3 vols. London, 1904–9.

Le Roi 1859
Joseph-Adrien Le Roi. "Madame Du Barry, 1768–1793." *Mémoires de la Société des Sciences Morales, des Lettres et des Arts de Seine-et-Oise* 5 (1859), pp. 1–106.

Learmont and Riddle 1985
David Learmont and Gordon Riddle. *Culzean: Castle & Country Park*. National Trust for Scotland. Edinburgh, 1985.

D. Ledoux-Lebard 1984
Denise Ledoux-Lebard. *Les ébénistes du XIXe siècle, 1795–1889: Leurs oeuvres et leurs marques*. Paris, 1984.

R., G., and C. Ledoux-Lebard 1953
R., G., and C. Ledoux-Lebard. "L'inventaire des appartements de l'empereur Napoléon 1er aux Tuileries." *Bulletin de la Société de l'Histoire de l'Art Français*, 1952 (pub. 1953), pp. 186–204.

Leeflang et al. 2003
Huigen Leeflang et al. *Hendrick Goltzius (1558–1617): Drawings, Prints and Paintings*. Exh. cat., Rijksmuseum, Amsterdam; The Metropolitan Museum of Art, New York; and Toledo Museum of Art. Zwolle, 2003.

Lefuel 1923
Hector Lefuel. *Georges Jacob: Ébéniste du XVIIIe siècle*. Archives de l'amateur. Paris, 1923.

Lemonnier 1983
Patricia Lemonnier. *Weisweiler*. Paris, 1983.

Lequesne 1997
M. Lequesne. "Un inventeur génial: Jean-Gotfritt Mercklein." *Perspectives et actualités* (Etablissement Technique Central de l'Armement [ETCA]), no. 41 (April 1997), pp. 30–31.

Lethaby 1935
William R. Lethaby. *Philip Webb and His Work*. London, 1935. [First published in serial form in *Builder* during 1925.]

Lettres de Mademoiselle Aïssé 1943
Charlotte Elisabeth Aïssé and Julie Pelissary Calandrini. *Lettres de Mademoiselle Aïssé à Madame Calandrini*. Collection "À la promenade" 2. Paris, 1943.

Levi 1985
Honor Levi. "L'inventaire après décès du cardinal de Richelieu." *Archives de l'art français*, n.s., 27 (1985), pp. 9–83.

Liedtke 2001
Walter Liedtke, with Michiel C. Plomp and Axel Rüger. *Vermeer and the Delft School*. Exh. cat., The Metropolitan Museum of Art, New York, and National Gallery, London. New York, New Haven, and London, 2001.

Lindemann 1989
Bernd Wolfgang Lindemann. *Ferdinand Tietz, 1708–1777: Studien zu Werk, Stil und Ikonographie*. Weissenhorn, 1989.

Litta 1818–83
Pompeo Litta. *Famiglie celebri italiane*. 10 vols. Milan, 1818–83.

Liversidge 1965
Joan Liversidge. "Greece, Rome." In *World Furniture: An Illustrated History*, ed. Helena Hayward, pp. 14–18. New York, 1965.

Loescher 1997
Wolfgang Loescher. "Ein 'Boulle'-Möbel von Ferdinand Plitzner: Zuschreibung mit Hilfe von Konstrucktions- und Boulle-Technik-Details." *Restauro*, November–December 1997, pp. 454–59.

Lohde 1836
Ludwig Lohde, ed. *Schinkel's Möbel-Entwürfe, welche bei Einrichtungen prinzlicher Wohnungen in den letzten zehn Jahren ausgeführt wurden*. Berlin, 1836.

Los Angeles County Museum of Art 1983
Los Angeles County Museum of Art. "Recent Acquisitions." In *Members' Calendar* 21, no. 12 (December 1983), unpaginated.

Louis XIV 1960
Louis XIV: Faste et décors. Exh. cat., Musée des Arts Décoratifs. Paris, 1960.

Luijten et al. 1993
Ger Luijten et al., eds. *Dawn of the Golden Age: Northern Netherlandish Art, 1580–1620*. Exh. cat., Rijksmuseum, Amsterdam. Amsterdam and Zwolle, 1993.

Lunsingh Scheurleer 1941
Theodoor H. Lunsingh Scheurleer. "Jan van Mekeren: Een Amsterdamsche meubelmaker uit het einde der 17de en begin 18de eeuw." *Oud Holland* 58 (1941), pp. 178–88.

Lunsingh Scheurleer 1942
Theodoor H. Lunsingh Scheurleer. "Het Amsterdamsche St. Josefsgilde, in het bijzonder met betrekking tot de meubelmakers." *Historia: Maandblad voor geschiedenis en kunstgeschiedenis* 8 (1942), pp. 33–45.

Lunsingh Scheurleer 1956
Theodoor H. Lunsingh Scheurleer. "Novels in Ebony." *Journal of the Warburg and Courtauld Institutes* 19 (1956), pp. 259–68.

Lunsingh Scheurleer 1961
Theodoor H. Lunsingh Scheurleer. *Van haardvuur tot beeldscherm: Vijf eeuwen interieur- en meubelkunst in Nederland*. Natuur en cultuur. Leiden, 1961.

Lunsingh Scheurleer 1964
Theodoor H. Lunsingh Scheurleer. "Amerongen Castle and Its Furniture." *Apollo* 80 (November 1964), pp. 360–67.

Lunsingh Scheurleer 1980
Theodoor H. Lunsingh Scheurleer. "Pierre Gole: Ébéniste du Roi Louis XIV." *Burlington Magazine* 122 (June 1980), pp. 380–94.

Lunsingh Scheurleer 1984
Theodoor H. Lunsingh Scheurleer. "The Philippe d'Orléans Ivory Cabinet by Pierre Gole." *Burlington Magazine* 126 (June 1984), pp. 333–39.

Lunsingh Scheurleer 1993
Theodoor H. Lunsingh Scheurleer. "Pierre Gole in volle glorie in het Rijksmuseum." *Bulletin van het Rijksmuseum* 41 (1993), pp. 79–95.

Lunsingh Scheurleer 2005
Theodoor H. Lunsingh Scheurleer. *Pierre Gole: Ébéniste de Louis XIV*. Dijon, 2005.

Lunsingh Scheurleer, Fock, and Van Dissel 1992
Theodoor H. Lunsingh Scheurleer, C. Willemijn Fock, and A. J. van Dissel. *Het Rapenburg: Geschiedenis van een Leidse gracht*. Vol. 6a, *Het Rijck van Pallas*. Leiden, 1992.

Luynes 1860–65
Charles Philippe d'Albert, duc de Luynes. *Mémoires du duc de Luynes sur la cour de Louis XV (1735–1758)*. Ed. Louis Dussieux and Eudoxe Soulié. 17 vols. Paris, 1860–65.

M. Harris and Sons 1935
M. Harris and Sons. *Old English Furniture: Its Designers and Craftsmen*. London, 1935.

Macquoid and Edwards 1983
Percy Macquoid and Ralph Edwards. *The Dictionary of English Furniture from the Middle Ages to the Late Georgian Period*. 3 vols. 2nd ed. London, 1954. Repr., Woodbridge, Suffolk, England, 1983.

Madame Du Barry 1992
Madame Du Barry: De Versailles à Louveciennes. Exh. cat., Musée-Promenade de Marly-le-Roi-Louveciennes. Paris, 1992.

Madocks 1984
Susan Madocks. "'Trop de beautez découvertes': New Light on Guido Reni's Late 'Bacchus and Ariadne.'" *Burlington Magazine* 126 (September 1984), pp. 544–47.

Malchenko 1974
Mariia Danilovna Malchenko. *Art Objects in Steel by Tula Craftsmen*. Leningrad, 1974.

Manchester City Art Gallery 1983
Manchester City Art Gallery. *A Century of Collecting, 1882–1982: A Guide to the Manchester City Art Galleries*. Manchester, 1983.

Mannheim and Rahir 1907
Jules Mannheim and Édouard Rahir. *Catalogue de la collection Rodolphe Kann: Objets d'art*. Vol. 2, *XVIIIe siècle*. Paris, 1907.

Manuels 2001
Marijn Manuels. "Technology and Attribution: Defining the Oeuvre of a Dutch Cabinetmaker." *Met Objectives: Treatment and Research Notes* 2, no. 2 (Spring 2001), pp. 1–3.

Marot n.d. (before 1703)
Daniel Marot. *Nouveau livre d'orfèvrerie*. The Hague, n.d. [before 1703].

Martin 1987
Jacques Martin. *Heraldry in the Vatican/L'araldica in Vaticano/Heraldik im Vatikan*. Gerrards Cross, Buckinghamshire, England, 1987.

Masching 1991
Gisela Masching[-Beck]. "Arrangements for the Margrave of Ansbach's Visit to Schloss Seehof, Whitsun, 1775." *Furniture History* 27 (1991), pp. 67–82.

Masching 1996
Gisela Masching[-Beck]. "À la Mode: Das Lust-schloss Marquardsburg ob Seehof 1757 bis 1779. Quellen zu seiner Ausstattung und Funktion." Ph.D. thesis, Technische Universität Berlin, 1996.

Massie 1990
Suzanne Massie. *Pavlovsk: The Life of a Russian Palace*. Boston, 1990.

Massinelli 1993
Anna Maria Massinelli. *Il mobile toscano*. Milan, 1993.

McCormick and Ottomeyer 2004
Heather Jane McCormick and Hans Ottomeyer. *Vasemania: Neoclassical Form and Ornament in Europe—Selections from The Metropolitan Museum of Art*. Exh. cat., Bard Graduate Center for Studies in the Decorative Arts, Design, and Culture. New York, 2004.

"Mediaeval Court" 1862
"The Mediaeval Court, International Exhibition." *Building News* 9 (August 8, 1862), pp. 98–101.

Medieval and Renaissance Sculpture 1997
Medieval and Renaissance Sculpture and Works of Art. Exh. cat., Blumka Gallery. New York, 1997.

Meister 1965
Peter Wilhelm Meister. "The Eighteenth Century: Germany." In *World Furniture: An Illustrated History*, ed. Helena Hayward, pp. 145–53. New York, 1965.

Meister and Jedding 1958
Peter Wilhelm Meister and Hermann Jedding, eds. *Das schöne Möbel im Laufe der Jahrhunderte*. Heidelberg, 1958.

Mentmore 1884
Mentmore. 2 vols. Edinburgh, 1884.

Mercier 1780
Louis-Sébastien Mercier. *Tableau de Paris*. 4 vols. Amsterdam, 1780.

Mesnard 1867
Jules Mesnard. *Les merveilles de l'Exposition Universelle de 1867*. 2 vols. Paris, 1867.

Metken 1978
Sigrid Metken. *Geschnittenes Papier: Eine Geschichte des Ausschneidens in Europa von 1500 bis heute*. Munich, 1978.

Metropolitan Museum of Art 1975
The Metropolitan Museum of Art. *The Metropolitan Museum of Art: Notable Acquisitions, 1965–1975*. New York, 1975.

Metropolitan Museum of Art 1977
The Metropolitan Museum of Art. *Highlights of the Untermyer Collection of English and Continental Decorative Arts*. New York, 1977.

Metropolitan Museum of Art 1983
The Metropolitan Museum of Art. *Notable Acquisitions, 1982–1983*. New York, 1983.

Metropolitan Museum of Art 1984
The Metropolitan Museum of Art. *The Jack and Belle Linsky Collection in The Metropolitan Museum of Art*. New York, 1984.

Metropolitan Museum of Art 1986
The Metropolitan Museum of Art. *Recent Acquisitions: A Selection, 1985–1986*. New York, 1986.

Metropolitan Museum of Art 1988
The Metropolitan Museum of Art. *Recent Acquisitions: A Selection, 1987–1988*. New York, 1988.

Meyer 1965
Daniel Meyer. "Les appartements royaux du Château de Saint-Cloud sous Louis XVI et Marie-Antoinette, 1785–1792." *Gazette des beaux-arts*, 6th ser., 66 (October 1965), pp. 223–32.

Meyer 1980a
Daniel Meyer. *L'histoire du Roy*. Paris, 1980.

Meyer 1980b
Daniel Meyer. "La restitution de la chambre de Louis XIV à Versailles." *La revue du Louvre et des musées de France*, 1980, pp. 240–48.

Meyer 1994
Daniel Meyer. "Quelques restitutions et restaura-tions dans les appartements royaux de Versailles." *Revue du Louvre/La revue des musées de France*, April 1994, pp. 45–50.

Meyer 2002
Daniel Meyer. *Versailles: Furniture of the Royal Palace, Seventeenth and Eighteenth Centuries*. Vol. 1, *Prestigious Royal Furniture*. Trans. Ann Sautier-Greening. Dijon, 2002.

Michaelsen, Barthold, and Weissmann 2003
Hans Michaelsen, Janko Barthold, and Robert Weissmann. "'Marmelirtes Helffenbein': Rekon-struktionsversuche zu einer Imitationstechnik in der Mitte des 17. Jahrhunderts." *Restauro* 109 (April–May 2003), pp. 194–202.

Mielsch 1985
Harald Mielsch. *Buntmarmore aus Rom im Antikenmuseum Berlin*. Berlin, 1985.

Miziołek 1996
Jerzy Miziołek. *Soggetti classici sui cassoni fiorentini alla vigilia del Rinascimento*. Warsaw, 1996.

Molinier 1898
Émile Molinier. *Le mobilier au XVIIe et au XVIIIe siècle et pendant les premières années du Ier empire*. Histoire générale des arts appliqués à l'industrie du Ve à la fin du XVIIIe siècle 3. Paris, 1898.

Molinier 1902a
Émile Molinier. "Le mobilier français du XVIIIe siècle dans les collections étrangères." *Les arts*, no. 2 (March 1902), pp. 24–27.

Molinier 1902b
Émile Molinier. *Royal Interiors and Decorations of the Seventeenth and Eighteenth Centuries: Their History and Description*. 5 vols. Paris, 1902.

Möller 1962
Lieselotte Möller. "Ein holländischer Bilderrahmen aus dem siebzehnten Jahrhundert." *Jahrbuch der Hamburger Kunstsammlungen* 7 (1962), pp. 7–34.

Morazzoni 1954–57
Giuseppe Morazzoni. *Mobili veneziani laccati*. 2 vols. Milan, 1954–57.

Moret 1837–40
Philippe Moret. *Moyen-Âge pittoresque: Monumens d'architecture, meubles et décors du Xe au XVIIe siècle*. 5 vols. Paris, 1837–40.

Morley 1999
John Morley. *The History of Furniture: Twenty-five Centuries of Style and Design in the Western Tradition*. Boston, 1999.

Morris 1751
Robert Morris. *The Architectural Remembrancer: Being a Collection of New and Useful Designs of Ornamental Buildings and Decorations for Parks, Gardens, Woods, &c. . . .* London, 1751. Repr., Farnborough, Hampshire, England, 1971.

Müller 1956
Theodor Müller. "Bayerisches Nationalmuseum: Der Ertrag des Jubiläumsjahres 1955." *Münchner Jahrbuch der bildenden Kunst* 7 (1956), pp. 217–42.

Mulliner 1924
Herbert Hall Mulliner. *The Decorative Arts in England, 1660–1780*. London, 1924.

Murdoch 1991
Tessa Murdoch. "A Pair of Armchairs from the Chinese Bedroom at Badminton House." *Newsletter* (Furniture History Society), no. 104 (November 1991), pp. 8–10.

Myers 1991
Mary L. Myers. *French Architectural and Ornament Drawings of the Eighteenth Century*. Exh. cat., The Metropolitan Museum of Art. New York, 1991.

Napoléon 1969
Napoléon. Exh. cat., Grand Palais. Paris, 1969.

National Art-Collections Fund 1929
National Art-Collections Fund. *Twenty-fifth Annual Report, 1928 (Twenty-fifth Anniversary).* London, 1929.

"Nederlandse Kunst- en Antiekbeurs" 1979
"13ᵈᵉ Nederlandse Kunst- en Antiekbeurs 't Turfschip, Breda." *Antiek* 13 (April 1979), pp. 632–38.

Nef 1974
John Ulric Nef. *Cultural Foundations of Industrial Civilization.* The Wiles Lectures, 1956. Hamden, Conn., 1974.

Neurdenburg 1948
Elisabeth Neurdenburg. *De zeventiende eeuwsche beeldhouwkunst in de noordelijke Nederlanden: Hendrick de Keyser, Artus Quellinus, Rombout Verhulst en tijdgenooten.* Amsterdam, 1948.

Nichols 1992
Lawrence W. Nichols. "The 'Pen Works' of Hendrick Goltzius." Exh. cat., published in *Bulletin* (Philadephia Museum of Art) 88 (Winter 1992).

Nickel 1974
Helmut Nickel. "Two Falcon Devices of the Strozzi: An Attempt at Interpretation." *Metropolitan Museum Journal* 9 (1974), pp. 229–32.

Niemann and Fellner von Feldegg 1893
George Niemann and Ferdinand Fellner von Feldegg. *Theophilos Hansen und seine Werke.* Vienna, 1893.

Nocq 1926–31
Henry Nocq. *Le poinçon de Paris: Répertoire des maîtres-orfèvres de la juridiction de Paris depuis le Moyen-Âge jusqu'à la fin de XVIIIᵉ siècle.* 5 vols. Paris, 1926–31.

North and Snapper 1990
Michael North and Frits Snapper. "The Baltic Trade and the Decline of the Dutch Economy in the Eighteenth Century." In *Baltic Affairs: Relations between the Netherlands and North-Eastern Europe, 1500–1800; Essays,* ed. J. Ph. S. Lemmink and Jacques S. A. M. van Koningsbrugge, pp. 263–86. Baltic Studies 1. Nijmegen, 1990.

Northumberland 1926
Elizabeth Seymour Percy, Duchess of Northumberland. *The Diaries of a Duchess: Extracts from the Diaries of the First Duchess of Northumberland (1716–1776).* Ed. James Greig. London, 1926.

Nützmann 2000
Hannelore Nützmann. *Alltag und Feste: Florentinische Cassone- und Spallieramalerei aus der Zeit Botticellis.* Bilder im Blickpunkt. Staatliche Museen zu Berlin—Preussischer Kulturbesitz. Berlin, 2000.

Obreen 1877–90
Frederik D. O. Obreen. *Archief voor Nederlandsche kunstgeschiedenis.* 7 vols. Rotterdam, 1877–90.

Odom 1966
William Macdougal Odom. *A History of Italian Furniture from the Fourteenth to the Early*

Nineteenth Centuries. Vol. 1, *Gothic and Renaissance Furniture.* Rev. ed. Preface by Olga Raggio. New York, 1966.

Olszewski 1989
Edward J. Olszewski. "Cardinal Pietro Ottoboni (1667–1740) in America." *Journal of the History of Collections* 1 (1989), pp. 33–57.

Olszewski 1999
Edward J. Olszewski. "Decorating the Palace: Pietro Ottoboni (1667–1740) in the Cancelleria." In Walker and Hammond 1999, pp. 93–111.

Olszewski 2004
Edward J. Olszewski. *The Inventory of Paintings of Cardinal Pietro Ottoboni (1667–1740).* American University Studies, ser. 20, Fine Arts 36. New York, 2004.

Oswald 1936
Arthur Oswald. "Chicheley Hall, Buckinghamshire, III: The Residence of the Misses Farrar." *Country Life* 79 (May 23, 1936), pp. 534–39.

Ottillinger and Hanzl 1997
Eva B. Ottillinger and Lieselotte Hanzl. *Kaiserliche Interieurs: Die Wohnkultur des Wiener Hofes im 19. Jahrhundert und die Wiener Kunstgewerbe-reform.* Museen des Mobiliendepots 3. Vienna, 1997.

Ottomeyer 1987
Hans Ottomeyer, with Ulrike Laufer. *Biedermeiers Glück und Ende: Die gestörte Idylle, 1815–1848.* Exh. cat., Münchner Stadtmuseum. Munich, 1987.

Ottomeyer 2004
Hans Ottomeyer. "The Metamorphosis of the Neoclassical Vase." In McCormick and Ottomeyer 2004, pp. 15–30.

Pallot 1987
Bill G. B. Pallot. *L'art du siège au XVIIIᵉ siècle en France.* Paris, 1987.

Pallot 1993
Bill G. B. Pallot. *Furniture Collections in the Louvre.* Vol. 2, *Chairs and Consoles (Menuiserie), Seventeenth and Eighteenth Centuries.* Trans. Ann Sautier-Greening. Dijon, 1993.

Pallot 1995
Bill G. B. Pallot. "Sur les traces du 4ᵉ fauteuil de la duchesse de Parme." *L'estampille/L'objet d'art,* no. 291 (May 1995), pp. 58–66.

Palmer 1963
Robert Roswell Palmer. *A History of the Modern World.* 2nd ed. Rev. with the collaboration of Joel Colton. New York, 1963.

Pantazzi 1994
Michael Pantazzi. "Italy and the Grand Tour." In Humbert, Pantazzi, and Ziegler 1994, pp. 36–45.

Paolini 2002
Claudio Paolini. *Il mobile del Rinascimento: La collezione Herbert Percy Horne.* Florence, 2002.

Paolini, Ponte, and Selvafolta 1990
Claudio Paolini, Alessandra Ponte, and Ornella Selvafolta. *Il bello "ritrovato": Gusto, ambienti, mobili dell'Ottocento.* Novara, 1990.

Paolucci 1994
Antonio Paolucci, ed. *Il Battistero di San Giovanni a Firenze/The Baptistery of San Giovanni, Florence.* 2 vols. Mirabilia italiae 2. Modena, 1994.

Parker 1960
James Parker. "The Kress Galleries of French Decorative Arts: Other Decorative Objects." *The Metropolitan Museum of Art Bulletin* 18, (May 1960), pp. 296–308.

Parker 1966
James Parker. "French Eighteenth-Century Furniture Depicted on Canvas." *The Metropolitan Museum of Art Bulletin* 24 (January 1966), pp. 177–92.

Parker 1973
James Parker. "Eighteenth-Century France Recreated in the 'cold, barbarous country': The Tapestry Room from Bernstorff Palace, Copenhagen." *Burlington Magazine* 115 (June 1973), pp. 367–72.

Parker 1983
James Parker. "A Pair of Bookcases on Stands from the Palazzo Rospigliosi." In *Studien zum europäischen Kunsthandwerk: Festschrift Yvonne Hackenbroch,* ed. Jörg Rasmussen, pp. 229–37. Munich, 1983.

Parry 1996a
Linda Parry. "Domestic Decoration." In Parry 1996b, pp. 136–47.

Parry 1996b
Linda Parry, ed. *William Morris.* Exh. cat., Victoria and Albert Museum. London, 1996.

Pastré 2003
Elke Pastré. "Der Goldschmied Napoleons." *Weltkunst* 73 (December 2003), pp. 2108–9.

Patterns of Collecting 1975
Patterns of Collecting: Selected Acquisitions, 1965–1975. Exh. cat., The Metropolitan Museum of Art. New York, 1975.

Peck 1998
Amelia Peck. *Lyndhurst: A Guide to the House and Landscape.* Tarrytown, N.Y., 1998.

Pedrini 1948
Augusto Pedrini. *Il mobilio: Gli ambienti e le decorazioni del Rinascimento in Italia, secoli XV e XVI.* New ed. Florence, 1948.

Pelinck 1960
E. Pelinck. "Mr. Karel Heydanus: Zijn verzameling en de beschikkingen van zijn dochter." *Jaarboekje voor geschiedenis en oudheidkunde van Leiden en omstreken,* 1960, pp. 148–55.

Pepper 1984
D. Stephen Pepper. *Guido Reni: A Complete Catalogue of His Works.* New York, 1984.

Pératé and Brière 1908
André Pératé and Gaston Brière. *Collections Georges Hoentschel.* 4 vols. Paris, 1908.

Percival 1927
MacIver Percival. *The Walnut Collector.* London, 1927.

Petzet 1993
Michael Petzet. *Seehof: Geschichte und Restaurierung von Schloss und Park/Seehof Palace and Park: History and Restoration.* Denkmalpflege Informationen (Bayerisches Landesamt für Denkmalpflege), Ausgabe D, 20. Munich, 1993.

Pfeil 1999
Christoph, Graf von Pfeil. *Die Möbel der Residenz Ansbach.* Munich, London, and New York, 1999.

Philadelphia Museum of Art 1995
Philadelphia Museum of Art. *Handbook of the Collections: Philadelphia Museum of Art.* Philadelphia, 1995.

Pohlmann 1997
Ulrich Pohlmann. "Alma-Tadema and Photography." In Elizabeth Prettejohn et al., *Sir Lawrence Alma-Tadema,* ed. Edwin Becker, Edward Morris, Elizabeth Prettejohn, and Julian Treuherz, pp. 111–24. Exh. cat., Van Gogh Museum, Amsterdam, and Walker Art Gallery, Liverpool. New York, 1997.

Pommeranz 1995
Johannes W. Pommeranz. *Pastigliakästchen: Ein Beitrag zur Kunst- und Kulturgeschichte der italienischen Renaissance.* Internationale Hochschulschriften 167. Münster and New York, 1995.

Pons 1996
Bruno Pons. "Arabesques, or New Grotesques." In *The History of Decorative Arts: Classicism and the Baroque in Europe,* ed. Alain Gruber, pp. 157–223. Trans. John Goodman. New York, 1996.

Poser 1975
Hasso von Poser. *Johann Joachim Dietrich und der Hochaltar zu Diessen.* Munich, 1975.

Post 1997
Jeffrey E. Post. *The National Gem Collection.* National Museum of Natural History, Smithsonian Institution, Washington, D.C. New York, 1997.

Pradère 1989
Alexandre Pradère. *Les ébénistes français de Louis XIV à la Révolution.* Paris, 1989. English ed.: *French Furniture Makers: The Art of the Ébéniste from Louis XIV to the Revolution.* Trans. Perran Wood. London, 1989.

Pradère 2003
Alexandre Pradère. *Charles Cressent: Sculpteur, ébéniste du Régent.* Dijon, 2003.

Praël-Himmer 1978
Heidi Praël-Himmer. *Der Augsburger Goldschmied Johann Andreas Thelot.* Forschungshefte (Bayerisches Nationalmuseum, Munich) 4. Munich, 1978.

Raggio 1960
Olga Raggio. "The Farnese Table: A Rediscovered Work by Vignola." *The Metropolitan Museum of Art Bulletin* 18 (March 1960), pp. 213–31.

Raggio 1994
Olga Raggio. "Rethinking the Collections: New Presentations of European Decorative Arts at The Metropolitan Museum of Art." *Apollo* 139 (January 1994), pp. 3–19.

Raggio 1999
Olga Raggio. *The Gubbio Studiolo and Its Conservation.* Vol. 1, *Federico da Montefeltro's Palace at Gubbio and Its Studiolo.* The Metropolitan Museum of Art. New York, 1999.

Raggio et al. 1989
Olga Raggio, James Parker, Clare Le Corbeiller, Jessie McNab, Clare Vincent, and Alice M. Zrebiec. "French Decorative Arts during the Reign of Louis XIV, 1654–1715." *The Metropolitan Museum of Art Bulletin* 46, no. 4 (Spring 1989).

Ramond 1994
Pierre Ramond. *Chefs-d'oeuvre des marqueteurs.* Vol. 1, *Des origines à Louis XIV.* Dourdan, 1994.

Ramond 2000
Pierre Ramond. *Masterpieces of Marquetry.* 3 vols. Los Angeles, 2000.

Randall 1970
Richard H. Randall Jr. "A French Quartet." *Bulletin of the Walters Art Gallery* 23, no. 3 (December 1970), unpaginated.

***Rapports des délégations ouvrières* 1869**
Rapports des délégations ouvrières, Exposition Universelle, 1867. Vol. 1, *Découpeurs, marqueteurs.* Paris, 1869.

Rathke-Köhl 1964
Sylvia Rathke-Köhl. *Geschichte des Augsburger Goldschmiedegewerbes vom Ende des 17. bis zum Ende des 18. Jahrhunderts.* Schwäbische Geschichtsquellen und Forschungen 6. Augsburg, 1964.

Reau 1971
Louis Reau. *L'Europe française au siècle des Lumières.* L'évolution de l'humanité 31. Paris, 1971.

"Recent Acquisitions" 1990
"Recent Acquisitions: A Selection, 1989–1990." *The Metropolitan Museum of Art Bulletin* 48, no. 2 (Fall 1990).

"Recent Acquisitions" 1996
"Recent Acquisitions: A Selection, 1995–1996." *The Metropolitan Museum of Art Bulletin* 54, no. 2 (Fall 1996).

"Recent Acquisitions" 1997
"Recent Acquisitions: A Selection, 1996–1997." *The Metropolitan Museum of Art Bulletin* 55, no. 2 (Fall 1997).

"Recent Acquisitions" 1998
"Recent Acquisitions: A Selection, 1997–1998." *The Metropolitan Museum of Art Bulletin* 56, no. 2 (Fall 1998).

"Recent Acquisitions" 1999
"Recent Acquisitions: A Selection, 1998–1999." *The Metropolitan Museum of Art Bulletin* 57, no. 2 (Fall 1999).

"Recent Acquisitions" 2000
"Recent Acquisitions: A Selection, 1999–2000." *The Metropolitan Museum of Art Bulletin* 58, no. 2 (Fall 2000).

"Recent Acquisitions" 2001
"Recent Acquisitions: A Selection, 2000–2001." *The Metropolitan Museum of Art Bulletin* 59, no. 2 (Fall 2001).

"Recent Acquisitions" 2002
"Recent Acquisitions: A Selection, 2001–2002." *The Metropolitan Museum of Art Bulletin* 60, no. 2 (Fall 2002).

"Recent Acquisitions" 2003
"Recent Acquisitions: A Selection, 2002–2003." *The Metropolitan Museum of Art Bulletin* 61, no. 2 (Fall 2003).

Reepen and Handke 1996
Iris Reepen and Edelgard Handke. *Chinoiserie: Möbel und Wandverkleidungen.* Exh. cat. Bestandskatalog der Verwaltung der Staatlichen Schlösser und Gärten Hessen 5. Bad Homburg, 1996.

Reichet 1856
R. Reichet. *Das Granatapfelmotif in der Textilkunst.* Berlin, 1856.

Reinhardt 1996
Ursula Reinhardt. "Acanthus." In *The History of Decorative Arts: Classicism and the Baroque in Europe,* ed. Alain Gruber, pp. 93–155. Trans. John Goodman. New York, 1996.

"Remarkable Cabinet" 1885
"A Remarkable Cabinet." *Art Amateur* (New York) 13 (June 1885), pp. 17–18.

Remington 1929
Preston Remington. "Late Eighteenth-Century English Furniture: Recent Accessions." *Bulletin of The Metropolitan Museum of Art* 24 (November 1929), pp. 295–301.

Remington 1931
Preston Remington. "An Ebony Cabinet of the Seventeenth Century." *Bulletin of The Metropolitan Museum of Art* 26 (October 1931), pp. 232–36.

Remington 1935
Preston Remington. "A French XVIII Century Fire Screen." *Bulletin of The Metropolitan Museum of Art* 30 (May 1935), pp. 109–11.

Remington 1954
Preston Remington. "The Galleries of European Decorative Art and Period Rooms, Chiefly XVII and XVIII Century." *The Metropolitan Museum of Art Bulletin* 13 (November 1954), pp. 65–137.

Rémusat 1917
Martine Rémusat. "L'aventure sentimentale de J.-H. Bernstorff (1741–1748)." *Revue des deux mondes,* 6th ser., 40 (1917), pp. 387–405.

Renger 1976–78
Konrad Renger. "Sine Cerere et Baccho friget Venus." *Gentse bijdragen tot de kunstgeschiedenis* 24 (1976–78), pp. 190–203.

***Reports on the Paris Universal Exhibition* 1868**
Reports on the Paris Universal Exhibition, 1867: Presented to Both Houses of Parliament by Command of Her Majesty. Vol. 2. London, 1868.

Reyniès 1987
Nicole de Reyniès. *Le mobilier domestique: Vocabulaire typologique*. 2 vols. Principes d'analyse scientifique 5. Inventaire général des monuments et des richesses artistiques de la France. Paris, 1987.

Ricci 1913
Seymour de Ricci. *Louis XVI Furniture*. London, 1913.

Richardson 1984
John Richardson. "Cubists among the Columns." *Vanity Fair*, July 1984, pp. 50–61.

Rieder 1978a
William Rieder. "Eighteenth-Century Chairs in the Untermyer Collection." *Apollo* 107 (March 1978), pp. 181–85.

Rieder 1978b
William Rieder. "A Gilt Gesso Set of Furniture Traditionally from Stowe." *Furniture History* 14 (1978), pp. 9–13.

Rieder 1993
William Rieder. "John Linnell's Furniture for the Dining Room of Lansdowne House." *Furniture History* 29 (1993), pp. 66–71.

Rieder 1994
William Rieder. "'B.V.R.B.' at the Met." *Apollo* 139 (January 1994), pp. 33–40.

Rieder 1996
William Rieder. "The Croome Court Tapestry Room, Worcestershire, 1771." In Amelia Peck et al., *Period Rooms in The Metropolitan Museum of Art*, pp. 157–67. New York, 1996.

Rieder 1997
William Rieder. "A Table for Madame de Pompadour." *Magazine Antiques* 151 (January 1997), pp. 226–29.

Rieder 2002
William Rieder. "A Royal Commode and Secretaire by Riesener." *Furniture History* 38 (2002), pp. 83–96.

Rietstap 1884–87
Johannes Baptist Rietstap. *Armorial général, précédé d'un dictionnaire des termes du blason*. 2 vols. Gouda, 1884–87.

Rijksmuseum 1952
Rijksmuseum, Amsterdam. *Catalogus van meubelen en betimmeringen*. 3rd ed. The Hague, 1952.

H. Roberts 1990
Hugh Roberts. "Metamorphoses in Wood: Royal Library Furniture in the Eighteenth and Nineteenth Centuries." *Apollo* 131 (June 1990), pp. 382–90.

H. Roberts 1996
Hugh Roberts. "Sir William Chambers and Furniture." In *Sir William Chambers: Architect to George III*, ed. John Harris and Michael Snodin, pp. 163–74. Exh. cat., Courtauld Institute of Art Gallery, London, and Nationalmuseum, Stockholm. New Haven and London, 1996.

H. Roberts 1997
Hugh Roberts. "A Neoclassical Episode at

Windsor." *Furniture History* 33 (1997), pp. 177–87.

Robertson 1986
Elizabeth Clare Robertson. "The Artistic Patronage of Cardinal Alessandro Farnese (1520–89)." Ph.D. diss., Warburg Institute, University of London, 1986.

Roche 1912–13
Denis Roche. *Le mobilier français en Russie: Meubles des XVIIe et XVIIIe siècles et du commencement du XIXe conservés dans les palais et les musées impériaux et dans les collections privées*. 2 vols. Paris, 1912–13.

Roda 1990
Burkard von Roda. "The Design for the 'Berceau' Room at Seehof." *Metropolitan Museum Journal* 25 (1990), pp. 161–68.

Rogasch 2004
Wilfried Rogasch. *Adel*. Dumont-Taschenbücher 548. Cologne, 2004.

Rogers 1922
Meyric R. Rogers. "An Eighteenth-Century French Day-Bed." *Bulletin of The Metropolitan Museum of Art* 17 (December 1922), pp. 258–60.

Ronfort 1985
Jean-Nérée Ronfort. "Le mobilier royal à l'époque de Louis XIV: Rapprochements et documents nouveaux—1651, 1681 et 1715." *L'estampille*, no. 180 (April 1985), pp. 36–43.

Ronfort 1986
Jean-Nérée Ronfort. "Le mobilier royal à l'époque de Louis XIV. 1685.: Versailles et le bureau du Roi." *L'estampille*, no. 191 (April 1986), pp. 44–51.

Ronfort 1991–92
Jean-Nérée Ronfort. "Jean Ménard (c. 1525–1582): Marqueteur et sculpteur en marbre et sa famille." In *Antologia di belle arti*, n.s., nos. 39–42 (1991–92), pp. 139–47.

Ronfort 2001
Jean-Nérée Ronfort. "The Armoires de l'Histoire d'Apollon." In *A Louis XIV Armoire by André-Charles Boulle*, pp. 7–45. Sale cat., Phillips, New York, December 5, 2001.

Ronfort and Augarde 1991
Jean-Nérée Ronfort and Jean-Dominique Augarde. "Le maître du bureau de l'Électeur." *L'estampille/L'objet d'art*, no. 243 (January 1991), pp. 42–75.

Roubo 1769–75
André-Jacob Roubo. *L'art du menuisier*. 4 vols. Paris, 1769–75. Repr., 1977.

"Royal Suite" 1933
"Loan Exhibition of a Royal Suite Held in Toledo." *Art News* 32, no. 13 (December 30, 1933), pp. 3, 16.

Rubinstein-Bloch 1926–30
Stella Rubinstein-Bloch, comp. *Catalogue of the Collection of George and Florence Blumenthal, New York*. 6 vols. Paris, 1926–30.

Rudolph 1999
Stephan Rudolph. "Metallauflage in Form einer

Wellenleiste: Rekonstruktion einer Herstellungstechnik für den Augsburger Kabinettschrank." *Restauro*, January–February 1999, pp. 42–43.

Sale 1979
John Russell Sale. *Filippo Lippi's Strozzi Chapel in Santa Maria Novella*. Outstanding Dissertations in the Fine Arts. New York and London, 1979.

Salmann 1962
Georges S. Salmann. "A Great Art Lover: The Late Arturo Lopez-Willshaw." *Connoisseur* 151 (October 1962), pp. 71–79.

Salverte 1927
François de Salverte. *Les ébénistes du XVIIIe siècle: Leurs oeuvres et leurs marques*. New ed. Paris and Brussels, 1927.

Salverte 1934–35
François de Salverte. *Les ébénistes du XVIIIe siècle: Leurs oeuvres et leurs marques*. 3rd ed. 2 vols. Paris, 1934–35.

Salverte 1962
François de Salverte. *Les ébénistes du XVIIIe siècle: Leurs oeuvres et leurs marques*. 5th ed. Paris, 1962.

Die Sammlung Dr. Albert Figdor 1930
Die Sammlung Dr. Albert Figdor, Wien. 5 vols. Sale cat. Vienna, 1930.

Samoyault 1979
Jean-Pierre Samoyault. *André-Charles Boulle et sa famille: Nouvelles recherches, nouveaux documents*. Hautes études médiévales et modernes 40. Geneva, 1979.

Sangl 1990
Sigrid Sangl. *Das Bamberger Hofschreinerhandwerk im 18. Jahrhundert*. Forschungen zur Kunst- und Kulturgeschichte 1. Munich, 1990.

Sargentson 1996
Carolyn Sargentson. *Merchants and Luxury Markets: The Marchands Merciers of Eighteenth Century Paris*. Victoria and Albert Museum Studies in the History of Art and Design. London, 1996.

Savill 1988
Rosalind Savill. *The Wallace Collection Catalogue of Sèvres Porcelain*. 3 vols. London, 1988.

Sayer 1762 (1966 ed.)
Robert Sayer. *The Ladies Amusement; or, Whole Art of Japanning Made Easy*. 2nd ed. London, 1762. Repr., Newport, [Monmouthshire, Wales], 1966.

Scalini 1992
Mario Scalini. "Divisi e livree: Araldica quotidiana." In *Leoni vermigli e candidi liocorni*, pp. 49–65. Quaderni del Museo Civico di Prato 1. Prato, 1992.

Scheibmayr 1989
Erich Scheibmayr. *Wer? Wann? Wo? Persönlichkeiten in Münchner Friedhöfen*. Munich, 1989.

Scheicher 1995
Elisabeth Scheicher. "Zur Ikonologie von Naturalien

im Zusammenhang der enzyklopädischen Kunstkammer." *Anzeiger des Germanischen Nationalmuseums*, 1995, pp. 115–25.

Scher 1994
Stephen K. Scher, ed. *The Currency of Fame: Portrait Medals of the Renaissance.* Exh. cat., Frick Collection. New York, 1994.

Schick 1998
Afra Schick. "Möbel nach Entwürfen von François de Cuvilliés D.Ä." *Münchner Jahrbuch der bildenden Kunst*, 3rd ser., 49 (1998), pp. 123–62.

Schmitz 1923
Hermann Schmitz. *Deutsche Möbel des Klassizismus.* Stuttgart, 1923.

Schottmüller 1921
Frida Schottmüller. *Wohnungskultur und Möbel der italienischen Renaissance.* Stuttgart, 1921.

Schreider 1971
Louis Schreider III. "Gouverneur Morris: Connoisseur of French Art." *Apollo* 93 (June 1971), pp. 470–83.

Schreyer 1932
Alexander Schreyer. *Die Möbelentwürfe Johann Michael Hoppenhaupts des Älteren und ihre Beziehungen zu den Rokoko-Möbeln Friedrichs des Grossen.* Studien zur deutschen Kunstgeschichte 288. Strassburg, 1932.

Schubring 1915
Paul Schubring. *Cassoni—Truhen und Truhenbilder der italienischen Frührenaissance: Ein Beitrag zur Profanmalerei im Quattrocento.* Leipzig, 1915.

Schubring 1923
Paul Schubring. *Cassoni—Truhen und Truhenbilder der italienischen Frührenaissance: Ein Beitrag zur Profanmalerei im Quattrocento.* 2nd ed. Leipzig, 1923.

Schütze 2005
Sebastian Schütze. *Kardinal Maffeo Barberini, später Papst Urban VIII., als Auftraggeber und Mäzen: Beiträge zu einer Archäologie des römischen Hochbarok.* Römische Forschungen der Bibliotheca Hertziana 32. Munich, 2005.

Second Empire **1978**
The Second Empire, 1852–1870: Art in France under Napoleon III. Exh. cat., Philadelphia Museum of Art; Detroit Institute of Arts; and Grand Palais, Paris. Philadelphia, 1978.

Seelig 1995
Lorenz Seelig. *Höfische Pracht der Augsburger Goldschmiedekunst.* Exh. cat., Bayerisches Nationalmuseum. Munich and New York, 1995. English ed.: *Silver and Gold: Courtly Splendour from Augsburg.* Trans. Elizabeth Clegg. Munich and New York, 1995.

Seelig 2002
Lorenz Seelig. "'Ein Willkomme in der Form eines Mohrenkopfs von Silber getriebener Arbeit': Der wiederentdeckte Mohrenkopfpokal Christoph Jamnitzers aus dem späten 16. Jahrhundert." In Eikelmann 2002, pp. 19–123.

Seling 1980
Helmut Seling. *Die Kunst der Augsburger Goldschmiede, 1529–1868: Meister, Marken, Werke.* 3 vols. Munich, 1980.

Seymour 1720
Richard Seymour. *The Court-Gamester; or, Full and Easy Instructions for Playing the Games Now in Vogue, after the Best Method, as They Are Played at Court and in the Assemblées, viz. Ombre, Picquet, and the Royal Game of Chess.* 2nd ed. London, 1720.

Sherrill 1996
Sarah B. Sherrill. *Carpets and Rugs of Europe and America.* New York, 1996.

Shrub 1965
Derek Shrub. "The Vile Problem." *Victoria and Albert Museum Bulletin* 1, no. 4 (October 1965), pp. 26–35.

Sievers 1942
Johannes Sievers. *Bauten für den Prinzen Karl von Preussen.* Karl Friedrich Schinkel Lebenswerk. Berlin, 1942.

Sievers 1950
Johannes Sievers. *Die Möbel.* Karl Friedrich Schinkel Lebenswerk 6. Berlin, 1950.

Snodin 1996a
Michael Snodin. "Interiors and Ornament." In *Sir William Chambers: Architect to George III*, ed. John Harris and Michael Snodin, pp. 125–48. Exh. cat., Courtauld Institute of Art Gallery, London, and Nationalmuseum, Stockholm. New Haven and London, 1996.

Snodin 1996b
Michael Snodin, ed. *Sir William Chambers.* Essays by John Harris et al. Catalogues of Architectural Drawings in the Victoria and Albert Museum. London, 1996.

Soieries de Lyon **1988**
Soieries de Lyon: Commandes royales au XVIIIᵉ s. (1730–1800). Exh. cat., Musée Historique des Tissus. Les dossiers du Musée Historique des Tissus 2. Lyons, 1988.

Spiazzi 1995
Anna Maria Spiazzi. "Gli armadi delle reliquie nella cappella del tesoro." In *Basilica del Santo: Le oreficerie*, ed. Marco Collareta, Giordana Mariani Canova, and Anna Maria Spiazzi, pp. 15–26. Padua and Rome, 1995.

St. Petersburg Jewellers **2000**
St. Petersburg Jewellers, Eighteenth–Nineteenth Centuries/Petersburgskie iuveliry, XVIII–XIX veka. Exh. cat., State Hermitage Museum. Saint Petersburg, 2000.

Stalker and G. Parker 1688 (1960 ed.)
John Stalker and George Parker. *A Treatise of Japaning and Varnishing, Being a Compleat Discovery of Those Arts.* Oxford, 1688. New ed.: *A Treatise of Japanning and Varnishing, 1688.* Introduction by H. D. Molesworth. Chicago, 1960.

Standen 1966
Edith Appleton Standen. "Working for Love and Working for Money: Some Notes on Embroideries and Embroiderers of the Past." In *East Side House, Winter Antiques Show*, pp. 16–27. New York, 1966.

Standen 1983
Edith Appleton Standen. "A Parrot and a Squirrel in a Landscape." In *Studien zum europäischen Kunsthandwerk: Festschrift Yvonne Hackenbroch*, ed. Jörg Rasmussen, pp. 251–56. Munich, 1983.

Standen 1985
Edith Appleton Standen. *European Post-Medieval Tapestries and Related Hangings in The Metropolitan Museum of Art.* 2 vols. New York, 1985.

Stanislas **2004**
Stanislas: Un roi de Pologne en Lorraine. Exh. cat., Musée Historique Lorrain, Nancy. Versailles, 2004.

Staring 1965
A. Staring. "Een borstbeeld van de Koning-Stadhouder." *Oud Holland* 80 (1965), pp. 221–27.

Stechow 1944
Wolfgang Stechow. "Marco del Buono and Apollonio di Giovanni: Cassone Painters." *Bulletin of the Allen Memorial Art Museum* 1 (June 1944), pp. 4–23.

Stegmann 1909
Hans Stegmann. *Die Holzmöbel der Sammlung Figdor.* 2nd ed. Vienna, 1909.

Stiegel 2002
Achim Stiegel. "Die Differenzierung der Autorschaft: Zum Verhältnis von Entwurf und Ausführung." In Hedinger and Berger 2002, pp. 23–29.

Stiegel 2003
Achim Stiegel. *Berliner Möbelkunst vom Ende des 18. bis zur Mitte des 19. Jahrhunderts.* Kunstwissenschaftliche Studien 107. Munich, 2003.

Strahan 1883–84
Edward Strahan [Earl Shinn]. *Mr. Vanderbilt's House and Collection.* 4 vols. Boston, 1883–84.

Strazzullo 1984
Franco Strazzullo. *La chiesa di S. Giovanni dei Fiorentini a Napoli.* Naples, 1984.

Strömer 1988
Wilfried Strömer. *Die Herrnhuter Brüdergemeinde im städtischen Gefüge von Neuwied.* Boppard, 1988.

Strozzi 1851
Lorenzo Strozzi. *Vita di Filippo Strozzi: Il Vecchio.* Florence, 1851.

Stuart and Revett 1825
James Stuart and Nicholas Revett. *The Antiquities of Athens.* New ed. Vol. 1. London, 1825.

Stürmer 1978
Michael Stürmer. "'Bois des Indes' and the Economics of Luxury Furniture in the Time of David Roentgen." *Burlington Magazine* 120 (December 1978), pp. 799–805.

Stürmer 1979a
Michael Stürmer. "An Economy of Delight: Court Artisans of the Eighteenth Century." *Business History Review* 53 (Winter 1979), pp. 496–528.

Stürmer 1979b
Michael Stürmer "Höfische Kultur und früh-moderne Unternehmer: Zur Ökonomie des Luxus im 18. Jahrhundert." *Historische Zeitschrift* 229 (1979), pp. 265–97.

Stürmer 1982
Michael Stürmer. *Handwerk und höfische Kultur: Europäische Möbelkunst im 18. Jahrhundert.* Munich, 1982.

Stürmer 1986
Michael Stürmer. *Herbst des alten Handwerks: Meister, Gesellen und Obrigkeit im 18. Jahrhundert.* Serie Piper 515. Munich, 1986.

D. Sutton 1982
Denys Sutton. "Rococo Furniture from Schloss Seehof." *Apollo* 116 (October 1982), pp. 263–66.

P. C. Sutton 1980
Peter C. Sutton. *Pieter de Hooch.* Ithaca, N.Y., 1980.

Symonds 1929
R. W. Symonds. *English Furniture from Charles II to George II: A Full Account of the Design, Material and Quality of Workmanship of Walnut and Mahogany Furniture of This Period; and of How Spurious Specimens Are Made.* London, 1929.

Syndram 1999
Dirk Syndram. *Die Ägyptenrezeption unter August dem Starken: Der "Apis-Altar" Johann Melchior Dinglingers.* Sonderbände der *Antiken Welt.* Zaberns Bildbände zur Archäologie. Mainz am Rhein, 1999.

Syndram and Scherner 2004
Dirk Syndram and Antje Scherner, eds. *Princely Splendor: The Dresden Court, 1580–1620.* Exh. cat., Museum für Kunst und Gewerbe, Hamburg; The Metropolitan Museum of Art, New York; and Fondazione Memmo, Palazzo Ruspoli, Rome. Milan, Dresden, and New York, 2004.

Syson and D. Thornton 2001
Luke Syson and Dora Thornton. *Objects of Virtue: Art in Renaissance Italy.* London, 2001.

Taylor 1957
Francis Henry Taylor. *Pierpont Morgan as Collector and Patron, 1873–1913.* New York, 1957.

Un temps d'exubérance 2002
Un temps d'exubérance: Les arts décoratifs sous Louis XIII et Anne d'Autriche. Exh. cat., Galeries Nationales du Grand Palais. Paris, 2002.

Terrasse 1920
Charles Terrasse. *Un mobilier de Weisweiler et Gouthière.* Paris, 1920.

Teuber 1740
Johann Martin Teuber. *Mechanici auch Kunst und Silber Drechslers in Regenspurg.* Regensburg, 1740.

Theophilus 1979
Theophilus. *On Divers Arts: The Foremost Medieval Treatise on Painting, Glassmaking, and Metalwork.* Trans. by John G. Hawthorne and Cyril Stanley Smith. New York, 1979.

Theunissen 1934
André Theunissen. *Meubles et sièges du XVIIIe siècle: Menuisiers, ébénistes, marques, plans et ornementation de leurs oeuvres.* Paris, 1934.

Van Thiel and De Bruyn Kops 1984
Pieter J. J. Van Thiel and C. J. de Bruyn Kops. *Prijst de lijst: De Hollandse schilderijlijst in de zeventiende eeuw.* Exh. cat., Rijksmuseum, Amsterdam. Amsterdam and The Hague, 1984.

Thiéry 1787
Luc-Vincent Thiéry. *Guide des amateurs et des étrangers voyageurs à Paris; ou, Description raisonnée de cette ville, de sa banlieue, & de tout ce qu'elles contiennent de remarquable, enrichie de vues perspectives des principaux monumens modernes.* 2 vols. Paris, 1787.

Thom 1999
Colin Thom. "From Pierpont Morgan to the Kennedys and Beyond: New Light on the Art and Architecture of No. 14 Princes Gate." *Apollo* 149 (June 1999), pp. 31–41.

P. Thornton 1972
Peter Thornton. "John Jones: Collector of French Furniture." *Apollo* 95 (March 1972), pp. 162–75.

P. Thornton 1990
Peter Thornton. *Seventeenth-Century Interior Decoration in England, France and Holland.* Studies in British Art. New Haven and London, 1990.

P. Thornton 1991
Peter Thornton. *The Italian Renaissance Interior, 1400–1600.* New York, 1991.

P. Thornton and Rieder 1971–72
Peter Thornton and William Rieder. "Pierre Langlois: Ébéniste." *Connoisseur* 178 (December 1971), pp. 283–88; 179 (February–April 1972), pp. 105–12, 176–87, 257–65; 180 (May 1972), pp. 30–35.

P. Thornton and Tomlin 1980
Peter Thornton and Maurice Tomlin. "The Furnishing and Decoration of Ham House." *Furniture History* 16 (1980).

Tipping 1911
H. Avray Tipping. "Furniture of the XVII and XVIII Centuries: Furniture at Hampton Court, near Leominster." *Country Life* 30 (November 25, 1911), pp. 787–91.

Tipping 1928
H. Avray Tipping. *Old English Furniture: Its True Value and Function; Being Two Lectures Delivered at Messrs. Waring & Gillow's on June 11th and 14th, 1928.* London, 1928.

Tipping and Hussey 1928
H. Avray Tipping and Christopher Hussey. *English Homes.* Period 4, vol. 2, *The Work of Sir John Vanbrugh and His School, 1699–1736.* Country Life Library. London, 1928.

Tomkins 1989
Calvin Tomkins. *Merchants and Masterpieces: The Story of The Metropolitan Museum of Art.* Rev. ed. New York, 1989.

Tomlin 1982
Maurice Tomlin. *Catalogue of Adam Period Furniture.* Victoria and Albert Museum. London, 1982.

Tomlin 1986
Maurice Tomlin. *Ham House.* Victoria and Albert Museum. London, 1986.

Tomlinson 1991
Richard Allan Tomlinson. *The Athens of Alma Tadema.* Stroud, Gloucestershire, England, and Wolfeboro Falls, N.H., 1991.

Toni 1987
Giovanni de Toni. *Macchine di Leonardo: Mostra di modelli.* Exh. cat., Ateneo di Brescia. Brescia, 1987.

Treuherz 1997
Julian Treuherz. "Alma-Tadema: Aesthete, Architect and Interior Designer." In Elizabeth Prettejohn et al., *Sir Lawrence Alma-Tadema,* ed. Edwin Becker, Edward Morris, Elizabeth Prettejohn, and Julian Treuherz, pp. 45–56. Exh. cat., Van Gogh Museum, Amsterdam, and Walker Art Gallery, Liverpool. New York, 1997.

"Trois meubles qui ont probablement appartenu à Marie-Antoinette" 1924
"Trois meubles qui ont probablement appartenu à Marie-Antoinette." *La Renaissance de l'art français et des industries de luxe* 7 (January 1924), pp. 114–15.

Tuppo 1485
Francesco del Tuppo, ed. and trans. *Aesopus: Vita e Fabulae.* Naples, 1485. Repr.: Ed. Carlo Zucchetti. Milan, 1963.

Universal Exhibition 1867–68
The Illustrated Catalogue of the Universal Exhibition. London and New York, 1867–68. Published in 2 parts with *Art-Journal,* n.s., 6–7 (1867–68).

Vasari 1996
Giorgio Vasari. *Lives of the Painters, Sculptors and Architects.* Trans. Gaston du C. de Vere. 2 vols. Everyman's Library. New York, 1996.

Vatel 1883
Charles Vatel. *Histoire de Madame Du Barry, d'après ses papiers personnels et les documents des archives publiques.* 3 vols. Versailles, 1883.

Veldman 1991
Ilja M. Veldman. "Bijbelse thema's in de Nederlandse prentkunst van de 16de en het begin van de 17de eeuw." In Kootte 1991, pp. 29–42.

Veldman 1993
Ilja M. Veldman. *The New Hollstein: Dutch and Flemish Etchings, Engravings and Woodcuts, 1450–1700.* [Vol. 1], pt. 1, *Maarten van Heemskerck.* Ed. Ger Luijten. Roosendaal, 1993.

Verlet 1963
Pierre Verlet. *French Royal Furniture: An Historical Survey Followed by a Study of Forty Pieces Preserved in Great Britain and the United States.* New York, 1963.

Verlet 1982a
Pierre Verlet. *Les meubles français du XVIIIe siècle.* 2nd ed. Paris, 1982.

Verlet 1982b
Pierre Verlet. *The Savonnerie: Its History.*
The Waddesdon Collection. The James A. de
Rothschild Collection at Waddesdon Manor.
Fribourg, 1982.

Verlet 1990
Pierre Verlet. *Le mobilier royal français.* Vol. 4,
*Meubles de la couronne conservés en Europe et
aux États-Unis.* 2nd ed. Paris, 1990.

Verlet 1994
Pierre Verlet. *Le mobilier royal français.* Vol. 3,
*Meubles de la couronne conservés en Angleterre
et aux États-Unis.* 2nd ed. Paris, 1994.

Verlet 1999
Pierre Verlet. *Les bronzes dorés français du
XVIIIe siècle.* 2nd ed. Grand manuels Picard.
Paris, 1999.

Victoria and Albert Museum 1947
Victoria and Albert Museum. *Georgian
Furniture.* Introduction by Ralph Edwards.
London, 1947.

Victoria and Albert Museum 1965
Victoria and Albert Museum. *English Chairs.*
Introduction by Ralph Edwards. 2nd ed.
London, 1965.

Vienna in the Age of Schubert 1979
*Vienna in the Age of Schubert: The Biedermeier
Interior, 1815–1848.* Exh. cat., Victoria and
Albert Museum. London, 1979.

Vitry 1898
Paul Vitry. "L'oeuvre décorative de M. Frémiet."
Art et décoration 4 (1898), pp. 65–77.

Vliegenthart 2002
Adriaan W. Vliegenthart. *Het Loo Palace: Journal
of a Restoration.* Trans. Margaret Clegg. Apeldoorn,
2002.

Völker 1996
Angela Völker. *Biedermeierstoffe: Die
Sammlungen des MAK—Österreichisches
Museum für Angewandte Kunst, Wien, und
des Technischen Museums, Wien.* Munich and
New York, 1996.

Wackernagel 1966
Rudolf H. Wackernagel. *Der französische
Krönungswagen von 1696–1825: Ein Beitrag zur
Geschichte des repräsentativen Zeremonienwagens.*
Neue Münchener Beiträge zur Kunstgeschichte 7.
Berlin, 1966.

Waddy 1990
Patricia Waddy. *Seventeenth-Century Roman
Palaces: Use and the Art of the Plan.* New York,
1990.

Wagner-Rieger and Reissberger 1980
Renate Wagner-Rieger and Mara Reissberger.
Theophil von Hansen. Die Wiener Ringstrasse,
Bild einer Epoche 8, pt. 4. Wiesbaden,
1980.

Wakefield 1983
Humphry Wakefield. "Secrets of Great Furniture
Revealed in the Analysis of a Chair: How to
Know the Value of Everything." *Connoisseur* 213
(December 1983), pp. 112–17.

Walker 1999
Stefanie Walker. "The Artistic Sources and
Development of Roman Baroque Decorative
Arts." In Walker and Hammond 1999, pp. 3–19.

Walker and Hammond 1999
Stefanie Walker and Frederick Hammond, eds.
*Life and the Arts in the Baroque Palaces of Rome:
Ambiente Barocco.* Exh. cat., The Bard Graduate
Center for Studies in the Decorative Arts, Design,
and Culture, New York, and the Nelson-Atkins
Museum of Art, Kansas City. New Haven and
London, 1999.

Wanscher 1980
Ole Wanscher. *Sella Curulis, the Folding Stool: An
Ancient Symbol of Dignity.* Copenhagen, 1980.

Ward-Jackson 1958
Peter Ward-Jackson. *English Furniture Designs of
the Eighteenth Century.* London, 1958.

Wardropper and L. S. Roberts 1991
Ian Wardropper and Lynn Springer Roberts.
*European Decorative Arts in the Art Institute of
Chicago.* Chicago, 1991.

Wardwell 1967
Allen Wardwell. "Continental Decorative Arts at
the Art Institute of Chicago." *Magazine Antiques* 92
(October 1967), pp. 508–23.

Watin 1778
Jean-Félix Watin. *L'art du peintre, doreur,
vernisseur.* New ed. Paris, 1778.

Watin 1828
Jean-Félix Watin. *L'art du peintre, doreur,
vernisseur.* 10th ed. Paris, 1828.

Watson 1960
Francis J. B. Watson. *Louis XVI Furniture.*
London, 1960.

Watson 1966a
Francis J. B. Watson. *The Wrightsman Collection.*
Vol. 1, *Furniture.* New York, 1966.

Watson 1966b
Francis J. B. Watson. *The Wrightsman Collection.*
Vol. 2, *Furniture, Gilt Bronze and Mounted
Porcelain, Carpets.* New York, 1966.

Watson 1970
Francis J. B. Watson. *The Wrightsman Collection.*
Vol. 3, *Furniture, Gold Boxes.* New York, 1970.

Watson 1989
Francis J. B. Watson. "The Informed Eye:
Joubert's Scarlet Lacquer *Bureau Plat* Made
for Louis XV." *Apollo* 130 (November 1989),
pp. 342–43.

Weil and Urban 1994
Thorsten Weil and Klaus-Peter Urban. "Ein Lacca-
Povera-Kleinmöbel aus dem 18. Jahrhundert:
Sichten der Quellen zur Verzierungstechnik und
zum Firnis." *Restauro* 100 (March–April 1994),
pp. 94–99.

Wells-Cole 1997
Anthony Wells-Cole. *Art and Decoration in
Elizabethan and Jacobean England: The Influence
of Continental Prints, 1558–1625.* New Haven
and London, 1997.

Westermann 2001
Mariët Westermann. *Art and Home: Dutch
Interiors in the Age of Rembrandt.* With essays
by C. Willemijn Fock, Eric Jan Sluijter, and
H. Perry Chapman. Exh. cat., Denver Art
Museum and Newark Museum, Newark, New
Jersey. Denver, Newark, and Zwolle, 2001.

White 1982
Lisa White. "Two English State Beds in The
Metropolitan Museum of Art." *Apollo* 116
(August 1982), pp. 84–88.

Wildenstein 1962
Georges Wildenstein. "Simon-Philippe Poirier:
Fournisseur de Madame du Barry." *Gazette
des beaux-arts,* 6th ser., 60 (September 1962),
pp. 365–77.

Wildman 1984
Stephen Wildman. "The International Exhibition
of 1862." In *William Morris and the Middle
Ages,* ed. Joanna Banham and Jennifer Harris,
pp. 124–33. Exh. cat., Whitworth Art Gallery.
Manchester, 1984.

Wildman and Christian 1998
Stephen Wildman and John Christian. *Edward
Burne-Jones: Victorian Artist-Dreamer.* Exh. cat.,
The Metropolitan Museum of Art; Birmingham
Museums and Art Gallery, Birmingham, England;
and Musée d'Orsay, Paris. New York, 1998.

Wilk 1996
Christopher Wilk, ed. *Western Furniture, 1350
to the Present Day, in the Victoria and Albert
Museum, London.* London, 1996.

Wilkie 1987
Angus Wilkie. *Biedermeier.* New York, 1987.

Willscheid 2002
Bernd Willscheid, ed. *Gäste des fürstlichen
Hauses Wied.* Exh. cat., Kreismuseum Neuwied.
Neuwied, 2002.

Wilmering 1999
Antoine M. Wilmering. *The Gubbio Studiolo
and Its Conservation.* Vol. 2, *Italian Renaissance
Intarsia and the Conservation of the Gubbio
Studiolo.* The Metropolitan Museum of Art.
New York, 1999.

G. Wilson 1985
Gillian Wilson. "Two Newly Discovered Pieces of
Royal French Furniture." *Antologia di belle arti,*
n.s., nos. 27–28 (1985), pp. 61–68.

T. Wilson 1989
Timothy Wilson. "Maioliche rinascimentali
armoriate con stemmi fiorentini." In *L'araldica:
Fonti e metodi,* pp. 128–38. Ti con erre 18.
Florence, 1989.

Winckelmann 1880
Johann Joachim Winckelmann. *The History of
Ancient Art.* 4 vols. Trans. G. Henry Lodge.
Boston, 1880.

Windisch-Graetz 1982
Franz Windisch-Graetz. *Möbel Europas von der
Romanik bis zur Spätgotik.* Munich, 1982.

Windisch-Graetz 1983
Franz Windisch-Graetz. *Möbel Europas:*

Renaissance und Manierismus, vom 15. Jahr-hundert bis in die erste Hälfte des 17. Jahrhunderts. Munich, 1983.

Wolvesperges 1998
Thibaut Wolvesperges. "Les vicissitudes du marché des laques à Paris au XVIIᵉ siècle." *Histoire de l'art*, nos. 40–41 (May 1998), pp. 59–73.

Wolvesperges 2000
Thibaut Wolvesperges. *Le meuble français en laque au XVIIIᵉ siècle.* Paris and Brussels, 2000.

Wolvesperges 2001
Thibaut Wolvesperges. "French Lacquered Furniture at Waddesdon Manor." *Apollo* 153 (January 2001), pp. 3–8.

Wood 1994
Lucy Wood. *The Lady Lever Art Gallery: Catalogue of Commodes.* London, 1994.

Young 1986
Hilary Young. "Sir William Chambers and John Yenn: Designs for Silver." *Burlington Magazine* 128 (January 1986), pp. 31–35.

Young 1987
Hilary Young. "Sir William Chambers and the Duke of Marlborough's Silver." *Apollo* 125 (June 1987), pp. 396–400.

Zelleke 2002
Ghenete Zelleke. "An Embarrassment of Riches: Fifteen Years of European Decorative Arts." *Museum Studies* (Art Institute of Chicago) 28, no. 2 (2002), pp. 22–89.

Zeri 1971
Federico Zeri, with Elizabeth Gardner. *Italian Paintings: A Catalogue of the Collection of The Metropolitan Museum of Art.* Vol. 1, *Florentine School.* New York, 1971.

Zinnkann 2005
Heidrun Zinnkann. *Entfaltung: Roentgenmöbel aus dem Bestand.* Exh. cat., Museum für Angewandte Kunst. Frankfurt am Main, 2005.

Index

Bauer, Nikolaus, 118
Baumgartner, Melchior, cabinets for Munich
 court, 42, 43n7
Baumgartner, Melchior, workshop of, collector's
 cabinet [no. 13], 2, 40–43, 40, 41, 42
Baumgartner, Ulrich, cabinets for Philipp
 Hainhofer, 42
Bavaria, Elector of, Audience Chair, 122
Bavarian Electoral household, 102
Bayerisches Nationalmuseum, Munich, 136
 altar clock (Johann Valentin Gevers; Johann
 Andreas Thelot), 81
 collectors' cabinets (Melchior Baumgartner),
 42, 43n7
 commode (David Roentgen) [fig. 104], 180,
 181, 181, 182–83, 183n12
 console table, 136, 136n1
Bayerische Verwaltung der Staatlichen Schlösser,
 Gärten und Seen, Munich, carvings from
 Schloss Seehof wall brackets, 154n6
Bayerlein, Fritz, painting of Green Salon, Schloss
 Seehof, 122
Bayreuth, Princess Elisabeth Sophie Friedericke
 von, 136
Beatty, Edith Chester, 204
Beaufort, Charles Noel, fourth duke of, 126, 128
Beaufort, duchess of, 126–28
Beaufort, ninth duke of, 128
Beauvais Manufactory, tapestry from, 125, 126,
 129, 129, 130, 130n4, 130n5, 131
Becker, Baroness Renée de, collection, 204
Beckford, William, 210
bed, English chinoiserie [fig. 77], 126, 128. See
 also state beds
Bedford, fourth duke of, 155
bedrooms
 Chinese, Badminton House [fig. 77], 126, 128
 "Cov'd" or "Wrought," Houghton Hall
 [fig. 53], 88, 88
 state bedroom, Burley-on-the-Hill [fig. 43],
 72, 72
 state bedroom, Het Loo Palace, near
 Apeldoorn, Netherlands, 64, 72
beeldenkast [no. 10], 31–34, 31, 32, 33, 34n5,
 34n16
bee motif, 28, 29, 29, 30n5
Belton House, Lincolnshire, cabinet (attributed to
 Jan van Mekeren), 78n3, 78n11
Beningbrough Hall, North Yorkshire, chandeliers
 from, 84, 85n2
Benneman, Guillaume, 145, 146n11, 206
 secretary [no. 85], 204–6, 205, 206
 writing table (Waddesdon Manor), 145, 146n10
Bérain, Jean, 52, 81; writing desk [no. 17], 5,
 50–53, 50, 51, 52
Berchem, Nicolaes, engravings after, 98
Bergamo, Fra Damiano da, after Jacopo Barozzi
 da Vignola, Guicciardini table, 25n10
bergère, term, 207. See also under armchairs
Bernheimer, L., Munich, 107, 108n14
Bernini, Gianlorenzo, 46; baldachin, Saint Peter's,
 29, 90
Bernstorff, Andreas Peter, 129–30
Bernstorff, Baron Johann Hartwig Ernst, 129
Bernstorff Palace, Copenhagen, 129–30; tapestry
 room [fig. 78], 129–30, 129, 130n6
Bibliothèque Mazarine, Paris, 85
Biedermeier style, 221, 222
Biennais, Martin-Guillaume, 216, 220
 athénienne (after a design attributed to
 Charles Percier) [no. 91], 216–18, 217

medal cabinet with silver decoration by
 [no. 92], 218–21, 219, 220
Bietz, Madame de, 37n7
Bildhauermöbel, 106
Biller family, candlesticks, 194n3
Bingham, D. G., collection, Utrecht, 34
Birmingham, England, mounts from, 176n18,
 183n16
Birmingham Museums and Art Gallery, England,
 drawing for The Backgammon Players
 (Sir Edward Burne-Jones) [fig. 133], 234,
 234, 236n11
Bleak House, Newport, 141
bleu turquin marble, 181
Bliss, Mr. and Mrs. George T., 180
Bliss, Susan Dwight, 3
Blondel, Jacques-François, plan of Hôtel de
 Toulouse [fig. 112], 190, 190
Blumenthal, Ann Payne, 3, 210n18
Blumenthal, George, 3, 177, 210
Boccaccio, Giovanni, Decameron, 16n1
Boccapaduli, Margherita Gentili, portrait of
 (Laurent Pécheux) [fig. 98], 168, 168
Bode, Wilhelm von, 12, 20
Bohr, Michael, 30
bois des Indes, 175, 176n16
Boizot, Louis-Simon, secretary with gilt-bronze
 mounts modeled by [no. 85], 204–6, 205, 206
bonheurs-du-jour, 156–58, 157, 158, 158n1
Bonzanigo, Giuseppe Maria, 197–98; console
 table attributed to [no. 81], 197, 197, 197–98
bookcase on stand, from Palazzo Rospigliosi
 [no. 33], 4, 90, 91
Borghese, Cardinal Scipione, 186
Borromini, Francesco, 90
Boucher, François, 176n15
 Beauvais tapestries after, 129, 129, 130n4
 Gobelins tapestries after, 124, 124, 126n3,
 159–60, 160
Boughton House, Northamptonshire, desk
 (Martin Carlin), 158
Bouillat, Edme-François, secretary on stand with
 porcelain plaque by [no. 71], 170–71, 171
Boulle, André-Charles, 51, 53, 55, 66, 70, 78, 85,
 86, 106
 bureau plat, 85
 cabinet attributed to [no. 23], 66–68, 66, 67
 Design for a Cabinet [fig. 40], 66, 66
Boulle, André-Charles, workshop of, 66–68,
 68n5, 86, 86n8
 "bureaux," 85, 86n2
 commode [no. 31], 85–86, 85, 86, 87
 sarcophagus-shaped commode, 86n8
boulle marquetry (boulle work; "Sommer mar-
 quetry"), 37n16, 51, 53, 55–56, 56n9, 66, 67,
 68, 68n8, 78, 86
 contre partie, 54, 67, 68, 71n5
 première partie, 51, 52, 53, 54, 54, 55, 67, 68,
 71n5
Bourbon, Louise-Marie-Thérèse de, duchess of
 Parma, 120
Bourbon, Louis-Henri de, prince de Condé, 85
Bourbon-Penthièvre, Louise-Marie-Adélaïde de,
 190, 192
Bousseux, Louis, 116n11
Bowes Museum, Barnard Castle, Durham,
 mechanical table (Jean-François Oeben), 152
Brandely, Jean, cabinet [no. 101], 6, 238–40, 238,
 239
Brandenburg-Kulmbach, Karl August, margrave
 of, 53

Braunschweig-Wolfenbüttel, Margravine Sophie
 Caroline von, 15
Breck, Joseph, 57
bridal chests. See chests (cassoni)
Bristol Museum and Art Gallery, armchairs,
 128n8
British East India Company, 111
British Museum, London, 148; medal cabinet
 (attributed to William Vile and John Cobb)
 [fig. 85], 148, 148
Brocket Hall, Hertfordshire, chairs for (Thomas
 Chippendale), 165
bronze, tax mark, 115
Bronzeure Werner und Neffen, Berlin, porcelain
 table with bronze and metal mounts by
 [no. 96], 5–6, 229–30, 230, 231
Bruchsal, palace at, carved wood paneling
 (Ferdinand Hundt), 110
Brunelleschi, Filippo, 20; Baptistery, Florence,
 20
Brustolon, Andrea, design for a looking glass, 48
Brydone, Patrick, 215n4
Brympton d'Evercy, Somerset, chandelier (James
 Moore and John Gumley), 85, 85n5
Buckingham and Chandos, Richard Grenville,
 second duke of, 99
Buckingham House (Palace), London, 184, 186,
 186n13; West Library, 148
buffet (South German), 56n9
Buffet-Challié, Laurence, 61
bureau bookcase, 96
bureau brisé [no. 17], 5, 50–53, 50, 51, 52
"bureaux" (commodes Mazarines) (André-Charles
 Boulle), 85, 86n2
bureaux Mazarins, 52
bureaux plats, 52, 85, 175
 for Louis XV at Versailles (Gilles Joubert)
 [no. 57], 5, 144–45, 144, 144, 145
 for Louis-Henri de Bourbon, prince de Condé
 (André-Charles Boulle), 85
 See also writing tables
Burges, William, 234
Burghley House, Lincolnshire, corner cupboards
 and commodes (John Mayhew and William
 Ince), 162
Burley-on-the-Hill, Rutland, state bedroom
 [fig. 43], 72, 72, 72n4
Burlington, Lord, 113–14
Burne-Jones, Sir Edward, 234
 The Backgammon Players (Cambridge)
 [fig. 133], 234, 234
 cabinet (Backgammon Players Cabinet)
 [no. 99], 3, 234–36, 235

C, tax mark, 115
cabinets
 Design for a Cabinet (André-Charles Boulle)
 (Paris) [fig. 40], 66, 66
 Dutch, with ebony veneer and painted marble
 plaques (Heino) [fig. 21], 39, 40
 Dutch beeldenkast [no. 10], 31–34, 31, 32, 33
 English, with Backgammon Players (Philip
 Webb; Sir Edward Burne-Jones; Morris,
 Marshall, Faulkner and Company)
 [no. 99], 3, 234–36, 235
 French armoire (attributed to André-Charles
 Boulle) [no. 23], 66–68, 66, 67
 French armoire, in Merovingian style (Jean
 Brandely; Charles-Guillaume Diehl;
 Emmanuel Frémiet) [no. 101], 6, 238–40,
 238, 239

Photograph Credits